The Independent Group

This book is for return on or before the last date shown below

The Independent Group: Postwar Britain and the Aesthetics of Plenty

Edited by David Robbins

Exhibition Organized by
Hood Museum of Art, Dartmouth College
Institute of Contemporary Arts, London
The Museum of Contemporary Art, Los Angeles
University Art Museum, University of California at Berkeley

Introduction by
Jacquelynn Baas

Chronology by
Graham Whitham

Essays by
Lawrence Alloway
Theo Crosby
Barry Curtis
Diane Kirkpatrick
David Mellor
David Robbins
Denise Scott Brown
Alison and Peter Smithson
David Thistlewood

Retrospective Statements by
Lawrence Alloway
Mary Banham
Richard Hamilton
Geoffrey Holroyd
Magda Cordell McHale
Dorothy Morland
Eduardo Paolozzi
Toni del Renzio
Alison and Peter Smithson
James Stirling
William Turnbull
Colin St. John Wilson

The MIT Press
Cambridge, Massachusetts, and London, England

This publication accompanies the exhibition,
The Independent Group: Postwar Britain and the Aesthetics of Plenty

February 1 – April 1, 1990
Institute of Contemporary Arts, London

May 16 – September 16, 1990
Instituto Valenciano de Arte Moderno (IVAM), Centro Julio Gonzalez, Valencia

November 4, 1990 – January 13, 1991
The Museum of Contemporary Art, Los Angeles

February 6 – April 21, 1991
University Art Museum, University of California at Berkeley

June 8 – August 18, 1991
Hood Museum of Art, Dartmouth College, Hanover, New Hampshire

Organized by the Hood Museum of Art, Dartmouth College, Hanover, New Hampshire;
the Institute of Contemporary Arts, London; The Museum of Contemporary Art, Los Angeles;
the University Art Museum, University of California at Berkeley.

Organizing committee for the catalogue and exhibition: Jacquelynn Baas (Director, UAM, Berkeley), Mary Jane Jacob,
James Lingwood (Adjunct Curator, ICA, London), David Robbins, Timothy Rub (Assistant Director, HMA, Hanover),
Elizabeth Smith (Associate Curator, MOCA, Los Angeles), and Graham Whitham.

Edited by David Robbins with Barbara Anderman, Brenda Gilchrist, and Sheila Schwartz
Designed by Lorraine Wild, Los Angeles
Typeset in Clarinda and Joanna by Continental Typographics, Chatsworth, California
Printed by Donahue Printing Co., Inc., Los Angeles

The Independent Group is made possible by generous grants from the National Endowment for the Humanities and the National Endowment
for the Arts, Federal Agencies. Support for this project was also provided by David Hockney and by The British Council.

Library of Congress Cataloging-in-Publication Data
The Independent Group: postwar Britain and the aesthetics of plenty / edited by David Robbins.
 p. cm.
Exhibition organized by the Hood Museum of Art, Dartmouth College . . . [et al.] held between February 1, 1990
and August 16, 1991 at various locations.
 Includes bibliographical references.
 ISBN 0-262-18139-8 (MIT Hardcover Edition)
1. Independent Group (Association: Great Britain)—Exhibitions. 2. Art, Modern—20th century—Great Britain—Exhibitions.
I. Robbins, David. 1937– II. Hood Museum of Art.
N6766.5.I53I53 1990
709'.41'074—dc20 89-43668 CIP

Table of contents

Foreword and acknowledgements

At the close of World War II, Britain emerged triumphant. Nevertheless, a period of extensive rebuilding lay ahead. Over one-third of London had been destroyed and consumer shortages and economic restraints would continue for a number of years. In 1951 a resurgence in consumer production and cultural activities was celebrated in the Festival of Britain, a massive fair held on the south bank of the Thames whose theme was one hundred years of British achievement.[1] At the same time, an emerging generation of artists, architects, and critics grew critical of the prevailing domesticated, watered-down version of modernism. The basic task of this group seemed clear: to develop a new aesthetic that fully belonged to contemporary life. For counsel they looked to earlier twentieth-century European avant-garde movements – the Futurist commitment to technology, the Dadaist appropriation of collage and found objects, and the Surrealist zest for the city. Postwar realities, however, were dominated by American technology and popular culture, including car designs, advertising, science fiction, popular music, movies, and art. The British intellectual establishment regarded this Americanization of culture with distaste. But for artists such as Richard Hamilton and Eduardo Paolozzi, for the architects Alison and Peter Smithson, and for the critics Lawrence Alloway and Reyner Banham, among others, "America" represented the future and the unprecedented opportunities and problems presented by a new global mass culture.

By 1952, about fifteen young artists, architects, and intellectuals who frequented the Institute of Contemporary Arts on Dover Street, with the encouragement of the director, Dorothy Morland, had organized themselves into an elite discussion group. They soon became known as the Independent Group, because they met apart from the general body of the ICA. Years later, one of the members, the art critic Lawrence Alloway, recalled the prevailing attitude within the Group's discussions:

> We felt none of the dislike of contemporary culture standard among most intellectuals, but accepted it as a fact, discussed it in detail, and consumed it enthusiastically. . . . Hollywood, Detroit, and Madison Avenue were, in terms of our interests, producing the best popular culture. . . . We assumed an anthropological definition of culture in which all types of human activity were the subject of aesthetic judgment and attention.[2]

The members had many divergent interests as well, as the essays and retrospective statements in this catalogue make clear. Collectively, however, the IG was committed to exploring the democratizing implications of the "aesthetics of plenty," as Alloway called the abundance of popular communications media.[3] This exploration was carried out in the art, exhibitions, and writings of the various members as well as in their formal and informal discussions. At the threshold of the 1990s, when the prescience of the IG's hunches and speculations about an "information society" has been fully confirmed, a review of the achievements of the group, collectively and individually, seemed long overdue. It was imperative to bring the members of the Independent Group into this process, and each has responded generously. At the same time, new critical perspectives have been brought to bear on their achievements and the issues they addressed in the 1950s.

This exhibition and catalogue have been developed by a team of colleagues working in England and the United States. Jacquelynn Baas launched the project in the summer of 1986 when she was the director of the Hood Museum of Art at Dartmouth College. Iwona Blazwick, director for exhibitions at the Institute of Contemporary Arts, London, and her colleague, curator James Lingwood, expressed an interest in sharing the exhibition early on. Mary Jane Jacob, former chief curator, and Elizabeth Smith, associate curator at The Museum of Contemporary Art, Los Angeles, also expressed early interest, and the project soon became a collaborative one. When Jacquelynn Baas became director of the University Art Museum at the University of California, Berkeley, in the winter of 1989, that museum also became a partner. At that point Hood Associate Director Timothy Rub, acting director at Dartmouth during much of 1988–89, became an active participant, planning and coordinating the installations at the various sites.

The exhibition and catalogue could not have been accomplished in their present form without the knowledge and energy of two scholars – David Robbins and Graham Whitham. From American and British contexts, respectively, they have provided the in-depth understandings of the IG and its members' productions that we have drawn upon since the earliest stages of planning. David Robbins has served as pilot editor of this catalogue, handling the task of organizing its diverse materials and viewpoints into a coherent form. Graham Whitham's extensive research on the Independent Group, originally conducted in the process of writing a doctoral thesis, enabled us to appreciate the Group's full complexity and historical development at the outset of our project. It is chiefly due to Mr. Whitham's photographic researches, and to the sustained co-operative efforts of James Lingwood at the ICA, that we have such a remarkably balanced collection of photographs of IG mem-

bers from the period.

No less essential have been the contributions of our respective staffs. At the ICA, we would like to thank Ingrid Swenson, Exhibitions Administrator; Stephen White, Gallery Manager; Paul Andrew, intern at the ICA in 1988; and Mariska van dan Berg, intern at the ICA in 1989. At Dartmouth, we are grateful for the assistance of Rebecca Buck, Registrar; Evelyn Marcus, Curator for Exhibitions; and Laura McDaniel, Administrative Assistant. At Berkeley, we would like to acknowledge the skills of exhibition designer Nina Hubbs and her team of preparators; Registrar Lisa Calden; Exhibition Coordinator Lynne Kimura; Development Director Kim Litsey; Publicity Director Barbara Webb; Education Coordinator Sherry Goodman; and administrative staff members Arnold Sandrock, Linda Lippman, and Rebecca Cavanaugh. And at The Museum of Contemporary Art, we would like to express our appreciation to Sherri Geldin, Associate Director; Erica Clark, Director of Development; Vasundhara Prahbu, Director of Education; Robin Hanson, Government Relations and Grants Manager; Jack Wiant, Controller; John Bowsher, Exhibition Production Manager; Mo Shannon, Registrar; Alma Ruiz, Exhibitions Coordinator; and Linda Hooper-Kawakami, Curatorial Secretary.

We would like to extend our collective thanks to the former members of the Independent Group, who have been unfailingly gracious and helpful, and whose contributions to both the catalogue and the exhibition were indispensable. Several closely associated individuals have also made important contributions and we would like to thank them for their generosity: Mary Banham, London; Theo Crosby, London; Steve Henderson and Mrs. Janet Henderson, Thorpe-le-Soken, Essex; Freda Paolozzi, Cambridge; Michael Pine, Ottawa; and Marlee Robinson, London. In addition, colleagues at other institutions have made indispensable contributions. We would like to particularly thank Tom Finkelpearl and Brian Wallis, who organized a 1987 exhibition on the Independent Group at The Clocktower, and who generously made both information and their exhibition material available to us. Meg Sweet, Curator of the National Archive of Art and Design, London, was also extremely helpful. A substantial amount of library research was required for this project, and we are greatly indebted to Barbara Reed, head librarian at the Sherman Art Library of Dartmouth College, who assisted us in many ways over a considerable period of time. In addition, two lenders deserve special thanks: Colin St. John Wilson and Bill Malone.

We are grateful to David Hockney for his generous support of this exhibition, and to The British Council for its generous support and cooperation. Final thanks must, of course, go to the federal agencies that have supported us in the course of this project, the National Endowment for the Humanities and the National Endowment for the Arts.

All those named above, as well as those who have helped in ways too numerous to mention here, have our deepest gratitude. We hope that this exhibition and catalogue are a source of satisfaction to them, just as the process of working with the Independent Group has been to us.

JACQUELYNN BAAS,
Director, University Art Museum, University of California, Berkeley, California
JAMES CUNO,
Director, Hood Museum of Art, Dartmouth College, Hanover, New Hampshire
RICHARD KOSHALEK,
Director, The Museum of Contemporary Art, Los Angeles, California
BILL MCALISTER,
Director, Institute of Contemporary Arts, London

1. See Mary Banham and Bevis Hillier, eds., A Tonic to the Nation (London, 1977).
2. Lawrence Alloway, "The Development of British Pop," in Pop Art, ed. Lucy R. Lippard (New York, 1966), pp. 32, 36.
3. Lawrence Alloway, "The Long Front of Culture," Cambridge Opinion, 17 (1959), p. 25; reprinted in Pop Art Redefined, ed. John Russell and Suzi Gablik (New York, 1969), p. 41.

Introduction

*The "interval of wonder" is astonishingly small in most people. . . . A world of
no change is boring beyond endurance – yet it seems to me that a lot of people
are missing the immense and joyous stimulus of living in a period when the
world is changing, accelerating, faster than it ever did before – by a sort of
mental blackout. They blank out the acceleration period, like a rocket pilot
who passes out during the 8g thrust of the takeoff, regaining awareness only
after the change of speed has been made.*

Nothing captures the aggressively contemporary spirit of the British Indepen-
dent Group of the 1950s better than this quotation from an editorial by John
W. Campbell, Jr., in the July 1953 issue of one of the IG's favorite American
magazines, *Astounding Science Fiction*.[1] Campbell's "interval of wonder," the
ardor for experiencing and analyzing the effects of change, was the unifying
attribute of this group of extremely talented young artists, architects, and
critics who were active at the Institute of Contemporary Arts. Their apt desig-
nation as the Independent Group, or IG, reflected their differences from one
another as well as their freedom from interference by the ICA, the sponsoring
organization.

The Institute of Contemporary Arts was founded and managed by
spokesmen for modern art such as Roland Penrose and Herbert Read, who
had established their reputations and developed their cultural perspectives
before World War II. In contrast, Independent Group members, most of
whom had been born between 1920 and 1925, were in some cases directly
influenced by their wartime experiences. Almost all of them were affected
indirectly by the war, since the return of the service generation placed their
careers at a disadvantage. The pent-up energy of this situation was partly
responsible for the creative friction that characterized the Independent
Group. These young professionals were prodigiously intelligent and argu-
mentative, with a zest for public debate. The present exhibition and cata-
logue are intended to identify the divergences as well as the convergences
within their productions from this period. Collectively, however, they chal-
lenged the humanist assumptions of British aesthetics, launching instead an
aesthetic of change and inclusiveness – anti-elitist and anti-academic, subver-
sive of hierarchies, and at home in mass culture. IG members were first cele-
brated as the "Fathers of Pop"; now we see them in a broader context, as
pioneers of the new directions in postwar cultural discourse. This catalogue
is intended to provide a contemporary sense of the achievements of the
Independent Group, collectively and individually. The precise extent and
nature of its influence on subsequent developments has never been more
vigorously debated – not least of all by the members themselves, as is evident
in the retrospective statements contained in this catalogue.

IG "membership" was an informal matter; no dependable records
listing those who attended meetings seem to have survived. Participation was
fluid, with a year-and-a-half hiatus between the first set of meetings in
1952-53 and the second in 1954-55. Furthermore, the Independent Group was
one of several groups within the same milieu of young professionals. Thus
the core group (primarily the principals in this exhibition and catalogue) was
regularly supplemented by friends and newcomers. (Attendance during the
1955 meetings fluctuated between fourteen and twenty-two.) In the course of
planning this exhibition, our working idea of IG membership was largely
developed from interviews with surviving ex-members, each of whom
would suggest a slightly different reconstruction of the group, tending either
toward an exclusive or inclusive definition. Although there will never be an
agreed-upon inclusive "membership list," our working list of the IG con-
tained the following names: the critics Lawrence Alloway and Reyner Ban-
ham; publications designer and critic Toni del Renzio; musician Frank
Cordell; artists Magda Cordell, Richard Hamilton, Nigel Henderson, John
McHale, Eduardo Paolozzi, and William Turnbull; architects Geoffrey
Holroyd, Alison and Peter Smithson, James Stirling, and Colin St. John
Wilson. The architect and editor Theo Crosby recalls attending early IG meet-
ings, was part of the milieu (as his essay here makes clear), and played a
major role in publicizing IG ideas as editor of *Architectural Design*, as the orga-
nizer of the *This Is Tomorrow* exhibition, and later as the editor of *Uppercase*. Yet
he is not generally recalled as being an "IG member." Again, some members
would omit a few of the above names or add others; we apologize to anyone
who has been left out.[2] The Independent Group would not have been what
it was – iconoclastic, professional rather than academic in outlook, prodi-
giously urbane and yet idealistic about the capacity of the common man for
criticism and change – were it not for the unprivileged, "street-smart" back-
grounds of most of its members. Paolozzi sold ice cream as a boy and
expected to be a commercial illustrator. Turnbull left school at age fifteen to
become a commercial illustrator. Banham left school to take industrial jobs.
Hamilton worked for a tool-and-die firm as a teenager. Peter Smithson was a
working-class boy in Newcastle, as was McHale in Glasgow. Alloway was writ-
ing "filler" book reviews for the *Sunday Times* when he was sixteen, and
learned art history in night school. They were thus commercially and techni-
cally trained, self-educated people, at home in the city, with a profound
underclass suspicion of social and academic privilege. Despite their talent
and maturity, most of the IG members saw themselves as outsiders, having
less professional standing, as yet, than they deserved. Their anti-
authoritarianism and iconoclasm thus had a distinctly personal, competitive
edge that defined the tone of the group's discussions.

Another important biographical point is that, while the members
tended to see America as "other," with a residue of exoticism attaching to its
magazines and commodities, a significant number of them had personal con-
tact with the United States during the late 1940s and 1950s. Del Renzio stud-
ied for fifteen months at Columbia University; Stirling worked in New York
and visited Chicago and Los Angeles in 1949; Holroyd studied at Harvard and
visited those and other cities in 1952-53; McHale studied with Albers at Yale
in 1955; Peter Smithson visited America in 1957; Alloway did so in 1958.
Frank Newby, an architectural engineer who was close to the architects in
the group, met the Eameses in California in the early 1950s. Magda Cordell
traveled to America in 1955. It was not, then, simply a matter of fantasizing an
"aesthetics of plenty," but of an informed, media-conscious engagement with
American culture.

Among the various writings in this catalogue are retrospective state-

ments by the surviving members of the Independent Group (including Dorothy Morland, the ICA director at the time), and longer essays by Lawrence Alloway, Theo Crosby, and Alison and Peter Smithson. These writings are the most important part of the catalogue, and it would be foolhardy to attempt to summarize the diversity of perspectives they represent. When we interviewed Alison Smithson she observed – quite prophetically, as it turned out – that any attempt to construct a history of the Independent Group was bound to be thwarted by the "*Rashomon* factor." Memories and opinions conflict and are intertwined with each individual's goals, feelings, and retrospective evaluations. Lawrence Alloway's introductory overview, however, conveys an undeniable fact – the most important characteristic of the Independent Group was its critical intelligence. That quality pervades his own essay, along with the sense that the issues raised by the IG are still with us.

Alison Smithson's discussion of the "as found" aesthetic recovers the special excitement of that historical moment, when the early avant-garde was being consciously revalidated in postwar terms. Theo Crosby's recollection of the architectural milieu in the early 1950s is charged with the sense of a world pulling itself together after the war, with the ruins still at hand. We should not forget this context as we reconstruct the appeal of American technology and media. Denise Scott Brown recalls her student days at the Architectural Association in London, when the ideas of the New Brutalism and the rediscovery of the city were vitalizing the cultural ambience of a new generation. Her discussion of the connections between British and American developments in the 1950s and 1960s clarifies her own important role in this regard.

The dialogue between British and American perspectives operates at every level of this catalogue, from the period of the Independent Group to the cooperative effort of producing this exhibition.[3] The interpretive discussions by American and British scholars reconstitute this dialogue in contemporary terms. Two richly contextualized British overviews by Barry Curtis and David Mellor represent a conversation, in effect, about the social significance of the Independent Group. Curtis stresses the IG's optimistic preoccupation with consumer culture on the threshold of an era of abundance, while showing how it used commercial and technological developments to challenge established notions of cultural value. Mellor places the IG in the historical context of "Tory futurism," interpreting the Brutalist side of the IG as an effort to counter the enthusiasm of Banham, Hamilton, and others for the "new tomorrow" of consumerism.

From an American perspective, David Robbins analyzes the contemporary significance of the Independent Group in pluralist terms, testing the relevance of a variety of postmodernist perspectives while identifying issues that divided IG members. Diane Kirkpatrick provides a useful view of the aesthetic approaches brought to the IG by Paolozzi, Henderson, Turnbull, and Hamilton, all of whom had revolted against the orthodoxy of the Slade School of Art. The British art historian David Thistlewood discusses the aesthetic and pedagogical issues generated at the Central School of Art, issues that the Smithsons, Paolozzi, Turnbull, and others who taught there brought into the ambience of the IG.

The lacunae created in this project by the absence of IG members who have not survived the thirty-odd years since the group's dissolution – Frank Cordell, Nigel Henderson, John McHale, and, most recently, Reyner Banham – have been felt deeply by all of us involved. The loss of Reyner Banham in the winter of 1988 was a special source of sorrow. A key member of the Independent Group who was to a certain extent its initiator and chief spokesman, Banham made himself available for two interviews with me, during which he several times expressed his enthusiasm for the project. As his contribution to this catalogue, he had intended to write a commentary on his poem "Marriage of Two Minds," which follows Lawrence Alloway's introductory statement in the catalogue for the *This Is Tomorrow* exhibition. Regrettably, he was unable to accomplish this before he died.

Both the poem and Alloway's catalogue statement, "Design as a Human Activity," are summations of the Independent Group's iconoclastic transformations of the modern tradition. As Alloway writes, art and architecture have become "a many-channeled activity, as factual and far from ideal standards as the street outside."[4] Banham's poem conveys the liberating excitement of this historical moment and of the IG itself as the laboratory of its collective discovery. Although we shall never have the benefit of Banham's own commentary, a brief sketch of his message will serve to introduce the ongoing critique of modernism within the Independent Group and to situate it historically.

"Marriage of Two Minds" is Banham's mini-history of modern design, structured around the playful conceit of the title. The marriage is between the two culture-worshiping traditions of modernism: "HIS," classical and totalitarian ("one will directing hierarchy of hands" toward the Wagnerian "dream of gesamtkunstwerk"), and "HERS," romantic and medievalizing (the Ruskin-Morris line of "wills and hands in free association"). The "orwellian consequence" of this marriage is to empower the macho architects as "self-imposed leaders of free collaborators," with Gropius as "culture hero." Since this "congress and union" forces all the arts to forget the egalitarian vision of van de Velde and Art Nouveau and submit to a single-minded discipline of geometrical rationalism, the progeny ("IT'S A CUBE!") is predictable – "mondriaan in 3D on the scale of man." Banham's generation (the "GROWING LAD") awakens within this "undifferentiated environment" of modernism. The youth discovers, however, that the apparently bleak situation contains liberating possibilities.

Since the separate arts have disappeared into a wholly abstract but human-scale world that "is environment when entered by you," neither the designers nor their media matter any longer. The old power of cult objects and cult heroes is finally broken.

> this is where you come in when
> the barriers are down and only
> undifferentiated environment remains
> even within the space frame opens out
> ways beyond the arts
> doorkeeper
>
> alexander dorner

Dorner, author of *The Way Beyond "Art"*, published in 1947, here performs the archetypal bodhisattva's task of guiding us beyond illusion without assuming any personal authority. I shall return to him shortly.

9

MARRIAGE OF TWO MINDS. by Reyner Banham

HIS
authoritarian hegelian metaphysical
dream of gesamtkunstwerk great union of
all disciplines total art
ideal conception of spiritual harmony under single
 godlike mind
tradition of
 roman planning wagnerian opera synthetist
 theatre
 eupalinos l'esprit nouveau la groupe espace
one will directing hierarchy of hands
culture hero
 leonardo da vinci

HERS
libertarian rousseauistic mediaevalising
dream of willing collaborators under
scriptorium conditions AMDG
or at least AMG of some high pure aspiration without pretense
tradition of
 nazarenes preraphs kelmscott century guild
 worpswede werkstatte bauhaus
wills and hands in free association
cult object
 gothic cathedral

10 DO YOU TAKE THIS?
in art nouveau
van der velde architect and needleman proclaims
equality of all the arts
but orwellian consequence
one
 architecture
 proves
more equal than the other arts together and
architects
 become
self imposed leaders of free collaborators
elected heads of ideal hierarchies
having it both ways and eating it
cult object
 AEG
culture hero
 walter gropius

IT'S A CUBE!
congress and union found to lie
in common logic of formal aesthetics
marriage that is of pure commensurables
ratio of measures and harmony of colours
tending to
 architecture painting sculpture
discipline seen as one
 of placing coloured planes in space
 square additive mechanical grounded
 in nature of materials and hue tone
 structure dimensions of art objects
cult object
 space frame
culture hero
 max bill
end product
 mondriaan in 3D on the scale of man

GROWING LAD
on the scale of man is big
enough to get inside
matrix of planes grid of lines
is environment when entered by you
and not you but catalogue alone can say
who put
coloured plane on coloured post
 painter? architect?
coloured post on coloured plane
 architect? sculptor?
coloured plane on coloured plane
 sculptor? painter?
this is where you come in when
the barriers are down and only
undifferentiated environment remains
even within the space frame opens out
ways beyond the arts
doorkeeper
 alexander dorner

MAN NOW
beyond art is a long way get off
wherever you like
beyond
 horizontal
 vertical
 measure
 harmony
the further on the nearer abstract
to the supremacy of you figurative
entered observer without aesthetic
whom even
the most complex structure
is no environment with
whom
even a hole in the ground is

for you
imprinted with symbols of human interests
contraceptive packs spent
cartridge cases roman pots
golf balls coal kilroy
was here
 symbols that work in some
social contexts channels of information
 but not all
men are equal
 as to
nose eyes ears mouth hands feet
 less so as to
language marrying brunettes
saying dont know 9 per cent
having heard of cybernetics
much less so as to
having heard of jackson pollock annette klooger
coppi oberth abarth dirty dick godot nkruma tex
RTP TNP IBM IBV PMI PLM PSI ESP EEG ARB IOJ NPL ZDA
providence rhode island or divine
never mind
 how you rate the fact is you do rate
contexts are made of you
 your likes
 and dislikes
 semblables
 and freres
 no need to stick to squares
master your context and the rest
symbols and channels shall be added unto
 you
cult object
 you
culture hero
 you
end product
 you

"MAN NOW" leads "beyond art . . . to the supremacy of you." It is we, the "entered observers," who alone can define the environment. The poem's final section is Banham's version of the IG aesthetic. It is a passage through the "symbols of human interests" – found objects, signs, and information bits, from Pollock and cybernetics to everyday abbreviations – that prove "contexts are made of you." "You" can thus receive back the cult object, culture hero, and "end product" that have been left behind, albeit now in the form of communications – through "symbols and channels." Banham's plea for an independent critical intelligence, freewheeling and context-responsive, is as badly needed today as it was in 1956. His own career was certainly a demonstration of its powers.

Finally, I want to return to Banham's epithet for Alexander Dorner: "doorkeeper." It was an apt designation for Dorner, who as a museum director in the 1920s showed how museums could work with modern artists to move beyond the traditional art historical presentation of isolated aesthetic objects, viewing them instead within their physical and cultural context. With the IG in mind, it is significant that the book to which Banham refers, The Way Beyond "Art", was written to promote the commercial design work of Herbert Bayer.5 Here, Dorner describes how his own traditional Germanic art-historical training was challenged when he was appointed director of the Hanover Museum in the mid-1920s. As Dorner describes it, the nineteenth-century traditions in which he had been trained ("art evolution" refers to Riegl's view of art as spiritual progress) left him ill-prepared to cope with the heterogeneity of the Hanover collection, which contained natural history and anthropological artifacts as well as traditional art objects. This led to his radical questioning of "art" as an arbitrary retreat from the "changing forces of life" and to the environmental exhibitions he organized with El Lissitzky and Moholy-Nagy, which assigned an active role to the spectator-observer. Dorner's account of these famous shows may have influenced the IG-related exhibitions of the Smithsons and Paolozzi; it certainly influenced those of Richard Hamilton.6

Like John Campbell in Astounding Science Fiction, Dorner in his Way Beyond "Art" strove to convince the postwar reader that coming to terms with change was the key to the creation of a "new species of visual communication" that would allow humankind to step over the threshold into the future:

> Socrates tried to find words that would express the newly discovered concept of immutability beyond all sensual change, while we are trying to coin terms which will thrust beyond this immutable cause into an even greater depth and dynamize the static ground itself. . . . The expression "the way beyond 'art'" . . . should mean an explosive transformation of the very idea art. We have set art in quotation marks to indicate that even our conception of art is but a temporary fact in human history. This semantic problem is part of a universal problem: the transition from thinking in terms of eternal basic conditions to thinking in terms of a self-changing basis.8

For Dorner, the means for this transition was provided by a seemingly unlikely source – American pragmatism, which, according to Dorner, "has set the formerly static ground of reality in motion." That formulation applies equally well to the Independent Group, which also assumed that "practical, i.e. change-creating, experience transforms the essence of conceptions."9 The depth of Dorner's interest in pragmatism is indicated by John Dewey's preface to The Way Beyond "Art."

As an American museum director who assumed responsibility for a museum in another Hanover with an equally eclectic collection, I find it curious that precisely when I was looking for conceptual assistance, there was also a revival of theoretical interest in heterogeneity and pragmatism. (I was appointed chief curator of Dartmouth College's Hood Museum of Art in Hanover, New Hampshire, in 1982.) I now find a remarkable set of affinities between the inclusivist horizon that clearly lies ahead for all museum people, the anti-elitist approach to culture shaped by the Independent Group of the 1950s, and Dorner's innovative approach to his museum thirty years before that. Facing up to the increasingly heterogeneous character of Western society, the Independent Group followed Dorner in rejecting the traditional assumptions of art history and aesthetics. For both, the redefinition of "art" was partly a social project. The members of the Independent Group were able not only to embrace change, but also to demonstrate the critical opportunities it provided. It is our hope that this exhibition and catalogue will stimulate a more informed recognition of their achievements, both individually and collectively.

JACQUELYNN BAAS

1. John W. Campbell, Jr., Astounding Science Fiction, 51 (July 1953), pp. 6, 8. Astounding Science Fiction was an Independent Group staple. Published in Manhattan (the offices commanded a view of the United Nations, photographed for the cover of the November 1953 issue), the magazine presented to its readership advanced research and speculation in fields as diverse as physics, mathematics (including game theory), and linguistics. These articles, which displayed a marked tendency toward the esoteric, were interspersed with works of fiction and reports on such topics as the threat of the bomb and problems of nuclear waste disposal. An editorial by Campbell introduced each issue.

2. Four women should also be mentioned in accounts of the IG, either because they regularly attended the meetings or because of their contributions to IG projects: Mary Banham, Terry Hamilton, Judith Henderson, and Freda Paolozzi. Mary Banham discusses the issue of women in the IG in her retrospective statement, and Lawrence Alloway in his essay acknowledges the prevailing sexist bias.

3. Editorially, we have acknowledged this dialogue by keeping British conventions of usage, rather than Americanizing them, in all writings by British authors outside of the catalogue staff.

4. Alloway's "Introduction 1: Design as a Human Activity" precedes Banham's "Introduction 2: Marriage of Two Minds" and David Lewis's "Introduction 3" in the unpaginated catalogue to This Is Tomorrow (London, Whitechapel Art Gallery, 1956). See the reprint of this catalogue on pages 00 of the present catalogue.

5. Alexander Dorner, The Way Beyond "Art": The Work of Herbert Bayer (New York, 1947).

6. See Dorner's description of El Lissitzky's Room of Abstract Art in the Hanover Art Museum (Way Beyond Art, pp. 114-117); or compare Dorner's publication of Herbert Bayer's "diagram of extended vision in exhibition presentation, 1930" (p. 199) with the Smithsons' plan for Parallel of Life and Art (cat. no. 70). Richard Hamilton's exhibitions appear to have been particularly close in spirit to Dorner's "relativistic," environmental philosophy of exhibition design. Compare Hamilton's Man, Machine and Motion and an Exhibit (see the "Exhibitions" section) with Dorner's description of El Lissitzky's exhibitions (p. 199): "It was first in the Leipzig exhibition of 1927, and later in the Pressa at Cologne, 1928, that Lissitzky used large suspended photomontages and enlargements (they were held only by a thin and barely visible wire netting), as well as cellophane and multicolored paper in such complete relativity that the visitor was irresistibly drawn into the exhibition and forced to exercise his energies."

7. Ibid., p. 15.

8. Ibid., p. 19.

Chronology

by Graham Whitham

Forty Thousand Years of Modern Art. Organized by the ICA. Held at the Academy Cinema, December 1948–January 1949.

1950 and before

Forty Thousand Years of Modern Art. Hans Arp's sculpture, Growth, with Picasso's Demoiselles d'Avignon in the background.

1946

July	Bread rationing introduced in Britain.
December	Coldest winter in Britain for fifty-three years.
January 30	First postwar meeting of the London ''Museum of Modern Art'' Organizing Committee.
May	Name ''Institute of Contemporary Arts'' adopted by Organizing Committee.
September	Council of Industrial Design's exhibition Britain Can Make It opens at the Victoria and Albert Museum.

1947

March	Severe flooding in southern England.
October	Butter and meat rationing increased in Britain.
November	Marriage of Princess Elizabeth to Lieutenant Philip Mountbatten.

1948

February 9	Forty Years of Modern Art exhibition opens at the Academy Cinema in Oxford Street. Organized by the ICA. Exhibition closes 6 March.
May	Victor Pasmore teaching at the Central School of Art.
December 21	Forty Thousand Years of Modern Art exhibition opens at the Academy Cinema. Exhibition closes 29 January 1949.

1949

March	Clothes rationing ends.
August	First test flight of the Comet (first commercial aircraft to be powered by jet engines).
December	First regional television station opens.
	Eduardo Paolozzi teaching at the Central School of Art.

1950

January	Milk rationing ends in England.
February 28	Labour government formed with reduced majority of seats in the House of Commons.
May 26	Petrol rationing ends in Britain.
June 25	Korean War begins.

Publication of David Riesman's The Lonely Crowd.

Work begins on Hunstanton Secondary School, designed by Peter and Alison Smithson.

January	Edward Wright teaching at the Central School of Art.
June	James Joyce: His Life and Work exhibition opens at the ICA in Dover Street. Catalogue and exhibition designed by Richard Hamilton.
October	William Turnbull teaching at the Central School of Art.
December	Aspects of British Art exhibition opens at the ICA. Exhibitors include Richard Hamilton, William Turnbull, and Eduardo Paolozzi.
12	ICA Dover Street premises officially opened.

17–18 Dover Street. The ICA occupied the first floor and some upstairs rooms between 1950 and 1968.

Roland Penrose, Henry Moore, Peter Gregory,
and Dorothy Morland at Venice Biennale, 1948.

Aspects of British Art
show at ICA, December
1950. The painting
behind the gallery
assistant is Richard
Hamilton's <u>Micro-
cosmos (Plant Cycle)</u>

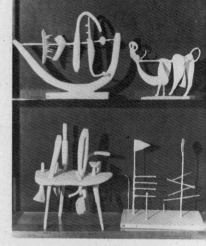

Sculptures by
Paolozzi (top: <u>Forms
on a Bow</u> and <u>Standing
Sculpture</u>) and Turn-
bull (bottom: <u>Mobile
Stabile</u> and <u>Sculp-
ture</u>), shown in
<u>Aspects of British
Art</u>, 1950.

Alison Smithson and Theo Crosby,
summer 1949.

Eduardo and Freda Paolozzi, 1950.

1950 and before

For the five years after the end of World War II, until it lost its working major-
ity in Parliament and eventually the election in 1951, the Labour government
strove to maintain full employment. Although it was largely successful in this
enterprise, the price was continued rationing, high taxation, and a general cli-
mate of austerity. For many people it was as if the war had never ended.
Symptomatic of this situation was the Victoria and Albert Museum's design
exhibition *Britain Can Make It*, held in 1946. Government policy to keep con-
sumption of goods down and encourage the export drive led to many of the
exhibits being labeled for export only and to the press retitling the show
"Britain Can't Have It."

Although rationing and shortages were a part of everyday life, the
cultural horizon looked a little rosier. There had been a slow but powerful
realization during the war that culture was one of the things for which Britain
was fighting. To some extent this was vindicated by events when the war
ended: the Council for Encouragement of Music and the Arts, which had
been formed in 1940, became the Arts Council in 1945; the following year
BBC Radio's Third Programme began broadcasting and the Institute of Con-
temporary Arts was established; and in 1947, the first Edinburgh Festival of
Music and Drama was held, whilst the announcement was made that a Festi-
val of Britain would open in May 1951.

Of all these events, the most significant for the future Independent
Group was the foundation of the Institute of Contemporary Arts. Originally
proposed before the war by Roland Penrose, Herbert Read, Peggy Gug-
genheim, and others, the ICA held its first event – an exhibition called *Forty
Years of Modern Art* – in the basement of the Academy Cinema in Oxford Street
during February 1948. The ICA had no permanent premises until the middle
of 1950, when it rented the rooms one floor up at 17-18 Dover Street, just off
Piccadilly and once the home of Lady Emma Hamilton. With various expan-
sions, it remained there until it moved to its present site in The Mall in 1968.

The ICA was one of the few forums available in postwar London
where artists, writers, musicians, and anyone else concerned about contem-
porary culture could discuss and exchange ideas. It was certainly the most
sophisticated forum, and after the Dover Street premises were opened in
December 1950, a full and lively program of events was operated under the
directorships, initially, of Ewan Phillips and then, after 1951, of Dorothy
Morland.

William Turnbull with
his <u>Hanging Sculp-
ture</u>, 1949.

13

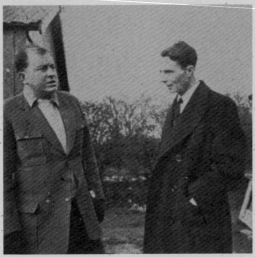

Construction of
Alison and Peter
Smithson's Secondary
School at Hunstanton,
about 1950.

Peter Smithson and
Ronald Jenkins at Hun-
stanton site.

● **1950** and before

''The beginnings of the Institute of Con-
temporary Arts go back to the thirties
and especially the International Surre-
alist exhibition held at the New Bur-
lington Galleries during the summer of
1936.... One result of this close con-
nection between the artists, galleries,
collectors and publications under the
banner of Surrealism was the idea of a
museum in London devoted to contempor-
ary art. Based on the model of the Museum
of Modern Art in New York, [it was] felt
that London could and should support
such an undertaking that would be far
more adventurous than the Tate Gallery
or the Arts Council. An establishment
that could allow contemporary artists
to meet frequently and talk about their
work was necessary as there was no sub-
stitute in London for the Parisian cafes
or the New York bars.''
John Sharkey, ''A History of the Insti-
tute of Contemporary Arts Compiled from
its Archival Material 1946–1968,''
unpublished manuscript.

''Now in those years leading up to the war,
it had reached the stage where Peggy
Guggenheim was going to open a museum of
modern art in London, and her collection
was going to be the core. And Read was

going to be the director of it. With the
problems of the war, Peggy Guggenheim
wasn't risking staying here and she went
to New York and eventually set up... Art
of This Century.... So, as the war was
over, there were a number of people
interested in doing something. And
there'd been a number of meetings. And
amongst the people who really virtually
set off to create the ICA was Roland Pen-
rose, Peter Gregory, who'd been the
director or owner of Lund Humphries, and
Peter Watson. I think they were the
chief financiers of it. There were other
people linked with it which included
Mesens.''
Toni del Renzio, Interview, 23 February
1984.

''The ICA premises in Dover Street were
nondescript and more suitable to the
garment trade than to lecturing and
mounting exhibitions.''
Edward Wright, ''The Anglo-French and
the ICA,'' unpublished manuscript, 16
February 1984.

''I remember it as being a very happy,
effervescent evening, everybody in good
spirits and looking very nice, but I
don't remember many details as they were
very early days for me. I was one of the
modest helpers running around with
glasses and trays and all that sort of

thing. But I do remember Eduardo
Paolozzi and Nigel Henderson stalking
in with two beautiful glass bricks full
of coloured waters and dumping them down
as much as to say, 'Here they are, take
them or leave them.' It was their idea of
decorating the bar, and I think they had
some coloured bottles too.''
Dorothy Morland on the opening of the
ICA in Dover Street, in Sharkey, ''A
History of the Institute of Contempor-
ary Arts.''

''And I got to know Roland Penrose....I
suppose they [the ICA] were always look-
ing for people who were prepared to put
in a bit of time and who were reasonably
knowledgeable. So I got into an exhibi-
tions committee there. And it was in the
Dover Street days, on a much more inti-
mate scale....It was a place you could
very conveniently and very amicably
just drop in on; there was a bar there.
And a number of one's friends, people
like Eduardo Paolozzi and so on, would
also be there. So it was quite a good
place to say, we'll meet in the evening,
if we're going to do something; just
meet in the bar. There was usually a good
exhibition on and you'd bump into people
like Peter Watson, who was another one
of the organizers there — a very
interesting man. And I suppose a general
result of the small talk, getting to
know people, one got more and more
involved, drawn into it.''
Colin St. John Wilson, Interview, 9 May
1983.

''I gave him [Paolozzi] a hand with the bar
[at the ICA] which, for people like
myself, who like to drink alongside all
that talk, became quite a meeting place.
Probably an important incubator for the
IG!''
Nigel Henderson, Letter to Graham
Whitham, 20 February 1983.

14

Richard Lannoy at the ICA's Graham Sutherland exhibition, April 1951.

The members' room at the ICA, 1951.

The Institute of Contemporary Arts requests the pleasure of your company at the private view of the exhibition, Ten Decades. 8 p.m.—10 p.m. on Thursday 9th August 1951 at the R.B.A. Galleries, 6½ Suffolk Street, Trafalgar Square, s.w.1.

Light Refreshments will be available

Ten Decades *A review of British Taste 1851-1951*

A Festival of Britain Exhibition by arrangement with the Arts Council of Great Britain

Invitation card to the private viewing of Ten Decades, ICA, August 1951.

January 1	End of Marshall Aid to Britain.	Publication of Marshall McLuhan's *The Mechanical Bride: Folklore of Industrial Man.*
June	Donald Burgess and Guy Maclean defect to the USSR. Both are members of the ICA.	
October 25	General Election won by the Conservatives. Winston Churchill becomes prime minister.	
January	Dorothy Morland appointed director of the ICA. Peter Smithson teaching at the Central School of Art.	
February 20	Paintings by Humphrey Jennings exhibition opens at the ICA.	
April 10	Graham Sutherland exhibition opens at the ICA.	
May 2	Festival of Britain opens.	
30	Young Painters and Sculptors exhibition opens at the Warner Theatre, Leicester Square. Exhibitors include Hamilton, Paolozzi, and Turnbull.	
July 3	Growth and Form exhibition opens at the ICA. Organized by Richard Hamilton. Exhibition closes 31 August.	
12	Lecture by Philip Johnson: Modern Architecture (ICA).	
August 9	Ten Decades: A Review of British Taste exhibition opens (ICA).	
11	Black Eyes and Lemonade exhibition opens at the Whitechapel Art Gallery.	
September	Discussion about Growth and Form (ICA).	
October	Nigel Henderson teaching at the Central School of Art.	
November 12	Lecture by Thomas Hess: New Abstract Painters in America (ICA).	

Toward the end of the year, some younger members of the ICA put forward suggestions for lectures to the Management Committee. These members are later to form the Independent Group.

15

July 4 — August 31

Open 10 a.m. - 6 p.m.

Closed Sundays and August 6

Admission 1/6

I.C.A. Gallery Institute of Contemporary Arts, 17-18 Dover Street, W.1.

exhibition GROWTH AND FORM

the development

of natural shapes

and structures

Nigel Henderson.

Judith Henderson.

1951

Less than a year after the ICA settled into its Dover Street premises, some of the younger members who met there informally began to sound out the management about the possibility of staging lectures and discussions of their own. The desire seemed to have been born out of the similar interests of these members, many of whom taught at the Central School of Art. Excluded from establishing their views by the entrenched hierarchy of British culture, and checked in their search for a professional role by the war, they were unified in their antagonism to what they regarded as an institutionalized view of twentieth-century art manifested in the ICA's program of events.

When the Festival of Britain opened in May, it confirmed the worst suspicions of the ICA's "Young Turks." It seemed that the cultural establishment had stumbled into the postwar world with its eyes fixed on a rearview mirror and was championing the Contemporary Style, a curiously eclectic and bizarre interpretation of modernism which was somewhere between thirties Deco, Joan Miró, and scientific models of molecular structure.

The ICA's own contribution to the festival was an exhibition entitled *Ten Decades: A Review of British Taste 1851-1951*. Although it was conventional in its theme and its exhibits, it would be a mistake to believe that the ICA was exclusively retrospective in its views. If this had been so, the *Growth and Form* exhibition might never have appeared. Originally mooted by Nigel Henderson, Eduardo Paolozzi, and Richard Hamilton, and eventually taken on single-handedly by Hamilton, this show was the ICA's other contribution to the festival. It proved to be far more original and controversial than *Ten Decades*, introducing the concept of a multi-media show with non-art imagery, with the exhibition to be seen as an art form in itself. Furthermore, it was the opening salvo in an attack upon the traditional, establishment aesthetic which Hamilton and his colleagues would launch, with ammunition provided by Sigfried Giedion, D'Arcy Wentworth Thompson, Marcel Duchamp, Alfred Korzybski, A. E. van Vogt, et al.

The rearview-mirror mentality which dogged British culture generally manifested itself at the ICA with special emphasis on Surrealism. This was neither surprising nor particularly regressive, first because the founding fathers of the Institute were almost all connected with prewar Surrealism, and second because Surrealism itself did represent something of a stand against accepted values. But a program of Buñuel, Eluard, Matta, and Humphrey Jennings was not especially significant for a generation with its eyes fixed firmly on the future and its minds attuned to clarifying the postwar condition.

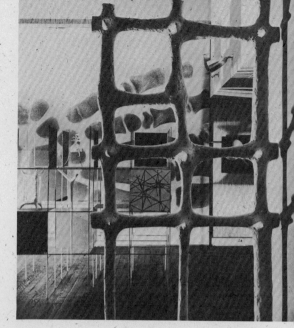

Growth and Form exhibition, ICA, July 1951.

1951

''The thing that I remember most about the binding influence of my friends and colleagues was a kind of resentment of the idea best expressed in little anecdotes like when Victor Pasmore came up before a conscientious objection tribunal in the later stages of the war, having been offered a commission and rejecting that, saying he was a conscientious objector. And Kenneth Clark sent a letter saying 'Victor Pasmore is one of the six best artists in England'; and as soon as he said 'the six best artists' you immediately knew who the five previous ones were: there was Henry Moore, John Piper, Ben Nicholson...and you could tick them off on your fingers and get to Victor Pasmore. And the idea that there was an establishment of this kind that could be so precise about what English art was, was anathema to me.''
Richard Hamilton in conversation with Reyner Banham, 27 June 1976. Used in the soundtrack of the Arts Council film Fathers of Pop (1979).

''We were all the lost generation together; that is, the generation immediately ahead of us were coming back from the war, back to their lives before the war. There was just no room, there was too great a backlog in all walks of life for any of us to be let in and we were all just the people queuing up; and while we were queuing we talked together, and that was the only common ground, the fact that we were all queuing to get into life, as it were.''
Alison Smithson in conversation with Reyner Banham, n.d. Recorded for Fathers of Pop but not used in the film.

''The Festival of Britain, supposedly commemorating the Great Exhibition of a century previously, on the contrary celebrated [English] deliverance from Europe with its resolute rejection of an international character.''
Toni del Renzio, ''Pioneers and Trendies,'' Art and Artists, 209 (February 1984), page 25.

''The authors of this exhibition are people who have observed, who are sensitive and who are poets....The exhibition has moved me very deeply, for I found in it a unity of thought which gave me great pleasure.''
Le Corbusier, Speech given at the opening of Growth and Form, 3 July 1951 (translated).

''At the time of Growth and Form I'd made certain criticisms of it, largely from the point of view that a lot of what was looked at with wide-eyed amazement simply came out of the very language that was used.... My criticism of Growth and Form was that it was a bit naive in its attitude.''
Toni del Renzio, Interview, 23 February 1984.

''A committee of young members of the ICA connected with the arts has recently been formed and has made the following suggestions for lectures: one by A. J. Ayer; one on Decadence in Twentieth Century Art; on Mannerism in Art, with a separate lecture on Mannerism in Twentieth Century Art; and on Photography. Mr. Watson added that they also asked for a lecture on Existentialism, and on the designs for Coventry Cathedral.''
Minutes of the meeting of the Sub-Committee on Lecture Policy and Programmes, 29 January 1952.

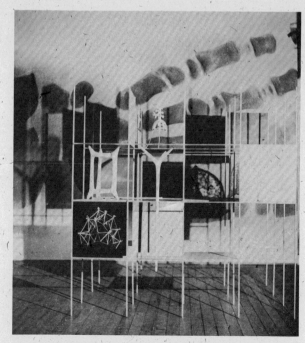

Growth and Form exhibition.

1952

February 6	Death of George VI.	Film: Arch Oboler's *Bwana Devil*, the first 3-D film.
October 3	Britain explodes atomic bomb.	
November 4	Dwight D. Eisenhower elected president of the U.S.	
16	U.S. explodes hydrogen bomb.	

Alison and Peter Smithson and Eduardo Paolozzi design Ronald Jenkins's office at Ove Arup and Partners.
Richard Hamilton teaching at the Central School of Art. He paints d'Orientation.
Reyner Banham joins the editorial staff of Architectural Review.
Nigel and Judith Henderson move from Bethnal Green in London's East End to Landermere Quay in Essex.
Eduardo Paolozzi begins to make collage portraits from the covers of Time magazine.
Geoffrey Holroyd visits Chicago.

Meetings of people at the ICA, some of whom taught at the Central School of Art and became IG ''members'' before Richard Lannoy's organized sessions.

Shop in Bethnal Green, photo by Nigel Henderson.

January	The ICA issues a questionnaire to members asking their opinions about the Institute.
3	Young Sculptors exhibition opens at the ICA. Exhibitors include William Turnbull and Eduardo Paolozzi. Exhibition closes 3 February.
15	Exhibition of William Turnbull's sculpture opens at the Hanover Gallery.
February 4	Points of View discussion about Young Sculptors exhibition. Speakers include Toni del Renzio (ICA).
27	Toni del Renzio engaged by the ICA as a part-time club managing consultant.
March 6	Photographs from Life Magazine exhibition opens at the ICA.
April	Three meetings organized at the ICA by Richard Lannoy for an invited audience: Epidiascope ''show'' of collage material by Eduardo Paolozzi; light show by Edward Hoppe (an American or Canadian ''discovered'' by Lannoy in the ICA gallery); and a talk by an aircraft designer from the De Havilland staff.
1	Wilfredo Lam exhibition opens at the ICA.
2	Eduardo Paolozzi, Nigel Henderson, Peter and Alison Smithson put forward a proposal to the ICA Management Committee for an exhibition later to materialize as Parallel of Life and Art.

18

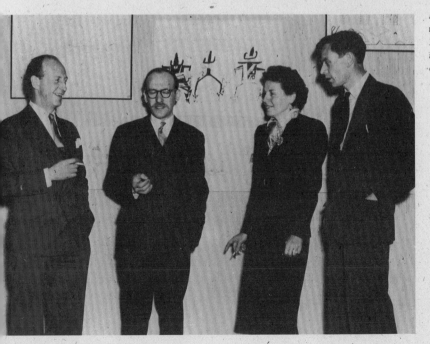

Anthony Kloman, Norman Reid, Dorothy Morland and Peter Watson at the Saul Steinberg exhibition, ICA, May 1952.

May 4	Saul Steinberg exhibition opens at the ICA.
13	Discussion about Alberto Giacometti. Speakers include William Turnbull (ICA).
June	Peter Smithson stops teaching at the Central School of Art.
5	Tomorrow's Furniture exhibition opens at the ICA. Organized by Toni del Renzio, exhibitors include James Stirling. Exhibition closes 29 June.
July	Toni del Renzio convenes the ''Young Group'' when Richard Lannoy leaves for India.
August	Toni del Renzio's paid part-time employment as club managing consultant at the ICA is terminated and he is subsequently paid for specific work undertaken.
	Reyner Banham convenes the ''Young Independent Group.'' He is called the ''secretary of the Independent Group'' in ICA Management Committee meetings.
October 1	The ICA asks Peter Smithson to look into the possibility of soundproofing for a cinema at the Dover Street premises.
22	Nine Young Painters exhibition opens at the ICA. Hanging committee includes Toni del Renzio. Exhibitors include Richard Hamilton. Exhibition closes 22 November.
November	Independent Group discussion about the Victoria and Albert Museum exhibition ''Victorian and Edwardian Decorative Arts.'' Discussion attended by Peter Floud of the Victoria and Albert Museum.
11	Points of View discussion about the exhibition of sculpture by Barbara Hepworth and F. E. McWilliam. Chaired by Toni del Renzio, speakers include John Voelcker and Lawrence Alloway (ICA).
12	ICA Management Committee proposes to encourage the Independent Group.
December 10	Max Ernst exhibition opens at the ICA. Hanging committee includes Toni del Renzio. Exhibition closes 24 January 1953.
16	Lecture by David Sylvester on Francis Bacon (ICA).

Ceiling of the Jenkins office with wallpaper by Eduardo Paolozzi, autumn 1952.

Alison Smithson in Ronald Jenkins's office, autumn 1952.

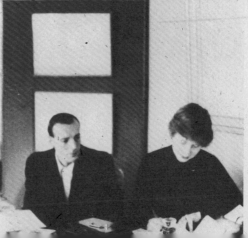

Toni del Renzio and Freda Paolozzi at the ICA.

CHRONOLOGY

Eduardo Paolozzi,
Keep it Simple, Keep
it Sexy, Keep it Sad,
collage of 1952.

Freda Paolozzi.

Early in the spring the ICA's gallery assistant, Richard Lannoy, asked the director, Dorothy Morland, if he could organize a meeting separate from the ICA program. Invited would be those members who had been meeting informally since 1951, whom Morland designated the "Young Group." Her decision to sanction this group by making its meetings semi-official was probably motivated by the results of a questionnaire issued in January to assess membership reaction to the Institute's program. Establishing a group might not only appease dissenting members but also provide the ICA with a kind of "research unit" for future programs.

With the help of the Central School group, especially William Turnbull, Lannoy selected about fifty names, and invitations were sent out. The first meeting was held one evening in April with some thirty-five people in attendance. Eduardo Paolozzi projected images – tearouts from popular magazines, postcards, advertisements, and diagrams – through an overhead projector called an epidiascope. It was significant that many of the images were from sources not usually associated with fine art and that he showed the material in no particular order – a random selection of imagery with no hierarchy of good or bad, no conscious thematic pattern, and no commentary other than judgments such as, "This is better; it's bigger."

After this meeting, Lannoy attempted to maintain the momentum by organizing two further sessions but neither were well attended and by the time he left for India, these semi-official meetings had ended. There was the suspicion that the meetings were not as autonomous from the ICA management as they might be, but there was also some factional infighting among the younger membership.

Despite the efforts of Toni del Renzio, who belonged to the Young Group and also worked for the ICA on a part-time basis, there was little collective activity until August, when Reyner Banham took on titular leadership. Banham had joined the ICA as a student member – he was studying for a Ph.D. at the Courtauld Institute – but he also worked as an editor at the *Architectural Review*. He had not been invited to Paolozzi's epidiascope show but had gatecrashed that first meeting, and so there was some irony in his role as convener. During his convenership, the group became more unified, the discussions, which had always taken place both inside and outside the ICA, were fueled by a series of organized meetings at the Institute, and the name under which these members met was established as the "Independent Group."

''It was [Richard Lannoy] who came to me to say that there was some dissatisfaction amongst a group of younger members...who felt that they weren't getting an opportunity to exchange views and who didn't fit into the pattern perhaps that was set by Herbert Read and some of the older members on the committee.''
Dorothy Morland, Interview, 26 May 1982.

''The idea was probably more mine than anyone's, though I at once put it to Toni del Renzio to actually get on with it and get meetings arranged....We must have sent out invitations or notices to about fifty people, but I would think there were nearer thirty-five present at the first meeting, less at the other two.''
Richard Lannoy, Letter to Graham Whitham, 1 August 1982.

''Banham was very vociferous, rather lecturing, really, about Eduardo Paolozzi's 'show.' I thought it was largely because the visual wasn't introduced and argued (in a linear way) but shovelled, shrivelling in this white hot maw of the epidiascope. The main sound accompaniment that I remember was the heavy breathing and painful sighing of Paolozzi to whom, I imagine, the lateral nature of connectedness of the images seemed self-evident, but the lack of agreement in the air must have been antagonistic and at least viscous.''
Nigel Henderson, Notes written in response to Peter Karpinski, ''The Independent Group 1952–1955 and the Relationship of the Independent Group's Discussions to the Work of Hamilton, Paolozzi and Turnbull 1952–1957,'' B.A. dissertation, Leeds University, 1977.

Ronald Jenkins and Peter Smithson in Jenkins's office, Charlotte Street, London, autumn 1952.

''Paolozzi's epidiascope show might have been the first Independent Group meeting, I don't know. It wasn't such a revelation to me; I'm sure it was to some. I'd known Paolozzi before in Paris; we'd collected images from popular art as well as other images (my studio walls were covered with them). Magazines were an incredible way of randomizing one's thinking (one thing the Independent Group was interested in was breaking down logical thinking) — food on one page, pyramids in the desert on the next, a good-looking girl on the next; they were like collages.''
William Turnbull, Notes from a conversation, 23 February 1983.

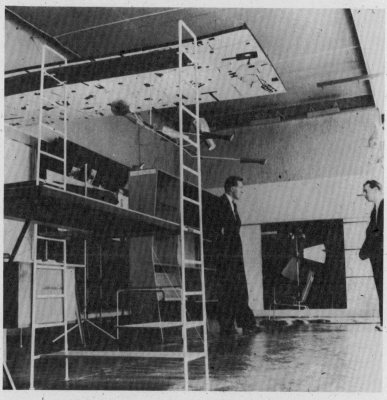

Toni del Renzio organizing the exhibition Tomorrow's Furniture, ICA, June 1952.

''Well, it just happened that I think I named it the 'Independent Group,' because I had to put something down in the diary so that it was booked — and I thought that they were independent. So that's how it went. But they're not entirely in agreement with that.''
Dorothy Morland, Interview, 26 May 1982.

''I understand that the title 'Independent Group' came from the idea of rejecting the mother image of the ICA. That it was a resentment of the ICA actually bringing these people together at all, and so we said, all right, we'll be together but we want to be independent of the ICA.''
Richard Hamilton in conversation with Reyner Banham, 27 June 1976. Used in the soundtrack of Fathers of Pop.

1953

January 20	Dwight D. Eisenhower sworn in as president of the U.S.	Publication of Oskar Morgenstern and John von Neumann's *The Theory of Games and Economic Behavior*.
March 5	Death of Joseph Stalin.	BBC Radio serial "Journey into Space" begins.
May	End of iron and steel rationing in Britain.	Film: André de Toth's *House of Wax*, the first grade A 3-D film.
June 2	Coronation of Elizabeth II.	
8	Truce agreement in Korea.	

Theo Crosby appointed technical editor of <u>Architectural Design</u>.

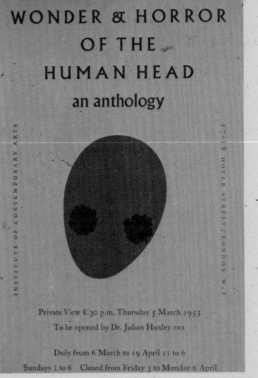

WONDER & HORROR OF THE HUMAN HEAD
an anthology

INSTITUTE OF CONTEMPORARY ARTS

17–18 DOVER STREET/LONDON W.1

Private View 8.30 p.m. Thursday 5 March 1953

To be opened by Dr. Julian Huxley FRS

Daily from 6 March to 19 April 11 to 6

Sundays 2 to 6 Closed from Friday 3 to Monday 6 April

Cover of the catalogue to <u>Wonder and Horror of the Human Head</u>, ICA, March–April 1953.

Informal gatherings at Reyner and Mary Banham's Primrose Hill house (usually Sunday mornings), which include some IG members.

Informal gatherings at the York Minster pub (known as the French Pub) in Dean Street, Soho (usually Saturday mornings). These gatherings include Toni del Renzio, Colin St. John Wilson, Sam Stevens, James Stirling.

Independent Group meetings held at the ICA between August 1952 and September 1953 include the following talks: Jasia S. Shapiro on Helicopter Design, A. J. Ayer on The Principle of Verification, Norman Pirie on Are Proteins Unique?, Reyner Banham on The Machine Aesthetic, Toni del Renzio on Pioneers of the Modern Movement.

Other Independent Group sessions include Architectural Association students Andrew Derbyshire, Pat Crook, and John Voelcker, reporting on their Zone Development scheme, a study of the ICA space and accommodation requirements.

January 14	Exhibition of the British entries for the <u>Unknown Political Prisoner</u> competition at New Burlington Galleries.
28	<u>Opposing Forces</u> exhibition opens at the ICA. Toni del Renzio designs the catalogue and is a member of the hanging committee. Exhibition closes 28 February.
30	Discussion about <u>Opposing Forces</u>. Speakers include Toni del Renzio (ICA).
February 20	Musique Concrète: an experiment in synthetic music by Pierre Schaeffer. Introduced by Toni del Renzio (ICA).
March 5	<u>Wonder and Horror of the Human Head</u> exhibition opens at the ICA. Designed by Richard and Terry Hamilton. Toni del Renzio assists in the planning of the show. Exhibition closes 19 April.
6	Lecture by Alfred Barr: They Hate Modern Art or Patterns of Philistine Power (Victoria and Albert Museum).
26	Lecture by Lawrence Alloway: The Human Head in Modern Art (ICA).
April 22	<u>Le Corbusier — Paintings, Drawings, Sculpture, Tapestry</u> exhibition opens at the ICA. Catalogue designed by Toni del Renzio; catalogue text by Colin St. John Wilson. Exhibition closes in May.
29	The ICA Management Committee suggests that Independent Group members might like to meet Le Corbusier when he visits London on 12 May.

May 5 Unknown Political Prisoner exhibition
opens at the Tate Gallery.

7 Discussion about the current Le Cor-
busier exhibition. Speakers include
Reyner Banham, Colin St. John Wilson,
Victor Pasmore (ICA).

13 The first public presentation by
the Independent Group: The Works
of Le Corbusier. Color slides of
his buildings 1924–52. Introduced
by Reyner Banham (ICA).

June 24 Reyner Banham nominated by the
Independent Group to represent
them on the ICA Management
Committee.

25 Discussion about the current Henry
Moore exhibition. Speakers include Law-
rence Alloway and Toni del Renzio (ICA).

July Reyner Banham appointed to the ICA
Management Committee as the Inde-
pendent Group representative.

CIAM 9 at Aix-en-Provence. The
Smithsons meet the leaders of the Modern
Movement and nail up diagrams, photos,
and descriptions from their ''Urban Re-
Identification'' document. This
becomes the basis of a revisionist move-
ment by the younger architects called
Team 10.

2 Eleven British Painters exhibition
opens at the ICA. Exhibitors include
William Turnbull. Exhibition closes 1
August.

22 Lecture by Lawrence Alloway: British
Painting in the Fifties (ICA).

29 Reyner Banham presents Indepen-
dent Group plans to the ICA Man-
agement Committee for a lecture
series called ''Aesthetic Prob-
lems of Contemporary Art.''

August Geoffrey Holroyd in Los Angeles, where
he visits Charles and Ray Eames.

5 Collectors Items from Artists' Studios
exhibition opens at the ICA. Exhibitors
include Hamilton and Paolozzi. Exhibi-
tion closes 6 September.

18 Reyner Banham presents draft introduc-
tion for Parallel of Life and Art exhi-
bition catalogue to ICA Management
Committee. Criticisms in it by Toni del

Renzio of the 1951 Growth and Form show
compel Roland Penrose to ask him to make
changes. Del Renzio refuses and resigns
from the ICA Exhibitions Committee (2
September).

September 10 Parallel of Life and Art exhibition
opens at the ICA. Organized by Nigel
Henderson, Eduardo Paolozzi, and Alison
and Peter Smithson. Exhibition closes
18 October.

22 Lawrence Alloway appointed to the ICA
Exhibitions Committee (after resigna-
tion of del Renzio).

24 Points of View discussion about Paral-
lel of Life and Art. Speakers include
Eduardo Paolozzi and Peter Smithson
(ICA).

October Richard Hamilton teaching at King's
College, University of Durham at
Newcastle-upon-Tyne.

14 Aesthetic Problems of Contempor-
ary Art lecture: Reyner Banham on
the Impact of Technology (ICA).

21 Painting into Textiles exhibition opens
at the ICA. Exhibitors include Eduardo
Paolozzi. Exhibition closes 14
November.

29 Aesthetic Problems of Contempor-
ary Art lecture: Richard Hamilton
on New Sources of Form (ICA).

November 12 Aesthetic Problems of Contempor-
ary Art lecture: Fello Atkinson
and William Turnbull on New Con-
cepts of Space (ICA).

24 Symposium on Paul Klee's Pedagogical
Sketchbook. Speakers include Lawrence
Alloway (ICA).

26 Aesthetic Problems of Contempor-
ary Art lecture: Colin St. John
Wilson on Proportion and Symmetry
(ICA).

December Parallel of Life and Art shown at the
Architectural Association, London.
Victor Pasmore stops teaching at the
Central School of Art.

2 Debate on Parallel of Life and Art
(Architectural Association).

10 Aesthetic Problems of Contempor-
ary Art lecture: Toni del Renzio
on Non-Formal Painting (ICA).

Reg Butler, final
maquette for The
Unknown Political
Prisoner, 1951–52.
Exhibited 1953.

23

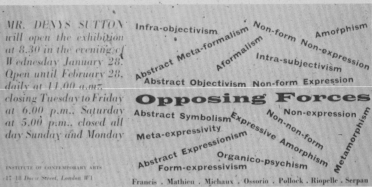

Eduardo Paolozzi, maquette for <u>The Unknown Political Prisoner</u>, 1952. Exhibited 1953.

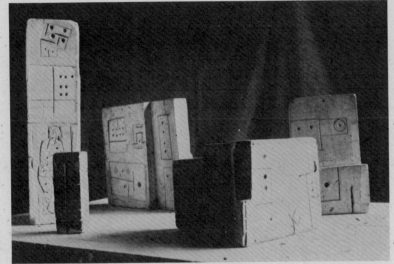

Lawrence Alloway, 1953.

Parallel of Life and Art, ICA, September–October 1953.

1953

The Independent Group was never fixed in time or place. Sunday morning get-togethers at Banham's Primrose Hill house, Saturday lunchtime in the French Pub in Soho, irregular gatherings at the Cafe Torino or the ICA bar, included IG members and ensured the free flow of conversation and the continuity of ideas. But it was at the ICA that the more formal meetings were held and during 1953 the Group organized a number of such sessions. Banham's concern for architecture dominated some discussions, but there was also a general interest in exploring the role and impact of science and technology.

Underlying much Group discussion was the reassessment of accepted interpretations of art. Herbert Read's aestheticism was acrimoniously attacked. To promote their point of view, some affiliates of the Independent Group organized a course of lectures called "Aesthetic Problems of Contemporary Art," which appeared as part of the ICA's official schedule between October 1953 and February 1954. Although the series allowed these members to expand their philosophies about twentieth-century art, it also established one of the roles of the Independent Group as an "inner research department" of the ICA, feeding the institute with ideas for evening activities. This view of the Group's function was reinforced by Banham's election to the ICA Management Committee in June.

In September the exhibition *Parallel of Life and Art* opened in the ICA gallery. It displayed a number of features which can be associated with the Independent Group aesthetic, such as its non-hierarchic approach to imagery and its unconventional display, but it was the sole creation of Nigel Henderson, Eduardo Paolozzi, and Alison and Peter Smithson, not of the Independent Group as such. Creative autonomy for those who might be considered as "members" of the Group was a crucial factor in its successes. There was never an exclusive Group manifestation in the form of an exhibition, lecture series, or any other composite presentation.

''Let's remember that the Independent
Group was a kind of movable scene which
took place in a series of well-defined
locales. Most of us, for one reason or
another, were relatively at leisure — a
euphemism — we weren't too busy. That
was terribly important...you had time
to talk. And you went to different sorts
of places and you talked to different
sorts of people. We all really talked to
each other. So the meetings [i.e., the
more formal meetings at the ICA] were
always a kind of culmination.''
John McHale in conversation with Reyner
Banham, 30 May 1977. Recorded for
Fathers of Pop but not used in the film.

''We were probably hanging the material
for [Parallel of Life and Art] for about
two or three days, and were trying to get
it into a kind of spider's web above the
heads of the people, because the room
had to be used for lectures during the
exhibition; by the time we'd strung up
an awful lot of wire and hooks and got
out of line and back into line and so on,
we'd built up a pretty good nervous
tension.''
Nigel Henderson, Interview, 17 August
1976.

''It [Parallel of Life and Art] was most
extraordinary because it was primarily
photographic and with apparently no
sequence; it jumped around like any-
thing. But it had just amazing images;
things that one had never thought of
looking at in that sort of way, in exhi-
bition terms. And the juxtaposition of
all those images! I was just knocked out
by it.''
Ron Herron, Interview, 10 January 1983.

''As it [the Independent Group] grew up
there were these people who understood
each other and...it became extremely
difficult for anybody to enter into it.
You imagine some eighteen to twenty peo-
ple who had been meeting fairly regu-
larly and also informally and who were
seeing a lot of each other and had got a
running debate — a discussion of ideas
going on. If you walked into the middle
of that, you wouldn't know what the hell
they were talking about. So that while
there was...this sense of being this
exclusive group because this gave you
something to hang on to, some status
which you were being denied elsewhere, I
think that it was kept exclusive also
because it was very hard for anybody
else to get in, even if they wanted to.''
Toni del Renzio, Interview, 1 December
1976.

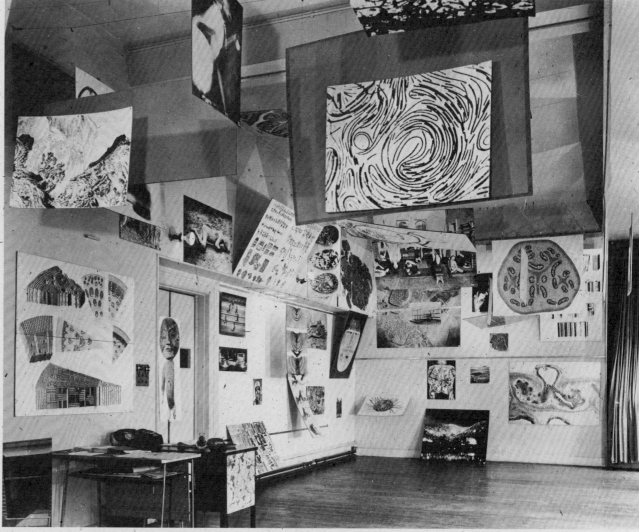

Parallel of Life and
Art, ICA, September–
October 1953.

1954

May 6 · Roger Bannister runs a mile in 3 minutes 59.4 seconds.

July 3 · End of all rationing in Britain.

Publication of the English edition of Le Corbusier's The Modulor.

Publication of Kingsley Amis's Lucky Jim.

Films: Jack Arnold's The Creature from the Black Lagoon and Elia Kazan's On the Waterfront.

15 · First flight of Boeing 707.

Preliminary meetings held to discuss the Groupe Espace exhibition, later called This Is Tomorrow.

Man versus Machine exhibition held at the Building Centre, London. Exhibitors include John McHale.

Publication of Lawrence Alloway's Nine Abstract Artists.

Sometime during the year, Reyner Banham ceases to convene the Independent Group.

Independent Group meeting for an invited audience: The Work of Buckminster Fuller. Held sometime between September 1953 and March 1954.

Nigel Henderson, Collage (known as Atlas), 1954.

January 19 · Lecture on science fiction by Lawrence Alloway (ICA).

28 · Aesthetic Problems of Contemporary Art lecture: Lawrence Alloway on The Human Image (ICA).

February 10 · Recent British Drawings exhibition opens at the ICA. Exhibitors include Eduardo Paolozzi. Exhibition closes 27 March.

11 · Aesthetic Problems of Contemporary Art lecture: Robert Melville on Mythology and Psychology (ICA).

25 · Aesthetic Problems of Contemporary Art lecture: Reyner Banham on Art in the Fifties (ICA).

March 9 · Discussion about fashion and dress design. Speakers include Toni del Renzio (ICA).

12 · Proposal to the ICA Management Committee from Richard Hamilton for an exhibition called Human Motion in Relation to Adaptive Appliances, later to appear as Man, Machine and Motion.

18 · Discussion about Le Corbusier's ''The Modulor.'' Speakers include Sam Stevens, Reyner Banham, Lawrence Alloway. Presented by the Independent Group (ICA).

29 · Reyner Banham suggests lecture series, ''Books and the Modern Movement,'' to the ICA Management Committee.

31 · Victor Pasmore: Paintings and Constructions 1944–54 exhibition opens at the ICA. Arranged by Lawrence Alloway, catalogue by Toni del Renzio. Exhibition closes in May.

April 1 · Nigel Henderson: Photo-Images exhibition held in the ICA Members' room until 15 May.

8 · Discussion about the work of Victor Pasmore. Speakers include Reyner Banham and Lawrence Alloway (ICA).

27 · The Pattern of Growth — extracts from films presented by Dr. Patrick Collard, Nigel Henderson, and Eduardo Paolozzi (ICA).

May 11	Discussion about André Malraux's <u>The Voices of Silence</u>. Speakers include Nigel Henderson and Lawrence Alloway (ICA).
June	Nigel Henderson stops teaching at the Central School of Art.
17	Discussion about advertising and the arts (ICA).
24	Lecture by Reyner Banham: Drawing as Communication (ICA).
July 1	Ambush at the Frontier — a dialogue on the Western film by Toni del Renzio and Lawrence Alloway (ICA).
August 5	<u>Items for Collectors</u> exhibition opens at the ICA. Exhibitors include Hamilton, Henderson. Exhibition closes 4 September.
September 8	<u>Sunday Painters</u> exhibition opens at the ICA. Designed by Richard and Terry Hamilton. Exhibition closes 9 October.
22	Discussion: What is Sunday Painting? Chaired by Lawrence Alloway (ICA).
24	Lecture by David S. Stevens: ''Louis Armstrong — Cause and Effect.'' Chaired by Lawrence Alloway (ICA).
29	Report on Triennale exhibition in Milan by Reyner Banham (ICA).
October 13	<u>Collages and Objects</u> exhibition opens at the ICA. Arranged by Lawrence Alloway, designed by John McHale; exhibitors include McHale, Eduardo Paolozzi, Nigel Henderson, William Turnbull. Exhibition closes 20 November.
21	Discussion about the importance of collages. Speakers include Lawrence Alloway and Toni del Renzio (ICA).
27	Lecture by Man Ray: Painting of the Future and the Future of Painting (ICA).
28	Books and the Modern Movement lecture: Lawrence Alloway on <u>Art Now</u> by Herbert Read (ICA).
November	Publication of Wyndham Lewis's <u>The Demon of Progress in the Arts</u>, which attacks the ICA.
11	Books and the Modern Movement lecture: Robert Melville on <u>Picasso</u> by Gertrude Stein (ICA).

19	Lecture by Albert MacCarthy: Mintons and its Aftermath — Emergence of New Forms in Jazz. Chaired by Eduardo Paolozzi (ICA).
December	Sometime at the end of 1954 or very early 1955, Dorothy Morland suggests that Lawrence Alloway and John McHale reconvene the Independent Group.
2	Books and the Modern Movement lecture: Toni del Renzio on <u>Vers une architecture</u> by Le Corbusier (ICA).
9	Books and the Modern Movement lecture: Robert Furneaux Jordan on <u>Pioneers of the Modern Movement</u> by Nikolaus Pevsner (ICA).
16	Books and the Modern Movement lecture: Reyner Banham on <u>Vision and Design</u> by Roger Fry (ICA).

Publicity shot for <u>The Creature from the Black Lagoon</u>, 1954.

27

Richard Hamilton, <u>re Nude</u>, 1954.

John McHale in his studio.

The Aesthetic Problems of Contemporary Art lectures continued into 1954, to be followed by a shorter series called Books and the Modern Movement. Banham had originally wanted to reassess the significance of certain documents and manifestos of twentieth-century art but the Management Committee thought this was too esoteric. So the series confined its assessment to those authors whose interpretation of modern art had become the established line. Roger Fry's *Vision and Design*, Le Corbusier's *Vers une architecture*, and Herbert Read's *Art Now* were three texts singled out for reevaluation.

The pressure of work for his Ph.D. dissertation forced Banham to relinquish his role as Independent Group convener during 1954. In effect, this marked the end of anything approaching a collectively organized program for the Group. A few evening discussions at the ICA were arranged but by and large they were isolated and hardly constituted IG meetings.

The appearance of Lawrence Alloway and his influence upon the ICA program was almost concurrent with Banham adopting a lower profile within the Independent Group. Critic, lecturer, and author of *Nine Abstract Artists*, Alloway first came to the ICA about the time of the *Opposing Forces* exhibition. Among other things during 1954, he contributed to both the Aesthetic Problems series and the Books and the Modern Movement series, delivered a lecture on science fiction, and was involved in numerous public discussions. His most ambitious project was the organization of *Collages and Objects*, an exhibition which opened in October. In this show, collages of established artists such as Ernst, Picasso, and Magritte were shown alongside work by Paolozzi, Henderson, Turnbull, and McHale. Significant among the exhibits was Henderson's photo-collage called *Atlas*, made from such things as close-up photographs of wood and metal and electron microscope readings. Also exhibited were collage portraits from *Time* magazine by Eduardo Paolozzi, as well as the first public showing of one of his scrapbooks, which he called *Psychological Atlas*.

Toward the end of the year, Dorothy Morland suggested to McHale and Alloway that they reconvene the Independent Group. One can speculate about her motives – to provide the ICA with new material for its program, to circumvent criticism that the institute was not fulfilling its role, or a purely magnanimous gesture to the younger membership. Whatever the case, this phase of activity was the closest the Independent Group ever came to a series of regular meetings.

Terry Hamilton.

John McHale and William Turnbull outside Turnbull's flat in Fellows Road, London.

''I think the Independent Group were romantics...in that they had this glorious view of technology, genuflecting before it...''
Frank Cordell in conversation with Reyner Banham, 7 July 1976. Recorded for Fathers of Pop but not used in the film.

''The period at which we were working in the fifties was characterized by a number of technological breakthroughs. If on the surface we were concerned with technology in many senses, our preoccupation was with the social implications of that technology; that was quite a different sort of thing. We weren't hung up on the technology but we were hung up on what the technology meant to people....We thought it meant a lot of things. On the one hand, positively, we saw that technology expanded the human range. The possibility for increased numbers of choices for human beings, increased social mobility, the increase in physical mobility. A good deal of increase through the media themselves — through photography, television, movies, microscopes and telescopes, if you like. A great increase in psychic mobility, and we thought that was terribly important. There was a feeling here of expansion, actually, of what people were capable of feeling, of what people were capable of doing. Doing also in larger lives — it expanded one's range rather than contracted it.''
John McHale in conversation with Julian Cooper, 19 November 1977. Recorded for Fathers of Pop but not used in the film.

''They were always ranging along the wilder shores of the smaller journals in a variety of disciplines trying to pick up the most recent thing, which was then, somehow or other, to be translated into art terms.''
Donald Holms, Interview, 9 June 1982.

Fish shop, photo by Richard Hamilton.

''I think by virtue of the way the Group itself coalesced and ran, it had a lot of arrogance, a lot of snobbery in itself. But that is not negative. It was a small, cohesive, quarrelsome, abrasive group, conscious also of the fact that if people came in from the outside, either they sank or swam. Because it was a difficult group in that sense, to stay afloat in unless you were on your toes, engaged in the kind of almost daily dialogue that members of the Group had; it was sort of difficult to keep track of what was going on for one thing — you weren't inside. So it had its own kind of snobbery.''
John McHale in conversation with Julian Cooper, 19 November 1977. Recorded for Fathers of Pop but not used in the film.

''I think Lawrence [Alloway] was interested in theory but what he wanted was ammunition. He wanted to be able to talk about art works referring to different things than the traditional reference and using a different language. He was very, very good at that. He used to take Scientific American — that was a key magazine — and he'd read something in there and assimilate it very quickly and then use a concept as an illustration of something effectively.''
Roger Coleman, Interview, 18 April 1983.

William and Kathy Turnbull at Regent's Park Zoo.

''We [Alloway and McHale] came along and attended the end part of the original Independent Group....And we found there was a kind of enquiry going on — it was historical in one sense, but it was interested, in part, in demolishing history. It was...very iconoclastic; one was very happy with that so we sort of went on attending. Then came the moment when [Banham didn't] have the time to convene the Group. Dorothy [Morland] simply mentioned it to me over coffee one day and said, 'Look, why don't you sort of take on convening the Group?' and I said, 'I'd like to discuss it with Lawrence and we'll get back to you.' I talked with him very briefly and he said, 'Fine. Why don't we.' [It was] very casual.''
John McHale in conversation with Reyner Banham, 30 May 1977. Recorded for Fathers of Pop but not used in the film.

1955

·Fairground sideshow, photo by Richard Hamilton.

April 5	Resignation of Winston Churchill as prime minister.	Nikolaus Pevsner's Reith lectures, "The Englishness of English Art."
6	Anthony Eden appointed prime minister.	Publication of Norbert Wiener's *The Human Use of Human Beings* and Philip K. Dick's *Solar Lottery* (U.S. title *The World of Chance*).
May		Films: Billy Wilder's *The Seven Year Itch*, Delbert Mann's *Marty*, Robert Aldrich's *Kiss Me Deadly*, Joseph Newman's *This Island Earth*.
26	General Election won by Conservatives.	
December 13	Hugh Gaitskell elected leader of the parliamentary Labour party.	

Nigel Henderson and Eduardo Paolozzi found Hammer Prints Ltd.

January	Richard Hamilton Paintings exhibition opens at the Hanover Gallery.
6	Discussion about Léger's current exhibition at the Marlborough Gallery. Speakers include John McHale (ICA).
13	Symposium on Sigfried Giedion's book Walter Gropius. Speakers include John McHale (ICA).
19	Francis Bacon exhibition opens at the ICA. Designed by John McHale. Exhibition closes in February.
20	Discussion about horror comics. Speakers include Lawrence Alloway (ICA).
February	Plans for a science fiction exhibition at the ICA by Lawrence Alloway, but never realized.
1	Films of Kenneth Anger shown at the ICA.
3	Dorothy Morland suggests that the Independent Group might produce a paper on whether the ICA was fulfilling its function.
10	Discussion about Francis Bacon. Speakers include Lawrence Alloway (ICA).
11	Independent Group discussion about Richard Hamilton's current exhibition. Speakers include Richard Hamilton, John McHale, Reyner Banham, Lawrence Alloway. Fourteen attend.
24	Film Seminar: Postwar American Memories — Carl Foreman. Chaired by Lawrence Alloway (ICA).
March	Groups for the exhibition eventually to be called This Is Tomorrow are formed after a meeting at Adrian Heath's studio.
4	Independent Group talk by Reyner Banham: Borax, or the Thousand Horse-Power Mink. Eighteen attend.
7	Isamu Noguchi to speak to the Independent Group (no record of whether the event took place).
8	Independent Group talk by E. W. ''Bingo'' Meyer: Probability and Information Theory and Their Application to the Visual Arts. Twenty-two attend.
10	Film Seminar: Recent American Movies— Karel Reisz. Chaired by Lawrence Alloway (ICA).
17	ICA Management Committee informs the Independent Group of Gillo Dorfles's impending visit to London.
22	A Communications Primer, film by Charles Eames, shown at the ICA.
24	Symposium on movie heroines. Speakers include Toni del Renzio. Chaired by Lawrence Alloway (ICA).
29	Jean Dubuffet exhibition opens at the ICA.
April 7	Lecture by Lawrence Alloway: The Movies as Mass Medium (ICA).
15	Independent Group discussion about advertising. Speakers include Peter Smithson, Eduardo Paolozzi, John McHale, Lawrence Alloway. Twenty-two attend.

''I think the Independent Group were romantics... in that they had this glorious view of technology, genuflecting before it...''
Frank Cordell in conversation with Reyner Banham, 7 July 1976. Recorded for Fathers of Pop but not used in the film.

''The period at which we were working in the fifties was characterized by a number of technological breakthroughs. If on the surface we were concerned with technology in many senses, our preoccupation was with the social implications of that technology; that was quite a different sort of thing. We weren't hung up on the technology but we were hung up on what the technology meant to people.... We thought it meant a lot of things. On the one hand, positively, we saw that technology expanded the human range. The possibility for increased numbers of choices for human beings, increased social mobility, the increase in physical mobility. A good deal of increase through the media themselves — through photography, television, movies, microscopes and telescopes, if you like. A great increase in psychic mobility, and we thought that was terribly important. There was a feeling here of expansion, actually, of what people were capable of feeling, of what people were capable of doing. Doing also in larger lives — it expanded one's range rather than contracted it.''
John McHale in conversation with Julian Cooper, 19 November 1977. Recorded for Fathers of Pop but not used in the film.

''They were always ranging along the wilder shores of the smaller journals in a variety of disciplines trying to pick up the most recent thing, which was then, somehow or other, to be translated into art terms.''
Donald Holms, Interview, 9 June 1982.

Fish shop, photo by Richard Hamilton.

''I think by virtue of the way the Group itself coalesced and ran, it had a lot of arrogance, a lot of snobbery in itself. But that is not negative. It was a small, cohesive, quarrelsome, abrasive group, conscious also of the fact that if people came in from the outside, either they sank or swam. Because it was a difficult group in that sense, to stay afloat in unless you were on your toes, engaged in the kind of almost daily dialogue that members of the Group had; it was sort of difficult to keep track of what was going on for one thing — you weren't inside. So it had its own kind of snobbery.''
John McHale in conversation with Julian Cooper, 19 November 1977. Recorded for Fathers of Pop but not used in the film.

''I think Lawrence [Alloway] was interested in theory but what he wanted was ammunition. He wanted to be able to talk about art works referring to different things than the traditional reference and using a different language. He was very, very good at that. He used to take Scientific American — that was a key magazine — and he'd read something in there and assimilate it very quickly and then use a concept as an illustration of something effectively.''
Roger Coleman, Interview, 18 April 1983.

William and Kathy Turnbull at Regent's Park Zoo.

''We [Alloway and McHale] came along and attended the end part of the original Independent Group.... And we found there was a kind of enquiry going on — it was historical in one sense, but it was interested, in part, in demolishing history. It was... very iconoclastic; one was very happy with that so we sort of went on attending. Then came the moment when [Banham didn't] have the time to convene the Group. Dorothy [Morland] simply mentioned it to me over coffee one day and said, 'Look, why don't you sort of take on convening the Group?' and I said, 'I'd like to discuss it with Lawrence and we'll get back to you.' I talked with him very briefly and he said, 'Fine. Why don't we.' [It was] very casual.''
John McHale in conversation with Reyner Banham, 30 May 1977. Recorded for Fathers of Pop but not used in the film.

29

1955

April 5	Resignation of Winston Churchill as prime minister.	Nikolaus Pevsner's Reith lectures, "The Englishness of English Art."
6	Anthony Eden appointed prime minister.	Publication of Norbert Wiener's *The Human Use of Human Beings* and Philip K. Dick's *Solar Lottery* (U.S. title *The World of Chance*).
May		Films: Billy Wilder's *The Seven Year Itch*, Delbert Mann's *Marty*, Robert Aldrich's *Kiss Me Deadly*, Joseph Newman's *This Island Earth*.
26	General Election won by Conservatives.	
December 13	Hugh Gaitskell elected leader of the parliamentary Labour party.	

Nigel Henderson and Eduardo Paolozzi found Hammer Prints Ltd.

January	*Richard Hamilton Paintings* exhibition opens at the Hanover Gallery.
6	Discussion about Léger's current exhibition at the Marlborough Gallery. Speakers include John McHale (ICA).
13	Symposium on Sigfried Giedion's book *Walter Gropius*. Speakers include John McHale (ICA).
19	*Francis Bacon* exhibition opens at the ICA. Designed by John McHale. Exhibition closes in February.
20	Discussion about horror comics. Speakers include Lawrence Alloway (ICA).
February	Plans for a science fiction exhibition at the ICA by Lawrence Alloway, but never realized.
1	Films of Kenneth Anger shown at the ICA.
3	Dorothy Morland suggests that the Independent Group might produce a paper on whether the ICA was fulfilling its function.

·Fairground sideshow, photo by Richard Hamilton.

10	Discussion about Francis Bacon. Speakers include Lawrence Alloway (ICA).
11	Independent Group discussion about Richard Hamilton's current exhibition. Speakers include Richard Hamilton, John McHale, Reyner Banham, Lawrence Alloway. Fourteen attend.
24	Film Seminar: Postwar American Memories — Carl Foreman. Chaired by Lawrence Alloway (ICA).
March	Groups for the exhibition eventually to be called *This Is Tomorrow* are formed after a meeting at Adrian Heath's studio.
4	Independent Group talk by Reyner Banham: Borax, or the Thousand Horse-Power Mink. Eighteen attend.
7	Isamu Noguchi to speak to the Independent Group (no record of whether the event took place).
8	Independent Group talk by E. W. ''Bingo'' Meyer: Probability and Information Theory and Their Application to the Visual Arts. Twenty-two attend.
10	Film Seminar: Recent American Movies— Karel Reisz. Chaired by Lawrence Alloway (ICA).
17	ICA Management Committee informs the Independent Group of Gillo Dorfles's impending visit to London.
22	*A Communications Primer*, film by Charles Eames, shown at the ICA.
24	Symposium on movie heroines. Speakers include Toni del Renzio. Chaired by Lawrence Alloway (ICA).
29	Jean Dubuffet exhibition opens at the ICA.
April 7	Lecture by Lawrence Alloway: The Movies as Mass Medium (ICA).
15	Independent Group discussion about advertising. Speakers include Peter Smithson, Eduardo Paolozzi, John McHale, Lawrence Alloway. Twenty-two attend.

Lawrence Alloway lecturing at the ICA.

19 Discussion about Jean Dubuffet. Chaired by Lawrence Alloway (ICA).

29 Independent Group discussion: Dadaists as Non–Aristotelians. Speakers include Anthony Hill, John McHale, Donald Holms, Toni del Renzio. Fourteen attend.

May Richard Hamilton's Man, Machine and Motion exhibition opens at the Hatton Gallery, Newcastle-upon-Tyne.

4 Mark Tobey exhibition opens at the ICA. Catalogue by Lawrence Alloway. Exhibition closes 4 June.

 Eduardo Paolozzi — Work in Progress exhibition opens in the ICA Members' room. Exhibition closes 4 June.

12 Discussion about the Daily Express Young Artists exhibition. Speakers include Lawrence Alloway (ICA).

23 Letter from Bryan Robertson, director of the Whitechapel Art Gallery, to Theo Crosby expressing a desire for the proposed exhibition (This Is Tomorrow) to show ''painting, sculpture and architecture in an integrated relationship.''

27 Independent Group discussion: Advertising — Sociology in the Popular Arts. Speakers include Eduardo Paolozzi, John McHale, Lawrence Alloway, Toni del Renzio. Sixteen attend.

June Arts Council's Alberto Giacometti exhibition results in resignations from the Council.

 Edward Wright and Eduardo Paolozzi stop teaching at the Central School of Art.

23 Discussion about Alberto Giacometti. Speakers include Lawrence Alloway and Toni del Renzio (ICA).

24 Independent Group talk by Toni del Renzio: Fashion and Fashion Magazines. Sixteen attend.

25 Le Corbusier's Notre Dame du Haut at Ronchamp inaugurated.

July Lawrence Alloway appointed assistant director at the ICA.

1 Independent Group discussion between Reyner Banham and Gillo Dorfles: Aesthetics and Italian Product Design. Twenty attend.

6 Man, Machine and Motion exhibition opens at the ICA. Organized by Richard Hamilton, with catalogue notes by Lawrence Gowing, Reyner Banham, and Richard Hamilton. Exhibition closes 30 July.

7 Lecture by Reyner Banham: Metal in Motion — the Iconography of the Automobile (based on a talk given to the Independent Group on 4 March). Chaired by Lawrence Alloway (ICA).

14 Discussion about Turn Again (MARS exhibition). Speakers include Alison Smithson (ICA).

15 Independent Group talk by Frank Cordell: Gold Pan Alley. Fourteen attend.

21 Discussion about Man, Machine and Motion. Speakers include Reyner Banham and Peter Smithson (ICA).

30 Monotypes and Collages by Magda Cordell exhibition opens at the ICA. Exhibition closes in August.

August John McHale attends Yale University as a ''special fellow'' under Josef Albers.

 Independent Group meetings held before 19 September: William Turnbull talks about his Basic Pictorial Design course at the Central School of Art; Ralph Erskine discusses his architecture in Sweden.

11 New Sculptors: Painters/Sculptors exhibition opens at the ICA. Exhibitors include John McHale.

October 18 Discussion about Le Corbusier at Ronchamp. Speakers include James Stirling, Colin St. John Wilson, Peter Smithson (ICA).

25 Discussion about fashion and fashion magazines. Main speaker is Toni del Renzio (based on a talk given to the Independent Group on 24 June). Chaired by Lawrence Alloway (ICA).

31

Alison Smithson and
her son Simon in
Regent's Park, July
1955.

November 10 Lecture by Charles Handley—Read: The
 Art of Wyndham Lewis. Chaired by Law-
 rence Alloway (ICA).
22 Discussion of Samuel Beckett's Waiting
 for Godot. Speakers include Toni del
 Renzio (ICA).
29 Discussion about children's books and
 periodicals. Chaired by Lawrence Allo-
 way (ICA).
December Publication of Reyner Banham's article
 ''The New Brutalism'' in the Architec-
 tural Review.
 Publication of Richard Lannoy's book
 India.
19 Lecture by Patrick Heron: The Content of
 Abstract Art (ICA).

The discussions organized by Alloway and McHale were held with some fre-
quency. Between February and July, nine evening meetings were arranged
with at least two more before September. The range of topics was pluralistic
and the approach egalitarian. For instance, no less importance was given to
an analysis of American car styling than to an assessment of Richard Ham-
ilton's exhibition at Hanover Gallery; popular music was discussed with the
same seriousness as the proposition that Dada was a manifestation of non-
Aristotelian logic. Indeed, there was considerable crossing of the supposed
boundaries of culture. One of Hamilton's paintings, for example, was related
to chase scenes in Hollywood movies, and non-Aristotelian logic, pains-
takingly explained by Alfred Korzybski in Science and Sanity, was also
interpreted through A. E. van Vogt's science fiction story The World of Null-A.

 Alloway defined this approach as the "fine art-popular art continu-
um," a concept which placed elite and mass culture on the same level, rather
than within a hierarchy of good and bad. Although popular mass culture and
elite fine art were still separate and, as far as Alloway was concerned, should
stay so in the creation of art, the "fine art-popular art continuum" proposed
an alternative to the sort of elitist snobbism which dogged much British cul-
ture and which the Independent Group found so distasteful.

 In May, Richard Hamilton's Man, Machine and Motion opened at the
Hatton Gallery, Newcastle-upon-Tyne, and in July it traveled to the ICA. Like
Parallel of Life and Art it used large-scale photographs, but unlike the previous
show, the material was determined by the subject implicit in the title.
Although this was Hamilton's exhibition, it was to some degree inspired by
Independent Group discussions during 1953 about technology. It also related
to his paintings Trainsition III and IIII (cat. nos. 9-10), and later was to feed into
such works as Hommage à Chrysler Corp. (cat. nos. 12-14).

 About the time that Man, Machine and Motion opened at the ICA, Law-
rence Alloway was appointed assistant director of the Institute. This was sig-
nificant because he was to introduce a specific interest in popular culture and
American art. His concerns were already declared to the Independent Group
and now were presented to ICA audiences through his lectures on such topics
as science fiction and the movies as mass media, and through his catalogue
notes to Mark Tobey's exhibition. As his role within the ICA as assistant direc-
tor and chairman of the Exhibitions Sub-Committee became more estab-
lished, his influence upon the program of events increased.

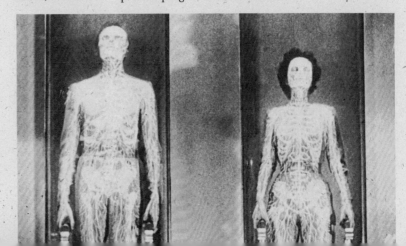

Still from the film This Island Earth, 1955.

''In 1951 and 1952, none of us really knew how to read the forms and the symbols of the car; that was to come later when John McHale and Lawrence Alloway took over the running of the Independent Group. But even then, we could hardly fail to be impressed by the sheer size of the thing, which in those days of austerity was a kind of effrontery. And at the same time, we could hardly help being amused by the claims to aristocratic good breeding of this heraldry on the front here. Or the implications of super-natural speed given by the <u>moderne</u> angel. Impressed by the sense of jet power, or is it sex, in these chromium bulges here. Certainly we were impres-sed by the sculptural skill with which this cascade of chromium round the front here is managed, and by the neat and dra-matic way in which the headlamps have been included in the design. And by the sheer mastery of line and curve in this kind of detailing; and the vast cinema-scope screen in front of the driver and all the science fiction imagery in front of him on either side of the steering wheel.''
<u>Reyner Banham</u>. Used in the soundtrack of <u>Fathers of Pop</u>, spoken while standing next to, and caressing, a Cadillac.

''The ideas of non-Aristotelian logic and the notion that you couldn't say that something was either good or bad led to the possibility of the inclusion in paintings of figurative matter which wouldn't have been conceivable without that fundamental notion of non-Aristotelian thinking.''
<u>Richard Hamilton</u> in conversation with Reyner Banham, 27 June 1976. Recorded for <u>Fathers of Pop</u> but not used in the film.

''Mr. Richard Hamilton suggested that discussions could be held about the films released to local cinemas, as these had an enormous influence, and were amongst the most significant things in film today....Mrs. Richard Hamilton asked whether a policy deci-sion had been taken in the film section: were the ICA to stick to 'Caligari and all that' (film society fare) or would discussions be held on the commercial cinema? [Later] a member asked whether there was any possibility of exchanging art magazines with America.''
Minutes of the ICA Annual General Meet-ing, 24 July 1954.

''There was a bit of cargo culturey at the ICA, both with respect to new emergent disciplines and to things North Ameri-can. They [the IG] seemed to me to see possibilities only over in those regions beyond the rainbow, as it were.''
<u>Donald Holms</u>, Interview, 9 June 1982.

''We had no single verbalizable aesthetic criterion which our opponents had because they'd had longer, generations to work out the vocabulary for formal innovation and formal structure. We were trying to deal with iconography and topicality on a broader base than the traditional humanists. So although we were vulnerable to [the accusation that the IG had no real scale of values] I think in fact, we were more innovative and more speculative.''
<u>Lawrence Alloway</u>. Used in the sound-track of <u>Fathers of Pop</u>.

''It was a great blow to me when Roland Penrose went to Paris for the British Council, but we had high hopes for Law-rence Alloway....At the beginning I found him an exciting person to work with as he was full of new ideas and was very much in touch with the younger groups of artists and writers....He had a stimulating, sharp, clear mind, but he was extremely ambitious, as most young men are. Sadly, in the end, I found that his ruthlessness and cynicism did not

Magda Cordell.

make for teamwork....However, he undoubtedly brought a new element into the ICA...Some of his interests were mass communication, science fiction, and Americana. Subjects of that kind which we had not touched upon till then, and which were very much in the minds of the younger generation of art students and students of all sorts really and most importantly of the Independent Group.''
<u>Dorothy Morland</u>, ''A Memoir,'' unpublished manuscript.

''The man Alloway is a phenomenon: sawed-off, dapper (in the Charing Cross mode), with his ginger nut cropped close to the bone, a wit like a slasher's razor, and a conversational range from Martin (K) and Lewis (D), the well-known abstrac-tionists, to Martin (D) and Lewis (J), the celebrated comics. Out of a whole generation of junior pundits raised in that nursery of promise, <u>Art News and Review</u>, he is not merely the most likely to succeed, but has. The job at the ICA might have been made for him – he cer-tainly made for it, like a man sighting a well in the desert....''
<u>Reyner Banham</u>, ''Alloway and After,'' <u>Architects' Journal</u>, 26 December 1957.

''A characteristic of post-war culture is the impact of the mass media. The impact has been felt before....But these revo-lutions in communications seem not to have achieved their full effect until confirmed by the new medium of televi-sion and by the popularity of the comic strip. In addition, the general increase in the imagination and effi-ciency of the popular arts has been recognized.

The popular arts are a fruitful area for objective audience research. Such research has always produced remarkable information about the way people perceive and interpret the sym-bols of advertisements and the movies, for example. This knowledge has impor-tant implications in a wider field than is yet realised; it may ultimately affect the traditional aesthetics of the fine arts. Because of the quantity of books, magazines, movies, ads, tele-vision and sound programmes which are available, there has been a great increase in our symbol-creating capac-ity. The tendency of intellectuals has been to oppose this process: Lewis Mum-ford, for example, believes that our senses are blunted by exposure to this flood of symbols. However, it may be that a system of meaning and a kind of aesthetic is implicit in the symbols of mass communications.''
<u>Lawrence Alloway</u>, <u>ICA Bulletin</u>, October 1955.

33

1956

April 18	Khrushchev and Bulganin visit Britain.	Publication of Colin Wilson's *The Outsider*, Colin Cherry's *Information Theory*, A. E. van Vogt's *The Players of Null-A*.
May 21	U.S. drops first hydrogen bomb from the air.	Film: Fred Wilcox's *Forbidden Planet*.
22	World's first atomic power station opened at Calder Hall, Cumberland.	Release of Elvis Presley's "Heartbreak Hotel" and "Blue Suede Shoes" and Bill Hayes's "The Ballad of Davy Crockett."
June 14	U.K.-U.S. agreement on atomic cooperation.	
October 22	Mass demonstrations in Hungary.	
24	Soviet troops invade Hungary.	
31	British bomb Egyptian airfields.	
November 5	French and British paratroops land at Port Said.	

Eduardo Paolozzi receives the William and Norma Copley Foundation Award for £1,000.

Alison and Peter Smithson, House of the Future, Ideal Home Exhibition, London, March 1956. View looking across the bedroom and patio.

January	Modern Art in the United States exhibition opens at the Tate Gallery. Magda Cordell Paintings exhibition opens at the Hanover Gallery.
12	Discussion: The Audience as Consumer – Independent Television and Audience Research. Chaired by Lawrence Alloway (ICA).
17	Lecture by J. Z. Young: The Meaning and Purpose of Communication (ICA).
26	Lecture by Meyer Schapiro: Recent Abstract Painting in America (ICA).
February 2	Lecture by Ben Shahn: Realism Reexamined (ICA).
21	Lecture by Reyner Banham: Futurism (ICA).
23	Discussion about architecture: The Open Plan Versus the Cellular. Speakers include Peter Smithson (ICA).
31	Lecture by N. F. Dixon: Information Theory and Its Applications to Psychology (ICA).
March	Daily Mail's Ideal Home Exhibition. Alison and Peter Smithson show their House of the Future.
28	Discussion about architecture: The New Brutalism. Speakers include Toni del Renzio (ICA).
April 19	Discussion about the toys and films of Charles Eames. Chaired by Lawrence Alloway (ICA).
May	Reyner Banham resigns from the ICA Management Committee.
24	Colin St. John Wilson joins the ICA Management Committee.
June 13	Discussion about Freud and the arts. Speakers include Lawrence Alloway (ICA).
19	Discussion about Marcel Duchamp. Speakers include Richard Hamilton, Anthony Hill, Colin St. John Wilson.
July	John McHale returns from the U.S. Richard Hamilton makes the collage Just what is it that makes today's homes so different, so appealing? for the catalogue and Group Two's poster for This Is Tomorrow.
4	Georges Mathieu exhibition opens at the ICA. Catalogue notes by Toni del Renzio. Exhibition closes 11 August.

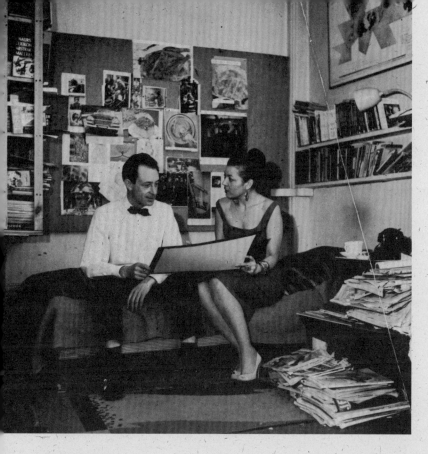

John McHale and Magda
Cordell in front of
McHale's tackboard,
1956.

25	Lecture by Georges Mathieu: Only the Really New Can Be Truly Traditional (ICA).
August	CIAM 10 conference at Dubrovnik, planned by Team 10.
8	This Is Tomorrow exhibition opens at the Whitechapel Art Gallery. Exhibitors include Theo Crosby, William Turnbull, Edward Wright, Richard Hamilton, Terry Hamilton, John McHale, Magda Cordell, Nigel Henderson, Eduardo Paolozzi, Alison Smithson, Peter Smithson, Colin St. John Wilson, Toni del Renzio, Geoffrey Holroyd, Lawrence Alloway. Exhibition closes 9 September.
September	Plans for a fashion photography exhibition at the ICA by Toni del Renzio (never realized).
	An Experiment with Child Art — an exhibition by Eduardo Paolozzi in the ICA Members' room.
October 2	John Hultberg exhibition opens at the ICA. Catalogue notes by Lawrence Alloway. Exhibition closes 17 October.
18	Talk by Alan Davie. Introduced by Lawrence Alloway (ICA).

November	Publication of Ark 18, edited by Roger Coleman. Includes A. and P. Smithson's article ''But Today We Collect Ads.''
7	Lawrence Alloway's title at the ICA changed to deputy director.
8	Discussion about Jackson Pollock. Chaired by Lawrence Alloway (ICA).
27	John McHale: Collages exhibition held in the ICA library (a newly acquired space three floors up in the Dover Street building, opened on 25 October). Exhibition closes 15 December.
December 13	Lecture by Frank John Roos: An Art Historian Looks at Contemporary American Painting (ICA).
14	Colin St. John Wilson resigns from the ICA Management Committee.

This Is Tomorrow,
installation view.
Whitechapel Art
Gallery, August–
September 1956.
View from wall by
Group Eleven.

John McHale, Magda
Cordell, and James
Stirling inside the
Group Two exhibit at
This Is Tomorrow.

Group Two construct-
ing its This Is Tomor-
row exhibit. Left (on
ladder), John McHale;
center (on ladder),
Richard Hamilton;
center (on ladder),
Magda Cordell; right
(holding optical
panel), Terry
Hamilton.

36

Pogo chair by Alison
and Peter Smithson for
House of the Future,
under construction in
a bicycle frame-
maker's shop, London,
January–February
1956.

Alison and Peter Smithson viewing the Group Six
exhibit, Patio and Pavilion, in This Is Tomorrow.

1956

Although the Independent Group ceased its formal meetings at the end of 1955, the "antagonistic cooperation" which had been a feature of the gatherings and a catalyst for much of the debate continued at the various venues frequented by the members. At the ICA itself, lectures, public discussions, and exhibitions involved Banham, del Renzio, Hamilton, Peter Smithson, Sandy Wilson, and others, with Alloway figuring in numerous activities, many of which he instigated in his role as assistant director. A number of these were part of a conscious desire to bring particular issues to ICA audiences. No doubt talks on communication and information theory, television audiences, American abstract and realist art, Jackson Pollock, and Charles Eames were organized or promoted by Alloway.

In March, at the *Daily Mail*'s annual *Ideal Home Exhibition*, Alison and Peter Smithson exhibited their House of the Future, which appeared to be a departure from their earlier work. Designed as a forecast of a house in twenty-five years' time, the House of the Future had the look of what critics would later call Pop Architecture. But the Smithsons had not jettisoned their Brutalist ethic, which accommodated diverse styles and was ultimately concerned with building, community, and territory, rather than with following any rigid aesthetic.

Two months after the *Ideal Home Exhibition*, Banham resigned from the ICA Management Committee. As far as the Independent Group was concerned this had little consequence other than to diminish Banham's own role at the Institute, for on the one hand he was replaced on the committee by Colin St. John Wilson, who continued to promote Independent Group concerns, and on the other, Alloway's presence ensured that the Group's voice was heard.

Plans which had been underway since 1954 came to fruition in August at the Whitechapel Art Gallery. *This Is Tomorrow* was a show made up of twelve exhibits, each designed by a team comprising a painter, sculptor, and architect. TIT, as it was affectionately known, presented a curious collaboration between the British Constructivists, some of whom regarded themselves as the guardians of Modernism, and the Independent Group, whose contributions promoted pluralist alternatives. In retrospect, it was an extremely influential exhibition. At the time, newsreels and newspapers presented it as a bizarre manifestation of abstract art, but it was also a remarkably popular show with up to one thousand visitors a day.

The dissemination of Independent Group ideas accelerated during 1956. In addition to the ICA program and *This Is Tomorrow*, many of the Group's ideas were aired in the pages of *Architectural Design* through the auspices of Theo Crosby, who co-edited the journal, and in November the Royal College of Art's student magazine, *Ark*, began to publish articles by Independent Group members.

''I don't think the Independent Group had any influence on the House of the Future because we arrived at all that prognostication by...a fixed forward projection, which I think was twenty-five years....We merely said that if such and such is available in America in small numbers, it will be generally available at a certain period.''
Peter Smithson, Interview, 22 November 1982.

''I feel very strongly that Ben Nicholson, Barbara Hepworth and either Martin, Fry or Drew should be asked to collaborate together to produce something for the exhibition [This Is Tomorrow].''
Bryan Robertson, Letter to Theo Crosby, 23 May 1955.

''With regard to your suggestion that Nicholson and Hepworth be included, it was generally felt that it would be difficult for them to attend the discussions which are really the point of the collaboration.''
Theo Crosby, Letter to Bryan Robertson, 8 June 1955.

Peter Smithson, Eduardo Paolozzi, Alison Smithson, and Nigel Henderson. Photo of Group Six by Henderson.

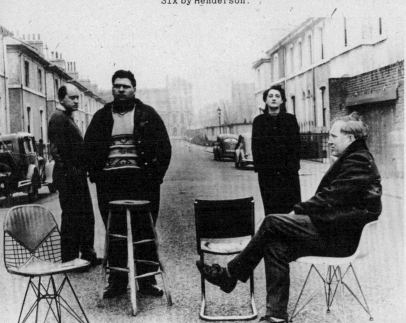

''I am sorry to hear about Nicholson and Hepworth. The difficulties can, I think, be fairly easily overcome and I still hope that your group will reconsider its decision and approach them.''
Bryan Robertson, Letter to Theo Crosby, 10 June 1955.

''This Is Tomorrow gives a startling foretaste of the diversity and enormous range of the Art of the Future. It ranges from orthodox abstract art, with its classical regularity and rational order, through room-size sculptures to walk through, to crazy-house structures plastered with pin-up images from the popular press. Behind this variety of appearances lies a whole gamut of aesthetic theories, from formal studies refined by two thousand years of enquiry and research, to spit-new approaches based on Communication Theory and the strange mathematics of Topology. And again and again, the visitor will find the emphasis and the pride of achievement thrown back on himself, that the Art of the Future is for him to choose, for him to participate in, the doors of the Ivory Tower are wide open.''
Lawrence Alloway, Press Release for This Is Tomorrow, 1956.

''We all had tackboards in our homes or our work spaces where we constantly pinned things up, removed things, and they were always in odd juxtapositions and we were making this relationship and contrast between them. This seemed to be something quite fundamental to Independent Group notions....[We were] making a principle out of something which was not at all that new. Artists had always done it but we believed it was a technique.''
Toni del Renzio on the Group Twelve exhibit in This Is Tomorrow, Interview, 17 March 1982.

''A backyard full of tatty old family miracles, but enclosed by a sand garden — I think that's the right way to put it — in which were inexplicably and unexplainably laid out things — objects, images, shards of real and imaginary civilisation dredged up from the subconscious of Eduardo Paolozzi, Nigel Henderson and, I don't know, the Smithsons themselves. A kind of personal archaeology which you just had to stand and look at.''
Reyner Banham, Lecture (discussing Group Six exhibit at This Is Tomorrow). Recorded for the film Fathers of Pop, but not used.

''People who drifted in off the street simply took in [Group Two's exhibit for This Is Tomorrow] and drifted out again because beyond that everything was static, calm, art gallery sort of stuff with no visible action of any sort.''
Reyner Banham in conversation with John McHale, 30 May 1977. Recorded for Fathers of Pop but not used in the film.

''There was a certain amount of high-spirited arrogance and one-upmanship in certain quarters and, in the case of Roger Hilton, one-over-the-eight-manship (he demanded that the 'word-men' should get out and leave the artists and architects to get on with it: exit Alloway et al.). But on the whole there was little dissension at the proposal that space in the Whitechapel would be split up like market stalls in a fair and autonomous groups should each do their own thing. The most striking image in the whole exhibition was Nigel Henderson's giant head (which I later bought from him), though what the hell it was doing in a potting shed I never understood. Nor do I know who thought up the catchy but ludicrous title to the show: it must have been one of those 'word-men'''!
Colin St. John Wilson, ''A Note About This Is Tomorrow,'' unpublished manuscript, 1988.

Geoffrey Holroyd (right) talking with Michael Farr (editor of Design) at This Is Tomorrow.

1957

January 9	Sir Anthony Eden resigns as prime minister.
10	Harold MacMillan becomes prime minister.

Film: Alexander Mac-Kendrick's *The Sweet Smell of Success*.

William Turnbull visits the U.S.

Plans for an exhibition at the ICA: Signs and Symbols — an attempt to place art in the general framework of communications research. Planners include Theo Crosby, William Turnbull, Geoffrey Holroyd, Edward Wright. Exhibition never realized.

Richard Hamilton paints Hommage à Chrysler Corp.

January 16	Statements: A Review of British Abstract Art in 1956 exhibition opens at the ICA. Exhibitors include Magda Cordell. Catalogue notes by Lawrence Alloway. Letter from Richard Hamilton to A. and P. Smithson suggesting future developments from This Is Tomorrow and Independent Group discussions.
February 7	''Man About Mid-Century'': a dialogue between Roger Coleman and Richard Smith (ICA).
11	Roger Coleman joins the ICA Exhibitions Committee.
March	Publication of Ark 19, with articles by Lawrence Alloway, John McHale, Edward Wright, Frank Cordell. Stefan Munsing appointed cultural affairs officer at the American Embassy in London.
5	Lecture by Toni del Renzio: The Strategy of Fashion (ICA).
April 12	Lecture by Tomàs Maldonado: The Pedagogical Impact of Automation (ICA).
18	Discussion about Karel Appel. Speakers include Roger Coleman (ICA).
May	Publication of John McHale's ''Marginalia'' in Architectural Review.
14	Lecture by Dwight MacDonald: A Theory of Mass Culture (ICA).

June	Richard Hamilton and Victor Pasmore's an Exhibit opens at the Hatton Gallery, Newcastle-upon-Tyne.
6	Lecture by Edward Wright: Painter's Task and Painter's Play (ICA).
27	Discussion about the importance of Wols. Speakers include Toni del Renzio (ICA).
July	Publication of Ark 20, with articles by Roger Coleman, Richard Smith, Lawrence Alloway, Toni del Renzio.
18	Discussion about the current Lynn Chadwick exhibition. Speakers include Lawrence Alloway and Richard Hamilton (ICA).
23	Discussion about planning control. Speakers include Peter Smithson (ICA).
August 12	an Exhibit exhibition opens at the ICA. Organized by Richard Hamilton, Victor Pasmore, Lawrence Alloway. Exhibition closes 24 August.
September	Roger Coleman appointed assistant editor of Design magazine. Richard Hamilton begins part-time teaching at the Royal College of Art, Interior Design Department.
24	William Turnbull: New Sculptures and Paintings exhibition opens at the ICA. Catalogue notes by Lawrence Alloway. Exhibition closes in November.
November 5	Discussion: Folklore and the Second Industrial Revolution. Speakers include Lawrence Alloway (ICA).
7	Eight American Artists exhibition opens at the ICA.
December	Dimensions — British Abstract Art 1948-57 exhibition at the O'Hana Gallery. Exhibitors include William Turnbull, Magda Cordell, John McHale, Richard Hamilton, Eduardo Paolozzi. Exhibition arranged by Lawrence Alloway.
17	Lecture by Reyner Banham: The Trapeze and the Human Pyramid (ICA).

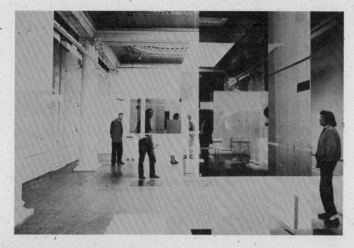

an Exhibit, Hatton Gallery, Newcastle, June 1957. Left to right: Victor Pasmore, Richard Hamilton, Terry Hamilton.

an Exhibit

ICA

a game	pre-planned	RICHARD HAMILTON	played
an artwork	individuated	VICTOR PASMORE	viewed
an environment	verbalised	LAWRENCE ALLOWAY	populated

at the ICA Gallery 17-18 Dover Street London W1
on August 12 at 6 p.m. George Brown will sing an Exhibit calypso

13-24 August Monday to Friday 10-6 Saturday 10-1

Invitation to the private viewing of an Exhibit, ICA, August 1957.

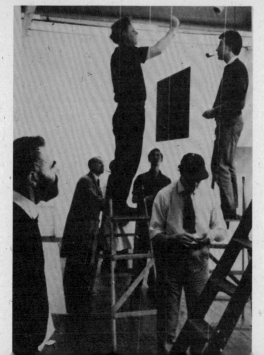

Installation of an Exhibit. Pasmore at left, Hamilton center right (with cap).

There was a growing awareness of American painting and sculpture in Britain during the fifties, but it was the Tate Gallery's 1956 exhibition, *Modern Art in the United States*, which made the work accessible and stimulated a response from artists. Although the ICA had shown American art before 1956, the peripheral nature of the Institute's activities minimized their impact. After the Tate show the ICA exploited the increased interest, with Lawrence Alloway, as always, in the forefront. His program for 1957 onward was liberally sprinkled with lectures, discussions, and exhibitions about American art and in this he was helped by the appointment of Stefan Munsing as cultural attaché at the U.S. Embassy. Munsing was sympathetic to the ICA and supplied Alloway and his colleagues with books and journals containing the latest information about American culture.

Connections between the ICA and the Royal College of Art were important at this time. At the RCA, Richard Smith was painting abstract canvases of transparent, dripping, and scumbled color passages. He was still a student and worked on two issues of *Ark* with the editor Roger Coleman. Both issues contained articles by Independent Group members as well as other pieces on American culture. RCA students such as Peter Blake, Robyn Denny, Smith, and Coleman frequented the Institute, with the latter joining the ICA's Exhibitions Committee early in the year, and Richard Hamilton and Edward Wright were part-time tutors at the college.

Hamilton was also teaching in Newcastle, and it was here that his show *an Exhibit* opened in June, later to appear at the ICA. Its formal, abstract character reflected the participation of Victor Pasmore and developments in the basic design course which they had organized. At the same time, Hamilton began painting *Hommage à Chrysler Corp*. Although the precise abstract forms found in *an Exhibit* appear in the picture, it is essentially a figurative piece, combining imagery from *Man, Machine and Motion* with American advertisements, ideas from his TIT exhibit, Reyner Banham's lectures on car styling and symbolism, and a free interpretation of Alloway's "fine art/popular art continuum," all suffused with Duchampian irony.

John McHale and Eduardo Paolozzi were also producing more figurative than abstract pieces at this time, both perhaps influenced by Independent Group interest in the concept of built-in obsolescence and the throwaway aesthetic inherent in the nature of mass media. McHale made collages of material he had brought back from the United States, which he conjured into heads and figures, displaying an appealing synthesis of texture and imagery. Paolozzi's bronze figures of robots, heroes, and deities have the texture of obsolete machinery, discarded on the rubbish dump and fused with the earth in which it lies.

39

Reyner Banham.

''[America is] the model for any fully
urban city, of any industrialised soci-
ety; we see in America simply what's
happening and what's available to any-
body who is living in the twentieth cen-
tury city. It's not an exotic...it's
everybody's right.''
Lawrence Alloway in ''Artists as Con-
sumers — the Splendid Bargain,'' BBC
Radio, broadcast 11 March 1960.

''The other connection...was with the
American Embassy and Stefan Munsing,
who was the cultural attaché. What was
dramatic then was that suddenly we saw
the American paintings, and that was
through Munsing. And a lot of those
early [i.e., mid-1950s] ICA exhibitions
were helped by the embassy. And Munsing
was also enormously involved in sending
a lot of the English painters off to the
States....His office in the embassy was
sort of open house....An amazing
library, of course, in which we could
see a lot of magazines and stuff,
because at that stage it was a bit like
an ordinary public library — we could
just go in and order magazines and
books, and records as well.''
James Meller, Interview, 12 March 1984.

''[The This Is Tomorrow Group Twelve
exhibit] was to be developed by myself,
William Turnbull, Theo Crosby and
Edward Wright, in the [proposed] Signs
and Symbols show....We produced writ-
ten outlines at Turnbull's suggestion,
and presented and discussed them at a
meeting at Theo's. It was to be a devel-
opment of the TIT panel and tackboard
[Group Twelve], like a tunnel of space
over the ICA exhibition space — a
'crossword puzzle' where the grid of
lines would be a steel space frame,
curved like a vault springing from the
floor. Coloured panels (like Eames's
collapsible giant constructor-display
kit, 'The Toy') would continue the head-

40

Mary Banham.

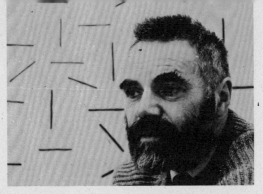

Victor Pasmore.

word colour-coding idea; images were
mounted in clusters and groupings. This
we could not semantically disentangle
at the time. We rested the idea....''
Geoffrey Holroyd, Letter, 23 April
1983.

''Ark was a very parochial thing. All it
was, was a professional magazine to give
the graphic designers...a chance to lay
out a real magazine. And I think they
discovered that they wanted some mate-
rial for it, so they appointed an editor
as well....I got a terrible lot of stick
from the RCA students' committee and
things like that because I didn't employ
enough students; I got too many outside
things...[but] a lot of it was policy
and a lot of it was opportunism and a lot
of it was to do anything to keep out the
people from the weaving department
who...wanted to do some article on the
decoration of barges which we were des-
perately trying to avoid. And so any-
thing, as long as it was made of
aluminium, you know, and went fast, then
it was okay and would get in [the
magazine].''
Roger Coleman, Interview, 18 April 1983.

Roger Coleman, editor of Ark 1957-58.

''Everyone was looking for new activity
and I suggested that we might now turn
our attention to using the experiences
and the investigations of the previous
years for the purpose of creating a new
aesthetic; to produce work which showed
the consequences of this thought. This
idea wasn't taken up by anybody, but I
thought it was something I could adopt
myself. So in 1957 I made a program for my
own work and the immediate outcome of
this was a painting called Hommage à
Chrysler Corp. I arrived at this picture
by adopting an analytical approach. I
looked at all the phenomena that we'd
been looking at; all the experience of
the pop art and said, is there anything,
any ingredient which these pop art phe-
nomena have which is incompatible with
fine art? I said, is big business incom-
patible with fine art? No. And I went
through a long list of all the things I
associated with the art of the mass
media and the only element which I
thought was not compatible was expen-
dability. There seemed to be an almost
accepted aspect of the mass media which
was a disposable element. That when
Elvis Presley produced a record, you
didn't get the feeling he was making it
for next year, he was making it for this
week and it didn't really matter very
much when it sold the first four million
whether the thing was ever heard again.
And I thought, this is something that
the fine artist cannot stomach, he can-
not enter the creative process of making
a work of art with an understanding that
it's not going to last until next year or
for very much longer than that. He has to
approach it with the idea that it has
some qualities which are enduring.''
Richard Hamilton, ''The Impact of Amer-
ican Pop Culture in the Fifties,'' Talk
recorded for the Open University.

1958

March 5 — Campaign for Nuclear Disarmament march to Aldermaston.

''After a Fashion'' by Toni del Renzio published in ICA Publications.

Plans by Lawrence Alloway and Roger Coleman for a magazine called Number, never realized.

Richard Hamilton paints Hers is a lush situation and begins work on $he (originally titled Woman in the Home).

January 8 — Lecture by Reyner Banham: Futurism and Modern Architecture (at the Royal Institute of British Architects).

9 — Five Young Painters exhibition opens at the ICA. Exhibitors include Richard Smith. Exhibition closes 8 February.

21 — Discussion about Kandinsky. Speakers include Toni del Renzio (ICA).

February — Publication of Lawrence Alloway's ''The Arts and the Mass Media'' in Architectural Design.
Daily Mail's Ideal Home Exhibition.
Richard Hamilton exhibits Gallery for a Collector of Brutalist and Tachiste Art.

13 — Some Paintings from the E. J. Power Collection exhibition opens at the ICA. Catalogue notes by Lawrence Alloway. Exhibition closes 19 April.

20 — Discussion about Pier Luigi Nervi. Speakers include James Stirling (ICA).

27 — Discussion about packaging. Speakers include Lawrence Alloway (ICA).

April 10 — ''Statements on the Motivation of Culture,'' a presentation by Cedric Price and Bill Cowburn. Chaired by Lawrence Alloway (ICA).

17 — Discussion about the impact of American art on Europe. Speakers include Richard Smith and William Turnbull (ICA).

30 — Illustrated Statement by Eduardo Paolozzi: Image-Making—God-Breaking (ICA).

May — Scroope Group exhibition at Cambridge University School of Architecture.

20 — Discussion on the role of the art director. Speakers include Toni del Renzio (ICA).

June — Drawings by Peter Smithson exhibition opens at the ICA.

6 — Lecture by R. Buckminster Fuller: Man Plus. Chaired by Reyner Banham (ICA).

July 4 — Program of films by Charles and Ray Eames (ICA).

8 — Lecture by Lawrence Alloway: Art in America Today (ICA).

October 7 — Visit to Ham Common flats with James Stirling (arranged at the ICA).

14 — Lecture by John Alford: Abstract Expressionist Painting and the Humanist Tradition (ICA).

21 — Lecture by Lawrence Alloway: Monster Engineering (ICA).

23 — Lecture by Robert Crawshay Williams on Alfred Korzybski's Science and Sanity (ICA).

November — Eduardo Paolozzi exhibits at the Hanover Gallery.

4 — Three Collagists exhibition opens at the ICA. Exhibitors include John McHale. Exhibition closes in December.

6 — Hans Namuth film of Jackson Pollock shown at the ICA.

December 16 — Lecture by Ian McCallum: America's Crystal Palaces. Chaired by Peter Smithson (ICA).

41

Richard Hamilton,
''Gallery for a Col-
lector of Brutalist
and Tachiste Art,''
Ideal Home Exhibi-
tion, March 1958.

42

If there had ever been a period of gestation for Independent Group concepts, clearly it was now over. The effects of the meetings held from 1952 through 1955 reverberated both inside and outside the ICA. More than any other artist member of the IG, Richard Hamilton turned its critical engagement with mass media society into art, and he transformed his style in the process. This work was not enthusiastically received by all of the IG members. Lawrence Alloway, for example, was less than complimentary about Richard Hamilton's *Hommage à Chrysler Corp.* and his 1958 panel *Hers is a lush situation.* Undeterred by such criticism, Hamilton began work on a third panel which was based on consumer product advertising.

At the same time, Hamilton's teaching post in the RCA's Interior Design department probably led him to create the *Gallery for a Collector of Brutalist and Tachiste Art* for the *Daily Mail's Ideal Home Exhibition.* A large window was planned through which one could see a streamlined car, to be appreciated on equal terms with the exhibits inside the gallery by Paolozzi, Sam Francis, and Yves Klein. To further confuse the apparent distinction between unique fine art and mass-produced popular art, the furniture in the gallery was designed by Harley Earl, chief stylist at General Motors.

While Hamilton's works of art brought into focus something of what the Independent Group had been about, others interpreted Group themes in different ways. At the ICA in 1957, Alloway had introduced an ongoing series of lectures and discussions about mass communication, and these continued into 1958 with contributions from Cedric Price and Toni del Renzio. Other ICA events featured Eduardo Paolozzi, James Stirling, and William Turnbull, while Peter Smithson exhibited his drawings and John McHale his collages. As a background to all this, the concern for American art continued: the impact of American art upon Europe, a lecture by Buckminster Fuller, Hans Namuth's film of Jackson Pollock, and so on.

In the pages of *Architectural Design* Alloway published an important essay entitled, "The Arts and the Mass Media," and Hamilton's *Hommage à Chrysler Corp.* was reproduced in line with an explanation of its source. In the *Architects' Journal* Banham wrote about the influence of Frank Cordell and the impact of science fiction.

During 1958, Alloway and Roger Coleman planned the magazine *Number,* a collection of artists' texts, but various difficulties prevented it from getting further than a series of manuscripts. Coleman himself had now left the Royal College and, although still a member of the ICA Exhibitions Committee, became assistant editor for *Design* magazine. His RCA colleague Richard Smith exhibited at the ICA early in the year, while in Cambridge, a group of architecture students showed paintings which had the characteristics of Abstract Expressionism but titles culled from the mass media.

''I think we were actually fundamentally
anti-pop. That is, the interest in cur-
rent phenomena, current imagery —
imagery that was thrown up by produc-
tivity, by advertising and so on, that
was studied in the Independent Group —
each person in the Group was studying it
for his own reasons. One emerges from it
as one went into it, with more informa-
tion, with one's lines established. But
certainly, those who used the informa-
tion directly — isn't that a handsome
picture or a handsome layout which I
could parody for a fine art picture? — I
really think that is a completely mean-
ingless activity.''
Peter Smithson in conversation with
Reyner Banham, 1976. Recorded for
Fathers of Pop but not used in the film.

''The interest for me was always in tech-
nological developments entering the
cultural scene.... Popular arts were
the arts of the people, it was hand-
icrafts. After the war there was a great
influx of technically oriented popular
art: there was Hollywood, the Hollywood
movie — Cinemascope was coming in in the
fifties, stereophonic sound, televi-
sion, radio — and artists [had to be]
fairly into this network to cope with
the visual problems. The good writers of
our time were going to Hollywood writing
scripts. So there was suddenly a new mix
of intellectuals and technology and the
need to spread this over a wide audi-
ence, because there's no point in spend-
ing a lot of money unless you can get it
back at the box office.''
Richard Hamilton in conversation with
Reyner Banham, 27 June 1976. Recorded
for Fathers of Pop but not used in the
film.

''One of the things I think is terribly
important about Paolozzi is that he was
a full-time fine artist. Wherever he
went he was, you know, bending things,

drawing things, or turning paper plates
into something, so that he was habitu-
ally an improvising working artist. But
his material was also continually sci-
ence fiction, movie stills. He and I
used to go quite a lot to the London
Pavilion in Piccadilly which in those
days was showing Universal horror
films... so he was kind of someone who
had this itchy creativity on a contin-
uous basis, always being bombarded by
mass-media imagery. And the example of
seeing this happen to someone, I think
sort of relaxed me and made it easier for
me to go to the lecture at the Tate Gal-
lery in the afternoon and go to the Lon-
don Pavilion as soon as I could get out
of there in the evening. He's been
influential, I think, in setting up this
notion of the fine art–pop art continuum
— the touchability of all the bases in
the continuum.''
Lawrence Alloway. Used in the sound-
track of Fathers of Pop.

''Was it only yesterday that the Treasures
of Cambridge were exhibited in London?
Stagnant symbols removed from their
sanctified preservation for a brief
public showing: a gesture indicating
the embarrassing wealth of the Univer-
sity's art stores? Today a new gesture
expressing in the loaded image on the
cover the paradoxical relationship of
the four artists with their environ-
ment. In the background, that momentous
symbol of a past age, King's Chapel,
and, edging towards it, a great hunk of
Neo-Classic. Basically the artists
react against this aspect of the envi-
ronment and its inevitable lack of
dynamic. Remember that Cambridge grew
from isolated monasteries into a womb
for fertilizing egg-heads, poets, top-
men, researchers, architects, and that
the original spirit of these institu-
tions still prevails, despite nearby
test-tube signs of tomorrow. The aver-
age speed is that of the bicycle, the
general atmosphere that of sleepy pro-

Lawrence Alloway and
his wife, Sylvia
Sleigh, with painting
by Sylvia Sleigh.

vincialism. Sometimes a dynamic can be
found as in a double-decker bus chan-
nelling its way through the narrow
streets like a technological dinosaur.
But such modern-age sensations are lim-
ited and so the artist turns towards the
tinsel and jazz of urban activity, with
its exploding gestures, galactic
streams of commuters, jukeboxes, mass-
media, and pin-tables. By establishing
a relationship with these phenomena,
the artists place themselves on the
mainland. (Islands are for uncom-
municating introspectives.) Their art
is an extension of their environment,
distilling its essence into four per-
sonal frames of reference. Not just
visual kicks, but anyway, kicks at the
'fineness' of Cambridge Culture.''
Robert Freeman, Comment from the cata-
logue of the Cambridge Group (Scroope
Group), New Vision Centre Gallery, Lon-
don. 8–27 February 1960.

''I was conscious of it [the ICA/IG] as
more of a social scene. And people were
kind of cracking jokes which... I had no
possibility of entering into. Everybody
seemed to have known each other for so
long.... It was more an attitude rather
than a work of art that one was admir-
ing.... In my own case, I came to it very
directly through the Independent
Group.... My interests coincided with
the Independent Group things.''
Richard Smith. Used in the soundtrack of
Fathers of Pop.

1959 and after

1959

June 9 — Launching of the first U.S. Polaris submarine.

October 4 — Soviet rocket photographs the far side of the moon.

Construction begins on James Stirling's Engineering Building at Leicester University (completed 1963).

January 8 — National Advisory Council on Art Education established. Discussion: A Critical Look at British Art Magazines. Can They Compare Favorably with Europe and the U.S.? Chaired by Lawrence Alloway (ICA).

20 — Lecture by Colin Cherry: Automation Amongst the Artists (ICA).

22 — Discussion about Milan s role in the avant-garde. Speakers include Reyner Banham. Chaired by Toni del Renzio (ICA).

February — Publication of John McHale's ''The Expendable Ikon'' in Architectural Design (February and March issues).

7 — Class of '59 exhibition opens at The Union, Cambridge University. Exhibitors are John McHale, Magda Cordell, Eduardo Paolozzi. Exhibition closes 19 February.

17 — Lecture by Reyner Banham: Le Corbusier's Oeuvres Supremees (ICA).

24 — The New American Painting exhibition opens at the Tate Gallery.

March 4 — Symposium on the Le Corbusier exhibition at the Building Centre, London. Speakers include Reyner Banham, Peter Smithson (ICA).

10 — Discussion about the Young Contemporaries exhibition at the RBA Galleries. Speakers include Roger Coleman, Toni del Renzio, Peter Smithson (ICA).

April 29 — The Developing Process exhibition opens at the ICA. Closes in May.

May 7 — Discussion about The Developing Process exhibition (ICA).

21 — Discussion about ergonomics. Speakers include Roger Coleman (ICA).

28 — Minority Pop. A discussion between Roger Coleman and Toni del Renzio (ICA).

June 2 — Richard Hamilton and Victor Pasmore discuss the different versions of an Exhibit (ICA).

3 — Adolph Gottlieb exhibition opens at the ICA.

11 — Lecture by Lawrence Alloway on Gottlieb (ICA).

18 — Screening of film 83B by William Turnbull and Alan Forbes (ICA).

July 2 — Design Centre Awards. Chaired by Toni del Renzio (ICA).

7 — Lecture by Richard Hamilton: The Design Image of the Fifties (ICA).

September 23 — Place exhibition opened by Stefan Munsing at the ICA. Exhibitors are Ralph Rumney, Robyn Denny, Richard Smith. Catalogue by Roger Coleman.

October 1 — Discussion about Place. Speakers include Roger Coleman and Richard Hamilton (ICA).

8 — Lecture series: The Fifties — Whatever Happened to the Avant-Garde? by Lawrence Alloway (ICA).

15 — Lecture series: The Fifties — The Revolution in Architectural Thinking Since 1950, by Peter Smithson (ICA).

November 5 — Lecture series: The Fifties — The Last Days of Design, by Reyner Banham (ICA).

December — Publication of Cambridge Opinion, 17. Edited by Robert Freeman, with articles by Lawrence Alloway, Reyner Banham, and John McHale.

Magda Cordell at the Class of '59 show. Cambridge University, February 1959.

Colin St. John Wilson.

1960

May 1 — Russians shoot down American U2 reconnaissance aircraft.

August 17 — U2 pilot Gary Powers on trial in Moscow.

September 24 — Launch of the USS Enterprise, first atomic-powered aircraft carrier and world's largest warship.

Publication of Reyner Banham's Theory and Design in the First Machine Age.

Construction begins on Alison and Peter Smithson's Economist Building (completed 1964).

Formation at the ICA of an exclusively painters' version of the Independent Group, called Talk.

Eduardo Paolozzi wins the David E. Bright Foundation Award at 30th Venice Biennale.

Richard Hamilton receives the William and Norma Copley Foundation Award.

January	Art – Anti-Art series produced for BBC Radio.
19	Discussion about the current issue of <u>Cambridge Opinion</u>. Speakers include Colin Cherry, John McHale, Reyner Banham, Robert Freeman, James Meller. Chaired by Lawrence Alloway (ICA).
21	Lecture series: The Fifties – Glorious Technicolour and Breathtaking Cinemascope and Stereophonic Sound, by Richard Hamilton (ICA).
February	Publication of Lawrence Alloway's ''Notes on Abstract Art and the Mass Media'' in <u>Art News and Review</u>. Publication of Richard Hamilton's ''Persuading Image'' in <u>Design</u>.
8	Cambridge Group (Scroope Group) exhibition at the New Vision Gallery, London. Exhibition closes 27 February.
9	Lecture series: The Fifties – Top Tens of the Fifties, by Roger Coleman (ICA).
23	Discussion about the current F. H. K. Henrion exhibition. Speakers include Geoffrey Holroyd (ICA).
March	Publication of Reyner Banham's ''Industrial Design and Popular Art'' in <u>Industrial Design</u>.
15	Discussion about architecture: City Lights. Speakers include Peter Smithson, John McHale (ICA).
17	Discussion about Hard Edge painting. Speakers include Roger Coleman (ICA).
23	<u>West Coast Hard Edge</u> exhibition opens at the ICA.
April 7	Lecture by W. Ross Ashby: Art and Communication Theory (ICA).
May 17	<u>Morris Louis</u> exhibition opens at the ICA.

June 1	Discussion about the Morris Louis exhibition. Speakers include William Turnbull, Roger Coleman (ICA).
August 29	Discussion: The Younger Generation Looks at Picasso. Chaired by Roger Coleman (ICA).
September	<u>Situation</u> exhibition at the RBA Galleries. Lawrence Alloway resigns as program director at the ICA.
October 13	Discussion about Reyner Banham's book <u>Theory and Design in the First Machine Age</u>. Speakers include Peter Smithson, Colin St. John Wilson (ICA).
26–28	National Union of Teachers Conference: ''Popular Culture and Personal Responsibility.''
November	National Advisory Council on Art Education recommends the creation of a diploma in art and design to replace the existing national diploma.
17	Lecture by Richard Hamilton: Duchamp's Green Box (ICA).
December	Completion of Eero Saarinen's U.S. Embassy building in London.

1961

February 12	Launch of Russian satellite to Venus.
April 12	Yuri Gagarin makes the first manned space flight.
May 5	Alan Shepard makes the second manned space flight.
June 4	President Kennedy meets Premier Khrushchev.
31	South Africa declares independence from the British Commonwealth.
August 13	East Germany closes the border with the West.
17	Erection of the Berlin Wall.
July	Lawrence Alloway appointed curator at the Guggenheim Museum, New York.

45

Magda Cordell/John McHale exhibition at the ICA.

January 19	Lecture series: Image of Tomorrow — Urban X–Ray, by Robert Freeman (ICA).
February 2	Lecture series: Image of Tomorrow — Slogans and People, by Roger Coleman (ICA).
8	Young Contemporaries exhibition opens at the RBA Galleries. Exhibition closes 25 February.
9	Lecture series: Image of Tomorrow — On a Planet With You, by Lawrence Alloway (ICA).
14	Discussion about the Young Contemporaries exhibition. Speakers include William Turnbull. Chaired by Lawrence Alloway (ICA).
16	Lecture series: Image of Tomorrow — The Plastic Parthenon, by John McHale (ICA).
28	Symposium on Image of Tomorrow lecture series. Speakers include Lawrence Alloway, Roger Coleman, John McHale, Peter Smithson. Chaired by Robert Freeman (ICA).
March	Lawrence Alloway resigns from the ICA Exhibitions Committee.
April 12	Nigel Henderson: Recent Work exhibition opens at the ICA.
20	Discussion: The Language of Art — The Image. Speakers include John McHale, Toni del Renzio (ICA).
May 18	Nigel Henderson answers questions about his work set by Colin St. John Wilson (ICA).
July 3–7	International Union of Architects Congress.

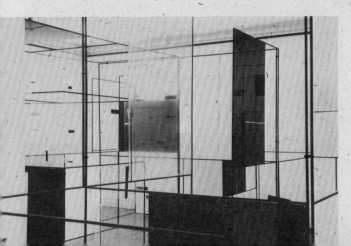

Exhibit 2, Hatton Gallery, Newcastle, May 1959.

20	Discussion about the integration of the arts. Speakers include Peter Smithson. Chaired by Lawrence Alloway (at the International Union of Architects Headquarters, South Bank, London).
September	Lawrence Alloway teaching at Bennington College, Vermont.
28	Discussion about the National Exhibition of Children's Art. Speakers include Eduardo Paolozzi (ICA).
October 10	Max Ernst symposium. Speakers include Toni del Renzio (ICA).

1962

Terry Hamilton killed in a car accident.

John McHale leaves London to teach at Southern Illinois University at Carbondale.

Colin St. John Wilson builds Harvey Court, Caius College, Cambridge University.

Publication of Reyner Banham's ''Who Is This Pop?'' in Motif.

May	Roger Coleman resigns from the ICA Exhibitions Committee.
	Marshall McLuhan lectures at the ICA.
August	Image in Progress exhibition, Grabowski Gallery, London.
September	John McHale and Magda Cordell exhibition at the ICA.
October	Publication of Richard Hamilton's ''An Exposition of $he'' in Architectural Design.
December	Publication of Lawrence Alloway's ''Pop Art Since 1949'' in the Listener.

1963

William Turnbull's sculpture exhibited in New York and Detroit.

Publication of ICA magazine Living Arts.

January	Toni del Renzio living in Paris.
November	Reyner Banham delivers the Terry Hamilton Memorial Lecture at the ICA: The Atavism of the Short–Distance Mini–Cyclist.

Construction begins on Alison and Peter Smithson's Economist Building (completed 1964).

Formation at the ICA of an exclusively painters' version of the Independent Group, called Talk.

Eduardo Paolozzi wins the David E. Bright Foundation Award at 30th Venice Biennale.

Richard Hamilton receives the William and Norma Copley Foundation Award.

January	Art – Anti–Art series produced for BBC Radio.
19	Discussion about the current issue of Cambridge Opinion. Speakers include Colin Cherry, John McHale, Reyner Banham, Robert Freeman, James Meller. Chaired by Lawrence Alloway (ICA).
21	Lecture series: The Fifties – Glorious Technicolour and Breathtaking Cinemascope and Stereophonic Sound, by Richard Hamilton (ICA).
February	Publication of Lawrence Alloway's ''Notes on Abstract Art and the Mass Media'' in Art News and Review. Publication of Richard Hamilton's ''Persuading Image'' in Design.
8	Cambridge Group (Scroope Group) exhibition at the New Vision Gallery, London. Exhibition closes 27 February.
9	Lecture series: The Fifties – Top Tens of the Fifties, by Roger Coleman (ICA).
23	Discussion about the current F. H. K. Henrion exhibition. Speakers include Geoffrey Holroyd (ICA).
March	Publication of Reyner Banham's ''Industrial Design and Popular Art'' in Industrial Design.
15	Discussion about architecture: City Lights. Speakers include Peter Smithson, John McHale (ICA).
17	Discussion about Hard Edge painting. Speakers include Roger Coleman (ICA).
23	West Coast Hard Edge exhibition opens at the ICA.
April 7	Lecture by W. Ross Ashby: Art and Communication Theory (ICA).
May 17	Morris Louis exhibition opens at the ICA.

June 1	Discussion about the Morris Louis exhibition. Speakers include William Turnbull, Roger Coleman (ICA).
August 29	Discussion: The Younger Generation Looks at Picasso. Chaired by Roger Coleman (ICA).
September	Situation exhibition at the RBA Galleries. Lawrence Alloway resigns as program director at the ICA.
October 13	Discussion about Reyner Banham's book Theory and Design in the First Machine Age. Speakers include Peter Smithson, Colin St. John Wilson (ICA).
26–28	National Union of Teachers Conference: ''Popular Culture and Personal Responsibility.''
November	National Advisory Council on Art Education recommends the creation of a diploma in art and design to replace the existing national diploma.
17	Lecture by Richard Hamilton: Duchamp's Green Box (ICA).
December	Completion of Eero Saarinen's U.S. Embassy building in London.

1961

February 12	Launch of Russian satellite to Venus.
April 12	Yuri Gagarin makes the first manned space flight.
May 5	Alan Shepard makes the second manned space flight.
June 4	President Kennedy meets Premier Khrushchev.
31	South Africa declares independence from the British Commonwealth.
August 13	East Germany closes the border with the West.
17	Erection of the Berlin Wall.
July	Lawrence Alloway appointed curator at the Guggenheim Museum, New York.

Eduardo Paolozzi at the Class of '59 show.

John McHale at the installation of the Class of '59 show.

Magda Cordell/John McHale exhibition at the ICA.

January 19	Lecture series: Image of Tomorrow – Urban X–Ray, by Robert Freeman (ICA).
February 2	Lecture series: Image of Tomorrow – Slogans and People, by Roger Coleman (ICA).
8	Young Contemporaries exhibition opens at the RBA Galleries. Exhibition closes 25 February.
9	Lecture series: Image of Tomorrow – On a Planet With You, by Lawrence Alloway (ICA).
14	Discussion about the Young Contemporaries exhibition. Speakers include William Turnbull. Chaired by Lawrence Alloway (ICA).
16	Lecture series: Image of Tomorrow – The Plastic Parthenon, by John McHale (ICA).
28	Symposium on Image of Tomorrow lecture series. Speakers include Lawrence Alloway, Roger Coleman, John McHale, Peter Smithson. Chaired by Robert Freeman (ICA).
March	Lawrence Alloway resigns from the ICA Exhibitions Committee.
April 12	Nigel Henderson: Recent Work exhibition opens at the ICA.
20	Discussion: The Language of Art – The Image. Speakers include John McHale, Toni del Renzio (ICA).
May 18	Nigel Henderson answers questions about his work set by Colin St. John Wilson (ICA).
July 3–7	International Union of Architects Congress.

Exhibit 2, Hatton Gallery, Newcastle, May 1959.

20	Discussion about the integration of the arts. Speakers include Peter Smithson. Chaired by Lawrence Alloway (at the International Union of Architects Headquarters, South Bank, London).
September	Lawrence Alloway teaching at Bennington College, Vermont.
28	Discussion about the National Exhibition of Children's Art. Speakers include Eduardo Paolozzi (ICA).
October 10	Max Ernst symposium. Speakers include Toni del Renzio (ICA).

1962

Terry Hamilton killed in a car accident.

John McHale leaves London to teach at Southern Illinois University at Carbondale.

Colin St. John Wilson builds Harvey Court, Caius College, Cambridge University.

Publication of Reyner Banham's ''Who Is This Pop?'' in Motif.

May	Roger Coleman resigns from the ICA Exhibitions Committee.
	Marshall McLuhan lectures at the ICA.
August	Image in Progress exhibition, Grabowski Gallery, London.
September	John McHale and Magda Cordell exhibition at the ICA.
October	Publication of Richard Hamilton's ''An Exposition of $he'' in Architectural Design.
December	Publication of Lawrence Alloway's ''Pop Art Since 1949'' in the Listener.

1963

William Turnbull's sculpture exhibited in New York and Detroit.

Publication of ICA magazine Living Arts.

January	Toni del Renzio living in Paris.
November	Reyner Banham delivers the Terry Hamilton Memorial Lecture at the ICA: The Atavism of the Short–Distance Mini–Cyclist.

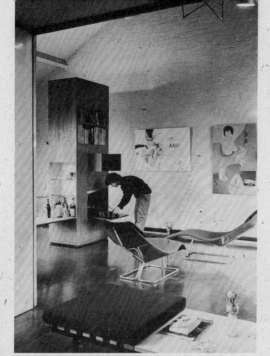

Terry Hamilton in Hamilton living room, 1962.

Richard Hamilton,
Glorious Techniculture in its original state at the IUA Congress site, summer 1961.

Nigel Henderson in Essex.

1959 and Beyond

By the end of the 1950s, significant changes in cultural attitudes were reshaping British society. The ICA, with its ever-present Independent Group milieu, was at the heart of these changes. The Institute's program featured discussions of issues which had developed out of interests initially aired at earlier Independent Group meetings – ergonomics and automation, popular culture, American abstract painting, product design and marketing. The decade was ushered out and the new one welcomed in by a lecture series called "The Fifties," with talks by Peter Smithson, Banham, Alloway, Coleman, and Hamilton.

Now indistinguishable from the ICA's program, Independent Group concerns influenced a younger generation through Coleman's issues of *Ark* and the so-called Scroope Group exhibitions at Cambridge University's School of Architecture. This influence was strengthened by the exhibition at the ICA called *Place*, featuring Richard Smith and Robyn Denny, and the publication of Robert Freeman's *Cambridge Opinion*, 17, with articles by Alloway, Banham, and McHale. Freeman appeared at the ICA during 1960 and 1961, helping to organize a lecture series called "Image of Tomorrow," which in some ways was a restatement of Independent Group interests.

Concurrent with this series at the beginning of 1961, the *Young Contemporaries* exhibition was held at the RBA Galleries in London and Pop Art burst onto the scene. If the Independent Group had not already relinquished its role as the chief catalyst of change in British art, then the emergence of David Hockney and his Royal College of Art colleagues surely indicated it was prudent to do so. The inquiring title of Lawrence Alloway's 1959 lecture – "Whatever Happened to the Avant-Garde?" – could now be answered by referring to the British Pop artists.

At the end of 1961, Alloway, having resigned as the ICA's director of programs a year previously, left Britain to take up a teaching post in the United States. In July 1962, he was appointed as curator at the Solomon R. Guggenheim Museum in New York. The same year, John McHale went to teach in the U.S., and in 1963 Toni del Renzio moved to Paris. In the early 1960s, both Colin St. John Wilson and James Stirling received important architectural commissions which made it more difficult for them to attend the ICA. Similarly, Alison and Peter Smithson were engaged on the design of the Economist Building, London, and their exit from the IG/ICA circle was made complete. In 1960, Eduardo Paolozzi began to teach in Hamburg, while Henderson's unsuccessful exhibition at the ICA in 1961 caused him to retreat to the seclusion of Landermere Quay in Essex. Tragically, in 1962, Terry Hamilton was killed in a car crash. Banham delivered the first Terry Hamilton Memorial Lecture at the ICA the following year, and then in 1964 he, too, left for the States.

The disbanding of the IG circle was complete by the early sixties.

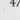

Alison Smithson at
André Bloc's house,
Paris, Autumn 1959.

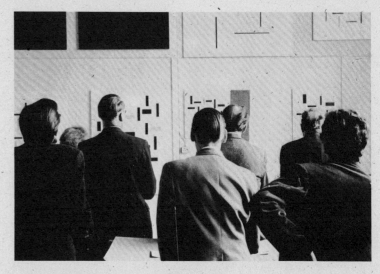

Criticism of work,
Fine Art Department,
University of
Newcastle.

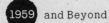1959 and Beyond

''1951 saw the 'futuristic' tendency of
the Festival of Britain, 1956 the stimu-
lating and rewarding grouping of ideas
in This Is Tomorrow. These and other
activities brought together, or showed
sympathy towards people outside the art
disciplines, ranging from sociologists
to engineers, scientists, ad men,
designers and architects. This was a
situation rarely if ever achieved
before. Perhaps environment would no
longer be created out of unrelated
chunks of individual concepts. With
this in mind the present series aims to
discuss the tomorrow of yesterday as
well as presenting visually aspects of
today's tomorrow.''
ICA Bulletin, January/February 1961, on
the lecture series Image of Tomorrow.

''I found that they [the IG] were incredi-
bly eclectic and that they were all bor-
rowing...there were very few who made
new statements to my mind.''
Frank Cordell in conversation with
Reyner Banham, 7 July 1976. Recorded for
Fathers of Pop but not used in the film.

''I think I wrote somewhere at the
time...'I'm entirely in favor of the
Kleenex aesthetic until it's extended
to human relationships'...it seemed
that [for some Independent Group mem-
bers] everything was there to be sucked
out, even including people's person-
alities; if that gave you your own iden-
tity which furthered your own career.''
Laurie Fricker, Interview, 14 March
1983.

''I don't think what happened in the six-
ties could have happened the way it did
without the ICA in the fifties. Art in
the fifties took English art away from
much of its parochialism — it laid the
foundations for the RCA students' atti-
tude to popular culture, I would have
thought. The fifties broke down atti-
tudes for a lot that developed in the
sixties.''
William Turnbull, Notes from a conver-
sation, 23 February 1983.

''You see, I think what [the IG] helped to
remove was a kind of snobbishness....It
helped, too, in accepting the situation
that everything is eclectic, there is no
culture, it is what we receive, what we
decide, what we choose, and it's our
responsibility to choose. And I think it
must have had, not a direct effect, but
gradually coming down, filtering.''
Roger Coleman, Interview, 18 April 1983.

''Well, broadly, I think what the Indepen-
dent Group did, although seeming to take
what a lot of people at the time saw as
very small subjects — like current bad
films, and so on — what I think we did, is
we sketched out a pragmatic, sociology-
based aesthetic, an aesthetic which
wasn't restricted to the traditional
circuit of the fine arts but in fact was
applicable to a very broad range of
experiences: you [Banham] with cars, me
with movies, Frank Cordell with pop
music, and so forth. It seems to me, we
were really taking seriously in a non-

patronizing way all the things which
intellectuals appeared to patronize.
And that provided a good, workable basis
for later development, I think.''
Lawrence Alloway. Used in the sound-
track of Fathers of Pop.

''We tried to bring pop art into fine art
where we worked because to leave it out
would have been to omit something of
importance, merely because it was awk-
ward to get it in. We did this, in the
first half of the fifties, in an aggres-
sive spirit, because we were tired of
the narrowness of traditional aes-
thetics...We deliberately crossed up
the borders of fine and popular art.''
Lawrence Alloway in ''Artists as Con-
sumers — the Splendid Bargain,'' BBC
Radio, broadcast 11 March 1960.

''One has to reiterate that all members of
the Independent Group contributed enor-
mously. After all, none of them indepen-
dently in isolation from each other
could have come up with the ideas that
became seminal to a different way of
thinking about art, culture and change.
It was the input from each as individ-
uals that jointly created that new way
of thinking.''
Magda Cordell McHale, Letter to Graham
Whitham, 5 July 1983.

48

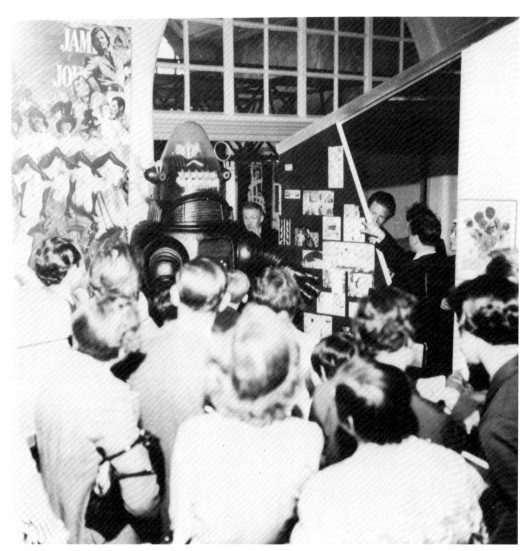

Robbie the Robot at the opening of <u>This Is Tomorrow</u>. Lawrence Alloway is behind Robbie to the right.

The Independent Group:
Postwar Britain and the Aesthetics of Plenty

Notes by Lawrence Alloway

A sense of isolation both geographic and generational in postwar England led to the founding of the Institute of Contemporary Arts (the first major exhibit was "40,000 Years of Modern Art" in 1949) and the later appearance of the IG. Europe was retarded by prewar memories or divided by postwar antagonisms. After World War II for instance even the native precedents of younger British artists were few and far between. Francis Bacon was admired for his intransigence, but the closeness of his art to his life was a limiting factor. Victor Pasmore had been a figurative rather than an abstract painter and subsequently a Constructivist, but his route after Euston Road (a British realist group to which he belonged) was generally viewed as a personal saga: his move from "the touch of the brush" to isolated parts was entirely his own. However Pasmore's attempt to revive a British sense of internationalism, such as had been developing in the abstract art of the 1930s, led to the formation of a Constructivist group. Pasmore's substitution of theories of Charles Biederman for the pre-war canons of construction as a method meant that the artists closest to Pasmore in using Constructivist principles (Anthony Hill, Kenneth Martin, and Mary Martin) had in fact room for reservation and dissent.[1] Prewar Europe or postwar New York often seemed more significant than the art and artists of postwar London. Eduardo Paolozzi and William Turnbull were both in Paris in the late 1940s, soon after World War II, and experienced at least the skeleton of that city's cellular pattern for artists. If the IG or I were accused of Americanization, the spiritless character of the British art scene may have been the real fault. The ICA evoked a genial, pro-Surrealist Paris and the IG took pleasure in an aesthetics of plenty that did not match postwar German or Italian consumerism. The IG was engaged in a game derived from its American possibilities.

The definition of the IG in British art history is not much like the lived experience of being involved in the group at the time, for individual profiles get dissolved in a bath of similarities, but there are verifiable factors. For example, Reyner Banham, convener of meetings in 1953, supported the second session and attached to him were a number of architects. They formed a tolerant, speculative group, near to the visual arts but not necessarily of them, like most of the IG. In addition Theo Crosby could be contacted personally through the ICA and the IG. Thus J. D. H. Catleugh, Peter Carter, Alison and Peter Smithson, James Stirling, John Voelcker, and Colin St. John Wilson, all associated with the IG, were assured of contact with Banham who worked at the Architectural Press (publisher of *Architectural Review* and *Architects' Journal*), and through the IG with Crosby who was editor of *Architectural Design*. Crosby was the central organizer of *This Is Tomorrow* in 1956, generally taken as the end of the IG.

The founders and officers of the ICA included Sir Herbert Read (president), E. C. Gregory, Roland Penrose, and Peter Watson. Dorothy Morland (who had driven an ambulance in Spain during the Civil War) was the second director. The IG was conceived by the ICA with the function of keeping the parent organization in touch with developing art and ideas. Morland

49

asked John McHale and me to convene the second session of IG meetings. I had attended only one prior meeting of the first session, convened by Banham on techniques, but as a member of the exhibitions committee I was a familiar figure to Read and the others. McHale and I talked the project over and concluded that the only subject likely to focus the attention of the IG and to interest the ICA at large was popular culture.

Popular Culture

This was not a neutral subject in England at the time. The term could be used to refer to either the mass media or the fairground/carnival, the twentieth century or the nineteenth. The nineteenth century was well represented by Barbara Jones with her exhibition *Black Eyes and Lemonade* and her book *The Unsophisticated Arts* (both 1951). The date may have seemed like a victory in the year of the Festival of Britain, but the IG, as McHale and I convened it in the mid-fifties, stressed the present environment in terms of advertising, Detroit cars, fashion, Hollywood movies, and science fiction. The fact that these topics entered English cultural discussion when they did seems in large part due to the activity of the IG at the ICA in 1954-55.

The membership of even a loose collaboration like the IG is susceptible to generalization. Despite the pictorial emphasis of the IG, it was comparatively low in visual artists: Magda Cordell, Richard Hamilton, John McHale, Eduardo Paolozzi, and William Turnbull are the leading artists. Cordell's female figures of the 1950s were a mixture of Dubuffet's *Corps-de-Dames* series and illustrations to *Galaxy Science Fiction*, a magazine that at that time was absorbed by human and superhuman nervous systems. Paolozzi's male figures fused the Frankenstein monster (as self-image), alien bodies, and imprinted circuits: his plaster and bronze surfaces are like an archaeology of the future, as if one were to discover computer circuits among the excavations of Pompeii. Turnbull shared some of Paolozzi's evocative texture in imagery that is tribal and schematic. Only Cordell, Paolozzi, and Turnbull could be regarded as full-time, productive artists. Hamilton was restricted by his pedagogical commitments from achieving all that his ideas promised, and McHale's ingrained teaching habits from earlier classroom experiences blocked the play of improvisation in his work. His collages sometimes read like rationalizations of Paolozzi's figures. The writer count was higher than average in a visually oriented group (Banham, Crosby, del Renzio, myself, and later Roger Coleman). It must be admitted that the IG possessed a male chauvinist streak more to be tolerated in the 1950s in Great Britain than elsewhere: the women in the group were without exception wives and girl friends.

Incidentally, the role of Paolozzi among the artists needs further definition. He taught extensively but his teaching and his practice were unified. There may be a question about the date of some of the early collages, but there is no doubt that they were part of an improvisatory, non-hierarchic vision of the human image and its machines, as stated in the collaborative exhibition *Parallel of Life and Art* (ICA, 1953). This was also demonstrated in Paolozzi's celebrated lecture of and about random images, a sort of Klee and chips, at the ICA and elsewhere. To achieve an effect of plenty in art it is necessary to have an endless supply of imagery (supplied by mass culture) and an omnivorous all-overism (for that imagery's development). Both were

native to Paolozzi when he taught at the Royal College of Art and at St. Martin's School of Art.

The word "convene" was used by the ICA as a neutral term, meaning to assemble or come together, but nothing else in the Institute's program had quite the same mix of election and informality as the IG discussions. Moreover the assigned tasks, to explore art and aesthetics for the ICA, gave the group and contact with it a certain *cachet*. The IG is often associated with British Pop Art, but I doubt that there is a link beyond the fact that the IG argued for an aesthetic of plenty. Previous art theory had supported either a straightforward line of modern geometry (Platonic geometrics) or at any rate an aesthetic of exclusions. Viewed as an aesthetic of austerity by complacent supporters it is probably better described as an aesthetic of scarcity. Although the materials are part of an aesthetic of plenty, Pop Art is other things as well. Personally, I believe that the IG's definition of culture, which brings it closer to descriptive accuracy, is a great deal to have done, without also being expected to serve some artists. Pop Art in the U.S. benefited from the fusion of fresh iconographical curiosity about the environment with the color restrictions and surface-control of Abstract Painting. In England artists had no comparable group with useful working assumptions and precedents, and as a result the graphic tradition, which has always been the English norm, was unopposed. The IG's expanded sense of culture certainly included the mass arts but its meetings were never intended as an index of pertinent subject matter. (The generational rejection of abstract art has potential for a much richer dialectic in New York than in London.) It is, as Peter Blake used to say, "a true fact" that most upcoming British Pop artists were not seen at the ICA or IG meetings. Richard Smith was the main exception.

The Royal College of Art in South Kensington, adjoining the Victoria and Albert Museum, was the production center of British Pop Art. Bacon taught there but of course he was never to be seen at IG meetings. (The closest he came to the ICA premises on Dover Street was probably Wheeler's restaurant.) His early, photo-based paintings were as pro-Pop as his Nietzschean attitudes were anti-Pop. Paolozzi taught at the college also, but the main influence was probably Ron Kitaj, an American born in Ohio, older and more assured than the British students around him. He was a diagrammatic and painterly iconographer. English Pop Art emerged unmistakably at the "Young Contemporaries" exhibition of 1961. Pop artists emerging a few years after the IG and working a few years further on were unaware of any intellectual and verbal precedents at the IG. It must be remembered that there is an aspect of English Brutalism that the Pop artists opposed. It can be seen succinctly in *Class of '59*, an exhibition of paintings, collages, and sculpture by Cordell, McHale, and Paolozzi.[2] The human figures tend to be massive, simplified, frontal, painterly, non-individuated: they differ from one another but Dubuffet is a common source, as is Theodore Sturgeon's augmented being in *More Than Human*, and Paolozzi's filtered version of Frankenstein's Monster.

The English university came in two especially tempting forms at the time: on one hand was Humphrey Slater, the editor of the journal *Polemic* and his editorial board (if that is the word) of Logical Positivists; on the other was Allan Pryce Jones, the editor of the *Times Literary Supplement* and gatekeeper of the Roman Catholic avant-garde. Both men, in their polish or their volubility, could show university backgrounds as necessary. However in practice

McHale and I unconditionally rejected infiltration or dominion by any established forms of university culture. Colin St. John Wilson was, I think, the only IG member to have been to Cambridge, though Banham earned a doctorate at the Courtauld Institute, the art history branch of the University of London. (He was teased at the ICA when he tried to make much of his newly-earned doctorate.) There was a third temptation of course, Adrian Stokes, a talismanic figure with shadowy affiliations to well-heeled, well-read, Hampstead-oriented psychoanalysis and hence to the roots of the ICA. However Stokes's involved prose was as disagreeable to the IG as his application of Melanie Klein's theory to art. My hostile reviews of his books and negative asides in lectures indicated his low usefulness to analysts of popular culture. (The Stokes revival postdates IG activity and those responsible for it did not see a need to contact IG members.) Thus none of the main agents of the IG had been formed through traditional British university lore. McHale's and my taste genuinely resembled that of vernacular society; in fact ours was a vernacular culture. The magazine material in McHale's collages is what he liked, not distanced by irony or condescension; and there was no irony in our liking the rapid sequence of widescreen Big Studio *movies*, a term preferred by the IG to "film" or "cinema." During the 1950s American scriptwriters, directors and actors were adept at code-stretching and burrowing, at working in the shadow of a tolerant censor. Certainly McHale and I valued the *production* of a new Western movie by Aaron Rosenberg more than repetitive screenings of the classics directed by, say, Pudovkin or Jean Vigo.

The university, to those for whom its culture seemed a limiting case, was disappointing in two ways: it cultivated a posture of detachment and nonchalance and it maintained a class- or education-bound dislike of popular culture. Its curriculum did not include current movies or SF, to name two areas that were absolutely central to me. Movies represented a condensed graph of current styles and motives and SF was at the time still a pro-technology hobby. University games, as they included games of desire, tended to affirm psychoanalysis or at least the depth of the human psyche, of which popular culture was largely free. Neither the intellectual elegance of Slater nor the rhetorical aplomb of Pryce Jones satisfied the earnest but restless IG. University culture is traditionally keyed to the ruling class in concept and style; it is very different from Saloon Bar Britain with its appetite for the royals. Most universities have the function of intervening in students' lives, to censor and judge vernacular culture, the culture with which one grows up. It is increasingly relegated to a less worthy level than that of the curriculum transmitted by universities. This is a form of the ongoing distinction between high and low style. Thus the IG assumption of a fine art/pop art continuum was both radical and cohesive.

The Avant-Garde

Cubism was (1) launched in Paris by an improvisatory and undisciplined core; then (2) systematized and sloganized by a second, larger group, still Paris-based; which led to (3) world-wide proliferation. The combination of geometrical form and optical space is Cubism's global form, with few artists going back to Braque's and Picasso's original work; but many slightly later artists were stimulated by the text or photographic illustrations in Albert Gleizes and Jean Metzinger's *Du Cubisme* (1912), a popularizing but extraordinarily

early book. Early twentieth-century avant-garde groups, though representing various modes of human action, tend to preserve a basic legibility. The case of Italian Futurism is significant, with F. W. Marinetti, its conspicuous leader who wrote the various manifestos, and a few artists who carried out his precepts brilliantly. *Der Blaue Reiter* was equally legible in its style and ideas. Where Futurism is urbanistic and pro-technological, the emphasis of the German group is pastoral and primitivistic. Wassily Kandinsky's management of both the group and its *Almanach* seem characteristic: he authenticated departures from academic naturalism through folk art, primitive art, and psychotic art.

As the twentieth century progressed the avant-garde prospered. André Breton had his favorites, from Max Ernst to Wifredo Lam, but ran Surrealism with a papal authoritarianism. He had the wit to tolerate artists such as Joan Miró who considered themselves as marginal Surrealists. After World War II however the avant-garde is rarely found in legible or succinct form, not because the impulse towards revision and change was exhausted, but owing to changed expectations. It should be remembered that the later level of art information includes knowledge of earlier avant-gardes. The IG had no consciousness of itself as an avant-garde, but it was opposed instinctively for instance to the inheritance of the Bauhaus, especially the constructive Morse code of a fundamental point-line-plane. The assimilation of Victor Pasmore's design ideas into British art schools (especially in London, Leeds, and Newcastle) rested on this geometric elementarism.

The sophisticated popularization of the new in art and news magazines is one of the factors that led to the larger but looser group forms. Another is the increased accessibility of art to more people. This is not the place to criticize *Art News* in the 1950s, say, because it was an unrivalled source of information about Abstract Expressionism. Producers no less than consumers of art were beneficiaries of the excellence of postwar communications. It was no longer enough to hold startling opinions about classical art (burn it, according to the Futurists) or content (all sexual according to Surrealists). To avoid too-rapid separation from their ideas the postwar avant-garde resorted to evasion. In the U.S. the groups tend to be artist-centered, such as the art school "Subjects of the Artist" or Abstract Expressionism, neither of which had an agreed-on theme or program. Jackson Pollock, Clyfford Still, Barnett Newman, and Mark Rothko overlapped at the Betty Parsons Gallery; Willem de Kooning, Franz Kline, and Philip Guston (as an abstract painter) were at Charles Egan's; and a ragbag of William Baziotes, Hans Hofmann, and Robert Motherwell was at the Samuel Kootz gallery. One critic favored the Parsons bunch, and others, slightly later, opted for Egan's. In any case the elements of field and gesture were hard to make into a coherent program. The next generation of pop artists made a point of their divisions and independent origins. The Art Workers' Coalition subsequently grouped artists by political disposition, as does the women's movement, which is emphatically non-style based.

In Europe there was an analogous loosening of style-based categories. In the case of painting, for instance, artists seemed to ignore Michel Tapié's slogans designed to set up *Art Autre* as a movement. Existentialism also was too ubiquitous and well-rooted as a postwar attitude for Jean-Paul Sartre to legislate by means of obscure principles. *Art Autre* signalled the European

absorption of postwar informal art and existentialism stressed individual accountability for a turbulent or deranged society. If the contemporaneous IG is judged by individual members it may seem comparatively unimpressive, but the total effect of its aesthetics of plenty was seminal and extends far beyond the simple charge of Americanization. Because it was casual, because its aims were loosely formulated, the IG is still a subject of inquiry and dispute three decades later in a country that is slow to celebrate either the formation of groups or the speed of near-total information. The fact that so many architects were involved ensured that the IG was aware of social and global problems. (It is only as architects become famous that their interests contract to single buildings and denunciatory aesthetics.) To this, communication theory added an awareness that early appearance and later proliferation, as in Cubism, were no longer mandatory. When town mouse and country mouse receive day-to-day, month-to-month information at the same rate it is impossible to maintain the former etiquette of priority. Center and periphery lose their distinctive character in an efficient aesthetics of plenty.

Plenty

It is relevant to remember that the Depression of the 1930s was ended in the US by that country's entry into World War II. (The situation was more complex in fact: in the late thirties economic life in America was relaxing but in England as in Europe, the major site of the war, the Depression was prolonged. Moreover in Great Britain rationing lasted longer after the war than in other countries of western Europe.) Hence an aesthetic of scarcity, with its related sense of hierarchy, a classification system born of limited amounts, was normal in the U.K. and an aesthetic of plenty – style-diversity and consumer affluence – was promulgated by the IG before they were available in postwar Britain. An aesthetic of plenty included two elements that then-available aesthetics tended to treat separately: the fine arts and the mass media. This is one reason for touchiness about the theme in popular culture. An aesthetic of plenty with its multiplicity of styles and consumer-mobility is appropriate to a non-Depression-based culture. The IG theory of a fine art/pop art continuum is appropriate too as it replaces the absolute classes and divisions of an aesthetic of scarcity with appreciation of different functions and occasions. Possibly art application followed media-use. I remember that Banham, like McHale and myself, was struck by reports of Detroit's capacity to run a production line in which colors and other variables could be ordered by consumers in advance. (Whoever heard of a pretty-pink Model-T Ford?) McHale applied the idea in his do-it-yourself construction kits and I wrote about them in "The Intervention of the Spectator."3

The phrase "aesthetics of plenty" comes from my article, "The Long Front of Culture," printed originally in 1959,4 and from its inception the term was resistant to any "keeper of the flame" theory. In the present catalogue it should be associated with non-Depression-limited productivity. Essentially, plenty was a way of referring to abundance, the European forms of which could never be confused with American standards.

Articles and lectures by Banham, McHale, and me give something of the tone of the meetings on popular culture. McHale wrote on "The Expendable Ikon" (expendability was a notion derived from Banham) and I wrote on "The Arts and the Mass Media."5 Topicality and impermanence

were essential criteria. I gave a couple of lectures on science fiction, the first moderated by Arthur Clarke, the second by Robert Freeman. Clarke, an exponent of literary form and rational extrapolation, was I think disconcerted by my kind of ebullient inclusiveness. He probably expected me to pursue respectability in the genre (Robert Heinlein, John Wyndham, and himself). Freeman had made the slides for the second lecture from current (random choice) magazines and was at home with Space Opera (bug-eyed monsters, galactic empires, and girls in transparent spacesuits). The IG had neither new heroes to set up nor traditional luminaries to honor. Just as my later admiration for Hal B. Wallis was part of an effort to carry movie-responsibility beyond the then-cited role of the director, it was also part of the fine art/pop art continuum, which rehabilitated all roles and actions. Neither the zeal of Terry Hamilton and myself for movies produced by Albert Zugsmith (culminating in *The Tattered Dress*), nor del Renzio's and Coleman's calibration of the MJQ (Modern Jazz Quartet) as "Min Pop" (short for Minority Pop), were meant to reform taste but to extend the boundaries of description.

There are several forms of art writing, including "on-behalf-of" writing, which belong to a custom of writing on contemporaries. "Eckhart van Syndow wrote in a pamphlet of 1920 on *German Expressionist Culture and Painting*: 'We may say, with but a few qualifications that the German Spirit has once more found immediate contact with the world soul. . . .'" 6 This kind of "on-behalf-of" writing can be paralleled by many later writers on art, but there is a distinction to be made. Art criticism about the IG in the 1950s, if it was laudatory, was antagonistic to prevailing taste. By contrast, recent supporters of TIT are not breaking new ground or taking risks. They contribute to a stable situation of improved data and research. The big audience is agreed upon the worthwhile status of contemporary art and artists.

In retrospect, *This Is Tomorrow* is usually taken as the end of the IG. (It is in the nature of a tribute that it should appear as period-defining and trend-setting, or perhaps it is the traditional British attitude toward the avant-garde as an institution, that is to say, bury it.) TIT was originally called for by Paule Vézelay with the critical intention of making a coalition of abstract arts. English abstract artists resisted a *Groupe Espace* conglomerate and the IG feared a picturesque revival with a scatter of Le Corbusier-like concrete sculptures from Colin St. John Wilson among others. Theo Crosby emerged as leader of the mixed bag, easygoing but authoritarian when necessary. As the exhibition developed in 1956 it contained both the form-makers of the tribe and the image-makers of the IG. The title was either ironic or intentionally inexact. The future it promises is withheld compared to, say, the city of the future by Moholy-Nagy in the movie *Things to Come*. Instead of Moholy's glamorous dissolves, the effect of the show was closer to the jumble of the present environment. As I observed in my third of the introductions: "Yesterday's tomorrow is not today."7 Another text is Banham's uncharacteristic, Buckminster Fullerish praise of technology. (Was Terry Hamilton in his mind? She was very amused by the words "We'll settle down in Dallas / In a little plastic palace," from a then-recent pop song.) The third introduction, by David Lewis, was a conventional listing of abstract art's simplificatory stages.

Of the dozen collaborative groups that made up TIT, half can be connected to the IG, sometimes an entire team (Cordell, Hamilton, McHale, Voelcker, for example), sometimes a member or two (J. D. H. Catleugh or

James Stirling). Included in the other half were abstract artists with a link to Victor Pasmore's Constructivism. Two stands were conspicuous at the time and particularly encourage the exhibition's connection to the IG – the second and the sixth. The second stand was the Cordell, Hamilton and McHale collaboration, with Voelcker as contractor-engineer; the sixth was "Patio and Pavilion," in which a frugal pastoral was animated by Paolozzi working with Henderson and the Smithsons. The second stand included cutouts of Robbie the Robot from *Forbidden Planet* and Marilyn Monroe on the subway grating from *The Seven Year Itch*. These alluded to male and female stereotypes, but any specifics dilated into a general pro-low-culture reading. Even when stands were scrupulously abstract the simultaneous visibility of other stands implicitly advanced the fine art/pop art continuum of the IG. Thus, TIT, whatever any individuals or teams may have intended, was conformable to an aesthetic of plenty. I was present in the show with Geoffrey Holroyd and del Renzio in the last-minute addition to Crosby's flow chart. The format was set as flat and restricted in area, because none of the artists were willing to share their allotted territory. In what could be called the "last stand," the Holroyds (Geoffrey and, I am sure, June) were responsible for the modular structure and del Renzio expanded his double-page spreads to bulletin board scale ("tackboard" in England). The stand as the work of an architect, an editor in the mass media, and an art critic (I supplied some of the imagery from various current sources) had endless applicability. We agreed that this was a naturally occurring module, its pathways and nodes offering an exemplary way to display group imagery in the symbol-thick world. Although it was not figurative art, it was (to use a word that flourished later) semiotic in its treatment of images.

There were more sculptors than painters in TIT as a whole, which reflected the views of the Constructivist group and the architecture-based IG, and there was virtually no nature-romanticism at all. This mode was a great temptation in England, from Paul Nash's landscape-object/Surrealism to Henry Moore's atavistic topography or the pervading mistiness of color of St. Ives's abstract painters. All this was regarded as nostalgic weekendiness by most of the IG and the Constructivists.

1. Lawrence Alloway, Nine Abstract Artists (London, 1954) *does not mention the Biederman problem, but discusses the artists around Pasmore, either in the context of ideology or friendship.*
2. Class of '59, *exh. cat. (Cambridge, Cambridge Union, 1959). Cordell, McHale, Paolozzi. Commentary: Lawrence Alloway.*
3. Lawrence Alloway, "L'Intervention du spectateur," Aujourd'hui: art et architecture, 5 *(November 1955), p. 25.*
4. *In* Cambridge Opinion, 17 (1959); *reprinted in* Pop Art Redefined, *eds. John Russell and Suzi Gablik (New York and London, 1969), pp. 41-43.*
5. John McHale, "The Expendable Ikon," *parts 1, 2,* Architectural Design, 29 *(February, March 1959), pp. 82-83, 116-117.* Lawrence Alloway, "The Arts and the Mass Media," Architectural Design, 28 *(February 1958), pp. 84-85.*
6. *Quoted by E. H. Gombrich,* Tributes *(Ithaca, New York, 1984), p. 68.*
7. Lawrence Alloway, "Design as a Human Activity," *in* This Is Tomorrow, *exh. cat. (London, Whitechapel Art Gallery, 1956), unpaginated.*

Illustrations from Ozenfant's <u>Foundations of Modern Art</u> (1928), in the 1952 Dover edition of the English translation.

The Bugatti of Egypt (circa 1500 B.C.).

Wheel of my Touring Bugatti, 1928.

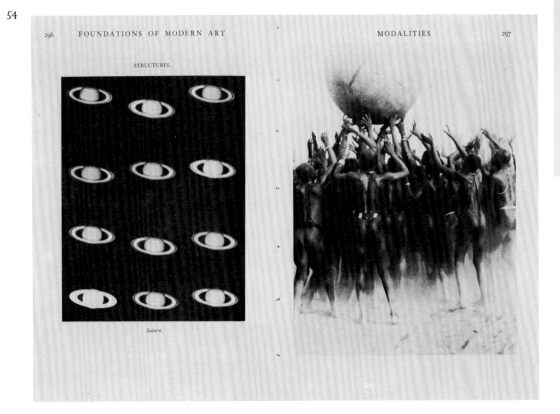

54

STRUCTURES.

Saturn.

Modernist sources

Modernist texts were frequently discussed by Independent Group members, often in conjunction with ICA activities, but always with a skeptical, anti-authoritarian intent that set the IG off from the rest of the ICA. The critical norm most often assumed was "anti-academic." Both Reyner Banham and Lawrence Alloway, for example, emphatically distinguished the "inherently dynamic" themes of Klee's *Pedagogical Sketchbooks* (motion and symbolism) from the academic side (traditional color theory).[1] Two articles are especially valuable for their clarification of the tension between continuity and criticism in Independent Group discussions of modernist theory. John McHale, in "Gropius and the Bauhaus" (1955), usefully distinguishes the outmoded utopian thinking of the Bauhaus from its four "still relevant" ideas: methodological self-consciousness, anti-traditionalism, investigations of mass communications, and the "both-and rather than either-or" spirit (see "Critical Writings").[2] Banham, in "The Bauhaus Gospel" (1968), recalls growing up with key modernist texts, then reacting against the canonization of Bauhaus ideas and exercises in British design. The creative vitality of individual Bauhaus leaders like Laszlo Moholy-Nagy, Banham argues, had been betrayed by the pedagogical rigidity of the Bauhaus's disciples.[3] The best-known statement about the use of modernist sources in the Independent Group is Lawrence Alloway's reference to three key texts on technology and modern art, in his 1966 essay on English Pop Art:

> Three influential books were Ozenfant's Foundations of Modern Art, Sigfried Giedion's Mechanization Takes Command, and Moholy-Nagy's Vision in Motion. These books were being read by the British constructivists (Victor Pasmore, for example), but the artists around the IG valued the illustrations more than the texts, which carried too many slogans about a 'modern spirit' and the 'integration of the arts' for their taste. It was the visual abundance of these books that was influential, illustrations that ranged freely across sources in art and science, mingling new experiments and antique survivals. I know that what I liked about these books, and other people in their twenties felt the same, was their acceptance of science and the city, not on a utopian basis, but in terms of fact condensed in vivid imagery.[4]

By "artists," Alloway was chiefly thinking of Eduardo Paolozzi, who had always found a *collagiste* excitement in the photographs accompanying Ozenfant's text. Ozenfant's defense of modernism as the recognition of "universal laws" appeared in 1928. It epitomized the essentialist side of the "modern spirit" that the Independent Group opposed. "What we wished to express in art," Ozenfant declared in his chapter on Purism, "was the Universal and Permanent and to throw to the dogs the Vacillating and the Fashionable."[5]

The appeal of his illustrations, however, was precisely that of the dated and exotic. Paolozzi, writing about his interest in primitive art for his *Lost Magic Kingdoms* catalogue, recalls finding a copy of Ozenfant in a small public library while in the army, and thinking it a "revelation" because of the range and impact of the illustrations – cars, machine parts and the new photographic view of the universe along with Dogon masks, pre-Colombian sculpture and photos of tribal peoples.[6] To Paolozzi, it testified to "that special French sensibility which was able to embrace all those different sorts of things *at once, at the same time, each with each.*" Ozenfant's romantic optimism about the machine, which even then Paolozzi considered a "late 1920s" curiosity, is treated as simply another delightful relic along with the photographs. Given Paolozzi's Surrealist perspective, Ozenfant's juxtaposition of concordant visual "facts" from disparate dimensions of human culture and the physical universe made it a valuable source for the iconographic explosion of *Parallel of Life and Art.*

Sigfried Giedion's *Mechanization Takes Command* (1948) particularly influenced Richard Hamilton, whose early series of Reaper engravings was inspired by Giedion's illustrated discussion of agricultural machinery as the interface between nature and technology. Hamilton associated the design of the *Growth and Form* show of 1951 with "the wide-ranging manner of Giedion's perception of technological form and process."[7] In fact, both Giedion's *Mechanization* and Moholy-Nagy's *Vision in Motion* (1947) provided theoretical underpinnings for Hamilton's explorations of motion and perception in the paintings at his Hanover Gallery show in 1955.

These two America-based texts of Moholy-Nagy and Giedion, published just after World War Two, contributed more than their wide-ranging illustrations to the thinking of people like Banham, Hamilton, and McHale. For us, they constitute the most reliable points of connection between the IG's preoccupations and the Modern Movement. Both *Vision in Motion* and *Mechanization* address the interrelations between modern art, technology, and industrial design in consumer society, while displaying vestiges of the two stages of modernism between the wars. Moholy-Nagy retains the socialist faith of the 1920s; Giedion promotes the humanist idealism (the unity of reason and feeling) that replaced political goals in the late 1930s. Nevertheless, their enthusiasm for the interconnections between the avant-garde and commercialism quite overshadows their political and ethical reservations.

Moholy-Nagy uses *Vision in Motion* to promote photography as the primary medium of consumer culture, arguing that its "direct visual impact" makes it especially useful for "the advertising arts."[8] The commercial adaptation of Dadaist photo-collage, and of collage strategies in general (juxtaposition and superimposition as "vision in motion"), is presented as the best evidence of the tie between the avant-garde and photography's mass production potential.[9] For the cover of the *Parallel of Life and Art* catalogue, Paolozzi, Henderson, and the Smithsons re-appropriate Moholy-Nagy's already appropriated X-ray photograph of "man shaving" (from the Westinghouse Research Laboratories), appearing on page 253 of *Vision in Motion*. *Parallel* also reflects Henderson's and Paolozzi's interest in the technical excitement of Moholy-Nagy's "varieties of photographic vision" – reportage, "rapid seeing" of movement, microphotography or "intensified seeing," and X-ray or "penetrative seeing."[10]

Moholy's discussion of the photomontage, furthermore, has a dis-

56 Page from Moholy—Nagy's <u>Vision in Motion</u> (1947
p. 253), showing ''man shaving'' X—ray photo,
used for the cover of <u>Parallel of Life and Art</u> by
Henderson, Paolozzi and the Smithsons.

Illustration from Sigfried Giedion's
<u>Mechanization Takes Command</u> (1948), p. 580: a
manufacturer's satiric version of the kitchen
of tomorrow with Giedion's caption.

408. Manufacturer's Satire on the Overgadgeted Kitchen. *It is a healthy sign that a critique of over-mechanization starts from within industry itself. This leaflet, widely circulated by an American plumbing-equipment manufacturer, satirizes the public's willingness to be sold any mechanical gadget whatsoever: 'In the kitchen of tomorrow (whenever that is) everything is automatically run by electronic control. Everything in easy reach of a giant whirling faucet ... Self-rocking rocket cradle for streamlined baby of tomorrow ... Packaged dust for a year's supply of food ... Flowers of tomorrow show influence of streamlining.' (Courtesy the Schaible Co., Cincinnati)*

tinctly Brutalist flavor. He emphasizes the intentional crudeness of the collages of the 1920s: "The dadaists in exhibiting the brutally torn and roughly-cut photographs, showed that they held in contempt historic 'beauty'."[11] Moholy compares this with Russolo's "futuristic symphony containing only electronic noises ('bruits')." Like Alloway, Hamilton, and McHale after him, Moholy also stresses the expansion of perceptual awareness for its own sake, arguing that photomontage demands "a concentrated gymnastic of the eye and brain to speed up the visual digestion and increase the range of associative relationships."[12]

Moholy-Nagy delights in "the vision in motion of a motorized world," since it presents "the artist, architect, advertising and display man" with new challenges. However, he also acknowledges that his own vision of a new society based on sociobiological principles has been thwarted by "the coming of the electronic age" led by American-style capitalism. Lamenting the perversion of the socialist mass-production ideals of the twenties, Moholy's complaint is ironically appropriate to the Independent Group: "The masses are filled with petit bourgeois ideology, the masculine superman ideal promoted by papers and radios, books and films – by the unofficial education which the people have been taught to enjoy in spite of lip service to casual revolutionary ideas." Likewise, Moholy complains of the throwaway principle in American design, which depended on "the frequent change of models and a quick turn-over," claiming that consumer preference stands behind the "longer lasting goods of the less affluent Europeans."[13] The Independent Group simply reversed these judgments.

Like Moholy-Nagy, Giedion blames the commercial philosophy of "that is best which sells best" for periodic breakdowns in American taste ("bastardized forms and materials react upon the spectator and corrode his emotional life").[14] His enthusiasm for American inventions, however, drowns out these occasional homilies. He traces the development of selected household appliances (e.g., "The Washing Machine Democratized"), proposing the industrial designer rather than the architect as the hero of the new consumer culture – an idea Banham in particular promoted. The designer's influence on public taste, Giedion observes, "is comparable only to that of the cinema."[15]

Within the Independent Group, the most pertinent aspect of *Mechanization Takes Command* was probably Giedion's abundant use of contemporary ads, mostly of housewives and appliances, to document his contention that the reconciliation of art and science in American mass production had produced something like the unity of thought and feeling long needed within modernism.[16] Giedion's discussion of kitchen and appliance developments, from the mid-1930s to the popular Libbey-Owens-Ford "Day After Tomorrow's Kitchen" exhibit of 1945, provides a useful context for appreciating the role the Smithsons' House of the Future must have played in postwar Britain. Giedion even reprints a commercially distributed visual satire of advertising claims for the "kitchen of tomorrow," with an "avant-garde" collage of ad blurbs in contrasting typefaces.[17] For the Independent Group, this would have struck just the right note.

DAVID ROBBINS

1. Reyner Banham, "Klee's 'Pedagogical Sketchbook'," Encounter, 2 (April 1954), p. 54.
2. John McHale, "Gropius and the Bauhaus," Art, (3 March 1955), p. 3.
3. Reyner Banham, "The Bauhaus Gospel," Listener (26 September 1968), pp. 90-92.
4. Lawrence Alloway, "The Development of British Pop," in Pop Art, ed. Lucy R. Lippard (New York, 1966), pp. 32-33.
5. Amedée Ozenfant, Foundations of Modern Art, trans. John Rodker (New York, 1952), p. 336.
6. Eduardo Paolozzi, "Primitive Art: Paris and London," Lost Magic Kingdoms and six paper moons from Nahuatl, exh. cat. (London, British Museum, 1985), p. 10.
7. Richard Hamilton, Collected Words: 1953-1982 (London, 1982), p. 12.
8. Laszlo Moholy-Nagy, Vision in Motion (Chicago, 1947), p. 178.
9. Ibid., p. 308.
10. Ibid., p. 207.
11. Ibid., p. 212.
12. Ibid., p. 212.
13. Ibid., p. 30.
14. Sigfried Giedion, Mechanization Takes Command (New York, 1948), pp. 360-361.
15. Ibid., p. 610.
16. Ibid., p. 107.
17. Ibid., p. 580.

American ads

American advertising was a major interest within the Independent Group, since it epitomized the "aesthetics of plenty" in a society of rapid consumption and obsolescence. Advances in the technology of color printing strengthened the aesthetic impact of ad images in the American media, reinforcing their message of a visual environment that was bolder and more frankly contemporary than anything known in England. In its discussions and in much of the artistic production of its members, the IG drew upon the avant-garde "found object" legacy to assert both the aesthetic excitement of this image-saturated world and its democratizing implications. This challenged not only the traditionalism and anticommercialism of British high culture, but also the modernist establishment at the ICA, typified by Herbert Read's commitment to a universalizing aesthetic. Paolozzi's collage scrapbooks and celebrated epidiascope presentations mark the beginning of this use of images torn from American magazines. Within the IG, "ads" connoted a more general explosion of significant subject matter. The tackboards of the artists and architects became sites of ongoing collages of media images of all kinds, from movie stars to technological developments.

The second series of Independent Group meetings, convened in 1955 by Lawrence Alloway and John McHale, was dominated by discussions of ads and commercial design (see McHale's notes in the Appendix). From the available reports and writings of the period, it appears that these discussions led on the one hand toward the symbolic role of mass media images, and on the other toward the anti-traditional aesthetic norms of industrial design. McHale's analysis of media images, published as the "The Expendable Ikon" in *Architectural Design* in 1959, elucidates two key themes of these discussions. First, McHale argues a position emphasized in different ways by Alloway, Hamilton and Paolozzi as well: the mass media generates the only viable symbolism of our time, since "the fine arts sector" has failed to develop "usable images of human action and experience," tending instead to the "exclusion of man as subject." Second, the "unprecedented scope of visual experience" in a technologically advanced society is linked to a system of production based on expendability rather than permanence. Inevitably, McHale argues, the emphasis must shift from the specific character of collective imagery to the activity of selection and consumption itself.[1]

The diversity of media images favored by the various IG members, however, indicates a lack of unanimity on this subject. A comparative analysis of the types of magazine tearouts selected by IG members would show Paolozzi chiefly exploring the "lowbrow" material, from pulps and soft porn to *Life*; McHale ranging across a broad "middlebrow" spectrum of themes and products from *Look* and *Life* to *Harper's Bazaar* and the *New Yorker*; and the Smithsons focussing primarily on car, home and other new lifestyle ads in the *Ladies' Home Journal* and the *New Yorker*.

Attitudinal differences also emerge in the writings of IG members about the mass media, especially as they define themselves in the period following the IG meetings. The Smithsons' oft-reprinted "But Today We Collect

Earth viewed from rocket; tear sheets from Look in John McHale's archive (the "trunk from America," 1956). The left section was used by Richard Hamilton for his collage, Just what is it that makes today's homes so different, so appealing?

Illustration from Marshall McLuhan's The Mechanical Bride (1951), p. 85.

Ads" is usually taken as the standard IG position on advertising. However, the text is more complex and rhetorically crafted, in significant ways, than the straightforward defenses of Alloway and McHale.

"Liking ads" is presented by the Smithsons as their way of personally renewing the modern tradition, which they chiefly identify with Le Corbusier and the Japanese aesthetic. However, the astonishing range of powers assigned to ads suggests an urban world flourishing in defiance of both architects and planning constraints. Ads are important information sources about "a way of life . . . they are simultaneously inventing and documenting." They are "good images" that reflect an "almost magical" technical virtuosity. They are not only more influential than architects in forming public taste, they constitute a judgment upon the self-absorbed isolation of high culture designers. The Smithsons' conclusion suggests their nervous recognition that ads are something of a Trojan horse in the modernist camp. This "powerful force," they observe, is not only usurping the traditional taste-shaping role of architects, it is "establishing our whole pattern of life." The issue that has crept up on us is finally left suspended: *how to control it?* The Smithsons can only hope to "somehow get the measure of this intervention." It is as though they had been found (and professionally challenged) by "mass production advertising" and not the other way around. They exit with the heroic resolve "to match its powerful and exciting impulses with our own."[2]

Other IG members had a less nervously engaged relation to advertising, although differing in their emphases concerning its significance. Paolozzi, who obviously delighted in the bright commercial images of American cars, foods, home products and celebrities, also treated ads as "readymade metaphors" that perform a sociological service by embodying popular fantasies.[3] Alloway, in quest of the "vivid, current, socially communicative symbols" of the age, emphasized that it was graphic designers who were producing them rather than artists.[4] McHale saw the proliferation of images as a therapeutic necessity of technological society, since it helped people adapt to the dizzying pace of change.[5] Hamilton, on the other hand, identified with the professional viewpoint of the commercial designer. In 1960 he even argued that the mass audience should be "designed" for products by the media, rather than the other way around. Banham took public issue with him, responding that this betrayed the democratizing role that had always been advertising's justification.[6]

The chief resource for the IG's analyses of ads was Marshall McLuhan's *The Mechanical Bride* (1951), which Alloway recalls ordering from an ad in *View* magazine.[7] In this early, ethically motivated study of the media, McLuhan applies his skills in textual analysis to a thematically based sequence of American magazine advertisements. Since the collage techniques of advertising are taken from the visual and literary avant-garde, he argues, we can turn our sophistication about the means employed into an analysis of the illicit appeals ad techniques facilitate. The IG in turn produced its own analyses, also indebted to the modernist avant-garde, but as a professional inquiry devoid of moralizing.

McLuhan had painstakingly traced the connections in car ads between the fetishized bodies of the machines and the "replaceable parts" of the glamour girls accompanying them. He thus introduced the basic terms Banham developed in his discussions of "vehicles of desire" at the ICA[8] as

Ad for the 1955 Plymouth in Life (April 11, 1955), later used by Richard Hamilton for his painting, AAH! (1962).

59

well as those of Hamilton's subsequent visual analyses of the ad-machine-model connections. McLuhan's selection of outrageous and sociologically revealing images also has striking consonances with Paolozzi's choices for his collages, drawn from the same late forties period of American media. The split-image model from the Ivory Soap ad, for example, appears in two Paolozzi collages – *Juice King* (1948) and *Dr. Pepper* (1948; cat. no. 49). However, the technical difference between McLuhan's black and white documentary reproductions and Paolozzi's colorful, high impact collage appropriations provides a measure of the sensuous appeal of American magazine ads at the time, an appeal that McHale exploited as texture in collages of the mid-fifties.
DAVID ROBBINS

1. *John McHale, "The Expendable Ikon 1," Architectural Design, 29 (February 1959), p. 82.*
2. *Alison and Peter Smithson, "But Today We Collect Ads," Ark, 18 (November 1956), pp. 49-53. See "Critical Writings."*
3. *Quoted by Uwe M. Schneede, Pop Art in England: Beginnings of a New Figuration, exh. cat. (Hamburg, Kunstverein, 1976), p. 100.*
4. *Lawrence Alloway, "Geigy," Graphis, 12 (May 1956), p. 197.*
5. *McHale, "The Expendable Ikon," p. 83.*
6. *Richard Hamilton, "Persuading Image," Design, 134 (February 1960), pp. 28-32. See "Critical Writings." Banham's critique appears in a symposium on Hamilton's article in Design, 138 (June 1960), p. 55.*
7. *Lawrence Alloway, interview by Jacquelynn Baas and David Robbins, 23 October 1987.*
8. *See Banham's analysis of the "kinship between technology and sex" in "Vehicles of Desire," Art, 1 (1 September 1955); reprinted in Modern Dreams: The Rise and Fall and Rise of Pop (New York, 1988), pp.64-69.*

Cover of <u>The World of Null-A</u> by A. E. van Vogt (1953 edition).

Covers of <u>Astounding Science Fiction</u>. <u>Left</u>: November 1953, showing view of U.N. Building from ASF office. <u>Right</u>: February 1951, used to illustrate Lawrence Alloway's ''Technology and Sex in Science Fiction'' in <u>Ark</u> 17, Summer 1956, p. 22. Caption: ''Cybernetics and the image of man.''

Science fiction

A Zhagon, from the film
<u>This Island Earth</u>, 1955.

Science fiction in the 1950s was a genre consigned to a literary ghetto by the guardians of established taste. To some extent it was this situation which attracted some members of the Independent Group whose aim was to be iconoclastic. Science fiction provided them with a wealth of suitably irreverent references which Lawrence Alloway, for one, delighted in parading before the intransigent ranks of traditional aesthetes.

While serious consideration of science fiction was a challenge to a cultural establishment whose critical appraisal of the genre never passed beyond prejudicial contempt, science fiction was also an area in which revealing analogies were made. In its attempt to reassess Dada,[1] the Independent Group connected it with non-Aristotelian logic, drawing upon Alfred Korzybski's weighty volume *Science and Sanity* (1933), as well as A. E. van Vogt's SF novel *The World of Null-A*.[2] Korzybski's belief that semantic adherence to an Aristotelian view – an either-or logic – inevitably led to unlogic, then illogic, prompted the IG to interpret Dada as a manifestation of non-Aristotelian ("Null-A") thought. Frank Cordell was of the opinion that none of the Group had ever read *Science and Sanity*[3] and that van Vogt must have been the source of information. But this was neither surprising nor improper. Korzybski's book is far more difficult to follow than van Vogt's story (which itself is easier than the virtually nonsensical sequels, *The Pawns of Null-A* and *Null-A Three*, published in book-form in 1956 and 1984, respectively), and the Independent Group regarded popular culture as capable of providing reference points that were as valid as those from any other cultural source. Banham, for example, invited readers of *Architectural Review* to seek the "handy back-entrance to topology without using the highly complex mathematics involved . . . [by] acquiring a copy of *Astounding Science Fiction* for July, 1954."[4] Likewise, Alloway supplemented his understanding of game theory, initially derived from John von Neumann and Oskar Morgenstern in *The Theory of Games and Economic Behaviour* (1953), with Philip K. Dick's story, *Solar Lottery*, of 1955. William Turnbull recalled that the best thing he had ever read on color was an article by Edwin Land in *Astounding Science Fiction*.

Turnbull added that science fiction was one of the few areas in which modern technology was being discussed,[5] and that this was at the heart of the Independent Group's interest in the genre. SF proposed the new and the immediately impossible in a way that strongly appealed to several of the members. Banham was particularly taken with *Destination Moon* (1950) and *Conquest of Space* (1955), two films produced by George Pal that had a quasi-documentary approach enhanced by the scenery painting of Chesley Bonestell. Manned space flight to the moon and Mars was made visually convincing here, and technology was shown to "deliver the goods." Banham praised Bonestell's pictures of the planets for drawing upon the most up-to-date information available.[6] Perhaps the illustrator's training as an architect figured in Banham's enthusiasm.

Significantly, it was American science fiction that chiefly attracted Independent Group members. To be sure, the majority of publications in the genre came from the United States, but there was no lack of British SF in the fifties. Apart from books by British authors and British editions of American SF magazines, BBC radio broadcast fifty-four episodes of *Journey into Space* between 1953 and 1955, which attracted the largest radio audience ever recorded in the U.K. Competition from Radio Luxembourg (a commercial radio station broadcasting from the Continent to Britain) took the form of *Dan Dare, Pilot of the Future*, first broadcast in 1953 and based on the characters who appeared on the front page of the Eagle comic. BBC television also competed in the science-fiction market, notably with the memorable *Quatermass Experiment* (1953), followed by two sequels, *Quatermass II* (1955) and *Quatermass and the Pit* (1958-59). But despite the high-profile technology and the promise of interplanetary exploration, despite Jet Morgan and his sidekick Lemmy Barnett, despite flying saucers, Professor Quatermass, and Dan Dare blasting off from Spacefleet Headquarters to do battle with the ruthless Mekon – or perhaps because of all this – British SF seems hardly to have touched the likes of Banham, Alloway, McHale, and Hamilton. The real stuff came from across the Atlantic, from Universal and Paramount, from the pages of *Astounding Science Fiction* and *Galaxy Science Fiction*, and from Harley Earl and his design team at General Motors. The resemblance between Earl's streamlined creations and Hollywood's concept of a space rocket is not coincidental. Banham was particularly taken with the symbolic imagery of tailfins, chromium, and dashboards festooned with dials.

If spacecraft were one potent image for the Independent Group, robots and aliens were another. Visits to the London Pavilion cinema to see such films as *The Day the Earth Stood Still* and *Invaders from Mars*, together with scrapbook pages and "Bunk" collages from magazines such as *New Worlds* and *Amazing Stories*, fed into some of Eduardo Paolozzi's sculpture.[7] *Robot* (1956) is an example, as is the bronze head *AG5* (1958). At *This Is Tomorrow*, Hamilton, McHale, and Voelcker used the image of Robbie the Robot, "star" of the film *Forbidden Planet*, as a central feature of their exhibit. Taken from a poster for the movie, Robbie is depicted cradling the unconscious and extremely curvaceous body of a girl, an image that did not, in fact, appear in the film.

The symbolism of the robot/alien as an image of man himself was investigated by McHale: "Robots, mutants and mechanomorphs furnish an image in the likeness of man which carries the strongest sense of wonder with a hint of dread."[8] The robot/alien as symbol of sexuality was explained by Alloway:

> The basic cast is girl, hero, and bem (bug-eyed-monster). The female type is mostly the 'stately chorus girl', half-undraped or wearing a transparent space suit. She is usually contrasted with great machines with flashing dials, with robots (armour against flesh), or with bems—macrocephalic, many-eyed, tentacular, green, or what have you.... The traditional theme of beauty and the beast has survived on the covers of Amazing Stories, Startling Stories, Science Fiction Quarterly, and others.... The point is, of course, that this is one of the channels open to erotic art in our half-censored urban culture.[9]

61

Robbie the Robot.

Sociological and cultural interpretation of science fiction was only an aspect of Alloway's encounter with the genre. In an attempt to extend his critical vocabulary along the length of the fine art-popular art continuum, his contribution to Magda Cordell's Hanover Gallery exhibition catalogue features a word list, in part derived from Theodore Sturgeon stories and *Galaxy Science Fiction* magazine: "solar, delta, galactic, amorphous, ulterior, fused, far out, viscous, skinned, visceral, variable, flux, nebular, iridescence, hyperspace, free-fall . . ."[10] Alloway's word list was not fanciful; Magda Cordell was as aware of science fiction as she was of Dubuffet and Abstract Expressionism. A year after her Hanover Gallery show, she wrote about one of her paintings: "The painting begins with opening the cans of colour, and ends when it has decided so. In between is–Indian country–unpredictable, lots of ambushes, landslides, eruptions and long quiet planes–a time journey, whose compass is paint–and it is always late! The finished work is a cluttered log and carries the prints of aliens, meteorites and galactic dust."[11]

Richard Hamilton was also aware of SF in the creation of his paintings. About *Hommage à Chrysler Corp.* he wrote: "The total effect of Bug-Eyed Monster was encouraged in a patronising sort of way."[12] Later he illustrated the sources of his work and the "Bug-Eyed Monster" was represented by a Zhagon from the film *This Island Earth*, typically humanoid in appearance with an enormous exposed brain and bug eyes.[13]

John McHale also acknowledged SF sources, notably by using the title *First Contact* for one of his large collages, which was also the title of a 1945 story by Laurie Leinster. McHale's aliens–or are they humans transmuted by their consumerism?–stand totemlike in a state of metamorphosis between organism and robot.

The science-fiction imagery evident in such works of art was part of a wider acceptance of the genre fostered by the Independent Group. The IG used science fiction as a means of assimilating emergent disciplines and the most advanced developments into the cultural spectrum, as well as for identifying social attitudes toward change. Lawrence Alloway was quite clear that the genre served to make such issues intelligible in a way that no other area did, not even art. He wrote: "Science fiction . . . helps to give currency to new ideas by finding traditional contexts for them to belong in or by translating new concepts into memorable images. This is worth doing and, on the whole, the fine artists have given us no recent aid in this kind of visualizing."[14]

Reyner Banham was equally sure about SF's role and noted that it was "one of the great mind-stretchers, specialization-smashers of our day. . . . It is part of the essential education of the imagination of every technologist."[15] By treating SF seriously in a nonpatronizing way, the Independent Group was not only able to employ it as a source of imagery and an integral element in the touchability of information inherent in the fine art-popular art continuum, but also to give the genre itself something of an intellectual status, which it had previously lacked. As Banham pointed out, "Who knows, you might even *enjoy* SF."[16] Clearly, he and his Independent Group colleagues did.

GRAHAM WHITHAM

Galaxy cover by EMSH ''showing ROBOTS REPAIRED WHILE U WAIT.'' Used by McHale to illustrate ''The Expendable Ikon'' (February 1959 <u>Architectural Design</u>).

1. Independent Group meeting at the ICA, 29 April 1955, "Dadaists as Non-Aristotelians."
2. Van Vogt's story was serialised in Astounding Science Fiction during 1945; a revised version was published by Simon and Schuster in New York in 1948, the first SF magazine story to emerge from a major publishing company.
3. Frank Cordell, interview by Reyner Banham, 7 July 1976, recorded for Fathers of Pop (Arts Council of Great Britain, 1979); it was not used in the film.
4. Reyner Banham, "The New Brutalism," Architectural Review, 118 (December 1955), p. 361. Banham's reference to information about topology in Astounding Science Fiction for July 1954 appears incorrect, since the topic is not directly addressed in that issue. Either he was merely alerting the reader to the magazine's importance or the topology discussion appears in another issue.
5. William Turnbull, conversation with the author, 21 April 1988.
6. Reyner Banham, "Who Is This Pop?," Motif, 10 (Winter 1962), p. 8.
7. Lawrence Alloway and Eduardo Paolozzi, The Metallization of a Dream (London, 1963).
8. John McHale, "The Expendable Ikon 1," Architectural Design, 29 (February 1959), p. 82.
9. Lawrence Alloway, "Technology and Sex in Science Fiction: A Note on Cover Art," Ark, 17 (Summer 1956), pp. 19-23. About the time that he wrote this article, Alloway was still in the process of planning an exhibition at the ICA on science fiction. This show, which had originally been proposed in February 1955, was never realized. Earlier, on 19 January 1954, Alloway had lectured at the ICA on science fiction.
10. Lawrence Alloway, Magda Cordell Paintings, exh. cat. (London, Hanover Gallery, 1956), unpaginated.
11. Statements; a Review of British Abstract Art in 1956, exh. cat. (London, Institute of Contemporary Arts, 1957).
12. Richard Hamilton, "Hommage à Chrysler Corp.," Architectural Design, 28 (March 1958), pp. 120-121. (See "Critical Writings.")
13. Richard Hamilton, "Urbane Image," Living Arts, 2 (1963), pp. 44-59.
14. Alloway, "Technology and Sex in Science Fiction," p. 23.
15. Reyner Banham, "Space, Fiction and Architecture," Architects' Journal, 127 (17 April 1958), p. 559.
16. Ibid., p. 559.

Catalogue of Works in the exhibition

MAGDA CORDELL

The only member of the Independent Group who was not British, the Hungarian-born Magda Cordell (b. 1921) brought a Continental painting perspective to the IG. From about 1950 she frequented the ICA, often coming to the bar at lunchtime. Around 1952, when the IG developed, she was producing large grid paintings, transferring painterly stripes of color onto masonite from paint-drenched strips of paper and string. Unfortunately, none of these works seem to have survived. Cordell's innovative, extremely physical approach to painting and sculpture was then applied to an extensive series of studies of female bodies that began at mid-decade and continued until 1961, when she and John McHale moved to the United States. In 1955, Reyner Banham included a photograph of Cordell's sculpture Figure among his illustrations of the New Bru-

Figure. Plaster sculpture, 1955.

talism (along with works by Burri, Henderson, Paolozzi, Pollock, and the Smithsons), calling it an ''anti-aesthetic'' human image.[1]

As in her grid paintings, Cordell employed strikingly innovative techniques in her two-dimensional works from the mid-1950s. In the monoprints, female torsos were painted onto a marble slab before being transferred to paper, and the paintings were built up on white-gessoed, stained canvas in translucent layers of powdered pigment mixed in glazes of plastic polymer resin.

It was Cordell's shift to a boldly iconographic style, however, that drew critical attention. Monotypes and Collages by Magda Cordell was shown at the ICA in the summer of 1955, and the following winter the Hanover Gallery showed Magda Cordell Paintings, for which Lawrence Alloway contributed the catalogue notes. Writing of the impact of American Abstract Expressionism upon European art, and of a ''period of reconstruction'' that was replacing the ''original explosions,'' Alloway saw Cordell defining this as an iconographic quest:

> The artist's gesture is now a sign. . . . A style has developed which preserves the physical means of action painting (with its lexicon of sensuous effects) but in which the physical act of painting is not the end. The

problem artists have set themselves is to establish images in the way of painting without becoming merely formal; to reconcile the plenty and variety of paint with the compulsion to found iconographies. Magda Cordell elaborates intricately the primary fact of the surface. . . . Her medium is inhabited, massively yet ingratiatingly, by a cast of women and long-necked figures (androids with a patina of pathos).[2]

Alloway closes with a ''word-list'' of science fiction terms suggested by Magda Cordell's paintings: ''solar, delta, galactic, amorphous, ulterior, fused, far out, viscous, skinned, visceral, variable, flux, nebular, iridescence, hyper-space, free fall,'' and so on.

Critics tended to pick up on this association with science fiction and America as a key to interpretation. ''Her pictures suggest a marriage between Jackson Pollock and the Thing from outer space,'' wrote Basil Taylor in the Spectator.[3] Stephen Bone of the Manchester Guardian noted that Cordell's paintings seemed ''typical of the ebullient, aggressive kind of modern, American art.'' Bone's emphasis, however, was on Cordell's primitivist inflection of science fiction fantasy, and he argued that her new paintings supplied the elemental qualities missing in the technological age:

> Now what exactly is it that is lacking from our environment and which we have to supply by seeking out and contemplating works like these? The obvious answer is ''mud and string,'' or the tangled, accidental, elemental muddle of natural conditions and simple artefacts among which our ancestors lived and worked. We have been deprived of these fundamental toys of our youth by

glass and chromium and plastic surfaces, by hygiene and organisation, so there is pleasure to be found in hanging in the place of honour over the aseptic, dustless, smell–less electric fire a symbolic representation of mud and string.[4]

Cordell's intentions were in fact not so far from this engagement with the ''elemental muddle of natural conditions.'' Rather than a nostalgic vision of the past, however, Cordell's women represented a triumph of the human organism over injury and change. In an interview following an exhibition in 1960, she formulated this as the miracle of self–renewal.

> When your car breaks and you take it to a garage they have to replace the whole of the defective part. But they can cut away huge pieces of your internal organs and you will grow them again or compensate for their loss. And also, all the time that your body is renewing itself, so in your lifetime you are remade countless times. This to me is an incredible thing.[5]

Unlike Dubuffet and Paolozzi's battered heads, Cordell's female bodies are composed of futuristic materials. Their glowing, affirmative presences are testimony to her commitment to found a new iconography through what Alloway called ''the plenty and variety of paint.''

JACQUELYNN BAAS

1. Reyner Banham, ''The New Brutalism,'' Architectural Review, 118 (December 1955), p. 357. See ''Critical Writings.''
2. Lawrence Alloway, Foreword, Magda Cordell Paintings, exh. cat. (London, Hanover Gallery, 1956), unpaginated.
3. Basil Taylor, Spectator, 27 January 1956, p. 8.
4. Stephen Bone, ''Love of Mud and String: Artistic Homeostasis,'' Manchester Guardian, 13 January 1956, p. 5.
5. Magda Cordell, interview by Peter Rawstorne, News Chronicle (London), 1 July 1960.

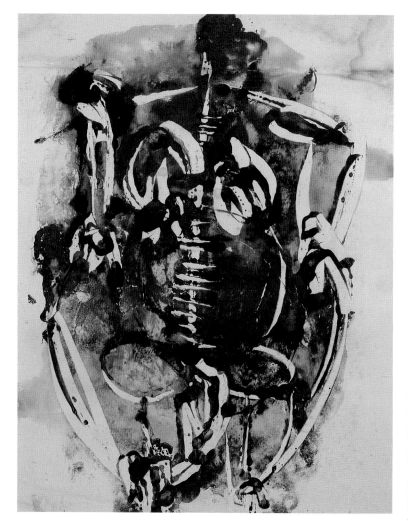

1.
UNTITLED, 1954
Monoprint; red, black, green and yellow paint on paper
20 ½ x 14 ½ in.
Collection of the artist

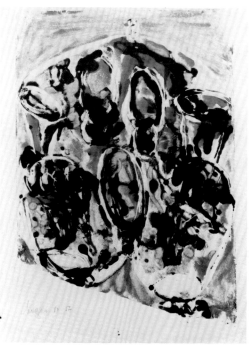

2.
UNTITLED, 1954–55
Monoprint; red, black, and yellow paint on paper, printed from a broken marble slab
20 ½ x 14 ½ in.
Collection of the artist

CORDELL

3.
UNTITLED, 1955
Monoprint; green, black, and yellow paint on paper
21 ¾ x 14 in.
Collection of the artist (U.S. only)

4.
UNTITLED, 1957
Pigment and polymer on canvas
60 x 39 ¾ in.
Collection of the artist (U.S. only)

5.
FIGURE '59, about 1958
Oil and acrylic on masonite
96 x 60 in.
Collection of the artist

6.
PRESENCES, 1959—60
Pigment, colored inks, and polymer on canvas
60 x 40 ⅛ in.
Collection of the artist

CORDELL

RICHARD HAMILTON

Richard Hamilton (b. 1922) was one of the
few regular attenders at the Indepen-
dent Group meetings who was a native
Londoner. In 1938, after a number of art
classes — the first when he was only
twelve — Hamilton became a student at
the Royal Academy Schools. The war
interrupted his studies but his job as a
jig and tool designer kept him out of the
services. When the war ended he returned
to the Royal Academy Schools. In 1946 he
was expelled for ''not profiting from
the instruction given'' and conscripted
for army duty. He married Terry O'Reilly
in 1947 and the following year enrolled
at the Slade, where he met Nigel Hender-
son. Henderson introduced him to the
ICA, Roland Penrose, and Marcel Duch-
amp's extraordinary publication, The
Green Box.

During the fifties Hamilton
designed a number of exhibitions for the
ICA as well as devising his own shows,
such as Growth and Form (1951) and Man,
Machine and Motion (1955). Throughout
these years he continued to produce
paintings, drawings, and prints, but
he was not prolific, partly because of
his extremely analytic method, but
chiefly because of his commitments to
teaching — at the Central School of Art
in London (1952–53), King's College,

Durham University at Newcastle–upon–
Tyne (1953–56), and the Royal College of
Art in London (1957–61). He had his first
one–person exhibition of paintings in
1955, but did not have a second until
nine years later.

Hamilton became a key figure in
the Independent Group during its later
sessions, and his own painting began to
show the influence of IG concerns as
early as 1955. However, his work for This
Is Tomorrow in 1956 opened the way for
paintings which in many ways were a
visual equivalent of Independent Group
ideas and themes. Unlike his fellow
artists in the Group — Cordell, Hender-
son, McHale, Paolozzi, and Turnbull —
Hamilton documented his work in a
remarkably stimulating series of essays
that catalogue and itemize his
sources.[1]

Largely as a result of his exhi-
bition at the Hanover Gallery in 1964 and
his reconstruction of Duchamp's Large
Glass (1965–66), his reputation as a
painter grew rapidly, but his success
was dampened by the tragic death of
Terry Hamilton in 1962.

In 1964 Hamilton noted that his
paintings of the mid– and late fifties
''were aggressively unfashionable at
the time of execution.''[2] This now seems
surprising since he was (and still is)
an artist very much concerned with the
present. But in retrospect, it was this
preoccupation with his own time — as
well as with the manner in which he went
about portraying it — that made it so
difficult for others to accept his work.

To a large extent, Hamilton's
oeuvre is theme–based as opposed to
style–based. On more than one occasion
he has remarked that he respects ideas
rather than style, and his catalogue
statement for This Is Tomorrow opens:
''We resist the kind of activity which
is primarily concerned with creation of
style.''[3] Thus the style exists to com-
municate ideas. This results not only in
works of art which are stylistically

dissimilar, but also in individual
works incorporating a variety of
styles. The unity of Hamilton's oeuvre
is most obviously thematic.

At the time of the Growth and
Form exhibition, Hamilton produced
paintings, drawings, and prints which
used D'Arcy Thompson–inspired imagery.
Self Portrait (cat. no. 7) shows the
artist as an assemblage of his current
interests: sea–urchin mouth, flat–worm
tie, bull sperm profile. In d'Orienta-
tion (cat. no. 8), the imagery suggests
a jellyfish but the concern now is for
methods of perception rather than for
the image alone, and the painting uti-
lizes a perspective system that incor-
porates the Golden Section.

This interest in how one depicts
what one sees was investigated in Ham-
ilton's work between 1952 and 1955 and
has remained an important element ever
since. Interest in Eadweard Muybridge,
E. J. Marey, and the Futurists led to a
series of pictures in which the process
of movement was explored. The system
implicit in d'Orientation was developed
to accommodate the superimposition of a
moving object or a moving viewpoint.
Hamilton's frequent journeys between
London and Newcastle (to teach at King's
College) were the direct inspiration
for a series of paintings called Train-
sition, in which the spectator is in a
train viewing a landscape which appears
to be moving. In Trainsition IIII (cat.
no. 10), views of a tree, telegraph pole

68

and automobile are represented, with an arrow symbol indicating both movement and direction. The composition of the painting is similar to a diagram reproduced in James J. Gibson's The Perception of the Visual World (1950), which Hamilton had borrowed from Alloway at this time.

Hamilton was no stranger to exhibition organization. When This Is Tomorrow was planned, he had already produced Growth and Form and Man, Machine and Motion and had assisted with numerous other ICA shows. Together with John Voelcker, John McHale, Magda Cordell, and his wife, Terry, Hamilton contributed what is arguably the most memorable section in This Is Tomorrow. For the catalogue and also for one of the posters, Hamilton produced the collage Just what is it that makes today's homes so different, so appealing? (it was not part of the exhibit). Much of the material came from McHale's legendary trunk of American magazines and was selected by Magda Cordell and Terry Hamilton from Richard Hamilton's ''list of interests,'' which were general categories such as man, woman, food, history, and cinema. Hamilton then made the final selection and arranged the images.

Wishing to build upon the suc-cess of This Is Tomorrow, Hamilton analyzed the major characteristics of popular art: it was not only ''popular,'' but transient, expendable, inexpensive, mass produced, youth-oriented, witty, sexy, gimmicky, glamorous, and ''big business.''[4] He had been liberated by the discussions of the Independent Group, especially those concerned with design styling and advertising, and by the currency within the IG of non-Aristotelian logic. ''The notion that you couldn't say that something was either good or bad, led to the possibility of the inclusion into paintings of some figurative matter which wouldn't have been conceivable without the fundamental notion of non-Aristotelian thinking''[5].

Incorporating popular imagery into fine art, Hamilton painted Hommage à Chrysler Corp. in 1957. Stylistically and thematically inspired by Duchamp's Large Glass, the painting is not a pastiche but a vigorously intellectual analysis of the consumer age. One's appreciation of this visually intriguing image is enriched by the layering of meanings and references, many of which Hamilton explained in his perspicuous writings of the late fifties and early sixties. Hers is a lush situation and $he (cat. no. 17) followed Hommage; each painting was accompanied by a number of preparatory studies, collages, and prints (cat. nos. 12–16). In Hers is a lush situation, the girl/car motif is explored again, whereas $he addresses issues of consumerism in the home and the woman's role, and was partly inspired by an ICA lecture Hamilton gave in July 1959 entitled ''The Design Image of the Fifties.'' In 1961 Hamilton produced Glorious Techniculture for the Union of International Architects Congress in London. The theme of the congress and the painting was architecture and technology. Dissatisfied with the original panel, Hamilton cut it in half and reworked it so that the architec-tural content was virtually abandoned.

These works, together with other, later panels, marked Hamilton's emergence as the ''Big Daddy of Pop,''[6] but although his role as one of the founders of Pop Art is important, his significance is far greater. Arguably, the most important aspect of his work is its ability to communicate on many levels, proposing a miscellany of possibilities which are at once intellectual, witty, calculated, stimulating, and innovative.

Graham Whitham

1. ''Hommage à Chrysler Corp.,'' Architectural Design, 28 (March 1958), pp. 120–121; ''An Exposition of $he,'' Architectural Design, 32 (October 1962), pp. 485–486; ''Urbane Image,'' Living Arts, 2 (1963), pp. 44–59.
2. Introduction, Richard Hamilton. Paintings 1956–64, exh. cat. (London, Hanover Gallery, 1964), unpaginated.
3. ''Are They Cultured?'' (Group Two statement), This Is Tomorrow, exh. cat., (London, Whitechapel Art Gallery, 1956), unpaginated.
4. Letter to Peter and Alison Smithson, 16 January 1957, in Collected Words, 1953–1982 (London, 1982), p. 28.
5. Richard Hamilton, conversation with Reyner Banham, 27 June 1976, recorded for Fathers of Pop (Arts Council of Great Britain); it was not used in the film.
6. This phrase was used as the title to M. G. McNay's article about Hamilton in the Guardian, 25 July 1966, p. 7.

Hers is a lush situation, 1958
Oil, cellulose, metal foil, collage on panel
32 x 48 in.
Colin St. John Wilson
Cambridge
Center for British
Art, New Haven

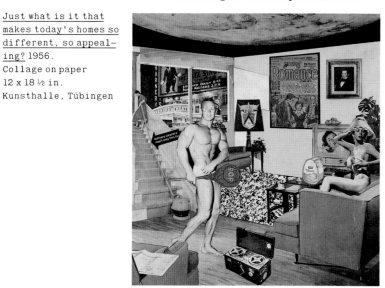

Just what is it that makes today's homes so different, so appealing? 1956.
Collage on paper
12 x 18 ½ in.
Kunsthalle, Tübingen

7.
SELF-PORTRAIT, 1951
Ink and wash on paper
11 ¾ x 7 ¾ in.
The Trustees of the Victoria and Albert Museum, London

8.
D'ORIENTATION, 1952
Oil on panel
46 x 63 in.
Collection of the artist

9.
TRAINSITION III, 1954
Oil on panel
35 ½ x 27 ½ in.
Mrs. Benn W. Levy, London (U.S. only)

10.
TRAINSITION IIII, 1954
Oil on panel
36 x 48 in.
The Trustees of the Tate Gallery, London (ICA and IVAM only)

HAMILTON

11.
COLLAGE OF THE SENSES, 1956
Collage and ink on paper
12 x 18 ½ in.
Museum Ludwig, Cologne (ICA and MOCA only)

12.
STUDY FOR ''HOMMAGE À CHRYSLER CORP.,'' 1957
Pen and ink, gouache and collage
13 ½'' x 8 ½ in.
Private collection, London

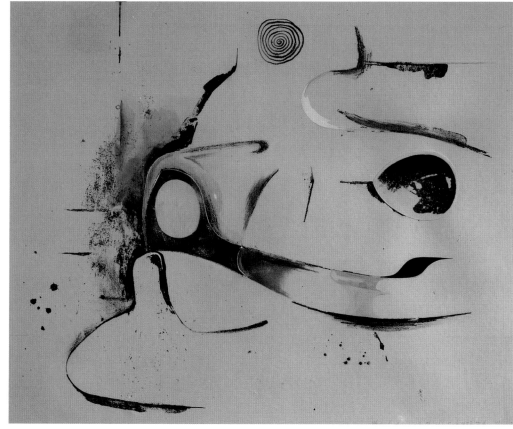

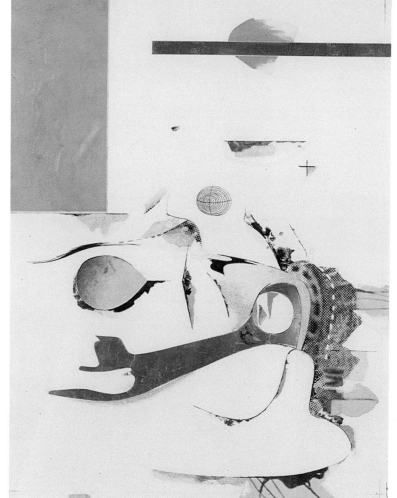

13.
STUDY FOR ''HOMMAGE À CHRYSLER CORP.,'' 1957
Lithograph with pastel, gouache, and collage on paper
15 x 21 in.
Richard Morphet, London

14.
HOMMAGE À CHRYSLER CORP. (version for line reproduction),
1958
Collage and ink
18 ½ x 14 ½ in.
T. Duchamp, Paris

HAMILTON

15.
STUDY FOR ''HERS IS A LUSH SITUATION,'' 1957
Ink, crayon, watercolor, gouache, metal foil on paper
9 x 14 in.
Rita Donagh

16.
STUDY FOR ''$HE,'' 1958
Ink, watercolor, collage
9 x 6 ¾ in.
Mrs. Benn W. Levy, London

17.
$HE, 1958–61
Oil and collage on panel
48 x 32 in.
The Trustees of the Tate Gallery, London (ICA only)

HAMILTON

NIGEL HENDERSON

Born in St. John's Wood, London, in 1917,
Nigel Henderson's upringing and con-
tacts hardly accorded with Reyner Ban-
ham's famous assertion that the IG was
''the revenge of the elementary school
boys.'' He was educated, unhappily, at
the boarding school Stowe, and was
already in his mid-thirties by the time
the IG was formalized. Through his
mother, Wyn Henderson, he had direct
access to the upper-class bohemia of
Bloomsbury. Between 1935 and 1936 he
lived with the Adrian Stephen family
(Stephen was the brother of Virginia
Woolf and Vanessa Bell). Within this
privileged milieu, Henderson had con-
tact with a wide range of literary fig-
ures, including Brecht, Auden,
MacNeice, and Dylan Thomas. More conse-
quentially, Wyn Henderson worked as
manager of Peggy Guggenheim's gallery
in London from its inception in 1938
until the outbreak of war a year later.
The avant-garde was thus a familiar and
accessible reality for Henderson.

When Marcel Duchamp came to Lon-
don to realize an exhibition at Gug-
genheim's gallery, Henderson worked
with him on the installation. He later
recalled discussing his fascination
with flying with Duchamp.[1] Henderson's
subsequent loan of The Green Box to
Richard Hamilton illustrates his cru-
cial role as a conduit of ideas and
information to younger participants in
the IG. While studying at the Slade
School of Art in London just after the
war, Henderson had formed friendships
with Paolozzi and Hamilton. From 1947
onwards Henderson stayed several times
with Paolozzi in Paris, where they met
Brancusi, Giacometti, Braque, and Arp.

Through his wife, Judith (daugh-
ter of Adrian and Karen Stephen), whom
he married in 1943, Henderson encoun-

tered another, more home-grown current
within postwar British culture, which
might broadly be termed ''anthropologi-
cal.'' Judith Henderson had graduated
from Cambridge as an anthropologist,
and they moved to Bethnal Green in the
East End of London in 1945. There she ran
a course called ''Discover Your Neigh-
bour,'' assisted and encouraged by Tom
Harrisson, one of the founders of Mass
Observation. Mass Observation had
sought to coordinate ''an anthropology
of ourselves'' in 1930s Britain, which
resulted in the quasi-scientific
researches of Northern working-class
morals and habits by waves of well-
intentioned Oxbridge graduates. For the
Hendersons, the social patterns of the
East End working-class communities were
similarly alien and exotic, and Nigel
began to take photographs of the area
and its inhabitants in 1949. The enthu-
siasm the Hendersons expressed for
Bethnal Green and the friendships they
made, however, suggest a genuine,
intense engagement.

In a prose poem to Paolozzi, Hen-
derson revealed his profound attachment
to these people and their streets:

I wish, looking back, that I had
been better technically; that I
could have sung the song of every
blotch and blister, of every

patch and stain on road and pave-
ment surface, of step and rail
and door and window frame. The
patched garments, the creaky
shoes, the warm bodies, the
stout hearts and quirky indepen-
dent spirit . . . the sheer
capacity to get on with it of the
disregarded . . . the humour and
the fatalism of those trapped,
possibly by choice, in the small
tribal liaisons of the back and
side streets.[2]

If it is possible to talk of Henderson's
artistic reputation having survived, it
is on the basis of the Bethnal Green pho-
tographs of 1948-1952. In fact, his rep-
utation mirrors the prejudices of
photographic historians obsessed with
the idea of constructing a British
''social documentary'' tradition. From
this perspective, Henderson fits neatly
into a picture that traces back through
the work of Bill Brandt and Humphrey
Spender (who had been active with Mass
Observation) and forward to the street
photographs of Roger Mayne in the
mid-1950s. To situate Henderson within
such a tradition is not erroneous, but
it is a partial and inadequate
perspective.

The influences on Henderson were
remarkably diverse, and in no way
restricted to a specifically British
tradition or to a snapshot aesthetic. He
worked with the less mobile Rolliflex
plate camera rather than with the Leica
generally preferred by street photog-
raphers. His fascination with the cal-
ligraphy of decay links him more
immediately to a French than to a Brit-
ish ancestry — to Brassai, certainly, and
to Cartier-Bresson, whom Henderson had
met and accompanied around the East End
of London in 1951. His photographs of
shop-windows and street signs appear to
derive from Walker Evans's pursuit of
the vernacular, or indeed from Atget's.
(While studying at the Slade in the late

1940s, Henderson had seen books of both these photographers, which was unusual then.) A recurrent interest in windows, screens, and reflections suggests that Henderson had thought a great deal about the aesthetic possibilities of the ''documentary style,'' as Walker Evans called his work. The photographs of decaying wall surfaces, pavements, and doors suggest that Henderson may have been seeking, on a small photographic scale, the kind of ''all-over'' effect that had been admired when Jackson Pollock's paintings were first exhibited in London, at the ICA, in 1953. At the time, Henderson's Bethnal Green photographs were chiefly valued as a social record. The Smithsons used them in their CIAM Grille (see Smithson, cat. no. 71), and several reproductions were featured in an issue of Crosby's Uppercase (no. 3, 1961) on the Smithsons' work, although they did not appear in other publications. Now, however, they figure for us as a promise of new directions in British photography that remained unfulfilled, since the experimental attitude behind Henderson's work was eclipsed by the demands of photojournalism and the conventions of social documentary.

The experimental side of Henderson's activity manifested itself throughout this same period, 1949–1952, in Henderson's work in the darkroom and through the medium of collage. In 1948 Paolozzi had given him an enlarger, and he proceeded to make photograms (or ''Hendograms'' as he called them) using material from bomb sites, vegetables, and other found items. Already, between 1948 and 1949, while he was staying with Paolozzi in Paris, Henderson had covered his wall with ornamentation, letters, and signs. A photograph of this working environment formed a partial background to the collage screen on which he began work in 1949 (cat. no. 31). Two parts of the screen were completed that year; the other two were

added in 1960 at the request of the owner, Sandy Wilson. The iconography ranges from primitive masks to Charles Atlas, figures with artificial arms to paintings by Titian and Cranach, English folk figures and Henderson's own photographs of wall surfaces. The screens reveal Henderson's early fascination with the iconography of head and body and his preference for the signs and symbols within vernacular culture, which are also apparent in his photographs of the flag-bedecked streets of Bethnal Green for the Coronation in 1953. In an interview made in 1978, he stated that at times he ''was consciously looking for chunks, bits of typification of Englishness, including the cliché British Oak,'' an attitude reminiscent of filmmaker Humphrey Jennings, whose brand of Surrealism Henderson much admired. Like Schwitters, Henderson introduced artifacts from daily life and presented the material in an unhierarchical, ''all-over'' way. Additionally, the screens contain a substantial amount of autobiographical information. For example, the written sign ''Pilot'' and some collaged targets relate specifically to Henderson's wartime experiences.[3]

World War II was a traumatic and formative experience for Henderson, and may be seen as the source of another strand in his work, which stretches from his recuperation of bomb-site material in the Hendograms to the Head of a Man, which was the central image in the Patio and Pavilion collaboration with Paolozzi and the Smithsons for This Is Tomorrow. Henderson suffered a nervous breakdown on leaving the Air Force and subsequently became preoccupied with what he called the ''stressed'' photograph, in which he used a variety of darkroom techniques to experiment with the image. The imagery of bomb sites and destruction, atrophy and decay recurs throughout the Bethnal Green photographs. Children wander through the

streets as if through an aftermath. The petrified figure from Pompeii, first used in Parallel of Life and Art (1953), recurs in the floor piece in Patio and Pavilion, alongside a range of microscopic and cultural material similar to that displayed in the 1953 exhibition. The collage Atlas (1954) was partly constituted from blown-up photographs of charred wood. (Now lost, Atlas was shown in Alloway's exhibition Collages and Objects. A photograph appears in the 1954 chronology.) Head of a Man could be regarded as the culmination of the ''stressed'' impulse in Henderson's work. Indeed, an existential attitude was latent in Patio and Pavilion, about which Reyner Banham noted: ''One could not help feeling that this particular garden shed with its rusted bicycle wheels, a battered trumpet and other homely junk, had been excavated after an atomic holocaust.''[4]

Henderson also contributed some bas-reliefs to Patio and Pavilion. He had developed the form while engaged with the abortive Hammer Prints Ltd. he had established with Paolozzi in Thorpe-le-Soken in 1955. The operation was finally closed in 1961, the year in which Henderson had a one-person exhibition at the ICA. From 1952 on, however, when he moved to Essex, Henderson was increasingly distanced from his activities in London. Thus, although several IG members, including Hamilton, the Smithsons, and Sandy Wilson, have attested to the seminal influence of Henderson's experimental attitudes and observational powers, the artist had situated himself peripherally. Both his contribution to Patio and Pavilion and his solo exhibition in 1961 were rare interventions in the metropolis, as Henderson devoted his time increasingly to teaching, first at Colchester School of Art and then at Norwich School of Art. He remained based in Thorpe-le-Soken until his death in 1984.
James Lingwood

1. Anne Seymour, <u>Nigel Henderson: Paintings, Collages, and Photographs</u>, exh. cat., Anthony d'Offay Gallery (London, 1977), p. 6. I am indebted to this catalogue for much of the biographical information used here.
2. Nigel Henderson, ''Prose Poem to Paolozzi,'' <u>Uppercase</u>, no. 3 (1961), unpaginated; reprinted in <u>Nigel Henderson: Photographs of Bethnal Green 1949–52</u> (Nottingham, 1978), unpaginated.
3. Jürgen Jacob, <u>Die Entwicklung der Pop Art in England . . . von ihren Anfängen bis 1957</u> (Frankfurt, 1986), pp. 49ff.
4. Reyner Banham, <u>The New Brutalism: Ethic or Aesthetic?</u> (London, 1966), p. 85.

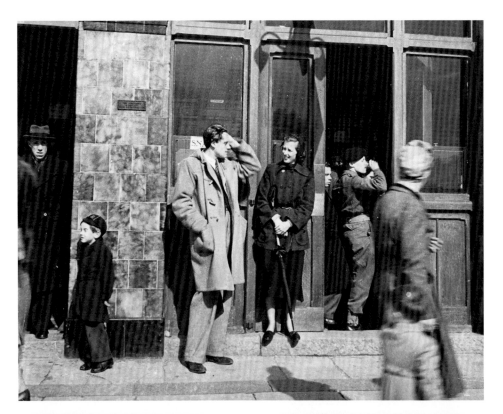

18.
<u>BOAT RACE DAY, HAMMERSMITH, WEST LONDON</u>, 1952
Gelatin silver print
8 x 10 in.
Estate of the artist

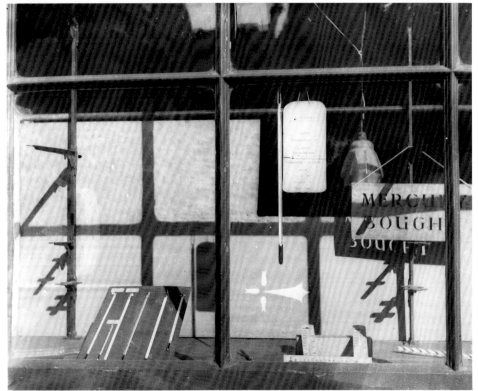

19.
<u>SHOP WINDOW, EAST LONDON</u>, 1949–52
Gelatin silver print
8 x 10 in.
Estate of the artist

1940s, Henderson had seen books of both these photographers, which was unusual then.) A recurrent interest in windows, screens, and reflections suggests that Henderson had thought a great deal about the aesthetic possibilities of the ''documentary style,'' as Walker Evans called his work. The photographs of decaying wall surfaces, pavements, and doors suggest that Henderson may have been seeking, on a small photographic scale, the kind of ''all-over'' effect that had been admired when Jackson Pollock's paintings were first exhibited in London, at the ICA, in 1953. At the time, Henderson's Bethnal Green photographs were chiefly valued as a social record. The Smithsons used them in their CIAM Grille (see Smithson, cat. no. 71), and several reproductions were featured in an issue of Crosby's Uppercase (no. 3, 1961) on the Smithsons' work, although they did not appear in other publications. Now, however, they figure for us as a promise of new directions in British photography that remained unfulfilled, since the experimental attitude behind Henderson's work was eclipsed by the demands of photo-journalism and the conventions of social documentary.

The experimental side of Henderson's activity manifested itself throughout this same period, 1949–1952, in Henderson's work in the darkroom and through the medium of collage. In 1948 Paolozzi had given him an enlarger, and he proceeded to make photograms (or ''Hendograms'' as he called them) using material from bomb sites, vegetables, and other found items. Already, between 1948 and 1949, while he was staying with Paolozzi in Paris, Henderson had covered his wall with ornamentation, letters, and signs. A photograph of this working environment formed a partial background to the collage screen on which he began work in 1949 (cat. no. 31). Two parts of the screen were completed that year; the other two were

added in 1960 at the request of the owner, Sandy Wilson. The iconography ranges from primitive masks to Charles Atlas, figures with artificial arms to paintings by Titian and Cranach, English folk figures and Henderson's own photographs of wall surfaces. The screens reveal Henderson's early fascination with the iconography of head and body and his preference for the signs and symbols within vernacular culture, which are also apparent in his photographs of the flag-bedecked streets of Bethnal Green for the Coronation in 1953. In an interview made in 1978, he stated that at times he ''was consciously looking for chunks, bits of typification of Englishness, including the cliché British Oak,'' an attitude reminiscent of filmmaker Humphrey Jennings, whose brand of Surrealism Henderson much admired. Like Schwitters, Henderson introduced artifacts from daily life and presented the material in an unhierarchical, ''all-over'' way. Additionally, the screens contain a substantial amount of autobiographical information. For example, the written sign ''Pilot'' and some collaged targets relate specifically to Henderson's wartime experiences.[3]

World War II was a traumatic and formative experience for Henderson, and may be seen as the source of another strand in his work, which stretches from his recuperation of bomb-site material in the Hendograms to the Head of a Man, which was the central image in the Patio and Pavilion collaboration with Paolozzi and the Smithsons for This Is Tomorrow. Henderson suffered a nervous breakdown on leaving the Air Force and subsequently became preoccupied with what he called the ''stressed'' photograph, in which he used a variety of darkroom techniques to experiment with the image. The imagery of bomb sites and destruction, atrophy and decay recurs throughout the Bethnal Green photographs. Children wander through the

streets as if through an aftermath. The petrified figure from Pompeii, first used in Parallel of Life and Art (1953), recurs in the floor piece in Patio and Pavilion, alongside a range of microscopic and cultural material similar to that displayed in the 1953 exhibition. The collage Atlas (1954) was partly constituted from blown-up photographs of charred wood. (Now lost, Atlas was shown in Alloway's exhibition Collages and Objects. A photograph appears in the 1954 chronology.) Head of a Man could be regarded as the culmination of the ''stressed'' impulse in Henderson's work. Indeed, an existential attitude was latent in Patio and Pavilion, about which Reyner Banham noted: ''One could not help feeling that this particular garden shed with its rusted bicycle wheels, a battered trumpet and other homely junk, had been excavated after an atomic holocaust.''[4]

Henderson also contributed some bas-reliefs to Patio and Pavilion. He had developed the form while engaged with the abortive Hammer Prints Ltd. he had established with Paolozzi in Thorpe-le-Soken in 1955. The operation was finally closed in 1961, the year in which Henderson had a one-person exhibition at the ICA. From 1952 on, however, when he moved to Essex, Henderson was increasingly distanced from his activities in London. Thus, although several IG members, including Hamilton, the Smithsons, and Sandy Wilson, have attested to the seminal influence of Henderson's experimental attitudes and observational powers, the artist had situated himself peripherally. Both his contribution to Patio and Pavilion and his solo exhibition in 1961 were rare interventions in the metropolis, as Henderson devoted his time increasingly to teaching, first at Colchester School of Art and then at Norwich School of Art. He remained based in Thorpe-le-Soken until his death in 1984.

JAMES LINGWOOD

1. Anne Seymour, <u>Nigel Henderson: Paintings, Collages, and Photographs</u>, exh. cat., Anthony d'Offay Gallery (London, 1977), p. 6. I am indebted to this catalogue for much of the biographical information used here.

2. Nigel Henderson, ''Prose Poem to Paolozzi,'' <u>Uppercase</u>, no. 3 (1961), unpaginated; reprinted in <u>Nigel Henderson: Photographs of Bethnal Green 1949–52</u> (Nottingham, 1978), unpaginated.

3. Jürgen Jacob, <u>Die Entwicklung der Pop Art in England . . . von ihren Anfängen bis 1957</u> (Frankfurt, 1986), pp. 49ff.

4. Reyner Banham, <u>The New Brutalism: Ethic or Aesthetic?</u> (London, 1966), p. 85.

18.
<u>BOAT RACE DAY, HAMMERSMITH, WEST LONDON</u>, 1952
Gelatin silver print
8 x 10 in.
Estate of the artist

19.
<u>SHOP WINDOW, EAST LONDON</u>, 1949–52
Gelatin silver print
8 x 10 in.
Estate of the artist

20.
<u>BOY IN WINDOW, EAST LONDON</u>, 1949–52
Gelatin silver print
10 x 8 in.
Estate of the artist

HENDERSON

21.
SHOP ENTRANCE, EAST LONDON, 1949–52
Gelatin silver print
8 x 10 in.
Estate of the artist

22.
BARBER'S SHOP, EAST LONDON, 1949–52
Gelatin silver print
10 x 8 in.
Estate of the artist

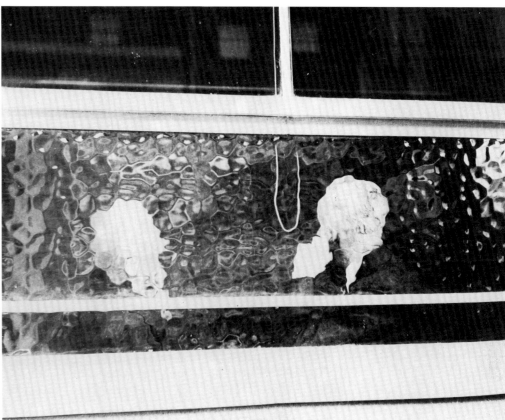

23.
<u>PETTICOAT LANE MARKET, EAST LONDON</u>, 1949–52
Gelatin silver print
8 x 10 in
Estate of the artist

24.
<u>CAFÉ, OFF BETHNAL GREEN ROAD, EAST LONDON</u>, 1949–52
Gelatin silver print
8 x 10 in.
Estate of the artist

HENDERSON

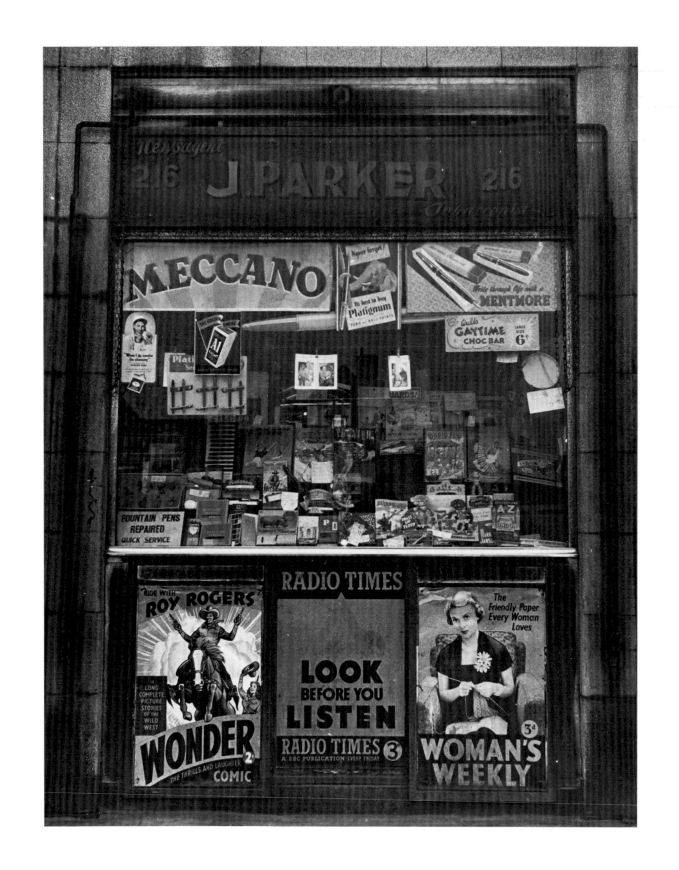

25.
NEWSAGENT, EAST LONDON, 1949–52
Gelatin silver print
10 x 8 in.
Estate of the artist

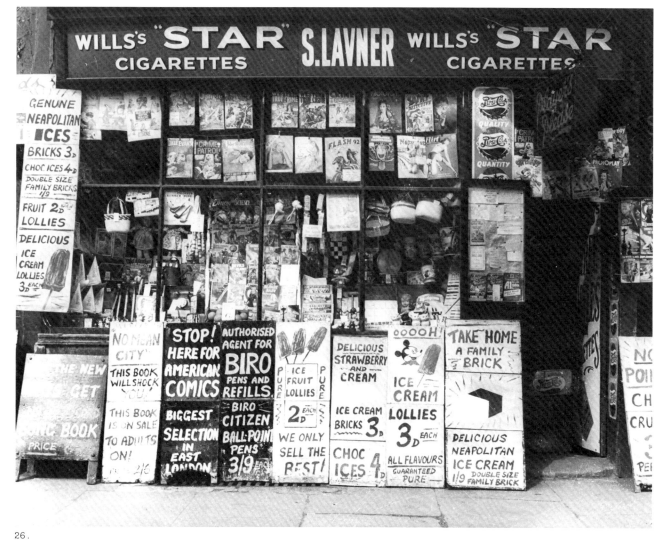

26.
SHOP FRONT, EAST LONDON, 1949–52
Gelatin silver print
8 x 10 in.
Estate of the artist

27.
CAFÉ, EAST LONDON, 1949–52
Gelatin silver print
8 x 10 in.
Estate of the artist

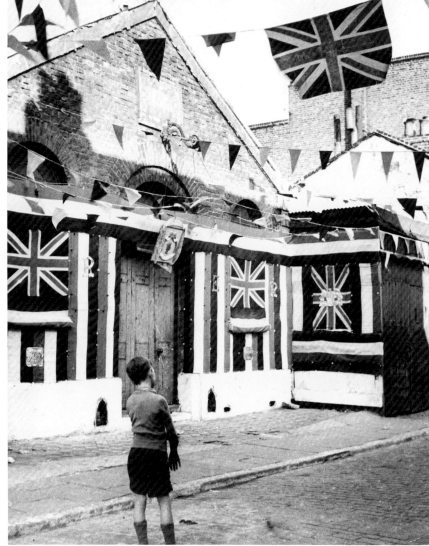

84

28.
PORTRAIT, EAST LONDON, 1949–52
Gelatin silver print
8 x 10 in.
Estate of the artist

29.
WALL, EAST LONDON, 1949–52
Gelatin silver print
10 x 8 in.
Musee d'Art Moderne, Saint–Etienne
(Photo not available)

30.
CORONATION DAY, BETHNAL GREEN, EAST LONDON, 1953
Gelatin silver print
10 x 8 in.
Estate of the artist

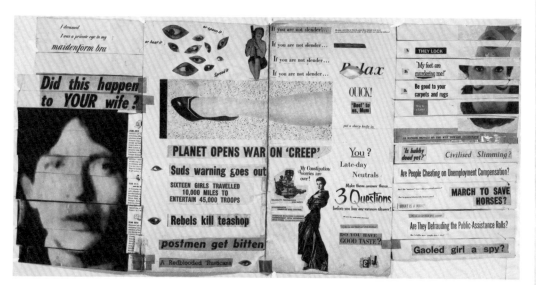

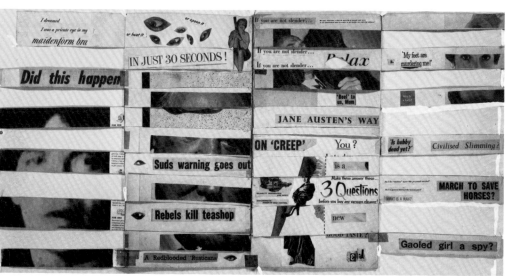

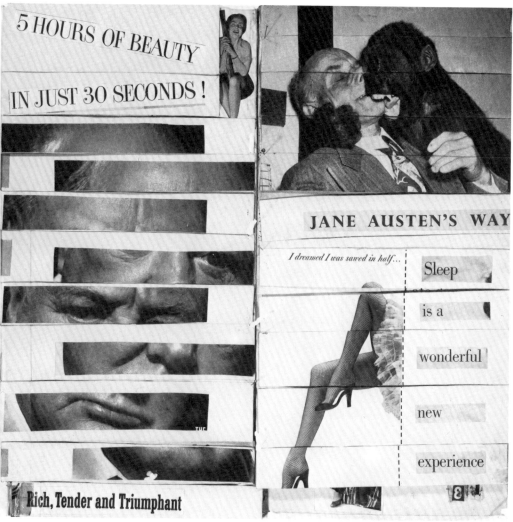

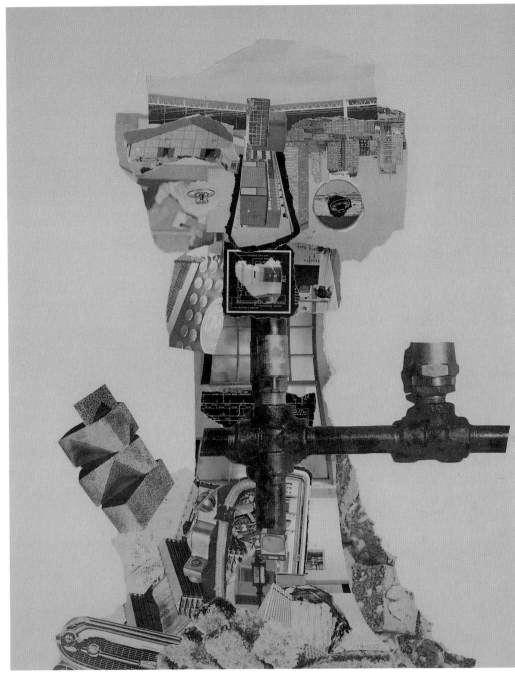

38.
MACHINE—MADE AMERICA I, 1956—57
Collage
29 x 23 in.
Magda Cordell McHale, Buffalo

39.
BREADHEAD, 1956
Collage, 60 x 39 ¾ in.
Magda Cordell McHale, Buffalo

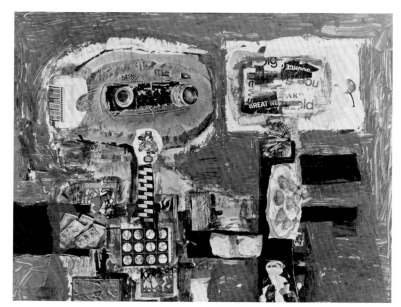

40.
<u>TELEMATH VI</u>, 1957
Collage, 35 ½ x 47 in.
Magda Cordell McHale, Buffalo

41.
<u>FIRST CONTACT</u>, 1958
Collage, 48 x 72 ¼ in.
Magda Cordell McHale, Buffalo

M c H A L E

Eduardo Paolozzi's influence on the Independent Group was immense, not only as an artist and exhibition planner but as the personal embodiment of the eclectic, populist outlook that typified the Group. In fact, Paolozzi can be credited with setting the terms for both the Brutalist and pop sides of the IG aesthetic, especially if we acknowledge the prophetic impact of his epidiascope ''lecture'' of 1952 using mass-media images.

Paolozzi's career and personal history reflect a thoroughly international perspective. Born in Edinburgh to immigrants from Viticuso, Italy, who ran an ice cream and sweet shop near the Scottish coast, Paolozzi visited Italy at intervals from boyhood. He lost his father during World War II and was interned as an alien. After a stint in the Royal Pioneer Corps, he attended the Slade School of Fine Art, where he met William Turnbull and Nigel Henderson. Turnbull also was a Scottish sculptor and painter with early ambitions as a commercial illustrator. Henderson, who grew up within the ambience of the avant-garde, had already developed a stylistic commitment to collage. Significantly, Henderson and Paolozzi spent less time in the Slade's resolutely traditional art classes than in the museums of natural history and of science and industry.

A successful exhibition at the Mayor Gallery in 1947 allowed Paolozzi to move to Paris, where he remained for over two years. During this time he got to know Dubuffet, Giacometti, Tzara and other leaders of the avant-garde, and he saw Mary Reynolds's Duchamp collection (including Duchamp's walls covered with magazine images) as well as other art from Dada and Surrealist contexts.

Paolozzi began his scrapbook of collages at this time, drawing on American magazines given to him by GIs. The collage aesthetic, both in two- and three-dimensional applications, was to inform Paolozzi's work throughout his career. Paolozzi's observation that ''all human experience is just one big collage'' is often quoted.[1] His point is anthropological as well as aesthetic: reality is many-sided, interpretation is active, and all cultures are ''read'' as simultaneous, through use-worn objects and images whose juxtaposition produces surprising tensions between wonder and familiarity. ''Things'' are transformed into ''presences.''

At the time of the epidiascope showing, which several members recall as the launching of the Independent Group, Paolozzi was publicly known for three ambiguously suggestive stylistic modes—a linear sculpture style, used in his two fountain commissions (Festival of Britain, 1951, and Hamburg, 1953); an architectural deployment of objects on a flat base (Paolozzi worked with the firm of Jane Drew and Maxwell Fry in the early 1950s); and plaster reliefs and cast objects with biomorphic and animallike associations. His epidiascope showing, however, directly confronted what Alloway called ''the modern flood of visual symbols.'' The projection of a heterogeneity of messages generated from SF magazine covers, car ads, animated film clips, and military images appears to have had a bewildering impact. No one had taken mass media imagery that seriously before. Since the epidiascope could only project a section of the page at a time, the collage effects would not necessarily have been evident. In any case, this kind of material had been regarded as only a source for art, and that was apparently how Paolozzi's collages were considered. Even though a Paolozzi scrapbook (Psychological Atlas, cat. no. 52) was exhibited in the Collages and Objects

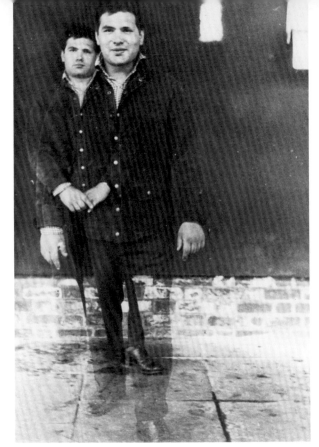

show of 1954, writers on the IG focused on his 1952 lecture and his recognizably Brutalist works, at least until 1972 when the silkscreen version of the Bunk collages was issued. In 1976, however, when the catalogue for the Pop Art in England show was published, Uwe Schneede focused on the collages alone. Resisting the Pop Art reading, Paolozzi has emphasized the Surrealist inspiration for the collages, which he calls ''readymade metaphors.''

Paolozzi's series of Head graphics in 1953 announced a period of intense preoccupation with the human head in several media, including bronze. (The important Wonder and Horror of the Human Head show had opened at the ICA in March 1953.) In Head (2) (1953, cat. no. 63), the softly emerging face within the larger wall-like face recalls the frottages of Max Ernst, which Paolozzi saw in Paris. Automobile Head (1954, cat. no. 65) states the fusion of man and machine that would

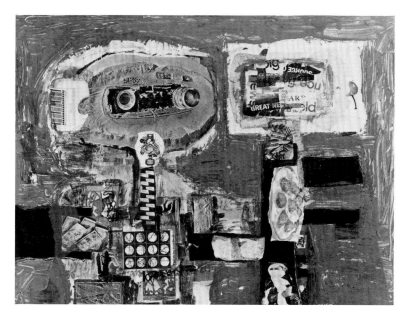

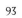

40.
<u>TELEMATH VI</u>, 1957
Collage, 35 ½ x 47 in.
Magda Cordell McHale, Buffalo

41.
<u>FIRST CONTACT</u>, 1958
Collage, 48 x 72 ¼ in.
Magda Cordell McHale, Buffalo

M c H A L E

EDUARDO PAOLOZZI

Eduardo Paolozzi's influence on the Independent Group was immense, not only as an artist and exhibition planner but as the personal embodiment of the eclectic, populist outlook that typified the Group. In fact, Paolozzi can be credited with setting the terms for both the Brutalist and pop sides of the IG aesthetic, especially if we acknowledge the prophetic impact of his epidiascope ''lecture'' of 1952 using mass-media images.

Paolozzi's career and personal history reflect a thoroughly international perspective. Born in Edinburgh to immigrants from Viticuso, Italy, who ran an ice cream and sweet shop near the Scottish coast, Paolozzi visited Italy at intervals from boyhood. He lost his father during World War II and was interned as an alien. After a stint in the Royal Pioneer Corps, he attended the Slade School of Fine Art, where he met William Turnbull and Nigel Henderson. Turnbull also was a Scottish sculptor and painter with early ambitions as a commercial illustrator. Henderson, who grew up within the ambience of the avant-garde, had already developed a stylistic commitment to collage. Significantly, Henderson and Paolozzi spent less time in the Slade's resolutely traditional art classes than in the museums of natural history and of science and industry.

A successful exhibition at the Mayor Gallery in 1947 allowed Paolozzi to move to Paris, where he remained for over two years. During this time he got to know Dubuffet, Giacometti, Tzara and other leaders of the avant-garde, and he saw Mary Reynolds's Duchamp collection (including Duchamp's walls covered with magazine images) as well as other art from Dada and Surrealist contexts.

Paolozzi began his scrapbook of collages at this time, drawing on American magazines given to him by GIs. The collage aesthetic, both in two- and three-dimensional applications, was to inform Paolozzi's work throughout his career. Paolozzi's observation that ''all human experience is just one big collage'' is often quoted.[1] His point is anthropological as well as aesthetic: reality is many-sided, interpretation is active, and all cultures are ''read'' as simultaneous, through use-worn objects and images whose juxtaposition produces surprising tensions between wonder and familiarity. ''Things'' are transformed into ''presences.''

At the time of the epidiascope showing, which several members recall as the launching of the Independent Group, Paolozzi was publicly known for three ambiguously suggestive stylistic modes—a linear sculpture style, used in his two fountain commissions (Festival of Britain, 1951, and Hamburg, 1953); an architectural deployment of objects on a flat base (Paolozzi worked with the firm of Jane Drew and Maxwell Fry in the early 1950s); and plaster reliefs and cast objects with biomorphic and animallike associations. His epidiascope showing, however, directly confronted what Alloway called ''the modern flood of visual symbols.'' The projection of a heterogeneity of messages generated from SF magazine covers, car ads, animated film clips, and military images appears to have had a bewildering impact. No one had taken mass media imagery that seriously before. Since the epidiascope could only project a section of the page at a time, the collage effects would not necessarily have been evident. In any case, this kind of material had been regarded as only a source for art, and that was apparently how Paolozzi's collages were considered. Even though a Paolozzi scrapbook (Psychological Atlas, cat. no. 52) was exhibited in the Collages and Objects

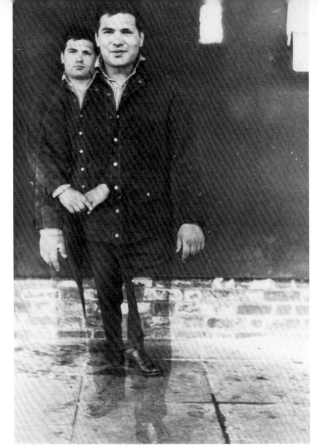

show of 1954, writers on the IG focused on his 1952 lecture and his recognizably Brutalist works, at least until 1972 when the silkscreen version of the Bunk collages was issued. In 1976, however, when the catalogue for the Pop Art in England show was published, Uwe Schneede focused on the collages alone. Resisting the Pop Art reading, Paolozzi has emphasized the Surrealist inspiration for the collages, which he calls ''readymade metaphors.''

Paolozzi's series of Head graphics in 1953 announced a period of intense preoccupation with the human head in several media, including bronze. (The important Wonder and Horror of the Human Head show had opened at the ICA in March 1953.) In Head (2) (1953, cat. no. 63), the softly emerging face within the larger wall-like face recalls the frottages of Max Ernst, which Paolozzi saw in Paris. Automobile Head (1954, cat. no. 65) states the fusion of man and machine that would

play a major role in Paolozzi's subsequent work. It is a Brutalist ''all-over'' elaboration of Raoul Hausmann's famous photo-collage, <u>Tatlin at Home</u> (1920), which superimposes a steering wheel mechanism on the subject's brain. Paolozzi's next major step was to fuse machine fragments with the human image, by casting bronze sculptures wrapped in sheets embossed with impressions of ''throwaway'' or ruined urban objects. In Paolozzi's anthropological vision of man as a tool-using animal, the machine partakes of the user's clumsiness and fragility, suggesting the contingency of culture.

Paolozzi's distance from the aestheticism of Pop Art is best measured from the standpoint of the two IG-related exhibitions he helped produce. <u>Parallel of Life and Art</u> acknowledged the ''new landscape'' of scientific photography, while absorbing it into an intellectually broader, iconically dense image field. Patio and Pavilion, the Group Six exhibit for <u>This Is Tomorrow</u>, brought the Surrealist-inspired imagination of Henderson and Paolozzi into the context of the Smithsons' architectural analysis of the patterns of working-class living. Both exhibitions used symbols and patterns that evoked the ''micro-macrocosmic exchange,'' as Alloway calls it, suggesting the constant erosion of the human image into the life and structure of the world. ''Does then the artist concern himself with / Microscopy? History? Palaeontology?'' Paolozzi asks in a 1958 lecture/poem. Then he answers: ''Only for the purpose of comparison, only in the exercise of his mobility of mind.''[2]

In the 1960s, Paolozzi reshaped his art to more directly represent modern industrial materials and techniques, producing aluminum and steel sculptures and three major series of prints exploring modern society and technology — <u>As Is When</u> (1965), <u>Moonship</u>

<u>Empire News</u> (1967) and <u>Universal Electronic Vacuum</u> (1967). Since then he has taught and produced major public art works both in Britain and West Germany. Paolozzi became a full member of the Royal Academy in 1979, was elected to the Council of the Architectural Association in 1984, and was knighted in 1989.
DAVID ROBBINS

1. Timothy Hyman, ''Paolozzi: Barbarian and Mandarin,'' <u>Artscribe</u>, 8 (September 1977), pp. 34-38. Hyman calls this ''his most-quoted statement'' (p. 34), emphasizing the advantages for Paolozzi of the directness of collage. In his 1965 interview with Paolozzi, Richard Hamilton remarks, ''It strikes me that all of your work comes out of the technique of collage, the idea of collage.'' Paolozzi responds by emphasizing the two virtues collage holds for him — things ''have to be constructed'' and it is ''a very direct way of working.'' Richard Hamilton, ''Interview with Eduardo Paolozzi,'' <u>Arts Magazine Yearbook</u>, 8 (1965), p. 160.
2. Eduardo Paolozzi, ''Notes from a Lecture at the Institute of Contemporary Arts, 1958,'' <u>Uppercase</u>, no. 1 (1958), unpaginated; see ''Critical Writings.''

23. Klokvormig masker, Luba, B.Kongo, cat. no. 33
◄ 24. Masker, Suku, B.Kongo, cat. no. 14

42.
<u>KLOKVORMIG MASKER</u>, about 1946-47
Collage
10 x 7 ½ in.
Collection of the artist

PAOLOZZI

96

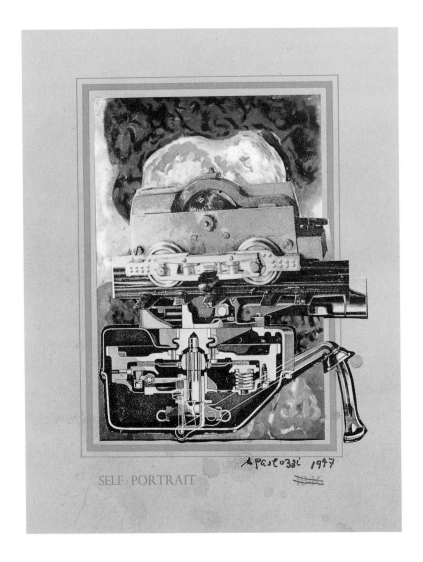

SELF-PORTRAIT

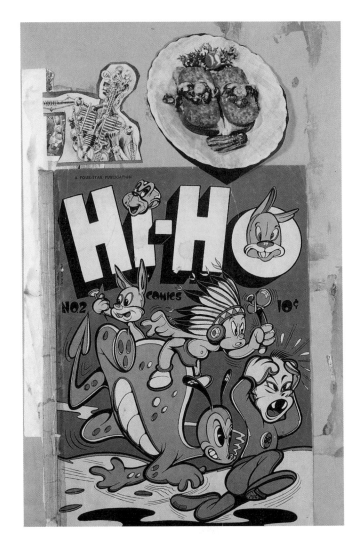

43.
SELF-PORTRAIT, dated 1947
Collage on paper
11 x 16 in.
Collection of the artist

44.
HI-HO, about 1947
Collage on paper
15 x 9 ¾ in.
The Trustees of the Victoria and Albert Museum, London

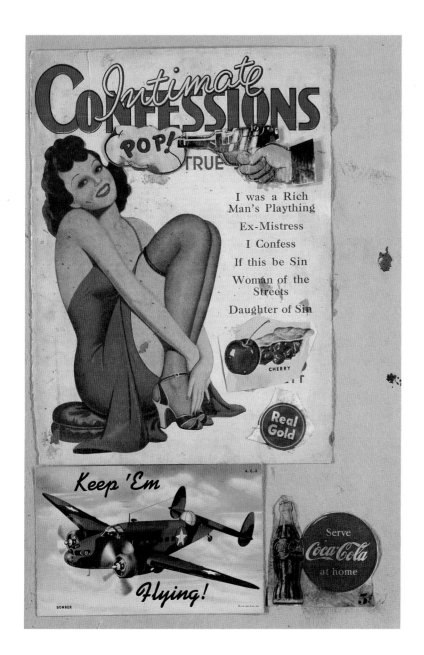

45.

<u>I WAS A RICH MAN'S PLAYTHING</u>, about 1947
Collage on paper
14 ⅛ x 9 ⅜ in.
The Trustees of the Tate Gallery, London (U.S. only)

46.

<u>LESSONS OF LAST TIME</u>, about 1947
Collage on paper
9 x 12 ¼ in.
The Trustees of the Tate Gallery, London (ICA and IVAM only)

PAOLOZZI

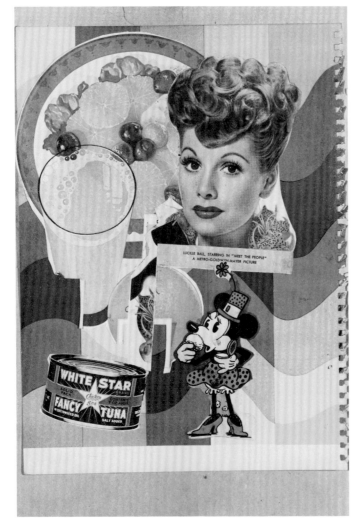

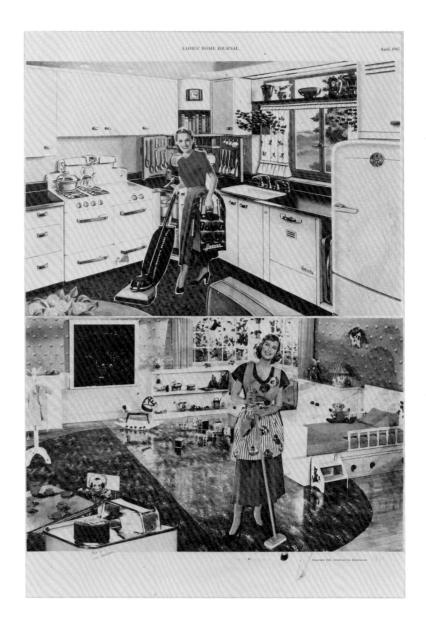

47.
MEET THE PEOPLE, about 1948
Collage on paper
14 ⅛ x 9 ½ in.
The Trustees of the Tate Gallery, London (U.S. only)

48.
IT'S A PSYCHOLOGICAL FACT PLEASURE HELPS YOUR DISPOSITION, dated 1948
Collage on paper
14 ¼ x 9 ⅝ in.
The Trustees of the Tate Gallery, London (ICA and IVAM only)

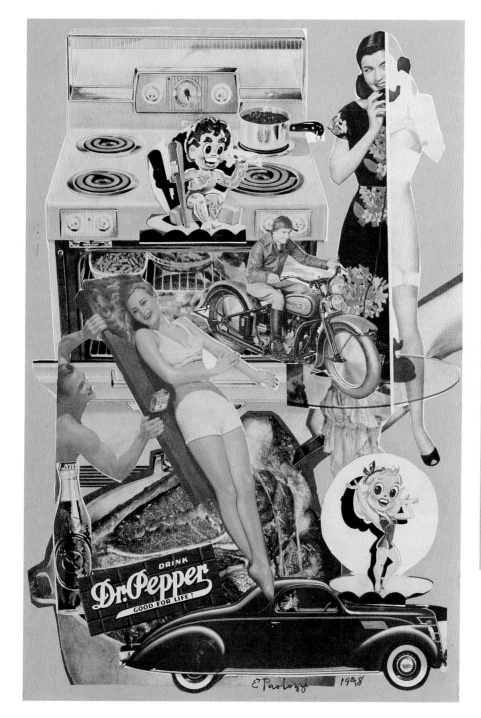

49.
DR. PEPPER, dated 1948
Collage on paper
14 ¼ x 9 ⅜ in.
Collection of the artist

50.
REAL GOLD, dated 1949
Collage on paper
11 x 16 in.
Collection of the artist

51.
ALIVE WITH INNOVATIONS, dated 1949
Collage on paper
9 x 13 ¾ in.
Collection of the artist

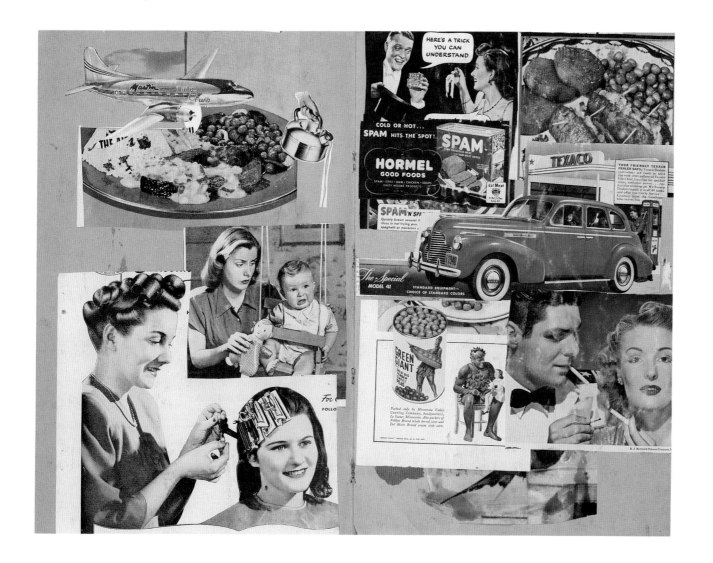

52.
PSYCHOLOGICAL ATLAS and four other scrapbooks, 1947–53
Collage
9 ⅛ x 6 ⅝ in. (Psy. Atlas)
By courtesy of the artist and the Trustees of the Victoria and Albert Museum, London

53.
REAL GOLD, about 1950
Collage on paper
14 x 9 ¼ in.
The Trustees of the Tate Gallery, London (ICA and IVAM only)

PAOLOZZI

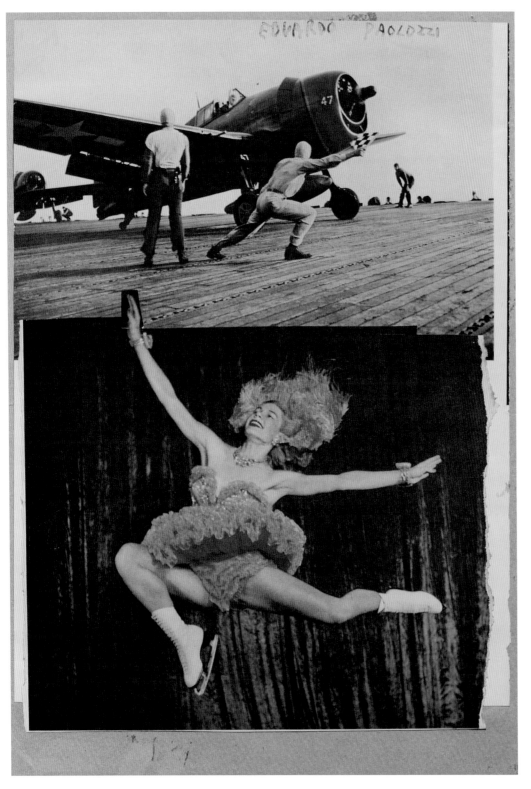

54.
TAKE OFF, about 1950
Collage on paper
13 ½ x 9 ½ in.
Collection of the artist

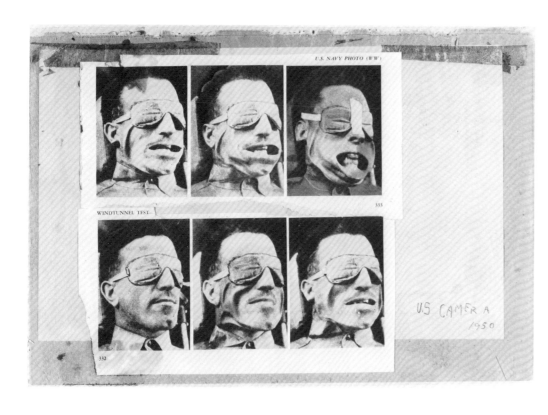

55.
<u>WINDTUNNEL TEST</u>, dated 1950
Collage on paper
14 ⅜ x 9 ¾ in.
The Trustees of the Tate Gallery, London (U.S. only)

56.
<u>YOURS TILL THE BOYS COME HOME</u>, about 1951
Collage on paper
14 x 9 ¾ in.
The Trustees of the Tate Gallery, London (ICA and IVAM only)

PAOLOZZI

57.
FROM MASS MERCHANDISING, PROFIT FOR THE MASSES, dated 1950
Collage, gouache, ink, pencil on paper
14 x 9 in.
Collection of the artist

58.
THE ULTIMATE PLANET, about 1952
Collage on paper
9 ⅞ x 15 in.
The Trustees of the Tate Gallery, London (U.S. only)

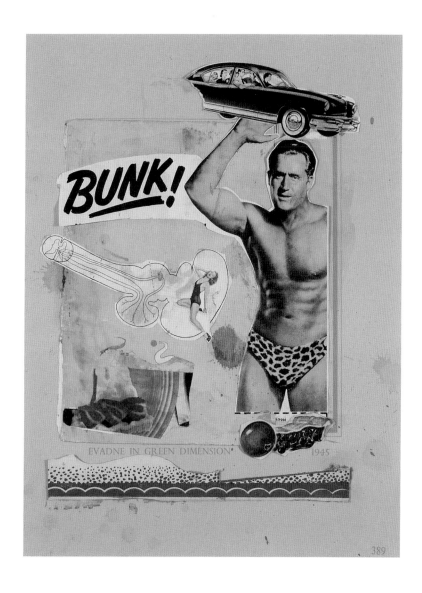

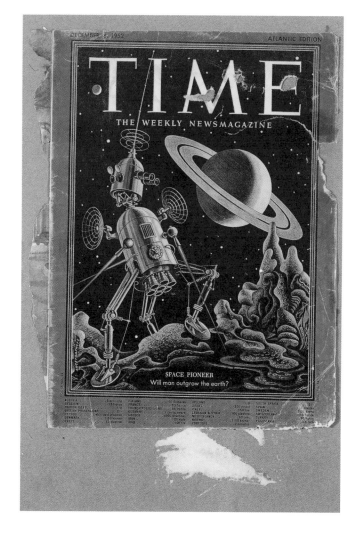

59.
<u>EVADNE IN GREEN DIMENSION</u>, about 1952
Collage on paper
12 x 8 ¾ in.
The Trustees of the Victoria and Albert Museum, London

60.
<u>WILL MAN OUTGROW THE EARTH</u>, about 1952
Collage on paper
12 ½ x 9 ½ in.
The Trustees of the Victoria and Albert Museum, London

PAOLOZZI

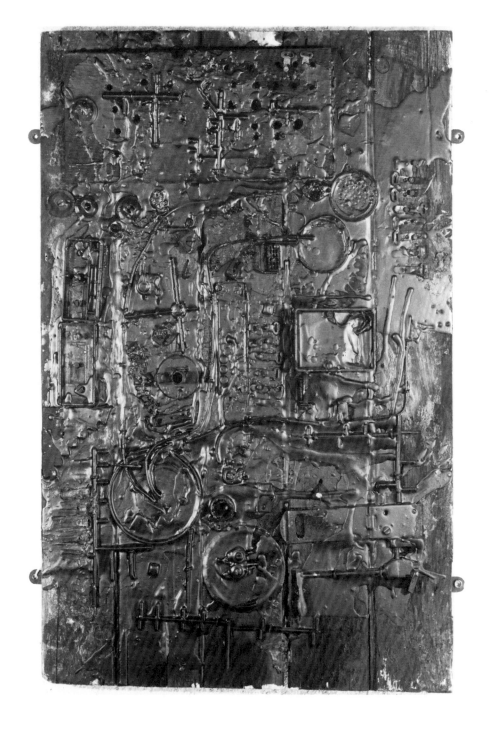

61.
<u>CONTEMPLATIVE OBJECT</u>, about 1951 (cast 1952)
Bronze, from plaster cast shown as part of Patio and
Pavilion exhibit in <u>This Is Tomorrow</u>
10 x 19 ½ x 10 in.
Colin St. John Wilson, Cambridge

62.
<u>RELIEF</u>, 1953–54
Wax, wood, nails, found objects
31 x 20 ⅜ x 1 ½ in.
Colin St. John Wilson, Cambridge

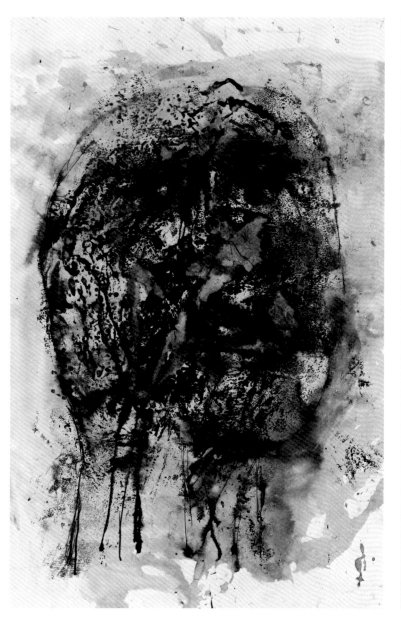

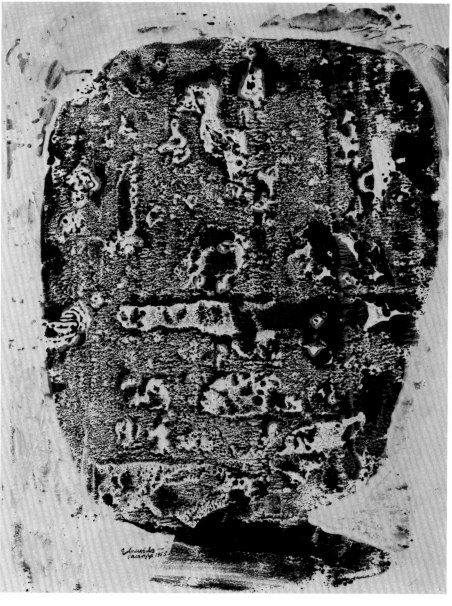

63.
HEAD (2), 1953
Collage, ink, and oil on paper
21 ½ x 14 ¼ in.
The British Council, London

64.
HEAD (3), 1953
Monotype; gouache on paper
22 x 17 in.
The British Council, London

PAOLOZZI

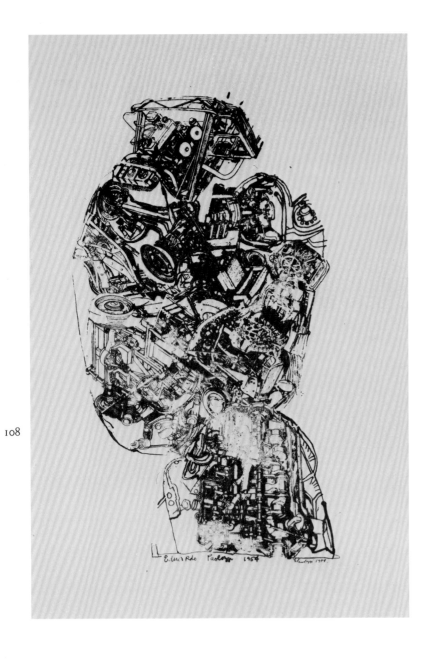

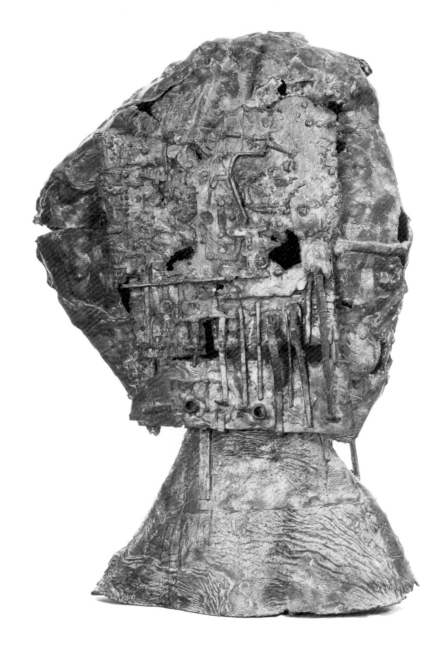

65.
AUTOMOBILE HEAD, 1954
Screenprint
18 x 13 in.
The British Council, London

66.
HEAD, 1957
Bronze
38 x 25 ¾ x 13 ½ in.
The University of Michigan Museum of Art, Gift of Dr. and Mrs. Barnett Malbin (U.S. only)

Alison and Peter Smithson

In 1950, soon after moving to London from Newcastle, Alison and Peter Smithson (b. 1928 and 1923, respectively) won the architectural competition for a school at Hunstanton, Norfolk. Completed in 1954, Hunstanton was quickly recognized as a masterpiece of modern architecture. In its respect for materials and clarity of structure and function, it constituted a rigorous critique of modernist formalism, despite being stylistically indebted to Mies's IIT buildings. Hunstanton placed the young architects in the foreground of British architecture. However, although the Smithsons achieved international prominence through their writings and projects of the 1950s, they were not to receive another major architectural

commission until the end of the decade. As they put it, ''permission to build was withheld.''

Using every available medium for expressing architectural ideas, the Smithsons proceeded to redefine the task of architecture in accordance with the needs of a society based on unprecedented mobility. Their entry for the Golden Lane housing competition of 1952 introduced the concept of mixed-use street decks into architectural thinking. It was accompanied by a now famous diagram of the city as a cluster pattern of roads, older elements, and interlinked streets-in-the-air, designed for ''ease of circulation and looseness of grouping'' (cat. no. 69). The Smithsons' use of anti-classical art sources at this time — Pollock's ''all-over'' composition, Dubuffet's city as texture, and the ''New Landscape'' scientific photography — indicates both the Brutalist direction of the works ahead and the intellectual range that equipped them to play a major role in the IG.[1] The new direction also reflects the personal and artistic influence of Nigel Henderson and Eduardo Paolozzi upon the Smithsons in the early 1950s. Partly because of them, the Smithsons took as their reference point the ''as found'' social and physical realities of London's working class streets, assisted by Judith and Nigel Henderson's understandings of their Bethnal Green neighborhood.

The period of this avant-garde engagement with the city coincided with the Smithsons' involvement in the Independent Group. (They recall it, in fact, as a continuation of discussions with friends and colleagues teaching at the Central School, including Henderson and Paolozzi.) For them, the IG was a laboratory for testing ideas, given the need for an aesthetic based on change rather than closure. In 1953 they took their ambitious, sociologically informed rethinking of architecture and dwelling

patterns into the international arena of CIAM (Congrès Internationaux d'Architecture Moderne), the Modern Movement's planning body. At the CIAM 9 meeting at Aix-en-Provence, the Smithsons presented Henderson's photographs of Bethnal Green street life. The real urban issue, they argued, was ''human association,'' in opposition to CIAM's Athens Charter (1933) with its mechanical division of the city into separate areas of housing, transport, industry, and recreation. Their CIAM Grille (cat. no. 71), with its ''urban reidentification'' theme emerging like the sun from the context of Henderson's photographs, represented the Smithsons' call for a more truly functional perspective. Instead of the four single-use zones, the Grille suggests interconnections between four scales of urban habitation — house, street, district and city. An international group of young architects joined the Smithsons in this challenge to the old guard. Meeting at Doorn, Holland in 1954 as ''Team 10,'' they planned the program for CIAM 10 in 1956, redefining the urbanist task in terms of the changing patterns of association within particular communities.

Parallel of Life and Art (1953), which the Smithsons organized in collaboration with Henderson and Paolozzi, called attention to the impact of an unprecedented range of images upon the cultural and physical landscape of the city, while challenging conventional aesthetics. The Smithsons' entry in the Sheffield University competition that same year became a paradigm of Brutalist architecture. Reyner Banham, defending ''The New Brutalism'' in his 1955 Architectural Review article (abridged in the ''Critical Writings'' section), emphasized the ''topological'' ingenuity of the Sheffield design, which linked the university to the city through a bold emphasis on the circulation patterns.

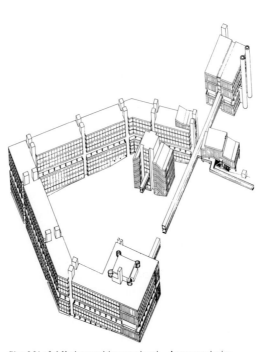

Sheffield University project. Axonometric
drawing by Alison Smithson, 1953.

In 1956 the Smithsons produced several uniquely significant works, each of which has been seen as entering into dialogue with the pop culture thrust of the 1955 series of IG meetings, whether it was intended so or not. In March 1956, as a contribution to the Daily Mail's Ideal Home Exhibition, they produced their remarkable House of the Future, with its imaginative design of the newest kitchen and home technology into a coherent vision (cat. no. 72). A patio—garden is wrapped by a variety of cave—like rooms, producing a continuous envelope of replaceable curved units. Banham, assuming that the House of the Future was based on the principles of car production much as he had discussed them in the Independent Group, saw it as an experiment in pop architecture. The Smithsons, however, regarded it as an original idea designed for and with a specific client. As in all their designs, they undertook the futurist project as an opportunity to rethink materials and methods. (The exhibition dwelling unit was molded in ''plastic impregnated fibrous plaster.''[2]) Sugden House, built that same year (1956), showed the Smithsons were equally innovative when using ''ordinary'' vernacular materials and methods. In retrospect, it appears that the Smithsons' radical designs of this period anticipated the freedoms of the 1960s more than they influenced anything else in the 1950s, when a ''taste-

ful'' toned—down modernism held sway.[3]

The elegant Patio and Pavilion exhibit for This Is Tomorrow (cat. no. 73), in which the Smithsons teamed once again with Henderson and Paolozzi, is discussed at several points in this catalogue. It is sometimes treated as a riposte to the ''crazy house'' of Hamilton, McHale and Voelcker. However, the garden shed and scattered relics of inhabitation reflect the ongoing centrality of the Bethnal Green back yard ''territory'' to the friendship and shared concerns of all four collaborators. For the Smithsons, the display also constituted an allegory of their preoccupation with the social patterns of dwelling from the early 1950s.

In November 1956, the Smithsons' famous essay on collecting ads (solicited by Roger Coleman for Ark) placed the mass media issues that had been raised by the Independent Group squarely within the tradition of the Modern Movement.[4] Quite rightly, the Smithsons used the essay to assume

responsibility as leaders of the third generation of modern architecture. However, the Smithsons did not assume the kind of public leadership that went with a fashionable style. As Banham suggested, this may have been the price they paid for their integrity as designers. ''Their stylistic development has been marked by complete and spectacular discontinuity,'' Banham observed. ''Such a result is inherent in their determination to approach every design problem from first principles and without formalistic preconceptions.''[5] From all accounts, the same fiercely independent spirit informed their participation in the Independent Group.

Among the buildings of particular note designed by the Smithsons since 1960 are the Economist Building in London (1960—64), the Robin Hood Lane housing in London (1964—70), the Garden Building at St. Hilda's College, Oxford (1967—70) and staff and arts buildings at the University of Bath (1979—81), where Peter Smithson is currently a professor at the School of Architecture and Building Engineering. The numerous writings of the Smithsons are best approached by starting with four books: Urban Structuring (1967, based on Uppercase 3, edited by Theo Crosby in 1961), which opens with the Henderson photographs and clarifies the urbanist concepts developed for Team 10; Ordinariness and Light (1970), which col-

Alison and Peter Smithson

In 1950, soon after moving to London from Newcastle, Alison and Peter Smithson (b. 1928 and 1923, respectively) won the architectural competition for a school at Hunstanton, Norfolk. Completed in 1954, Hunstanton was quickly recognized as a masterpiece of modern architecture. In its respect for materials and clarity of structure and function, it constituted a rigorous critique of modernist formalism, despite being stylistically indebted to Mies's IIT buildings. Hunstanton placed the young architects in the foreground of British architecture. However, although the Smithsons achieved international prominence through their writings and projects of the 1950s, they were not to receive another major architectural

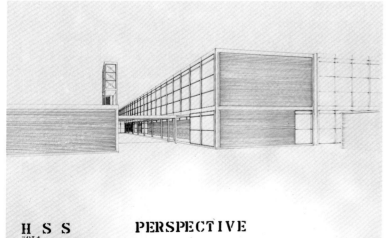

Peter Smithson. Perspective drawing of Hunstanton Secondary Modern School, 1950.

commission until the end of the decade. As they put it, ''permission to build was withheld.''

Using every available medium for expressing architectural ideas, the Smithsons proceeded to redefine the task of architecture in accordance with the needs of a society based on unprecedented mobility. Their entry for the Golden Lane housing competition of 1952 introduced the concept of mixed-use street decks into architectural thinking. It was accompanied by a now famous diagram of the city as a cluster pattern of roads, older elements, and interlinked streets-in-the-air, designed for ''ease of circulation and looseness of grouping'' (cat. no. 69). The Smithsons' use of anti-classical art sources at this time — Pollock's ''all-over'' composition, Dubuffet's city as texture, and the ''New Landscape'' scientific photography — indicates both the Brutalist direction of the works ahead and the intellectual range that equipped them to play a major role in the IG.[1] The new direction also reflects the personal and artistic influence of Nigel Henderson and Eduardo Paolozzi upon the Smithsons in the early 1950s. Partly because of them, the Smithsons took as their reference point the ''as found'' social and physical realities of London's working class streets, assisted by Judith and Nigel Henderson's understandings of their Bethnal Green neighborhood.

The period of this avant-garde engagement with the city coincided with the Smithsons' involvement in the Independent Group. (They recall it, in fact, as a continuation of discussions with friends and colleagues teaching at the Central School, including Henderson and Paolozzi.) For them, the IG was a laboratory for testing ideas, given the need for an aesthetic based on change rather than closure. In 1953 they took their ambitious, sociologically informed rethinking of architecture and dwelling

patterns into the international arena of CIAM (Congrès Internationaux d'Architecture Moderne), the Modern Movement's planning body. At the CIAM 9 meeting at Aix-en-Provence, the Smithsons presented Henderson's photographs of Bethnal Green street life. The real urban issue, they argued, was ''human association,'' in opposition to CIAM's Athens Charter (1933) with its mechanical division of the city into separate areas of housing, transport, industry, and recreation. Their CIAM Grille (cat. no. 71), with its ''urban reidentification'' theme emerging like the sun from the context of Henderson's photographs, represented the Smithsons' call for a more truly functional perspective. Instead of the four single-use zones, the Grille suggests interconnections between four scales of urban habitation — house, street, district and city. An international group of young architects joined the Smithsons in this challenge to the old guard. Meeting at Doorn, Holland in 1954 as ''Team 10,'' they planned the program for CIAM 10 in 1956, redefining the urbanist task in terms of the changing patterns of association within particular communities.

Parallel of Life and Art (1953), which the Smithsons organized in collaboration with Henderson and Paolozzi, called attention to the impact of an unprecedented range of images upon the cultural and physical landscape of the city, while challenging conventional aesthetics. The Smithsons' entry in the Sheffield University competition that same year became a paradigm of Brutalist architecture. Reyner Banham, defending ''The New Brutalism'' in his 1955 Architectural Review article (abridged in the ''Critical Writings'' section), emphasized the ''topological'' ingenuity of the Sheffield design, which linked the university to the city through a bold emphasis on the circulation patterns.

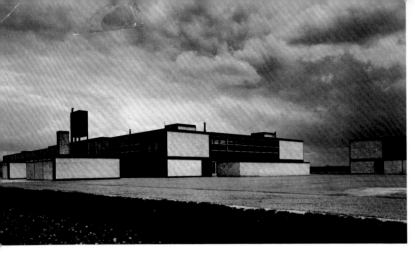

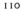
Hunstanton Secondary Modern School, completed 1954.

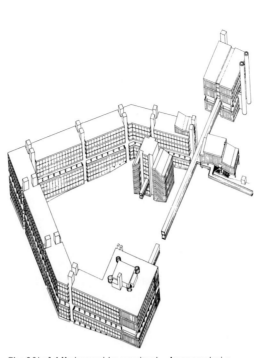

Sheffield University project. Axonometric drawing by Alison Smithson, 1953.

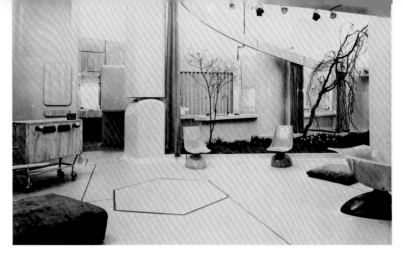

House of the Future, 1956. Living room (table in down position) with view of kitchen in back.

In 1956 the Smithsons produced several uniquely significant works, each of which has been seen as entering into dialogue with the pop culture thrust of the 1955 series of IG meetings, whether it was intended so or not. In March 1956, as a contribution to the Daily Mail's Ideal Home Exhibition, they produced their remarkable House of the Future, with its imaginative design of the newest kitchen and home technology into a coherent vision (cat. no. 72). A patio-garden is wrapped by a variety of cave-like rooms, producing a continuous envelope of replaceable curved units. Banham, assuming that the House of the Future was based on the principles of car production much as he had discussed them in the Independent Group, saw it as an experiment in pop architecture. The Smithsons, however, regarded it as an original idea designed for and with a specific client. As in all their designs, they undertook the futurist project as an opportunity to rethink materials and methods. (The exhibition dwelling unit was molded in ''plastic impregnated fibrous plaster.''[2]) Sugden House, built that same year (1956), showed the Smithsons were equally innovative when using ''ordinary'' vernacular materials and methods. In retrospect, it appears that the Smithsons' radical designs of this period anticipated the freedoms of the 1960s more than they influenced anything else in the 1950s, when a ''taste-

ful'' toned-down modernism held sway.[3]

The elegant Patio and Pavilion exhibit for This Is Tomorrow (cat. no. 73), in which the Smithsons teamed once again with Henderson and Paolozzi, is discussed at several points in this catalogue. It is sometimes treated as a riposte to the ''crazy house'' of Hamilton, McHale and Voelcker. However, the garden shed and scattered relics of inhabitation reflect the ongoing centrality of the Bethnal Green back yard ''territory'' to the friendship and shared concerns of all four collaborators. For the Smithsons, the display also constituted an allegory of their preoccupation with the social patterns of dwelling from the early 1950s.

In November 1956, the Smithsons' famous essay on collecting ads (solicited by Roger Coleman for Ark) placed the mass media issues that had been raised by the Independent Group squarely within the tradition of the Modern Movement.[4] Quite rightly, the Smithsons used the essay to assume

responsibility as leaders of the third generation of modern architecture. However, the Smithsons did not assume the kind of public leadership that went with a fashionable style. As Banham suggested, this may have been the price they paid for their integrity as designers. ''Their stylistic development has been marked by complete and spectacular discontinuity,'' Banham observed. ''Such a result is inherent in their determination to approach every design problem from first principles and without formalistic preconceptions.''[5] From all accounts, the same fiercely independent spirit informed their participation in the Independent Group.

Among the buildings of particular note designed by the Smithsons since 1960 are the Economist Building in London (1960–64), the Robin Hood Lane housing in London (1964–70), the Garden Building at St. Hilda's College, Oxford (1967–70) and staff and arts buildings at the University of Bath (1979–81), where Peter Smithson is currently a professor at the School of Architecture and Building Engineering. The numerous writings of the Smithsons are best approached by starting with four books: Urban Structuring (1967, based on Uppercase 3, edited by Theo Crosby in 1961), which opens with the Henderson photographs and clarifies the urbanist concepts developed for Team 10; Ordinariness and Light (1970), which col-

Sugden House, Wat-
ford, 1956.

lects key articles of the IG period and after; <u>Without Rhetoric</u> (1973), which explains the Smithsons' ideal of the calm city; and <u>The Shift</u> (1982), which charts the development of their archi-tecture, exhibitions and designs from Hunstanton on (it also includes a useful bibliography). Alison Smithson's novel, <u>Portrait of the Female Mind as a Young Girl</u>, was published by Chatto and Windus in 1966.

DAVID ROBBINS

1. For the Smithsons' formulation of the New Brutalism, see Alison and Peter Smithson, ''The New Brutalism,'' <u>Architectural Design</u>, 27 (April 1957), p. 113. See also Reyner Banham, ''The New Brutalism,'' <u>Architectural Review</u>, 118 (December 1955), pp. 355–361. (''Critical Writings'' contains a reprint of the former article and extracts from the latter.)
2. Alison and Peter Smithson, ''House of the Future at the Ideal Home Exhibition,'' <u>Architectural Design</u>, 26 (March 1956), p. 101.
3. See Nigel Whiteley, ''Arenas for Performance,'' <u>Art History</u>, 10 (March 1987), pp. 79–91.
4. Alison and Peter Smithson, ''But Today We Collect Ads,'' <u>Ark</u> 18 (November 1956), pp. 48–50. (See ''Critical Writings.'')
5. Reyner Banham, ''Apropos the Smithsons,'' <u>New Statesman</u>, 62 (8 September 1961), p. 317.

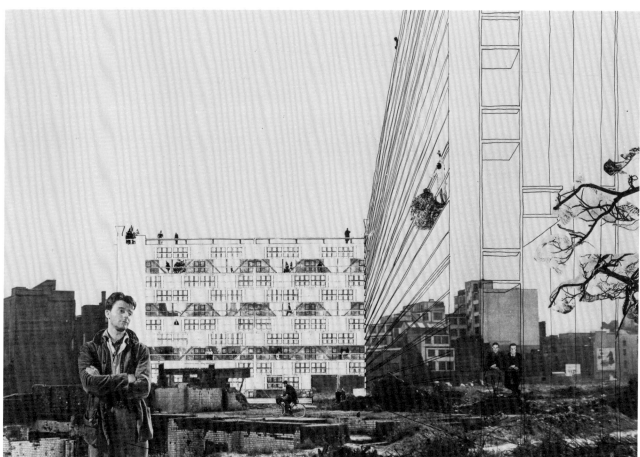

67.
<u>GOLDEN LANE</u>, 1952
Collage (P.S.); photographs, magazine cutouts, and pen on paper
17 ⅝ x 25 ½ in.
Alison and Peter Smithson, London

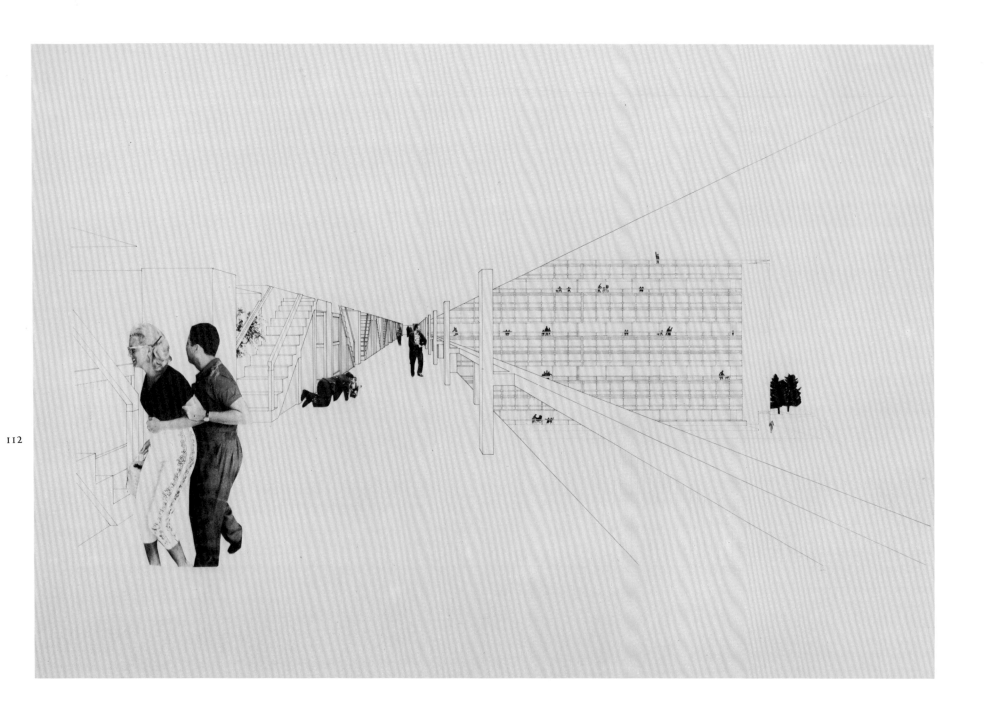

68.
GOLDEN LANE: STREET DECK, 1952–3
Collage (P.S.); rapidograph and magazine cutouts
(Marilyn Monroe and Joe DiMaggio) on paper
20 ½ x 38 ½ in.
Alison and Peter Smithson, London

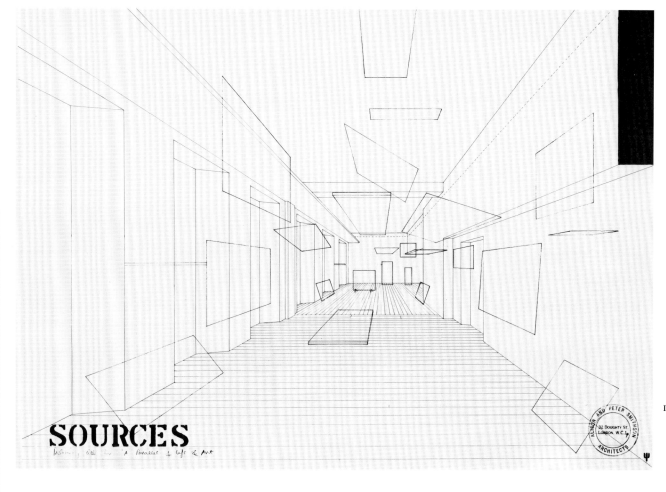

69.
GOLDEN LANE: THE CITY, 1952
Drawing (P.S.); ink on tracing paper
10 x 8 in.
Alison and Peter Smithson, London

70.
EXHIBITION PLAN FOR PARALLEL OF LIFE AND ART, 1953
Perspective drawing (P.S.); ink on tracing paper
22 x 33 in.
Alison and Peter Smithson, London

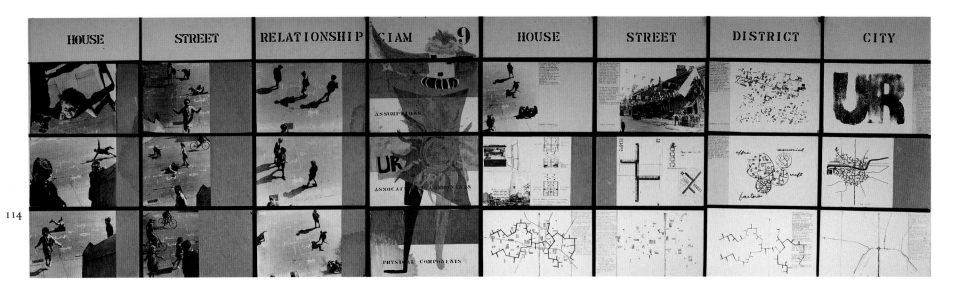

114

71.
CIAM GRILLE, 1953
Collage; photographs (by Nigel Henderson), ink, and stencil mounted on card and canvas
Eight panels, each 31 ½ x 13 in.
Alison and Peter Smithson, London

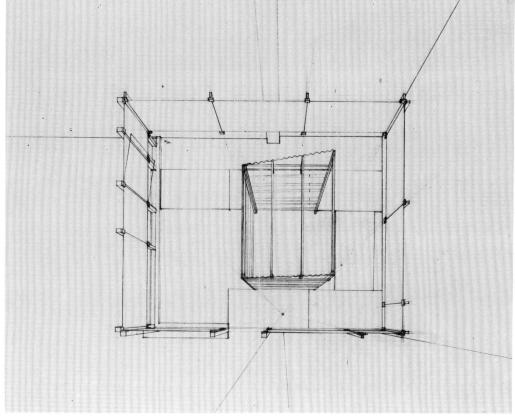

72.
<u>AXONOMETRIC DRAWING FOR THE HOUSE OF THE FUTURE</u>, 1956
Pencil and stencil on paper
38 x 30 in.
Alison and Peter Smithson, London

73.
<u>EXHIBITION DESIGN FOR PATIO AND PAVILION</u>, 1956
Drawing (P.S.); ink on tracing paper
13 x 26 in.
Alison and Peter Smithson, London

SMITHSON

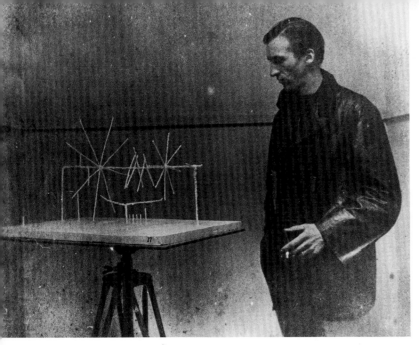

WILLIAM TURNBULL

After leaving school at the age of fifteen, William Turnbull (b. 1922) worked during the day to earn his living and attended art classes in the evening. In 1939 he was employed in his home town of Dundee in the illustration department of the publisher D. C. Thompson. This experience, together with his exposure to comics and magazines received from relatives in the United States, influenced his first contacts with modern art: he experienced it as he did the illustrations with which he was familiar, as a direct expression of form and content. As a result, he never approached art purely as a cognoscenti.

Turnbull's aspirations to become an artist were interrupted by the war, during which he served as a pilot in the RAF. In 1946 he enrolled at the Slade School of Art, where he met Nigel Henderson and Eduardo Paolozzi. All three displayed a healthy skepticism of the Slade. In 1947 Turnbull visited Paris, settling there the following year. Besides visiting Brancusi, Léger, and Giacometti, Turnbull also went to Parisian ciné clubs, the Musée de l'Homme, Dubuffet's Foyer de l'Art Brut and, like Paolozzi who was also in Paris at this time, he collected a diverse range of images from magazines.

In January 1950, Turnbull returned to London for his first one-person show at the Hanover Gallery. After a further eight months in Paris, he settled in London, exhibiting at the ICA in December 1950 and again at the Hanover in January 1952. Later that year he was represented in the British Pavilion at the Venice Biennale.

Although always receptive to a diverse range of stimuli, Turnbull's painting and sculpture does not display the overt interest in manufactured objects and advertising found in Richard Hamilton's work, nor the references to consumables, machinery, and science fiction which can be recognized in Eduardo Paolozzi's sculpture or John McHale's paintings and collages. Indeed, scrutiny of Turnbull's work might lead one to suspect that he was merely a fellow-traveler in the IG. The opposite, however, was the case. Turnbull was a central figure in the discussions and activities of the Group.

Turnbull was a familiar figure at the ICA, not only for having exhibited there in Aspects of British Art (1950) and Young Sculptors (1952), but as a frequent participant at informal discussions. When Richard Lannoy, under the auspices of the ICA's director, Dorothy Morland, was planning to formalize the spontaneous meetings, it was Turnbull he sounded out as to the viability of such an enterprise.[1] Toward the end of 1952, Reyner Banham began to convene the IG, and Turnbull was actively involved. He contributed to the ICA's public lecture series called ''Aesthetic Problems of Contemporary Art,'' organized by the IG in 1953. His talk was entitled ''New Concepts of Space,'' and he recalled:

There were no formal notes for it, just headings — it was about the way space affects works of art, and how it's used differently in different places at different times. For instance, the space of a cave painting is different from the formal, organised hieratic space of an Egyptian painting.[2]

Although Turnbull did not make a formal presentation at any of Alloway's and McHale's reconvened meetings of the IG at the beginning of 1955, he doubtless attended at least some of those gatherings. His friendship with both conveners, especially Alloway (with whom he made numerous trips to the cinema) must have kept him in close contact with IG dialogue. Even after the end of the IG meetings convened by Alloway and McHale, Turnbull talked at an IG gathering about his basic pictorial design course at the Central School of Art.

Turnbull has always been of the opinion that art is not necessarily regenerated from art but can be synthesized equally well from life. His work is thus a confluence of many references from both inside and outside the IG. Some of these references were to be found on the walls of his studio in the mid-1950s — a collage of imagery arranged without hierarchical controls, where a reproduction of a Modigliani nude was juxtaposed with images of a jellyfish, an African mask, Marilyn Monroe, Arthur Miller, and a scene from Rashomon (figs. 1–2). Similarly, discussing his early work, he recalls drawing upon a remarkably disparate range of examples of movement, including

the random movement of pin-ball machines, billiards . . . and ball games of this sort . . . the predictable movement of machines . . . movements in different planes at different speeds . . . Fish in tanks hanging in space and moving in shoals.

The movement of lobsters . . . a
diabolo.''[3]

Some of these references underlie the
sculpture Horse (1950; cat. no. 74),
which also shows affinities with Klee
and Giacometti, abstract concerns for
form and space, and an egalitarian dis-
persal of articulated parts. With Mask
and Head (cat. nos. 75, 76, 77), Turn-
bull shows a balance of feeling for mass
and elementary volumes, for making
marks on a surface, and for the material
itself. Although the references are
fully absorbed into the works, one can
detect the influence of tribal art, nat-
ural forms, Picasso, Dada, Oriental
philosophy, and much more. The Mask
series (cat. no. 75) was an ''attempt to
fix that which is maybe most continu-
ously fleeting and mobile — the expres-
sion on a face.''[4] Heads was ''a format
that could carry different loadings.
Almost anything could be a head — and a
head almost anything — given the slight-
est clue to the decoding.''[4] Both sug-
gested landscape formations, offering a
continuous, undulating surface that
might be explored by touch, by an insect
crawling across the surface, by a fiber
optic, or by the naked eye. Head (Drum)
and Head 2 are dramatically separated
from the body, elementary volumes lying
anonymously on their sides. Like the
sculptures, the painting Head (cat. no.
79) is a sign for a head; it might be
Dubuffet, Pollock, calligraphy,
spores, or the shattered face of a
robot, its wiring spilling out. Specif-
ically, of course, it is none of these
things.

In 1956 the sculptured head was
attached to an upright form to create
Sungazer, a piece that appeared in This
Is Tomorrow (cat. no. 78). The head now
has a ''body'' and the reference is per-
haps more figurative, but this does not
make the origins of the work any less
numerous and diverse, or any less syn-
thesized. Compare the ''drumhead''

and ''body'' of Ancestral Totem (1956;
fig. 3).

Even before the Independent
Group, Turnbull was referring to multi-
farious sources for his work. Perhaps as
much as Paolozzi, he fed the Group's
appetite for a non-hierarchy of imag-
ery, an aesthetic related to the collage
and the tackboard, to leafing through a
magazine or visiting an art gallery, an
aquarium, a cinema and a billiard hall,
without thinking one should be any less
or any more a source of inspiration than
the other. Perhaps more than any other
artist associated with the IG, Turnbull
ranged the fine art–popular art contin-
uum and even beyond, but he so immersed
his references in works that emphasized
an integral, self-sufficient unit, the
initial sources were buried. Underlying
this process of creation is the philoso-
phy that ''a work's reality always mat-
ters more than the headings under which
it is discussed.''[5] Although this sug-
gests that it may be fruitless to
attempt to connect Turnbull's work with
specific IG concerns, the fundamental
pluralism, variety of provenance, and
level of receptivity inherent in it is
characteristic of the Independent
Group.

Graham Whitham

1. Richard Lannoy, letter to the author, 1
August 1982.
2. William Turnbull, conversation with the
author, 23 February 1983.
3. William Turnbull, letter to the Tate Gal-

Figs. 1–2.
Media images on wall of William Turnbull's studio in mid-1950's

lery, 7 June 1967; quoted by Richard Morphet,
''Commentary,'' in William Turnbull: Sculp-
ture and Painting, exh. cat. (London, Tate Gal-
lery, 1973), p. 26.
4. William Turnbull, statements in Uppercase,
no. 4 (1961), unpaginated.
5. Richard Morphet, in William Turnbull, p. 50.

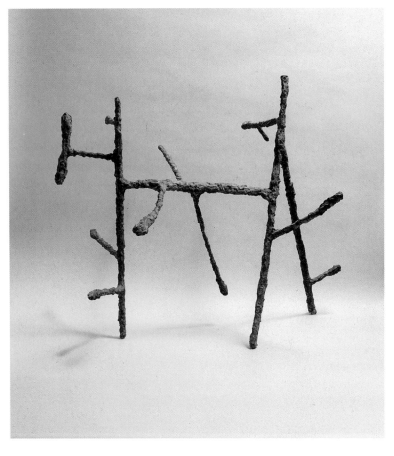

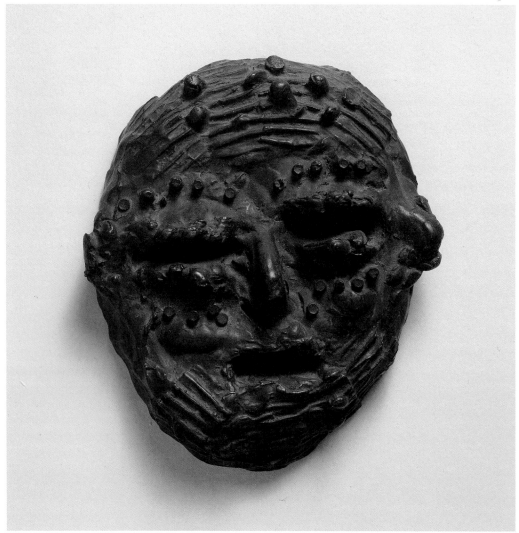

74.
HORSE, 1950
Bronze
31 x 36 ½ x 24 ½ in.
Waddington Galleries, London

75.
MASK, 2, 1953
Bronze
10 ¾ x 9 ½ x 2 ¾ in.
J. Turnbull, London

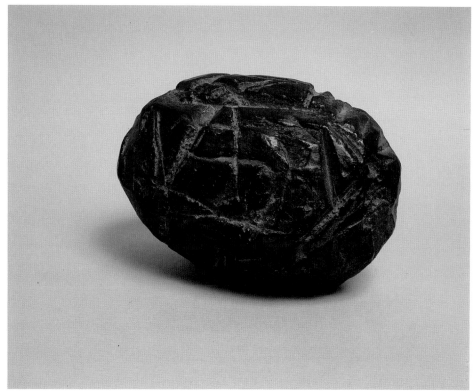

76.
HEAD (DRUM), 1955
Bronze (edition of 2)
12 ½ diameter x 25 in.
A. Turnbull, London

77.
HEAD 2, 1955
Bronze (edition of 2)
5 x 5 ½ x 8 in.
Collection of the artist

TURNBULL

78.
SUNGAZER, 1956/1989
Plaster cast from a bronze cast of
the plaster (shown here) made for the Group One
display in This Is Tomorrow
60 x 23 x 15 in.
Authorized and supervised by the artist

Fig. 3.
ANCESTRAL TOTEM, 1956
Bronze
73½ x 17 x 29 in.
Private Collection

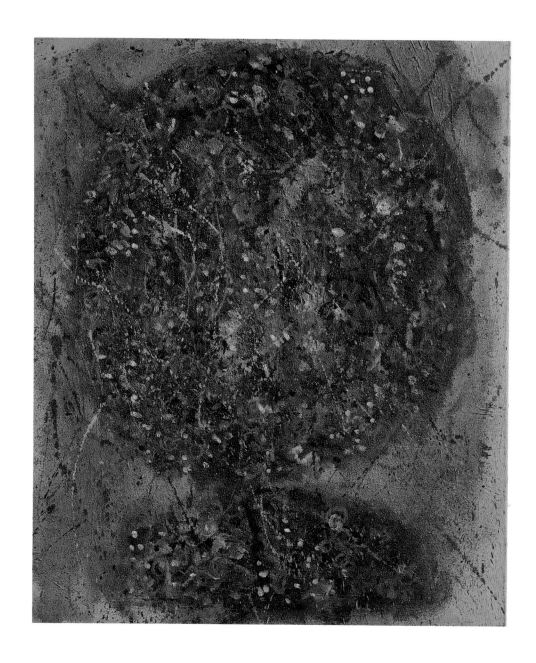

79.
HEAD, 1955
Oil on canvas
30 x 25 in.
Waddington Galleries, London

80.
HEAD, 1956
Screenprint
30 x 22 in.
The Trustees of the Tate Gallery
(Photo not available)

TURNBULL

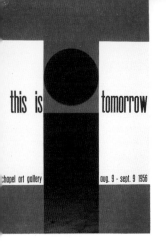

Group One. Designed by
Theo Crosby.
Letterpress.

Group Six. Designed by
Nigel Henderson.
Screen print. (Left to
right: Peter Smithson,
Eduardo Paolozzi,
Alison Smithson, Nigel
Henderson.)

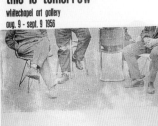

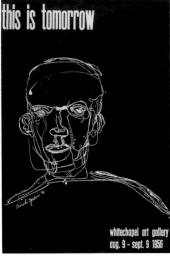

Group Seven. Designed
by Victor Pasmore.
Screen print.

Group Four. Designed
by Sarah Jackson.
Photoprint.

GROUP POSTERS FOR THIS IS TOMORROW

There are no ''Independent Group exhibi-
tions,'' only IG—related exhibitions by one or
more IG members, with diverse goals. These
posters (each about 30 by 20 inches, loaned by
Theo Crosby) were among those produced for This
Is Tomorrow by each of the participating
groups. The two that were entirely produced by
IG members — Richard Hamilton's ''pop'' living
room for Group Two and Nigel Henderson's Group
Six portrait — typify their different
approaches to urban culture. The other posters
illustrate the range of aesthetic tendencies
that vied for attention in This Is Tomorrow.

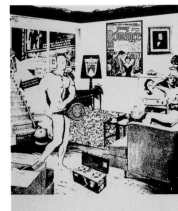

Group Two. Designed by
Richard Hamilton.
Screen print, ''using
a collage of photo-
graphic symbols of our
time'' (Crosby).

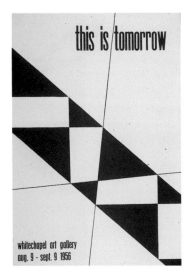

Group Five. Designed
by John Ernest.
Dyeline print.

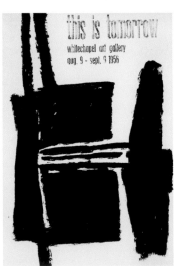

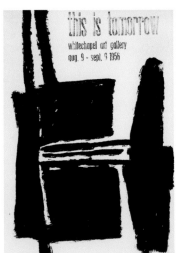

Group Three. Designed
by James Hull.
Photoprint.

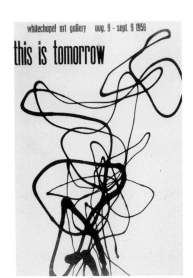

Group Three. Designed
by J.D.H. Catleugh.
Screen print.

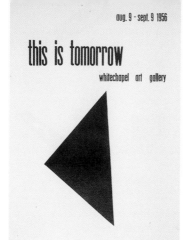

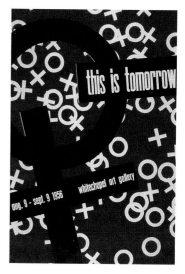

Group Nine. Designed
by Kenneth Martin.
Screen print.

Group Eight. Designed
by Richard Matthews.
Screen print.

Exhibitions by Graham Whitham

Because the Independent Group was not a particularly homogeneous body, there never was an exhibition specifically identified with it. IG members who participated in exhibitions did so as individuals rather than as representatives of the Group.

Until recently, accounts of the IG have nearly always credited the entire group with the creation of such shows as *Parallel of Life and Art* (1953), *This Is Tomorrow* (1956), and sometimes even *Man, Machine and Motion* (1955). This must have been irksome to those who actually organized and participated in these shows. Alison and Peter Smithson have always denied that *Parallel of Life and Art* was anything other than an exhibition devised by themselves with Henderson and Paolozzi, and as such they emphasize its separateness from Independent Group discussions. *Man, Machine and Motion* was almost totally organized by Richard Hamilton, as was *an Exhibit* (1957), in some ways its "sister" show. The organizer and driving force behind *This Is Tomorrow* was Theo Crosby, a friend of many associated with the IG but never a "member" in the sense that he attended meetings with regularity.

There is some logic and value, nonetheless, in associating certain exhibitions with the IG, as long as the terms of the connection are understood. The IG rarely acted as an integrated entity and did not usually hold regular meetings. Probably the closest it came to this was early in 1955, when Alloway and McHale organized nine meetings in a relatively short space of time. Furthermore, the IG did not have a fixed membership or venue. In retrospect, then, the most tangible manifestations of the IG appear to have been the exhibitions organized by those who met, albeit irregularly, under that name.

The Independent Group was always the sum total of its members,

and although it is virtually impossible to determine what each person contributed and what each took away, the exhibitions discussed below embody attitudes and strategies that are rightly associated with the IG, chiefly because of their independence of concept and execution. *Parallel of Life and Art* and *Man, Machine and Motion*, for instance, usefully clarify the different perspectives their organizers brought to the IG discussions. The choice and treatment of photographic images – one broad and evocative, the other iconographically specified – reflect contrasting anti-art approaches to the "art and technics" relationship emphasized in the Smithsons' planning statement for *Parallel*. Moreover, as the Chronology indicates, there was an abundance of important exhibitions at this time, largely because of the ICA, with IG members (especially Hamilton, McHale, del Renzio, and Alloway) playing major roles in most of them. Thus ICA shows like *Opposing Forces* (1953) and *Collages and Objects* (1954) would constitute important reference points in any serious analysis of the IG's debates over aesthetic issues. However, they were not "IG-related" in the sense that the exhibitions discussed in this catalogue are. Each of the latter had an independently creative concept and design, and tended to function as a discourse or commentary within the world at large. *This Is Tomorrow* presents special problems, since both IG and non-IG people participated, and since such a bewildering, incoherent assemblage of displays was presented. How, for example, can we reconcile the McHale/ Hamilton/ Voelcker exhibit with that of Henderson/ Paolozzi/ Smithson? In fact, the differences clarify. Given its collective agreement that a more inclusive understanding of culture was needed, the Independent Group is best understood through its heterogeneity and conflicts. The integrity of individuals, or of small groups of individuals, was essential to its aims and achievements.

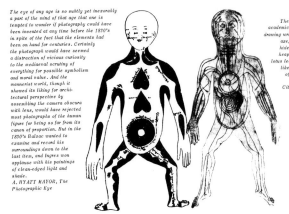

The eye of any age is so subtly yet inexorably a part of the mind of that age that one is tempted to wonder if photography could have been invented at any time before the 1850's in spite of the fact that the elements had been on hand for centuries. Certainly the photograph would have seemed a distraction of vicious curiosity to the mediaeval scrutiny of everything for possible symbolism and moral value. And the mannerist world, though it showed its liking for architectural perspective by assembling the camera obscura with a lens, would have rejected most photographs of the human figure for being so far from its canon of proportion. But in the 1850's Balzac wanted to examine and record his surroundings down to the last item, and Ingres won applause with his paintings of clean-edged light and shade.
A. HYATT MAYOR, The Photographic Eye

There are ten ways, say the Chinese academicians, of depicting a mountain: by drawing wrinkles like the slashes of a large axe, or wrinkles like hair on a cow's hide; by brushstrokes wrinkled like a heap of firewood, or like the veins of lotus leaves. The rest are to be wrinkled like the folds of a belt, or the twists of a rope; or like raindrops, or like convoluted clouds etc. Cited by Leo STEINBERG, The eye is part of the Mind.

Who shall criticise the builders? Certainly not those who have stood idly by without lifting a stone.
E. T. BELL, The Queen of Sciences.

One must be willing to dream and one must know how.
BAUDELAIRE

6

72

Catalogue for Parallel of Life and Art.

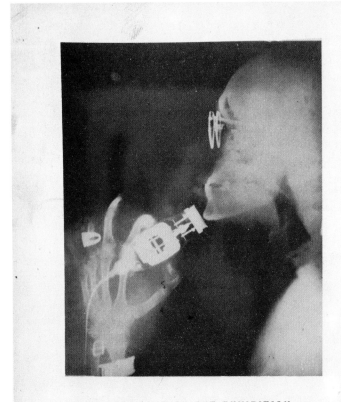

CATALOGUE OF THE EXHIBITION
Parallel of Life and Art
Held at the Institute of Contemporary Arts
September 11th to October 18th, 1953.

Parallel of Life and Art

Reviewing *Parallel of Life and Art*, Bryan Robertson wrote that it was a "beautiful and rewarding exhibition . . . [which] should be seen by everyone."[1] This was one of only a handful of positive reviews that accompanied the show. Generally there was the sort of criticism that is reserved for avant-garde manifestations, and it is not difficult to see why. Installation photographs of the exhibition record the ICA's gallery decked out with black and white photographs of various sizes, attached to and leaning against the walls, and suspended by wires from the ceiling. One wit advised: "Take your stilts; for some reason the greater part of the exhibition has been hung above head level."[2]

When, in March 1953, the exhibition *Wonder and Horror of the Human Head* had been staged in the ICA gallery, the evening activities – lectures, discussions, and recitals – were held at other venues, since the show took up all the space. Now, with *Parallel of Life and Art*, the problems for Dorothy Morland, the ICA's director, were too many to contemplate so soon after the previous disruption. Therefore, the exhibitors' system – mounting the photographs on cardboard and plugging them with brass eyelets at the corners so they could be suspended – had practical advantages. This sort of hanging also suited the exhibition very well, since it emphasized the apparent randomness of the imagery displayed and presented the photographs in a singularly fascinating way.

The organizers of *Parallel of Life and Art* were Alison and Peter Smithson, Nigel Henderson, and Eduardo Paolozzi. All except Alison Smithson had taught at the Central School of Art and all frequented the ICA. Largely as a result of their having met at these two venues, their friendship had grown.

Apparently, it was Paolozzi's suggestion to organize an exhibition.[3] The initial concept was no more than to "ferret about for some common

ground, some basic stand where [the exhibitors] felt a certain mutuality." They agreed to meet once a week and generally to "keep in touch and . . . throw material into the pool for general discussion, acclaim or rejection, and build up a sort of pool of imagery and maybe a spin-off of ideas really to see what happened – if anything more tangible and usable should take place."4 The choice of images was limited to those upon which all four organizers agreed, partly in order to keep the numbers of images to a manageable level.5

A proposal for the show was put to the ICA in April 1952. At this time the title was *Sources*; later it changed to *Documents '53*, and finally to *Parallel of Life and Art*. The ICA was reluctant to take it on; Jane Drew told the Management Committee that "some of the material [was] interesting, though rather incoherent."6 Paolozzi, more than anyone, urged the ICA to accept the show.7 This was not an easy task, but eventually the members of the committee agreed that if the costs of the exhibition were met, they would sanction it. By March 1953, financial guarantees had been obtained, largely through Ronald Jenkins, who had worked with the Smithsons on their Hunstanton Secondary School.

Parallel of Life and Art had its private view on 10 September 1953. (It closed on 18 October.) Nigel Henderson recalls the difficulty finding the right speaker for the opening: "We didn't want Herbert Read to open it, because he seemed automatically to be doing everything, and I think we had some fairly bumptious ideas. We wanted André Malraux, and somehow it was asking too much and we didn't have a second string. Ultimately, I was asked to invite Sir Francis Meynell, who most unwillingly agreed. He was getting a little old for controversy, I think, and this looked controversial. It was visual stuff, not quite his line. He agreed from sheer friendliness, really. That didn't come off, because he turned over his car on the morning he was coming to open the exhibition – so guess who opened it: Herbert Read."8

It is significant that all four organizers were "founding members" of the IG. Before Richard Lannoy's formalized meetings and before Banham's convenership, the Smithsons, Paolozzi, Henderson, and others had met at the ICA for discussions. In this way, similar ideas were fed into the IG and into *Parallel of Life and Art*. Many aspects of the show, in fact, were commensurate

with the general viewpoint of the Independent Group: the juxtaposition of imagery in a way that denied the hierarchy of one thing over another; the breaking down of boundaries between disciplines; and even the foldout, concertina catalogue, deliberately designed as a throwaway object that could be pinned on a board and then discarded when it was of no further interest.

It was always recognized that *Parallel* was a historically momentous exhibition, both because of its subversion of conventional humanist assumptions and because of its emphasis on "image" as an aesthetic and environmental category. Beyond this, however, interpretations have differed. In the 1976 discussions he organized for *Fathers of Pop*, Reyner Banham recalled *Parallel* as "a superinclusive collection of extraordinary imagery."9 Nigel Henderson agreed that it was "superinclusive" but not that the material was extraordinary. "I don't think we used any extraordinary imagery. It was all around. Quite a lot of it was from known art; some of it was from geology, micro-biology; you know, stuff which we now regard as quite commonplace."10

In fact, this disagreement recalls a tension inflecting contemporary interpretations of the show as aesthetic or referential, with the organizers favoring the latter aspect. In a "Statement of Purpose" that was not published at the time, Henderson, Paolozzi, and the Smithsons stressed the significance of the new technical developments in photography, which allowed the artist "to expand [his or her] field of vision beyond the limits imposed on previous generations."11

Banham, in his review of *Parallel of Life and Art* for the *Architectural Review*, also saw it as about photography, but with purely aesthetic consequences. Although the observer might indeed draw parallels, he argued, the controlling fact was the artificial connections between the images themselves: "The photograph, being an artefact, applies its own laws of artefaction to the material it documents, and discovers similarities and parallels between the documentations, even where none exist between the objects and events recorded."12 (See "Critical Writings" for an excerpt from this review.)

Both aesthetic and cognitive interests contributed to the excitement of *Parallel*, of course. Fortunately, the Smithsons have preserved the original

125

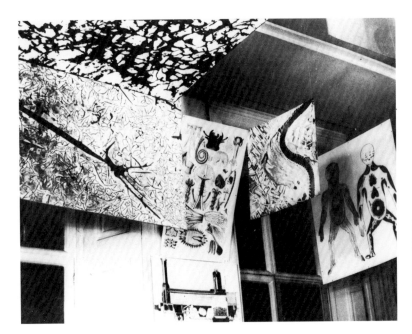

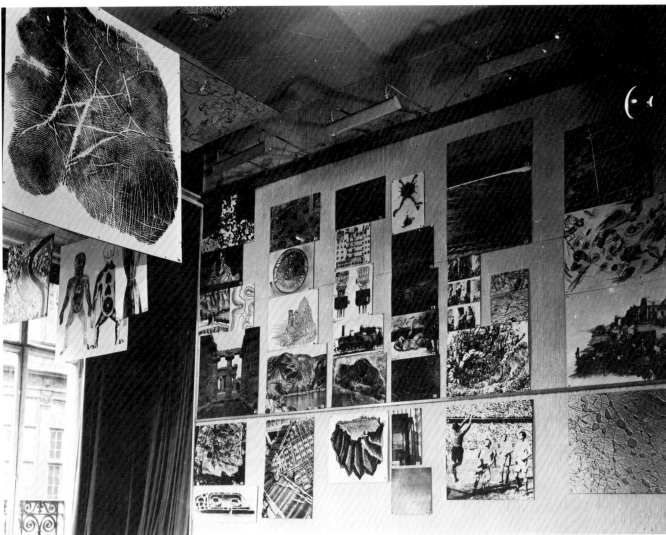

<u>Parallel of Life and Art</u>. Views of the installation at the Institute of Contemporary Arts. September–October 1953.

ground, some basic stand where [the exhibitors] felt a certain mutuality." They agreed to meet once a week and generally to "keep in touch and . . . throw material into the pool for general discussion, acclaim or rejection, and build up a sort of pool of imagery and maybe a spin-off of ideas really to see what happened – if anything more tangible and usable should take place."[4] The choice of images was limited to those upon which all four organizers agreed, partly in order to keep the numbers of images to a manageable level.[5]

A proposal for the show was put to the ICA in April 1952. At this time the title was *Sources*; later it changed to *Documents '53*, and finally to *Parallel of Life and Art*. The ICA was reluctant to take it on; Jane Drew told the Management Committee that "some of the material [was] interesting, though rather incoherent."[6] Paolozzi, more than anyone, urged the ICA to accept the show.[7] This was not an easy task, but eventually the members of the committee agreed that if the costs of the exhibition were met, they would sanction it. By March 1953, financial guarantees had been obtained, largely through Ronald Jenkins, who had worked with the Smithsons on their Hunstanton Secondary School.

Parallel of Life and Art had its private view on 10 September 1953. (It closed on 18 October.) Nigel Henderson recalls the difficulty finding the right speaker for the opening: "We didn't want Herbert Read to open it, because he seemed automatically to be doing everything, and I think we had some fairly bumptious ideas. We wanted André Malraux, and somehow it was asking too much and we didn't have a second string. Ultimately, I was asked to invite Sir Francis Meynell, who most unwillingly agreed. He was getting a little old for controversy, I think, and this looked controversial. It was visual stuff, not quite his line. He agreed from sheer friendliness, really. That didn't come off, because he turned over his car on the morning he was coming to open the exhibition – so guess who opened it: Herbert Read."[8]

It is significant that all four organizers were "founding members" of the IG. Before Richard Lannoy's formalized meetings and before Banham's convenership, the Smithsons, Paolozzi, Henderson, and others had met at the ICA for discussions. In this way, similar ideas were fed into the IG and into *Parallel of Life and Art*. Many aspects of the show, in fact, were commensurate

with the general viewpoint of the Independent Group: the juxtaposition of imagery in a way that denied the hierarchy of one thing over another; the breaking down of boundaries between disciplines; and even the foldout, concertina catalogue, deliberately designed as a throwaway object that could be pinned on a board and then discarded when it was of no further interest.

It was always recognized that *Parallel* was a historically momentous exhibition, both because of its subversion of conventional humanist assumptions and because of its emphasis on "image" as an aesthetic and environmental category. Beyond this, however, interpretations have differed. In the 1976 discussions he organized for *Fathers of Pop*, Reyner Banham recalled *Parallel* as "a superinclusive collection of extraordinary imagery."[9] Nigel Henderson agreed that it was "superinclusive" but not that the material was extraordinary. "I don't think we used any extraordinary imagery. It was all around. Quite a lot of it was from known art; some of it was from geology, micro-biology; you know, stuff which we now regard as quite commonplace."[10]

In fact, this disagreement recalls a tension inflecting contemporary interpretations of the show as aesthetic or referential, with the organizers favoring the latter aspect. In a "Statement of Purpose" that was not published at the time, Henderson, Paolozzi, and the Smithsons stressed the significance of the new technical developments in photography, which allowed the artist "to expand [his or her] field of vision beyond the limits imposed on previous generations."[11]

Banham, in his review of *Parallel of Life and Art* for the *Architectural Review*, also saw it as about photography, but with purely aesthetic consequences. Although the observer might indeed draw parallels, he argued, the controlling fact was the artificial connections between the images themselves: "The photograph, being an artefact, applies its own laws of artefaction to the material it documents, and discovers similarities and parallels between the documentations, even where none exist between the objects and events recorded."[12] (See "Critical Writings" for an excerpt from this review.)

Both aesthetic and cognitive interests contributed to the excitement of *Parallel*, of course. Fortunately, the Smithsons have preserved the original

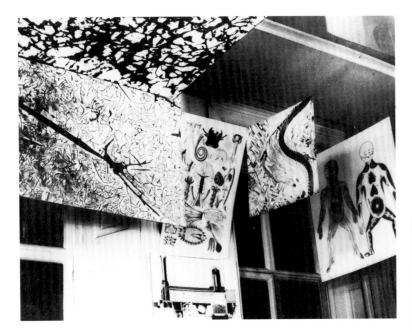

Parallel of Life and Art. Views of the
installation at the Institute of Contemporary
Arts. September–October 1953.

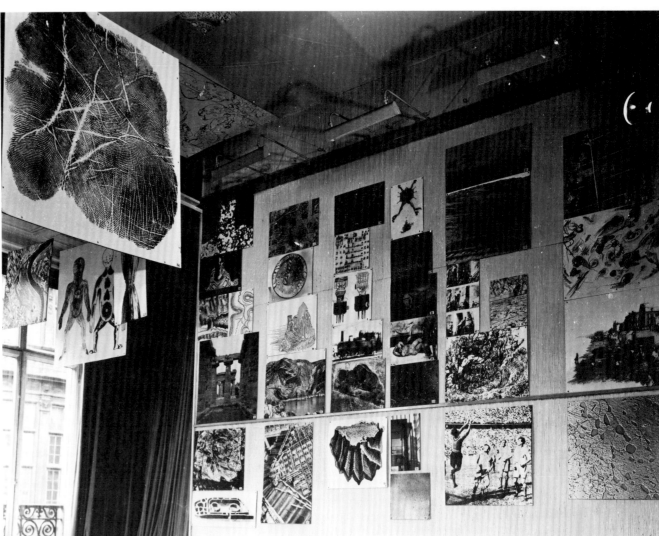

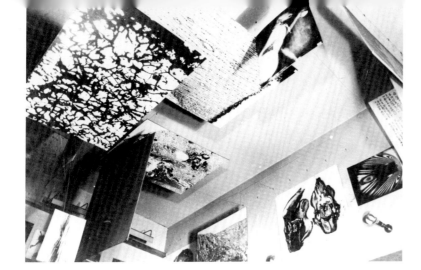

explanatory texts documenting the show's evolution, and their presentation of them closes this section. These texts indicate that in the process of planning an important shift in emphasis took place, from an initial presentation of avant-garde achievements in several fields (parallel manifestations of a creative awakening) to a photographic documentation of the encompassing realities of contemporary life, including images of major cultural developments.[13]

1. Bryan Robertson, "Parallel of Life and Art," Art News and Review, 5 (19 September 1953), p. 4.
2. Astragal, "Steam Photography," Architects' Journal, 118 (24 September 1953), p. 365.
3. Anne Seymour, "Notes towards a Chronology Based upon a Conversation with the Artist," in Nigel Henderson: Paintings, Collages and Photographs, exh. cat. (London, d'Offay Couper Gallery, 1977), unpaginated.
4. Nigel Henderson, conversation with Reyner Banham, 7 July 1976, recorded for Fathers of Pop (Arts Council of Great Britain, 1979); it was not used in the film.
5. Alison Smithson, conversation with the author, 21 April 1988.
6. Minutes, ICA Management Committee meeting, 14 January 1953, ICA archives.
7. Alison Smithson, telephone conversation with the author, 12 July 1988.
8. Nigel Henderson, interview by Dorothy Morland, 17 August 1976, ICA archives.
9. Reyner Banham, "Treatment for a 40 Minute 16mm film by Reyner Banham and Julian Cooper. Fathers of Pop (The Independent Group)," draft script, Arts Council of Great Britain, 1976, p. 6.
10. Nigel Henderson, Fathers of Pop conversation with Reyner Banham, 7 July 1976.
11. Reprinted in Diane Kirkpatrick, Eduardo Paolozzi (London, 1970), p. 19.
12. Reyner Banham, "Photography: Parallel of Life and Art," Architectural Review, 114 (October 1953), p. 260.
13. The following text is taken from Alison and Peter Smithson, "Asides to 'Thoughts on Exhibitions'," unpublished manuscript, Alison and Peter Smithson archive, pp. 6-9. The "manifesto" of 1952 appears in amplified form in Alison and Peter Smithson, Ordinariness and Light (Cambridge, Mass., 1970), p. 84.

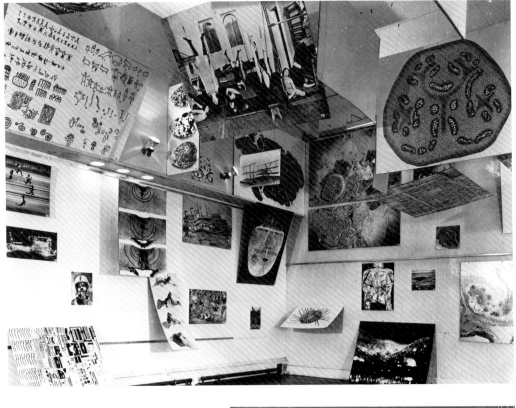

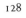

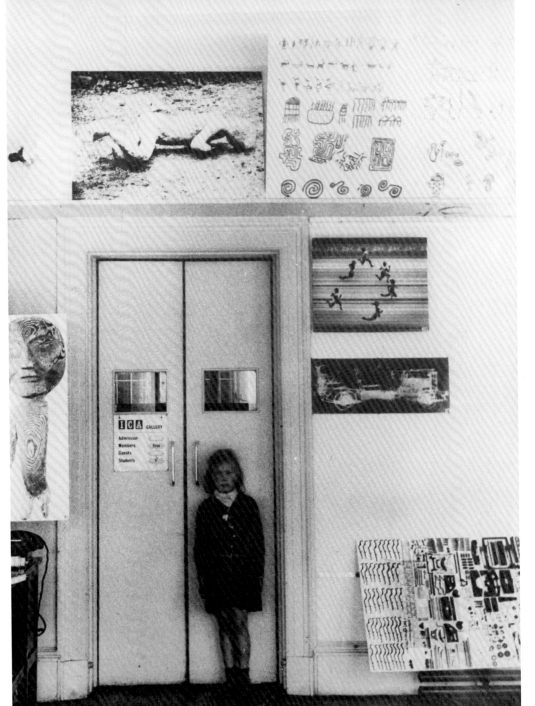

Cover of
Architectural
Review, October 1953,
showing Parallel of
Life and Art
photograph of Alaskan
Eskimo whalebone head
carving.

ADDENDUM: TEXTS DOCUMENTING THE DEVELOPMENT OF <u>PARALLEL OF</u>
<u>LIFE AND ART</u>, BY ALISON AND PETER SMITHSON

1. *Sources* (first name given), 1952:
By presenting phenomena from our various fields we can demonstrate the
existence of a new movement – classical – complex – human – a fundamental
outlook from common sources to future synthesis.

"This is a movement I call epiphany."
JAMES JOYCE: *Stephen Hero*: 1904-1906.
(Epiphany: "A reality behind the appearance.")
A. & P. S., Nigel Henderson, Eduardo Paolozzi.

2. *Documents '53* (title later altered to *Parallel of Life and Art*), 1953:
"Some evidence of a new attitude."

In 1952 the hard core of an idea for an exhibition was presented to the ICA by
Alison and Peter Smithson. (For which the Coventry Cathedral model was
made: exhibition not held.)
This took the form of a manifesto.

> *The first great creative period of modern architecture finished in 1929 and*
> *work subsequent to this can be regarded as exploratory work for the second*
> *great creative period beginning now.*
> *Both periods are characterised by simultaneous parallel development in archi-*
> *tecture – engineering – painting – sculpture: the attitudes, theorems, images,*
> *of each, finding unsought consonance in the others.*
> *In the '20s a work of art or a piece of architecture was a finite composition of*
> *simple elements: elements which have no separate identity but exist only in*
> *relation to the whole. The problem of the '50s is to retain the clarity and*
> *finiteness of the whole but to give the parts their own internal disciplines and*
> *complexities.*
> *The second great creative period should be proclaimed by an exhibition in*
> *which the juxtapositions of phenomena from our various fields would make*
> *obvious the existence of a new attitude. Our exhibition would present the open-*
> *ing phase of the movement of our time and record it as we see it now, as did*
> *the Esprit Nouveau Pavilion for 1925.*

As a result of this manifesto, an exhibition of documents, etc., – principally
photographs and diagrams – has been scheduled at the Institute of Contem-
porary Arts, 17 Dover Street, W1, from September 2nd to 27th, 1953.

> The editors of this material are:
> Nigel Henderson – photographer
> R. S. Jenkins – engineer
> E. Paolozzi – sculptor
> A. and P. Smithson – architects

The exhibition will present material belonging intimately to the background
of everyone today. Much of it has been so completely taken for granted as to
have sunk beneath the threshold of conscious perception. An introduction to
these visual by-products of our way of thinking will perhaps dispel the bewil-
derment people feel when confronted with the most recent manifestations of

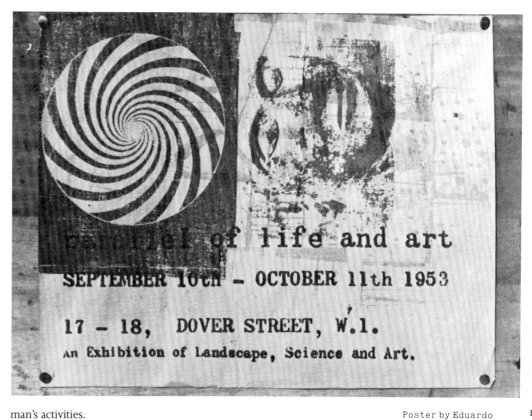

Poster by Eduardo
Paolozzi for <u>Parallel</u>
<u>of Life and Art</u>.

man's activities.

The exhibition will provide a key – a kind of Rosetta Stone – by
which the discoveries of the sciences and the arts can be seen as aspects of
the same whole, related phenomenon, parts of that New Landscape which
experimental science has revealed and artists and theorists created.

The method used will be to juxtapose photo-enlargements of those
images judged to be significant by the editors. These images cannot be so
arranged as to form a consecutive statement. Instead they will establish the
intricate series of cross relationships between different fields of art and tech-
nics. Touching off a wide range of association and offering fruitful analogies.

In sum they will provide an outline, a fugitive delineation of the fea-
tures of our time as they have appeared to one particular group working
together.

The material for the exhibition will be drawn from life – nature –
industry – building – the arts – and is being selected to show not so much
the appearance as the principle – the reality beneath the appearance – that is,
those images which sum up the significant development in each field since
1925 and contain within them the seeds of the future.

Man, Machine and Motion, Hatton Gallery,
Newcastle, May 1955.

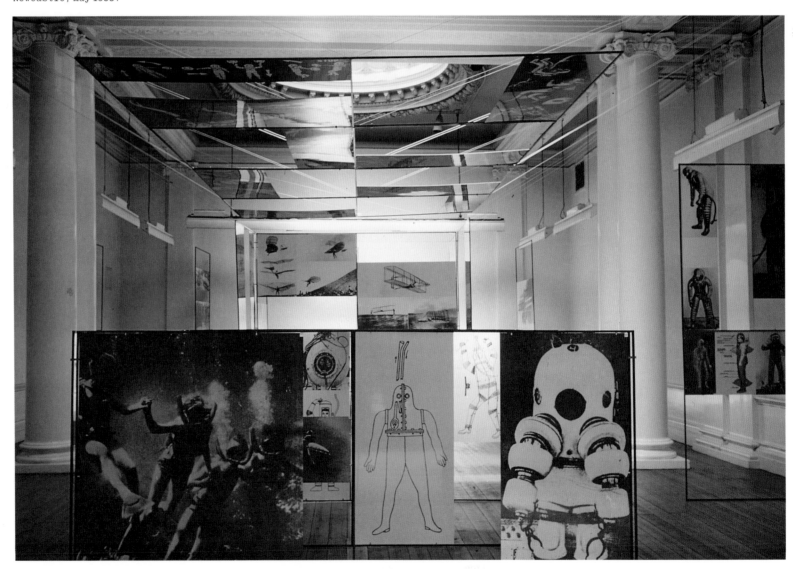

130

Man, Machine and Motion

In 1953, Richard Hamilton was appointed to teach in the fine art department at King's College, Durham University (later the University of Newcastle-upon-Tyne). One of his earliest projects there was to plan an exhibition whose theme was "a visual survey of man's relationship with the machinery of movement."[1]

This was not a particularly surprising idea, given the general direction of Hamilton's art at the time. Although his paintings and prints in the early fifties had been influenced by the imagery of natural forms, largely inspired by his *Growth and Form* show of 1951, in 1953 Hamilton had begun a series of works that were concerned with movement. These were directly inspired by Cubism, Futurism, Duchamp, and the photographs of Eadweard Muybridge. After the autumn of 1953, his experience of commuting between London and Newcastle inspired a series of paintings called *Trainsition*, where the spectator's viewpoint is from a moving train. The depiction of movement here implies the movement of the spectator as well, which earlier work, such as *Man Walking (after Muybridge)*, does not. Furthermore, the imagery of the *Trainsition* paintings is that of technology, specifically machines of motion – the train and the automobile. Hamilton was no stranger to technology. His wartime occupation as a jig and tool designer, his reading of Sigfried Giedion's *Mechanization Takes Command*, and the subsequent series of *Reaper* etchings, provided a background for this type of imagery. But in 1954, the further influence of classic Hollywood movie car/train chases and his own experiences of traveling led him to consider the theme of "man's relationship with the machinery of movement."

While Hamilton was collecting material on this topic, it was not at all certain that an exhibition would emerge. Lawrence Gowing, then a professor of fine art at Durham University, was supportive of Hamilton's proposed show but unable to guarantee adequate funds, even though the university had its own exhibition space in the Hatton Gallery and Hamilton had connections with the ICA as a designer of many of its shows. In March 1954, Hamilton proposed that the exhibition be held at the ICA as well as at Newcastle; four months later the ICA Management Committee discussed the possibility. Peter Gregory, a committee member, said that having seen the material he "did not think it would attract a large public," but Roland Penrose noted that "it was the kind of exhibition the ICA should show, but should not risk losing money on."[2]

Initially the proposal bore the cumbersome title "Human Motion in Relation to Adative Appliances," but by the time Hamilton had maneuvered his way through the vagaries of finance the exhibition had taken on the more euphonious title *Man, Machine and Motion*. In May 1955, it opened at the Hatton Gallery and two months later it was shown at the ICA.

Man, Machine and Motion contained 223 photographs or photographic copies of drawings illustrating "the mechanical conquest of time and distance [through] the structures which man has created to extend his powers of locomotion, and to explore regions of Nature previously denied to him."[3] These

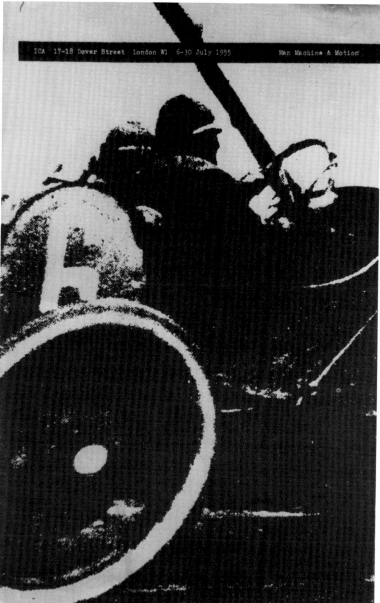

Man, Machine and Motion. Cover of catalogue, designed by Anthony Froshaug.

Terry Hamilton at Man, Machine and Motion.

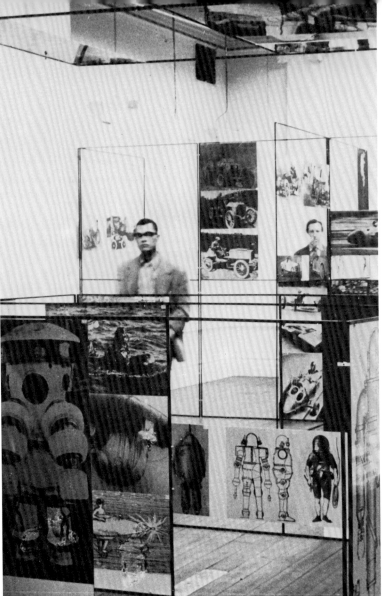

Man, Machine and Motion. View of the
installation. Richard Hamilton
at right.

images were mounted on Formica sheets of various sizes, each designed to fit into a series of elegant, open steel frames measuring eight by four feet. This allowed the exhibition to be easily stacked for storage and transportation; it made possible an almost infinite variety of arrangement; and it gave the show a uniformity of display.

Hamilton arranged the imagery into four distinct areas: aerial, aquatic, interplanetary, and terrestrial. The frames and panels were then symbolically placed to represent these areas: space-travel images were suspended from the ceiling, aircraft displayed four feet off the floor, underwater imagery set on the floor, and so on.

Inevitably, there is a comparison to be made with the earlier ICA exhibition of photographic imagery, *Parallel of Life and Art*, not only because the same medium was used for each, but also because the organizers of the two shows were stalwarts of the Independent Group. The "modular grid describing a very sophisticated spatial articulation" of *Man, Machine and Motion* and "the images . . . chosen within a rigorously defined set of parameters announced in the title"[4] appear to be at odds with *Parallel of Life and Art*, however. The less symmetrical display of the latter was endowed with a randomness that was foreign to *Man, Machine and Motion*, and the imagery in the earlier show was more diverse. Indeed, Hamilton's imagery was in one sense so limited that a critic commented wittily on it: "It contains enough aircraft of the strut and string variety and motor-cars of the milk-float epoch to have all the architecture teddy-boys in there in force, and enough space-fiction and aqua-lung pictures to have Astragal muttering, 'Technology, you gorgeous beast.'"[5]

The images chosen by Hamilton spanned a long historical period (to as far back as 1200 BC), but the majority were from recent times. In a review of the exhibition, Reyner Banham explained:

> The basis of selection of the material exhibited was that each image should show a motion-machine, or similar piece of equipment, and a recognisable man. Photographic images were preferred since photography is more or less coeval with mechanised transport and belongs to the same technological environment, but this rule has not been rigidly followed to the exclusion of patent-drawings or space-fiction illustrations.
>
> Nevertheless the preference for photography, and the insistence on the recognisable and visible presence of man, sets definite limits on the material shown. There are very few images from the pre-photographic era, but the oldest known photograph of a self-propelled vehicle is included, Boydell's steam tractor of 1857, and this date marks the effective beginning of this picture history of transport. Present-day tendencies toward saloon bodies and pressure cabins have tended to make travellers and explorers invisible to the photographer, and for this reason the coverage tends to narrow toward the fifties, leaving the show broadest, thickest and richest in the period 1890-1920.[6]

The technological inclination of the exhibition, most marked in the imagery, system of display, and medium (the photograph), was enhanced by the catalogue. As well as the introduction, jointly signed by Hamilton and Lawrence Gowing,[7] there was a commentary that took the form of technical notes by Reyner Banham. In a contemporary review, Toni del Renzio applauded the content of the catalogue but decried the design:

> New techniques are employed, a post-Baconian attitude to the aesthetics of news-photography carefully exploited, but an arty, 'Mittel-Europa' 'New Typography' gives it a self-conscious, would-be-modern look with type much too small for comfortable reading. And this is a pity, because there's a lot written in it that demands the closest attention.[8]

If *Parallel of Life and Art* embodied some of the pervading attitudes of the IG in 1953, then *Man, Machine and Motion* reflected them two years later. At the time when Henderson, Paolozzi, and the Smithsons had been especially conspicuous among those younger members who asserted their independence from much that the ICA stood for, the tenor of their gatherings was informed by a freewheeling, multi-referential iconoclasm. By 1955, certain issues had been promoted above others, largely as a result of the leading roles taken by Banham, Alloway, McHale, and Hamilton himself in the IG. Banham seems to have exerted a particular influence on Hamilton at this stage, chiefly through his concern with technology. Only four months before *Man, Machine and Motion* opened at the ICA, he spoke on American car styling at one of the IG's more formal meetings,[9] and on the day the show opened to the public, he delivered a lecture to the general ICA audience called "Metal in Motion" – a version of his IG talk. No doubt Lawrence Alloway, who had just been appointed assistant director of the ICA, recognized the close affinity and scheduled Banham's lecture to coincide with the opening of Hamilton's exhibition.

1. Invitation card to the private viewing of Man, Machine and Motion, Institute of Contemporary Arts, 6 July 1955, ICA archives.

2. Minutes, ICA Management Committee meeting, 6 July 1954, ICA archives.

3. Press release for Man, Machine and Motion, 23 June 1955, ICA archives.

4. Toni del Renzio, "Slipping it to us – Richard Hamilton in den 50er und 60er Jahren" in Richard Hamilton: Sources – Studien 1937-1977, exh. cat. (Kunsthalle Bielefeld, 1978), p. 82. Text in German. Translation by Toni del Renzio.

5. Astragal, Architects' Journal, 122 (14 July 1955), p. 37.

6. Reyner Banham, "Man, Machine and Motion," Architectural Review 118 (July 1955), pp. 51-52.

7. "Lawrence Gowing rewrote my introduction to the catalogue so that the language soared like the men in their flying machines. He was generous enough to suggest a joint signature" (Richard Hamilton, Collected Words 1953-1982 [London, 1983], p. 18).

8. Toni del Renzio, "Neutral Technology – Loaded Ideology," Art News and Review, 7 (23 July 1955), p. 3. Apparently Hamilton asked Lawrence Alloway to contribute to the catalogue but he "failed to come up with a usable formulation" (Lawrence Alloway, "The Development of British Pop," in Pop Art, ed. Lucy Lippard [London, 1966], p. 34).

9. Reyner Banham, "Borax, or the Thousand Horse-Power Mink," 4 March 1955. No text of this lecture has survived.

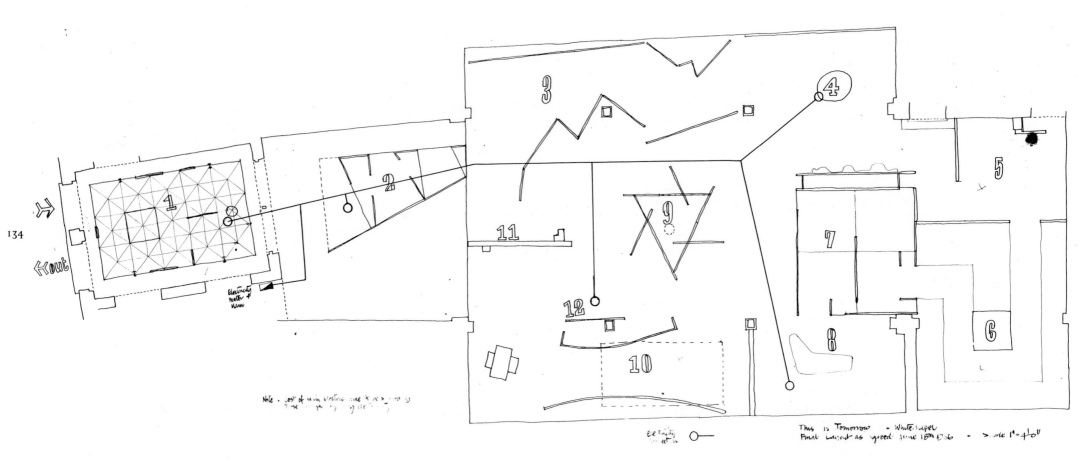

134

This Is Tomorrow. Floor plan of the Whitechapel
Art Gallery, showing the placement of the
twelve groups. Drawn by Colin St. John Wilson.

This Is Tomorrow

This Is Tomorrow opened on 9 August 1956, and thereafter nearly a thousand people a day saw the show. The catalogue (which cost five shillings – expensive by 1956 standards) sold out and had to be reprinted. The popularity of the show was largely due to Lawrence Alloway, who acted as information officer and publicized the exhibition through the press, radio, television, and cinema newsreel. The venue, the Whitechapel Art Gallery, was not in central London but in the East End, which made the high number of visitors an even more staggering statistic. But, as Reyner Banham pointed out, many people drifted in off the street, looked at the first couple of exhibits (one of which included some popular art imagery), "and drifted out again because beyond that everything was static, calm, art gallery sort of stuff with no visible action of any sort."[1]

This Is Tomorrow had been almost two years in the planning. The initial suggestion for an exhibition that demonstrated the collaboration of architects, painters, and sculptors came from Paule Vézelay, the London representative of the Groupe Espace.[2] In contacting Sir Leslie Martin, then chief architect to the London County Council, she hoped to find a kindred spirit, for in 1937 he had been co-editor of the anthology Circle: International Survey of Constructive Art together with Ben Nicholson and Naum Gabo.[3] Apparently too busy to pursue the idea, Leslie Martin passed on Paule Vézelay's proposals to Colin St. John Wilson, who was working for him in the LCC housing division. At a meeting that included Wilson, Victor Pasmore, Robert Adams, Roger Hilton, Theo Crosby, and Paule Vézelay, the initial notion of "an exhibition at the Royal Festival Hall . . . showing the integration of the arts . . . [in] the form of mounting paintings and photographs of architecture and odd tiles and fabrics"[4] was questioned. Paule Vézelay took exception, "there was a big fight and we were all promptly excommunicated from Le Groupe Espace. Theo Crosby, who had been the most forceful protagonist of Gesamtkunstwerk, then came up with the idea of mounting a large-scale show at the Whitechapel Gallery."[5] With the new proposals, a meeting was held at the studio of the painter Adrian Heath on Charlotte Street in London. The climate of this assembly seems to have been no less fractious than the previous one with Paule Vézelay, "but on the whole there was little dissension at the proposal that space in the Whitechapel would be split up like market-stalls in a fair and autonomous groups should each do their own thing."[6]

By the spring of 1955, it was apparent that the exhibitors were roughly divided into two camps: one was Constructivist, the other was Independent Group, which Theo Crosby called "Group X" for some time.[7] Even when the show opened, this division was recognizable. The art critic for the London Times wrote:

> There is no over-all unanimity in the exhibition. However, two distinct tendencies are revealed both by the exhibits and the contributions which each group has made to the sumptuous catalogue. On the one hand a number of collaborations have brought sculpture and architecture together in a genuine synthesis. These works aspire to an ideal style, a conscious purity of form. . . .

> Against these formally coherent and discrete works of art are to be set a number of exhibits whose purpose is the exact opposite. The interest of their designers, if one interprets them correctly, centres on the relationship between onlooker and the world at large rather than between him and the qualities of a work of art. The work is significant as symbol, not as form.[8]

In March 1955, Reyner Banham wrote to Bryan Robertson, the director of the Whitechapel Gallery, that "most of the groups now exist and most have some idea of what they want to do."[9] However, two months later, Robertson was trying to establish another group and, to some extent, change the existing groups. He wrote to Theo Crosby:

> I am not at all keen to exhibit sculpture by Sarah Jackson; I think the list of painters could be improved and enlarged without sacrificing point of view; I think that Bernard Meadows, as a sculptor, could well be invited to contribute something to the exhibition; and above all, I feel very strongly that Ben Nicholson, Barbara Hepworth and either Martin, Fry or Drew should be asked to collaborate together to produce something for the exhibition. . . . From the point of view of courtesy, seniority, and historical perspective, I feel that there should be a contribution from the Hepworth-Nicholson faction together with work by an architect of approximately their generation.[10]

Crosby waited until June to reply. He tried to deflect the suggestion of a Nicholson-Hepworth group. "It was generally felt that it would be difficult for them to attend the discussions which are really the point of the collaboration. It was stressed that the exhibition will not be a collection of miscellaneous art works."[11] Although Robertson argued that "both Barbara and Ben are more mobile than your friends imagine and all their architect friends are frequently in St. Ives to see them,"[12] Crosby was resolute in maintaining that the show was for the younger generation of artists and architects.

Financial support for This Is Tomorrow was limited. Each of the twelve groups was allocated about forty pounds, so there was much borrowing and scrounging of materials to supplement this meager sum. Each group also produced a poster in a limited edition – another way of cutting costs – and this led to twelve highly individual creations that to some extent mirrored the separate exhibits.

After numerous changes, some disagreements, and more than a few frayed friendships – all in all, a spirit born out of "antagonistic co-operative groups"[13] – the show opened with a private viewing on 8 August 1956. "It is suitable," wrote Lawrence Alloway, "that MGM's full-size model of a robot of the 22nd century should open an exhibition in which many of the younger artists and architects are collaborating to show what Tomorrow may be like."[14] Richard Hamilton had achieved something of a coup in borrowing Robbie the Robot, star of the then current film Forbidden Planet. At the opening of the exhibition, an operator working inside the robot read a speech prepared by Alloway. "Unfortunately [it] was too long, and Robbie's great domed head steamed up, dimming his banks of flashing lights, as the man inside sweated it out."[15] Reyner Banham, also present at the opening, described it in Architects' Journal: "'This is the first time a robot has opened an art exhibition,' enunciated Robbie, star of Forbidden Planet. 'Formerly, people were used.' The innovation made no difference to the sherry-snatchers in the middle of the gallery, who continued to talk and laugh just as loudly, and rudely, as if people were still being used."[16]

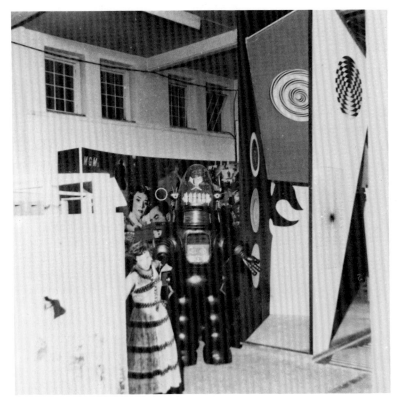

Robbie the Robot beside Group Two exhibit.

1. Reyner Banham, conversation with John McHale, Mary Banham, and Magda Cordell McHale, 30 May 1977, recorded for Fathers of Pop (Arts Council of Great Britain, 1979); it was not used in the film.

2. Formed in 1951 in France, the Groupe Espace was a neo-Constructivist association whose principal philosophy centered on the idea that art was simply part of the larger urban space and therefore was a social and not an individualistic activity. Paule Vézelay was born in England, spent her formative years in France, then returned to England in 1939 to paint, sculpt and design fabrics. She became the president of the British branch of the Groupe Espace in 1957.

3. "Circle was conceived as a platform for exchange of ideas referring to subjects as diverse as painting, sculpture, architecture, typography, choreography, engineering, art education, and biotechnics. In art, the tendency was towards pure abstraction, in other fields the stress was on the connecting links between progress in technology, art and philosophy." Jasia Reichardt, "Notes and Documentation," Art in Britain 1930-40, Centered Around Axis, Circle, Unit One, exh. cat. (London, Marlborough Fine Art, 1965), p. 10.

4. Colin St. John Wilson, interview with the author, 9 May 1983.

5. Colin St. John Wilson, "A Note About This Is Tomorrow," unpublished MS.

6. Ibid.

7. John McHale, conversation with Reyner Banham, Mary Banham, and Magda Cordell McHale, 30 May 1977, recorded for Fathers of Pop (Arts Counciul of Great Britain, 1979); it was not used in the film.

8. "Architect and Artist. Ideal Realised," Times (London), 9 August 1956.

9. Reyner Banham, letter to Bryan Robertson, 30 March 1955, Whitechapel Art Gallery archives.

10. Bryan Robertson, letter to Theo Crosby, 23 May 1955, Whitechapel Art Gallery archives. Robertson noted in a postscript: "Also, although John Forrester at St. Ives is not yet the genius some people think, he has got something interesting of his own to offer and he's certainly up to most of the other painter-decorators' level. Could he be invited?"

11. Theo Crosby, letter to Bryan Robertson, 8 June 1955, Whitechapel Art Gallery archives.

12. Bryan Robertson, letter to Theo Crosby, 10 June 1955, Whitechapel Art Gallery archives.

13. Lawrence Alloway, "Design as a Human Activity," This Is Tomorrow, exh. cat. (London, Whitechapel Art Gallery, 1956).

14. Lawrence Alloway, press release for This Is Tomorrow, Whitechapel Art Gallery archives.

15. Lawrence Alloway, "The Development of British Pop," in Pop Art, ed. Lucy R. Lippard (London, 1966), p. 210, n. 23.

16. Reyner Banham, "Not Quite Architecture, Not Quite Painting Either," Architects' Journal, 124 (16 August 1956), p. 217.

The twelve exhibits

The exhibits for *This Is Tomorrow* were each produced separately and were independent of each other. By June 1956, their positions within the gallery had been fixed, so that upon entering the visitor could move in a counter-clockwise direction through each environment, beginning at Group One and ending at Groups Eleven and Twelve.

The division between Constructivist oriented exhibits and those devised by Independent Group artists and architects was clear in only some cases. Group Five (John Ernest, Anthony Hill, Denis Williams), Group Seven (Ernö Goldfinger, Victor Pasmore, Helen Phillips), and Group Nine (Kenneth and Mary Martin, John Weeks) were undeniably Constructivist in intention, whereas Group Twelve (Lawrence Alloway, Geoffrey Holroyd, Toni del Renzio) was overtly concerned with issues that had preoccupied the Independent Group.

As for the remaining seven groups, some of the teams included Independent Group "regulars": William Turnbull was a member of Group One with Theo Crosby, Germano Facetti, and Edward Wright; Group Six comprised the four who had organized the *Parallel of Life and Art* exhibition at the ICA in 1953 (Nigel Henderson, Eduardo Paolozzi, Alison Smithson and Peter Smithson); Group Eight included James Stirling (with Michael Pine and Richard Matthews), and Group Ten included Colin St. John Wilson (with Frank Newby, Peter Carter, and Robert Adams).

Of the remaining three groups, there was no obvious allegiance to either Constructivist or Independent Group concerns. Group Three (James Hull, J. D. H. Catleugh, and Leslie Thornton) produced abstract murals out of folding screens; Group Four (Anthony Jackson, Sarah Jackson, and Emilio Scanavino) made a study of wall, sculpture, and space; Group Eleven (Adrian Heath and John Weeks) explored the aesthetics of a free-standing wall of concrete blocks.

The catalogue for the exhibition was designed by Edward Wright, who had just been appointed to teach typography at the Royal College of Art. For the catalogue, each group was to produce a statement about and a diagram of their exhibit, a picture of themselves, and one other image. Most of the groups kept to this format, if somewhat loosely, but Groups Six and Twelve went against the proportions of the catalogue as well as the limitations of the brief, much to Wright's consternation.

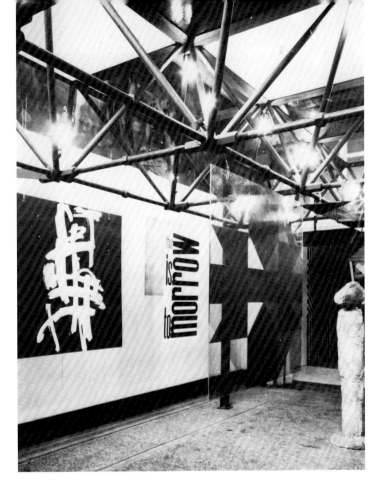

Group One display.

GROUP ONE
(Theo Crosby, Germano Facetti, William Turnbull, Edward Wright)

This exhibit occupied the vestibule of the Whitechapel Art Gallery and every visitor to the show had to walk through it in order to reach the other exhibits.

Across the ceiling was a spaceframe structure designed by Theo Crosby and later utilized by him in the International Union of Architects Congress building on London's South Bank (1961). Reminiscent of Buckminster Fuller structures, this roof was intended to symbolize the mechanical environment, while the image of a leaf skeleton on one of the suspended panels at the side of the exhibit was to symbolize structure in the natural environment. Edward Wright and Germano Facetti decorated these blockboard, plywood, and plastic panels with images and lettering – some were photostats, others were produced with masking tape and printing ink.

Standing to the right in this exhibit was William Turnbull's five-feet high plaster sculpture called *Sungazer*, intended to represent the irrational within the mechanical environment. (It was later cast in bronze.)

The symbolic nature of this exhibit was essential to the overall effect. So was the concept of letting the various images and objects assert their significance both separately and in relation to one another.

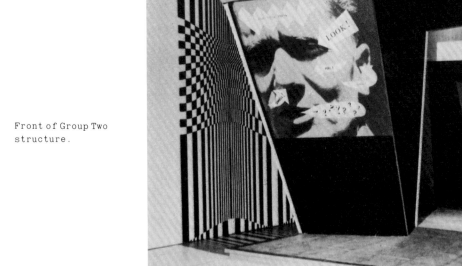

Front of Group Two
structure.

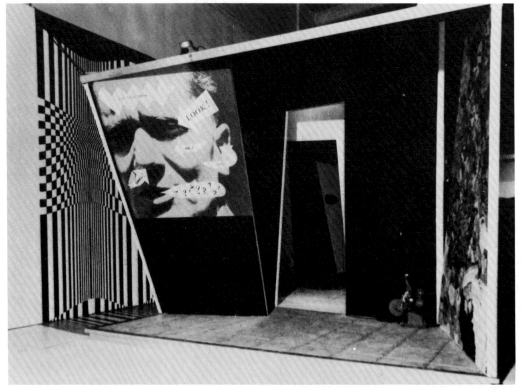

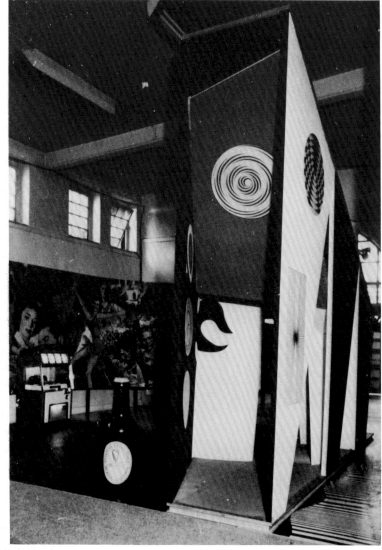

View of Group Two structure from back, showing
''Cinemascope'' collage screen, giant Guin-
ness bottle, and rotoreliefs.

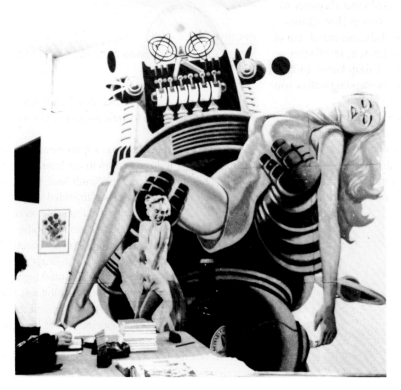

Side panel with
popular culture
imagery.

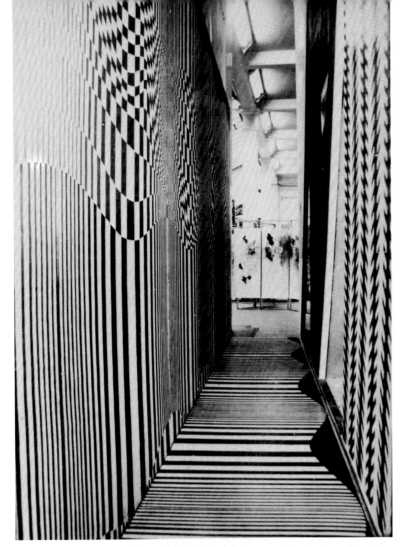

Optical illusion corridor.

GROUP TWO
(Richard Hamilton, John McHale, John Voelcker)

Initial ideas for the Group Two exhibit ranged from an inhabitable Möbius strip to a crazy house such as one might find on a fairground. The final structure, designed by John Voelcker, reflected the topological motive and housed two specific types of imagery: sensory stimuli and optical illusions from the Bauhaus and Marcel Duchamp (the theme of perception), and images from popular art, chiefly from the cinema and science fiction (the theme of what we perceive at the moment).

A good deal of the visual material was supplied by John McHale when he returned from his year-long fellowship at Yale; while projectors, gramaphone motors for moving the Duchamp rotoreliefs, film posters, and probably the jukebox, were supplied by Frank Cordell.

During the planning and building of the exhibit, Hamilton, McHale and Voelcker were helped by Magda Cordell and Terry Hamilton, although the team did not always work in a spirit of friendly cooperation. Nevertheless, the exhibit was regarded as the most successful contribution to *This Is Tomorrow*. Certainly it drew a good deal of attention, with its sixteen-foot-high image of Robbie the Robot; Marilyn Monroe, her skirt flying, in a scene from *The Seven Year Itch*; the giant bottle of Guinness; the spongy floor that, when stepped on, emitted strawberry air freshener; the optical illusion "corridor"; the total collage effect of the "Cinemascope" panel; the jukebox; and the reproduction of van Gogh's *Sunflowers*. This last item was the most popular art reproduction on sale at the National Gallery. Its inclusion obscured the distinction between popular and fine art, for, as an image, *Sunflowers* was probably more popular than the so-called "popular" art images of Robbie and Marilyn, which were placed next to the van Gogh reproduction on the outer panel of the Group Two structure.

Interior of the pavilion with Nigel
Henderson's <u>Head of a Man</u>.

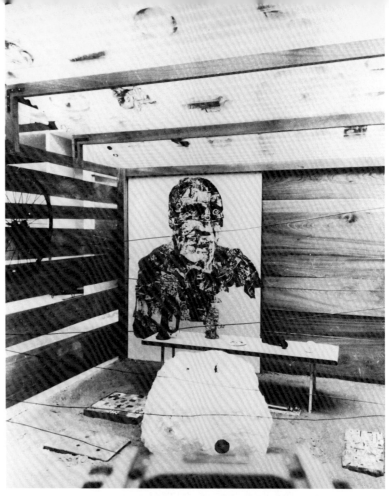

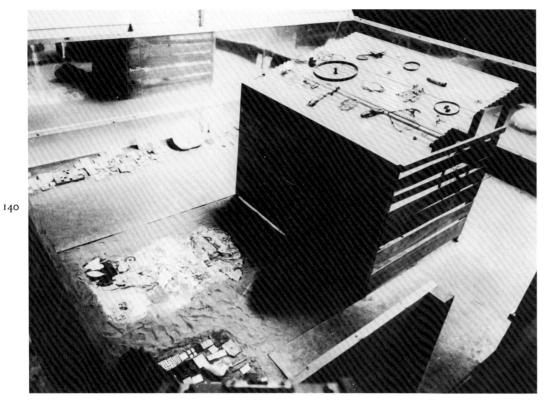

Patio and Pavilion.

Rear view of the pavilion.

GROUP SIX
(Nigel Henderson, Eduardo Paolozzi, Alison and Peter Smithson)

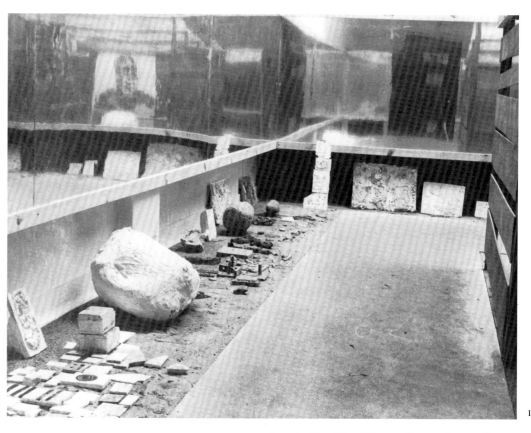

The approach of Group Six was for the architects, Alison and Peter Smithson, to provide a space and shelter that the artists, Henderson and Paolozzi, could fill with objects and imagery. The Patio and Pavilion, as the exhibit was called, was a habitat symbolic of human needs – space, shelter, and privacy–and the objects it contained represented the range of human activity: the wheel for movement and machine, the sculpture for contemplation, and Henderson's photo-collage head symbolizing man himself as an amorphously complex being.

Patio and Pavilion was to some extent a parody of Nigel Henderson's backyard in Bethnal Green, but only insofar as his backyard was a parody of others, with their sheds and pigeon lofts.

The structure was built of wood, most of it secondhand; the pavilion roof was translucent, corrugated plastic through which one could see objects laid on top; and the interior walls of the surrounding patio were lined with an aluminum-faced plywood that subtly reflected the interior and was symbolic of light. The Smithsons planned and constructed the environment, then left for the CIAM congress in Dubrovnik, asking Henderson and Paolozzi to invest the structure with signs of habitation. "For in this way," the Smithsons declared, "the architects' work of providing a context for the individual to realise himself in, and the artists' work of giving signs and images to the stages of this realisation, meet in a single act, full of those inconsistencies and apparent irrelevancies of every moment, but full of life."[1] The floor of the patio was covered with sand. Impressed clay tiles, bricks, stones, and plaster sculptures were arranged around the perimeter. A large photo-collage, some of whose imagery had been used earlier in *Parallel of Life and Art*, was revealed on the floor behind the shed where the sand had been brushed away.

The whole exhibit had a timeless quality; it was more a statement about occupancy and territory than a program announcing a particular style or approach.

1. *From a statement by Peter Smithson, July 1956, requested by Leonie Cohn, Talks department, BBC. Included in "Asides to 'Thoughts on Exhibitions,'" unpublished MS., Alison and Peter Smithson archive.*

141

Area to the side of the pavilion, showing the reflective aluminum.

Patio floor with collage by Nigel Henderson.

Group Eight exhibit.

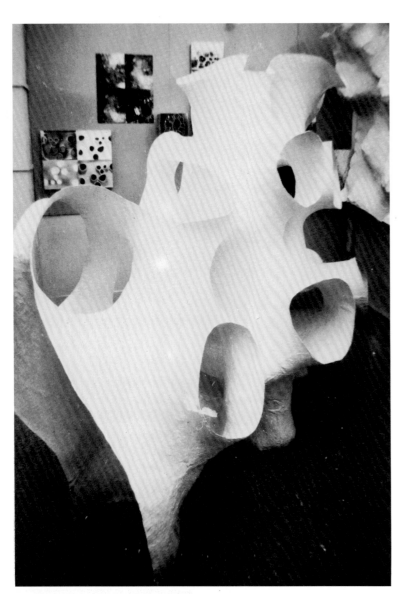

The ''bubble'' sculpture.

GROUP SIX
(Nigel Henderson, Eduardo Paolozzi, Alison and Peter Smithson)

The approach of Group Six was for the architects, Alison and Peter Smithson, to provide a space and shelter that the artists, Henderson and Paolozzi, could fill with objects and imagery. The Patio and Pavilion, as the exhibit was called, was a habitat symbolic of human needs – space, shelter, and privacy–and the objects it contained represented the range of human activity: the wheel for movement and machine, the sculpture for contemplation, and Henderson's photo-collage head symbolizing man himself as an amorphously complex being.

Patio and Pavilion was to some extent a parody of Nigel Henderson's backyard in Bethnal Green, but only insofar as his backyard was a parody of others, with their sheds and pigeon lofts.

The structure was built of wood, most of it secondhand; the pavilion roof was translucent, corrugated plastic through which one could see objects laid on top; and the interior walls of the surrounding patio were lined with an aluminum-faced plywood that subtly reflected the interior and was symbolic of light. The Smithsons planned and constructed the environment, then left for the CIAM congress in Dubrovnik, asking Henderson and Paolozzi to invest the structure with signs of habitation. "For in this way," the Smithsons declared, "the architects' work of providing a context for the individual to realise himself in, and the artists' work of giving signs and images to the stages of this realisation, meet in a single act, full of those inconsistencies and apparent irrelevancies of every moment, but full of life."[1] The floor of the patio was covered with sand. Impressed clay tiles, bricks, stones, and plaster sculptures were arranged around the perimeter. A large photo-collage, some of whose imagery had been used earlier in *Parallel of Life and Art*, was revealed on the floor behind the shed where the sand had been brushed away.

The whole exhibit had a timeless quality; it was more a statement about occupancy and territory than a program announcing a particular style or approach.

1. From a statement by Peter Smithson, July 1956, requested by Leonie Cohn, Talks department, BBC. Included in "Asides to 'Thoughts on Exhibitions,'" unpublished MS., Alison and Peter Smithson archive.

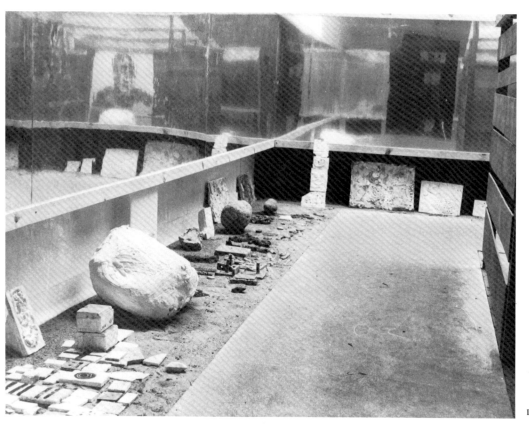

Area to the side of the pavilion, showing the reflective aluminum.

Patio floor with collage by Nigel Henderson.

Group Eight exhibit.

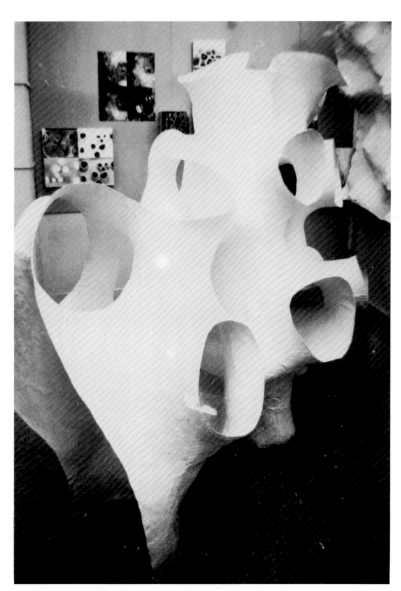

The ''bubble'' sculpture.

GROUP EIGHT
(Richard Matthews, Michael Pine, James Stirling)

When the groups for *This Is Tomorrow* were formed, Michael Pine and James Stirling (the only IG member in this group) worked as a team; Richard Matthews joined them at a later date. Pine, then a sculptor and now an architect in Canada, was responsible for the physical construction of this piece.

In retrospect, the exhibit of Group Eight seems related to the natural imagery that had been seen in the ICA's *Growth and Form* exhibition of 1951, but both Pine and Stirling have discounted this influence, recalling a more experimental intent. Whereas the imagery of *Growth and Form* required little analytic or creative input other than that provided through the display itself, the Group Eight sculptural piece was inspired by a desire to "recover the vitality of the research artists of the '20s," as Stirling put it in his catalogue statement at the time. The problem they set was to extrapolate the shape and structure for a sculptural form from a photographic study of soap bubbles.[1]

Michael Pine recalls that the construction had "tree-like overtones." It was built with half-inch chicken wire, covered with pasted newspaper strips (papier-mâché) and painted white. The photographic studies, which were mounted on the adjacent wall, were executed by David Wager. In a note for the organizers of this exhibition, Pine recalls the photographs as "great fun to do."

> An enlarger was focussed through an aspirin bottle containing soapy water onto photosensitive paper on the wall. This was all set up using a red filter, and when we had a good bubble image, the red filter was removed for about four seconds, and the paper immediately developed. The problem with this was the tendency of the bubbles to burst during the four seconds of exposure. However, we got enough prints for our purpose.[2]

As their statements in the TIT catalogue make clear, all three collaborators intended this piece as a rejection of formalism for the "practical arts" (Stirling), chiefly architecture.

1. Soap bubbles, along with crystals, living cells, and crazed ash trays, were a standard subject for topological analyses at this time. See Cyril S. Smith, "The Shape of Things," Scientific American 190 (January 1954), pp. 58-64.

2. Michael Pine, notes accompanying letter to Jacquelynn Baas, 20 August 1988.

Photograph of detergent bubbles exhibited with the sculpture.

143

Maquette for the Group Ten sculpture.

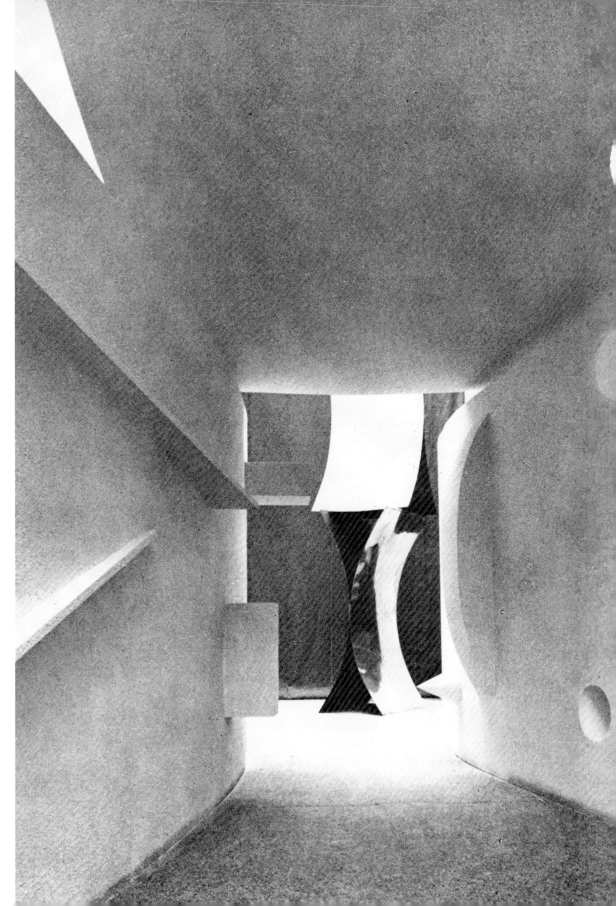

Looking through the passageway of
the Group Ten exhibit.

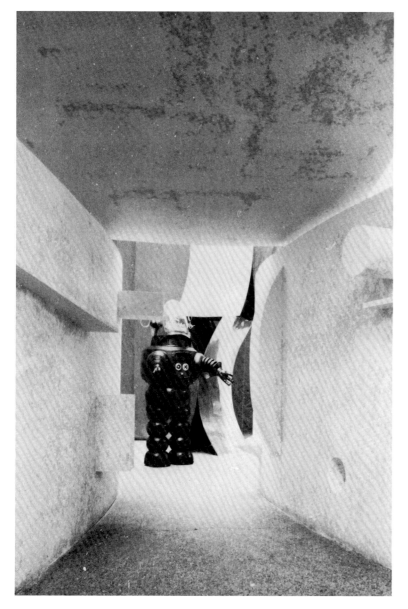

Group Ten sculpture
with Robbie the Robot
at entrance.

GROUP TEN
(Robert Adams, Peter Carter, Frank Newby, Colin St. John
Wilson)

The initial idea for the exhibit came from Colin St. John Wilson, who envis-
aged an environment that one could pass through. Robert Adams then
devised the form of the exhibit as a maquette and the others worked closely
to this.

Much of the construction for this large piece of sculptural architec-
ture was done at Frank Newby's Maida Vale studio. The three main panels
were made from hardboard and formed the "walls" and "ceiling" of a pas-
sageway. The space was wide enough and high enough to accommodate
Wilson's original idea of a walk-through environment, and at the opening of
This Is Tomorrow Robbie the Robot managed to propel himself between the
panels and out the other side.

At the end of the passage, and standing free of it, was an eye-
catching object made by Robert Adams out of concave aluminum sheets.
Again neither sculpture nor architecture, this object restated the curved
forms of the passageway and provided a point of focus at its exit.

The curved forms of the main structure, their surfaces articulated
by various sizes and shapes of rectilinear blocks, cylinders, and a circular
void, were partly intended as a *hommage* to Le Corbusier's pilgrimage chapel
of Notre Dame du Haut at Ronchamp, inaugurated just over a year before *This
Is Tomorrow*. Colin St. John Wilson had seen a model for Ronchamp in Le Cor-
busier's office in 1951 and had not recognized it as a building, since it was so
different from the Unité d'Habitation.

Group Ten's exhibit was perhaps the most complete collaboration
of the whole show. Each individual contributed to the whole.

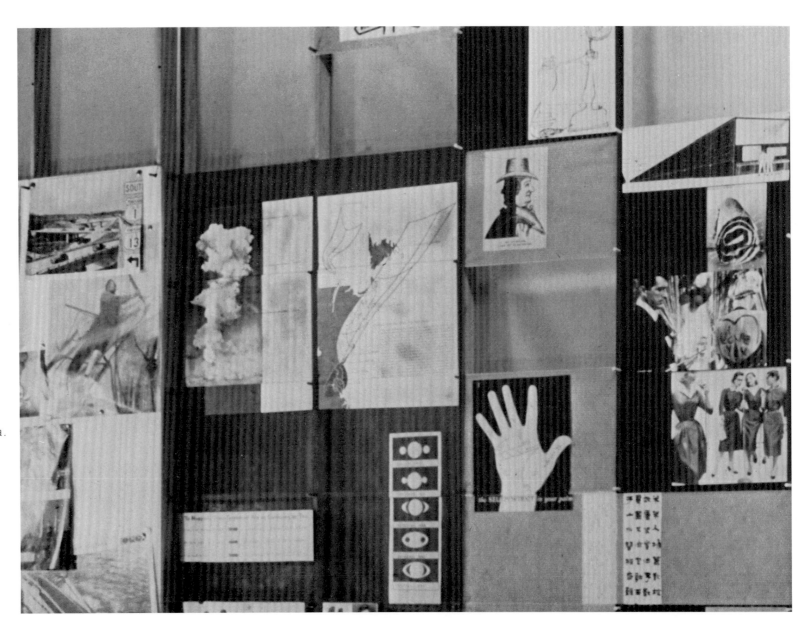

The Group Twelve tackboard.

GROUP TWELVE
(Lawrence Alloway, Geoffrey Holroyd, Toni del Renzio)

This exhibit on the use of the tackboard reflects the IG's pioneering investigations into signs and communication the previous year, which drew upon the emerging fields of communication theory and information theory. The architect Geoffrey Holroyd was instrumental in developing the ideas for the Group Twelve exhibit and devising its display. In 1953 while visiting California Holroyd had met Charles and Ray Eames, and in April 1956 Holroyd had joined with Lawrence Alloway and Frank Newby in presenting the Eames film, *A Communications Primer*, at the ICA. Alloway, whose idea of a "fine art-popular art continuum" had become a key referent within the milieu, worked with Holroyd in developing the concepts and choosing the images. Toni del Renzio designed the catalogue section for the group.

The Group Twelve exhibit was inspired by the Eames *House of Cards* toy of 1952, but it resembled a magazine spread open, with a tackboard on the left and a didactic display on the process of connecting found images on the right, combining an underlying grid system with a "discourse" system of image groupings. For the grid fabric, Holroyd built a wooden frame of pegged struts overlaid with colored Perspex panels. It functioned both as an "assembly kit" container for the photo-images and as an analogue for the mental and linguistic systems underlying our association of images.

Each photo-image suggested a distinctive sign system and was also identified with a color-coded grouping of conceptual themes: blue panels (B) were for images with a space-time emphasis ("order-searching"); yellow (Y) for images based on some type of relationship exchange ("adaptability"); and red (R) for object-based relationships ("focussing"). The photo-images included an open hand as a spatial system for palmistry readings (B); a panel of Braille lettering (Y); an air travellers' version of a village signpost (B); a still from *Artists and Models*, showing Dean Martin drawing a Valentine symbol on Doris Day's back (R); a Dead Sea Scroll (R); a graphic anti-nuclear message–the damage area of the Hiroshima nuclear explosion superimposed upon a map of the U.S. East Coast (Y); a computer depicted as a large urban building (R); a scientific diagram of the sound of Louis Armstrong's trumpet (Y); a seventeenth century cartoon of a two-faced swindler (B); historical changes of cosmological images (Y); secretaries representing their telephones (R); the telephone as a standing person (R); and footprints signifying the dweller's movements in a kitchen design study (B).

The "action" tackboard of tearsheets from magazines (thematically linked to photo-images on the right side) was intended to be regularly changed during the exhibition. Rejecting any hierarchic valuation of one image over another, the entire tackboard display doubtless called to mind the *Parallel of Life and Art* exhibition of 1953.

In 1957, Holroyd, together with William Turnbull, Theo Crosby, and Edward Wright, proposed an exhibition to the ICA called "Signs and Symbols," partially based upon the displays of Groups One and Twelve. However, this project was never realized.

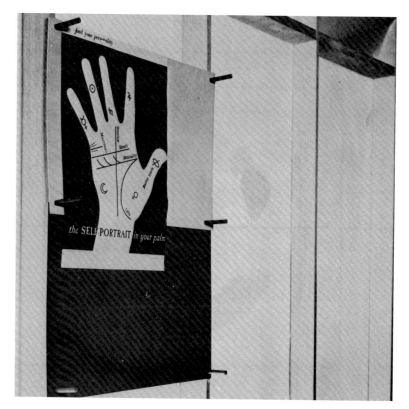

Detail of tackboard by
Group Twelve.

147

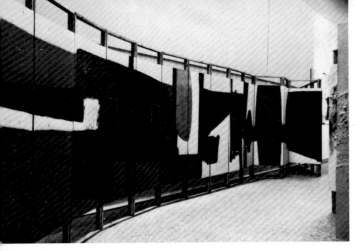

<u>Group Three</u>. J. D. H. Catleugh, James Hull,
Leslie Thornton. Two large murals (Catleugh
and Hull) on successive folding screens create
a processional space, climaxing in Thornton's
metal and plastic sculpture.

148

<u>Group Four</u>. Anthony Jackson, Sarah Jackson,
Emilio Scanavino. The growth of a sculpture (S.
Jackson) in tension with wall and space.

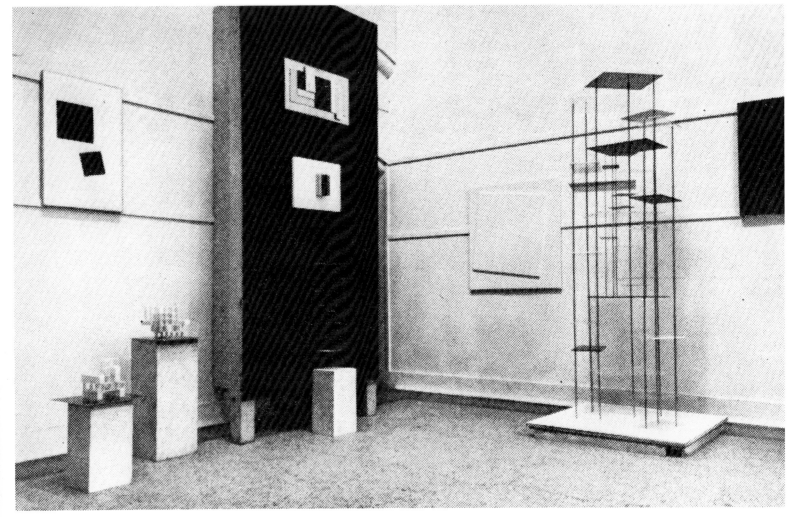

<u>Group Five</u>. John Ernest, Anthony Hill, Denis
Williams. Constructions by Ernest and Hill
beside replicas of works by Malevich and other
Constructivists, evoking the historical
linkage with the pioneering years of 1913–1923.

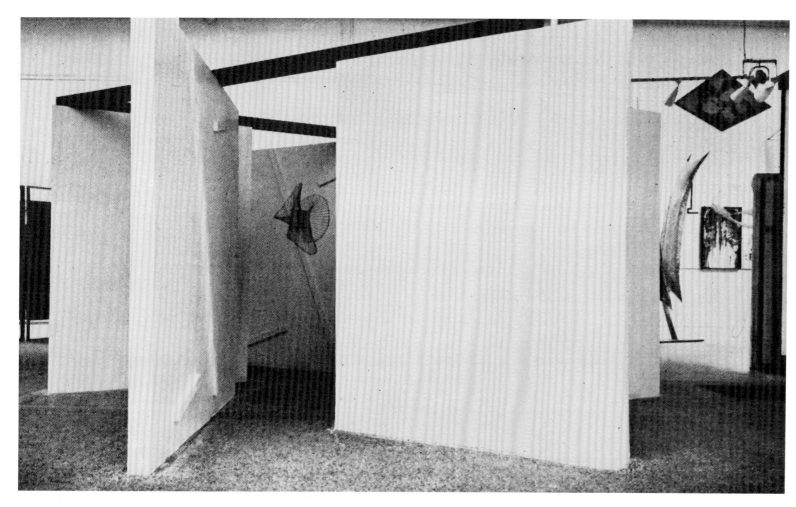

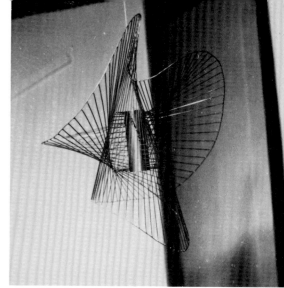

Group Nine. Kenneth Martin, Mary Martin, John Weeks. A construction of white panels based on an equilateral triangle, with a Kenneth Martin mobile at the center.

Group Seven. Victor Pasmore, Ernö Goldfinger, Helen Phillips. A square pavilion with Pasmore's relief and Phillips's sculpture carefully related, using a 4 by 4 feet module.

Group Eleven. Adrian Heath and John Weeks. Projecting and receding concrete blocks stabilize a wall and produce an aesthetic effect using simple materials.

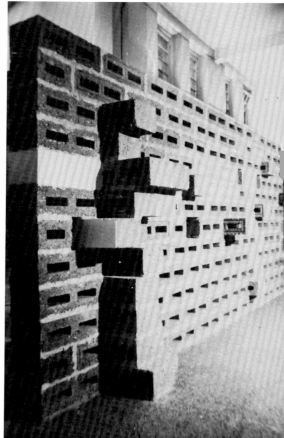

The catalogue

The catalogue for This Is Tomorrow was designed by
*Edward Wright, with each participating group contributing
visual and textual materials to its own section. The pages
photographed here are those of the six more or less IG-
related groups (1, 2, 6, 8, 10 and 12) whose displays have
been reconstructed for this retrospective exhibition.*

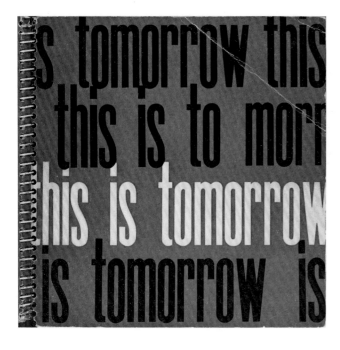

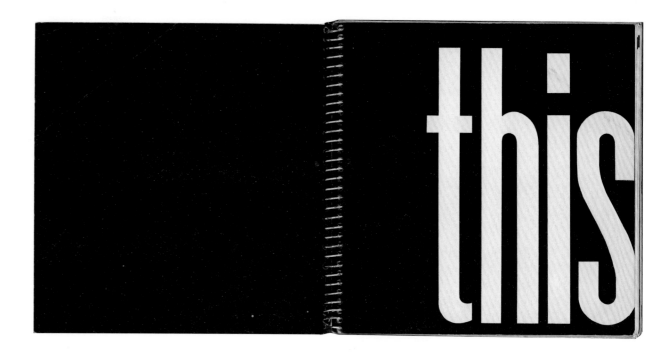

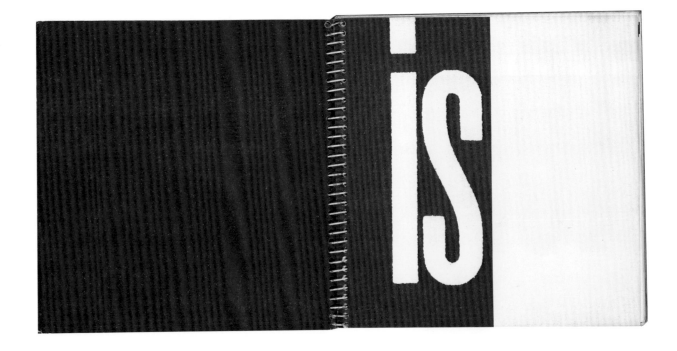

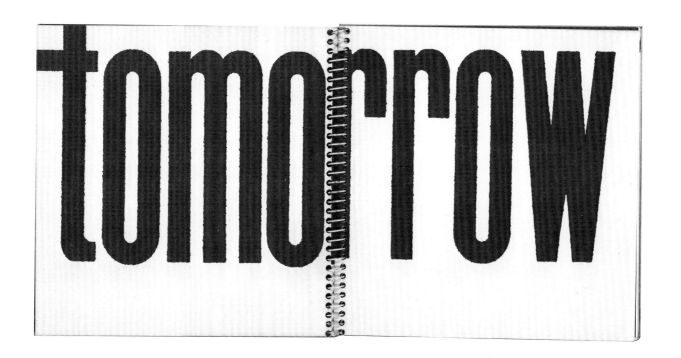

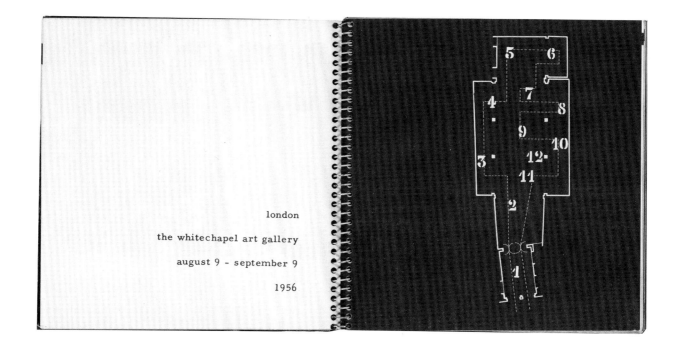

london

the whitechapel art gallery

august 9 – september 9

1956

Group 1

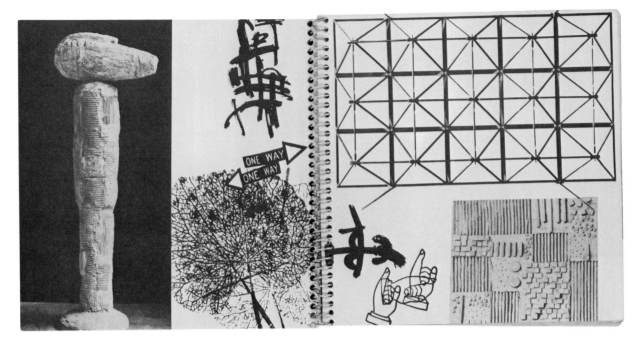

Group 1

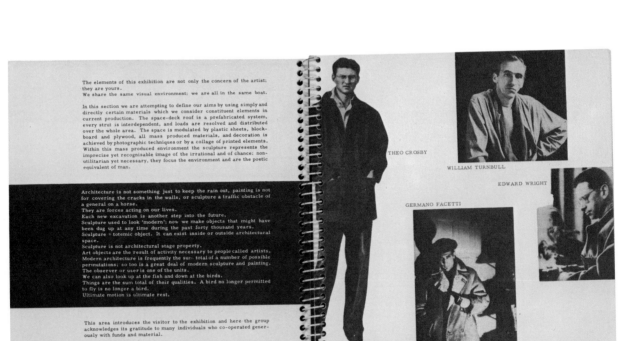

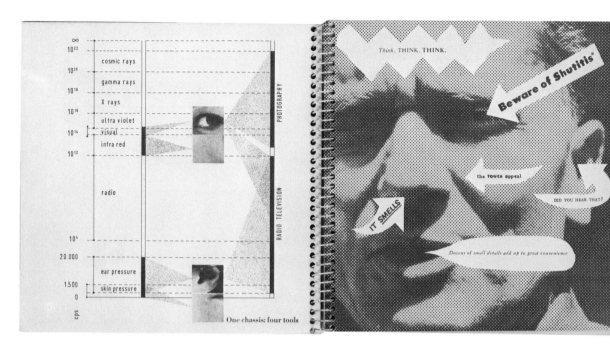

Group 2

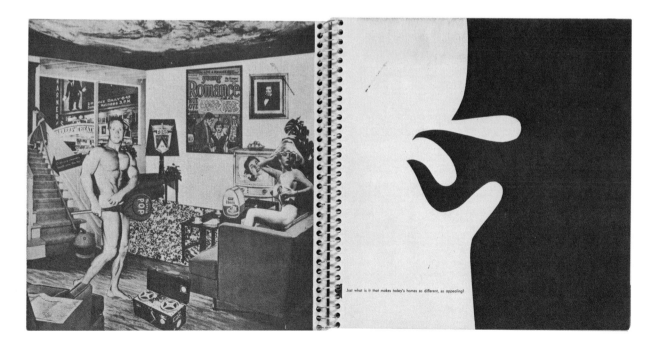

Group 2

Group 2

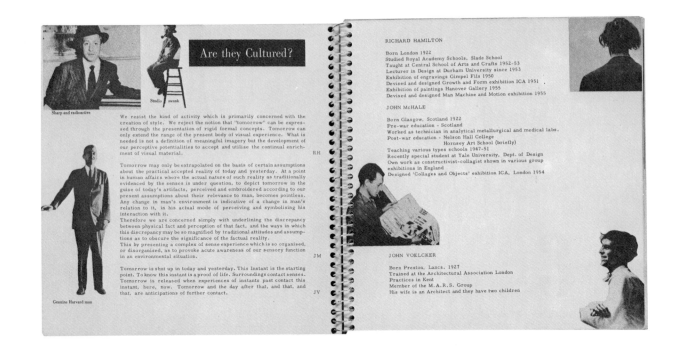

54

Group 6

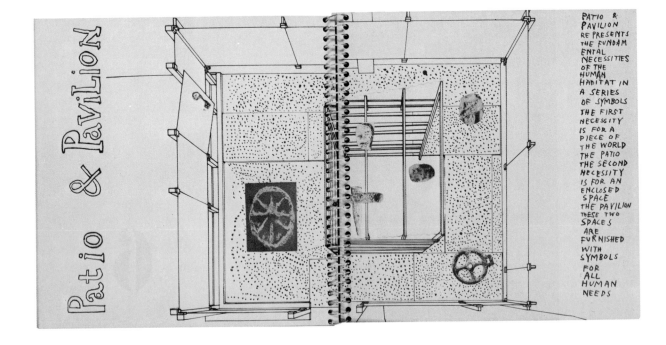

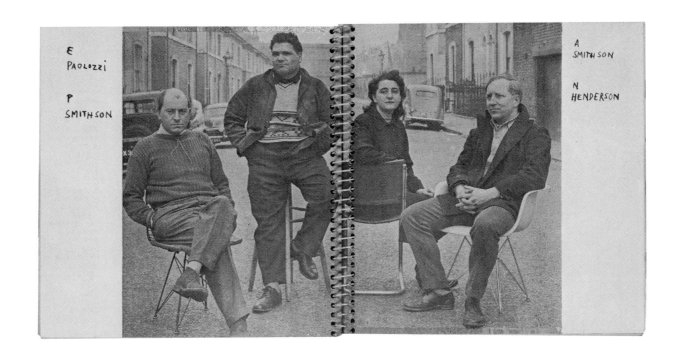

E
PAOLOZZI

P
SMITHSON

A
SMITHSON

N
HENDERSON

Group 6

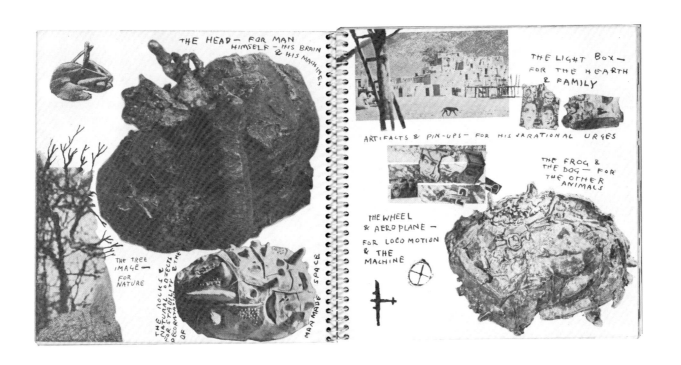

THE HEAD— FOR MAN HIMSELF — HIS BRAIN & HIS MACHINES

THE LIGHT BOX— FOR THE HEARTH & FAMILY

ARTIFACTS & PIN-UPS— FOR HIS IRRATIONAL URGES

THE FROG & THE DOG— FOR THE OTHER ANIMALS

THE TREE IMAGE— FOR NATURE

THE ROCKS & NATURAL OBJECTS FOR STABILITY & THE DECORATIVITY OF MAN MADE SPACE

THE WHEEL & AERO PLANE— FOR LOCO MOTION & THE MACHINE

Group 6

THIS IS TOMORROW CATALOGUE

Group 8

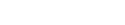

Group 8

Why clutter up your building with 'pieces' of sculpture when the architect can make his medium so exciting that the need for sculpture will be done away with and its very presence nullified.
The painting is as obsolete as the picture rail. Architecture, one of the practical arts, has, along with the popular arts deflated the position of painters, sculptors, - the fine arts.
The ego maniac in the attic has at last starved himself to death.
If the fine arts cannot recover the vitality of the research artists of the 20's (who through the magazines generated a vocabulary for the practical arts), then the artist must become a consultant, just as the engineer or quantity surveyor is to the architect, though their relationship to the specialist, e.g. industrial designer or furniture maker, would be more intimate for they would be directly concerned with conception.

JAMES STIRLING

MICHAEL PINE The Artist feels the loss of vitality in the formal expressions of Art, and realises that his work is more than the satisfaction of a personal and emotional requirement.
The elements of painting and sculpture have already lost a sense of descriptive function or intentional indication of scale.
They can be extended in size, shape or role and in the process of interpretation these are only determined by the superimposition of a finger, a human figure or a crowd.
The single element extends by implication from the smallest constructed part, to Architecture and to the whole environment without clear individual demarcation.

RICHARD MATTHEWS A total sense of environment will only be brought about by people themselves wanting it. Architects, painters and sculptors can only help by developing together their means of expression to act as a stimulus to this end, and not by working in a formalist vacuum. This means of expression has already been increased in painting and sculpture through the breaking down of conventional form (elsewhere modern musicians are doing the same). This type of disruption is only about to take place in architecture - the wall at least is beginning to go. The next step will be with the volume of the building, which at present is based on structural geometry. Schwitters' ideal was a cathedral of wood filled with wheels - the static volume disrupted into a dynamic one by implication, for wheels are always revolving even when they are not being propelled. Finally the total plastic expression (architecture, painting, sculpture) will be in the landscape with no fixed composition but made up of people, volumes, components - in the way that trees, all different, all growing, all disrupted into each other, are brought together in an integrated clump.

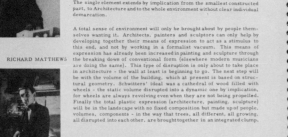

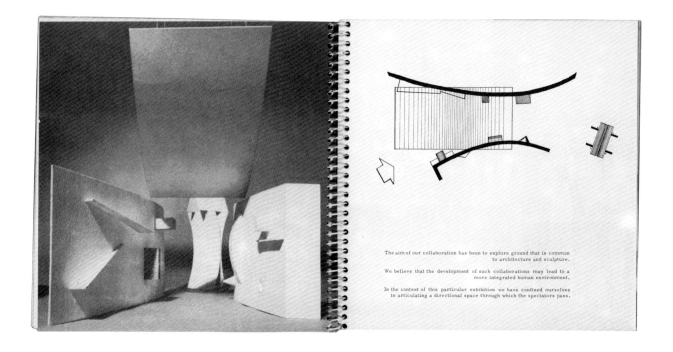

The aim of our collaboration has been to explore ground that is common to architecture and sculpture.

We believe that the development of such collaborations may lead to a more integrated human environment.

In the context of this particular exhibition we have confined ourselves to articulating a directional space through which the spectators pass.

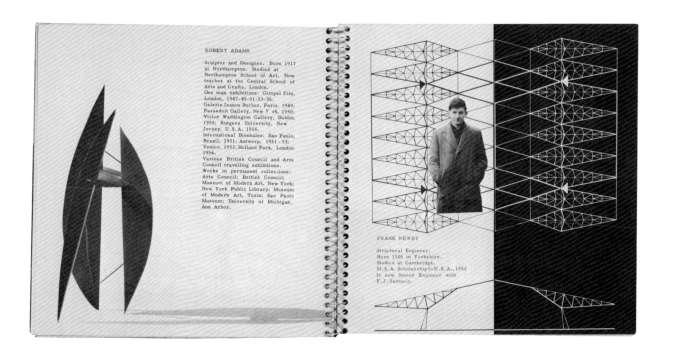

ROBERT ADAMS

Sculptor and Designer. Born 1917 at Northampton. Studied at Northampton School of Art. Now teaches at the Central School of Arts and Crafts, London.
One man exhibitions: Gimpel Fils, London, 1947-49-51-53-56; Galerie Jeanne Bucher, Paris, 1949; Passedoit Gallery, New York, 1950; Victor Waddington Gallery, Dublin, 1955; Rutgers University, New Jersey, U.S.A. 1955.
International Bienhales: Sao Paulo, Brazil, 1951; Antwerp, 1951 - 53; Venice, 1952; Holland Park, London 1954.
Various British Council and Arts Council travelling exhibitions.
Works in permanent collections: Arts Council; British Council; Museum of Modern Art, New York; New York Public Library; Museum of Modern Art, Turin; Sao Paolo Museum; University of Michigan, Ann Arbor.

FRANK NEWBY

Structural Engineer.
Born 1926 in Yorkshire.
Studied at Cambridge.
M.S.A. Scholarship to U.S.A., 1952
Is now Senior Engineer with F.J. Samuely.

PETER CARTER

Architect.
Born 1927 in London.
Studied at the Northern Polytechnic.
1950 - 56 worked in the Housing
Division of the Architects Depart-
ment at the L.C.C., engaged prin-
cipally upon multi-storey develop-
ment design. Produced competition
projects with Wilson for:
Coventry Cathedral, Shell Garage,
and Sheffield University.
Also 'Habitat' project for C.I.A.M.
X 1956 and research on Helicopter
Landing Sites in City Centres.
At present working in the office of
Eero Saarinen in U.S.A.
Member of M.A.R.S. group.

ST. JOHN WILSON

Architect.
Born 1922 in Cheltenham.
Studied at Cambridge and University
College, London.
1950 - 55 worked in the Housing
Division of the Architects Depart-
ment at the L.C.C.
At present principal architect to a
Development Company.
Member of M.A.R.S. group.

Group 12

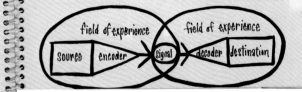

THIS section of This Is Tomorrow represents the basis of collaboration between architect and artist as part of a general human activity rather than as the reconciliation of specialised æsthetic systems. It is communications research which offers a means of talking about human activities (including art and architecture) without dividing them into compartments. Hitherto the conventional definition of

the artist and architect has limited their efficiency to narrow mutually exclusive areas. It is this that has made collaboration difficult. Seeing art and architecture in the general framework of communications, however, can reduce these difficulties by a new sense of what is important.

GEOFFREY HOLROYD, TONI DEL RENZIO, LAWRENCE ALLOWAY.

All communication depends on the transmission of signs. Fig. 1 is a simple diagram of a communication system. In an efficient communication system the field of accumulated experience must be similar in encoder and decoder (see Fig. 2), because without learned responses there is no communication. However, learned responses become stereo-typed and stale in time and need to be revised.

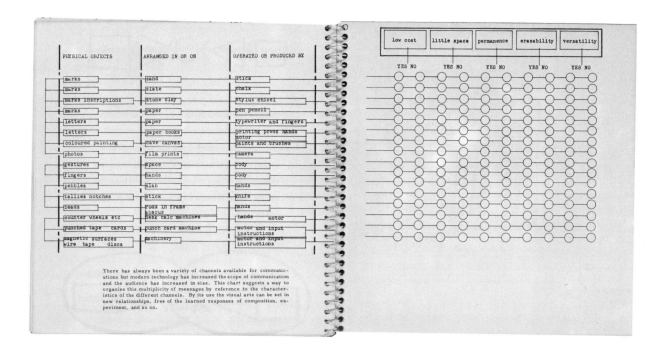

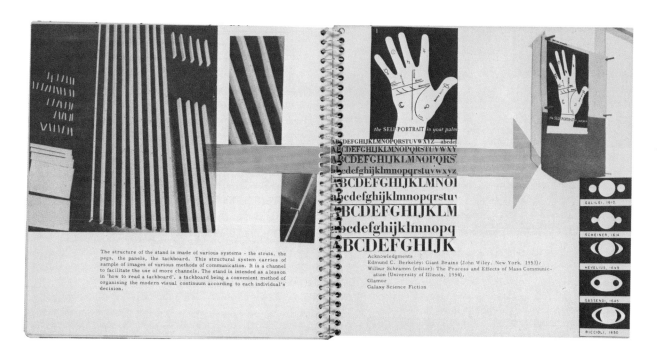

an Exhibit

an Exhibit.
Installation View.
ICA, August 1957.

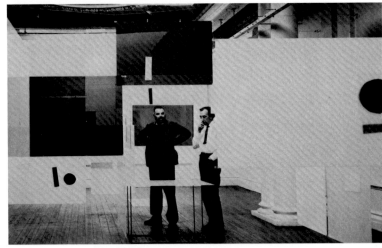

an Exhibit. Installation view. Hatton Gallery,
Newcastle, June 1957. Victor Pasmore and
Richard Hamilton.

Of all the exhibitions initiated by members of the Independent Group, *an Exhibit* seems the most incompatible with what one supposes to have been the IG's aesthetic goals. This is primarily because it was conceived with abstract forms rather than imagery, and at a time when one of its two artist creators–Richard Hamilton–was exploring figurative ideas in his painting and prints. Furthermore, it represented a partnership between figures who a year earlier, at *This Is Tomorrow*, seemed to be completely opposed in their approach to art. Both Hamilton and Lawrence Alloway had promoted the idea of image as symbol in their TIT exhibits, whereas Victor Pasmore's interest was in pure form without regard for representational elements. Now, in 1957, all three came together to produce *an Exhibit*.

The initial idea to stage an exhibition seems to have been Pasmore's. Both he and Hamilton had been teaching at King's College at Newcastle-upon-Tyne–Hamilton since 1953, Pasmore since 1954. Both introduced a basic course, Hamilton to support his design teaching, Pasmore in the painting school, and they cooperated on a joint course between 1958 and 1961. Hamilton recalls Pasmore's reaction to *Man, Machine and Motion* as the origin of *an Exhibit*:

> He thought it was very beautiful [but] the trouble was it had photographs on all the panels. He liked the system but not the photographs, and I remembered what he had said . . . So I proposed that if we were going to collaborate, we might do an exhibition that hadn't got any photographs but had the panel system and just treat it as purely an exhibition in its own right. The structure would be the exhibit, and that's how *an Exhibit* came about. . . . Lawrence Alloway came in as a kind of mouthpiece for the project.[1]

The display system used in *Man, Machine and Motion* was refined for *an Exhibit*. The same proportions were used: 8 by 4 feet, although all the panels were cut to 4 by 2 feet 8 inches (therefore allowing three to be cut from a standard 8-by-4 sheet). The steel framework was replaced by a nylon frame, the panels were colored acrylic sheets with varying degrees of translucency, and the total effect was of floating planes of color. Once this had been arranged, Pasmore attached cut-paper shapes to some of the panels, making them seem less anonymous.

As with *This Is Tomorrow*, and to a lesser extent *Parallel of Life and Art* and *Man, Machine and Motion*, *an Exhibit* was an environmental show. However, it differed from all of them, in Hamilton's words, because although "the panels were static . . . new experiences of panel groupings were available to the spectator passing through them–his mobility gave him the opportunity to generate his own compositions."[2]

At some point during the planning of the show, the arrangement of panels came to be conceived as a game. The private view invitation card stated: "*an Exhibit* is a game, an artwork, an environment; pre-planned, individuated, verbalised by Richard Hamilton, Victor Pasmore and Lawrence Alloway, to be played, viewed, populated."[3] Lawrence Alloway posed the show's challenge memorably in the catalogue: "*an Exhibit* is a test and an

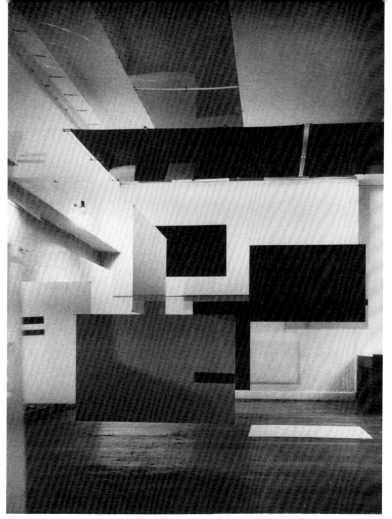

McHale) in foreign periodicals, staged discussions, written articles, catalogue notes, prefaces, and organised or helped to organise exhibitions. . . .

Alloway can be sure of remaining Mr. Abstract until such time as he cares to break it up.[9]

As for Hamilton, his experiences teaching at Newcastle were doubtless a more persuasive influence upon *an Exhibit* than his experiences in the IG. Rather than contradicting an IG influence, however, this reflects the open attitude toward art that was fostered within the Group. In his basic course at Newcastle, Hamilton was suspicious of the division between abstract and figurative art, which threatened to encourage inflexibility in students and so categorize art into one approach or another. "There is a danger that the method will be misapplied and the attitudes distorted," he wrote. "The major distortion, to my mind, being the implication that basic design can teach art students to become Modern Artists, that Abstract Art is the objective of basic design studies."[10] Hamilton's judicious response to this dilemma was reflected in his own work. He, for one, could not be accused of following one direction with complete disregard for another – compare *Man, Machine and Motion* with *an Exhibit*, or look at the juxtaposition of figurative and abstract elements in his paintings and prints.

At the Hatton Gallery in May 1959, Hamilton and Pasmore rearranged the acrylic panels in the same frames that had been used for *Man, Machine and Motion*. Set in an open box format, small strips of color were added to the panels to give a more linear, irregular, and elaborate effect than in the previous show. This was *Exhibit 2*.

Later in 1959 at the ICA, Robyn Denny, Richard Smith, and Ralph Rumney exhibited "an environment made from the paintings of [these] three artists and organised by certain rules decided upon by the painters before the paintings began."[11] Two standard sizes of paintings were used (7 by 6 feet and 7 by 4 feet), the notion of a game environment was incorporated, and colors were restricted to red, green, black, and white. Roger Coleman, who was then on the ICA's Exhibitions Committee and had studied at the Royal College of Art with Denny and Smith, recalled that *Place*, as the show was called, "was a kind of offshoot of . . . *an Exhibit*."[12]

entertainment: are you maze-bright or maze-dim?"[4]

The exhibition was shown at the Hatton Gallery, Newcastle, from 3 to 19 June 1957, and then at the ICA from 13 to 24 August. Response to the exhibition was mixed. The *Manchester Guardian* critic disliked the show, describing it as "an idea that lacks novelty, badly carried out by persons with little talent for translating their intentions into reality."[5] Dorothy Morland called it "a sort of honourable failure."[6] The *Architects' Journal*, however, recommended it as an investigation of architectural experience, citing the changing open and closed views and the play of transparency and reflectivity.[7] The *Times* critic delighted in the show's perceptual and conceptual ambiguities, noting that "[it] can be a game or an entertainment, or a test of one's intuitive visual responses according to how you look at it."[8]

The relationship of *an Exhibit* to the Independent Group is problematic. Pasmore's involvement in the show was certainly not a surprise. Nor indeed was Alloway's, for although he had been to the fore in promoting the imagery of popular culture as no less valuable than that of fine art, his public reputation was based upon his writing about abstract art. Reyner Banham emphasized this point not long after *an Exhibit* closed:

Quite apart from the book which made a movement out of a mess [Nine Abstract Artists, 1954], Alloway has put articles on key men (Pasmore,

1. *Interview, edited version, Richard Hamilton and Dorothy Morland, n.d., p. 4 ICA archives.*
2. *Richard Hamilton, Collected Words 1953-1982 (London, 1982), p. 26.*
3. *Invitation card to private view of an Exhibit, 12 August 1957, ICA archives.*
4. *an Exhibit, exh. cat. (London, Institute of Contemporary Arts, 1957).*
5. *Stephen Bone, "All a Matter of Environment," Manchester Guardian, 15 August 1957.*
6. *Dorothy Morland, interviewed by the author, 26 May 1982.*
7. *Astragal, "Space Planes," Architects' Journal, 125 (20 June 1957), p. 907.*
8. *"An Inside View of Abstract Art: Entertaining Exhibit," Times (London), 14 August 1957.*
9. *Reyner Banham, "Alloway and After," Architects' Journal, 126 (26 December 1957), p. 493.*
10. *Richard Hamilton, "About Art Teaching Basically," Motif, 8 (Winter 1961), p. 17.*
11. *Roger Coleman, in Place, exh. cat. (London, Institute of Contemporary Arts, 1959).*
12. *Roger Coleman, interview by the author, 18 April 1983.*

Critical writings

The following selections from the writings of Independent Group leaders are intended to represent their distinctive critical perspectives while gathering some key formulations into a convenient space. The sole purpose of the IG was critical discussion. The various articles published by its principals in the 1950s provide valuable evidence of the specific issues and arguments that emerged, although it should be noted that several of the most influential texts appeared well after the meetings ended. Separate bibliographies for each IG member appear at the close of this catalogue, and will repay scrutiny. Widely available accounts of the IG, such as Lawrence Alloway's essay in Lippard's Pop Art (1966) and Reyner Banham's recollections in The New Brutalism (1966), are not drawn upon here.

For the IG's three major critics – Alloway, Banham, and Toni del Renzio – these writings must stand for their achievements just as visual works do for other members. I have therefore prefaced their texts with brief accounts of their careers and intellectual contributions to the Independent Group.

D.R.

Lawrence Alloway

In 1955, at the outset of his distinguished career as an art critic, Lawrence Alloway (b. 1926) joined John McHale in convening the final series of IG meetings, focusing discussion on the mass media. The ideas Alloway was developing at this time — particularly his emphasis on a ''fine art/popular art continuum'' that corresponded to the pluralist terms of urban culture — served as working assumptions in his subsequent critical career in England and America.[1] Alloway's lifelong delight in the city is inseparable from his distaste for academicism. His father was a bookseller, and as a teenager Alloway wrote ''filler'' book reviews for the Sunday London <u>Times</u>. He studied art history in London University's evening school program. When he came to the ICA, Alloway was a docent at the Tate and National Galleries and art reviewer for <u>Art News and Review</u>. From 1953 to 1957 he was the British correspondent for <u>Art News</u>, which Thomas Hess had turned into the leading forum for Abstract Expressionism. In 1954 Alloway published a study of contemporary British abstract art called <u>Nine Abstract Artists</u>. Characteristically, he was involved at the same time with the return to iconography in both sculpture and painting, a trend that was influencing the careers of the artists in the Independent Group.

The IG and other forums and activities at the ICA provided Alloway with opportunities to test and formulate his radically inclusive understanding of culture. He pointedly drew at least as much from science fiction and Hollywood films as from new conceptual developments like cybernetics, communications theory, and game theory. Alloway's anti-hierarchic perspective,

which he justified in both anthropological and egalitarian terms, supported an often polemical commitment to American culture and technology.

Alloway became a central figure at the ICA between 1953 and 1954, lecturing on Hollywood films as mass media ''channels,'' as well as on artists and issues of the modern movement. In 1953 he was elected to the Exhibitions Committee, and in 1954 he organized the important <u>Collages and Objects</u> show (designed by John McHale) and assumed a major role in the IG's lecture series, Aesthetic Problems of Contemporary Art. In July of 1955, at the close of the IG sessions he and McHale organized, Alloway became assistant director of the ICA.

In 1958 Alloway went to New York on a State Department grant. During this trip he met Barnett Newman and visited the studios of Jasper Johns and Robert Rauschenberg. In 1961 he moved to the United States to teach at Bennington College, and the following year he became a curator at the Guggenheim Museum, just as Pop Art was emerging.

Alloway's analyses of Pop Art constituted an important aspect of his critical activity over the following fifteen years. When he coined the term ''pop art'' in the 1950s, he meant the productions of the mass media, under-

stood as ''one of the most remarkable and characteristic achievements of industrial society.''[2] This is how the IG used the term ''pop'' in its 1955 discussions. ''Pop art'' in this sense belonged to a pluralist approach to cultural description (Alloway's ''fine-art popular art continuum''). A range of conventions was assumed, with audiences moving knowingly between them. When a painting style called Pop Art emerged in the early 1960s, Alloway regarded it as a ''second phase'' aesthetic withdrawal from the inclusivist consciousness of the Independent Group. As an art critic, however, he brought his interest in communications systems to his analyses of specific works of Pop Art and to his historical interpretations of the movement. Pop Art was characterized as a transformation of ''material that already exists as signs,'' producing an interplay between popular and fine art uses of relatable iconographies.[3] Alloway thus defended Pop Art both as a welcome immersion of art in the contemporary city and as a metonym for the information-saturated, topical status of all art. This communications-based position, which Alloway did so much to promote within the informal context of the Independent Group in the 1950s, has since been elaborated on many fronts.

After leaving the Guggenheim in 1966, Alloway took on major editorial roles with <u>The Nation</u> (1968–80) and <u>Artforum</u> (1971–76). Among his many books of criticism, four are particularly relevant in their development of issues and themes that emerged from the Independent Group — <u>Violent America: The Movies 1946–64</u> (1971), <u>American Pop Art</u> (1974), <u>Topics in American Art Since 1945</u> (1975), and <u>Network: Art in the Complex Present</u> (1984).

1. The first published appearance of Alloway's concept of a ''fine art/popular art continuum'' is John McHale's citation of it in his 1955 article ''Gropius and the Bauhaus.'' (See ''Critical Writings.'') Given McHale's polemical application of the Alloway quote in this critique of the Bauhaus legacy, it can be assumed that Alloway was using it at the time in the IG discussions on popular culture.
2. Lawrence Alloway, ''The Arts and the Mass Media,'' Architectural Design, 28 (February 1958), p. 84. (See ''Critical Writings.'')
3. Lawrence Alloway, ''Popular Culture and Pop Art,'' Studio International, 178 (July–August 1969), p. 19.

Lawrence Alloway,
''Dada 1956'' (excerpt),
Architectural Design,
November 1956

The post-war atmosphere of the 1950s is probably more congenial to dada than the period between the wars with its compulsive system-building (surrealist or purist). In America, occasional gestures of Jackson Pollock, such as cigarette stubs left in the paint, have been interpreted as dadaistic. In France, Michel Tapié has praised the dadaists for their "authentic individuality" in comparison with which the artists of the later 1920s and '30s (Matisse, Picasso, Braque, Dali, and so on) seem conformists to fairly narrow ideas of art.

Faced with a non-figurative painting by, say, Mondrian or a surrealist painting by, say, Tanguy, it is possible to recognise a work of art of a particular sort. Most rational people can do just this. Faced with a product of dada this reaction is inadequate. The question arises: what is art? Or, is this art? This power of questioning our aesthetic assumptions by contravening the traditional status of art is of prime importance to anybody interested in art. It is hardly answering the questions to write dada off as artistic delinquency. Its ironies and double takes put us on the spot because they are performed by men with a great deal of artistic talent, more than most of us have: Arp, Duchamp, Ernst, Picabia, Schwitters, Tzara.

The point about the dada attitude, which we can see clearer now than at any time before, is its indifference to strict, exclusive categorised thinking. Instead of setting up an absolute standard of performance dada is skeptical and permissive. To quote Tzara:

> Dada tried to destroy, not so much art, as the idea one had of art, breaking down its rigid borders, lowering its imaginary heights – subjecting them to a dependence on man.

Tzara wrote that, rather reflectively, in 1953. In 1918 he wrote:

> A work of art is never beautiful by decree, objectively, and for all. Hence criticism is useless, it exists only subjectively, for each man separately, without the slightest character of universality. Does anyone think he has found a psychic base common to mankind? . . . How can one expect to put order into the chaos that constitutes that infinite and shapeless variation: man?

This acceptance of the multiple value of life is the great achievement of dada. It does not insist upon the abstraction of fixed aspects of life for aesthetic treatment. Hence its power of setting deadly sphinx-like questions to art-lovers. It effectually consigns art to the tangled channels of everyday communications. A work of art may be made of bus tickets or it may look like an advertisement. It may be an ad.

REMEMBER, DADA WRITTEN BACKWARDS SPELLS AD/AD.

Lawrence Alloway,
''Personal Statement,''
Ark 19, Spring 1957

If I have a reason for writing a personal statement it is because of my consumption of popular art. Many art critics do this, by the fire or in bed, but they don't let it show. Alan Clutton-Brock told me once that he read science fiction (English SF, of course) but, like the Times-man he then was, he did not let it show when writing "seriously." And I suppose other art critics consume the usual detective stories. For me, however, the consumption of popular art (industrialized, mass produced) overlaps with my consumption of fine art (unique, luxurious).

I think there are two problems common to many people of my age (I was born in 1926) who are interested in the visual arts.

(1) We grew up with the mass media. Unlike our parents and teachers we did not experience the *impact* of the movies, the radio, the illustrated magazines. The mass media were established as a natural environment by the time we could see them.

(2) We were born too late to be adopted into the system of taste that gave aesthetic certainty to our parents and teachers. Roger Fry and Herbert Read (the two critics that the libraries were full of ten years ago) were not my culture heroes. As I saw the works of art that they had written about I found the works remained obstinately outside the systems to which they had been consigned. Significant form, design, vision, order, composition, etc., were seen as high level abstractions, floating above the pictures like ill-fitting haloes. The effect of all these redundant terms was to make the work of art disappear in an excess of "aesthetic distance."

The collapse of old-hat aesthetics was hastened for me by the discovery of Action Painting which showed that art was possible without the usual elaborate conventions.

The popular arts reached, soon after the war, a new level of skill and imagination. Berenson, Fry, Read and the others gave me no guidance on how to read, how to see, the mass media. Images of home, the family, and fashion, in the glossy magazines; narratives of action and patterns of behaviour in the pulps; the co-ordination of both these images and these narratives in the movies. My sense of connection with the mass media overcame the lingering prestige of aestheticism and fine art snobbism.

I have been accused (by Basil Taylor among others) of being Americanized and, since I am English, thus becoming a decadent islander, half-way between two cultures. I doubt that I have lost more by my taste for the American mass media (which are better than anyone else's) than have those older writers who look to the Mediterranean as the "cradle of civilization."

The pressure of the mass media and the failure of traditional aesthetics combined to unsettle fixed opinion and hint at new pleasures. I tried various ways to hold the experiences of fine and popular art together. My first strategy was the surrealist one of looking for hidden meanings to unify John Wayne and Bronzino, Joan Crawford and René Magritte. But one day my patient Mr. Goldwyn got up and walked away and as his couch cooled I knew a chapter had closed. A trap for the consumer looking for a unifying but tolerant aesthetic is the alignment of the top and bottom without the middle. On this scale Picasso is fine and so are comic books, but in between is the unspeakable middlebrow. But in this excluded middle are novels like *The View from Pompey's Head* and art like Ben Shahn's which are neither "difficult" nor "lively." What is needed is an approach that does not depend for its existence on the exclusion of most of the symbols that people live by. Now when I write about art (published) and movies (unpublished) I assume that both are part of a general field of communication. All kinds of messages are transmitted to every kind of audience along a multitude of channels. Art is one part of the field; another is advertising.

We begin to see the work of art in a changed context, freed from the iron curtain of traditional aesthetics which separated absolutely art from non art. In the general field of visual communications the unique function of each form of communication and the new range of similarities between them is just beginning to be charted. It is part of an effort to see art in terms of human use rather than in terms of philosophical problems. The new role of the spectator or consumer, free to move in a society defined by symbols, is what I want to write about.

Lawrence Alloway,
''The Long Front of Culture'' (excerpts),
Cambridge Opinion 17, 1959

The abundance of twentieth-century communications is an embarrassment to the traditionally educated custodian of culture. The aesthetics of plenty oppose a very strong tradition which dramatizes the arts as the possession of an elite. These "keepers of the flame" master a central (not too large) body of cultural knowledge, meditate on it, and pass it on intact (possibly a little enlarged) to the children of the elite. However, mass production techniques, applied to accurately repeatable words, pictures and music, have resulted in an expendable multitude of signs and symbols. To approach this exploding field with Renaissance-based ideas of the uniqueness of art is crippling. Acceptance of the mass media entails a shift in our notion of "what culture is." Instead of reserving the word for the highest artifacts and the noblest thoughts of history's top ten, it needs to be used more widely as the description of "what a society does." Then, unique oil paintings and highly personal poems as well as mass-distributed films and group-aimed magazines can be placed within a continuum rather than frozen in layers in a pyramid. (This permissive approach to culture is the reverse of critics like T. S. Eliot and his American followers – Allen Tate, John Crowe Ransom, who have never doubted the essentially aristocratic nature of culture.)

Acceptance of the media on some such basis, as entries in a descriptive account of a society's communication system, is related to modern arrangements of knowledge in non-hierarchic forms. . . . Techniques are now available (statistics, psychology, Motivation Research) for recognizing in "low" places the patterns and interconnections of human acts which were once confined to the fine arts. The mass media are crucial in this general extension of interpretation outwards from the museum and library into the crowded world.

One function of the mass media is to act as a guide to life defined in terms of possessions and relationships. The guide to possessions, of course, is found in ads on TV and cinema screens, hoardings, magazines, direct mail. But over and above this are the connections that exist between advertising and editorial matter: for example, the

heroine's way of life in a story in a woman's magazine is compatible with consumption of the goods advertised around her story, and through which, probably, her columns of print are threaded. Or, consider the hero of two comparable Alfred Hitchcock films, both chase-movies. In the pre-war 39 *Steps* the hero wore tweeds and got a little rumpled as the chase wore on, like a gentleman farmer after a day's shooting. In *North by North West* (1959) the hero is an advertising man (a significant choice of profession) and though he is hunted from New York to South Dakota his clothes stay neatly Brooks Brothers. That is to say, the dirt, sweat and damage of pursuit are less important than the package in which the hero comes – the tweedy British gentleman or the urbane Madison Avenue man. The point is that the drama of possessions (in this case clothes) characterise the hero as much as (or more than) his motivation and actions. This example, isolated from a legion of possibles, shows one of the ways in which lessons in style (of clothes, of bearing) can be carried by the media. . . .

We speak for convenience about a mass audience but it is a fiction. The audience today is numerically dense but highly diversified. Just as the wholesale use of subception techniques in advertising is blocked by the different perception capacities of the members of any audience, so the mass media cannot reduce everybody to one drugged faceless consumer. Fear of the Amorphous Audience is fed by the word "mass." In fact, audiences are specialized by age, sex, hobby, occupation, mobility, contacts, etc. Although the interests of different audiences may not be rankable in the curriculum of the traditional educationist, they nevertheless reflect and influence the diversification which goes with increased industrialisation . . .

As the market gets bigger consumer choice increases: shopping in London is more diverse than in Rome, shopping in New York more diverse than in London. General Motors mass-produce cars according to individual selections of extras and colours.

There is no doubt that the humanist acted in the past as taste-giver, opinion-leader, and expected to continue to do so. However, his role is now clearly limited to swaying other humanists and not to steering society. One reason for the fail-

ure of the humanists to keep their grip on public values (as they did in the nineteenth century through university and Parliament) is their failure to handle technology, which is both transforming our environment and, through its product the mass media, our ideas about the world and about ourselves. . . .

Lawrence Alloway,
''The Arts and the Mass Media''(excerpts)
Architectural Design,
February 1958

The increase of population and the industrial revolution that paced it has, as everybody knows, changed the world. In the arts, however, traditional ideas have persisted, to limit the definition of later developments. As Ortega pointed out in *The Revolt of the Masses*: "The masses are to-day exercising functions in social life which coincide with those which hitherto seemed reserved to minorities." As a result the elite, accustomed to set aesthetic standards, has found that it no longer possesses the power to dominate all aspects of art. It is in this situation that we need to consider the arts of the mass media. It is impossible to see them clearly within a code of aesthetics associated with minorities with pastoral and upper class ideas, because mass art is urban and democratic.

It is no good giving a literary critic modern science fiction to review, no good sending the theatre critic to the movies, and no good asking the music critic for an opinion on Elvis Presley. Here is an example of what happens to critics who approach mass art with minority assumptions. John Wain, after listing some of the spectacular characters in P. C. Wren's *Beau Geste* observes: "It sounds rich. But in fact – as the practised reader could easily foresee – it is not rich. Books with this kind of subject matter seldom are. They are lifeless, petrified by the inert conventions of the adventure yarn." In fact, the practised reader is the one who understands the conventions of the work he is reading. From outside all Wain can see are the inert conventions; from inside the view is better and from inside the conventions appear as the containers of constantly shifting values and interests. . . .

If justice is to be done to the mass arts

which are, after all, one of the most remarkable and characteristic achievements of industrial society, some of the common objections to it need to be faced. A summary of the opposition to mass popular art is in "Avant Garde and Kitsch" (*Partisan Review*, 1939, *Horizon*, 1940), by Clement Greenberg, an art critic and a good one, but fatally prejudiced when he leaves modern fine art. By kitsch he means "popular, commercial art and literature, with their chromotypes, magazine covers, illustrations, advertisements, slick and pulp fiction, comics, Tin Pan Alley music, tap dancing, Hollywood movies, etc." All these activities to Greenberg and the minority he speaks for are "ersatz culture . . . destined for those who are insensible to the value of *genuine* culture . . . Kitsch, using for raw material the debased and academic simulacra of *genuine* culture, welcomes and cultivates this insensibility" (my italics). Greenberg insists that "all kitsch is academic," but only some of it is, such as Cecil B. De Mille-type historical epics which use nineteenth-century history-picture material. In fact, stylistically, technically, and iconographically the mass arts are anti-academic. Topicality and a rapid rate of change are not academic in any usual sense of the word, which means a system that is static, rigid, self-perpetuating. Sensitiveness to the variables of our life and economy enable the mass arts to accompany the changes in our life far more closely than the fine arts, which are a repository of time-binding values.

The popular arts of our industrial civilization are geared to technical changes which occur, not gradually, but violently and experimentally. . . . Colour TV, the improvements in colour printing (particularly in American magazines), the new range of paper back books; all are part of the constant technical improvements in the channels of mass communication. . . .

The mass arts orient the consumer in current styles, even when they seem purely, timelessly erotic and fantastic. The mass media give perpetual lessons in assimilation, instruction in role-taking, the use of new objects, the definition of changing relationships, as David Riesman has pointed out. . . . A clear example of this may be taken from science fiction. Cybernetics, a new word to many people until 1956, was made the basis of stories in *Astounding Science Fiction* in 1950.

SF aids the assimilation of the mounting technical facts of this century in which, as John W. Campbell puts it, "a man learns a pattern of behaviour – and in five years it doesn't work." Popular art, as a whole, offers imagery and plots to control the changes in the world; everything in our culture that changes is the material of the popular arts. . . .

Lawrence Alloway,
''City Notes'' (excerpts),
Architectural Design,
January 1959

Cities are, to quote John Rannells, [1] "the piling up of people's activities" and these change quicker than buildings or architects' ideas. To describe architecture as "the creation of pure forms of an uncompromising technical perfection and aesthetic integrity," as Colin Glennie did, leaves you alone on an island with Mies. Louis Sullivan had a better idea when he said that it is "the drama of created things" to go "into oblivion." This is nowhere more visible than in the crowded, solid city and nowhere are "permanent" formal principles less likely to survive intact. The past, the present, and the future . . . overlap in a messy configuration. Architects can never get and keep control of all the factors in a city which exist in the dimensions of patched-up, expendable, and developing forms.

The city as an environment has room for a multiplicity of roles, among which the architect's may not be that of unifier. Consider, for example, images of the city in popular arts which reflect and form public opinions in that transmitter-audience feedback which is the secret of the mass media. *Charm*, "the magazine for women who work," gives a bachelor-girl's eye-view of the city, in terms not only of serviceable clothes and crisp make-up tips, but also in terms of the theatre, restaurants, good books, office equipment and work schedule ("alive after five . . . thanks to her Remington Electric Typewriter"). The centenary number surveyed the technology that has changed female status (the sewing machine, the typewriter and the telephone), especially as they affected the careers open to women in the big city. . . .

The mass arts contribute to the real environment of cities in an important way. It is absurd to print a photograph of Piccadilly Circus and caption it "ARCHITECTURAL SQUALOR" as Ernö Goldfinger and E. J. Carter did in an old Penguin book on the County of London Plan. In fact, the lights of the Circus are the best night-sight in London, though inferior to American displays. Related to the neon spectacle are other aspects of the popular environment. The drug stores, with dense displays of small bright packages, arrayed in systems to throw the categorist. The LP environment at airports, restaurants, bars, and hotel lounges, of light and long-lived pop music that extends radio and TV sound outside the house and into a larger environment.

The CinemaScope screen, with its expanded visibility also has connections with the "real" environment. The American cars which match the scale of American streets with a visual ease unimaginable in England, link with the movies. This is not only a matter of design symbolism (rocket outside, theatre within), but also of spatial experience. The panoramic view from inside the luxurious car (comfortable as a first run cinema) echoes the horizontal screen. Thus the windscreen is both a communications device itself and the analogue of another communications device. . . .

Consider the function of one set of symbols for a visitor arriving in a strange city. The city is a complex of communications (postman's route, housewife's route, motorist's route, etc.) which the stranger is not tuned into. The anonymous and recognizable displays of the entertainment section, however, act as instant signals. The services symbolized by the lights and the posters are an extension of the channels of easy communication of trains and planes. The ride from Chicago's O'Hare Airport into the Loop at night is a journey along a noisy, narrow corridor of neon. To the compilers of the *Architectural Review's* "Man-Made America" this would be "unintended squalor," intolerable to people living the architectural way. In fact, it is one stretch of the lighted street which runs across America. . . .

Attempts are now being made to bring within architectural reach much of the pop art that has thrived without being architecture in the qualitative sense of the word. *Forum*, in August last year, discussed an upcoming reciprocal interchange between architecture and popular taste. This was presented as a programme for *schmaltze*, symbolism and *shariwaggi*. Stone's success is a symptom, Yamasaki's Memorial Conference Hall at Wayne University an auger, of the new mood . . . It appears that the architects' professional desire to shape the world may lead them to feed off the public gingerbread. In fact, however, the city seems to be unplannable in popular terms, precisely because of its extension in time and the way people keep moving. . . .

Architecture has its own popular art, without incorporating (and, of course, "improving" in the process) the complex, untidy, fantastic, quick-paced environment. Pop architecture now would include the West Coast domestic leisure style and the Mies vernacular office towers and slabs, spread by Skidmore, Owens and Merrill. Popular art in the city is a function of the whole city and not only of its architects. If the architect learns more about subjective and "illogical" human values from the study of popular art, then architecture will have gained and so will future users; but to adopt playful and odd forms, without their spirit, without their precise functions, will make a solemn travesty of the environment in which pop art naturally thrives.

1. John Rannells, The Core of the City (New York, 1956).

167

Lawrence Alloway,
''Notes on Abstract Art and The Mass
Media'' (excerpts from a review of the
Cambridge Group show of ''pop art'' at
the New Vision Centre, London, February
1960),
Art News and Review,
February 1960

Malevich observed that "Futurism is not the art of the provinces but rather that of industrial labour. The Futurist and the labourer in industry work hand in hand – they create mobile things and mobile forms . . . The form of their work is independent of weather, the seasons . . . It is the expression of the rhythms of our time." Post-war urban-directed art, however, postulates the artist as a consumer, not as a producer changing the world with the co-operation of the worker. Today's artist receives and accepts the media's messages and spectacles. The basic idea is that it is natural for the artist to have absorbed pop culture from the environment (and environment does not mean a street map but a complex of variable opportunities for communication). . . .

The bombardment of the mass media is the man-made analogue of the "sensory bombardment" of our senses at all times. It is by this bombardment that we know the world, and interruptions of this input cause disorientation, anxiety, panic. Since the media is a great carrier of cohesive information (topicality and commonplaces) lack of receptivity to its messages might be said to leave you disorientated. Because the media is a fund of known allusion, shared names and attitudes, shapes and colours, it has a claim to be common ground between artist and audience. . . .

The pop art which is attractive to painters in England is mostly (wholly?) American. It is not a nostalgia for the U.S. It is simply that American pop art is a maximum development of a form of communication that is common to all urban people. British pop art is the product of less money, less research, less talent, and it shows. Geography note: England's position between America and "the rest of Europe" is relevant. We are (a) far enough away from Madison Avenue and Hollywood not to feel threatened (as American intellectuals often do) and (b) near enough (owing to language similarity and consumption rates) to

have no ideological block against the content of U.S. pop art. In Paris, on the contrary, acceptance of American movies and Mad is subject to both a surrealist filter and a language barrier. The result is that French intellectuals judge U.S. pop by a canon of strangeness and eroticism which is sheer fantasy. Luckily England is not subject to this exotic view: the balance of distance and access is just right for U.S. pop art to be real but not common, vivid but not weird. . . .

The world we live in is so well covered by communications that we have learned to experience space and time in a new way. The aesthetic distances of isolate art are replaced by close-up art. CinemaScope aesthetics ousts the Baroque theatre which was the previous model for spectator participation. It is an aesthetics of the enlarged threshold. The boundary between picture space and our space is filled, crossed entered, blurred, reduced. The development of the media of mass communications has multiplied the speed, number, and intensity of these contacts, and artists now in their thirties and twenties have never known a world which was not small in this way. [1]

To refer to bems instead of chimeras, to quote Asimov instead of Plato, separates one from Berenson, Fry, and Read. Today such usage (begun in the early part of the '50s) continues, though it has become frivolous in Ark, where the rigour and intelligence of Roger Coleman's Arks (18 through 20) has subsided, leaving pop as a fund of novelties and funny faces, a compound of the bizarre and the cute. The Victorian craze of the staff of the college of ten years ago has been succeeded by the pop kicks of the students. The Cambridge group at the New Vision, however, shows that a polemical use of pop is still possible without going soft. Robert Freeman, editor of Cambridge Opinion, 17, the "living with the '60s" number, kicks the neo-classic in the dentils and yawns at King's Chapel, reminding us that "Cambridge grew from isolated monasteries" and that "the average speed is [still] that of the bicycle." In reaction to this the four artists have turned "towards the tinsel and jazz of urban activity," like "commuters, juke-boxes, mass-media, and pin-tables." Freeman says they establish a "relationship with these phenomena." How? Mainly by means of pop as polemic and affiliation. . . .

Related to pop as polemic is pop as affil-

iation, and this depends on the existence of the gulf between artist's intention and spectator's reaction. Knowledge of the ambiguity of interpretation of any stimuli, has destroyed the confidence early abstract artists retained in a one-to-one communication with their spectators. Now abstract pictures are subject to the psychology of rumour, to oscillating responses, to the appetite and wiles of the spectator. The problem of the artist in this situation is how to influence the spectator towards the kind of meaning-atmosphere-tone that he intends, even though he knows that he cannot count on an accurate reading of abstract imagery.

The idea that assimilation and (automatic) learning from the mass media is bound to make a difference to the art, even if you can't see it, is just too easy. If your pop consumption shows, so will everything else, and there comes a point at which any meaning is assignable to any work: formal education, nurture, love life, your dreams, your telephone number, how you vote, may all get in, too. Basically, however, pop art, so far as abstract art is concerned, is a vocabulary, or a set of metaphors. Still and Rothko, let it be noted, achieve intimacy in presentation without thinking about "Scope"; both artists believe that abstract art has a "subject" without nominating the media as a source of art's mysterious and integral impurity. Pop's value is as an idiomatic and not-yet-too-hackneyed way of discussing aesthetic problems, free of hierarchic ranking and idealism. Pop serves to dramatise our interest in the spectator, not in his purely aesthetic moments, but as a man or woman whose aesthetics are inseparable from the "multiple affiliations and ambivalent motivations" (Karl Mannheim) of our whole life.

The connection between fine and pop art, then, is not basically one of subject matter. Neither is it a short cut to being hip. The difference the arrival of pop art makes to art is part of a larger shift in attitude. As a result of psychological, sociological, and historical study, and a sensitivity to iconology, art can now be sited within a general field of visual communications. It is now necessary to make a new set of connections between art and the spectator, more accurate and extensive than the currently run-down state of traditional aesthetics allows. . . .

1. It is noticeable that no significant differences have yet emerged in our definition of pop art's role in the environment between the early and the later '50s. TIT, Ark, and Talk rest on the original unrevised hunches and research of the IG.

Reyner Banham

More than anyone, it was Reyner Banham
who defined the character of the Inde-
pendent Group. He was not the founder of
the IG — he became its convener after
Richard Lannoy, who planned the first
meetings, left for India in mid-1952.
However, Banham's preoccupation with
technology and change and his insis-
tence on a genuinely contemporary aes-
thetic decisively influenced the IG's
character and direction. Consciously
indebted to Futurism, Banham was criti-
cal of the constraining influence of the
classical legacy on the Modern Move-
ment. His historical analysis of this
problem became first a doctoral thesis
(under Nikolaus Pevsner, whose ''main-
stream'' history Banham challenged),
then a major public reappraisal of the
modernist architectural tradition,
published in 1960 as Theory and Design in
the First Machine Age. His talks and
writings during the time of the Indepen-
dent Group thus have a twin message — the
history of the Modern Movement must be
rewritten in more inclusivist terms,
and the fast-changing processes of con-
sumer society call into question the
ideological assumptions of machine age
modernism.

During World War II, Banham, who
was born in 1922, went directly from
school into engineering work at the
Bristol Aeroplane Company Engine Divi-
sion, where he received an achievement
award from the Society of British Air-
craft Contractors. His thoroughly prag-
matic, anti-academic approach to
technological issues dates from this
early industrial experience. After the
war, Banham taught local history in his
native Norfolk, where he also worked as
a stage manager, produced criticism for
the local paper, and wrote poetry.
Thanks in part to the interest taken in

his career by a friend, he enrolled at
the Courtauld Institute of Art in Lon-
don, graduating in 1952. He became an
active contributor to several journals
at this time, including the Architec-
tural Review, where he was a conspicuous
presence both as writer and editor until
1964.

Even in Banham's earliest arti-
cles, from 1951 on, we find anticipa-
tions of what now appear to be
historically significant shifts in
thinking about aesthetics and design.
Gathered together, they provide useful
evidence of the issues Banham raised in
IG discussions and formally presented
in ICA programs. Reviewing the ICA's
1951 Growth and Form show, Banham argued
for the reception-based aesthetic that
the IG subsequently developed: ''aes-
thetic value is not inherent in any
object, but in its human usage.''[1]
(Kepes and Paolozzi, he suggests, teach
us how to find aesthetic stimulation in
such a show.) In a 1953 article on
abstract theory, Banham argued that the
contingency-based perspectives of
Gestalt psychology and communications
theory challenge such essentialist
axioms of modern art theory as the faith
in universal forms and physiologically
invariable responses to color.[2] Review-
ing a ''Shell-Mex/BP petrol station''
exhibition in 1952, Banham observed
that its ''facade architecture'' is a
psychological and commercial neces-
sity, and that this calls into question
the modernist axiom that function and
material dictate form.[3] In a 1951 arti-
cle on the aesthetic and commercial
inadequacy of British packaging, Banham
argued that ''technology has out-
stripped art,'' blaming this on the lin-
gering influence of a pre-Bauhaus split
between fine and applied art.[4] In his
important review of the Parallel of Life
and Art show in 1953 (extract follows),
Banham proposed that the meaning of the
visual environment did not lie in the
connections between images and reality,

but in the interactions between the
images themselves (''visual
currency'').[5]

The most important single idea
introduced into the Independent Group
discussions, however, was Banham's the-
ory of expendability, first presented
in an IG talk on the purist ''machine
aesthetic'' in 1953. Praising the
achievements of Detroit car styling,
Banham declared that the marketplace
had more relevance to design than the
laws of nature, and that change and
obsolescence were built-in features of
technology itself.[6] This argument
opened the door to the entire range of
industrial design productions as well
as to the popular media. In ''Industrial
Design and Popular Art,'' first pub-
lished in 1955 in Italy (extract fol-
lows), Banham formulated a new urban
aesthetic out of the connections
between the ''throw-away economy,''
American car design, and the symbol sys-
tems of popular culture (''the dreams

that money can buy''). Richard Hamilton drew the concepts for his car-and-model paintings in the later 1950s from Banham's talks at this time. Finally, Banham contended that architecture had no equivalent for ''that extraordinary continuum of emotional-engineering-by-public consent which enables the automobile industry to create vehicles of palpably fulfilled desire.''[7] This criticism of architecture's self-removal from contemporary social meanings was to have considerable influence upon the inclusivist tendencies of the following decade.

Banham's writings remain an essential source for understanding the issues and disagreements within the Group. In 1955 he wrote on the New Brutalism for the Architectural Review, affirming a unity of avant-garde intent for the artists and architects of the IG, led by the Smithsons, who were influenced by the Art Brut tendency (extract follows). A decade later, in The New Brutalism (1966), Banham portrayed the Smithsons as pulling back from the challenge at the time of This Is Tomorrow. Banham, of course, was redefining the avant-garde in terms of his conceptual fusion of technology and populism.

Banham taught at University College in London from 1964 to 1976, when he came to SUNY-Buffalo as chairman of the department of design studies. In 1980 he became professor of art history at the University of California at Santa Cruz. The attraction of the IG to the urban landscape of the West Coast is reflected in Banham's 1971 study, Los Angeles: The Architecture of Four Arcologies. Reyner Banham died in March 1988, shortly after being appointed to the chair in Architectural Theory and History at New York University.

1. Reyner Banham, ''The Shape of Everything,'' Art News and Review, 3 (14 July 1951), p. 2.
2. Reyner Banham, ''On Abstract Theory,'' Art News and Review, 22 (28 November 1953), p. 3.
3. Reyner Banham, ''Royal Institute Galleries,'' Art News and Review, 4 (23 August 1952), p. 4.
4. Reyner Banham, ''Packaging,'' Art News and Review, 3 (24 February 1951), p. 6.
5. Reyner Banham, ''Photography,'' Architectural Review, 114 (October 1953), p. 260. Toni del Renzio has observed that this review ''does read very much as a piece of the ongoing IG discussions'' (letter to the author, 15 May 1989). Excerpts from Banham's review follow.
6. The published version of this argument is ''The Machine Aesthetic,'' Architectural Review, 117 (April 1955), pp. 295-301.
7. Reyner Banham, ''Vehicles of Desire,'' Art, 1 (1 September, 1955), p. 3. Reprinted in Modern Dreams: The Rise and Fall and Rise of Pop (New York, 1988), pp. 65-70.

Reyner Banham,
''Parallel of Life and Art'' (excerpts from a review of the exhibition),
Architectural Review,
October 1953

The veracity of the camera is proverbial, but nearly all proverbs take a one-sided view of life. Truth may be stranger than fiction, but many of the camera's statements are stranger than truth itself. We tend to forget that every photograph is an artefact, a document recording for ever a momentary construction based upon reality. Instantaneous, it mocks the monumental; timeless, it monumentalizes the grotesque. In the strange photographic record of a ladies' gymnasium of 1910, the camera's unwinking eye, incapable of embarrassment or mirth, perpetuates an anthology of poses as unlikely as those in an Pollaiuolo engraving, in a geometrical setting as rigid as a Piero della Francesca. But in perpetuating what can have been no more than a ludicrous and uncomfortable moment and presenting it to us with a surface texture which, after countless processes of reproduction and re-reproduction, has become an autonomous entity on its own, this old greying photograph functions almost as a symbol, an image, a work of art in its own right. It has so little, now, to do with the recording of any conceivable reality that it is hardly rendered any less, or more, probable by being turned upside down.

This extraordinary image is a photographic document of an event remote both in time and probability, and is one of a hundred such images of the visually inaccessible or improbable which have been assembled for the exhibition, Parallel of Life and Art at the Institute of Contemporary Arts. Such documentation of the remote and unlikely is one of the greatest services which the camera has done for the western man and the western artist, not only in recording works of art and architecture – the contents of André Malraux's "Imaginary Museum" – but also in recording transient human occurrences like gymnasia and coronations, and in investigating worlds beyond human vision, as in ultra-microscopy or extreme range astronomy.

But the photograph, being an artefact, applies its own laws of artefaction to the material it documents, and discovers similarities and paral-

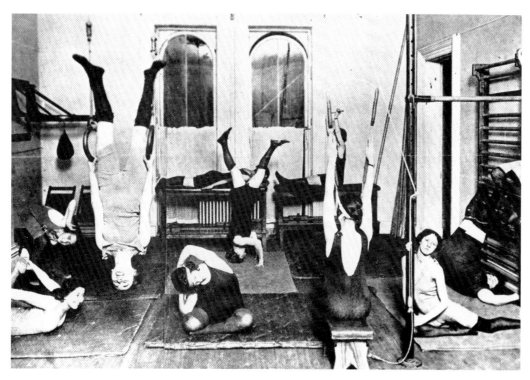

lels between the documentations, even where none exist between the objects and events recorded. Thus, between a head carved in porous whalebone by an eskimo and the section of a plant stem from Thornton's *Vegetable Anatomy*, there is no connection whatsoever except their community of outline and surface texture (even matrix of alveoles with symmetrically disposed roughly lenticular irruptions) in photographic reproduction. They come from societies and technologies almost unimaginably different, and yet to camera-eyed western man the visual equivalence is unmistakable and perfectly convincing. . . .

The organizers of this exhibition are obviously sensitive to many of the implications of the camera. It is creating a new visual environment and they, with their hundred (literally) far-fetched images, have put before us those aspects of the enriched visual scene which they find most stimulating. But we should recognize that if the camera has increased our visual riches, we are richer only in bills of credit, most of which cannot be cashed – there can be no direct visual apprehension of scenes which have passed, or of those which exist only on the photographic plate of instruments like the electron microscope. The

camera, with its strong moral claims to truth and objectivity now over a century old, has established its manner of seeing as the common visual currency of our time, and we come to think of the photographic experience as the equivalent of personal participation. But we should ask ourselves who would be truly richer – one who possessed photographs of every surviving building of the Classical world, or Sir John Soane, who had measured every stone of the orders of the Coliseum and could quote its intercolumniation even in his old age.

Reyner Banham,
''The New Brutalism'' (excerpts),
Architectural Review,
December 1955.

What is interesting about R. Furneaux Jordan's parthian footnote on the New Brutalism – ". . . Lubetkin talks across time to the great masters, the Smithsons talk only to each other" – is not the fact that it is nearly true, and thus ruins his argument, but that its terms of valuation are historical. The New Brutalism has to be seen against the background of the recent history of history, and, in particular, the growing sense of the inner history of the Modern Movement itself. . . .

Adopted as something between a slogan and a brick-bat flung in the public's face, The New Brutalism ceased to be a label descriptive of a tendency common to most modern architecture, and became instead a programme, a banner, while retaining some – rather restricted – sense as a descriptive label. It is because it is both kinds of -ism at once that The New Brutalism eludes precise description, while remaining a living force in contemporary British architecture.

As a descriptive label it has two overlapping, but not identical, senses. Non-architecturally it describes the art of Dubuffet, some aspects of Jackson Pollock and of Appel, and the burlap paintings of Alberto Burri – among foreign artists – and, say, Magda Cordell or Eduardo Paolozzi and Nigel Henderson among English artists. With these last two, the Smithsons collected and hung the I.C.A. exhibition *Parallel of Life and Art*, which, though it probably preceded the coining of the phrase, is nevertheless regarded as a *locus classicus* of the movement. . . . Many critics (and students at the Architectural Association) complained of the deliberate flouting of the traditional concepts of photographic beauty, of a cult of ugliness, and "denying the spiritual in Man." The tone of response to The New Brutalism existed even before hostile critics knew what to call it, and there was an awareness that the Smithsons were headed in a different direction from most other architects in London. . . .

An Image – with the utterance of these two words we bridge the gap between the possible use of The New Brutalism as a descriptive label covering, in varying degrees of accuracy, two

or more buildings, and The New Brutalism as a slogan, and we also go some way to bridge the gap between the meaning of the term as applied to architecture and its meaning as applied to painting and sculpture. The word *image* in this sense is one of the most intractable and the most useful terms in contemporary aesthetics, and some attempt to explain it must be made.

A great many things have been called "an image" – S. M. della Consolazione at Todi, a painting by Jackson Pollock, the Lever Building, the 1954 Cadillac convertible, the roofscape of the *Unité* at Marseilles, any of the hundred photographs in *Parallel of Life and Art*. "'Image" seems to be a word that describes anything or nothing. Ultimately, however, it means something which is visually valuable, but not necessarily by the standards of classical aesthetics. Where Thomas Aquinas supposed beauty to be *quod visum placet* (that which seen, pleases), image may be defined as *quod visum perturbat* – that which seen, affects the emotions, a situation which could subsume the pleasure caused by beauty, but is not normally taken to do so, for the New Brutalists' interests in image are commonly regarded, by many of themselves as well as their critics, as being anti-art, or at any rate anti-beauty in the classical aesthetic sense of the word. But what is equally as important as the specific kind of response, is the nature of its cause. What pleased St. Thomas was an abstract quality, beauty – what moves a New Brutalist is the thing itself, in its totality, and with all its overtones of human association. These ideas of course lie close to the general body of anti-Academic aesthetics currently in circulation, though they are not to be identified exactly with Michel Tapié's concept of *un Art Autre*, even though that concept covers many Continental Brutalists as well as Eduardo Paolozzi.

This concept of *Image* is common to all aspects of The New Brutalism in England, but the manner in which it works out in architectural practice has some surprising twists to it. Basically, it requires that the building should be an immediately apprehensible visual entity, and that the form grasped by the eye should be confirmed by experience of the building in use. Further, that this form should be entirely proper to the functions and materials of the building, in their entirety. Such a relationship between structure, function

and form is the basic commonplace of all good building of course; the demand that this form should be apprehensible and memorable is the apical uncommonplace which makes good building into great architecture. . . . It has become too easy to get away with the assumption that if structure and function are served then the result must be architecture – so easy that the meaningless phrase "the conceptual building" has been coined to defend the substandard architectural practices of the routine-functionalists, as if "conceptual buildings" were something new, and something faintly reprehensible in modern architecture.

All great architecture has been "conceptual," has been image-making – and the idea that any great buildings, such as the Gothic Cathedrals, grew unconsciously through anonymous collaborative attention to structure and function is one of the most insidious myths with which the Modern Movement is saddled. Every great building of the Modern Movement has been a conceptual design, especially those like the Bauhaus, which go out of their way to look as if they were the products of "pure" functionalism, whose aformal compositions are commonly advanced by routine-functionalists in defence of their own abdication of architectural responsibility. But a conceptual building is as likely to be aformal as it is to be formal, as a study of the Smithsons' post-Hunstanton projects will show.

Hunstanton's formality is unmistakably Miesian, as Philip Johnson pointed out, possibly because IIT was one of the few recent examples of conceptual, form-giving design to which a young architect could turn at the time of its conception, and the formality of their Coventry Cathedral competition entry is equally marked, but here one can safely posit the interference of historical studies again, for, though the exact priority of date as between the Smithsons' design and the publication of Professor Wittkower's *Architectural Principles of the Age of Humanism* is disputed (by the Smithsons) it cannot be denied that they were in touch with Wittkowerian studies at the time, and were as excited by them as anybody else. . . . The effect of *Architectural Principles* has made it by far the most important contribution – for evil as well as good – by any historian to English Architecture since *Pioneers of the Modern Movement*, and it precipitated a nice disputation on the proper uses of his-

tory. The question became: Humanist principles to be followed? or Humanist principles as an example of the kind of principles to look for? Many students opted for the former alternative, and Routine-Palladians soon became as thick on the ground as Routine-Functionalists. The Brutalists, observing the inherent risk of a return to pure academicism – more pronounced at Liverpool than at the AA – sheered off abruptly in the other direction and were soon involved in the organization of *Parallel of Life and Art*.

Introducing this exhibition to an AA student debate Peter Smithson declared: "We are not going to talk about proportion and symmetry," and this was his declaration of war on the inherent academicism of the neo-Palladians, and the anti-Brutalist section of the house made it clear how justified was this suspicion of crypto-academicism by taking their stand not only on Palladio and Alberti but also on Plato and the Absolute. The new direction in Brutalist architectural invention showed at once in the Smithsons' Golden Lane and Sheffield University competition entries. The former, only remembered for having put the idea of the street-deck back in circulation in England, is notable for its determination to create a coherent visual image by non-formal means, emphasizing visible circulation, identifiable units of habitation, and fully validating the presence of human beings as part of the total image – the perspectives had photographs of people pasted on to the drawings, so that the human presence almost overwhelmed the architecture.

But the Sheffield design went further even than this – and aformalism becomes as positive a force in its composition as it does in a painting by Burri or Pollock. *Composition* might seem pretty strong language for so apparently casual a layout, but this is clearly not an "unconceptual" design, and on examination it can be shown to have a composition, but based not on the elementary rule-and-compass geometry which underlies most architectural composition, so much as an intuitive sense of topology. As a discipline of architecture topology has always been present in a subordinate and unrecognized way – qualities of penetration, circulation, inside and out, have always been important, but elementary Platonic geometry has been the master discipline. Now, in the Smithsons' Sheffield project the roles are

reversed, topology becomes the dominant and geometry becomes the subordinate discipline. The "connectivity" of the circulation routes is flourished on the exterior and no attempt is made to give a geometrical form to the total scheme; large blocks of topologically similar spaces stand about the site with the same graceless memorability as martello towers or pit-head gear.

Such a dominance accorded to topology – in whose classifications a brick is the same "shape" as a billiard ball (unpenetrated solid) and a teacup is the same "shape" as a gramophone record (continuous surface with one hole) is clearly analogous to the displacement of Tomistic "beauty" by the Brutalist "Image,"[1] and Sheffield remains the most consistent and extreme point reached by any Brutalists in their search for *Une Architecture Autre*. It is not likely to displace Hunstanton in architectural discussions as the prime exemplar of The New Brutalism, but it is the only building-design which fully matches up to the threat and promise of *Parallel of Life and Art*.

And it shows that the formal axiality of Hunstanton is not integral to New Brutalist architecture. Miesian or Wittkowerian geometry was only an *ad hoc* device for the realization of "Images," and when *Parallel of Life and Art* had enabled Brutalists to define their relationship to the visual world in terms of something other than geometry, then formality was discarded. The definition of a New Brutalist building, derived from Hunstanton and Yale Art Centre, must be modified so as to exclude formality as a basic quality if it is to cover future developments and should more properly read: 1, Memorability as an Image; 2, Clear exhibition of Structure; and 3, Valuation of Materials "as found." Remembering that an Image is what affects the emotions, that structure, in its fullest sense, is the relationship of parts, and that materials "as found" are raw materials, we have worked our way back to the quotation which headed this article, "L'Architecture, c'est, avec des Matières Bruts, établir des rapports émouvants," but we have worked our way to this point through such an awareness of history and its uses that we see that The New Brutalism, if it is architecture in the grand sense of Le Corbusier's definition, is also architecture of our time and not of his, nor of Lubetkin's, nor of the times of the Masters of the past. Even if it were true that the Brutal-

ists speak only to one another, the fact that they have stopped speaking to Mansart, to Palladio and to Alberti would make The New Brutalism, even in its more private sense, a major contribution to the architecture of today.

1. *This analogy could probably be rendered epistemologically strict – both beauty and geometry, hitherto regarded as ultimate properties of the cosmos, now appear as linguistically refined special cases of more generalized concepts – image and topology – which, though essentially primitive, have been reached only through immense sophistication. Once this state of sophistication has been achieved, and the new concept digested, it suddenly appears so simple it can be vulgarized without serious distortion, and for a handy back-entrance to topology without using the highly complex mathematics involved, the reader could not do better than acquire a copy of Astounding Science Fiction for July 1954.*

Reyner Banham,
''Industrial Design and Popular Art''
(excerpts), <u>Industrial Design</u>, March
1960. (English version of ''Industrial
Design e arte popolare,''
<u>Civiltà delle Macchine</u>, November 1955.)

We live in a throw-away economy, a culture in which the most fundamental classification of our ideas and worldly possessions is in terms of their relative expendability. Our buildings may stand for a millennium, but their mechanical equipment must be replaced in fifty years, their furniture in twenty. A mathematical model may last long enough to solve a particular problem, which may be as long as it takes to read a newspaper, but newspaper and model will be forgotten together in the morning, and a research rocket – apex of our technological adventure – may be burned out and wrecked in a matter of minutes.

It is clearly absurd to demand that objects designed for a short useful life should exhibit qualities signifying eternal validity – such qualities as "divine" proportion, "pure" form or "harmony" of colours. In fairness to Le Corbusier, it should be remembered that he was the first to raise the problem of permanence and expendability in engineering: "Ephemeral beauty so quickly becomes ridiculous. The smoking steam engine that spurred Huysmans to spontaneous lyricism is now only rust among locomotives; the automobile of next year's show will be the death of the Citroën body that arouses such excitement today." Yet, recognizing this much, he declined to accept the consequences. He singled out the work of Ettore Bugatti for special praise, using components from his cars as examples of engineering design that supported his fine-art view of product aesthetics.

As a result, the engines of the Bugatti cars have been regarded as models of the highest flights of engineering imagination – *except* by some of the most distinguished automobile designers. Jean Gregoire, for example, on whose work in the field of front-wheel drive all subsequent vehicles of this type depend, has refused to find the Bugatti engine admirable. He speaks from inside engineering: "In a particular component, mechanical beauty corresponds to the best use of materials according to the current state of technique. It fol-

lows that beauty can vary, because the technique, upon which the utilization of material depends, is progressive. . . ."

If we examine the qualities that give the Buick engine its unmistakable and exciting character, we find glitter, a sense of bulk, a sense of three-dimensionality, a deliberate exposure of technical means, all building up to signify power and make an immediate impact on whoever sees it. Now these are not the qualities of the fine arts: glitter went out with the gold skies of Gothic painting. Platonic and neo-academic aesthetics belong to the two-dimensional world of the drawing board. But if they are not the qualities of the fine arts, they are conspicuously those of the popular arts.

The words "popular arts" do not mean the naive or debased arts practiced by primitives and peasants, since they inhabit cultures in which such artifacts as Buicks have no part. The popular arts of motorized, mechanized cultures are manifestations like the cinema, picture magazines, science fiction, comic books, radio, television, dance music, sport. The Buick engine, with its glitter, technical bravura, sophistication and lack of reticence admirably fulfils the definition of "Pop Art" of Leslie Fiedler: "Contemporary popular culture, which is a function of an industrialized society, is distinguished from other folk art by its refusal to be shabby or second rate in appearance, by a refusal to know its place. Yet the articles of popular culture are made, not to be treasured, but to be thrown away." This short passage (from an essay on comic books) brings together practically all the cultural facts that are relevant to the Buick.

We have discussed the absurdity of requiring durable aesthetic qualities in expendable products, but we should note that aesthetic qualities are themselves expendable, or liable to *consumo* or wastage of effect, in the words of Dorfles and Paci; and this using up of aesthetic effect in everyday objects is due, precisely, to that daily use. We can see the correctness of this in communications jargon: the "signal strength" of many aesthetic effects is very low; and being unable to compete with the "random noise" aroused in situations of practical use, any low-strength signal (fine arts or otherwise) will be debased, distorted or rendered meaningless where use is the dominant factor. Such situations require an aesthetic

effect with high immediate signal strength; it will not matter if the signal strength is liable to taper off suddenly, if the object itself is expendable, since the signal strength can always be kept up if the signal itself is so designed that use acts on it as an amplifier, rather than as random noise.

In other words, if one opens the Bugatti hood and finds that motor covered with oil, one's aesthetic displeasure at seeing a work of fine art disfigured would be deepened by the difficulty of repair work when the ailing component proves to be hidden away inside the block "for the sake of beauty." In similar circumstances, the Buick would probably be far less disfigured by an oil leak, and its display of components make for much easier repairs, so that visual gratification is reinforced by the quality of the motor as an object of use.

More than this, the close link between the technical and aesthetic qualities of the Buick ensures that both sets of qualities have the same useful life, and that when the product is technically outmoded it will be so aesthetically. It will not linger on, as does the Bugatti, making forlorn claims to be a perennial monument of abstract art. This, in fact, is the solution to Le Corbusier's dilemma about the imminent death of the "body that now causes excitement." If these products have been designed specifically for transitory beauty according to an expendable aesthetic, then they will fall not into ridicule, but into a calculated oblivion where they can no longer embarrass their designers. It is the Bugatti that becomes ridiculous as an object of use, by making aesthetic claims that persist long after its functional utility is exhausted.

We may now advance as a working hypothesis for a design philosophy this proposition: "The aesthetics of consumer goods are those of the popular arts." But this still leaves us with the problem of how such an hypothesis may be put into a working methodology.

Unlike criticism of fine arts, the criticism of popular arts depends on an analysis of content, an appreciation of superficial rather than abstract qualities, and an outward orientation that sees the history of the product as an interaction between the sources of the symbols and the consumer's understanding of them. To quote Bruno Alfieri about the 1947 Studebaker, "The power of the

174

motor seems to correspond to an aerial hood, an irresistible sensation of speed." He sees a symbolic link between the power of the motor and the appearance of its housing, and this is made explicit by the use of an iconography based on the forms of jet aircraft. Thus we are dealing with a *content* (idea of power), a *source of symbols* (aircraft), and a *popular culture* (whose members recognize these symbols and their meaning). The connecting element between them is the industrial designer, with his ability to deploy the elements of his iconography – his command and understanding of popular symbolism. . . .

Reyner Banham,
''Towards a Pop Architecture'' (excerpts),
Architectural Review,
July 1962

Pioneer studies of Borax styling, such as those that appeared in the *Architectural Review* in 1948, were resumed at the Institute of Contemporary Arts in the early fifties, but in an altered tone of voice – approval, not deprecation. This set in motion a series of repercussions among the painters under ICA influence (e.g. John McHale's cover for "Machine Made America," *Architectural Review*, May 1957), created a school of Pop-Art fanciers in the Royal College of Art, and led to awards and other recognitions for artists like Peter Blake and David Hockney. . . . That this was an extension, revolutionary and perhaps beneficial, of the iconography of the Fine Arts, is clear – but it is not clear how it might benefit architecture. The fundamental reason why it will have little to say to the arts of building and town-making is that architects and planners have got there already. For instance, the collage-effect of violent juxtaposition of advertising matter with older art forms, which appears in, say, Peter Blake's work as clusters of fan-club badges on realistic paintings of the human form, was being widely discussed in architectural circles around the time of the Festival of Britain and the Hoddesdon meeting of CIAM, or, in *Architectural Review*, as early as December 1952, when the editors took Professor Guyatt smartly to task for his "aesthetically purist" views on advertising in the townscape.

The fact is that architecture, in a capitalist society, deals in real property and is therefore a branch of commerce. Furthermore, since it creates visible forms, it is apt to become a branch of advertising as well, and in the latter sense there has been a Pop architecture for some time now – Albert Kahn's Ford Pavilion at the New York World's Fair of 1939 is probably the true ancestor of the genre, and its progeny are in various ways widely diffused throughout the U.S. in the form of exclamatory hamburger bars, and other roadside retail outlets. . . .

Architecture can become involved in Pop-Art at its own level and according to the same set of Madison Avenue rules. One way has already been discussed: it can serve as a selling point for some desirable standardized product that is too complex or too expensive to be dispensed from slot machines, and in this sense we have had a sort of Pop architecture in Britain since the beginnings of the Granada and Odeon chains of cinemas. Or, the other way in which architecture can be a part of the Pop world is in becoming, in itself, a desirable standardized product, and in this sense we have had Pop architecture in Britain ever since the more progressive and aggressive speculative builders decided that it was time for housing to quit the eotechnic phase and to take over current advertising and marketing techniques, instead of methods that still smacked of the transfer of fiefs from one vassal to another. Since buildings, despite Buckminster Fuller, are still too heavy to be sent to supermarkets, the consumers instead must be mobile and locally numerous, and these more modern merchandising techniques can only be employed in heavily motorized conurbations. We have had a Pop architecture in Britain, to be precise, ever since SPAN set up shop at Ham Common.

It will certainly be objected that buildings of the sort that have been discussed above are not architecture. The *cordon sanitaire* between architecture and Pop-Art, to which reference was made earlier, represents a very deep-seated desire, as old as the reformist sentiments of the pioneers of modern architecture, that the profession should not be contaminated by commercialism, that architecture should remain a humane "consultant" service to humanity, not styling in the interest of sales promotion. Yet SPAN housing is unquestionably accepted as architecture, for all that it is a nearly-standardized, almost mass-produced, accessible and attractively packaged product. The question of where to draw a line between architecture and commerce becomes almost unanswerable as soon as one tries to draw it. . . .

Reyner Banham,
''The Atavism of the Short Distance
Mini-Cyclist'' (excerpts),
Living Arts,
1963

We are not, as Basil Taylor said at the time of *This Is Tomorrow*, "sophisticated people meddling in unsophisticated matters." I would in any case dispute that Pop Art is an unsophisticated matter, or that any other part of Pop culture is particularly unsophisticated. We were very much at home with this material, it was return-of-the-native stuff, we were in our own culture, sub-culture, or whatever you like to call it. We were natives back home again. But at home in a what? Not a working-class culture à la Hoggart, not a working-class culture as it has been heavily documented of late by a number of people who have fought their way "up" from a proletarian background. What I mean is working-class culture in the sense that an anthropologist would normally describe it and understand it; the way that working-class people live, the kind of cultural standards they hold, enjoy, respond to. Thinking back, the cultural background against which I grew up was a very curious one indeed, if one is to believe the sort of things in Hoggart. The area had a certain amount of "real" culture with a capital C, like the local Philharmonic Society, which could never even play Beethoven right, an occasional concert by someone like Muriel Brunskill, and the local operatic society in *The Mikado*. This was the capital C culture background against which I grew up, and which really meant nothing to any of us. The live culture, the culture in which we were involved, was American pulps, things like *Mechanix Illustrated* and the comic books (we were all great Betty Boop fans), and the penny pictures on Saturday mornings; I know the entire Chaplin canon back to front and most of the early Buster Keatons, not through having seen them at the National Film Theatre under "cultural" circumstances with perfect air-conditioning, but at a 1d or 2d a whack, in a converted garage (practically next to Nelson Street Primary School which was the rest of my cultural background, not to mention the speedway. I was a bob-ender in the days when a bob-ender meant a certain class of person doing a particular kind of thing on a Saturday night). Now the

thing about this background is that it really was the live culture of a place like Norwich at that time in the thirties. The emphasis and most of the content of this culture was American because there was nothing else. Once when we couldn't get American comics we bought a copy of *Punch* by mistake and never again, do you blame us? This was our scene. And I think this is true for a great many of us, especially those who made up the Independent Group, who were the pacemakers of the early and middle fifties in London. Now if this is where we came from, it left many of us in a very peculiar position, vis-à-vis the normal divisions of English culture, because we had this American leaning and yet most of us are in some way Left-oriented, even protest-oriented. This was why I picked this subject to discuss in the first Terry Hamilton Memorial Lecture, because Terry in many ways pinpointed this peculiar situation; people whose lightweight culture was American in derivation, and yet, in spite of that, were and are, of the Left, of the protesting sections of the public.

It gives us a curious set of divided loyalties. We dig Pop which is acceptance-culture, capitalistic, and yet in our formal politics, if I may use the phrase, most of us belong very firmly on the other side. I remember John McHale saying to Magda Cordell once, "If we go on voting Labour like this we shall destroy our own livelihood," – it was during their advertising period, and that's the way this particular split of loyalties struck many people. But equally it struck a lot of people outside our group and they genuinely believed that we didn't know where we were going, or had got into a contradictory position.

To some extent I think we were the victims of the Cold War. Something very weird happened around 1946-47 when the lines were being drawn for the Cold War. Suddenly there came a moment when it was very difficult to read *Time* or any American magazine at all, simply because of one's political loyalties. In that period there arose a situation where one's natural leanings in the world of entertainment, and so on, were to the States, but one's political philosophy seemed to require one to turn one's back to the States. I remember the curiously divided mind in which one listened to Pop records on Radio Luxembourg in the evenings and wondered just whose side you were on.

And, as I say, this Cold War distinction made, in the forties, a division which runs right through English thinking, and indeed much American thinking (people like Dwight McDonald): that to accept, to enjoy, the products of Pop, the products of the entertainment industry, Detroit-styling and such things, was to betray one's political position. We left ourselves with one foot on either side of the dividing line that had been drawn through the culture of the West. And we were blamed from this very platform. Five or six years ago I gave a talk at the ICA which was simply a descriptive attempt to sort out the way the Pop and fine art cultures were related, but I got a tremendous hammering during the questions afterwards from people who genuinely felt that I was deluding myself, confusing the public, misleading everybody, simply by being prepared to regard Pop as something which might be merely described. Apparently it was something which had to be rejected. . . .

It is fairly clear that most hostile responses to Pop culture stem from an ingrained, built-in, previous commitment. But this is not only for political reasons; the response of architects to Pop culture has been – to a person like myself, watching from close-in on the side-lines – continuously fascinating, frustrating and in the end disappointing. There are certain aspects of Pop culture which architects find extremely hard to take. The most obvious one is expendability; the new President of the AA is already on record against expendability on a fairly well-taken, purely mechanical point, that if you make a building which will stand twelve months of English weather it will need to have sufficiently high safety factors to stand for twenty cycles of the English seasons. (I'm surprised he put the figure as low as twenty.) But, as I say, expendability is difficult to take because you're dealing with a body of men who, for good reasons or ill, are traditionally involved with the erection of long term permanent structures. The autumn issue of *Archigram*, admittedly, is devoted entirely to expendability in architecture, and I think it does great credit to Peter Cook and the boys who did the *Living City* exhibition here at the ICA that they are trying to grapple with the problem. I'm not quite sure where they have got with it so far, but this is still a minority reaction within the general body of

architecture, which remains extremely cautious in its response to Pop because of the expendability aspect. But there are more things than just the time-span problems involved here. Pop is economically linked to what, for architects, is an alien culture. Pop puts the ultimate command in the hands, if not of the consumer, then at least of the consumer's appointed agents. And architects cannot really manoeuvre themselves into this position. Some architects have good personal relationships with their clients but it's a different matter when you come to the social relationships of town planning and other large scale matters. You could put it like this: could architects accept the position of being designers of a technological infrastructure, but not be responsible for its eventual appearance? There have been lots of schemes recently in which parts of the building are expendable or are at the whim of the individual occupant, or consumer, or whatever you like to call him, but it's always been arranged so that the big frame dominates visually over the individual private unit. As far back as the apparently permissive aesthetics of the Tecton schemes for Finsbury, where you had a big façade full of little windows, and each window a carefully framed working-class still-life with Nottingham lace curtains and a plaster dog and a pot plant, the whole proposition still called for a *carefully framed* working-class still-life. It kept such firm quotation marks round the inhabitants that they were not deciding the aesthetic of their own dwelling or anything of the sort, the big frame dominated and the working-class inhabitant was simply allowed to peep out through carefully-framed holes on every floor. . . .

It's interesting to see how many architects who at one time were with the Pop scene, have in their various ways resigned or withdrawn from it. Peter Smithson in his House of the Future was designing a fully styled-up house *intended* to be styled-up, in order to make it desirable. The House of the Future had token chrome strips painted round it, and so on. It was to be a fully Pop product so that it would move realistically on the Pop market – it had the sort of gimmicks that were thought necessary then in order to make it viable on the Pop scene. But, more recently, the Smithsons and Eduardo Paolozzi and people like that, have been calling rather necrophilic revivalist meetings of the Independent Group to try and

clear their names of being responsible for the present Pop Art movement in England. It's now become necessary for them to revise their own immediate back-history and autobiography, almost in the Le Corbusier manner. And people like Sir Hugh Casson, for instance, who were very keen and with it when Pop was new and jolly fun are pulling back rather cautiously now because they feel they've opened Pandora's Box and are not quite sure what's coming out. I think David Hockney's hair-dos were enough of a shock to make the Royal College of Art terrified that Pop might spread to industrial design and areas like that where it would cease to be jolly fun. . . .

What it comes to in the end is that for good reasons or bad, with or without political predilections, education gives people a sort of slant or twist of mind which means they can accept or not accept Pop. This is the real determinant – that the English educational system, as you get towards the top of the academic pyramid, cuts certain people off from their origins, their ability to remember what they were like. I am not talking about people who don't have Pop origins – I'm talking about people like myself who have come up the educational ladder hand over hand. They can either accept, or not accept – and slumming is no substitute for being able to accept. Too many progressive people are not with it, they don't dig the scene, they are slumming. They think they're enjoying it but they don't really understand what it is they're with, what is that they're exposing themselves to, and the result produces false expectations. . . .

Progressive people, the people who are going to have to make social action, have got, somehow, to learn to ride with the real culture of the working classes as it exists now. It's no good these well-meaning people deluding themselves with trad jazz and Morris dancing and reed thatching and all that. It is time for them to try and face up to Pop as the basic cultural stream of mechanized urban culture. . . .

Pop is now so basic to the way we live, and the world we live in, that to be with it, to dig the Pop scene, does not commit anyone to Left or Right, nor to protest or acceptance of the society we live in. It has become the common language, musical, visual and (increasingly) literary, by which members of the mechanized urban culture

of the Westernized countries can communicate with one another in the most direct, lively and meaningful manner.

Toni del Renzio

Toni del Renzio (b. 1915) was one of the intellectual leaders of the Independent Group, drawing from a remarkably eclectic intellectual horizon that emphasized aesthetic theory, information theory, modern design, fashion, and the mass media. At the time of the IG, del Renzio had already had considerable personal experience with Surrealist and Futurist art movements. Born in Russia and educated in England and Switzerland, his advanced study was in mathematics and philosophy, which he pursued at Columbia University and at the University of Bologna. He wrote his thesis on William of Occam and logical positivism.[1] During World War II del Renzio associated himself with E. L. T. Mesens and other members of the British Surrealist group, revitalizing their movement with his poetry and painting and by launching a magazine, Arson.[2] After marrying the Surrealist painter Ithell Colquhoun, who had rejected Mesens's political dogmatism, del Renzio also separated from the group.[3] Equally important for the IG, del Renzio worked professionally in mass media publications, having been a fashion art editor for women's magazines before joining the ICA staff as an assistant to the director in the fall of 1951. In 1952 he organized the Tomorrow's Furniture show at the ICA.

In his frequent talks on a broad range of topics at ICA symposia and IG meetings, del Renzio argued for a ''multi-valued logic'' (''non-Aristotelian,'' some called it), rejecting any distinction between form and content and stressing the active, constructive role of the perceiver (or consumer). When del Renzio pressed his radical position in a polemical preface to the Parallel of Life and Art cata-

logue, his criticism of the earlier Growth and Form show as naive prompted the rejection of the preface and finally led to his resignation from the ICA Exhibitions Committee (see his retrospective statement in this catalogue). Nevertheless, del Renzio later played a major role in the ICA lecture series, Aesthetic Problems of Contemporary Art (1954), and in the second IG session in 1955, during which he gave presentations on fashion, on advertising, and on the ''Dadaists as non-Aristotelians.''

Del Renzio joined Harper's Bazaar in 1958, contributing both technical and stylistic innovations to the magazine, and in the 1960s he served as a design consultant for cultural journals in England, France and Italy. He also worked in film and television during this period. In 1975, after a dozen years in Italy, he joined the Canterbury College of Art as head of the department of art history and complementary studies. In 1980 he became acting director of the British Studies Centre in Canterbury of the American Institute for Univer-

sities. From the mid-1970s on, del Renzio has published articles on a characteristically broad range of topics, first in Art and Artists, then in Art Monthly in the 1980s.

1. Toni del Renzio, interview with Jacquelynn Baas and David Robbins, 29 August 1987.
2. See Paul Ray, The Surrealist Movement in England (Ithaca, N.Y., 1971), pp. 231–234.
3. Paul Ray provides a useful account of the rift in the British Surrealist movement between 1940 and 1944 (ibid., pp. 227–248). Ray suggests that Del Renzio's rejection of the Mesens group had as much to do with his interest in occultism as with his anti-Stalinist political position. In his articles on Surrealism in this period, del Renzio defended Breton's theories of automatic writing and attacked the separation of the sign from the thing signified (p. 243) — a position he was to reverse at the time of the IG.

Toni del Renzio,
''Pioneers & Trendies'' (excerpts),
Art and Artists, February 1984

The dominant ideology of the Independent Group was itself contradictory as the most esteemed books clearly show: Giedion's *Mechanisation Takes Command* and, to a lesser degree, his *Space Time and Architecture* as well, McLuhan's *Mechanical Bride*, Norbert Wiener's *Human Use of Human Beings*, Harold Rosenberg's famous/notorious action painting essay (though the book, *Tradition of the New*, in which it was included, appeared later and attitudes were somewhat ambiguous towards it), and Parker Tyler's writings on the cinema, esteemed particularly by Alloway and myself. There was a vague leftish sympathy but it often seemed to be swamped by a fierce "Americanism," an admiration for American technology rather than conscious approval of American foreign policy; and the spectre of Cohn and Shine and McCarthyite witch-hunting was ever present. Some of us, too, had met some of the refugees from Hollywood and this tempered our attitudes.

We were put off by any precise Marxian notions – though maybe Banham's ideas about typicality derived from Lukacs though this name was never mentioned – largely by the cloying sentimentality and clodhopper aesthetic of Berger who appeared to have appropriated sole claim to Marxist art criticism. Certainly I felt that Marxism had little to offer any more and drifted away. Moreover, throughout Europe, the various Communist Parties which were closely associated with aesthetic notions hardly progressed from what was seen by us as discredited social realism. . . .

Besides the more or less formal meetings of the Independent Group, both before, during and after its formation, there were many informal gatherings, lunchtimes at the ICA which was where I first met Alloway and discovered we had some admirations in common, notably, I now recall, for Matta, and over several years Saturday lunchtimes at the French Pub in Dean Street, largely architects, Sandy Wilson, Jim Stirling, occasionally I think, the Smithsons, and sometimes, too, Germano Facetti. For a time, in the early fifties, I lived in Paulton Square, Chelsea, and Paolozzi lived across the square in Kathleen Raine's house. The Smithsons moved nearby and other artists and architects were round about. We all used to see each other often and ideas and arguments flew about. There was something similar in the Hampstead-Swiss Cottage area, with Banham and Turnbull. In some ways, the Independent Group, whatever the motives of the ICA management in promoting it, merely – if that's the right word – crystallised for two or three years, in a more or less formal grouping, something that was under way already elsewhere. And this was significant in the way that decisions on Independent Group activities came to be made, outside any formal committee or other such structure, by a sort of lobbying consensus.

If any one thing could be said to be the unifying principle of the Independent Group, it was a rejection of the very institutionalisation of modernism it most admired in New York. This was not quite as contradictory as it may at first appear. Herbert Read, for example, was seen as compromising and compromised. Banham and myself, particularly, used to say we needed a new book, "*Not Art, Not Now*." Our objections were primarily concerned with a certain academicising "purism" which somehow separated art from life and spoke about "harmony" while already we had recognised in Rosenberg something of the view we took of art. "The painting itself is a 'moment' in the adulterated mixture of his [the artist's] life – whether 'moment' means the actual minutes taken up with spotting the canvas or the entire duration of a lucid drama constructed in sign language. The act of painting is of the same metaphysical substance as the artist's existence. The new painting has broken down every distinction between art and life." But we also felt Read not to be entirely honest inasmuch as he professed anarchism and was a member of the Labour Party, accepted a title for services, not to art but to literature, flirted with aspects of Catholic theology and with the idealist aesthetics of Suzanne Langer. In addition we suspected that our notions of expendable aesthetics and aesthetic expendability, seen first of all in the media and in design, were not limited to that sphere but invaded the whole practice of arts in general. Consequently art could never be pure.

I think the attitudes to art which varied considerably between us shared in a consideration of the meaning of what was then a surprising, even shocking, development – action painting, abstract expressionism or *tachisme*. Indeed, in one of the first public manifestations of the Independent Group, a series of lectures on new departures, my contribution was on the new American painting largely from the point of view established by Rosenberg and therefore something of a corrective to Tom Hess's earlier lecture at the ICA on American abstract painting. I departed from Rosenberg on several important issues which also concerned other preoccupations of the Independent Group, notably as regards Information Theory and the Theory of Games, where I made use of a piece Norbert Wiener contributed to the United States Line's magazine edited by Mathieu. This had quoted a French theoretician, Mandelbrot, who had proposed that any communication process should be seen as a game in which two players are in alliance against a third malevolent player called the devil or entropy.

Due to our overall interests in advertising and the media it was not possible for us to remain tied to non-figurative art, however much we felt unsympathetic to most of the work shown at the *Beaux Arts Gallery*, "kitchen sink." Dubuffet and Giacometti also figured in our Pantheon, and Francis Bacon too. We began to argue that the question of figurative or non-figurative art was irrelevant and that the meaning of form was what counted. This could lead one into a fruitless argument as it did at one of the discussions about signs and images, when it became clear that the majority of the audience, especially a vociferous American presence, clung to a naive philosophical realism which gave words absolute and unchanging significance and for whom "image" was a value to be prized as a quality of a work. To say to them that Pollock's work was constructed of signs and Golub's, say, of images, was heresy not to be tolerated. My plea that debate could only take place if we accepted the conventions and agreed what the words would mean for this discussion only further enraged them, and a reference to Charles Pierce and his classification, iconic, indexical and symbolic, mystified them.

By now the Independent Group had run its span and its ideas had become common property. The Whitechapel show, *This Is Tomorrow*, marked the end of the Group, though there had been some notable absence from time to time;

179

and since I recall nothing like the accounts of the last meeting with everyone running off to the *Biograph* or the *Tolmer* to see some crummy B-movie best forgotten, I suppose I was not at it – already an absence, noted or not I wouldn't, of course, know.

Richard Hamilton,
''Persuading Image'' (excerpts),
Design, February 1960.

The student designer is taught to respect his job, to be interested in the form of the object for its own sake as a solution to given engineering and design problems – but he must soon learn that in the wider context of an industrial economy this is a reversal of the real values of present-day society. Arthur Drexler has said of the automobile, "Not only is its appearance and its usefulness unimportant . . . What is important is to sustain production and consumption." The conclusion that he draws from this is that "if an industrialised economy values the process by which things are made more than it values the thing, the designer ought to have the training and inclinations of a psycho-analyst. Failing this he ought, at least, to have the instincts of a reporter, or, more useful, of an editor."[1]

The image of the fifties shown here is the image familiar to readers of the glossy magazines – "America entering the age of everyday elegance"; the image of *Life* and *Look*, *Esquire* and the *New Yorker*; the image of the fifties as it was known and moulded by the most successful editors and publicists of the era, and the ad-men who sustained them – "the fabulous fifties" as *Look* named them. Being "plush at popular prices" is a prerogative that awaits us all. Whether we like it or not, the designed image of our present society is being realized now in the pages of the American glossies by people who can do it best – those who have the skill and imagination to create the image that sells and the wit to respond humanly to their own achievements.

The present situation has not arrived without some pangs of conscience. Many designers have fought against the values which are the only ones that seem to work to the economic good of the American population. There is still a hangover from the fortyish regret that things do not measure up to the aesthetic standards of pure design; the kind of attitude expressed in 1947 by George Nelson when he wrote: "I marvel at the extent of the knowledge needed to design, say, the Buick or the new Hudson – but I am also struck by my inability to get the slightest pleasure out of the result."[2] There has since been a change of heart on both sides; on the part of the designers, the men who establish the visual criteria, towards a new respect for the ability of big business to raise living standards – and an appreciation, by big business, of the part that design has to play in sales promotion. What was new and unique about the fifties was a willingness to accept a new situation and to custom build the standards for it. . . . The market is made by the virtues of the object: the Eames chair and the Volkswagen, best-sellers in recent years, are concepts which date back to the thirties. Detroit cannot wait that long and this impatience is a clue to what we can expect in all the consumer industries. New products need market preparation to close the gap. Industry, and with it the designer, will have to rely increasingly on the media which modify the mass audience – the publicists who not only understand public motivations but who play a large part in directing public response to imagery. They should be the designer's closest allies, perhaps more important in the team than researchers or sales managers. Ad man, copywriter and feature editor need to be working together with the designer at the initiation of a programme instead of as a separated group with the task of finding the market for a completed product. The time-lag can be used to design a consumer to the product and he can be "manufactured" during the production span. Then producers should not feel inhibited, need not be disturbed by doubts about the reception their products may have by an audience they do not trust, the consumer can come from the same drawing board.

Within this framework the designer can maintain a respect for the job and himself while satisfying a mass audience; his responsibility to that amorphous body is more important than his estimation of the intrinsic value of the product itself – design has learned this lesson in the fifties. The next phase should consolidate that understanding of the essential service he is providing for industry and consumer, and extend the use of new psychological techniques as part of the designer's equipment in finding more precise solutions to the needs of society.

1. *Foreword to George Nelson*, Problems of Design, (*New York, 1957*). pp. vii-viii.
2. *A lecture at the Chicago Institute of Design, reprinted in* Problems of Design, pp. 35-41.

Richard Hamilton,
''Hommage à Chrysler Corp.''
Architectural Design,
March 1958

The artwork on this page is not a reproduction of an existing drawing. It was conceived and executed as a piece of "artwork" in the sense in which the term is used by technical artists and process engravers when referring to drawings made specifically for reproduction. I was asked to provide a drawing which could be reproduced by a line block: a greater tonal range than could be achieved with a line block seemed essential to the pictorial quality of the things I had been doing. The only way to get half tone was to build it into the drawing with ready-made material. I decided to put an existing painting into a form which a line block could assimilate by using drawn marks, pieces of blown up half tone prints, Plastitone and mechanical tints applied by the process engraver to specification. My paintings, lately, have all had aluminum foil applied to certain areas. The editor of *Architectural Design* permitted an additional line block which would enable me to simulate this essential feature of the theme.

Partly as a result of the *Man, Machine and Motion* exhibition, biased by the pop-art preoccupation of the Independent Group and the ICA and using directly some material investigated by Reyner Banham in his auto styling research, I had been working on a group of paintings and drawings which portray the American automobile as expressed in the mag ads. The painting *Hommage à Chrysler Corp.*, of which this is a version, is a compilation of themes derived from the glossies. The main motif, the vehicle, breaks down into an anthology of presentation techniques. One passage for example (though this sequence has been evened out to meet the needs of reproduction) runs from a prim emulation of in-focus photographed gloss to out of focus gloss to an artist's representation of chrome to an ad-man's sign meaning "chrome." Pieces are taken from Chrysler's Plymouth and Imperial ads, there is some General Motors material and a bit of Pontiac. The total effect of Bug Eyed Monster was encouraged in a patronising sort of way.

The sex symbol is, as so often happens in the ads, engaged in a display of affection for the vehicle. She is constructed from the two main elements — the Exquisite Form Bra diagram and Voluptua's lips. It often occurred to me while I was working on the painting that this female figure evoked a faint echo of the Winged Victory of Samothrace. The response to the allusion was, if anything, to suppress it. Marinetti's dictum "a racing car . . . is more beautiful than the Winged Victory of Samothrace" made it impossibly corny. In spite of a distaste for the notion it persists.

The setting of the group is vaguely architectural. A kind of showroom in the International Style represented by a token suggestion of Mondrian and Saarinen. One quotation from Marcel Duchamp remains from a number of rather more direct references which were tried. There are also a few allusions to other paintings by myself.

Richard Hamilton,
Letter to Peter and Alison Smithson.
From Collected Words 1953–1982
(London, 1982).

16th January 1957

Dear Peter and Alison
I have been thinking about our conversation of the other evening and thought that it might be a good idea to get something on paper, as much to sort it out for myself as to put a point of view to you.

There have been a number of manifestations in the post-war years in London which I would select as important and which have a bearing on what I take to be an objective:

Parallel of Life and Art
(investigation into an imagery of general value)

Man, Machine and Motion
(investigation into a particular technological imagery)
> Reyner Banham's research on automobile styling
> Ad image research (Paolozzi, Smithson, McHale)
> Independent Group discussion on Pop Art-Fine Art relationship
> House of the Future
> (conversion of Pop Art attitudes in industrial design to scale of domestic architecture)

This Is Tomorrow
Group 2 presentation of Pop Art and perception material attempted impersonal treatment. Group 6 presentation of human needs in terms of a strong personal idiom.

Looking at this list it is clear that the Pop Art/Technology background emerges as the important feature.

The disadvantage (as well as the great virtue) of the TIT show was its incoherence and obscurity of language.

My view is that another show should be as highly disciplined and unified in conception as this one was chaotic. Is it possible that the participants could relinquish their existing personal solutions and try to bring about some new formal conception complying with a strict, mutually agreed programme?

Suppose we were to start with the objective of providing a unique solution to the specific requirements of a domestic environment e.g. some kind of shelter, some kind of equipment, some kind of art. This solution could then be formulated and rated on the basis of compliance with a table of characteristics of Pop Art.

> Pop Art is:
> Popular (designed for a mass audience)
> Transient (short-term solution)
> Expendable (easily-forgotten)
> Low cost
> Mass produced
> Young (aimed at youth)
> Witty
> Sexy
> Gimmicky
> Glamorous
> Big business

This is just a beginning. Perhaps the first part of our task is the analysis of Pop Art and the production of a table. I find I am not yet sure about the "sincerity" of Pop Art. It is not a characteristic of all but it is of some — at least, a pseudo-sincerity is. Maybe we have to subdivide Pop Art into its various categories and decide into which category each of the subdivisions of our project fits. What do you think?

Yours,

(The letter was unanswered but I used the suggestion made in it as the theoretical basis for a painting called Hommage a Chrysler Corp., the first product of a slowly contrived programme. R.H.)

John McHale, ''Gropius and the Bauhaus'' (excerpts), Art (London), March 3, 1955

The basis of the Bauhaus was developed at Weimar, continuing, after the move to Dessau, along the lines laid down, broadening and developing the initial formulation. It stands now to the lasting credit of Gropius, as the first complete attempt at a total design education, in terms of a real situation, in the early 20c scene.

The actual influence on design, then and since, was great, although this is not the place to discuss this, but rather its relevance as idea, and how this fits with our situation now. . . .

There is the concrete fact of a school – with nearly the productive capacity of a factory. This was adequate, and only possible, in the technology of its period – but the machine, which the Bauhaus viewed as an extension of the hand tool, is now much more the autonomous machine; major changes in industrial techniques and the new synthetics have extended the issue further. Not only this kind of factor has changed in our situation, but also, to quote Lawrence Alloway, "a fine art/popular art continuum now exists," and so, where the Bauhaus had its amateur jazzband and kite festivals – we have bop and Cinemascope.

Dr. Giedion, in the book which gives rise to this discussion [*Walter Gropius – Work and Teamwork*], sums up his idea of the significance of the Bauhaus by saying, "it consisted in exploring the means of bringing the repetitive work of the machine into harmony with the eternal laws of the nature of material." This version of truth to materials seems pretty useless now, in a situation where material may be synthesised according to whichever particular eternal law you feel you would like to be in harmony with.

The ideas of the Bauhaus which seem now more significant, and transmissible, are: –

> *The emphasis on method and angle of approach to problems.*
> *The rejection of certain traditional modes.*
> *The stress on communication – in the sense of the vocabulary to be developed in collective work, and, through its range of publication, in which the function of a kind of information centre is assumed.*
> *Finally, the general preference for both/and rather than either/or.*

These ideas, one feels, developed out of expedience, rather than any consistent body of theory.

Efforts to re-establish the Bauhaus elsewhere have had varying results. There have been no major attempts to do so in England. Many schools use scraps of Bauhaus technique, but usually only in ways which turn any specifically anti-academic qualities, inherent in them, to academic ends. Discussion of Bauhaus theory in the past few years has been mainly among those drawn to it from the angle of the art-object in relation to the machine – a curious inversion of original intent

If, as Gropius says, we are tending to yield to expedience rather than building a new faith, it is because we now find it necessary to revaluate most of our traditional formulations, of even such apparently basic ideas as "harmony," "organic growth," and "universal outlook." Previously it was possible to think in terms of eternal basic conditions, now we have to learn to think in terms of a self-changing basis.

John McHale, ''The Fine Arts in the Mass Media'' (excerpts), <u>Cambridge Opinion</u> 17, 1959

The invention of printing from movable type, first harbinger of the mass production of identical replaceable culture products, began a cultural revolution which is still on the move. Printed books, Riesman's "Gunpowder of the Mind," fractured the matrix of classical culture – by changing the media of communication, the "content," society or culture, was transformed.

But the print-oriented phase generated forces which, in turn, rendered its own cultural assumptions obsolete. The emergent middle classes of the Industrial Revolution rationalized the need for minimal literacy in a growing machine economy, with the pious hope that "universal education" would make the "classical heritage" viable for all. The same hope is still reiterated today, when the changes wrought in society have made this "heritage," where relevant, simply one of a number of possible cultural strategies. Mass production on a phenomenal scale, oriented to mass preference, not elite direction, and the multiplicity of new communicating channels, are producing a culture which bears as little relation to earlier cultural forms as the Atlas rocket does to a wheeled cart. The printed word, once prime medium, takes second place to new uses of aural and visual imagery. By means that have not formerly existed man is given simultaneous global presentation of the events in his culture. In one medium alone, television, his environment is the world, "brought to his home," to quote Max Lerner, "wrapped up in a single gleaming febrile package whose contents change magically and continuously on the quarter and half hour."

The elite of the earlier vertical society has, in the sense of representing and directing cultural preferences, become simply one of a plurality of elites. These relate, and overlap, horizontally – fashion, sport, entertainment, politics, etc. – and are as diverse, and relatively powered, as their audiences and ingroups can be numbered. The apex of the pyramid has become one node in a mesh of interrelated networks spread over the communications system. . . .

This axiom of a change of media affecting form/content is evident even in a borderline case like Malraux's "Museum Without Walls." Photography and modern printing techniques produce a new visual image, the "experience" of which is, in reality, at some remove from that engendered by the original artifact – although this latter experience is also not a constant. Transformation along these lines occurs, in varying degree, however the fine arts are diffused through mass media channels, and is central to consideration of the theme

The point is co-existence of a huge number of available and unconditional choices open to the consumer – a glance at the *Radio Times* will underline this mobile and inclusive aspect of the situation. To like A you don't have to forego B. The Cliff Richard fan doesn't have to switch off Maria Callas. There is no inherent value contradiction in enjoying both a comic strip and a symphony. The degree to which "taste" is imposed, by producing for mass demand, is fractional. The mass audience produced for is sufficiently diverse and mobile in itself, to ensure that the products offered for its consumption will exhibit the same range and variety.

Eduardo Paolozzi, ''Notes from a Lecture at the Institute of Contemporary Arts, 1958,'' <u>Uppercase No. 1</u>, 1958

Key phrases, like key sculpture, take time to make. The arrival at a plastic iconography is just as difficult as a language. A few sculptures per year can alter other plastic values. A few key statements can have a similar effect.
It is my opinion that to talk of ART or, to be specific, modern sculpture, requires a special language:
Avoid using worn cliches, the words that can't even indicate or scratch at the hundred hidden meanings in objects & structures.
My own reading or source material is largely that of previous art works, technical magazines & books, a world of intricate problems and a lucid language.
Experiment, discipline seem to find their own system. Rational order in the technological world can be as fascinating as the fetishes of a Congo witch doctor.

The multi-evocative image demands a prose lyrical style at least.
Anyway, an object which suggests a number of things might be described by the spectator in that order.
Certain expressions are affected by developments such as "as far as the eye can see."
SYMBOLS CAN BE INTERPRETED IN DIFFERENT WAYS.
The WATCH as a calculating machine or jewel, a DOOR as a panel or an art object, the SKULL as a death symbol in the west, or symbol for the moon in the east, CAMERA as luxury or necessity.
Acid etched, copper plated, dipped in liquid solder, the printed circuit, intricate, complex, evocative, as pretty as a Faberge jewel.
Modern polythene toys, due to the combination of plastic injection methods and steel dies, have a microscopic precision impossible to the hand-craftsman of the past.
Giant machines with automatic brains are at this moment stamping out blanks and precision objects, components for other brains which will govern other machines.

Here is a list of objects which are used in my work, that is to say, pressed into a slab of clay in different formations. This forms an exact impression (in the negative of course) and from this a store of design sheets can be built up. They range from extremely mechanical shapes to resembling pieces of bark.

METAMORPHOSIS OF RUBBISH
Dismembered lock
Toy frog
Rubber dragon
Toy camera
Assorted wheels and electrical parts
Clock parts
Broken comb
Bent fork
Various unidentified found objects
Parts of a radio
Old RAF bomb sight
Shaped pieces of wood
Natural objects such as pieces of bark
Gramaphone parts
Model automobiles
Reject die castings from factory tip sites
CAR WRECKING YARDS AS HUNTING
GROUNDS

At the elbow, in wax form: a DIRECTORY OF MASKS, sheets of an ALPHABET OF ELEMENTS awaiting assembly: boxlike LEGS tube ARMS, square HEADS, copper WORDS, WHEELS like eyes for symbols. GRAMMAR OF FORMS neo-geometric ENCYCLOPAEDIA OF FORMS including non-FACE ELEMENTS at the ready DICTIONARY OF DESIGN ELEMENTS

My preoccupation or obsession with metamorphosis of the figure:
That is a CRACKED COLUMN resembling a PETRIFIED TOWER
DISINTEGRATING FIGURE with a SHATTERED HEAD
a CRACKED TOWER like a SHATTERED FIGURE
the METAMORPHOSIS OF A COLUMN INTO A FIGURE
INTO A TOWER A MAZE OF PARTS AND PERSONS
like an avant garde POWER PLANT

This is what I have in mind:
THE CLOCK AS A TOY
 Sites for imaginary ball games
 Slot slit

Non-mechanical toys
Mechanical non useful dolls
Useful non useful Toyclock Toy Man
Experience as a factor
Projects for sites for monuments
A Fantastic
Autobiography
A Biographical fantasy of a
Project of a hundred faces
A fantastic project for a playground
A Historical playground for fantastic
 people
A Battlefield of ideas
A Monument peopled by historic
 fantasies
Weep at monuments to
Fantastic weapons
Pathos
Psychological Atlas
Secret Map
Secret word
Unknown Frontiers
Mud language
Written with object trouve and broken
 toys
A sunken city empire town
The written word as a weapon
The word written is to weep
Cry out a language
Sea light Sun Wheel
Electric Sculpture
The magic Japanese Water Language
Plugs London World
Supply Maps to a
Creative
The paradoxes
A world of shifting dissolving horizons
A traveller in a hostile land
Ephemeral Tracings in the sand
Water signs and shadow language

PRINTED CIRCUIT
The process where SCIENTIFIC PHENOMENA
become
 SIGNIFICANT IMAGES
 the ENGINE FORCE directing the
 construction of
 HELLISH MONSTERS
where is MAGIC & INTUITION now?

PAUL KLEE
And is it not true that even the small step of a glimpse through the microscope reveals to us images which we should deem fantastic and over imaginative if we were to see them somewhere accidentally & lacked the sense to understand them.
Does then the artist concern himself with
 Microscopy? History? Palaeontology?
Only for the purposes of comparison, only in the exercise of his mobility of mind.
And not to provide a scientific check on the truth of nature.

COMPLEX MICROSCOPIC WORLD LIVES IN
THE MOUTH
 ANIMALS WITHOUT BACKBONES
ACCORDING TO SCIENTIFIC TRUTH
SAND WHICH IS CUSHIONED WITH THIN FILM OF
SEA WATER
HERE LIVES A WORLD THE SEASHORE MYSTERY
THESE ANIMALS FIGHT, DIE, REPRODUCE
LIFE OF AN INVISIBLE DIATOM.

DISINTEGRATE
An image is cut out of a newspaper; shall we say a blurred news photo, flashlight taken in the rain, of a crashed aeroplane.
A battered wheel rises sharply in the foreground near a happy face, a cowling like an eye waits in the vegetation.

Twisted and pulled still recognizable crashed
JUNKER
part of the anatomy/fuselage exposed like a wounded beast
zinc-alloy piece filled with Scottish clay
Fragment of an autobiography

THE REDISCOVERY OF AN IMAGE CAN BE
FORCED UPON THE SCHOLAR LONG AFTER
THE INITIAL OPENING OF THE TOMB.
ASSYRIAN MUD LANGUAGE WRITTEN WITH
BRONZE OR WOOD STYLUSES INDICATE THE
CAPACITY OF A GRAIN WAREHOUSE.
CLAY TABLETS UNEARTHED IN A SUNKEN
EMPIRE TOWN
ANONYMOUS FINGERS TRACE A PATTERN,
UNKNOWN, SOON TO BE SOLVED BY A
JESUIT WITH A CALCULATING MACHINE.

HEAD OF CYCLOPS

The amount of movie footage used on films based on Greek mythology could be quickly assessed, though the assembly of people thinly dressed in front of eroded Mediterranean islands would be easier than M.G.M.'s Diane of Poitiers, or, say, The Parson & The Cowboy.

The evolution of the cinema monster from Melies onwards is necessary study for the fabricator of idols or gods containing elements which press in the direction of the victims nerve senses.

SCIENCE FICTION

It is conceivable that in 1958 a higher order of imagination exists in a SF pulp produced on the outskirts of LA than the little magazines of today. Also it might be possible that sensations of a difficult-to-describe nature be expended at the showing of a low-budget horror film. Does the modern artist consider this?

BAS RELIEFS

A fossil fish made not by liquid rocks and millions of years but by a punch on wood
Winter light shines on MARKS & SCRATCHES
 SPECIFIC SMEARS
 TECHNICAL TRACE of a
 BOX CAR IMPRINT
 PLASTIC
 BROKEN CABOOSE SHAPE &
 BENT CLOCK CHASSIS
A path is drawn with a giant finger
Here is an excerpt from a diary written in plastic ciphers
A temple ground lit by flares
A parade of political robots gone criminal

SAINT SEBASTIAN I

My occupation can be described as the ERECTION OF HOLLOW GODS with the head like an eye, the centre part like a retina.
This figure can three parts be described in the use of a form of principle of Architectural Anatomy.
A base containing the title, date and author in landscape letters.
The legs as decorated columns/or towers. The torso like a tornado struck town, a hillside or the slums of Calcutta.
A bronze framework containing symbols resembling bent mechanisms. An automata totally

exposed, with ciphers.
A statement is printed on the back.

HEAD OF SAINT SEBASTIAN II

From the legs as columns and the torso as framework we shift to the HEAD.
A dome, a shell. Partly bent under pressure.
Containing; but only superficially some kind of mechanism.
This might be described as anti-mechanism.

Alison and Peter Smithson, ''But Today We Collect Ads,'' Ark 18, November 1956

Traditionally the fine arts depend on the popular arts for their vitality, and the popular arts depend on the fine arts for their respectability. It has been said that things hardly "exist" before the fine artist has made use of them, they are simply part of the unclassified background material against which we pass our lives. The transformation from everyday object to fine art manifestation happens in many ways: the object can be discovered – objêt trouvé or l'art brut – the object itself remaining the same; a literary or folk myth can arise, and again the object itself remains unchanged; or, the object can be used as a jumping-off point and is transformed.

Le Corbusier in Volume 1 of his Oeuvre Complète describes how the "architectural mechanism" of the Maison Citrohan (1920) evolved. Two popular art devices – the arrangement of a small zinc bar at the rear, with a large window to the street of the café, and the close vertical patent-glazing of the suburban factory – were combined and transformed into a fine art aesthetic. The same architectural mechanism produced ultimately the Unité d'Habitation.

The Unité d'Habitation demonstrates the complexity of an art manifestation, for its genesis involves: popular art stimuli, historic art seen as a pattern of social organization, not as a stylistic source (observed at the Chartreuse D'Ema 1907), and ideas of social reform and technical revolution patiently worked out over forty years, during which time the social and technological set-up, partly as a result of his own activities, met Le Corbusier half-way.

Why certain folk art objects, historical styles or industrial artifacts and methods become important at a particular moment cannot easily be explained.

> Gropius wrote a book on grain silos,
> Le Corbusier one on aeroplanes,
> And Charlotte Periand brought a new
> object to the office every morning;
> But today we collect ads.

185

Advertising has caused a revolution in the popular art field. Advertising has become respectable in its own right and is beating the fine arts at their old game. We cannot ignore the fact that one of the traditional functions of fine art, the definition of what is fine and desirable for the ruling class and therefore ultimately that which is desired by all society, has now been taken over by the ad-man.

To understand the advertisements which appear in the *New Yorker* or *Gentry* one must have taken a course in Dublin literature, read a *Time* popularizing article on Cybernetics and have majored in Higher Chinese Philosophy and Cosmetics. Such ads are packed with information – data of a way of life and a standard of living which they are simultaneously inventing and documenting. Ads which do not try to sell you the product except as a natural accessory of a way of life. They are good "images" and their technical virtuosity is almost magical. Many have involved as much effort for one page as goes into the building of a coffee-bar. And this transient thing is making a bigger contribution to our visual climate than any of the traditional fine arts.

The fine artist is often unaware that his patron, or more often his patron's wife who leafs through the magazines, is living in a different visual world from his own. The pop-art of today, the equivalent of the Dutch fruit and flower arrangement, the pictures of second rank of all Renaissance schools, and the plates that first presented to the public the Wonder of the Machine Age and the New Territories, is to be found in today's glossies – bound up with the throw-away object.

As far as architecture is concerned the influence on mass standards and mass aspirations of advertising is now infinitely stronger than the pace setting of *avant-garde* architects, and it is taking over the functions of social reformers and politicians. Already the mass production industries have revolutionized half the house – kitchen, bathroom, utility room, and garage – without the intervention of the architect, and the curtain wall and the modular prefabricated building are causing us to revise our attitude to the relationship between architect and industrial production.

By fine art standards the modular prefabricated building, which of its nature can only approximate to the ideal shape for which it is intended, must be a bad building. Yet generally speaking the schools and garages which have been built with systems or prefabrication lick the pants off the fine art architects operating in the same field. They are especially successful in their modesty. The ease with which they fit into the built hierarchy of a community.

By the same standards the curtain wall too cannot be successful. With this system the building is wrapped round with a screen whose dimensions are unrelated to its form and organization. But the best post-war office block in London is one which is virtually all curtain wall. As this building has no other quality apart from its curtain wall, how is it that it puts to shame other office buildings which have been elaborately worked over by respected architects and by the Royal Fine Arts Commission.

To the architects of the twenties "Japan" was the Japanese house of prints and paintings, the house with its roof off, the plane bound together by thin black lines. (To quote Gropius "the whole country looks like one gigantic basic design course.") In the thirties Japan meant gardens, the garden entering the house, the tokonoma.

For us it would be the objects on the beaches, the piece of paper blowing about the street, the throw-away object and the pop-package.

For today we collect Ads.
Ordinary life is receiving powerful impulses from a new source. Where thirty years ago architects found in the field of popular arts techniques and formal stimuli, today we are being edged out of our traditional role by the new phenomenon of the popular arts – advertising.

Mass production advertising is establishing our whole pattern of life – principles, morals, aims, aspirations, and standard of living. We must somehow get the measure of this intervention if we are to match its powerful and exciting impulses with our own.

(List of Key Ads: number and sources: *New Yorker* 9, *Ladies Home Journal* 31, *Saturday Evening Post* 2, *Holiday* 2, *Paris Match* 1, *American Vogue* 1.)

Alison and Peter Smithson, ''The New Brutalism,'' Architectural Design, April 1957

If Academicism can be defined as yesterday's answers to today's problems, then obviously the objectives and aesthetic techniques of a real architecture (or a real art) must be in constant change. In the immediate post-war period it seemed important to show that architecture was still possible, and we determined to set against loose planning and form – abdication, a compact disciplined architecture.

Simple objectives once achieved change the situation, and the techniques used to achieve them become useless.

So new objectives are established.

From individual buildings, disciplined on the whole by classical aesthetic techniques, we moved on to an examination of the *whole* problem of human associations and the relationship that building and community has to them. From this study has grown a completely new attitude and a non-classical aesthetic.

Any discussion of Brutalism will miss the point if it does not take into account Brutalism's attempt to be objective about "reality" – the cultural objectives of society, its urges, its techniques, and so on. Brutalism tries to face up to a mass-production society, and drag a rough poetry out of the confused and powerful forces which are at work. Up to now Brutalism has been discussed stylistically, whereas its essence is ethical.

Retrospective statements

LAWRENCE ALLOWAY

I first read science fiction (SF) as a teenager in the early 1940s, when American pulp magazines reached England in fairly large numbers, as cheap bulk cargo or ballast or something, and I began to search for earlier publications. There were no paperback novels then, of course. After a few years my taste changed and I sold the hundred or so magazines I had assembled. At some point in the 1950s, however, I began to read SF again – the now numerous paperbacks and the English edition of *Astounding Science Fiction* – and I found a lending library in London dedicated to SF. It was in Holborn, not far from familiar haunts: the offices of the English *Sunday Times*, where I collected review books and delivered copy, and the National Gallery. By this time SF was as it has always remained for me, a polemical addition to a fine-art-based aesthetic. I read Clifford Simak rather than Elizabeth Bowen, then as now preferring specialized popular culture to Min Pop (Minority Pop).

I had been attracted to movies all my life, which may be why SF movies were mostly disappointing to me, apart from a shock or two. The basic horror-film format was an iconography I had already learned. The genre had its pleasures, though, from Dr. Frankenstein in the clinic during his collecting phase ("This hand shall pick no more pockets"), to the Doctor again who, when informed by his assistant that the patched-up prototype is crying, remarks: "Excellent, even the tear duct works." Efficient illusion films cost more – *This Island Earth*, for example, not as special as a Raymond F. Jones novel, but strong on model work and special effects, or *Forbidden Planet*, the film that supplied *This Is Tomorrow* with Robbie the Robot.

My liking for SF the second time around was, I think, compounded of several elements. First, it was American-based so far as inventive authors, tough editors, and a knowledgeable readership went. Second, it was written by men (rarely by women) who were free of classical culture and – though this is not the same thing – of university influence. (The British mystery story, on the other hand, offended me because of its pro-university aura.) Third, it was a popular art form with set, non-psychologized figures of hero, heroine, and villain shown in situations wittily extrapolated from modern society.

According to an unpublished thesis by Graham Whitham, Richard Lannoy remembers my purely verbal handling of SF terms. If true, this shows my use of SF for verbal aggression, to put down an antagonist, but this is not what attracted me to the mode nor how I regularly used it. I liked SF because it stressed man as a tool user, weapons being tools that extend reach. This definition of reach was shared by the driver of the automobile in the first

Futurist manifesto and the then-new Detroit ads for fingertip control. Incidentally, the theme of contrasting technologies was a constant of *Astounding* covers (primitive and spaceman, for example). Lannoy, it seems, attached no value to SF as a Huizingaesque play with tools and societies. For me, it functioned precisely as that, and not as a personal mystique or a form of camp.

The fact that both of my SF lectures – one in 1954 and one in 1958 – were in the context of the ICA and not given to the IG is an example of the way in which the personal tastes of the IG spilled over. I never doubted, nor to my knowledge did McHale, that the ICA was the parent body, the governing context, the prior organization. Suggestions that the IG, especially McHale and myself, cared nothing for the ICA are an exercise in retrospective cynicism that does not reflect the real situation. Incidentally, on my first visit to the United States in 1958, my list of admired New Yorkers to meet included Mark Rothko and John W. Campbell, Jr. This may have been the only time that an American State Department-sponsored visitor wanted to meet the editor of *Astounding Science Fiction*. In California I discovered that Charles Eames, a West Coast designer whom I greatly admired, subscribed to *Astounding*, liking it, in his words, as "a random triggering device."

As I remember it, the ICA's annual deficit was balanced by Roland Penrose. When I was getting started, he took this situation as normal. Then, after accepting an appointment to Paris by the British Council, he returned to England to face a conflict between the ICA's financial dependence on him and my more developed pro-Americanism, of which SF was one sign. (I had salaried jobs at the ICA continuously from 1954 to 1959.) Sir Roland's taste was pro-School of Paris, and I persistently criticized Picasso, whom he admired especially. I was let go at the end of the 1950s, and accidentally but happily moved to the United States in 1961. *Astounding Science Fiction* changed publishers and got a new title, *Analog: Science Fact and Fiction*. Rothko's presence shone for me as his paintings got darker. And I mostly forgot about the IG until I met Jacquelynn Baas and David Robbins in the summer of 1988.

MARY BANHAM

In January 1977 the Arts Council staged a grand opening for its film, *Fathers of Pop*, about the Independent Group at the Institute of Contemporary Arts in the 1950s. It was written and largely narrated by my husband, Reyner Banham, and directed by Julian Cooper, a friend and colleague from the BBC. The two had made films together before, notably *Reyner Banham Loves Los Angeles* for BBC TV in 1972. The friendship grew during the making of *Fathers of Pop* until it included many of the Independent Group members, men and women, and in some cases their growing families.

It seems astonishing now that none of us questioned the title of the movie at the time. Even without many years of women's lib behind them, the female members of the IG were highly aware and exceptionally strong personalities. As a group they were certainly not submissive, and their contributions to the programs were of great importance. Nor do I think the men saw them in a supporting role. So why FATHERS of Pop? I was already in the United States on opening night, so I did not hear any protests about the title,

if there were any, in 1977.

Recent events, however, especially the appreciations of my husband's life and work that appeared in the press early in 1988, made me think again about this strange omission. Several of the writers talked about the meeting places (other than the ICA) of the early 1950s, where ideas and opinions were exchanged with enthusiasm and vehemence. Some claimed that these were the spawning grounds for the ideas that led to the IG lecture series, exhibitions, and meetings. I believe this is true. And what were the venues? The most regular were the weekly Sunday coffee mornings at our flat in Primrose Hill. Intermittent but quite frequent parties were held at the home of Magda Cordell in Cleveland Square, at Alison and Peter Smithson's house in Limerston Street, and at Richard and Terry Hamilton's house in Highgate. Many more were held in the homes and studios of the large and loosely organized membership of the Independent Group.

While we often strongly disagreed over details, the cement that held us together was an overwhelming belief in the future and in technology as the means, along with a certainty that the past was of interest only as a tool for thinking about the brighter future. In the early 1950s the recent past and the austere present was something we did not like to dwell on. Tomorrow had to be "new and improved." The women, all young and some with children, believed most strongly of all. We threw our best efforts into the ongoing discussion; opened our homes to provide the places; worked on publicity; designed and installed exhibitions; and talked, listened, and wrote.

In those days, no one thought about posterity and who should get credit for what, although Reyner Banham and John McHale kept careful records. Everyone soon passed on to other lives and other places. We did not begin to suspect the importance of the movement until a new generation began to ask us about it. That generation made no gender distinctions – we were all waylaid and our memories picked, with the greatest determination.

RICHARD HAMILTON

It is surprising to find, after thirty-five years, continued public interest in a group of young men and women whose eagerness to explore a new cultural climate was their only shared feature. The tag "group" is a familiar one in London – London Group: an exhibiting society; The Camden Town Group: like-minded painters; The Euston Road Group: like-minded painters; The Bloomsbury Group: an artistic coterie with a recognizable life style, affecting identifiable mannerisms and with sexual habits that make the relationships of their descendants look more like the London Underground map than a genealogical tree. The word "group" appears in the name adopted for our loose-knit organization but it was the independence of the members of the Independent Group that united them.

Discerning the unifying factors that brought the IG together is difficult because there was an artificiality in the founding concept of the association. It was the notion, probably emerging at an Institute of Contemporary Arts committee meeting, that it might be nice if some of the brighter young occasional frequenters of the gallery's bar were brought together under the banner of the ICA. The invitation was accepted by the front runners (it was gratifying to be bracketed as "bright"), though the banner was immediately hauled down and used as a doormat.

Any common characteristics were the result of fortuitous circumstances of time and place. We all had youthful experience of the war in Europe and had been barred from the usual pattern of education. Some of us had been in the forces, some in factories. We were granted the means (by the generosity of a post-war Labour government) to recover this loss and many "mature" students were added to the normal population of higher education centers. It was this emergent generation, hungry for knowledge and seeking a vocation, that formed the backbone of the IG.

What marked the fellowship was skepticism and a desire to know what had been happening in the lost years. There was no meeting of minds such as one might suppose occurred in New York to produce Abstract Expressionism. Clearly, a Jackson Pollock doesn't look like a Barnett Newman, any more than a Franz Kline looks like a Rothko, yet there is a sense of mutual purpose. The members of the Independent Group were bound by no aesthetic brotherhood and sought no concrete outcome of their deliberations. Their research was "pure" rather than "applied."

The crunch came when IG activists were offered the opportunity to contribute to an exhibition at the Whitechapel Gallery. *This Is Tomorrow* made apparent the divisions of sympathies and interests, because the main requirement for inclusion was that each exhibit should be a collaboration. The nearest thing to a common vision was the bond already established between Paolozzi, Henderson, and the Smithsons, and demonstrated by their earlier exhibition *Parallel of Life and Art*. Other teams were either temporary alliances or shotgun marriages. John McHale, John Voelcker and I were brought together on demand and I suspect this was the usual pattern. Two formal statements stood out from the rest – the Paosmithend stockade and the McVoelham construction. The Smithsons' strategy was acute and direct: first stake out a territory and fence it to keep out intruders, then make a shelter in the protected garden and fill the created interior and exterior spaces with artefacts – a classic representation of the human impulse. Instead of isolating and guarding our domain, my partners and I asserted ourselves, blasting the opposition with every gun blazing. What we couldn't occupy we overwhelmed with gaudy visual and aural clamor. Seeing the two reconstructions in New York at the Clocktower (1987), I was struck by their disparity – yet they serve well as complementary symbols of their times. I began to see the Smithson enclosure as standing for post-atomic Earth, a dying world filled with rare fossils and touching memories. The cabinet of Dr. Voelcker was taking off, filled with brash ephemera, to other planets; a cultural spaceship going who knows where.

Like others in the Independent Group in the 1950s, I was searching for a new model of popular life to replace the universalist model of the 1920s, which Le Corbusier, the sculptor of timeless forms, was still triumphantly revalidating. In this context, my trip to America was decisive. I left London with my wife, June, in the summer of 1952 for a year of graduate study at Harvard. In April 1953 we visited Chicago to see the buildings of Wright, Mies, and Sullivan, and carried introductions to the Illinois Institute of Design, where Moholy-Nagy was renewing the prewar European Bauhaus legacy. In August 1953 we drove to San Francisco and Los Angeles. Through John Entenza we met Gregory Ain, Raphael Soriano, and Charles and Ray Eames. We walked into the Beverly Hills showroom of Herman Miller and saw the chairs, storage units, and coffee tables displayed among a host of visual symbols – pebbles, butterflies, feathers, driftwood, folk art, and playing cards – arranged to create a new image of modernism. In late August we met with the Eameses in their high-tech Santa Monica studio, beautiful inside and out. We returned in fall 1953 to work for another year in Chicago, in several offices including Skidmore, Owings and Merrill. In October 1953, Eames and George Nelson showed their film, *A Communications Primer*, at the Art Institute of Chicago, along with a "slide carnival" of symbolic objects. Through these and other American influences, I learned a way of seeing architecture as part of a general cultural situation focused on daily life and experience. I began to see the immense potential of a psychological and sociological approach to art. I returned to London in the summer of 1954, impressed by Charles Eames's visual intuitions of a design theory based on assemblages of signs and symbols. Even then I was sure it had to point away from fixity (even the fixed image of a typical consumer), toward a constantly changing model of popular life. What I could not guess at the time, or even when these ideas were presented in our *This Is Tomorrow* exhibit (1956), was the complexity of the problem involved and the amount of misunderstanding generated by the theme of symbols.

Along with this first-hand acquaintance with Eames, who was to have a profound influence on the Smithsons, I brought several books back to my English circles from American universities. Norbert Wiener's *The Human Use of Human Beings* was then widely read by American students. Even more popular was Suzanne Langer's *Philosophy in a New Key*, which was the first cheap intellectual paperback printed in the United States. (Loose pages floated about Harvard Yard – it fell apart as you read it.) Langer's discussion of symbol-using as the most distinctive human activity impelled me toward the study of imagery and signification as design components. Huizinga's *Homo Ludens*, which became an important text for Alloway, exploded hierarchical norms of expression by stressing the role of play and its symbolism in art and society. Finally, the example of Jean Piaget was influential, through his insights into symbols. He describes them as mental images, or visual forms developed by association rather than by integration. His understanding of the importance of communication to learning, and his opposition to utilization of the concept only for control, was a crucial connection for me. My saturation in Piaget at this time was due to a friend, the Norwegian architect-critic Chris Norberg-Schulz, whom I met at Harvard while he was doing research for *Intentions in Architecture*. Translations of Piaget were available in London then, and I recall discussing *Play, Dreams and Imitation* with several IG members because of its imaginative challenge to reductively "scientific" views of the man-made environment.

Although these books and ideas pointed in different directions, they all complemented the IG's focus on change in modern society and its rejection of humanist ideology. Eames, however, trusted experience rather than books. The public dissemination of his concepts at the ICA can be dated precisely, because *A Communications Primer* was shown in March 1955. In April 1956 Lawrence Alloway, Frank Newby, and I led an ICA discussion of Eames's work, entitled "The Toys and Films of Charles Eames." The tackboard exhibit that Alloway, del Renzio, and I produced for *This Is Tomorrow* was derived from Eames's House of Cards toy, wherein idea-connecting images were served by a component structural system. To my mind, Eames's balance between a rational system as fabric and a language of images is the crucial point. (Neglect of the rational has seriously weakened Post-Modern architecture, for example.) In the exhibit of Group Twelve, side one was a color-coded panel showing how to organize and think with imagery; side two was the "random" side, for magazine tearouts and participation. (Theo Crosby wanted me to change the clippings daily, as I recall.) This probably should have offered more guidance for its use. It was not dependent on chance action (like Tzara's Dadaist poems, composed by drawing words from a bag), nor upon some original "pidgin-picture" language (like Duchamp's metal-anguage of body organs). In effect, the magazine tearouts provided linked memory contexts and new idea bases for people. Side two thus represented art as choice, and choice as producing significance in the mass-media environment. However blurry the concept may have seemed at the time, it represented a new sensibility.

After *This Is Tomorrow*, four of us (Theo Crosby, Bill Turnbull, Edward Wright, and myself) projected a *Signs and Symbols* show at the ICA which would have translated the Group Twelve display at TIT into a large environmental exhibit. We each wrote outlines at Turnbull's suggestion and organized the project at a meeting at Theo's. We planned to transform the ICA's exhibition space into a huge space-frame tunnel, enclosing visitors within a gridded volume, vaulted like a medieval nave – a modified "crossword puzzle," in effect, with colored panels and image clusters mounted onto it. (The prototype for this was Eames's collapsible giant constructor-display kit called The Toy.) My own vision of this evokes a double image of the Eames house's structural fabric (a material-connecting process) and the idea-linking language of assembled signifiers within it. You could hardly regard this mix just as high tech; it combined relaxed seriousness and exuberant symbolizing to explore what is meant by the symbol-concept, "house." The wildly assorted contents of our exhibit would have been assimilated with no sense of aesthetic falsity.

The others did not fully agree with this vision, of course, nor were my own communications about it always clear. We were testing new possibilities, making difficult connections. Nevertheless, it is a great pity this exhibition was not produced. For me, it was really a Gothic image, inspired (like the educational art of the cathedrals) by the classical art of mnemonics, reseeded in medieval pluralism. This was the visual lineage I had attached to

189

the work of Eames in Los Angeles: a continuing flow of classical culture adapted to circumstance. We could not diagnose all this at the time, of course, but the immense scope and potential of "communication theory" was quite evident to us. Since then I have come to realize that "signification" is a better term than Eames's word, "communication." Only if signifiers work effectively, focusing and emphasizing, can communication follow.

MAGDA CORDELL McHALE

Recollecting experience is always difficult, especially when the past is remembered by many individuals who have shared time together. Our memories constantly reshape our history. We tend to reselect and rearrange events and impressions of the past, using them to suit our present expediencies. In reflecting on the Independent Group, I want to try to be as objective as my memory allows and as written documentation supports. The task is made difficult now by the absence of several in the Group. Some left us very early, others later, and some only very recently.

The 1950s found most of us in London, each of us independently examining the images left in our minds and souls in the aftermath of World War II. In some sense we felt that new images might help us to prevent the repetition of the inhuman and unseemly past. It was with some excitement, then, that we approached the new and tried to erase the old. These were important times for us, since we were trying to catch up in our intellectual development, which had been put on hold during the war years. It was not so much that we wanted to learn about art per se; we had immense curiosity about social changes and unexperienced places. Nor was it Paris that drew us; we had known, loved, and visited that city. It was the United States that intrigued us – the America we knew from magazines, books, and occasional movies.

What eventually became the Independent Group started slowly, in spontaneous discussions among friends and foes about shared interests in art and social change. The ICA was a wonderful place to meet. Some of us were members, others brought their friends. And so programs evolved, discussions started, and exhibitions were created. We all participated one way or another, and gradually some of us became friends. It was not so much who started it all or who was more influential that matters. The importance of the Group, for us, lay in its educational value. We learned from each other.

In terms of my own development, I would say that I owe the greatest debts to Lawrence Alloway, Peter and Mary Banham, Bill Turnbull, and the Hamiltons. And of course to John McHale. I think John would say that he felt the same way about these people. Since he is no longer here, I want to emphasize that John McHale's role in the Independent Group was extremely important. He and Lawrence Alloway convened the second round of Independent Group sessions and their fine, imaginative minds guided many discussions and exhibitions into new directions.

I also wish to emphasize, however, that all of the Independent

Group members contributed enormously, and that the Group's success should be remembered as a joint one. Other members whose importance I then recognized and whom I greatly admired were Eduardo Paolozzi and the architects Peter and Alison Smithson. Without the Smithsons, whom I grew to love and respect, my understanding of cities would be much less than it is. I also feel debts of gratitude to John Voelcker, Jim Stirling, Theo Crosby, and the rest of the Group who used to congregate with us at the Banhams' Sunday mornings in Primrose Hill, at occasional parties, at coffee places where we met after movies, and at the ICA. To Frank Cordell, who influenced me in many special ways, I owe that part of me that helped me be whatever I am now. Finally, I apologize to those whom I have not mentioned by name.

It might be useful to clarify John McHale's contribution to *This Is Tomorrow*. The official team for the Group Two Exhibit was McHale, Hamilton, and Voelcker. My own contribution was not in my professional capacity as a practicing painter. Since I was interested in and excited by the content of the exhibit, I wanted to help in any way I could to realize the group's original concepts and design. I sat in on – and participated in – all discussions from the very beginning, as did the late Terry Hamilton. What can be attributed to whom is difficult to say.

It was just before John McHale's departure for the States that the discussions about the exhibit took place, its content and style fixed, and an agreement reached between McHale, Hamilton, and Voelcker. John did not arrive back from the States until a few weeks before the show opened, and we painted and installed the structures of the final exhibit together with the Hamiltons and Voelcker. I recollect many days painting some of the "corridor" flats with Terry Hamilton at the Hamilton's studio garden, as they had a lot of space.

During John McHale's absence, he sent me instructions for exchanging ideas and messages with Richard Hamilton. After my own short visit to America (as I recall, the last two weeks of January 1956 and all of February, or thereabouts), I brought back magazines and bits of materials for the show, including a rough sketch of an exhibit poster by John. I can't recollect if the poster was ever used, but I still have it. John also brought back with him several Duchamp disks (he met with Duchamp during his stay at Yale), enlargements of which were used in the exhibition.

While Richard, of course, "put together" the well-known poster collage for the group (*Just what is it that makes today's homes so different, so appealing?*), some of the material in that collage came from John McHale's files, and both Terry Hamilton and I helped gather the images. We often looked for material in the studio John and I shared. Sometimes when I look at that poster, I think it looks a bit like the sitting room in Cleveland Square where our studio was, but this may be only my imagination.

In 1946 London was a war-weary city; food was rationed, fuel was short, and we had the coldest winter for fifty years. In January the first postwar meeting took place of the organising committee of what was to become the Institute of Contemporary Arts.

In 1947 butter and meat rationing increased, but in 1948 an astonishing event burst on London, organised from a little office on Charlotte Street. This event was the ICA's second exhibition, called *Forty Thousand Years of Modern Art*, which opened at the Academy Cinema in Oxford Street on 21 December and closed on 29 January 1949.

The show displayed just what its title suggested. There were dazzling exhibits of ethnographic masks and other objects lent by museums and collectors, as well as great paintings such as Picasso's *Les Demoiselles d'Avignon* (lent by Alfred Barr of the Museum of Modern Art, New York). A photograph of a fine Cycladic Venus was juxtaposed with an equally hieratic figure by Giacometti. The public loved it; I can remember joining the queue to get in. The ICA was launched. The inspiration and energy for this achievement was engendered by the four principal members of the management committee: Herbert Read, poet, writer, art critic, "the Angel Anarchist"; Roland Penrose, artist, collector, poet, Picasso's friend and biographer; Eric (Peter) Gregory, a director of Lund Humphries, the publishing firm; and Peter Watson, a founder of the magazine *Horizon*.

In 1950 premises were found on Dover Street, one floor up, in a building that had once been the house of Lady Hamilton – in fact, our office had been her boudoir. Jane Drew converted the large drawing room into a gallery, with a club room and a small bar leading off it. There were two exhibitions that year, one in June – *James Joyce: His Life and Work*, with a catalogue and exhibition design by Richard Hamilton – and in December *Aspects of British Art*, which included Richard Hamilton, Eduardo Paolozzi, and William Turnbull.

On December 12th the Dover Street premises were officially opened. The ICA had arrived and quickly established itself as a gallery where the work of international avant-garde artists, including, of course, British artists, was to be seen, most often for the first time. In addition the ICA provided a forum for lectures and discussions on every aspect of contemporary art and related subjects, such as science, poetry, theatre, philosophy, and architecture. In the somewhat cramped conditions of the club room, members and their friends and visiting artists were made welcome; at lunchtime it sometimes happened that spontaneous meetings occurred between some of the younger artists.

In 1952 Richard Lannoy, our gallery manager, came to me with a request from Richard Hamilton and some others for the use of the gallery from time to time, so that they could have private gatherings, exchange ideas, and project some of the images that were influencing their creative development. We discussed their aspirations and they were absolutely clear that they wanted to be independent (so far as I recall, that is how the name arose) from the main ICA activities, from the members whom they did not want dropping in, and from the Free Painters, as they were later called, who also borrowed the room at the ICA.

The Management Committee agreed, after a short discussion. Perhaps there was some surprise that the idea had arisen and that this group (although it didn't really appear to be a group at the time) felt the need for its activities to be private. The Committee was very open, very tolerant. In April 1952 the IG had its first meeting. Paolozzi gave an explanatory show of his scrap book material, using our ancient epidiascope, which caught fire now and again, adding a further element of excitement to a surprising and iconoclastic evening. The principal figures in the beginning were Hamilton, Paolozzi, Henderson, McHale, and the Smithsons. Each one was free to choose his or her own priorities with regard to images from popular magazines, fine art, and technical journals. My impression from those early days is that Hamilton and Paolozzi stood out as the initiators of the group, although the Smithsons had many meetings with Henderson and Paolozzi at Paolozzi's Bethnal Green studio. The personalities were all very different – Paolozzi vigorous and somewhat aggressive, Hamilton quieter and more intellectual. Henderson and Paolozzi were inseparable, and Henderson, who was older, undoubtedly had a strong influence at that time on Paolozzi. The Smithsons always seemed in perfect accord and came up with startingly fresh ideas. McHale had a quiet, determined Scottish manner and was always thoughtful and coherent. He inspired a feeling of respect for anything he had to say.

The meetings of the IG lapsed after the first few months, but revived again in 1953 when Banham joined the ICA Management Committee, representing the IG. Before his arrival, it had met rather sporadically; someone, perhaps Richard Lannoy, would approach me informally and say that they would like a meeting, and I would give them a date. Banham gave the IG a coherence it had previously lacked. There were a few jokes about him joining the establishment, but perhaps the IG needed some direction from someone who was not a practicing artist.

Lawrence Alloway, who was appointed assistant director in 1955 with responsibility for certain exhibitions and their related activities, introduced a further level of structure. He was energetic and ambitious, and the activities of the IG increased and became more organised. But at the same time Alloway created a more divisive feeling within the ICA. He was very hostile to Herbert Read and Roland Penrose, to the ICA hierarchy. Although he championed the IG – he indubitably helped put the whole thing on the map – and though he brought in new people like John McHale and Magda Cordell, somehow, by 1956, it felt as though the Institute had become more splintered and restless.

So much has been said and written about the ICA and the IG that it would be tedious for me to add further to it. I saw my role as that of a reliable godmother. When I look back on the eighteen years I spent in Dover Street, my memory is of very hard work with many rewards. The first five years were the best, immensely exhilarating. My association with the main figures of the Management Committee was an inspiration to me. I grew to love them – Herbert Read, Roland Penrose, and Peter Gregory especially. (I recall Peter Watson as a more shadowy figure.) All four were visionaries, idealistic and unassuming. There were difficult times, as when Penrose went to Paris for three years, but I had help and support from many people – too many to name here. In particular, though, I must mention Reyner Banham, warmhearted and supportive; Julie Lawson, my closest colleague and sweet,

intelligent friend; and Geoffrey Lawson (no relation), our wonderful bar manager.

EDUARDO PAOLOZZI

The story of my connection with the Independent Group begins in June 1947. I had my first one-man show at the Mayor Gallery and completed my last term at the Slade School of Art. Apart from a few friends, who all made their mark in their field some way or other in later life, most of the students at the Slade belonged to a world different from mine – a world antipathetic to modern art in any form. Both students and teachers admired "academic" Royal Academy paintings of horses in landscapes or ships at sea with readable rigging. I reacted to the work of Picasso and Matisse – artists then much derided in London, where Augustus John and Alfred Munnings were idealised. Fortunately, others shared my interests. There were friendships with John Davenport and Peter Watson, who had lived abroad and whose apartments were full of works by artists such as Max Ernst, Giacometti, and Picasso, in an ambience charged with books and music that came from the culture of Paris.

For me there was also the stimulation of the London Gallery, owned jointly by Peter Watson, A. Zwemmer, and Roland Penrose. E. L. T. Mesens was the manager; Mesens's assistant was George Melly. The London Gallery was operated ideologically for the promotion in England of living Surrealist artists. On view were paintings by de Chirico, Ernst, and Schwitters, as well as by leading English Surrealist artists. Dear Toni del Renzio will remember this world better than I – he was married at the time to a prominent English Surrealist painter, Ithell Colquhoun. Together we would visit Roland Penrose at Downshire Hill, Hampstead – a home overflowing with bizarre books, African carvings, peculiar documents, and strange indescribable objects reflecting Penrose's admiration for Breton and Ernst. The Surrealist literature there and at Zwemmer's bookshop pointed to the making of art using unconventional materials and images. To my eye it was a happy return to my familiar Scottish street culture, to the cigarettes and film stars pasted in scrapbooks during my childhood.

Through the winter and spring of 1946 to 1947, I worked on collage with a heavy debt to Picasso and on black and white drawings of fishermen inspired by Ernst. These were reproduced in the magazine *Horizon*, run by Peter Watson, with a text by Robert Melville. Melville bought a collage for twelve pounds – the equivalent of a week's wages.

My exhibition at the Mayor Gallery in June 1947 featured the fishermen drawings, and with the proceeds – seventy-five pounds – I left for Paris in July. Thanks to the generosity of Raymond Mason, a Ruskin and Slade School friend who went to Paris in 1946, this money lasted me the entire year. I lived in a room vacated by Raymond on the Ile Saint Louis, and laid out or hung up pictures from American magazines given to me by a large group of ex-GIs working and playing in Paris. An ex-GI and painter, Charlie Marks, gave me a number of *View* magazines sent to him from America. From these and other magazines I reaped images to make collages. It is important to say that

at that time, when I showed this material to anyone, it raised a smile – the same problem I had encountered several years earlier at the Edinburgh College of Art.

Living in Paris from 1947 to about 1950 was everything I had hoped for, and I kept myself going with annual exhibitions at Freddy Mayor's London gallery. The third exhibition sold badly, although one relief was purchased by Roland Penrose. The money problem became acute, and when I was offered a job at the Central School of Art in London to teach design in the textile department, I accepted it and reluctantly returned.

Back in England I lived briefly with Lucien Freud and his wife in St. John's Wood, then in Margaret Gardiner's house next to Roland Penrose, and finally, after marriage, in Paulton Square, Chelsea. I rented a workshop at 4 Bursen Street. At the Central School I learned silkscreen painting under Anton Ernzweig, and after classes I would descend to the basement to make mainly terra-cotta reliefs in the ceramic department. The atmosphere in the school seemed bizarre to me. Head teachers on duty wore handmade yeoman's smocks and represented the English Arts and Crafts movement of the 1950s – thoroughly parochial and sterile but reflecting strongly the ethos of the time. Only the most progressive collectors accepted that modern art was represented by the Surrealists and a handful of abstract painters. Ben Nicholson and Barbara Hepworth were considered radical.

Against this background, any consideration of American art was deemed unworthy. This included American films, plays, and any additional artefacts, such as the advertising materials and other imagery that were the basis of my collages at the time. This explains the ripples of shock that ran through a gathering of friends labeled the Independent Group when I gave a lecture called "BUNK" at the ICA in 1952. The ICA had been established through the efforts of Peter Watson, Roland Penrose, and Peter Gregory. The clubroom-cum-bar was modest but vital for the discussions that we organised for ourselves before and after the formal and informal lectures. Sophisticated lectures by eminent persons – for example, Henry-Russell Hitchcock on Frank Lloyd Wright – contrasted with our talks, which were managed awkwardly with marked books maneuvered into position on a rather hot epidiascope. Toni del Renzio and Lawrence Alloway did this brilliantly. I did it differently with "BUNK."

Group members such as del Renzio, Alloway, Reyner Banham and I were bound together by our enthusiasm for the iconography of the New World. The American magazine represented a catalogue of an exotic society, bountiful and generous, where the event of selling tinned pears was transformed into multi-coloured dreams, where sensuality and virility combined to form, in our view, an art form more subtle and fulfilling than the orthodox choice of either the Tate Gallery or the Royal Academy. The exoticism of the American magazine was also recognized by part of the English book trade, and piles of copies of *Colliers* and the *Saturday Evening Post* were always on sale in the Charing Cross Road for a shilling to half-a-crown. The fact that my friends and I were bound together by a form of poverty, living in rented rooms with no ice boxes, no cameras, and no fancy clothes, only added to the piquancy of these lush magazine images. Yet the reaction to my "BUNK" lecture was one of disbelief and some hilarity. Material treated by all of us as interesting "sources" of ideas was still regarded as banal. I was look-

ing at the source itself as worthy of serious analysis. To me this alternative culture had – and has – more energy and excitement than official culture. The problem of dealing with the immediate is still a problem for many people – witness the adverse reaction to the Saturday cavalcade on Chelsea's King's Road, a more or less undocumented culture in endless transition.

The architects Alison and Peter Smithson, the photographer Nigel Henderson, and I wanted to do an exhibition for the Independent Group with material borrowed from a government surplus shop, Laurence Corner. (At the time, I used the shop's light green bags of exceptional strength to carry my sculptures to Wilkinson's foundry for casting.) The nearest we got to fulfilling that idea was an x-ray photograph of a jeep in the exhibition *Parallel of Life and Art* in 1953. The latter show was a shoe string operation done entirely for ideological reasons. The ICA, although in constant need of financial injections from Roland Penrose or Peter Watson, funded photographic enlargements and the wonderful catalogue. The research and mounting of the exhibition was done by us, the participants, at our expense and for no fee. To aim at profundity with little or no budget seemed to be the norm for most of us. This was also good training for an exhibition I did in London in 1985 for the Museum of Mankind. *Lost Magic Kingdoms and six paper moons* is a kind of child of the Independent Group exhibitions. It is a selection of ethnographic work from the British Museum stores arranged by me with raw material from my studio and finished sculpture and scrapbooks. Mounted for a projected ten-month run, it remained on view at the Museum of Mankind for two years and traveled after that until 1989. The initial cost of the show to the Museum of Mankind was four hundred pounds.

Sometime after *Parallel of Life and Art*, the architect Jim Stirling gave an informal slide talk at the home of Adrian Heath, based on his recent trip to America. Photographs of Frank Lloyd Wright's California house were shown to, among others, Colin St. John Wilson, Lawrence Alloway, Toni del Renzio, Theo Crosby, and myself. It was there that the first seeds of *This Is Tomorrow* were planted, although it was about two years before the show appeared at the Whitechapel Gallery. By then our approach was becoming accepted, almost official, and I had moved on to other things, exploring the relationship between man and machine in sculpture: wax heads and figures embedded with found objects. But that is another story.

TONI DEL RENZIO

Yet again I find myself writing about the Independent Group. Again I am committed to the polemics, arguments, exchanges, stances, theories, and practices of nearly forty years ago. Many of the issues involved had been discussed informally, for the most part, since the late forties by some of us who were to constitute the IG as well as by a number of others. This discussion partly determined both the nature of the group and its agenda. Again I am wondering about the authenticity of the eyewitness account, the testimony of the participant, the fragility of memory, and the ambiguity of the interior process of reconstruction. I mistrust my own accounts even more than those of the others. I certainly seem to myself to be reinventing the Group and enriching it with the accumulated cultural debris of the intervening years. It appears to me that my recollected Group is quite "other" than that of each of the other survivors. Indeed, the view I now express reflects the present moment as well as the half-dozen years of the mid-fifties I am supposedly remembering, not to mention the intervening developments of the last thirty years or so.

There are many instances in which my present attitudes seem to contradict, sometimes to a large extent, those expressed at the time of the IG. Of course hindsight enters into the process, but it is also a question of involvement in other polemics, other ends, other perspectives, and of having advanced. All this is complexly interrelated. History is something we write as well as undergo. The selective use of the past tense which is the writing of history does not easily mesh with "reality" – also a loaded term, preempting what it is supposed to designate.

If the Independent Group was not the invention of Reyner Banham, it certainly was his intellectual cradle. Some of its significance is very much a reflection of the trajectory of Banham's career – and not his alone, of course, but also the careers of Hamilton, Paolozzi, and the others who, each in his own way, have "made it." At the time, we were more united by what we opposed than by what we supported. "Antagonistic co-operation" – a term we found in Riesman's "peer group" sociology of *The Lonely Crowd* – constitutes the most accurate description of the Group.

Sharp as they most often were, and wounding as they sometimes became, the exchanges within the Group marked its ideological progress and spilled over into our publications, which served more to further our development than to enlighten any audience. This may well underlie the difference between my evaluation of, say, *Man, Machine and Motion* in the mid-fifties[1] and what I wrote in 1978 for the catalogue of Richard Hamilton's show in Germany.[2] The polemics were considerably sharper, though, in a preface I wrote for *Parallel of Life and Art*. If the exhibition by Henderson, Paolozzi and the Smithsons was controversial, that preface was provocative and did not even find the tolerance I expected from the other members of the Group. Banham saw the typescript that I had left with Ian McCallum at the *Architectural Review*, took exception to it, and got the ICA Management Committee to refuse it, while neither Paolozzi, Henderson, nor the Smithsons felt obliged to stand up for it. As a result, I resigned from the ICA's Exhibitions Committee, not because the preface was refused, but because of the way in which it was handled. I only rejoined the committee some time later at Lawrence Alloway's invitation, when my bitterness had somewhat subsided.

Another mode of the Independent Group's operation was as a clearing house for new ideas, notions, and, above all, terminology. Books and magazines were passed around. The latest in American slang was eagerly adopted alongside the neologisms of technology and science, with new meanings and expression wrung from their conjunction. Conspicuous in this mix were the vocabularies of information theory and cybernetics. Ours was not only the adoption of a phraseology, but sometimes of a methodology, as was the case, particularly, with information theory, which was to form the

basis of much Independent Group theorizing. Invited by Alloway and Holroyd to collaborate on an exhibit for the Whitechapel Gallery show, *This Is Tomorrow*, I found them already certain that they wanted to develop the notions that would link information theory to the tackboard. This, indeed, is what we did. Our exhibit was almost the swan song of the Independent Group, but its importance has been lost behind other and flashier claims, for the most part more difficult to sustain.

1. Toni del Renzio, "*Neutral Technology – Loaded Ideology,*" Art News and Review, 7 (July 1955), p. 3.

2. Toni del Renzio, "*Slipping It to Us – Richard Hamilton in den 50er und 60er Jahren,*" in Richard Hamilton: Studies – Studien, 1937-1977, exh. cat. (Beilefeld, Kunsthalle Bielefeld, 1978), pp. 79-98.

ALISON AND PETER SMITHSON

We always considered ourselves very English and – contrary to what Frampton infers[1] – we have always been oriented towards Europe and never deviated,[2] reacting to aspirations beamed out from America that we saw would be irresistible, but also, recognising these as part of a wider threat to Europe's cultural identity. I think this was not necessarily the case with anyone else.

The Independent Group was only a small part of our history: like convivial evenings with friends. Most young people feel the need to get together to talk with those of like minds: a phenomenon of a part of life. There were many regular weekly social gathering points but – after that initial, informal, Central School nucleus, autumn's meetings – the Independent Group's structured evenings, of an in-put by a lecturer, or later, by one of the Group, was to focus the discussion.

Most importantly, the name-tagged arrangement – Independent Group, ICA – was necessary to each one's sense of presence in London. The Independent Group was greater than any reality of togetherness: it was a deliberate "marker" of our difference from others – and there seemed to be many – and our difference from whatever had been before; for although we knew all about manifestos and movements and groups (Camden Road Group, Bloomsbury Group, Vorticists, Omega Workshops), there was never any manifesto, nor an IG exhibition (for that was not what TIT was by any stretch of the imagination; the seeming connection is simply that two groups consisted principally – for Voelcker was not an IG member – of people who had also been in the IG).

A part of the necessity for the Independent Group was taking position – literally in the "nest" of the previous generation – and that, I suspect, was always part of the excitement of the 1953-1954 meetings After that, progressive merging, as the IG members became increasingly among the ICA's star performers and then its establishment.

At its outset, in our setting up our own "flag" as marker of the territory in which we intended to spend our lives, its cohesive energy was tangible It was vital to us personally as an energising "togethering," to feel we were not alone in needing to think quite differently, not out in the cre-

ative wilderness; that our sense of difference was supportably real by there being other, equally strong senses of difference to the previous generation's Englishness-as-appendage-to-Europe . . . and not by any means least important – to the rest of one's generation around, acquiring another layer of identification in that a sense of difference can be raised to a special plane, secure in a knowledge that a likely high percentage of you will, by their individual creative contributions, end up still working when you are, to the end of their lives . . . and that this significant proportion will, both in the recordings of the glow of the moment of beginning and in the retrospect, by back reference to early days or awakenings, assure that the IG would go down in history as "a movement."

It was with this sense of history, and knowing the organisational energy of Theo Crosby, that before the late-eighties interest in the fifties surfaced, my own instincts suggested to Theo – beginning May 1986 – the making of a "Cabinet of Curiosities" by those of us still working, in a paper as follows:

```
                                      I.G. and AFTER:
Those of the initial, informal Independent Group, who
appeared in Uppercase, who exhibited in T.I.T.
      some of those, who as students, sat at the back of the
later Independent Group meetings or were energised by the
T.I.T. exhibition,
          who appeared at Art Net,
                share a connection originating in the 1950s.
The idea is to contribute small items of their own special
making to a Cabinet of Curiosities.
In preliminary thoughts about the Cabinet, the contained vol-
umes offered for objects, in millimetres....
                              100 wide x 50 high x 50 deep
                            100 wide x 100 high x 200 deep
                          125 wide x 250 high x 125 deep
or the contained volumes for panels, folios, videos, tapes,
postcards, in millimetres....
                          100 or 50 wide x 305 high x 220 deep
                        50 wide x 220 high x 155 deep
                      50 or 25 wide x 155 high x 110 deep.
The Cabinet will then be designed by A.&P.S. while the con-
tributions are being made. (The Cabinet would be donated by
the participants to a national collection....opinions as to
recipient welcomed.)
```

Theo, having no connection to the Independent Group, wanted to invite all those who had participated in TIT, which did not mesh with the original impulse to have only those of the Independent Group who were still working, perhaps joined by those directly energised by the Independent Group. There the matter rests.

1. Kenneth Frampton, "*New Brutalism and the Welfare State,*" This Is Tomorrow Today, exh. cat. (New York, The Institute for Urban Resources, Clocktower, 1987), pp. 47-52.

2. A. and P. S. were not under the pop-influence of Eduardo: A.M.S. received American magazines in the form of the Ladies Home Journal and the Companion respectively through her Grandmother and Great Aunt while evacuated in Edinburgh 1940 onwards, and therefore saw the Green Giant grow; Singer sewing machine become electric, miniaturized; Mama Mia sauce for spaghetti displayed by a fat lady before our troops landed in Italy; and so on, while Eduardo was, from their sea-front stall, still serving wartime ice cream, made by his mother, to us as maroon uniformed school girls coming out of Portobello Baths on Saturday mornings.

JAMES STIRLING

I recall the Independent Group as being more social than intellectual. I suspect there was a division between those who saw the IG in social terms and those who saw it in public relations terms. I was definitely in the social category. The IG was a manifestation of interests we all shared and discussed regularly anyhow in pubs and restaurants in Soho and more formally at the ICA; the semi-public meetings were secondary for me. Those whom I recall as being most central to the wider milieu were Peter Banham, Toni del Renzio, Magda Cordell, John McHale, Alan Colquhoun, Sandy Wilson, Sam Stevens, and, to a lesser extent, Lawrence Alloway, Eduardo Paolozzi, and Alison and Peter Smithson. Richard Hamilton wasn't around much because he was teaching at Newcastle. Del Renzio was always very involved and he was knowledgeable in a great many areas. I found him particularly interesting as he was well informed about Italian and Continental avant-garde developments.

There was considerable fascination with American popular culture in IG circles, and I contributed somehow to this since I had visited America in 1949 in my next-to-last year at architecture school in Liverpool. I went to New York where I worked in an architecture office for six months and visited Boston, Chicago, Philadelphia, San Francisco, and Los Angeles. I recall my amazement, coming from Europe soon after the war, on seeing the bright chrome buildings and spotless pavements of New York. People forget how clean and bright and shiny New York was back then. Also I was surprised that all the cities I visited were quite amazingly different. In Los Angeles I visited Charles and Ray Eames at home on the cliff edge in Santa Monica and went to the factories where his designs were being produced. I think I was the first of several in the group to visit America in that postwar period. I remember when John McHale came back from studies with Josef Albers at Yale. He brought with him not only the famous trunk of magazines that we all went through, but some collages he had made in America from tearouts. Most of us were familiar with McHale's collages; I thought them clever and free, but except for a small display in the ICA library they were largely unknown in London.

Given how important architecture was in our milieu, it played a relatively insignificant role in the IG's programs and exhibitions. I remember, though, a passageway Sandy Wilson, Frank Newby, and one or two others did for This Is Tomorrow. It was just right for that moment because Ronchamp had recently been built (I had written an article on it for the Architectural Review) and we were still coming to terms with the shift in Le Corbusier's work. My own ambivalence was evident in the articles I published at the time. Since I had been drawing on Le Corbusier's work of the 1920s and 1930s (it converged with my enthusiasm for the Italian rationalists), I was disoriented by his new direction, though it soon became important in my work. To most of us Le Corbusier seemed richer and more interesting than Mies, who had been the key figure slightly earlier. Le Corbusier could be tied in with popular culture more easily and even his modular system, which was widely discussed after his book was translated, seemed to have an integrative potential that was lacking in Miesian grids.

I suppose I should say a word about the little exhibit I contributed to This Is Tomorrow, in collaboration with two friends: a sculptor, Michael Pine, and a graphic artist, Richard Matthews. I wanted to see if it was possible for us to work together in an equal way, and we did. I knew I was involved with something a bit off-track for me; far from having any burning convictions, I was a bit casual and tongue-in-cheek about the project, and I learned that this was probably the only way I could cooperate with people from other media. It required the freedom of an informal problem, where the only program was the technical possibilities.

WILLIAM TURNBULL

I had left London for Paris to escape the prevailing postwar neo-romanticism, and soon after my return to London at the end of 1950, it was a great pleasure to find the ICA with its outward looking international attitude.

I don't think of the IG separately from the ICA and doubt if it would have happened without the existence of Dover Street as a meeting place.

I had developed a liking for French café life and public meeting places that were attractive and stimulating. The ICA was the nearest I found to this in London. Apart from seeing the work of many international artists for the first time at the ICA, and attending the discussions, I met some of the most interesting of my contemporaries there. The IG was a more intense version of the ICA discussion forums, and everything was debated – cinema, jazz, fashion, science fiction, cybernetics, and current exhibitions. There wasn't any particular emphasis on "pop art" but a general interest in popular culture as a source. There was little homogeneity and a good deal of disagreement. All of this was to my liking.

The ICA exhibitions that interested me the most were 40,000 Years of Modern Art and Wonder and Horror of the Human Head.

I gave a talk at the ICA in 1953, entitled "Concepts of Space." I dealt with the way I thought the organisation of pictorial space related to current beliefs and to the concept of the physical world from the earliest times. There was a generous, open, unguarded reception to art and ideas at the ICA then, without any feeling that a rigid attitude needed to be adopted.

London would have been a much less interesting place for me in the 1950s without the IG and the Dover Street ICA, and they influenced much that happened later.

[1] *Reyner Banham, "A home is not a house," Architectural Design, 34 (January 1969), p. 48.*

I first met Peter Reyner Banham and Mary Banham in 1950. They lived next door to my student lodging in Oppidans Road off Primrose Hill. I realized that they were involved in architecture, because booming farewell discussions took place on their doorstep, during which the names "Corb" and "Mies" floated up through my bed-sit window. One night, when Peter Carter and I ran out of india ink while drawing up our project for the Coventry Cathedral competition, I thought I might touch my next-door neighbours for a replacement bottle. No luck with the ink, but a most genial friendship began. At about this time Banham finished at the Courtauld Institute and took a job with the *Architects' Journal*. This meant that he had access to lots of architectural magazines, and the Banham front room became a sort of salon, soon to be the seedbed of the Independent Group. On weekends it shared honours with the "French pub" in Soho as a rendezvous for our gang: Saturday morning the pub, Sunday morning the Banhams. The regulars were Turnbull, Hamilton, Stirling, Stevens, Colquhoun, Carter, McHale, and Cordell. Out of the raging debate there evolved the use of a third forum, a back room in the Dover Street premises of the Institute of Contemporary Arts, which was already the regular meeting place of a wider group that included Paolozzi, Henderson, the Smithsons, and del Renzio.

As I recall, the first paper read to the Independent Group was Banham's piece on the Futurists, and I was in the chair. However, now that the Group has become the subject of Ph.D. dissertations and a travelling exhibition, I realize that such claims are liable to be disputed in the law courts, so I will not press the point. The undeniable fact is that Banham was chief provocateur, spokesman, and historian of our goings-on, and in his capacity as active journalist as well as scholar he was able to publicize them in a regular way. His *Theory and Design in the First Machine Age* was written for us – the dedication says so – and much of it was hot off the anvil. My copy is smothered in notes of protestation. (He dared to pit Bucky Fuller against Corbu!) The fact is, however, that Banham helped to arm us against the insularity of "the Englishness of English art" by hauling out the manifestos of our fighting inheritance – Futurism, Constructivism, Elementarism, Purism, G, and De Stijl – and he nailed the opposition to the mast. As to his journalism, I recall lending him my copy of *Finnegan's Wake*, which he read from cover to cover (?) in what must be record time. He digested the contents to such a degree that much of the rambunctious verbal pyrotechnics of that book began to infuse his own style. But his real muse was Marinetti, and his polemical motorcars vied with buildings even more than they did in *Vers une architecture*. When I bought a car (seventy pounds for a Lancia, the one that appears in the photographs of Terragni's Casa del Fascio), I was co-opted as a family chauffeur for windblown visits to car racing at Silverstone, to see Fangio, Gonzales, Moss, and Hawthorne in action.

This was the time of the emergence of the New Brutalism, for which Banham became the instant historian in a rather provocative way; but his Futurist heart really lay in high technology, and he became guru to the world of Archigram. With foresight he focused on mechanical engineering as a significant design discipline, and pushing it, as usual, to the limit, he ended up in a big bubble without a stitch on.[1] As ever, you could not peel away the laughter from the seriousness.

Night Thoughts
of a Faded Utopia

by Theo Crosby

I came to London in the golden autumn of 1947. It was beautiful, dusty, faded and broken. The streets were quiet and empty, and one walked, simply and gratefully, everywhere. The great city was healing, wounded but alive with underground energies. The pubs were full of returned soldiers elbowing their way into the universities, into the professions, and of eager colonials come to challenge a civilisation known only through books and faded photographs.

I had been in Italy for a year at the end of the war, and spent much time after the armistice wandering about. A third-year architectural student, hooked on Le Corbusier, Giedion, Mumford and Banister Fletcher, I found Italy truly wonderful. A year and a hasty degree later I came to London.

It was impossible to find work in Italy, but in London I found a place with Max Fry and Jane Drew. Their office was made up of energetic exiles who disappeared in the spring and returned in the autumn to beg another few months of employment. It was also kindly, open and encouraging, and a step into the great world of CIAM and the Modern Movement.

We worked on schools for Ghana, and the Festival of Britain, and the first part of Harlow New Town, and many more of the magical tasks which seem to come so easily to Max and Jane. They lived a full, noisy, and energetic life in the flat above the Gloucester Place office. There were modern paintings on the walls, and writers and artists came to visit. Among them was the beautiful, young Eduardo Paolozzi, who was persuaded to show his collection of slides and images, and gave the first of his Surrealist, disjointed lectures. He made us see the continuing vitality of the modern spirit, already weighed down by the old men. Or so they seemed then, although they themselves – Mies, Le Corbusier, Gropius, Picasso – were to develop and flourish for another twenty years.

Through Jane Drew I joined the MARS Group and became involved with the ICA. Its first headquarters in Dover Street was designed by Jane, and the drawings were done on the adjoining board by a very persnickety girl, Mary Reader. It became a kind of club for my kind.

In the summer of 1948 I had met Peter Smithson in Florence. We picked each other up in the Biblioteca Laurenziana, and that autumn we shared a flat in Doughty Street while he went to the Royal Academy School – the last gasp of the great Academy teaching tradition in architecture. Peter Smithson's thesis was the redesign of the Fitzwilliam Museum in the Miesian manner. We were much involved with history, however, mainly through Wittkower's *Architectural Principles In the Age of Humanism*. The passion for geometrical analysis is slow to fade, and it links our generation to the first modernists and the Constructivists.

At the ICA the Smithsons, who, having won the Hunstanton School competition in 1951, were suddenly comfortably off and famous, participated in the *Parallel of Life and Art* exhibition and began their odyssey of theory and practice. Peter married Alison from our original ground-floor flat in the Bloomsbury house, and I moved upstairs. (We found that Wells Coates had lived on the first floor and had behaved badly with women.)

At this time, and indeed for many years after, I used to spend my evenings at art school learning sculpture and gradually came to know the teachers: Turnbull, Pasmore, William Roberts, Caro, Frank Martin. Beginning in 1953 I was able to go in the mornings. Denys Lasdun and Lindsay Drake had taken over the Fry Drew office while Max and Jane were in Chandigarh with Le Corbusier and Pierre Jeanneret, and in 1953 I was gently fired.

I became technical editor of *Architectural Design*, at a big table with Monica Pidgeon. We did it all together, very amicably and cheerfully, from 2 to 7 every afternoon until 1962. I did the page layouts and covers and slowly began to involve my friends. I tried to learn graphics from Edward Wright, and became involved with the group of architects and artists who frequented his studio.

At this time the ICA showed the first American Abstract Expressionist paintings, and we could all see that something new had arrived. We tried to relate it to the other manifestations of America that we knew, or could gather. I had copies of *View*, the New York Surrealist magazine, and all the MOMA catalogues which I had hauled from South Africa, and occasionally someone would return from the promised land with a cargo of U.S. ephemera. Paolozzi and the Smithsons "collected ads" and John McHale cut them up into collages. It was an interest, along with many other interests.

In 1952, I went for a holiday and ended by the usual chance at St. Ives. I found a firm friend in David Lewis, the son of a successful South African painter (Neville Lewis), a poet and, at the time, a waiter. He was involved with the Nicholson-Hepworth circle and married to Wilhelmina Barnes Graham. Lewis was the chief interpreter of the St. Ives School, showing and explaining its relations to de Stijl, to Mondriaan and to Constructivism through Naum Gabo and Pevsner. Through Lewis I met Nicholson (who was persuaded later to do a drawing for *Architectural Design*), Hepworth, Lanyon, Frost, Heron, and Wells; also Dennis Mitchell (who made the Hepworth sculptures), and Bernard Leach and David Batterham. These connections to the dispersed avant-garde were important to us, and they mediated the new U.S. influences. As Patrick Heron has shown, the traffic in ideas was very much a two-way affair.

By 1955 the pattern of London life had steadied somewhat. The flood of ex-army officers had passed through the schools and they had fought on into jobs and careers, or were teaching in the ever-expanding art schools. At the ICA the young Lawrence Alloway (he seemed very young at the time, even to us) was making waves. His writing was sharp and clear, and he was beginning to play the favourite game of critics: the creation of groups and schools.

At first Alloway championed the Constructionists who had gathered around Victor Pasmore after his conversion to abstraction. They were Kenneth and Mary Martin, Adrian Heath, Anthony Hill, and John Ernest. Then he moved to the Situationists and Colour Field painters just then coming out of the Royal College of Art and the Slade: the Cohen brothers, Peter Stroud, Richard Smith, and John Plumb.

We were grateful for this activity and for the aura of movement and energy. It made us confident.

Into this lively ambience came Paule Vézelay, from Paris. She came

as an ambassador from André Bloc (abstract artist and editor of *Architecture d'aujourd'hui*) to found an English branch of the Groupe Espace. This was to be a great European academy of abstract artists. She started very reasonably with Henry Moore and progressed down a line of eminent rejections until she invited Pasmore, Colin St. John Wilson, and myself to her flat in Earls Court to talk about it.

We listened politely enough, giggled a little at the elaborate academic structure Vézelay proposed, and trooped off downstairs to the pub across the road. There we agreed that the Group Espace was not for us, but why not an exhibition about architecture and art and the modern sensibility?

We set up a meeting in Adrian Heath's studio in Charlotte Street and asked our friends to come. Reyner Banham was discouraging. *Gesamtkunstwerk* was an idea long since played out. But we agreed to give it a try and I was made secretary. Banham and I went to see Bryan Robertson to ask for the Whitechapel Gallery, which he bravely gave, and Robin Campbell at the Arts Council gave £500.

We all met again, now divided into groups of about three or four, each of which was allocated £30 to make its section. Those architects with work managed to squeeze small amounts of material and services out of friendly contractors, but mostly we made everything ourselves. I took on the catalogue and sold advertising to pay for it, and Edward Wright designed the logo and the layout.

The principle behind the exhibition was one that I have tried to follow ever since: a collaboration of equals. Each group produced thirty posters which we distributed mainly to each other. Each incorporated the standard logo. I designed an office for the director of Whitefriars Press and got one thousand posters printed; Hamilton and McHale persuaded a film company to lend Robbie the Robot, who opened the show, and an enormous juke box appeared which was to play throughout the month.

I must say I enjoyed it thoroughly. *This Is Tomorrow* represented a moment when there seemed to be many directions for art and a camaraderie sustained by appreciation but not spoiled or isolated by success. Of the thirty participants some have died, some have disappeared from the scene, and some have become immensely successful architects and artists. Each has taken a separate direction. I had hoped that the success of the show would lead to regular collaborations and demonstrations of this kind, but that is not the English way.

British art consists of isolated manifestations, of individuals who search for their own identities and who see groups and schools as an aid to propulsion, as a platform. It is an attitude that has its strengths, though the penalty of failure is instant obscurity.

A few years later, at the 1961 International Union of Architects Congress in London, I was able to put together a manifesto of art and architecture with many of the same artists: Edward Wright, William Turnbull, Anthony Hill, Kenneth and Mary Martin, John Ernest, Bernard Cohen, Peter Stroud, Eduardo Paolozzi, Bryan Kneale, John McHale, Gillian Wise, Richard Hamilton, John Plumb and Anthony Caro. In front of the Shell building, then in construction, we made two pavilions full of integral paintings, reliefs, and sculptures. It was very successful, and we even had a party and a meeting to talk about it.

But it was not a direction that was followed, and throughout the boom years that came after, art and architecture diverged even further. We have, in the English manner, gone our separate, friendly ways, some following Max Fry and Victor Pasmore into the very Royal Academy we so loved to hate. That is also the English way of incorporating the rebellious into the establishment.

What can be learned from *This Is Tomorrow*?

First, selfless collaboration is possible, particularly among young, talented people who are not totally secure in the world. They use and need the comradeship and the conversation.

In later life the relationships are more edgy and the collaboration of equals has to be worked for rather harder. There is less common ground. Artists do not now share the preoccupations of architects as once they did. The key books are different and the market has intervened. The "basic design" training, inherited from the Bauhaus, underlies art education. It has wiped out the tradition of life drawing and of decorative design that was the original content of art training, and the school system has destroyed the master-apprentice relationship that produced all good art up to the twentieth century.

There is now, thirty-three years after *This Is Tomorrow*, the faintest glimmer of an understanding that things are wrong, and why. But that is the subject of a *very* long article.

It is, however, very apparent that the seeds of the present were sown in the 1950s. Those issues – historicism, ornament, the integration of the arts – that now dominate the architectural dialogue were first raised in the discussions and hesitant publications at the ICA, in a few architectural offices, and in the art schools. They were not coordinated but were perhaps focussed by the Independent Group at the ICA. It was never very coherent or programmatic, but one could get a sense of cultural direction.

It was a place to meet, of course, but above all it was a place to meet interesting people who were passing through London, or who were showing there. We were treated to Marshall McLuhan, Gabo, Fuller, and many others. Visiting firemen were also to be met at the MARS Group, the English branch of CIAM which was still active. It organised the CIAM conference at Hoddesdon in 1951 and all the great men came. Its members were all architects who had made their names before the war – Fry, Gibberd, York, Rosenberg, Goldfinger, Tubbs, Cadbury-Brown – and who would flower at the Festival of Britain and set the pace, scale, and direction of architecture for the next thirty years. It took in a few new members in 1952: Bill Howell, Trevor Dannatt, John Voelcker, myself, and the Smithsons. We worked for CIAM 10 as Team 10.

The death of CIAM in 1956 is perhaps the only known example of an astonishingly successful international organisation committing suicide at the height of its power and influence.

From the end of the war, Britain began a long drawn out political decline, as the empire and colonies were jettisoned. It was a country battered by the war and poverty; industry was chaotic and disorganised, many great enterprises were taken into public ownership. But the war had released a marvelous sense of fairness and equality, and there was a unity of belief in social responsibility manifested by the welfare state, the health service, free

education, the planning system. This gave immense impetus to the great communal projects of the 1950s: the thirteen new towns, the new and expanded universities, the national parks system, the provision of social housing. In all these projects architects were involved, for the first time, and the profession expanded rapidly. Teaching architecture became an alternative career, and rather more fun than building.

It was then that the Modern Movement, a style promoted by a few young architects before the war, with the active support of the *Architectural Review*, became dominant. But it was not a simple process; there were many reservations.

By the end of the 1930s, de Cronin Hastings at the *Review* had gathered a group of literate, intelligent and cultured young men around him – Betjeman, Piper, Casson, Cullen – and their attitudes toward Continental modernism were, to say the least, ambivalent. They sought, during and after the war, to find an English way, related to the romantic painting of the period, to the paintings of Sutherland, Piper, Minton, Craxton, and the sculptures of Moore and Hepworth, who sought to draw a new art directly from nature, pebble forms, and landscape.

This was remote from and generally in opposition to the Bauhaus aesthetic or the planning doctrines of Hilbersheimer. The country from which we could learn was Sweden, where an equally socialist government had, in the 1940s, built housing of poetic sensibility, and there was, in Asplund, a great architect who produced modern but humane buildings.

This was one model. What had been derived from our own Arts and Crafts movement and the Garden City tradition of the turn of the century now appeared to have returned, rarified and pure, but somehow emasculated. It lacked the energy and directness of Le Corbusier's postwar buildings, their acceptance of "poor" materials, their bright colouration. The New Brutalism emerged as a similar rough poetry, making do.

The main thread of discussion at the Independent Group was, in fact, history. Some of the participants were art historians at the Courtauld, which also provided wives for several members. Banham was concerned to write the alternative history of the Modern Movement, to balance Giedion's and Pevsner's mainstream history. They had tended to relegate the German Expressionists to a side stream, emotional and a little embarrassing, and we were perhaps congenitally unable to incorporate that Teutonic stream into British architecture. Even now it still beckons like fairy lights in the forest.

The emphasis on history and precedent made us travel, to see the buildings of the heroic period but also to examine the buildings of the past. Ours was a history of beginnings. My teacher, Rex Martiennsen, had made spatial analyses of Greek sites and loved the early Renaissance. We went to see Alberti, Brunelleschi and Michelangelo; Palladio rather than Bernini. The Mannerists were very fashionable, but of course it was impossible to translate this interest directly into practice.

We had little of the classical language and could not bring ourselves to betray our masters and the Movement. After a few years, however, we began to look about, to be critical. As the world began to fill with modern buildings, their modernity was an insufficient defence, and we began to taste the inadequacy of their language of forms. It was Jack Cotton's incredibly vulgar proposal for Piccadilly Circus that began the reevaluation of modern

building, and the moving spirit of the opposition was Jane Drew. The road to conservation had begun, the first protests articulated.

This Is Tomorrow had, outwardly, a strong commitment to modernism, but it was also a demonstration of alternative directions: Paolozzi, Henderson and the Smithsons demonstrated a deliberate archaism; Voelcker, Hamilton, and McHale were concerned with sensual disorientation overlaid with popular art; there were demonstrations of mainstream modernism, of Corbusian formalism, of the organic lightweight structures that would later be fully developed by Frei Otto, of high technology, of semiotics. The latter, more or less unintelligibly presented by Geoffrey Holroyd, was only to be explained a few years later by writers from the Hochschule für Gestaltung (HfG) at Ulm in *Uppercase 5* (1962).

There were also several demonstrations of Abstract Expressionism and bad taste which are best passed over in silence. The show did, however, make it clear that there was to be no simple, direct road to the future, but a maze of contradictory paths and personal preferences. It was diffused, unedited and innocent, and that was its strength and weakness. It had no progeny, but it brought amicably together a great variety of intelligence.

Alison and Peter Smithson, <u>Art of the ''As Found</u>.'' Tile mural for the Old People's Club Room at Robin Hood Gardens, composed of shards picked up on the Robin Hood Gardens site by Alison Smithson and her son, Simon, then set into cement molded in a wood–box shutter, 1968–70.

The 'As Found' and the 'Found'

Alison and Peter Smithson

Seen from the Late 1980s:

The "as found," where the art is in the picking up, turning over and putting-with. . . .

and the "found," where the art is in the process and the watchful eye. . . .

With Hindsight. . . The ''As Found'' in Architecture:

In architecture, the "as found" aesthetic was something we thought we named in the early 1950s when we first knew Nigel Henderson and saw in his photographs a perceptive recognition of the actuality around his house in Bethnal Green: children's pavement play-graphics; repetition of "kind" in doors used as site hoardings; the items in the detritus on bombed sites, such as the old boot, heaps of nails, fragments of sack or mesh and so on.[1]

Setting ourselves the task of rethinking architecture in the early 1950s, we meant by the "as found" not only adjacent buildings but all those marks that constitute remembrancers in a place and that are to be read through finding out how the existing built fabric of the place had come to be as it was. Hence our respect for the mature trees as the existing "structuring" of a site on which the building was to be the incomer. . . . As soon as architecture begins to be thought about its ideogram should be so touched by the "as found" as to make it specific-to-place.

Thus the "as found" was a new seeing of the ordinary, an openness as to how prosaic "things" could re-energise our inventive activity. A confronting recognition of what the postwar world actually was like. In a society that had nothing. You reached for what there was, previously unthought of things. . . . In turn this impressed forcibly – seen in the coat of white paint that "renewed" the ship, 1957 – how the new could re-energise the existing fabric.

We were concerned with the seeing of materials for what they were: the woodness of wood;[2] the sandiness of sand.[3] With this came a distaste of the simulated, such as the new plastics of the period – printed, coloured to imitate a previous product in "natural" materials. Dislike for certain mixes, particularly with technology, such as the walnut dashboard in a car. We were interested in how things could be with technology touching everything and everyone. We foresaw a general reappraisal of values would occur, since as we "read" through the aspiration-images on offer in the magazines, the approach of the acquisitive society.

Our reaction to the 1940s – for us "design" was a dirty word – tried never to be negative. By "taking position" we rejected the then fashionable, but for us too simple, literal and literary attitudes, represented for socialist-minded intellectuals by the writings of Herbert Read. We were the generation stepping aside from politics as no longer appropriate to our needs. All this was an intellectual activity, extending to a care for "literacy" in the language of architecture. We worked with a belief in the gradual revealing by a building-in-formation of its own rules for its required form.

The "as found" aesthetic fed the invention of the "random aesthetic" of all our "Cluster" ideograms, diagrams and theories, which we took first to CIAM 9 at Aix-en-Provence, then to La Sarraz, and finally to CIAM 10 at Dubrovnik.

The ''As Found'' in Exhibitions:

Nigel Henderson made up the quartet with ourselves and Eduardo Paolozzi that manifested our intellectually different aspect of the Independent Group. This difference – even to a certain apartness – can be seen in our exhibition *Parallel of Life and Art* of 1953; which although mounted in the front room at the ICA, had nothing to do with the Independent Group also meeting in that room. In willing the exhibition to happen, developing its idea, and during its making, our meetings with Nigel and Eduardo were often excruciatingly funny, especially in word play and cross reference.[4] Our shared values – of not needing to say again what had been adequately said by their "inventor" – were bodied out by the sense of a continuity parallel to that of the heroic period of modern architecture, flowing through Nigel; from the Bloomsbury Group, from Paris of the 1930s and 1940s, from Marcel Duchamp, from early Dubuffet and so on. . . .

Again, our Patio and Pavilion of 1956 had nothing whatsoever to do with the Independent Group but was part of the *This Is Tomorrow* exhibition that grew out of a series of meetings in Bill Scott's studio in Charlotte Street – the tail end of the Euston Road Group? – to do with a vague English inherited belief that the arts should be able to again collaborate as in the Renaissance. The initial discussions, with people stacked up in a wonderful Edwardian way, were long, contentious. The studio venue changed once, as those attending gathered, to the adjacent top floor studio; the personnel changed dramatically, the originators virtually all dropping out. We stuck with the discussions – as did John Weeks and Erno Goldfinger, who had been their artist's choice from the start – and once Theo Crosby appeared and agreed to organise it, rounded up all the architects we knew of, including Michael Pine who worked in plaster, so that each group had an architect. Catleugh might have been Theo's contact.

The *This Is Tomorrow* exhibition at Whitechapel Art Gallery was only possible through Theo Crosby's willingness to undertake the organisation; his position at *Architectural Design* offering the necessary contacts for materials and so on, since nobody had any money. Our Patio and Pavilion answered a "programme" of our own making, offering a definitive statement of another attitude to "collaboration": the "dressing" of a building, its place, by the "art of inhabitation." We were taking position in the acquisitive society as it began its run, by offering in a *gîte* a reminder of other values, other pleasures.[5] With the transparent roof of the pavilion made to display Nigel's arrangement of the "as found," the sand surface of the patio (ultimately) chosen to receive Nigel and Eduardo's tile and object arrangement, the reflective compounding walls to include every visitor as an inhabitant, the "art of the as found" was made manifest. The complete trust in our collaboration was proved by our Patio and Pavilion being built to our drawings and "inhabited" by Nigel and Eduardo in our absence, as we were camping on our way to CIAM at Dubrovnik.

This Is Tomorrow turned out to be the quartet's final joint "as found" manifestation.

In Sculpture:

Through other powerful influences, the idea of arranging metal things "found" was taken up in sculpture – to run – and run – and maybe it still has to run. Now, nearly forty years later, does it any longer have such an energising or revitalizing power? Around us again, no intellectual process seems involved in parallel; we see no reappraisal – of society, or meaning, or whatever – coming to formal presence; no new position being taken with respect to the immediately previous generation; no reaction occurring to parallel phenomena outside the discipline. The "as found" school appears to be as a stuck gramophone needle: maybe as outdated as that image.

In Polemic:

At one time in 1954-55 it was agreed that our quartet would all collect snippets out of newspapers or magazines of lines and phrases that struck us as demonstrating the sort of nonsensical "explosion" in use of images and words that was happening. What we kept ended up barely covering two sides of a page and, whatever Eduardo had in mind, he never called on its use. But this interest in groups of words was perhaps connected to watching us collage typescripts in Doughty Street while editing[6] our *Urban Reidentification* – UR – manuscript, with its proposed covers in Neapolitan ice stripes. The text was finally published as *Ordinariness and Light*.

In the mid-1950s, the "found" manuscripts for *Young Girl* started, in frustration at the Bates House (Burrows Lea Farm) not building.[7]

The next two writings, which might – through their detailed accuracy and the integration of text and imagery/documents (to use the period word) – be considered as growing out of their "as found" period locations, were "Breath of India" and "1916aso"; started respectively in the late 1950s and the late 1960s. They cannot be thought of only as period pieces because the unpublished fiction writings continue to be edited for pleasure whenever there is a suitable gap. Nevertheless, in these fictions the characters remain portrayed as if found, in that place, in that period of their supposed existence, for the characters do not represent types or philosophical/ psychological attitudes but are themselves, like people, largely unexplainable, reflecting the fact that in real life a person is something in the eye of each beholder. We see this in Jane Austen's supporting characters, whose "natures" seem to change when the beholder becomes sensible to other qualities in them.

Until these writings are published – the integration of imagery being resisted by potential publishers – it will be unclear whether there is a "school" of "as found" writing: even then, some critic may – as in the case of New Brutalism – include, for the sake of fashion or to body out a theory, things that muddy the issue and not explore fully, through ignorance, the then virtually unknown key figure . . . as in the case of New Brutalist architecture, where the work of Sigurd Lewerentz, virtually by itself, could have explained some deeper, enduring quality.

Some Doubts about the ''Found Image'' in Painting

There are bound to be doubts about the "found image" in painting, at a time when the whole of past art is ransacked for imageable material to be enfolded into the ever-faster-consumed commercial graphics.

Looking back to the 1940s and 1950s – the period of Dubuffet and Pollock – the image was discovered within the process of making the work. It was not prefigured but looked-for as a phenomenon within the process.

As an art activity this was something new, since the "found objects" for Marcel Duchamp were of the previous period and were once "made" objects. That is, the objects "discovered" and transformed into art objects were originally made in the mind by an artisan or engineer, then drawn or sketched or modeled, then prototyped and so on, following the whole traditional process of invention and perfection. And as the stock of made-objects is continuously renewed by the activities arising from the different needs, intelligences and sensibilities of each period, the art activity of wit-and-eye founded on these objects can continue.

Current graphic art treats in this wit-and-eye way the painting of the past which was always prefigured – that is, first made in the mind. But in "found image" painting the first making-in-the-mind is missing, except in the sense that the process itself is pre-thought. In the 1980s, when that process is an inherited one, it can hardly be said to be pre-thought; it is a copy of a process already invented.

We could ask what are the new finding processes of our period, if the found-image in painting is now a genre?

1. *See Uppercase*, 3 (1961). Also A. and P. S.'s *Grille for CIAM 9 at Aix-en-Provence, cat. no. 71.*

2. *TIT pavilion; Upper Lawn pavilion.*

3. *Iraqui House, Piccadilly.*

4. *We inadvertently tested our sense of value by introducing a young person to Nigel just before his untimely death, and it was wonderful to hear and watch the old magician at work. This lack of a "studio" humour is strikingly absent in the late 1980s: does it reflect a lack of intellectual activity?*

5. *Something that we were discovering through other architects, Bill and Jill Howell, in their need to take us camping en route to CIAM at Aix-en-Provence and so on.*

6. *Two particularly fine strips were put in a frame and given as a wedding present to Trevor and Joan Dannatt, c. 1953.*

7. *See Alison Smithson, Portrait of the Female Mind as a Young Girl (London, 1966).*

Learning from Brutalism

by Denise Scott Brown

I was a student at the Architectural Association in London during the early years of the Independent Group. Although I was not aware of its name, I did know of an exciting community of architects, architectural historians, artists and engineers connected with the architects Alison and Peter Smithson. I remember seeing Nigel Henderson's photographs and the *Parallel of Life and Art* show at the ICA and, like others at the AA at the time, I knew the work of Eduardo Paolozzi and Reyner Banham. However, because the Smithsons' architecture and ideas were extremely important to me, it was primarily through them that IG perspectives came to influence my thinking. Also, my rebellious-minded friends at the AA, who were no more aware than I of the closed meetings at the ICA, resonated to wave lengths similar to those of the IG, and they loosely associated themselves with the New Brutalism, as the Smithsons, partly in joke, named their architecture.

Now that people are re-examining the IG and its milieu, it may serve some purpose to recount my experience of being around, but not in, London's avant-garde movement in the 1950s, and to give my perspective on the development of IG-related ideas in America, chiefly through the Smithsons' influence.[1]

Architectural historians have trouble perceiving transatlantic connections. For this reason, few have recognized that the New Brutalism exercised a powerful influence in America on work that was far removed from the Late Modern style of, say, the Yale Art and Architecture Building, which we commonly associate with Brutalism. For example, the earliest phase of Brutalism, which revived the Cubist Modern architecture of the 1920s, was brought to America by Colin Rowe and appeared on the East Coast as the "White" architecture of the late 1960s and early 1970s. Things might have been different had Rowe remained in England long enough to see the Brutalists shift their focus to Le Corbusier's postwar architecture, after the Maisons Jaoul became known in London. But one needed to have been in both places, as I was, to spot this.

Another link that has gone unnoticed was made, I believe, through my own work. This involved what Peter Smithson called "active socioplastics." The New Brutalists found value and delight in places and things other architects considered ugly, and they agreed that beauty could emerge from designing and building in a straightforward way, for community life as it is and not for some sentimentalized version of how it should be. This view evoked a sympathetic response in me, deriving from my childhood and youth in Africa. At the University of Pennsylvania in the late 1950s, I found Herbert Gans and, later, the social planners preaching a similar philosophy (minus the aesthetics). During the stormy 1960s, socioplastics became my ground of appeal when, on the faculty at Penn, I tried to evolve a conceptual and aesthetic framework that could draw together the diverging philosophies of architects and social scientists in planning. At this time, the only architect at Penn who understood and agreed with what I was attempting was Robert Venturi. Our subsequent collaboration has worked because we both bring a rule-breaking outlook to aesthetics – we like the same "ugly" things – and we both think that rule-breaking should be not willful but based on the demands of reality.

In a 1967 essay, "Team 10, Perspecta 10 and the Present State of Architectural Theory,"[2] I noted some striking parallels between the concerns of the Brutalists and Team 10 in the 1950s and those of the inclusivist architects, led by Venturi and Charles Moore, in America in the 1960s. Both movements related urban form to social forces, countering the orthodoxies of Modern architecture by acknowledging changing social needs. And both movements promoted an aesthetic that could respond to the vitality of the non-architect-designed environment. My chief concern in this essay was to prove to my social planner colleagues that socially responsible architects actually existed. It was only secondarily to identify the connection between the two schools of thought. However, through such writing, and through my academic and professional work, I believe I have contributed to American architectural thought by forging my own alloy of English and American social and aesthetic concepts. I also pushed hard at American architects to heed the American social planners and *vice versa*, but that is another story.

My professional outlook has been influenced by several shifts of country and culture, through which I encountered variations of the same rift between the categories of the "official" aesthetic culture and the terms of the immediate environment. This was what the rebellion of young architects and artists in London in the early-to-mid 1950s was chiefly about.[3] In America the split was between high culture and low culture, and it has been aptly described by thinkers such as Herbert Gans, John Kouwenhoven, and J. B. Jackson. But there was also the rift between metropolitan and colonial cultures, which I had known as a child. Growing up, I learned that my intellectual tradition was rooted elsewhere. The books I read described the landscapes and manners of England and America, but the bushveld and the ways of Africa were immediately around me. I was aware, from childhood, that this constituted an artistic problem. When, at the AA, I found a group of students looking intensely at what was immediately around them – popular culture, the industrial and commercial vernacular, and neighborhood street life – I felt on sympathetic ground. More than anyone, it was the Smithsons who decried the gap between the sentimentalism of British architecture's domesticated Modernism and the facts ("brutal" and ordinary) of urban experience. At the AA, I allied myself with the students who were responsive to this message.

Looking back at the Architectural Association at that time, I particularly remember the range of intellectual and professional contexts that students drew upon. This mix of ideas provided the foundation for my architectural thinking. Immediately after the war there was a swing in British architecture away from austerity. This climaxed with the frou-frou of the Festival of Britain. Then came a reaction against the Festival toward social idealism, and the returning ex-service people carried this spirit into the AA. They addressed Europe's rebuilding task with a strong social conscience mixed with CIAM rhetoric. After graduating, some found employment in the housing division of the London County Council, where they produced an architectural revolution. The ex-servicemen's generation was leaving the AA as I entered it in 1952, but their influence was still strong. A more immediate

architectural influence there was Arthur Korn, a Bauhaus architect and social utopian who taught that social structure determined urban form. Then there was John Summerson, whose loving analyses of Georgian London and incisive descriptions of Mannerist rule-breaking were an antidote to the heroic "urban removal" projects that were on students' drawing boards in the early 1950s. Summerson's lectures on English Classicism ended with Lutyens.

I think I first met Peter Smithson in 1953 after a lecture or panel discussion. Although the Smithsons did not teach at the AA while I was there, they were increasingly influential at the school from the early 1950s. When they arrived in London from Newcastle, the word went out that they were exciting architects; the students began to visit them. They became teachers of AA students before they joined the faculty. Recalling Le Corbusier's disdain for "eyes that do not see" and moving beyond grain elevators to popular culture and advertising, the Smithsons were far from doctrinaire. Their appeal, I think, lay in combining the Dadaist found-object aesthetic with an interest in community development. For me, this balance was terribly important. I believed, and still believe, that beauty (albeit an agonized beauty) can be derived from hard reality, and that facing uncomfortable facts can sharpen the eye and refine one's aesthetic ability. The New Brutalism suggested to me that social objectives might be achieved with beauty, if we could only learn to broaden our definition of beauty – and that doing so could make us better artists.

The Smithson influence was not an isolated one, either at the IG or the AA. In this rich time of changing sensibility there was a spontaneous combustion of Brutalist-like ideas in many quarters without direct reference to each other or to one source. The full etiology of this movement has yet to be established. Has anyone tried to gauge, for example, to what extent the IG's aesthetic ideas were developed in opposition to the heated aesthetic and the "New Humanism" of the Festival of Britain? The "New Brutalism" – even its name – certainly was.

I have often wondered whether there was a connection, via the IG or the London County Council, between the Smithsons and Michael Young and Peter Willmott, as they were undertaking their study of the East London poor.4 Does this account for the type of social awareness expressed during the early phases of Brutalism? Gans knew the work of Young, Willmott, and Peter Marris, another English urban sociologist; so perhaps there is a link from the IG through these sociologists to the Chicago school of sociology that trained Gans and other urban social scientists and that, arguably, fathered the American social planning movement of the 1960s. Another piece of the pattern may be the planner Paul Kriesis, who worked, I believe, at the London City Council. A discussion with him in 1956, just before Robert Scott Brown and I left London for America, broadened my view of socioplastics and prepared the way for Gans's lectures in urban sociology at Penn in 1958. Kriesis, I realized later, sounded like a Chicago University urban planner.5

There was a connection between the New Brutalists and the antiheroes of English literature of the 1950s. The play, *Look Back in Anger*, which opened in London when I was there, could almost have described our lives. A few years later, when the Beatles arrived on the scene, they too looked familiar, a second cultural import from the north. In retrospect, the Smithsons were like early architectural Beatles. And the ripples widen further

with the Beatles-Elvis connection, linking Liverpool to Memphis and ultimately, full circle to the architectural group Memphis, in Milan.

Certainly Brutalist and IG thinking influenced the Pop-zoom visions and megastructuralist fantasies of Archigram and its imitators – although I doubt whether the progenitors would be happy to claim the offspring. If there is any historical relation between the IG and American Pop Art, others can interpret it better than I. However, it may be illuminating of transatlantic differences at the time to note that when I first met American Pop Art, at the Venice Biennale in 1958, I assumed it was an exciting continuation of a well-established trend. I felt the artists were finally catching up with the architects – that is, with the Brutalists. Bob Venturi, from America, saw Pop Art as a new statement.

In our AA student group, Brutalist or neo-Brutalist thinking came in many shades. There were machine romanticists, industrial romanticists, Early-Modern romanticists, folk romanticists, pop culture-socioplasticists, technocrats, and mannerists. (I suspect that Colin Rowe, from Cambridge, had an unseen influence on us through one of our members, a transfer from the Cambridge school of architecture.) Outside our group but in loose relation with it were Marxist romanticists, megastructuralists, Wrightian deviationists and Lutyens enthusiasts – all before 1955. This was a time of high spirits and irreverence. Although arrogantly self-defined as "we precious few" and riven by in-group schisms, the members of our group nevertheless had a lot of fun; much of it came from learning to like the unlikable, as Bob Venturi and I did later. Discovering a Constructivist-looking steel and glass storefront or a concrete warehouse with strangely proportioned industrial windows, my friends would say, "That's Gothic," which could mean something terribly good or terribly bad, depending on the situation. They even called themselves "Goths." A young machine romanticist who left for America sent a letter home describing an experience of "travelling at 90 miles an hour, 80 feet in the air, in a steel and glass Cadillac!" Was he on the Pulaski Skyway?

My 1954 thesis project, housing and planning for a Welsh mining village, designed in collaboration with Brian Smith, had Brutalist affinities, not so much in its forms as in its subject matter, and in that all dwelling units were on or near the ground. Our drawings had the Brutalist industrialized look that was introduced at the AA then and remained in fashion in England for years. As I recall, Brian Smith hoped to make our project more Cubist, but I argued that he wanted a "functional" appearance for aesthetic not functional reasons. We took our completed drawings to the Smithsons for a "crit." The memory of their Brutalist apartment has stayed with me longer than the content of their criticism, but I think they found the grid base of our design too rigid.

During the following year, Robert Scott Brown and I approached Peter Smithson for career advice. He recommended we attend the University of Pennsylvania because Louis Kahn was there. Kahn had emerged as a quite unexpected American confirmation of Brutalist ideas, owing chiefly to his Trenton Bath House. He had made contact with the Brutalists and Team 10 in the late 1950s and their influence is visible in his Richards Medical Research Building.6 As it turned out, it was not Kahn, nor indeed the Smithsons, who helped me develop a personal approach to socioplastics; it was the planning faculties at Penn and Berkeley.7 In the late 1950s and early 1960s they brought

Signs of Life: Symbols in the American City
exhibition by Venturi, Rauch, and Scott Brown,
at Renwick Gallery, Washington, D.C., 1976.
View of entrance (left) and suburban living
room display (right).

Although the historians and critics have not noticed it, they are an important component of the philosophy and architecture we have built together since then.

Socioplastics and the pop imagery and collage techniques launched by the IG, although they are not our only sources, obviously inform our "Learning from Las Vegas" and "Learning from Levittown" research projects and the *Signs of Life: Symbols in the American City* exhibition that resulted from them. Brutalism has influenced the urban planning and architecture of our firm as well, although here other concepts predominate: as planners, our span is broader and more interdisciplinary than that of the Brutalists, we approach the problems they defined from more points of view than they did; as architects, we enjoy the "uncomfortably direct" solutions of the Brutalists, but we value as highly the "uncomfortably indirect" solutions of mannerism. Our studies of Pop Art and the pop environment led us to reassess the role of symbolism and allusion in architecture and the use of traditional forms, decoration, and pattern in design. This took us away from the New Brutalism. Nevertheless, when the critics defined our aesthetic as tasteless and our design as "ugly and ordinary," I felt a sense of *déjà vu*, having heard the same objections to Brutalist designs in England.

By the mid-1960s, Venturi and I were headed in a direction quite different from that of the Smithsons. They had, I believe, departed from socioplastics long before, having decided that architects could not obtain help from sociologists. I disagreed with their opinion, feeling that the Brutalists and Team 10 were, in part, up against the blank wall of their own ignorance, particularly of urban planning and the social sciences. Brutalist insights did not lead the Smithsons to break with the constraining dogma of the Modern Movement. In fact, they abandoned socioplastics in favor of Late Modern structural expressionism – for me a lesser creed. The Smithsons had the additional and tragic problem of not finding sufficient support for their work from clients. For whatever reason, there is sadly little to show (apart from the early buildings and writings of the Smithsons and the writings of Reyner Banham) for the brilliant ideas of the Brutalists.

Although I had previously published my reservations on the Brutalists and Team 10,[9] our differences did not become public until our four-person exchange on the architecture of Lutyens, in 1969.[10] But the Smithsons and Banham had always looked askance at Venturi's work and, since our col-

an array of intellectual resources unknown in British architecture to the critique of CIAM urbanism (as interpreted in American urban renewal). Their proposals for American cities served as muse and spur to me. The social planners in particular seemed to provide conceptual tools for approaching Brutalist urban aims.

I taught for ten years at the nexus between architecture and planning, trying to relate architectural and urban design to the planning philosophies emerging from the social crises of the 1960s. In this effort, the IG members' interest in pop imagery, urban communications and advertising, their recognition of the design implications of car culture, and their use of exhibitions to clarify new perspectives, became increasingly relevant. For me, at least, the British avant-garde was more relevant than American Pop Art (which I love and admire) because the collagist sensibility of the British suggested a direct artistic expression for the pluralist city and for the linkages between its disparate elements.

As I juggled the Anglo-American combinations of socioplastics and social planning, IG and Pop Art, I continued to formulate my own ideas on the joining of physical and social, and to evolve my own architectural aesthetic.[8] When I had time, I photographed the American pop environment, adding to a collection Robert Scott Brown and I had begun in Europe. I used the images for teaching. All this – ideas, aesthetics and slide collection – I brought to my collaboration with Robert Venturi, which started in 1960.

laboration, presumably at mine as well. I find that sad, having learned from them. However, we've diverged far from Brutalism, especially in its later forms, and we never were part of this group – if such a group existed – or of any other. Perhaps, like the IG members, we were too "independent" to join a movement.

Finding myself between several continents, schools of thought, and professional disciplines, I have had an unusual vantage point, a good one I think, for spotting trends and connections. I have tried to spell these out – or at least my interpretation of them – and have also gone beyond what I saw to infer the existence of other connections, based on an analysis of the ideas and designs that were produced. These guesses and hunches may be inaccurate, but they can be checked. It is fortunate that the rebirth of interest in the IG should have occurred while many of its members are still available to give evidence.

1. *My account is based on an interview conducted by Jacquelynn Baas and David Robbins in Philadelphia in spring 1988, the aim of which was to clarify my association with the Brutalists in the early 1950s and discuss my own role in the cross-Atlantic dissemination of ideas that developed from the IG milieu.*

2. Journal of the American Institute of Planners, 32 (January 1967), pp. 42-50.

3. *I have recalled this period at the AA in other contexts in "Between Three Stools: A Personal View of Urban Design Practice and Pedagogy," in* Education for Urban Design, *ed. Ann Ferrebee (Purchase, New York, Institute for Urban Design, 1982), pp. 132-172, and in "A Worm's Eye View of Recent Architectural History,"* Architectural Record, *172 (February 1984), pp. 69-81.*

4. *Michael Young and Peter Wilmott,* Family and Kinship in East London *(London, 1957).*

5. *Kriesis gave us a pamphlet,* Paralipomena in Town Planning, *dated 1951, explaining that paralipomena was Greek for "things that have been left out." These omissions I was later to find included on the agendas of Herbert Gans, Paul Davidoff, Melvin Webber, et al., my professors and colleagues in planning school. Kriesis's writings of the early 1950s were republished as* Three Essays on Town Planning *(St. Louis, The School of Architecture, Washington University, 1963).*

6. *In the extensive literature on Kahn this connection is barely noted – perhaps because it was short-lived. I discuss it in "A Worm's Eye View."*

7. *See "Between Three Stools" and "A Worm's Eye View."*

8. *See, for example, "On Pop Art, Permissiveness and Planning,"* Journal of the American Institute of Planners, *35 (May 1969), pp. 184-186; "On Architectural Formalism and Social Concern,"* Oppositions *5 (Summer 1976), pp. 99-112; "Architectural Taste in a Pluralistic Society,"* Harvard Architectural Review, *1 (Spring 1980), pp. 41-51. At the Universities of Pennsylvania and California, from 1963 to 1966, I gave three studio projects and a course on the subject "Form, Forces and Functions." My aim was to teach architects to make connections between the physical and the social as designers, not as scientists or analysts.*

9. *"Little Magazines and Urbanism,"* Journal of the American Institute of Planners, *34 (July 1968), pp. 223-233 and "Urban Structuring," a review in* Architectural Design, *38 (January 1968), p. 7.*

10. *Alison Smithson, "The Responsibility of Lutyens,"* Journal of the Royal Institute of British Architects, *76 (April 1969), pp. 146-151; Peter Smithson, "The Viceroy's House in Imperial Delhi,"* Journal of the Royal Institute of British Architects, *76 (April 1969), pp. 152-154; Robert Venturi and Denise Scott Brown, "Learning from Lutyens,"* Journal of the Royal Institute of British Architects, *76 (August 1969), pp. 353-354.*

The Artists of the IG:
Backgrounds and Continuities

by Diane Kirkpatrick

In the mid-1940s, Eduardo Paolozzi, William Turnbull, and Nigel Henderson were fellow students at the Slade School of Art in London.[1] Turnbull and Henderson came to the school from war service as pilots. Paolozzi had been briefly interned as the "alien" son of Italian parents, and then had served several months in the Pioneer Corps. He was discharged in 1944 and entered the Slade, which was still evacuated to Oxford. The school there did not excite him, although visits to the Ashmolean Museum introduced him to the power of intimate size in the etchings of Rembrandt and the wonder of intricate detail in the paintings of Piero di Cosimo. He also explored art of a very different sort by making drawings of African sculpture in the collection of the Pitt Rivers Museum.

When the Slade was once again back home as part of the University of London, Paolozzi was delighted to discover how much he had in common with Turnbull and Henderson. Paolozzi was born to working-class parents in Leith near Edinburgh. Turnbull was a fellow Scot, born in a tough section of Dundee. As a boy, Paolozzi had spent summers in Italy and was bilingual. Turnbull had done his war service in Canada, Ceylon, and India and was intrigued by the communication properties of different languages. Paolozzi grew up fascinated by American movies, comic books, and popular male fiction. He attended evening classes at the Edinburgh College of Art with the intention of becoming a commercial artist. Turnbull was attracted from youth by "quantities of magazines and comics sent to his family by cousins in America,"[2] and he had earned his prewar living as an illustrator for pulp detective and love magazines.

Nigel Henderson was a Londoner. His interest in many of the same things that fascinated Paolozzi came from his prewar exposure to avant-garde art in Peggy Guggenheim's Guggenheim Jeune London gallery, which his mother managed, and from a home environment that thrust him into the company of artists and writers like Duncan Grant, Max Ernst, Marcel Duchamp, Yves Tanguy, Dylan Thomas, and W. H. Auden, as well as the scientists J. D. Bernal and Norman Pirie. Henderson had flown bombers during the war, until he suffered a nervous breakdown which he later saw as a "rebirth." When he enrolled at the Slade in 1945, he found it "fearfully out of whack with the atom-smashing world," a view shared by Paolozzi.[3] The two young artists spent hours going to the movies, attending lectures on all kinds of topics in other parts of the university, and looking for treasures in the collections of London's non-art museums. Moreover, through Henderson, Paolozzi was introduced to a cross-section of contemporary European art of the day.

There were two important exhibitions mounted by the ICA in 1948: *Forty Years of Modern Art*, a collection of works by established modern artists such as Joan Miró, Picasso, Paul Klee, and Wassily Kandinsky, and *Forty Thousand Years of Modern Art*, which placed Picasso's *Les Demoiselles d'Avignon* and other modern works side by side with art from other times and places. Both would have been extremely important for Henderson, Turnbull, and Paolozzi, even though Paolozzi was based in Paris at the time. We must remember how difficult it was to see modern art in England during the years immediately following World War II.

Paolozzi was the first of the trio to break out of the student world into the professional art world. The vigor of some of his 1946 drawings and plaster sculptures persuaded Fred Mayor to offer the youthful artist a show at the Mayor Gallery in the spring of 1947. This was a coup for one so young. The Mayor Gallery had established a reputation in the 1930s for exhibiting both abstract and Surrealist avant-garde art and had been one of the few West End galleries to remain open during World War II.

Mayor had no idea that Paolozzi was still a student at the time. The works he exhibited were created under the spell of Picasso's paintings of the 1930s, in which Synthetic Cubism is bent to expressive, surreal ends. From the works in the Mayor exhibition, it is clear that Paolozzi admired Picasso as an inventor of patterns that fill every section of his figures and often the background as well. But Paolozzi's roughly drawn or incised surface patterning on the works from this period owes much also to the surfaces of African sculpture, and the jaunty awkwardness of his figures speaks of his interest in art that did not follow any academic line.

Paolozzi sold enough works from his Mayor Gallery exhibition to pay his way to Paris, which he was longing to visit. He left the Slade without graduating and went off to live in France, armed with letters of introduction from Henderson's mother to many artists he wanted to meet. In Paris he came to know Alberto Giacometti and Tristan Tzara, and met Jean Hélion, Jean Arp, Georges Braque, Constantin Brancusi, and Fernand Léger (who arranged for the young Scot to see the French artist's pioneering 1920s film *Ballet Mécanique*). Paolozzi also became immersed in the wealth of Duchamp materials in the collection of Mary Reynolds.

Turnbull came to Paris for a visit in 1947 and returned in 1948 for a longer stay. With Paolozzi he visited the Musée de l'Homme and saw Dubuffet's collection of Art Brut. Like Paolozzi, he met Giacometti and Tzara. Such meetings fed the interest Turnbull shared with Paolozzi in varieties of visual communication. Turnbull also visited Hélion, Léger, and Brancusi.

Shortly after Turnbull left for Paris, Richard Hamilton came to the Slade. There he quickly connected with Nigel Henderson. Like Henderson, Hamilton was a native Londoner. But he had taken a more circuitous route to the Slade, working from the age of fourteen in an advertising department during the day while attending evening art classes. Finally he managed to attend two full years at the Royal Academy School before it closed for the war in 1940. Too young to be called up for active duty, he worked as an engineering draftsman and looked at art in the Bond Street galleries. He reentered the Royal Academy School when it reopened in 1946, but a new ultraconservative teaching regime led to his expulsion, and he entered active military service. Finally he arrived at the Slade. There Henderson introduced Hamilton to a copy of Duchamp's *Green Box* in the library of Roland Penrose. Penrose was well known as an artist and critic who had championed Picasso and the Surrealists during the 1930s. In the 1940s, he was one of the founding spirits of the Institute of Contemporary Arts, along with Herbert Read and others interested in maintaining a vital presence for modern art in London.

Paolozzi and Turnbull returned to London at the end of the 1940s. For a time they shared a studio. They were each teaching at the Central

School of Art, and they shared an exhibition in 1950 of the work they had produced during their Paris years. At the end of 1950, they were included, along with Richard Hamilton, in the exhibition *Aspects of British Art* at the ICA. Slightly older, Nigel Henderson formed a strong link with the other three artists, who shared his catholic interest in things and ideas from the worlds of science, art, communication, and the artifacts of diverse cultures. The early work of the four artists reveals profound interconnections, despite the differences in artistic temperament that would soon lead them in contrasting directions.

Hamilton's paintings of the early fifties tend to have lines and forms dispersed sparsely over a light-colored field-ground. The paintings read like spare scattergrams, which might on closer inspection become parts of an almost invisible figure-sign or might remain suggestive of a diagrammatic illustration in some abstruse scientific tome.

Turnbull's work from the late 1940s also suggests much with a minimum of means: spare assemblies of modeled or painted marks that appear teasingly close to signs. Turnbull remarks that he was intrigued both with random movement, as in pinball machines and billiards, and with "the predictable movements of machines." Preoccupied with the playful possibilities of "energy as creation," he drew formal ideas ("movements in different planes at different speeds," "things in a state of balance"[4]) from analogies between electrical phenomena and the movement of insects, fish, and plants.

Both Turnbull and Paolozzi made sculptures at this time in which forms are suspended on a horizontal rod frame. Turnbull's forms, however, resemble delicate, spiky rods, while Paolozzi's evoke thick sensual organisms with stubby tentacles. The details of Turnbull's compositions, which suggest the slender stems, seeds, and pistils of plants, seem drawn from a world like that which inspired some of Hamilton's painted marks. However, Hamilton's work is invested with the tension of forms on the brink of moving apart, while the elements of Turnbull's paintings and sculptures cohere as a unit that, however fragmented, seems centered within itself.

Paolozzi's work of the same period is more visually aggressive than either Hamilton's or Turnbull's. By the early 1950s, Paolozzi's sculptures had moved away from the expressionist animals of his London student years toward strange mixtures of organic and machined forms. The forms are bold and massive. Yet they are infused with a mysterious aura that opens the works outward to a succession of varied associations. The Surrealist quality here is drawn from visits to natural history museums of science and industry, as was that in the work of Max Ernst.

Paolozzi's collages of the late 1940s contrast with the massive style of his sculpture of the same period. One group of Paris collages was inspired by street fair shooting gallery booths. These works are composed of flat planes of torn colored paper, with linear ink details that extend the compartmentalized designs of Paolozzi's Slade work, while evoking the strange personages of Paul Klee. The compositions also speak with the push-pull energies of Picasso's Synthetic Cubism.

During the past decade a number of collage heads made by Paolozzi in 1946-47 have surfaced (see cat. no. 43). They are done in a very different style: an underlying painted or found image is overlaid with an assembly of disjoined image fragments torn from mass-media sources. These works recall the collaged images fashioned by Max Ernst beginning in the late teens from nineteenth-century industrial catalogues and illustrative engravings. In the substitution of artifacts for facial features, Paolozzi's figures have an eerie connection with the African and Indian masks found in Hannah Höch's collage figures and in George Grosz's *Remember Uncle August, The Unhappy Inventor* (1919).

A different group of popular media collages from 1948-49 was published much later as the *Bunk* silkscreen series (1972). In these, the collection of images covers the surface of the support in a continuous array of figures and objects of different types, sizes, and styles of depiction. The effect resembles a type of Berlin Dada collage found in much of the work of Raoul Hausmann and in some pieces by Höch. Addressing these collages, it may be useful to recall Sergei Eisenstein's theory and use of montage in his films, where meaning is created by jump-cutting between two disparate images to suggest a conceptual link not found in either subject on its own. While Paolozzi's head-collages of the early 1950s point toward his wax-sheet bronze figures from the later 1950s and his collage-based movie, *The History of Nothing* (1960), the Paris and *Bunk* collage sheets prefigure the compositions of the screenprint portfolios *As is When* (1965) and *Universal Electronic Vacuum* (1967), the architectural wall reliefs of the 1980s, and the Tottenham Court Underground mosaics (1979-86).

In Paris, Paolozzi had found a ready source of mass-media magazines, freshly arrived from the United States, through American friends who were in France studying under the GI Bill. Paolozzi and Turnbull both collected such material, and each put his favorite images up on the walls surrounding his work space. Paolozzi used many of these images in collages of this period and squirreled a huge number away in boxes and trunks for possible future use. To the two young Britons, American magazines were a direct window into the postwar United States – an unbelievably lush consumer world from the transatlantic view of one living in a Europe still on "short rations." Max Ernst had gone to the nineteenth century to find images that would introduce into his collages the exotic quality of remoteness from everyday life in early twentieth-century Europe. Paolozzi and other Independent Group members after him discovered a similar fantastic quality in the commercial magazines of an affluent contemporary culture that seemed far removed from Europe's wartime experience.

The first IG meeting was an evening in 1952 at which Paolozzi projected an array of mass-media images from his collection through a simple overhead projector called an epidiascope. There is some disagreement about whether the images were all individual found-object sheets or whether some of them were collaged pages. But everyone who was present remembers being moved by the deluge of visual material delivered without pause, logical organization, or didactic explanation.

Whether or not the artist threw any of his actual collaged images into the heat of the epidiascope on this historic occasion, it appears that the effect of Paolozzi's performance was that of a single, grand montage stretched out into time. The random juxtapositions of images would have seemed like a fast flip through a picture magazine or newspaper. As John Cage remarked with reference to the mid-1950s Assemblage paintings of Robert Rauschenberg, on a newspaper page every item is of equal value. Any single piece can

be removed and another substituted without changing the overall impact.[5] But the collision of images can generate a powerful emotional experience, as Eisenstein, Dziga Vertov, and other Russian filmmakers had demonstrated in their montages. However, the "meanings" generated by Paolozzi's succession of images were more closely linked to the Surrealist aesthetic than to the Russian avant-garde. Chance and dream merged, and each member of the IG audience was free to experience something quite different from his or her neighbor. Today, Paolozzi calls himself "an ordinary surrealist," emphasizing the underlying roots of his material.[6]

In September 1953, an exhibition opened called *Parallel of Life and Art*, organized by Paolozzi and Henderson along with Alison and Peter Smithson. Like two shows Hamilton had designed, *Growth and Form* (1951) and *Wonder and Horror of the Human Head* (1953), *Parallel of Life and Art* presented ideas through enlarged photographs of objects from art and nature, drawn from a wide variety of sources. But in contrast with Hamilton's orderly exhibitions, the *Parallel of Life and Art* installation used the panels holding the photographs to enclose the visitor with images apparently arranged in random order. Nothing was given more importance than anything else. The catalogue lists images under eighteen "categories." Some of the titles have a literal relation to the pictures they contain. But seven of them are more analogically related to the items in their groups. These "strange bedfellows" could trigger a reexamination of the viewer's assumptions. For example, the "Architecture" section of *Parallel of Life and Art* included pictures of Greek temples, modern skyscrapers, and other "normal" views of human-designed structures. But it also had air views of ancient cities, details of a mask, and pictures of the cellular tissue of vegetables. The emphasis here was on the structure of systems, but there was no didactic presentation of a particular type of system to fit the "architecture" category.

Parallel of Life and Art was inspired by the recognition that images from disparate sources and different points of view, often transformed by different scales of magnification, could stimulate a new kind of awareness of the contemporary world. Paolozzi and Henderson were particularly interested in such works as E. A. Gutkind's photo book *Our World From the Air* and Gyorgy Kepes's exhibition (and later book) *The New Landscape*. Kepes's ideas were an extension of those of his friend and mentor Laszlo Moholy-Nagy. Moholy-Nagy founded the New Bauhaus in Chicago in the late 1930s, and his books *The New Vision* (1928) and *Vision in Motion* (posthumously published in 1947) explored the ways in which heterogeneous images can help us develop the kind of perception we need to understand the contemporary world.

The overall effect of the installation in *Parallel of Life and Art* was related to the experience of looking at Art Informel or an Abstract Expressionist painting by Jackson Pollock or Sam Francis, although the details of the British exhibition remained recognizably photographic. Earlier, in January, an exhibition at the ICA called *Opposing Forces* had showcased works by Pollock, Francis, and the French *informelistes* Henri Michaux and Georges Mathieu. Paintings by these artists have intricate visual textures spread in an almost unaccented way over the entire surfaces of their canvases. They share with the *Texturologies* of Dubuffet an excitement about the kind of patterns in nature which have recently been studied by scientists under the title "Chaos Theory." By the 1950s, scientists had already expanded the picture of reality

to include the atomic level, at which atoms appear to move randomly through an "empty field." This atomic activity takes place well beneath the threshold of unaided human sight. The concept, however, stimulated artists' interest in overall patterns recurring throughout the visible world.

Photographs of all-over texture had intrigued Bauhaus artists like Moholy-Nagy from the 1920s on, but they did not use such patterns in most of their work. Such photographs were not only part of *Parallel of Life and Art*, but Paolozzi, Henderson, Turnbull, and Hamilton each were creating personal scattergram patterns in their paintings, sculptures, prints, and collages of the early 1950s. Henderson also was very interested at this time in making close-up photographs of evenly textured surfaces like concrete.[7] The effect of overallness in Hamilton's paintings of the early 1950s was generated by his interest in superimposing layers of images and selectively omitting parts from each layer to create compositions in which small, delicately rendered and unmatched formal elements seem to be scattered over a pale ground.

Turnbull, in his paintings from 1949, dispersed repeated symbols or shapes over the entire surface of his canvases. And many of his sculptures from the same period are compositions in which assemblies of thin linear elements spread out across a base to suggest the pattern of a host of people, grass blades, or mysterious machines frozen momentarily in the midst of their normal motions of life. Later, in 1953, the disks of Turnbull's *Masks* were encrusted with bumps and striations which foreshadow the overall brushed, incised, or impressed markings that completely cover the surfaces of his painted and sculpted heads and figures of the mid-1950s.[8]

By the early 1950s, Paolozzi had perfected a kind of rough-hewn, meandering linear network design, which visually resembled his fountain for the Festival of Britain.[9] This kind of design, in two dimensions, allowed him to cover areas of any scale and any orientation with a pattern that suggested everything from vines to the lineaments of a human or insect community seen from above. There was no beginning and no end to such patterns. There was also no sense of gravity, no up or down. They looked equally bizarre and at home on a ceiling or wall.[10]

The interest of the IG in overall compositions prepared them to find an intriguing theoretical basis in the ideas of what was called (after Alfred Korzybski) "non-Aristotelian thinking." The assumption here is that all experience is influenced by every detail of the physical, psychological, and rational makeup of the perceiver. In order to understand anything, one must take into account the effect of our personal "filters" upon our perception of it. This means that everything must be considered with equal attention and as of equal importance. In April 1955, the IG had a discussion about "Dadaists as Non-Aristotelians."

Korzybski's ideas may have influenced Hamilton in his bold adoption of popular imagery on an equal basis with fine art references and techniques.[11] The IG members apparently did not explicitly link Korzybski's General Semantics to their interest in overallness, despite the innate affinity between the two. However, the preoccupation of member artists with overall composition intensified, if anything, during the period of IG meetings. Art Informel appeared in 1955 exhibitions at the ICA of the works of Dubuffet (March) and Mark Tobey (May). That same year, Henderson and Paolozzi founded Hammer Prints Ltd. to market their textile and wallpaper designs.

Paolozzi's *Work in Progress*, containing many pieces with "overall" elements, was shown at the ICA in May. An exhibition of monotypes by Magda Cordell, with visual links to the French artists, was held at the ICA in July, and some of the same pieces would be included in her one-person show at the Hanover Gallery in January 1956.

Cordell's work of this period is expressionist and elemental. Her subjects are looming earth mothers, android figures, or galactic visions. Her approach is Brutalist, in the spirit both of Dubuffet and of some of the CoBrA paintings being done during these years. However, unlike the rough-hewn shapes of the Paris artists, Cordell's forms resemble dynamic fields of boiling particle energy, barely held in check by the boundaries of her figures.[12]

The Independent Group's interest in exploring the anti-hierarchic social and aesthetic assumptions of "all-over" and non-Aristotelian thinking led to tension between the responses of Hamilton and Paolozzi to this challenge. The contrast between them was vividly seen in their two teams' immensely successful displays for *This Is Tomorrow*.[13] On the one hand, Hamilton, McHale, and Voelcker (Group Two) directed "all-over" thinking toward the perceptual density of an egalitarianism based upon mass consumption. On the other, Paolozzi, Henderson, and the Smithsons (Group Six) used "all-overness" or "scatter" effects to reject the hierarchic prejudices and sentimentalism of British taste. Their vision of fundamentals was symbolized by the evenly scattered relics of the workingman's life. These two installations reveal the two fully matured sides of the IG aesthetic.

In the Group Two display, John Voelcker designed a series of enclosed spaces within one area that faced the other exhibits. From within the enclosed spaces, the visitor was subjected to a barrage of visual stimuli that included giant reproductions of black-and-white Bauhaus optical illusions, spinning enlargements of Duchamp's *Rotoreliefs*, montages of images projected through a film projector, and a dense Dadaesque collage of material from the mass media. In the inner rooms, the spectator encountered a flexible floor, crisscrossing light beams, and loud rock music played on a jukebox.[14] The side panel of the area that could be seen from elsewhere in the exhibit sported a giant image of Robbie the Robot carrying a languishing human damsel (from the science fiction film *Forbidden Planet*, then in the cinemas). Partially overlaying Robbie was an enlargement of a still from the movie *The Seven Year Itch*, showing Marilyn Monroe with her skirt billowing from a blast of air from a sidewalk grating. Nearby was a reproduction of Vincent van Gogh's *Sunflowers* to represent the most popular side of fine art.

Hamilton later described Group Two's mini-exhibit as "a kind of fun house of all the multifarious intrusion of the mass media into our lives."[15] In contrast to the other exhibits, which asked spectators to take a more passive role, here they were invited to enter in and play. As science museums in particular have discovered in recent years, this kind of exhibit is what the crowd likes. There is evidence that many visitors to *This Is Tomorrow*, having realized that this was the only carnival-like part of the exhibition as a whole, did not explore further.

Some of the technical equipment (like the motors to propel the Duchamp discs, the film projectors, and the large movie posters) were provided by Magda Cordell's husband, Frank Cordell, who had been participating in the IG as a musician and who had professional contacts in the film and music business. The Duchamp *Rotoreliefs* and most of the imagery in the mass media collage in the Hamilton-Voelcker-McHale section, were provided by McHale. He brought them back with him when he returned in July 1956 from a year's fellowship in the United States working with Josef Albers at Yale University. During his absence from England, McHale sent many ideas for the exhibition to Hamilton. Cordell acted as liaison for the transmission of concepts and materials. She also helped Terry Hamilton plunder the trunkful of American magazines McHale had collected for imagery for the large montage in the exhibition, and for suitable details to be included in a collage Richard Hamilton was creating to be used as a poster for the show and as a black-and-white illustration in the catalogue.

Hamilton's small collage *Just what is it that makes today's homes so different, so appealing?* has become the most renowned contribution to *This Is Tomorrow*, because it was eventually taken up as the first real Pop Art image by Lawrence Alloway, Reyner Banham, and others writing later about the evolution of that style. Hamilton had given his wife, Terry, and Magda Cordell a list of the types of objects he wanted to use, which they were to locate and cut out, in the appropriate sizes, from McHale's store of magazines and any other sources they could find. The list included: "Man, woman, humanity, history, food, newspapers, cinema, TV, telephone, comics (picture information), words (textual information), tape recording (aural information), cars, domestic appliances, space."[16] Among the things they appropriated was the image of an American Tootsie Pop sucker, not because it was on the list, but because it was the right size. Hamilton later was looking for something that size for the muscle man's hand, and used it. Its intuitive inclusion in the collage only enhanced the reputation of this work as the granddaddy of all Pop images.

The display by Paolozzi, Henderson, and the Smithsons for *This Is Tomorrow* was called Patio and Pavilion. Like the Hamilton-Voelcker-McHale display, and unlike the other entries, it was entirely designed by IG members. As Group Six wrote in the catalogue, their exhibit represented "the fundamental necessities of the human habitat in a series of symbols." The exhibition space was defined by a fenced open yard area – the Patio (to serve the "first necessity – a piece of the world"); within it was a rough garden lean-to – the Pavilion (to fulfill the "second necessity – an enclosed space"). Within the patio was a collection of essential symbols: Paolozzi sculptures of a head, to stand "for man himself – his brain and his machines"; a rock to represent "natural objects for stability and decoration of man made space"; a frog and a dog "for the other animals"; and a Henderson-provided photographic "tree image – for nature." On the roof of the pavilion was an assortment of found-object wheels, representing both "the wheel and aeroplane – for locomotion and the machine." The translucent plastic roof admitted some light, but there was a "light box – for the hearth and family" and an assortment of "artifacts & pin-ups – for . . . irrational urges."[17]

Two huge photo-collages by Henderson were placed on the Patio floor.[18] On the shed wall was another large photo-collage by Henderson – a sort of paterfamilias image, *Head of a Man* (cat. no. 33). The latter, now in the collection of the Tate Gallery in London, is composed on two sheets of ordinary paper. The image is partially based on close-up photographs of earth or craggy concrete, superimposed in the darkroom over a photograph of a

man's head. A mixture of photographed textures and details comprises the rest of the face, the hair, and the suitcoat (we see head and shoulders and part of the chest and one upper arm). Each texture is chosen to allude to the figurative element it replaces. The suggestively analogic aspect of the whole and the irregular torn edges along the bottom create an uncanny resemblance to Paolozzi's *Shattered Head* (1956), which was cast from an original fashioned from sheets of roughly textured wax.

Paolozzi's sculptures in the exhibition included a *Head* with startled upturned eyes, a wedge-shaped nose and a tortured hand raised over its mouth. This piece relates to some earlier works inspired by casts of writhing human shapes in the museum at Pompeii.[19] Paolozzi's *Rock, Frog,* and *Dog* resembled other works from the early 1950s, in which he wrapped the surface of his bulky forms in a relief pattern that suggests surreal prehistoric landscapes.

Both of these more famous *This Is Tomorrow* displays testify to the immense accomplishment of the IG's artists in adapting avant-garde traditions to the postwar situation. By examining their roots and the evolution of their art through the period of the IG, we become aware of the fact that the engagement of the IG with America was in many ways a profoundly European reproof to British parochialism and sentimentalism. We also recognize that the IG's dialogue between art and non-art sources was much broader based than that of Pop Art. The astonishing experimental fluency of the Independent Group artists demonstrates their continuity with the most vital moments of modernism.

1. *A complete chronology of Paolozzi's career is found in Robin Spencer, Eduardo Paolozzi: Recurring Themes, exh. cat. (Edinburgh, Royal Scottish Academy, 1984), p. 140. Many details of Turnbull's career are found in Richard Morphet, William Turnbull: Sculpture and Painting, exh. cat. (London, The Tate Gallery, 1973). Information on the career of Hamilton is found in Richard Hamilton, Richard Hamilton: Collected Words 1953-82 (London, 1982). For Henderson, see Heads Eye Wyn: Nigel Henderson, exh. cat. (Norwich School of Art, 1982).*
2. *Morphet, William Turnbull, p. 21.*
3. *Graham Whitham, "The Independent Group at the Institute of Contemporary Arts: Its Origins, Development and Influences, 1951-1961," Ph.D. dissertation, University of Kent at Canterbury, 1986, p. 47, and passim for biographical information on Henderson.*
4. *Quoted in Morphet, William Turnbull, p. 26.*
5. *John Cage, Silence (Cambridge, Massachusetts and London, 1966), pp. 98-99.*
6. *Paolozzi's self-description occurs in E. P. Sculptor, a film by Barbara and Murray Grigor, 1987. The aggressive surreality of Paolozzi's "lecture" at the ICA may be at least part of the reason why Reyner Banham took refuge in scathing laughter as image followed image on the screen. See Whitham, "The Independent Group," pp. 69-70, for a more complete account of both the event and Banham's reaction to it.*
7. *These and some of his other work were shown in "Nigel Henderson: Photo-Images" at the ICA in April 1954.*
8. *Richard Morphet describes two films made by Turnbull in the 1950s in collaboration with Alan Forbes, which seem to have a similar quality of open-ended overallness. In one, the filmmakers allowed color film "to blister in the camera," creating an extension in time of an experience similar to that of watching a single frame of film trapped in a jammed projector mechanism as it overheats and dissolves into an amoeba-shaped hole spreading from the middle outward. The visual content of Turnbull and Forbes's second film was a montage of isolated shadows cast by Turnbull sculptures placed just out of camera range. The sound track for this film was a montage of ambient noises and music from varied cultures, occasionally speeded up or slowed down to create a shifting auditory stream in which individual sounds became almost interchangeable with one another (see Morphet, William Turnbull, p. 25). As Morphet points out, the emphasis in these films on the processes which made them as well as on permutability represent ongoing interests for Turnbull.*
9. *The fountain that Paolozzi designed for the 1951 Festival of Britain looked rather like a fantastic vegetal cage and seemed to be a re-creation in three dimensions of some of the network patterns he had begun spreading over the surfaces of paper and incising into the surfaces of sculpture during this same period. The shapes of the fountain also suggested links with some of the photographed shapes included in Hamilton's Growth and Form exhibition, created as his contribution to the same festival.*
10. *An example of the ceiling work is the decoration done by Paolozzi in 1952 for the London offices of R. B. Jenkins. An extant mural from these years, also in London, is in the offices of Jane Drew and Maxwell Fry. For many years, Nigel Henderson had in his collection several relatively small paper "modules" for such patterns. They had been deliberately created by Paolozzi to produce overall designs on wallpaper or fabric, by fitting stacks of them together with no particular attention paid to aligning the edges of the pattern. At the time of the Henderson photo exhibition at the ICA, he and Paolozzi collaborated with Dr. Patrick Collard to present a montage of film extracts, The Pattern of Growth, which extended into time some of the concerns that had intrigued the two artists in Parallel of Life and Art.*
11. *The ideas of non-Aristotelianism were initially framed in Alfred Korzybski's Science and Sanity: An Introduction to Non-Aristotelian Systems and to General Semantics (1933). While some of the IG group may have tackled the original, many of them undoubtedly first encountered General Semantics in the science fiction world of A. E. van Vogt. In 1945 van Vogt published The World of Null-A, in which he located the saga of a superman hero (with an extra brain) within a world in which the ideas of non-Aristotelianism were in conflict with those of a more reactionary human behavior. This story first appeared in three parts in Astounding Stories magazine. Its publication in book form was shortly followed by The Players of Null-A and later, in 1985, by Null-A Three.*
12. *Cordell was the only woman artist member of the IG actively exhibiting her own work. It is interesting that the Group scheduled no discussion of her work, as they did for the exhibitions of other members.*
13. *Planning for This Is Tomorrow began in 1954. For the exhibition at the Whitechapel Gallery in London, ten teams of painters, sculptors, and architects each designed an installation along the mazelike route that led through the site.*
14. *This section was an early example of the kinds of environment created by some of the optical kinetic artists in Paris in the late 1960s. It also is related to Bridget Riley's design for her three-dimensional optical painting Continuum (1963).*
15. *Richard Hamilton, "The Impact of American Pop Culture in the Fifties," a talk broadcast by the BBC for the Open University, undated, quoted in Whitham, "The Independent Group," p. 260.*
16. *Richard Hamilton, Collected Words, p. 24, and Magda Cordell in a 1983 communication to Graham Whitham, published in Whitham, "The Independent Group," p. 266.*
17. *This Is Tomorrow, exh. cat. (London, Whitechapel Art Gallery, 1956), unpaginated.*
18. *Whitham, "The Independent Group," p. 256.*
19. *These casts faithfully record the dying gestures of Romans caught in the cataclysmic volcanic explosion in the first century A.D.*

212

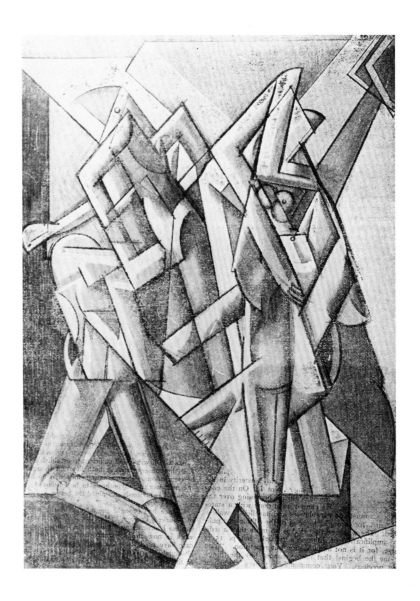

Fig. 1
Study by William Roberts, <u>The New Age</u>,
16 April 1914, p. 753.

The Independent Group and Art Education in Britain 1950–1965

by David Thistlewood

It is hard to define a typical member of the ICA in its formative years, for there were many categories of purpose and motivation. Art students joined in order to supplement their regular courses. General enthusiasts came in large numbers, curious to gain entry through previously closed doors to modern art, only recently unlocked by Penguin and Phaidon publications. Many members were teachers, educating themselves in modern art at the ICA's evening lectures and seminars and passing on their experiences to pupils and students by day. This conformed exactly to the ICA's prime objective – to create a highly informed nucleus of individuals, practising contemporary arts and deeply committed to their theoretical development, which would effectively inform the mass of the population through widening circles of communication. Many people subscribed, of course, for the convenience of an inexpensive London club. And there was a normal representation of individuals exchanging city day clothes for badly sewn and knitted evening garments, individuals more concerned with such attendant images of modern aestheticism than with its content.

However, it is relatively easy to characterize members of the Independent Group. They were ICA activists; they were few in number; and they were conscious of being on the thresholds of futures in contemporary art, art criticism, or design. Part-time teaching in an art college was regarded as a normal means of subsisting during the lean years of an early career. Most were thus involved in education, and – given the likelihood that Britain would remain unfavourable toward contemporary forms of expression – they were conscious of the probability of long dependence on teaching, and they were serious about doing it well.

Nigel Henderson, Eduardo Paolozzi, Reyner Banham, Alison and Peter Smithson, and William Turnbull taught at the Central School of Art. Richard Hamilton taught there for one year, before accepting an appointment at King's College, University of Durham, that obliged him to commute between London and the north of England until 1966. In 1955, Eduardo Paolozzi moved from the Central School, where he had taught textile design, to nearby St. Martin's, where he taught sculpture until 1958. Toni del Renzio taught at Camberwell School of Art, and Lawrence Alloway was resident lecturer at the Tate Gallery before joining the ICA's administration in 1956, leaving as director of programmes in 1960. All divided their days between practice and teaching,[1] while devoting most of their evenings to the ICA, where they were deeply involved as lecturers, seminar organizers, and rapporteurs. The ICA was in fact conducting a "crusade" to educate its general membership rapidly toward a consciousness of modern art, and members of the IG were at the heart of this enterprise.

Speakers on a vast variety of subjects, ranging from sociology and psychology to the physical sciences, were being invited to the ICA, ostensibly to highlight aspects of their own disciplines, while in reality casting side illumination on the visual arts. Before the formation of the IG, and certainly afterwards, members were responsible for much of the choosing and inviting. They did not sectionalize because of disagreement, but because of a desire to widen the scope and content of what was being offered. Discussion of the IG's significance for education must therefore draw in events in which certain members were active on behalf of the wider institute,[2] one of which (the exhibition *Growth and Form* preceded the group's origination. The two most important of the ICA's mainstream educational issues were the analogous relationship between modern art and modern science and the principle of adopting "primitive" percipience toward visual and plastic creativity. When the issues with which the IG became specifically identified were added – a concern for peculiarly contemporary techniques of form-origination; an interest in modern technology; a fascination for popular culture; an affection for modern fantasies (especially as they focused upon vehicular transportation); and a celebration of urban environments – the result was the most profound questioning of conventions that had occurred in the one-hundred-year history of public art education in Britain.

The IG's significance for education therefore has two distinct aspects. There was a direct influence on the art schools where members taught, and there was a broader effect as their ideas were conveyed into general circulation through the ICA. The art school arena had recently been cleared of outmoded examination requirements and techniques and an iconography that had been in force for almost a century. Study of the Antique, the Life Figure, Nature, and Architecture, chiefly through the medium of drawing, had been abandoned in a single round of reforms, replaced in 1946 by greater opportunities to paint, carve, and engage subjects more relevant to the mid-twentieth century. Of course the vast majority of serving teachers were steeped in the old system and found this difficult to abandon. In addition, the reformed system was still examination-led, and new scholastic conventions had materialized that focused on the New English Art Club, the Camden Town Group, and the Euston Road School, intermixing Impressionism and Social Realism. Typical art school diploma paintings in 1952, when the IG was first convened, would have represented such subjects as untidy interiors, industrial streetscapes, mothers with children in unglamorous poses, and pastoral scenes featuring toil and marginal existence. It had become almost a subconvention that figures exhibiting lighter aspects of the human condition were to be clothed in historical costume, and in fact depictions of people enjoying themselves were not fully acceptable until after the following year's crop of coronation street-party compositions, a temporary cliché.

In the closed world of education this sort of work was fondly regarded as belonging to a national style: with few exceptions the art schools were immune to imported modernism. Impressionism, it is true, had taken root in Britain in the first decade of the century and was still being practised. But Post-Impressionism had been derided in 1910 and 1912, on the occasions of Roger Fry's famous expositions,[3] and was popularly considered the art of deranged individuals, Fry's interest in it explained as the eccentricity of an otherwise respected scholar. International Surrealism had been exhibited in London in 1936, inexplicable and unexplained;[4] and international Constructivism had followed a year later, accompanied by a public information programme which, at the opposite extreme, had almost overdone its apologia.[5] The wartime works of Picasso and Matisse had been exhibited at the Victoria and Albert Museum in 1946 and had outraged polite taste.[6] Bauhaus princi-

ples had gained footholds, since many of its major figures had taken refuge in Britain before the war and had earned their livings in architecture, film design, photography, and typography; but its main manifestations – geometricism, functionalism, truth-to-materials – had been admitted into certain corners of "design" while having been excluded from "art."

Critics and theorists had tended to assume European origins for the avant-garde of British art, an alternative view having been offered by Herbert Read, the ICA's president. He had stressed a native Surrealism in English literature, a native Constructivism in the national characteristic feeling for organic nature, and a tendency to combine and interrelate these themes consistently in English painting and sculpture, as exemplified in the specifically modern works of Henry Moore, Barbara Hepworth, Ben Nicholson, and Paul Nash.[7] Vorticism, the one notable exception to Read's analysis, and to the alternative view that important aesthetic developments had originated abroad, was largely forgotten more than thirty years after its sudden and intense eruption. Wyndham Lewis, its founder and the "enemy" of the establishment, had lapsed into fashionable portraiture which had camouflaged his continuing, serious aesthetic writings. But his Vorticist mechanical abstraction had survived into the 1930s, in something like its original form, in an unlikely quarter – the Royal College of Art.

William Lethaby had been the founding professor of design at the RCA, and though he resigned in 1918 he left a profound legacy in the conviction that modern designs should be precise, smart, and hard. The most authentic models of these qualities consisted of reproductions of Vorticist works from 1914 issues of *The New Age*.[8] These were reduced in scale, monochromatic, and overlaid with the aesthetic properties of print (Fig. 1), but they had given rise to a derivative style in the Design Department of the RCA (Fig. 2). In the work of the artist-teacher Albert Halliwell,[9] the style had then suffused the Camberwell and Central School of Art (Figs. 3-4). Halliwell was still head of design at the Central School when the IG's artist-teachers taught there, Hamilton and Henderson working particularly closely with him in his department. And the appropriate abstract tradition – one of abstracting from disciplined observation – was strengthened by the presence of William Roberts, the former Vorticist, in the painting school. These are tenuous links with Vorticism, it is true, and the most that can be claimed for them (which is actually of some significance) is that they gave rise to vague memories of an alternative pedigree for native British modernism, besides the one represented by Henry Moore and the Hampstead-St. Ives axis.

This was the context in which the ICA mounted its educational crusade. One of the management committee's first acts was to establish an ICA "study department" to promote objective methods of historical research and in particular to analyse the influence of scientific thought on the progressive development of contemporary art.[10] The art-science analogy was considered relevant because of an "aesthetic" aspect perceptible in modern physics and because it seemed reasonable to identify with the idea of a continuously expanding science, served by an "avant-garde" of "creative" practitioners and theorists.[11] Among the first results of this enterprise was the exhibition *Growth and Form*,[12] designed by Richard Hamilton and offered as the ICA's contribution to the Festival of Britain in 1951. *Growth and Form* was devoted entirely to natural subject matter – scientific specimens juxtaposed with dia-

Thames Water and Racemic Acid Dihydrate; Hamilton lecture slides of microscopic images (King's College, University of Durham at Newcastle–upon–Tyne), illustrating the principle of significant marks held in tensioned equilibrium.

Figs. 7–8
''Organicism'' evident in successive Point, Line, and Plane projects; Hamilton course, King's College.

Fig. 9
Spatial construction, the goal of ''organic'' development.

Fig. 10
''Diagrammar...the result of taking a small piece of lino, cutting successive marks and making adjacent prints after each additional cut. This cinematic realisation of the time element registers in a clear way the growth of ideas and the sequential aspect of each act.'' Hamilton, in Victor Pasmore, Harry Thubron, Richard Hamilton and Tom Hudson, The Developing Process, King's College and ICA, 1959, pp. 19–20.

215

grams of molecular structures and photographs of organic growth taken with the most sophisticated cameras and microscopes. A deliberately declassicized environment, featuring cinematic projection onto surfaces above and below the spectator, objects lit by strobe flashes, and images infinitely multiplied by means of mirrors, directed the membership's attention to an inner world of abstract images conforming to an evolutionary logic.

Corresponding debates conveyed the message that these were imitable in principle in processes of visual and plastic creativity – for example by respecting the positive and negative extension and diminution of shapes, allowing each mark or form to "suggest" a subsequent addition or erasure, building into the work a record of its own originative processes, the counterpart of those detected by scientists in natural organisms. This was the ICA's answer to the problem of "closed" contemporary expression: each work respecting the organic principle would thus reveal its creative logic openly, and successions of such works would present frame-by-frame chronologies of aesthetic research in constructivist and expressionist abstraction.

Now these idioms may not have seemed particularly related, yet it was recognized at the ICA that they possessed a common fundamental principle which served to unite them: they were process-dominant. Creative direction was determined neither by technical expertise nor by inside knowledge of art education's great themes – the Antique, the Life Figure, Nature, and Architecture. Instead, form was divined in each work as it progressed and thus revealed itself. Hamilton has described what occurred when such creative activity was given momentum. Each of his works, he said, began with a point, the simplest mark, its position arranged in significant relationship (as were those of all subsequent marks) with elements already existing (in the first instance with the dimensions of the given surface). As the number of elements within the composition increased, so did the complexity of the problem of arranging each part in satisfying relationship with all the others. He said he took a blank canvas and after considerable thought placed a mark on it; then he made an addition in considered association with the first and with the boundary. The marks in this way accumulated, at each stage contributing to the growth of an emergent idea.[13]

This way of working was given prime importance at King's College, the Central School, and, indirectly, at Leeds College of Art.[14] The term "organic" was considered especially relevant, helping students to rationalize a creative process in which images or forms would seem to appear, and to take on symbolic characteristics, with little specific pre-intention on the part of the painter or sculptor (Figs. 5-10). It is not true that end products were completely ignored, but more accurate to say that they were allowed to take care of themselves, the means becoming the focus of attention. This left open, of course, the question of what informed or motivated each minute aesthetic judgment, and here the work of Paul Klee was considered instructive.

In fact the ICA exploited Klee's approachable creativity to establish several important precepts. First there was the principle of progressive development: Klee himself had proclaimed each of his works to be an act of self-revelation, the graphic elements moving through sequences of dimensional shifts to reveal forms just beyond the artist's previous experience. Visual expression begins with the point which moves, creating line; this in turn moves laterally, describing plane; and plane moves similarly, creating volume.

This simple doctrine provided the initiate with a means of entry into constructive abstraction and the more practised with a tangible grasp of the organic analogy, thus illustrating the criterion of authentic creativity.

In 1953 the ICA presented *Wonder and Horror of the Human Head*, a survey of the vast range of possible symbolic meaning attachable to depictions of heads and faces, in an exhibition calculated to superimpose an awareness of the potential emotional content of contemporary art over the by-now accepted principles of organic formation. Once more members of the IG were prominent as organizers and coordinators of accompanying debates. Statements by Read and Roland Penrose, the ICA's vice-president, barely disguised their concern at the prospect of having encouraged a contemporary art authentic in form but lacking significant content. The exhibition's purposes were to "give courage to those who find our Present an impenetrable chaos," to "stimulate poetic reflection upon our human condition," and to "act as a mirror or a window for the imagination" – in other words, to accentuate the significance of irrational symbolism as well as developmental logic.[15]

The human head was a peculiarly appropriate subject matter in this regard, composed as it is of a few apparently simple features, capable of expressing the full complement of human feelings by minutely subtle changes in the spatial relationships of its parts. The head itself might symbolize other phenomena – the sun, the earth, the creative wellspring, life or death. Outside the institute, Hamilton, Paolozzi, and Turnbull exploited this subject in their teaching, using it to divine purpose in simple mark-making or shape-making. Their students were offered insights into how a dot might become a gazing eye, how a line might smile or grimace, how the elevation of a plane might indicate arrogance or humility, and a volume convey the summation of a personality – qualities evident in Klee's pictographic heads and faces.

Such complex emotional expression, a constant feature of Klee's art, was easily overlooked when following his disarmingly simple mechanical directives. Klee of course was not the only model: Leonardo had "seen" facial expressions in stains on walls; Max Ernst had found them in rubbings of floorboards, leaves, and stones; for Tanguy, strange oneiric faces had appeared unbidden in the mists of his Surrealist images; and both Masson and Sutherland had discovered faces in their depictions of landscapes and natural forms.[16] This tradition argued that very little mark- or shape-making was necessary to suggest facial images conveying the most complex of human emotions, ranging from wonder to horror; and, as these emotions were latent in the elements of visual expression (rather than in their styles or cultural affinities), it maintained also that they were realizable in students' constructivist and expressionist abstractions.

The head, crudely drawn, simply modeled, or assembled from collected junk, became an important motif for Hamilton, Turnbull, and Paolozzi as well as for their students. It was a question of perceiving the difference between creating a resemblance and a presence.[17] Images of great emotional potency could be achieved without conventional expertise – indeed, conventions would only hinder the recognition of powerful imagery as it emerged in the processes of drawing, painting, or constructing. This rationale for the previously-uninitiated to enter the flow of contemporary art downgraded

technical expertise and familiarity with art history's great themes. Instead, it emphasized raw emotional expression and constructive sensibility, and proved to be so compelling that within a decade of its original airing at the ICA, and its incorporation into teaching strategies by members of the IG, it had entered formal art school programs throughout the country and was enshrined in government policy.[18]

Yet organic abstraction was quickly passed over by the IG painters and sculptors in their own work. It is significant that they were the first in Britain to respect the achievements of Jackson Pollock, but they did not emulate them. They had cleared the slate of conventions, isolated a basic discipline of accumulating marks and forms, and in so doing recognized the receptivity of art to a more appropriate, contemporary iconography. This achievement anticipated a series of preoccupations that affected British art schools in the 1950s and 1960s, in the course of which abstraction became transmogrified into Pop.

Paolozzi's celebrated epidiascope show of his pulp literature collection at the first IG meeting in 1952 became the traumatic event it is now reputed to have been precisely because it was hard to imagine fine art applications for his images.[19] Skills for appreciating and responding to such material had to be learned, and although Paolozzi maintained they had come naturally to him, it should not be overlooked that he was one of a very small number of British artists who had studied European contemporary art at first hand, having visited Hélion, Braque, Arp, Léger, Brancusi, Giacometti, Dubuffet, and Tzara, and having also gained access to many of Duchamp's unpublished works. He regarded himself a Surrealist,[20] and his projected sheets of images were the equivalents of Ernst's collage books. His popular magazine, comic book, and science fiction images were in fact Surrealist in two distinct senses. They were obviously vulgar in form, yet shared emotional content with art of established refinement; and their mainly American origins betrayed an "aesthetic of plenty" that was the antithesis of anything to be experienced in contemporary Britain. Moreover, receptivity to the symbolic significance of his images was essentially similar to that other quality being cultivated by the ICA – sensitivity to emergent imagery in the process of organic abstraction.

The idea of collecting such ephemera, embodying symbolism from the profoundly mysterious to the simply quaint, and placing them beside mutually contrasting "respectable" iconography, rapidly gained currency within the IG and became, for members' students, a preferred alternative to keeping sketchbooks. The exhibition *Parallel of Life and Art* (1953) was presented as an externalization of the private scrapbooks of the organizers – IG members Nigel Henderson, Eduardo Paolozzi, Alison and Peter Smithson, together with Ronald Jenkins.[21] It also offered a display of superficial resemblances shared by images and objects classified as works of art and others drawn from outside the aesthetic realm. Thus comparison of a Jackson Pollock painting to the surface markings of a guillemot's egg, an eskimo carving of a head to a section of a plant stem from Thornton's *Vegetable Anatomy*, and a medieval clog almanac to an inventory of typewriter parts served to emphasize that art involved a recognition of visual and formal potency, and a (Surrealist) capacity to make unsuspected, and therefore perceptually shocking, connections.

217

It also stressed the value of a catholic curiosity in making such exotic matchings and, of course, demanded an appreciation of certain relevant movements in modern art. Banham was concurrently engaged on the thesis that would ultimately be published as *Theory and Design in the First Machine Age*, and there is little doubt that this work introduced to the IG and the world of art education authentic information on such tendencies as Futurism and Purism, both featuring doctrines of specifically modern form-types. It is equally certain that Paolozzi, Henderson, Hamilton, and Turnbull brought to IG meetings their great respect for Duchamp, bestower of iconic potency on everyday objects.

Man, Machine and Motion (1955), an exhibition Hamilton and Banham researched and designed, was a photographic celebration of bicycles, automobiles, boats, submarines, and aircraft – inventions that had extended the human body's capabilities of autonomous movement on land, on and in water, and in the air. Having "evolved" in processes of constant perfection, like Purist object types, these machines conformed to the idea of an organic creativity; and having been born of impossible (Futurist) ambitions – high speed, flight, ocean travel, and undersea exploration – they were affected by myths as powerful as any that had inspired artists throughout history (Figs. 11-12). Advertising and styling exploited their fantastic associations; and Hamilton maintained that an everyday commodity such as an effective poster or product image could thus provide a form of creative stimulation, already

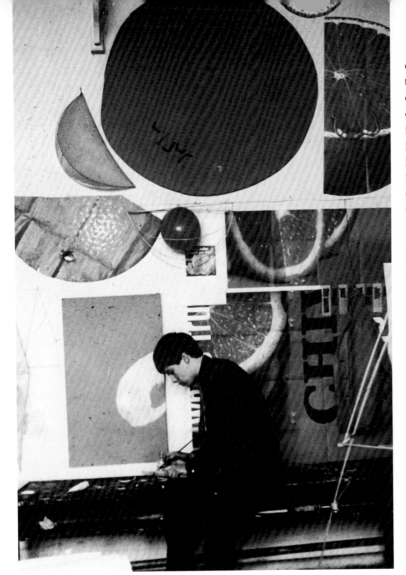

Fig. 13
Student ''environment''; intermixing pop,
constructivist, and academic conventions
(Hamilton course, King's College).

enriched by countless layers of emotional energy, an equally valid alternative to that language of coded emotions accessible only through scholarly appreciation of artistic conventions. His own paintings of this period, and the work of his students at King's College, drew equally upon the popular and the refined, for example, juxtaposing advertising imagery with allusions to life models in classic poses or to still lifes traditionally disposed (Fig. 13). This meant that an art student's visual research would be impoverished if it did not accord comparable textual significance to the icons of advertising and contemporary art as well as to those of the great art of other ages and civilisations.

Man, Machine and Motion, installed in the gallery at King's College as well as at the ICA, was the educational event that synthesized the IG's concerns for technology and popular culture. Focusing primarily on the application of technology to problems of human mobility, it also stressed that the machine became part of the user to the extent of altering personality. Being coveted, the motorcar particularly became endowed with myths and epic fantasies that ranged between the twentieth-century cults of the mechanic and the Hollywood dream (Fig. 14). Despite an apparent paradox, this justified the educational use of such subject matter in art schools that had only just accommodated abstraction. There seemed a fundamental dissimilarity, if not mutual negation, between, on the one hand, the search for formal significance internal to the progressing image as required by abstraction and, on the other, a receptivity to external images of popular appeal. The connection between the two lay in the dimension of fantasy evident in the most practical of pursuits. If certain aspects of pragmatic twentieth-century designing (for example, the "abstract" lines and forms of motorcar styling) were pregnant with myths as powerful as any of the great themes of art history, then it seemed reasonable for art students to exploit popular as well as refined vocabularies of form.

It also seemed reasonable to maintain that abstract images were capable of embodying profound, deep-rooted, archetypal emotions, a principle ingrained in much avant-garde art of the twentieth century. But this was applicable also to the superseded compositional diet of the art schools – kitchen sink dramas, mothers with children, pastoral scenes, historical reconstruction. What distinguished the new approach to populism was its concentration on particular drives (including youthfulness, glamour, and sex) as defined by Hamilton in his famous list and its exclusion of other popular motives such as nostalgia.

The idea of a lack of qualitative distinction between avant-garde abstraction and popular images, each shot through with primary emotional symbolism, inspired the exhibition This Is Tomorrow, held at the Whitechapel Gallery in 1956, in which the two formal languages were intermixed. Designed in twelve sections, each produced collaboratively, this exhibition drew spectators into a sequence of different environments. One group chose to display a museum of pioneer Constructivist works; another developed the theme "the growth and formation of soap bubbles"; and another produced an "anonymous" Constructivist environment in which evidence of individual personality on the part of its collaborators had been entirely eliminated. Such contributions as these were intended to reflect a modern abstract aesthetic only just being disseminated in Britain through the efforts of the ICA.

Two groups, however, produced environments which were "more than abstract" and which – though the exhibition itself was not an IG creation – were highly characteristic of some of the group's principal concerns. One of these, the work of the Smithsons, Paolozzi, and Henderson, was an archetypal habitat – a small pavilion and surrounding patio, each furnished with art objects symbolizing man's essential needs – that became a common referent for critiques in schools of architecture for years to come. The other, the work of Hamilton, John McHale, and John Voelcker, was an eclectic but carefully orchestrated mixture of visual illusions, recognizable works of art, famous cinema publicity stills, advertising images of consumer goods, and the disorientating architecture of a fairground crazy house. It was designed to be popular, but made the very serious point, not lost on the art schools, that such an objective required substantial sophistication – in this case, the combined technologies of Renaissance inventor-artists and their counterparts of more recent times, along with the best efforts of modern cinema and the advertising and entertainment industries.

In a conscious tribute to Wyndham Lewis, receiving his first major retrospective showing at the Tate Gallery that same summer,[22] the exhibition catalogue carried lists of "loves" (abuse, confusion, disregard for ordinary decencies . . .) and "hates" (taste, duty, toeing the line . . .) that were reminiscent of Lewis's Vorticist "blesses" and "blasts" of 1914.[23] The exhibition reveled in urbanism, as Vorticism had done: it evoked feelings of the city as defined by counter-crossing and competing human activities and fashions, and conveyed the designers' obvious pleasure in fulfilling urban roles.[24] This essentially optimistic aspect challenged the conventional art school view – not least at the RCA – of the city as a subject matter imbued with desolation and despair.

It is often acknowledged that the IG inspired two generations of students at the RCA in the 1950s, in the process elevating popular images to the realm of acceptable subject matter for British painting as a whole. Peter Blake, Richard Smith, and Joe Tilson were at the RCA during the IG's productive period, when most of its issues were also engaged by *Ark*, the RCA student journal; and Derek Boshier, Allen Jones, David Hockney, Ronald Kitaj, and Peter Phillips were at the RCA while Hamilton was teaching there between 1957 and 1961. Nevertheless, this acknowledgment represents only part of the IG's educational influence. It also invariably implies that old conventions were merely replaced with exact counterparts, classic ads substituting for the Antique; the Life Figure, an essentially anonymous subject, giving way to depictions of known (famous) individuals striking attitudes (rather than posing); and Nature and Architecture replaced by the detritus of modern urban life. Even if this were so, the new "conventions" were in fact interrogated far from conventionally, for the old, established methods of working required detached observation, while the new demanded engagement and commitment, messages and points of view.

This is especially evident in the work of Kitaj and Boshier, whose iconographies often contain as many references to obscure regions of human experience as to commonplace ones, and who often bury their messages deep but expect a logic – something more than a logic of material and composition – to be found.[25] The annexation and deployment of images that had acquired significance in a popular constituency were, then, evident in IG-

Fig. 14
Hamilton lecture slide (King's College) illustrating the fantastic dimension as exploited in advertising.

inspired student art at the RCA. But these were intermixed and cross-referenced as intricately as religious and classical symbolism, the icons of a scholarly constituency, had been interwoven, disguised (and revealed to the initiated) in the art of the High Renaissance. They were also executed crudely, using specially learned techniques of unrefinement. And they were often presented as networks of scales and symbols to be read and negotiated like the competing visual forces of the street. It was in fact a late educational manifestation of Vorticism and Surrealism combined.

The work of IG members infiltrated the art schools fairly quickly through emulation of what was happening at the few active centres. There had been an awkward period in the 1950s when art schools had taught neither iconography nor technique. Initiatives of many kinds were drawn into this vacuum, but among the most important, in terms of immediate value and enduring effects, was the series of creative strategies first given expression by the IG. These began with the principle that techniques should be largely dictated by the nature of the materials employed. The IG members embraced the idea that the modern environment as shaped by urban forces, advertising, technology, and mass communication, should suggest an iconography. And they anticipated one of the central messages of the 1960s – that celebration of urban themes should replace soulful social commentary. In the process they gave rise to social commentary that possessed the bite of Vorticism and a Surrealist perceptual edge. These qualities gave tangible form in anticipation to the consumer society and, when it came, helped students relate knowingly to phenomena they could not buy. They are still vital in British art school education long after the aesthetics of plenty has lost its immediate relevance.

219

1. *For accounts of IG members' teaching appointments, see the autobiography of William Johnstone, the principal who recognized their talents and appointed them to the Camberwell and Central Schools of Art:* Johnstone, Points in Time (London, 1980), pp. 187, 201, 203 (del Renzio), 233 (Banham), 240 (Henderson), 252 (Smithsons), 260-261 (Hamilton), 261-262, 280 (Paolozzi).

2. *For example, in 1953 the IG presented a series of lectures on "Aesthetic Problems of Contemporary Art" to the Institute's general membership, which included the following:* "The Impact of Technology" *by Reyner Banham;* "New Sources of Form" *by Richard Hamilton;* "Concepts of Space" *by Fello Atkinson and William Turnbull;* "Proportion and Symmetry" *by Colin St. John Wilson;* "Non-Formal Painting" *by Toni del Renzio;* "The Human Image" *by Lawrence Alloway;* "Mythology and Psychology" *by Robert Melville; and* "Summing Up Art in the Fifties" *by Reyner Banham.*

3. Manet and the Post-Impressionists, *Grafton Gallery, London, November 1910-January 1911;* The Second Post-Impressionist Exhibition, *New Grafton Galleries, London, October-December 1912.*

4. The International Surrealist Exhibition, *New Burlington Galleries, London, 1936.*

5. The International Constructive Art Exhibition, *The London Gallery, 1937; see Leslie Martin, Naum Gabo, and Ben Nicholson, eds.,* Circle: International Survey of Constructive Art *(London, 1937).*

6. *For a contemporary account, see Herbert Read,* "The Problem of Picasso," *Journal of the Royal Society of Arts, 18 (January 1946), pp. 127-128.*

7. *See David Thistlewood,* Herbert Read: Formlessness and Form: An Introduction to His Aesthetics *(London and Boston, 1984), chap. 4.*

8. *These reproductions were as follows: A Dancer by Henri Gaudier-Brzeska, New Age, 19 March 1914, p. 625; Chinnereth by David Bomberg, ibid., 2 April 1914, p. 689; Study by William Roberts, ibid., 16 April 1914, p. 753; The Chauffeur by Charles Nevinson and The Farmyard by Edward Wadsworth, ibid., 30 April 1914, pp. 814-815.*

9. *A. E. Halliwell was a student at the RCA in the late 1920s, a freelance graphic designer in the 1930s, and a teacher first at the Camberwell School of Art and then the Central School of Art; see Johnstone,* Points in Time, *pp. 188-189, 239-240, 254, 260-261. Halliwell's portfolios, containing his own student and professional work and examples of the work of his students, are preserved in the National Arts Education Archive, Bretton Hall, University of Leeds. Halliwell confirmed the sustaining influence of Vorticist imagery.*

10. *See J. P. Hodin,* "The London Institute of Contemporary Arts," *Journal of Aesthetics and Art Criticism, 12 (December 1953), pp. 278-282.*

11. *See Thistlewood,* Herbert Read, *chap. 6, note 7.*

12. *For a discussion of the specific educational significance of this exhibition, see David Thistlewood,* A Continuing Process: The New Creativity in British Art Education 1955-1965 *(London, 1981).*

13. *See Richard Morphet, in* Richard Hamilton, *exh. cat. (London, Tate Gallery, 1970), p. 18.*

14. *Tom Hudson, friend of Hamilton and Paolozzi, taught at Leeds and is representative of a few educationists outside London who were in tune with IG concerns; see Thistlewood,* A Continuing Process, *pp. 22-28.*

15. *Herbert Read and Roland Penrose, in* Wonder and Horror of the Human Head: An Anthology, *exh. cat. (London, Institute of Contemporary Arts, 1953), pp. 3 (Read) and 7 (Penrose).*

16. *Ibid., p. 37.*

17. *See Frank Whitford,* Eduardo Paolozzi, *exh. cat. (London, Tate Gallery, 1971), pp. 15-19; also Richard Morphet,* William Turnbull: Sculpture and Painting, *exh. cat. (London, Tate Gallery, 1973), pp. 30-34; Morphet,* Richard Hamilton, *pp. 21-23. The term* "presence" *is used here as Reyner Banham has used it in connection with Paolozzi's work; see Banham,* The New Brutalism: Ethic or Aesthetic? *(London, 1966), p. 66.*

18. *In response to recommendations in* The First Report of the National Advisory Council on Art Education *(the so-called Coldstream Report), 1961.*

19. *Whitford,* Eduardo Paolozzi, *p. 45, note 17.*

20. *For a discussion of Paolozzi's Surrealism see Frank Whitford,* "Who Is This Pop? The Early Developments of a Style," *in U. M. Schneede, ed.,* Pop Art in England: Beginnings of a New Figuration, *exh. cat. (Hamburg, Kunstverein, 1976), pp. 16, 18.*

21. *Whether Parallel of Life and Art was an IG event is a matter of dispute. It was described as such by one of the leading authorities on Paolozzi's work, Frank Whitford, in Eduardo Paolozzi, p. 47. However, it was not advertised as an IG presentation in contemporary ICA literature, although the ICA Calendar for September 1953 offered the following IG-like passages:* "In this exhibition an encylopaedic range of material from past and present is brought together through the common medium of the camera, functioning respectively as recorder, as reporter and as scientific investigator. The editors of the exhibition, a photographer, a sculptor, an [sic] architect and an engineer, have selected a hundred images of significance for them. These they have ranged in a number of categories suggested by the material and which underline the common visual denominator, independent of the field from which the image is taken."

22. Wyndham Lewis and Vorticism, *exh. cat. (London, Tate Gallery, 1956).*

23. *See Wyndham Lewis, ed.,* Blast: Review of the Great English Vortex, *1 (20 June 1914), pp. 11-28; facsimile ed. Santa Barbara, 1981.*

24. *See Lawrence Alloway,* "The Development of British Pop," *in* Pop Art, *ed. Lucy R. Lippard, 3rd ed. (London, 1970), p. 40.*

25. *For a discussion of the post-IG development of Pop Art at the RCA, see ibid., pp. 53-65.*

From Ivory Tower
to Control Tower

by Barry Curtis

Are They Grateful?

In the last chapter of *The Long Revolution*, published in 1961, Raymond Williams turned his attention from the gradual progress of social justice to the troubling signs of regeared capitalism. The chapter, "Britain in the Sixties," foresees a challenge to the social realm in the formulation of "the consumer," a threat to democracy in the rise of "management," and the beginnings of a consensual resistance to "society" as a limiting and depriving force. Williams's predictions for the oncoming decade are poised between an optimistic refusal to believe in the passivity of the "telly-glued masses" and a pessimistic concern that the social revolution has been prematurely consigned to history and replaced by a focus on the adequacy of individual effort. Vivid signs of individual revolt characteristic of the second half of the fifties are, he fears, too commodified and recuperable, too easily adapted to serve the new, anti-democratic forces of the status quo.

Much of Williams's critique is phrased in terms which have been characterised as "left-Leavisite." He sets working-class institutions and practices within the same field of reference as "high culture," but he retains a hierarchy of cultural values, determined to expel the products of profit making and "calculated dissemination." The task of the cultural critic is to distinguish "good art and argument from bad" and to resist the commercial vitiation of cultural standards. Among the most vivid examples of the bad are the manifestations of encroaching Americanisation: "the horror film, the rape novel, the Sunday strip paper and the latest Tin Pan drool."[1] The corrective is "an educated capacity for significant response." In this polarisation of good and bad there is no place for notions of use and gratification or for the options of appropriation.

The emerging interest in the new phenomenon of mass media involved close attention to modes of production and address. For Williams and other critics who followed his lead, this interest was modulated and constrained by a political concern for its detrimental effects on reasoned and democratic responses. The Independent Group, whose meetings began in 1952, was symptomatic of the uncritical acceptance feared by Williams and other cultural critics on the left and right. The writers and practitioners of the IG embodied what Williams characterised as a sign of those times, "the loss of certain habits of deference and postponement."[2] They too were interested in the new meanings and subjectivities generated by the regearing of consumer capitalism in the postwar period, but their approach was at a distinct remove from that of cultural critics on the left and right who sought to define the problems and formulate modes of resistance.

The Independent Group was distanced in a number of other ways from Williams's analysis. Its cultural formation was derived from the visual arts and technology; its members were of a generation and class background that had an early and lasting experience of the mass media, particularly mass media with marked transatlantic characteristics; they were, generally speaking, more interested in processes of production, mediation, and the engineer-ing of effects than in the "object"; and they enjoyed the irony of their ambiguous and simultaneous roles as experts, fans, consumers, and intellectuals. Their "louche" situation gave them an early purchase on, and a critical vocabulary for, describing shifts in economy, culture, and subjectivity that have since become a feature of the postmodern in both its de- and pre-scriptive moods. (They seem, in many respects, to be guilty of proceeding from that point which Williams detected as the moment when social effort gives way to the sense of the dynamics of individual freedom.) For the IG, Williams's "bad art" was the agenda for a new consciousness and the basis for a new aesthetic.

The debates instigated by the IG at the ICA in 1952 were initially rooted in a modernist tradition of raiding the commercial, technological, and popular for subject matter and sources of inspiration. Reyner Banham described their inspirational materials as "cultural tilth,"[3] implying both the seedbed and the cultivating labour. "Pop" stood for a new field of operations, a sensibility, and an aesthetic. It was a commitment to a dense, vivid, and ubiquitous culture which needed to be assimilated to, and in some cases would come to challenge, the values of artistic modernism.

An engagement with Pop necessitated a revised attitude to consumption and transience. The innovative market economy of postwar capitalism posed fundamental challenges to culturally enshrined notions of integrity and durability. Consumers were born into a new Britain, which was evidently post-Imperial, in many ways post-industrial and, as many feared, post-High Cultural. Fantasies of technology, exploration, and leisure marched with a new openness to Europe and America. Britain in the 1950s seemed increasingly bereft of its traditional power and authority, destined, at best, to play a James Bondian role as a cool, super-traditional and super-technological medi-ator between the new imperial powers of West and East.

There were signs that transformations in Britain's economy were empowering hitherto marginal or invisible groups. Youth, the working classes, women, even Commonwealth citizens began to constitute problems and subjectivities that required investigation and disciplinary measures. There were indications too that the working-class beneficiaries of the 1944 Butler Education Act and the grant system were challenging the authority of the traditionally conforming and co-opted intellectual classes, either by "angry" confrontation or, as was the case with the Independent Group, by various outflanking strategies.

The austerities of the postwar years were alleviated very slowly; rationing was in force for some items until 1954, the year that the first cycle of Independent Group meetings ended. Notwithstanding the Conservative party's 1955 election slogan – "Invest in Success" – there was a major balance of payments crisis, followed in 1956 by the Suez crisis – a Falklands gone wrong – which represented a threat to the economy and a sign of Imperial incompetence. From mid-decade on, the conspicuous indications of a shift toward a more intensified consumer culture became points of reference and concern in the media.

The early topics on the IG agenda prefigure the experience of excess and abundance associated with the inflationary economy of the post-Suez years. Nineteen fifty-six was the year of the Soviet invasion of Hungary, which had the effect of impelling a "new left" interest in the possibilities of cultural

Hotpoint Customline Kitchen, from ''Technology and the Home,'' by John McHale, Ark, 19 (March 1957).

''At last a contemporary film set,'' Design Magazine (August 1952). Note tackboard on left.

222

politics. The more general mobilisation of protest among pacifist and Christian groups generated a constituency and an expressive political style around the Campaign for Nuclear Disarmament, whose first march from the experimental weapons base at Aldermaston took place during Easter 1958.

The modes and tone of cultural production from the mid-decade were inflected by other events which have been accorded landmark status by historians of the period. The London performances of the Berliner Ensemble, Peter Hall's production of *Waiting for Godot* in 1955, and John Osborne's *Look Back in Anger* the following year at the Royal Court Theatre were events which focused attention on a convergence of Brechtian devices – the absurd, black comedy, and "angry" social drama. Unfamiliar strands of modernism were imbricated with domestic docudrama and generated debates over the merits of "sociological" and "imaginative" realisms. In 1955, too, the first commercial television channel began to broadcast, and the concentrated and experimental imagery of advertising was widely disseminated. That same year, Mary Quant opened London's first "boutique." The Bazaar, in the King's Road, Chelsea, brought together ideas derived from démodé work clothes, art school, and the eccentricities of upper-class bohemia in a new, informal commercial context. In 1956 John Stephen opened his first menswear shop and a few years later made a pioneering move to Carnaby Street. The Conran Design Group (1955), Jocelyn Stevens's reorientation of *Queen* magazine for youthful consumers (1957), and the popularisation of Continental food by Elizabeth David marched with the rhetoric of a seemingly permanent rise in the standard of living and a relaxation of the material and visual austerities of British life. In the visual arts, in 1956 Lindsay Anderson, Karel Reisz, and Tony

Richardson published their Free Cinema manifesto, which challenged the perceived lack of contemporaneity and seriousness in filmmaking and promoted "the importance of people and the significance of the everyday event."[4] Most relevant to the somewhat similar programme of the contributors to the *This Is Tomorrow* exhibition at the Whitechapel Gallery, then in preparation, was the manifesto's stress on the relationship between meaning and appearance: "An attitude means a style. A style means an attitude."[5]

The physical landscape of British cities began to change in the mid-fifties, with the appearance of office blocks, supermarkets, high-rise flats, and parking meters. In 1957 the superabundance of new products and the discontent they often generated was reflected in the founding of the Consumers' Association. The magazine *Which* offered objective information to a public subjected to the rival claims of numerous unfamiliar products. *Which* argued for a programme of shrewd and methodical testing that exposed the dark side of the landscape of consumer fantasy and satisfaction inhabited by advertisers and the Independent Group. The editor of *Which* experimented with the idea of a political party formed by and for consumers, an indication perhaps of a new attitude to the relationship between the consuming citizen and the state.

The publicity devoted to youth, conceived as economically empowered, "angry," and irresponsible, was part of a wider representation of the "crisis" in British culture. The barbarism of the young, the tendency for the welfare state to promote a lack of self-reliance, and the debased culture of the new Americanised mass media were common terms for debate. Fears were expressed that the combined influence of consumerism and welfarism would transpose the upwardly mobile working classes from their traditional communities into individuated, ersatz, and manipulated entities.

The spectre of arrivism on an enormous scale resulted in calls for new forms of education which would simultaneously inoculate against the worst excesses of "admass" and prepare the young for a technological future. Standards and values were widely acknowledged to be in a state of flux, with youth in particular danger of brainwashed co-option or resistant psychosis. For an older generation, the problems of social mobility were compounded by the prominent roles played by women and youth. And the difficulty of maintaining traditional structures of power under the impact of a meritocracy was considered indicative of the waning authority of state and nation. Kenneth Allsop, in his study of the literature of the Angry Decade, noted a distur-

bing attitude among the new recruits to the traditional institutions of cultural authority: "And are they grateful, this plebeian elite who have been creamed off from the admass?"[6]

For the cultural pessimists, the consumer boom and the benefits from a benevolent state combined the worst of the American and Soviet systems. A delicate and disturbed balance of cultural health, responsibilities, and pleasure was constantly under review. The new mixed economy was regarded by its critics as unwholesome and vitiated – a hothouse, airless culture where consumers were force-fed with predigested goods and experiences. In one key adversary text, Michael Farr, writing on design, deplored the non-participation of users in a creative process which "left [them] with finished designs only."[7] Denys Thompson found that the most fundamental natural instincts were being manipulated, to a point where women were encouraged to drink in pubs and men to use cosmetics.[8] V.S. Pritchett was one of many who sought to establish the link between America, technology, and anti-culture:

> Why [Americans] should not be originally creative is puzzling. It is possible that the lack of organic sense, the conviction that man is a machine . . . turns them into technicians and cuts them off from the chaos, the accidents and intuitions of the creative process.[9]

The passive internalisation of such fundamental cultural change was deemed likely to produce effects of fetishism, aggression, and hysteria, particularly in women and young people. For the members of the Independent Group, the new elements of pop culture produced a scenario of both ends against the cultural middle ground occupied by most critics. They envisaged a future both more technologically rational *and* imaginatively fantastic. They were interested in the new identities created for the reception of new pleasures and in an aesthetic of use and assimilation which was generally complicit with, and expert in, the terms of mass culture.

The Long Front of Culture

The Independent Group had affinities with the social documentarists of the 1930s, most notably those of Mass Observation, with its mixture of anthropology and Surrealism, but in many respects the IG represented a new class of intellectuals. Its members combined a tolerant fascination with the new commercial culture and a learned familiarity with the high culture of modernism. They were detached from the traditional, legitimating role of the intellectual and trusted the exercise of market forces and individual discrimination to bring about equality and pleasure. The individuation of desires and appropriations, which they understood through their own engagement with "Pop," was perceived as presenting new opportunities for the artist-designer-technician-copywriter.

The writings and, by all accounts, the debates of the IG disturbed the traditional guardians of visual culture because of their extended range from seriousness to levity. Although the divergent backgrounds of the Group render Banham's "revenge of the elementary school boys"[10] an inaccurate description of the mode of revolt, the phrase does capture the sense of the element of "class struggle, real or imagined" referred to by John Russell.[11] The "disinterested aesthetic," with its complementary structures of hierarchy and discrimination, was displaced by a more attentive and generous attitude.

Characteristic of the writings of Alloway, Banham, Hamilton, and McHale is their simultaneous absorption and detachment and an interest in liberating images from the notional ranking of their referents. They explained their irreverence toward the world of established categories by the term "Null-A" (anti-Aristotelian), a term borrowed from the traditionally despised genre of science fiction.[12]

In the late forties and early fifties the enthusiasm of Alloway, Banham, Hamilton, and McHale was directed toward scarce resources of magazines and films. They acquired iconographical expertise through analysis of the products of Madison Avenue, Hollywood, and Detroit. Knowledge of the sweet chariot of abundance came from catalogues and manuals of both popular culture and the great traditions of European art – it was *Life*, *Popular Mechanics*, and Skira, Phaidon, and Penguin, augmented by a bulletin board culture which, as Hamilton pointed out, had the advantage of allowing an assessment of the power of decontexted images.

The writings of the IG express the Group's oblique relation to the official art culture of postwar Britain and its immediate embodiment in the authorities of the ICA. They testify to the irrational and uncomfortable sorting of cultural experience into the categories "high" and "low." The publications of IG members associate the technological with premonitions of social change and displace traditional elitist and authentic values. The Group's affiliation to Pop was underwritten by a Futurist-inspired faith in the technologically progressive and its visual and thematic links with the "primitivism" inherent in a new sensibility. There was, moreover, a materialist understanding of the materials, techniques, and appropriate terminologies of this sensibility. As cultural producers, IG members were more evocative *and* empirical than the critics who were dismissive of commercial culture.

The peculiar status of intellectuals within the British art school system has been analysed in some detail by Frith and Horne.[13] Art schools brought together theory and application in a way that generated a constant negotiation between high and commercial art practices. Art students and teachers had to tread a line between autonomy and entrepreneurship. The *Realpolitik* of art school subjectivity lay in their ability to range far and wide across the inspirational field, as *bricoleurs* and inventors of new meanings, from expressive gestures to rarefied conceptual activities. The IG inhabited this field and played a part in extending it in the direction of communication skills.

At a time when the debate on the health of high culture was carried on in a mood of seriousness, the IG proposed an incorporation of the everyday and banal. In Alloway's "general field of communication,"[14] the distinctions implied by use and exchange were blurred. The desired effect was to set the "spectator or consumer free to move in a society defined by symbols." In the interests of recognising a "unifying but tolerant aesthetic,"[15] the IG explored continuities between validated art and the new mass media. Art was to benefit from media inventiveness and professionalism, freed from arbitrary standards and models. Alloway attacked the notion of aesthetic distance and referred to "pure form" as "just another iconology." On the other hand, there was considerable interest in the ways that ideas generated from within high modernism had penetrated the homes and minds of consumers. Domestic design became a key area for investigation; Banham referred to

himself as a "product critic" with a mission to ease and clarify the relationship between consumer and manufacturer in the interests of improved products.[16]

The no-man's-land of mass culture, scorned by the defenders of the authentically high and popular, had previously been the concern of anthropology and journalism. The photographs of Nigel Henderson and the personal experiences of IG writers testify to a fascination with the hybridity and productive confusion of cultural levels in the everyday life of British people. They proceed from an uneven, cross-cultural, inbetweenness specific to their generation. Alloway and Banham pointed out that they were born into the environment of the mass media after its initial impact had been assimilated, and that it was thus too late for them to be inhibited by the aesthetic certainties of the previous generation, which continued to dominate the British art scene in the 1950s.[17] Banham wrote of his youthful need to negotiate the claims of Beethoven and *Mechanix Illustrated*.[18]

The encounter of young British artists and critics with the early signs of a culture of abundant and enabling consumption was a grateful one. Dick Hebdige's perception that America functioned as an "unconscious source of imagery and inspiration"[19] is a key to the "dream work" of condensation in the collages and paintings produced at the time of the IG, which function as taxonomy and assimilation. Cargo cultish enthusiasm was an early camp strategy for widening the scope of inspiration and evading preset categories of value. The influx of Americana was assimilated along with the encyclopedists of modernism – Moholy-Nagy, Giedion, and Kepes – all of whom had proceeded by elevating the anonymous and incidental. A mood of Surrealism crossed with attention to "workings" conceptually guided the contents of John McHale's imported imagery – a spectacular constellation of natural forms, mail-order catalogues, and the melodrama of consumption.

McHale expressed the new fluidity of the aesthetic in monetary terms: "We came off the cultural gold standard decades ago and have long been in a period of convertible currencies."[20] The "gold standard" was the triumvirate of "authority, tradition and scarcity" which had been used to dictate the terms of personal status and choice, the model of what constituted "depth" and the sense of sustained value. The run on the currency of high culture and its devaluation focussed attention on its elements of exchange and negotiability. It proposed a new attention to the style of cultural objects as a meaningful and key component in their social meaning, rather than as a deceptive shroud to be discarded in the pursuit of integrity. The notion of style as meaning also promoted a new openness to intertextual and generic relations and modes of address and perception – the selling and buying of the product.

In order to achieve this reorientation of the object, the IG adopted a critical position closely aligned with the consumer. The Group asserted the significance of consumption as both a personal and a collective activity. This implied that the notion of a disinterested aesthetic should give way to a more committed model, one that eliminated critical distance and substituted a participative closeness capable of comprehending the social dimensions of use. A metaphoric shortening of the focal length characterised the mediation of the visual in the post-Suez years, signaled by the use of terms connoting the new "private eye" of the intelligent consumer: "focus," "close-up," "con-

trast," and "insight." A sensitivity to the appearance of things was manifested in the cultural authority of a new class of image producers in the late fifties and early sixties, agents whom David Mellor has termed "vertical invaders."[21] These arbiters of the new values of consumer culture shared with the earlier Independent Group the advantages conferred by an eclectic and déclassé sensibility formed on the social margins. Banham commented on the potential for creativity in the areas of art and music (at some distance from the literary-dominated centre), "where education has not been laid on so thick."[22]

The issue of critical distance was important in the negotiation of the new terrain between art and life. Daniel Bell expressed a traditional objection: "The disruption of distance means that one has lost the control over the experience – the ability to step back and conduct one's 'dialogue' with the art."[23] The desire to see things distantly and whole assumes an organic integrity in the work and a detached role for the critic. The Pop sensibility addressed its objects as Gestalt, serial, fragmentary, fascinating, and expendable – certainly not suitable for sustained and disinterested dialogues. Pop was a process of immersion, rescuing the work from what Alloway called "an excess of aesthetic distance."[24]

The generic quality of the new mass culture was regarded by defenders of traditional values as an inevitable outcome of the primacy of the consumer. Where art should be mysterious, the mass-produced commodity was predictable; it was collective rather than individual, formulaic in the interests of profit and easy assimilation. Generic objects traded on "off-the-peg" rather than "bespoke" values. The formula of "sameness, yet difference," which governed the aesthetics and economy of Genre, predicated its interchangeable and expendable nature. The IG proposed a critical system that was familiar with this relativity, with the metatextual knowledge consumers brought to the conventions of mass culture, and with the procedures of distraction and disengagement it implied.

The related issue of expendability was a direct challenge to established notions of cultural value. Hannah Arendt observed:

> Culture relates to objects and is a phenomenon of the world; entertainment relates to people and is a phenomenon of life. An object is cultural to the extent that it can endure, its durability is the very opposite of functionality, which is the quality which makes it disappear again from the phenomenal world by being used and used up.[25]

The division between world and people, between culture and entertainment, the high valuation of the non-functional and the significance of durability were consistently opposed in the writings of the IG. Banham in particular celebrated the expendability of Pop, which he saw in the context of initial impact rather than durability. A full awareness of Britain's emergence into a "post-scarcity" culture, where the implications of machine production could at last be taken seriously by educated consumers, was fundamental to the IG's optimistic aesthetic. Banham brought a reassessment of the Modern Movement to bear on the issue, pointing out the fundamental misunderstanding perpetrated on modernism by an elitist system: "In engineering a standardised product is essentially a norm, stabilised only for the moment, the very opposite of an ideal because it is a compromise between possible production and possible further development into a new and more desirable

norm."[26] The role of the new "product critic" was to promote the continuous revolution of mechanical production and confound the old nexus of quality and culture, using the "new slogan that cuts across academic categories – MANY BECAUSE ORCHIDS."[27]

A Drama of Possessions

In 1961 Raymond Williams expressed his concern that the new consumer-driven individualism would fail to acknowledge the necessity of maintaining a collective effort in pursuit of social justice. There is little in the writings of the Independent Group to suggest that this was a concern they shared. To a large extent the IG seems to have acknowledged a significant shift of power from the state and its associated cultural priorities to the marketplace, and with it an eruption of primary desires into everyday life. Members were particularly alive to the potential of mass culture as a means of orientation and identity for citizens freed from the subtle constraints of systematic protocols of class and taste. Hamilton's enthusiasm for "designing the consumer," first expressed in an article published in *Design* in February 1960, met with considerable opposition. It was seen as complicitous with an industry which sought to move from "giving the consumer what he thinks he wants" to moulding the consumer to its own needs.[28] Hamilton intended this symbiosis of profit and pleasure to offer "more precise solutions to the needs of society," based on the assumption that "increased productive capacity is a basic social good." The affirmative mood of the IG members (although they were not always in agreement) was wittily characterised by Hamilton as "Mama," combining Dada and Futurism: "Mama: a respect for the culture of the masses and a conviction that the artist in twentieth century urban life is inevitably a consumer of mass culture and potentially a contributor to it."[29]

Alloway rejected the dismissive model of "false consciousness" with a number of well-observed insights which were not fully assimilated into the field of cultural studies until much later. In his essay "The Long Front of Culture," which first appeared in 1959, he stressed the inutility of the term "mass," preferring to think of the audience for mass culture as "numerically dense but highly diversified."[30] Hamilton commented, ironically, on the lonely-crowd paradox by pointing out the conformity to type of his own consuming impulses: "When I bought just one car, we had a national traffic problem."[31] In general, the Independent Group's rejection of the mass-culture thesis is more optimistic and attentive to detail than Baudrillard's "soft sticky lumpenanalytical notion."[32] The IG embarked confidently on an analysis of the objects and procedures which would reach and satisfy the silent majorities of the fifties, who were entering the realms of consumption for the first time.

First Past the Post

Perhaps it is too easy, in retrospect, to assign a coherent project to the members of the Independent Group. Their writings are remarkable for their rejection of many aspects of the cultural status quo of the time. However, the writings also revel in a continuation of the heroic modernist project, unalloyed by the national, revivalist, and picturesque adjustments of the postwar period in Britain and passionately interested in new technologies of construction and dissemination. IG publications are true to the Futurist spirit,

A Lincoln is to dress up and go

Every day's a party
in the new new new Lincoln

A Lincoln is a moving idea
with 285 horsepower
to second the motion

Each inch is luxury:
222 new inches of beauty and comfort
based on strength and safety and power

A Lincoln is one of the Ford family of fine cars

Every mile from the dealers' doors
these are the five best ways to get from place to place

the Ford • the Thunderbird • the Mercury • the Lincoln • the Continental

1956 Lincoln car ad,
Art and Industry (July
1956).

foreseeing continuous revolution rather than the static utopias assigned to modernism by postmodernists. But though they may be perceived as late modernists, IG authors were rarely avant-garde; their writings often define the commercial vernacular as the true cutting edge of contemporary sensibility. If they were "ahead of their time," the moment when their ideas became popular coincided with the short-lived adoption by the Labour Party of the rhetoric of technology in the early sixties.

The IG started from an interest in popular culture in all its hybridity. The Group rejected the metaphoric, "organic" models of art and society and substituted "the long front" of democratic images, serials, and quantities. By locating themselves close to the point of sale, IG members shared in the "ecstasy of communication." Roger Coleman, who edited the Royal College magazine *Ark* at the time when the ideas of the Independent Group were most influential, recognised that "a large part of the function of the modernised urban human is to be communicated to."[33] In the same essay, he goes on to locate notions which conform closely to the perceptions of simulacra, double coding, and the waning of affect as formulated in recent debates on postmodern culture.

The term "image," which describes the relative autonomy of the sign from its meaning, began to pass from professional advertising into journalistic and conversational use around 1958. It was closely associated with perceived manipulations of opinion during the 1958 election campaign. The Conservatives' winning slogan – "You've had it good, have it better" – addressed consumption directly, and the novelty of opinion polls gave the issue of personal choice in politics a new dimension. "Image" became a way of describing the manufacture of social presence through consumption.[34] Daniel Boorstin's *The Image*, first published in the U.S. in 1962, defined the issue as "the new-fangled puzzle of what is really real."[35] In 1959, Hamilton lectured on the image at the ICA, rejecting the accepted sense of an image as a

mask for reality and refusing to discriminate needs from desires.[36] The lecture celebrated the emergence of a generation of designers who were specialists in appearance and who asserted the relation between appearance and appropriation as a cultural dominant, more important than function or aesthetic standards and much more important than durability.

This abandoning of the exclusive and integral derived from a reinflection of modernism. Approaches which had been marginalised by whiggish "pioneers" were reinstated, and alternatives to Herbert Read's "abstract-left Freudian aesthetics" were explored. In the present catalogue, David Thistlewood indicates the centrality of Hamilton's interest in Duchamp. Banham reevaluated the theories of the deviant "uncles" of modernism and reassessed the technologies behind the walls. The jettisoning of greatness paradigms, mingled with the unusual technological experience of their generation, enabled IG members to develop an interest in objects and components which were anonymous, additive, and expendable. The shift away from the organic and centrifugal mode of thinking, which consigned styling to a matter of "mere" appearance and, at the same time, showed little interest in practicalities of construction, refocused attention on a range of non-canonical design objects. Paradoxically, an emphasis on the materiality of production methods generated a new interest in signification and consumption.

The IG rejected the pure and ordered components of modernism in favour of complexity and ad hoc informalism. Specificity was abandoned in favor of intertextuality. The collective and interactive characteristics of the generic were given precedence over the authority of canonical works. The IG constantly employed a creative tension between coexisting, but not coherent, frames of reference, abandoning the millennial foreclosure of what Lyotard has referred to as the "last rebuilding"[37] for an incessant process of discovery, refinement, and interaction.

No Future? The Independent Group in the 1980s

The term "Pop" shares a number of characteristics with the term "postmodern." It is used descriptively and prescriptively, to refer to a mood, a condition, and an inspirational set of mind. The IG used "Pop" to address the problems of cultural production in a world of new objects and relations. Looking both to the furthest reaches of technology and at what people do with their everyday lives, the Group wanted to redirect capitalism from its task of accumulating wealth to a concern with issues of use and desire. The writings of IG members presupposed that the postwar aspirations behind "planning" would be fulfilled by releasing the power of the consumer. Their project was based on the assumed interdependence of egalitarianism, abundance, technological advance, and the extension of the creative energies of modernism into the domestic realm. From the wide-ranging writings and practices of the IG it is possible to distill some basic propositions:

> That all images are equal.
> That the market could galvanise an aesthetic.
> That an artist could be consumer as well as creator.
> That the sign and the surface were not reliant on reality or depth.
> That art could be multiply coded with no normative meaning.
> That attention to relative qualities was more important than discrimination between levels of value.

These proposals presaged the late capitalism characteristic of cultural production in the 1960s. In this context, it is particularly interesting that in the eighties, the sixties became associated with lapsarian and destructive deviations. The dangerous loss of liminality attributed to such closely linked phenomena as Pop and permissiveness has been an important factor in recent ideological investments in traditional values. Today, the decade of the sixties is doubly coded as a psychic epidemic and as a golden age of inspired entrepreneurship, leaving the political right with the task of sifting the gold of talent from the dross of permissiveness.

Is Pop simply explicable by the cultural logic of late capitalism? Certainly, in the sixties, the art market expanded and spilled over into other commodity forms. Lynda Myles has catalogued the exponential boom in galleries, exhibitions, and sponsorship in those years.[38] Fragmentations and fetishisms of the sign made it possible to subvert the dominant artistic and cultural values, but it also eased the introduction of new commodity forms and consuming subjects. The ways in which the consumer was reevaluated and privileged implicated artists and designers in a more complicit practice.

The IG produced new paradigms for an imaginary remodeling of Britain and a new attitude to the creative process. The members' technological expertise gave them a vantage point from which to question the institutionalised alliance between modernism and traditional cultural values. Revisions which first appeared at IG seminars were incorporated into the discussions that began in the late fifties on the reformulation of art education. Those discussions, whose initial impact was in the early sixties, deemphasised traditional craft skills and values in favour of a more technologically ambitious programme. Students were to be versed in the history and theory of their work. The new artist-designers were to be capable of moving into industry and commerce at managerial levels, capable of comprehending the processes involved in the production and dissemination of goods intended for a new consumer market. By the time the first beneficiaries of these reforms were graduating, the long-serving Conservative establishment was being eclipsed and replaced by Labour, whose Kennedy-influenced electoral campaign stressed "the planned, purposive use of scientific progress to provide undreamed of living standards and the possibility of leisure ultimately on an unbelievable scale."[39] Pop was conceived by Alloway as tutelary, as a "drama of possessions" and a "treasury of orientations." Objects produced by artists and designers were recognised as having a potential for social and existential self-discovery and motivation. It could be argued, as it certainly was by more orthodox cultural critics of the time, that those potentials had long been known and mobilised in advertising. The IG analysis was closer to the integration of anthropologically derived notions like ritual and *bricolage*, which provided a new purchase for cultural studies in the seventies.

In the IG's engagement with consumer capitalism, there was an element of "situationist" intent. Hamilton's work in particular demonstrates an interest in the manipulation of image and caption; the miscegenation of cultural levels and a reduction to the absurd are present in the work of all the IG members. However, the politics of the IG are to be found more in their rejection of the profundities of the established culture than in a consistent critique of the "society of the spectacle." Although generally sympathetic to the Labour party and the anti-nuclear movement, the IG was also aware of the

contradictions implicit in its affiliation to consumer capitalism. Hamilton described the mood, retrospectively, as "between cynicism and reverence," and Banham noted that he had "divided loyalties."

The multiplication of cultural elites and the high visibility of socially mobile individuals – features of the sixties culture of Pop – masked the persistence of structures of privilege left untroubled by the logic of the long front of culture. Enthusiastic endorsements of the new aesthetic failed to negotiate the issues of ownership and power which troubled Raymond Williams's perspective on the sixties. The debut of the new, Null-A-spawned, technologically competent, style-as-meaning cultural producer and critic, was a significant factor in, and sign of, the regearing of the British economy in the postwar years. In the sixties, production and power were increasingly replaced as metaphors by style and process. Britain's option was to play a supporting Athenian role to the Roman Imperial burden that had fallen to the United States and, at the same time, to promote technological sophistication as a counter to the puritanical single-mindedness of the Eastern bloc.

The IG's optimism in the 1950s countered the gloomy predictions, offered by the left and the right, that all critical and creative energies would be co-opted by the culture industries or assimilated into the ersatz culture of the masses. The IG argued that the pleasures of engaging with consumer culture were compatible with socially progressive negotiations of needs and desires. Like most futurologists of the time, the Group seems to have assumed a sustaining welfarism as a basis for experiments in supply and demand. Unlike earlier cultural critics, the IG explored the assumption that commercial considerations could enable rather than inhibit.

The early meetings of the IG looked forward, via the United States, to a culture created by the post-scarcity generation of the later fifties. The members foresaw and provided terms through which cultural value could be renegotiated in the interests of "absolute beginners," and the range and hybridity of their concerns reflected the agenda of the new culture industries. The futures of the IG were technologically secured by a new sensibility rooted in intelligent consumption and leisure. It is difficult, in the late 1980s, to recall the optimism of pre-oil crisis futurism. As Fredric Jameson has remarked, the task of the right in recent years has been to commoditise and proletarianise the forces liberated by the empowering modernity of the sixties.[40] The IG provided terms for countering these tendencies, along with the gloomy no-futurism of most postmodern thinking, through active and selective engagement with the potentials of the popular and technological.

Thanks to Judith Williamson for help with organising ideas and Joanne Gooding for organising the text.

1. *Raymond Williams, The Long Revolution (London, 1961), p. 336.*
2. *Raymond Williams, Politics and Letters: Interviews with the New Left Review (London, 1979), p. 173.*
3 *Reyner Banham, "The Gutenberg Backlash," New Society, 10 July 1969, p. 63.*
4. *Quoted in Jim Hillier and Alan Lovell, Studies in Documentary (London, 1972), p. 143.*
5. *Ibid., p. 143.*
6. *Kenneth Allsop, The Angry Decade (London, 1958), p. 19.*
7. *Michael Farr, "Design," in Discrimination and Popular Culture, ed Denys Thompson (Harmondsworth, 1964), p. 183.*
8. *Denys Thompson, ibid., p. 14.*
9. *Quoted in Geoffrey Wagner, Parade of Pleasure (London, 1958), p. 19.*
10. *Reyner Banham, "Pop and the Body Critical," New Society, 16 December 1965, p. 25.*
11. *In John Russell and Suzi Gablik, Pop Art Redefined (London, 1969), p. 32.*
12. *See A. E. van Vogt, The World of Null-A (1945, 1948; 1970 introduction in London, 1971 ed.), p. ix: "General semantics, as defined by the late Count Alfred Korzybsky in his famous book Science and Sanity, is an over-word for non-Aristotelian and non-Newtonian systems. Don't let that mouthful of words stop you. Non-Aristotelian means not according to the thought solidified by Aristotle's followers for nearly 2,000 years."*
13. *Simon Frith and Howard Horne, Art into Pop (London, 1987).*
14. *Lawrence Alloway, "A Personal Statement," Ark, 19 (1957), p. 28.*
15. *Ibid.*
16. *Reyner Banham, " A Throw-Away Aesthetic," in Design By Choice, ed. Penny Sparke (London, 1981), p. 93.*
17. *See Alloway, "A Personal Statement," p. 28: "We were born too late to be adopted into the system of taste that gave aesthetic certainty to our parents. Roger Fry and Herbert Read . . . were not my cultural heroes."*
18. *Reyner Banham, "The Atavism of the Short-Distance Mini-Cyclist," in Sparke, p. 84.*
19. *Dick Hebdige, "In Poor Taste," Block, 8 (1983), p. 56.*
20. *John McHale, "The Fine Arts in the Age of Mass Media," in Russell and Gablik, p. 45.*
21. *David Mellor, "David Bailey from New Wave Photographer to the Box of Pinups," David Bailey, exh. cat. (London, Victoria and Albert, 1983), pp. 3-12.*
22. *Banham, "The Atavism of the Short-Distance Mini-Cyclist," Sparke, p. 88.*
23. *Daniel Bell, quoted in Stuart Hall and Paddy Whannel, The Popular Arts (London, 1964), p. 58.*
24. *Alloway, "A Personal Statement," p. 28.*
25. *Quoted in Hall and Whannel, p. 51.*
26. *Banham, "A Throw-Away Aesthetic," Sparke, p. 93.*
27. *Ibid.*
28. *Richard Hamilton, "Persuading Image," in Richard Hamilton, Collected Words: 1952-83 (London, 1983), p. 142.*
29. *Richard Hamilton, "For the Finest Art, Try Pop" (1961), in Hamilton, p. 42.*
30. *Lawrence Alloway, "The Long Front of Culture," reprinted in Russell and Gablik, p. 42.*
31. *Richard Hamilton, "Popular Culture and Personal Responsibility," in Hamilton, p. 151.*
32. *Jean Baudrillard, In the Shadow of the Silent Majorities (New York, 1983), p. 4.*
33. *Roger Coleman, "Dream Worlds, Assorted," Ark, 19 (1957), p. 30.*
34. *Christopher Booker, The Neophiliacs (London, 1969), p. 44: "But the word 'image' floated into the general consciousness at this time for a reason deeper than its application to politics alone For if there was one bond that linked the different aspects of the changes which had come over British life since 1956, it was the extent to which so many of them contributed to the presence in society of a new body of eye- and mind-catching imagery."*
35. *Daniel Boorstin, The Image (London, 1962), p. 8.*
36. *Richard Hamilton, "Persuading Image," in Hamilton, p. 135.*
37. *J. F. Lyotard, "Defining the Postmodern," in Postmodernism, ICA Documents 4 (London, 1986), p. 6.*
38. *Lynda Myles, "What Made the Sixties Art So Successful, So Shallow?" Art Monthly, 1, 1976.*
39. *Harold Wilson, quoted in Paul Foot, The Politics of Harold Wilson (London, 1968), p. 150.*
40. *Fredric Jameson, "Periodizing the Sixties," in The 60s Without Apology, edited by Sonnya Sayres, Anders Stephanson, Stanley Aronowitz, and Fredric Jameson (Minneapolis, 1984), p. 208.*

Festival of Britain <u>Official Guide</u>, 1951, pp.
lviii and lix.

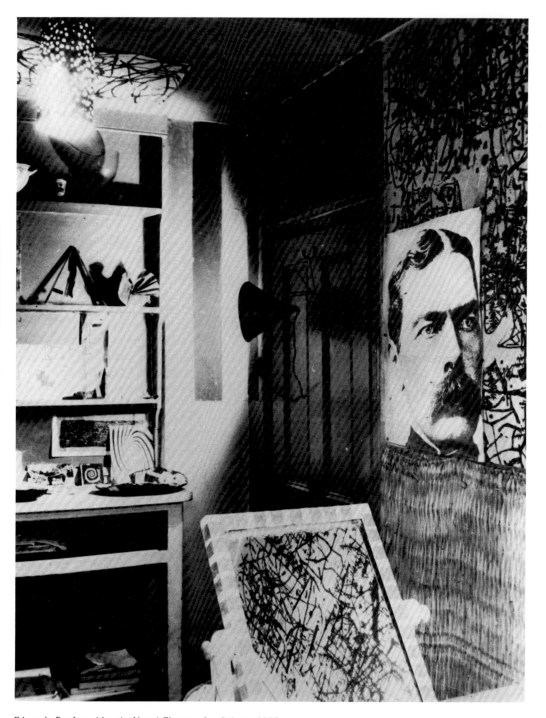

Eduardo Paolozzi's studio at Thorpe-le-Soken, 1955.

A 'Glorious Techniculture' in Nineteen-Fifties Britain: The Many Cultural Contexts of the Independent Group

by David Mellor

In the middle 1950s, the Independent Group was the standard-bearer of a burgeoning, spectacular, technicist culture. To recover the full density of that moment entails a patient remapping of the textual sites of the period, beyond the simplicities of received political and social histories. This essay, then, will trace the registers, surfaces, and texts which were the cultural ground for Eduardo Paolozzi, Nigel Henderson, and Richard Hamilton from 1952 until the close of the fifties. It will be within the turbulent spaces of resistance to and complicity with these discourses – the discourse of atomic catastrophe, the multitude of attitudes about consumption, the new regimes of commercial spectatorship, the mental regions of aviation and space as technicist legends – that we discover the authorising texts of Paolozzi, Hamilton, and Henderson. Once an intertextual frame is placed around the various positions and productions of these artists, the structuring relationship with the encompassing culture becomes apparent.

A voracious consumption of products and signs had commenced in the early and middle years of the decade, once the Conservative government accelerated policies of military-industrial growth and a consumer economy. This economic "takeoff" for a limitless expansion was enshrined in the period cult of the renovated, electronicised New Elizabethan Age. The prosperous economic underpinning of the era runs directly counter to recent simplistic representations of British culture and the Independent Group, such as that by Thomas Lawson.[1] Mistaking received historical myths, Lawson presents a culture which had lost its confidence. "Control of the future seemed no longer so certain . . . A nearly senile Churchill was returned [1952], ushering in a decade of cultural enervation and decline . . ." The "ruling elite," Lawson declares, had a "reluctance to modernize anything."[2] An opposite reading is possible and necessary. The "super-priority" rearmament program, first initiated to cope with Britain's role in the Korean War, transformed the "technoscape," the universe of electronic and aerospace technologies already well advanced by World War II, while from 1952 onward consumer demand entailed a definite period of forced economic expansion and social modernisation; so much so that by 1960 many sectors of British industry – for example, communications, construction, and food processing – had been rationalised and were in a state of seemingly boundless growth. That the styles of political power might masquerade as archaic is unarguably the case, since they were as ambivalent as that meeting of the monarchic, adventuring past and the nuclear, space-exploring future which was the essential component of the New Elizabethan mythology.

We can name the functional mentality which managed the fifties epoch of technological innovation and inaugurated a British society of the spectacle: it was *Tory Futurism*. This renovating style of power was disseminated and diffused through the body of British culture, multiplying a utopian technicism to be enjoyed by sovereign consumers – by the British people, who were joined at this moment with the peoples of the United States and the British Commonwealth of Nations into a new polity. A conflicted ambivalence marked the relationship of Hamilton, Henderson, and Paolozzi to this enveloping discourse of social modernisation, experienced within the constraints of a British culture that was Conservative in its politics and equally conservative in its psychology. On the one hand, there was a celebration of the FD2 – an experimental British military aircraft which gained the world's air speed record in 1956 – by incorporating it as part of the WE LOVE slogans one of the walls of *This Is Tomorrow* ("...1, 132 M.P.H."); on the other hand, the the rapid development of air- and rocket-borne thermonuclear weaponry by the reconstituted Grand Alliance of the West seemed to Richard Hamilton to be "leading us steadily to perdition."[3] Contrasting, conflicting fantasies of catastrophe or cornucopia, of loss or compensation, structure their pictorial works and make manifest their negotiation of the acute tensions – spectacular, deterrent, and military-industrial – of this moment of social modernisation. Perhaps these thematics are most legible in the contrast between the pavilions of the Smithson/Henderson/ Paolozzi team and the Hamilton/ McHale/Voelcker team at TIT. It is manifest in the tension between the semi-domestic figures of the former group's post-apocalyptic shed, and the "fun house" of the latter, with its emphasis on stimuli and pleasures – death *and a* carnival moment within and against high British culture.

The Independent Group developed a patriarchal model of modernism, which meant that belatedness and loss were inscribed as the unsettling, paradoxical obverse of *This Is Tomorrow*. "The show is pervaded by nostalgia, like those current writings about jazz," wrote Basil Taylor in the *Spectator*, referring to the revival and citation of the signs of heroic modernism within the exhibition and aligning it with the revivalist "Trad" jazz boom.[4] A sense of the belated can be identified here, that is, of having arrived at a late moment in the narrative of the fathers of modernism. But it was something that might be overcome by simulating, by mimicking through photography, the postures and scenes of the authentic cultural heroism of a Europe that was being contemporaneously excavated by Reyner Banham in his studies with Nikolaus Pevsner. Basil Taylor, looking upon the estranged photograph by Nigel Henderson of the Smithson/Henderson/Paolozzi team, suspected that "one of the portrait group photographs . . . seems to emulate those photographic documents of the beginning of the Modern Movement. . . . The exhibition is typical of the historical bias of our post-war period."[5] Thus would other "groups" stand for their publicity photographs in archaic, circa 1910 poses: art college satellites or "Trad" bands like the Temperance Seven, which had emerged in 1955 (or, seven years later, the Beatles).

The portentous Edwardian face of Lord Kitchener, traditional icon of the British martial spirit, appears and reappears in Nigel Henderson's collages (a link, perhaps, with the British Surrealist practice of Humphrey Jennings, who figuratively abused Kitchener's face in his 1936 montage, *The Minotaur*). Twenty years later, Henderson's photomontage of a glaring Kitchener sat in Paolozzi's studio. From this image we might reconstruct a fascination with the order of the past, the Law incarnate, the fathers of the era of military-industrial modernisation *and* modernism. Such neo-Edwardianism was, of course, a salient part of British culture at all levels: in Jimmy Porter's grudging admiration in John Osborne's important play *Look Back in Anger* (1956); in the delinquent "Teddy Boys," with their Edwardian-revival dress, over whom a moral panic developed in the late spring of 1955; in *Genevieve*

The Elizabethan Galleon and the Giant Air Freighter of the Reign of Her Majesty Queen Elizabeth II, as far removed in power, speed and appearance, as in time, have this one thing in common — each is representative of the highest skill and enterprise of its age.

Universal

Blackburn and General Aircraft Limited. Brough. E.Yorks

Cover of Flight and Aircraft Engineer, June 1953

(1953), the popular colour film centered around vintage cars, directed by Henry Cornelius; or, finally, in the political persona which, beginning in 1957, Harold Macmillan cultivated as prime minister.[6] The Edwardian resonances of vulgarity and cultural confidence[7] were acute for the diagnosticians of the fifties. Kenneth Allsop acknowledged a parallel belatedness to that which possessed IG members in his 1958 survey of the "dissentient," the "delinks" – the literary Angry Young Men – in The Angry Decade. For him and for the dissentients there was an "intense nostalgic longing for the security and innocence" of the moment before 1914, which he admits to be a risible myth, yet had "an inner confidence that we shall never know."[8] For the IG the same structures of assimilation to a confident, mythical, media-celebrated cultural paradigm (whether contemporary American or heroic European modernist) seems to have been operative and was a vital defense for these "latecomers" against "the anxiety of influence."[9]

The IG's identification with the sublimity of paternal power[10] found its object in the distanced fetish of photographed technology. It was the pathos of half-century old photographs of men and aeroplanes which had engaged Richard Hamilton in his Man, Machine and Motion exhibition of 1955. "There is something fabulous in this aspect of modern history, the men are acclaimed heroes,"[11] he wrote in the catalogue together with Lawrence Gowing, in a panegyric to what we might define as a genre closely identified with the IG: the technological-sublime, the "terrible" and awe-inspiring aspect of man and machine. Man immersed in a technological fantasy had mythical connotations. This sublimity was also to be associated with the technicism of the U.S., incarnated in the latest USAF bombers, the B-47 and B-52. Although

Bernard Myers, writing on current military aircraft design for the Royal College of Art's magazine Ark in 1956, led his essay with an epigraph quotation from the just-released British RAF film, Reach for the Sky, and illustrated it with a silhouette of the new RAF Victor V-Bomber, truly visceral sublimity seemed only to be possessed by the USAF. "Aesthetically," Myers wrote, "some of the new American machines hit me in the solar plexus with their impression of power and purpose, comparable to the eighteenth century gentleman's emotions of the 'Sublime' on beholding a cyclopean-beam engine."[12]

But the aspect of a fetishistic archaism of technology, viewing the spidery wing webs of circa 1910 from the year 1955, had its counterpart in the patriarchal world of contemporary British aerospace. Here the most advanced "supersonic" jets were being produced by tribal companies presided over by the likes of Lord Brabazon of Tara, Sir Thomas Sopwith, and Sir Sidney Camm – the elderly veterans of the first, heroic age of powered flight who were still, spectacularly, in the public gaze. For example, Lord Brabazon, age eighty, tobogganed down the Cresta Run as a publicity stunt in the early fifties. This sort of fetishistic archaism was also present in the film Genevieve. But the sublime power of science and technology was not the prerogative of the IG's fathers. The protagonists of the IG were often drawn from skilled working- or lower-middle-class technical cadres; they were ex-servicemen or industrially trained "professionals" who territorialised their status by setting themselves in opposition to the ubiquitous upper-middle-class British art-amateur and his milleu.[13] In line with this assertion of a "tough-minded" technicist persona, Reyner Banham was described as an "aero-engine mechanic turned art-historian."[14] The career patterns of Banham, Henderson (an ex-RAF Bomber Command pilot), and Hamilton were symptomatic of the social restructuring of a modernising Britain. "New groupings of skilled and scientific workers complicated the traditional picture of British society. Polarisation between workers and management was dissolving in the subtle hierarchies of a world based upon status symbols as measured by consumer goods – badges of the new affluence."[15] Hamilton's career is an emblem of just this process: the accession to power of the skilled, socially mobile consumer (albeit in the sector of high culture) and the manipulation of the signs of affluence. Crucially, he was a carrier of its systems of publicity and representation and a paragon of the new technicist culture. His biography spells it out. At fourteen, in 1936, Hamilton was working in the advertising department of an electrical engineering firm; from 1937 he worked in the display department of an advertising studio, then trained as an engineering draughtsman. Between 1942 and 1945, he was a jig and tool draughtsman with the giant electronics company, EMI. This kind of technical milieu – a world of engineers and technocrats – was the basis of Nevil Shute's best selling postwar novels. It was certainly not the muscular heroics of heavy industry embraced in the fantasy narratives of labour for Social Realists in the thirties or by the neo-Romantic artists of the forties, but instead a projection of something mathematic and cerebral. In a way, this situates the elective affinity of Hamilton and Henderson to their most preferred imaginary father, the draughtsman Marcel Duchamp.

The polemical advocacy of a scientific techno-culture over and against an established traditional culture was a standard frame of reference in the mid-fifties. C. P. Snow's "Two Cultures" argument, published in the

autumn of 1956, enunciated the same discourse. The patriarchal motifs of confidence, "frontier qualities," and normative, heterosexual affiliations were brought to the fore.[16] "The traditional culture, which of course is mainly literary, is behaving like a state whose power is rapidly declining," Snow declared, "whereas the scientific culture is expansive, not restrictive, confident at the roots."[17] Here was the re-emergence of a historical narrative of long duration – to be exact, the late Victorian and Edwardian discourse of crisis around national efficiency and industrial modernisation.[18] But at this juncture, it was the successful advent of a technocratic New Elizabethan culture which was the project at issue within a cultural crisis that erupted in 1956 in concert with another – the scandal of mass culture. The diverse concerns of the IG and TIT, in all their specificities, might, in this perspective, be mapped over positions within a programme of Tory Futurist national renewal. The general terms of that programme are manifest in schemes circulated by figures such as Sir Edward Hulton, with his moralisation of a consumer technocracy by his press empire, in publications such as Picture Post in the mid-fifties, and in the schooling of the male children of New Elizabethan Britain through the comic The Eagle from 1950 on. A set of discourses preparing an already economically and industrially expansive Britain for mutation into a complex, scientific state "on the threshold of space"[19] would, in order to rediscipline the body for new skills and accustom it to new consumer pleasures and terrors,[20] entail a corresponding devaluation of traditional "established" cultural values.

With this overlay, the IG and British proto-Pop might cease to be perceived as essentially transgressive (except in terms of surface effects) in relation to the thrust of British culture, as it has previously been presented by Dick Hebdidge.[21] The resistance on the part of the New Brutalist (Paolozzi/ Henderson/ Smithson) group to complicity with versions of consumer "sovereignty" and the disciplinary powers of industrial modernisation becomes distinct and conspicuous, with their TIT pavilion as locus. Any unitary view of TIT or the IG is, therefore, untenable: in the contrast of their pavilion and its ruination of surfaces with the Hamilton/McHale/Voelcker "fun house," there is a fissuring of projected intents and cultural destinations. The architectural historian Kenneth Frampton has epitomised the situation: "This is the moment [1956] in which the incipient consumerism of the so-called Open Society confronts the Brutalist spirit of resistance."[22]

The consensus vision of a new tomorrow for Britain was shaped in authoritative statements by individuals such as Sir Harry Pilkington, president of the British Federation of Industrialists, in Hulton's Picture Post: "We are undergoing a new industrial revolution . . . [with] peaceful atomic power, electronics, marvelous new machines, automatic processes on a new scale."[23] This was the Tory Futurist precondition for the sanctioned utopia of "The Leisure State." In the foreground, along with the exponential growth of atomic power and a booming electronics industry,[24] was automation, and its universal sign and anthropomorphic personification was the robot. It had been a part of high and low culture iconography from the period of interwar modernism and social modernisation – a puppet, a mannequin of the "modern" which melodramatised automatic functioning and regulation of production. Through 1955 and 1956 the robot was remobilised in the press and on TV as a sign of the imminent arrival of automated industrial processes. In 1956

the Conservative government's new Department of Scientific and Industrial Research established a research council with wide-ranging powers. Their report, Automation, published the same year, gained immense publicity as a forecast of what was being dubbed, in the title of Pollock and Weber's current book, The Revolution of the Robots.

But the robot had not returned as threat, as the ominous unheimlich sign of dehumanisation; instead, it now connoted consumption – it was a homely, heimlich, domesticated sign for automation. It was given a consumer gloss by Leonard Bertin, science correspondent of the Daily Telegraph, in his book Atom Harvest (1955): "Many of us have seen examples of this already. Many of us have gas or electric stoves . . . that are controlled by thermostats. . . . We may have seen fruit canning carried out by extensions of the same principle."[25] The populist cartoonist "Giles" of the Daily Express repeatedly returned to the image of the robot through May and June 1956.[26] Harold Macmillan, as chancellor, introduced the British public to ERNIE, a genial robot who in June 1957 chose bond numbers for an immense, automated public lottery, the Premium Bond.

It was into this field of representations that Robbie the Robot came, along with the science-fiction film Forbidden Planet, which opened in London in the middle of June 1956; and it was from here that he would be appropriated by Hamilton for TIT. In the film, he was predictably amiable and domestic, producing and synthesising food and drink, although in the publicity poster used at the entrance to TIT at the Whitechapel Gallery, Robbie appeared as a castrating threat and rival, carrying off the blonde starlet. Robbie's significance for TIT's narrative lay in his public currency, his recognition factor as a highly condensed, embodied, electronically speaking fragment of the popular iconography of automation. Modernisation as incarnation of the Law, and that Word made electronic. The speaking (and writing) voice possessed by cybernetics had primacy. Already, in the year before Robbie's arrival, the specialist jargon of cybernetics – which the IG and Alloway in particular wished, scientistically, to annex as a lexicon of technicism – had in fact become common journalistic property, popularising terms such as "feedback" in an effort to accustom general readers to the imminent onset of "Leisure Unlimited."[27]

Robbie's arrival was the arrival of the future, the SF metaphor for the jetztzeit, the apocalyptic advent of tomorrow, manifested and located in the very title of the TIT exhibition. The exploration of space provided a scenography for the imaginary tomorrow. In the Festival of Britain Guide of 1951, a spread of two advertisements juxtaposed perspective destinations, two projects of "Englishness" – one pointing to the past and "tradition," the other to the future.[28] On the left page was a photograph of a pastoral scene, an avenue of beech trees, captioned "This tradition of a thing well made . . ."; it was an advertisement for the Bass/Worthington brewery conglomerate. The right-hand page showed a colour reproduction of one of the American artist Chesley Bonnestall's "Exploration of Space" series, an utterly alien scene, with the planet Saturn seen from "an outer moon," advertising Sperry navigational equipment: "These instruments will, no doubt, make possible the spanning of the Universe and the navigation of outer space." Here, at the beginning of the fifties, the familiar, pastoral scenography was defined against an alien scenography. By the mid-fifties this opposition was dissolved and the alien

future was reterritorialised (as we noticed with Robbie and ERNIE) to a seemingly domesticated terrain. Much science fiction was intimate chamber work, such as the hugely successful BBC radio series "Journey into Space" (1954), broadcast to family circles. It was the terrain of the Hulton press's *Eagle* comic hero, Dan Dare, who successfully imposed a British Commonwealth of Nations-United Nations-Western Alliance policy on the recalcitrant colonials of Venus, with the aid of RAF Air Marshal-type patriarch, Sir Hubert Guest, and whose spacecraft were mocked-up for the *Eagle's* team of graphic artists out of household vacuum cleaner casings.

Inside the Hamilton/McHale/Voelcker pavilion was the cabin of a space ship, with a BEM (Bug Eyed Monster) on the exterior. The allusion was not to alien otherness so much as to the disorienting stimuli of the good humoured, populist, crafted world of the British fairground – the imaginary locale of so many of Peter Blake's contemporary pop paintings and an area exempt from rationalised modernisation. One foot, then, was uneasily still in the frame of that urban folkishness surveyed in the thirties by Humphrey Jennings and Humphrey Spender for the Mass Observation project – an organisation Nigel Henderson was associated with in the late forties in Bethnel Green. The other, though, was edging toward a scientistic play of redisciplining the body according to the languages of marketing. This latter tendency was emblazoned across the front of the pavilion, where the screened and blown-up head of Tito was beset by behavioural stimuli in the form of fragments of advertising discourse beguiling his five senses, through ad-debased Klee-like arrows. In the Tito blowup, the body (or rather the head) is a field crisscrossed by apparently capricious marketing versions of those "routinised rhythms of the industrial organisation of social reproduction."[29] Tito's head becomes a zone for the suddenly visible, distracting and interrogating new disciplinary powers that are welcomed as pleasures. From side to side of this human head under siege, the spectator reads an astounding coded version of the reterritorialised body of the consumer which figuratively rivals Zygmunt Bauman's Foucaultian analysis of the consumer body of nearly thirty years later: "[The body] must be made fit to absorb an ever growing number of sensations the commodities offer or promise. . . . Its capacity as a 'receptacle of sensations' is the training target, it is the condition *sine qua non* of consumerism that the body becomes richer and life is fuller depending on the ubiquity of the training."[30]

Alloway, along with Hamilton, emerges as most persistent in his emphasis on the schooling, training, and drilling function of popular culture as a means of easing the spectator into modernised patterns of existence in the world. In his essay "The Long Front of Culture" (1959) he announces this, disavows it, represses it, but finally is enraptured with the lesson-making capacity of Hollywood films – "lessons in the acquisition of objects."[31] Paralleling C. P. Snow's argument concerning the impotence of the literary, humanist, established culture in the face of scientific advance, Alloway portrays the humanist intellectual as incompetent to act as "taste giver and opinion leader" because of the "failure to handle technology." The torch has been passed to the mass media: "the media . . . whether dealing with war or the home, Mars or the suburbs, are an inventory of pop technology . . . a treasury of orientation, a manual of one's occupancy of the twentieth century."[32] Mars *and* the suburbs were adjacent in this discourse of accommodation. SF

was hailed by Alloway, in 1956, for its operational capacity to "orient its readers in a technological and fast moving culture." As he described the SF magazines that were putting into circulation the elements of this new regime of technological rationality and consumer diversity, he was also disclosing the tactics and wished-for goal of some of the IG members: "the currency of such symbols, drawn easily from a wide range of social and technical sciences, is an index of the acceptance of technological change by the public in the United States."[33]

Hamilton and Gowing's 1955 eulogy of sublime technology in the air, underwater, on land, and in interplanetary space in *Man, Machine, and Motion* was qualified by an invocation of catastrophe.[34] It is as though some Mazeppa-like (or James Deanian) figure of energy and destruction countersigning for man and machine had intruded itself into their argument. In the sculpture of Eduardo Paolozzi during the second half of the fifties and in the entire *oeuvre* of Henderson in this decade, we may find this important countervailing force of the apocalyptic sublime, the ruination of the utopian disciplines of technicism, at the very moment of their apogee. The New Elizabethan project banked on Britain taking the lead in the new field of aerospace, a notion which in 1952-53 appeared to be vindicated with the inauguration of the world's first regular jet passenger service, the BOAC De Haviland Comet. Its prestige in civilian jet flight was as enormous as the first glimpse of the RAF's Delta-winged jet bombers and fighters at the Society of British Aircraft Constructors Farnborough Air Display in September 1952. But in a hubris of high technology, first the De Haviland DH 110 "disintegrated" at Farnborough,[35] and between late 1953 and early 1954 three Comets similarly broke up in flight due to metal fatigue. "Stress" – the fatalism of machines, the nemesis of technology – operated as a strong metaphor in early fifties British culture. Henderson's anamorphic photographs of dismantled, blackened, shattered pieces of human culture – bottles, machine parts, or the body itself – were described by him as "stressed": "stretching or distorting the printing paper."[36] The disintegrative metaphor was loose, like a virus in the culture. Nevil Shute, in his novel *No Highway* (1948), had prophesied such stress disasters (the book is the great ancestor of the aircraft disaster genre in novels).

In this "imagination of disaster"[37] that was active in Britain during the fifties, there is a repressed element – the atomic future. It is absent, too, from the art historical accounts of Henderson and from the existing critical readings of Paolozzi. But this contemporary cultural metaphor is legible in their New Brutalist works, in the scarred evidence of detritus following the release of hideous energy, the motif of the apocalyptic sublime. Henderson's photogrammed bottle recollects the lacerated glass of Hiroshima, while bearing analogy to the irradiated "squashed . . . litter of small objects"[38] which Sir William Penney, the chief of Britain's nuclear weapons program, collected from the aftermath of Operation Havoc (the detonation of Britain's first A-Bomb, October 1952). For domestic readers and viewers, Operation Havoc was represented as being essentially in alignment with the New Elizabethan agenda: "It would seem that Britain has taken the world's lead in atomic weapons . . . a blast which revises Britain's place in the hierarchy of nations."[39] There was a common denominator for Henderson and Penney in the impacted indexical sign of energy released to a smoky violence upon the discarded, abject object. Penney was perceived at the time as a D-I-Y, a Do-It-

Yourself scientist, a kind of nuclear *bricoleur* with a "genius for improvisation"[40] – he constructed measurement devices to record the load of an atomic blast from odds and ends of old pipes, tin cans, and oil drums. Just so appeared the abject, lost wax metal agglomerates of Paolozzi, such as *Krokodeel* (1956) and the *St. Sebastian* series of 1957-59. These desolate figures may be read as Paolozzi's mobilisation of the grotesque and abject as Brutalist visual strategies. These are the apocalyptic sublime burn-outs of fission, a scarring and vapourising of the pristine surfaces of the electronic and mechanical cores of consoling consumer objects – those things which Hamilton was currently displaying in *Just what is it that makes today's homes so different, so appealing?* (1956).

The Brutalist grotesque, in resisting pristine commodification, took as its point of departure an aformal raw "image" often drawn from media superimpositions. At the end of 1955, Reyner Banham theorized New Brutalism around a definition of "the image." It was something super-sensible and exceeding conventional emotions. It was, by his definition, dislocatingly sublime: "that which seen affects the emotions."[41] It was a program for resistance to and devaluation of the coded frames of the aesthetic world – particularly the liberal humanism evident in such architecture as the then current neo-Palladianism – dissolving them in favour of the gross material fragment of manufacture or the directly indexical mass-media sign.

The brute factuality of Francis Bacon's news photo-based indexical paintings were at this moment praised in Brutalist parlance by Robert Melville, a critic linked to the IG, when he admired Bacon's exhibition at the Beaux-Arts Gallery late in 1953 for its "uninhibited conduct," specifying "the take it or leave it "newsprint" technique."[42] There were regular contacts between Paolozzi and Bacon at this time, centred upon their shared interest in a grotesque shaping of news and magazine photos. But Bacon's appearance in this context again raises the wider, generic issues of abjection and horror as modes of representation within British Culture at this time. There are Brutalist traces in the news reports of the "Angries" – of, for example, Colin Wilson the young author, who was an instant media success in the spring of 1956 with his novel *The Outsider*. The following year he was assailed by newspaper articles that drew attention to his sordid habit of living in squalor, Bacon-like, with "a shelf of books including volumes of forensic medicine containing some lurid coloured pictures of cadavers."[43]

The macabre had now returned in the genres of popular culture that the IG members were drawn to, especially horror-SF films of the mid-fifties. Again the "super-priority" was that Britain should lead with modernised products. In June 1955 the Hulton film commentator Robert Muller wrote an article entitled "Why People Enjoy Horror Films": "Britain has lagged behind America in satisfying the demand for horror films. Now comes a British 'X' film worth the old 'H' certificate."[44] The film in question was *The Quatermass Experiment* produced by Hammer (that same indexical, Brutalist name adopted by Henderson and Paolozzi for their printmaking company the year before). The ruling assumption of the film rested on catastrophic mutation: a British space scientist, returning from the first manned orbit of the earth, has come into contact with spores which devolve him back to a primeval plant form. The transformation is gradual and disgusting, as a leathery fungal being – with leaves for hands, but still man-shaped – makes his

way through London. This abjection[45] of the modernised rationality embodied in the scientist, this downfall into a set-apart accretion of the organic, has a powerful analogic link with the inhabitant of the Henderson/Paolozzi/Smithson shed in the TIT pavilion the following year. Henderson described his grotesque, Brutalist photo-collage *Head of Man* (cat. no. 33) as a "head worker": "The face was heavily textured to underline the association with hide or bark and the busts/shoulders were adumbrated with bits of photo-material like stone or leaf to further this association with nature."[46] It was a new macabre pastoral, a landscape of the body like the diverse superimpositions of brute nature which had been in formation since *Parallel of Life and Art*, the 1953 exhibition by Henderson, Paolozzi and the Smithsons. Here, at *This Is Tomorrow*, the macabre pastoral appears as the shattering and dispersal back into nature of that orthopedic unity found in the whole, immaculate, commodified body that was carnivalised by Hamilton in his representation of the man and woman inhabiting *Just what is it that makes today's homes so different, so appealing?*

Catastrophe was, then, widely held as the other grand assumption, the obverse face of the prosperity and technicist modernisation of the New Elizabethan universe; it was the *other* of the future, the potential realisation of the theory of nuclear deterrence, which was established between 1954 and 1958. (There was, of course, also the grotesque *racial other* of the usurping colonial subject – the loathsome, "feelthy" Colonel Nasser, whose monstrousness was represented in the British media in the summer of 1956 as part of the prelude to the Suez crisis.[47]) The anamorphic form of film technology and spectatorship, Cinemascope, which was introduced in 1953, was continually cited in TIT in distended – "stressed" – formats, and frames and in WE LOVE affirmations. But its all-inclusiveness, its awe-inspiring positioning of the viewer, linked it to the imaginary structures of sublime, apocalyptic spectacle. Film entertainment was catastrophised. A hysterical 1954 *Picture Post* article entitled "Has Hollywood Gone Mad?" captures the mood: "Is it yet another coincidence that the ages revived by Cinemascope tremble on the brink of oblivion; that the futuristic horrors of the Science Fiction film are either caused or ended by the Atom Bomb? The common denominator of both types of film is the feeling of life lived on the edge of doom."[48]

The grotesqueries of modern technology might also be less apocalyptic and more eccentric in significance, yet still remain a locus for phantasmic identification and cathection. Paolozzi's screenprint *Automobile Head* (1954; cat. no. 65) showed a monumental head, figuratively self-inscribed by punning, maplike, upon the outline of his native Scotland. Here is a motley body – a display of motor car chassis and engine parts, carburetors, and dynamos, partly within the head's outline and partly breaking beyond it. This bristling exposure of (metaphoric) mechanical insides resembles that eccentric monster of the SBAC Farnborough Display of 1954, the Rolls Royce "Flying Bedstead," which was a paradigm of Brutalist design, exposing all its motors, pipes, circuitry and parts on a crude, bedstead-like rig which took off vertically. Bizarre techno-eccentricity was a paradigm of the *Goon Show* mentality of levitating, cumbersome Imperial machinery.[49] But eccentricity aside, Paolozzi's body is permeable to technicism and crammed with products, the promised prizes, which dissolve into a simulation of organic patterning. The head bursting with motor cars was Arcimboldo rewritten for the age of con-

Nigel Kneale, <u>Quatermass and the Pit</u>, (1960). Illustration by Bryan Kneale.

233

sumer affluence, where the body is the site for the absorption of commodities. *Automobile Head* is a Brutalist counterpart to the head of Tito on the TIT pavilion entrance. Both depict the sovereign consumer's head; ironically, that former seat of noble rationality is now "trained into a capacity to will and absorb more marketable goods."[50] Yet, transforming *Automobile Head* is the saving grace of the figural. For the body is redefined by the Brutalists within the IG as textured by the flows of technicism, which are themselves mutated into an anti-functionalist organic condition. A constructed product – a house, for example – eludes, in Brutalist theory, Le Corbusier's machinist dictum. Thus D. E. Harding, in his essay "Embodiment" for the February 1955 *Architectural Review*, challenges Corbusier: "No, the house is not a machine for living in, but an organ for living through."[51]

The gendered, phenomenal body spreads and moves, bounded by technicist metaphors of specular engagement, by photomechanical information and entertainment, in Richard Hamilton's paintings and drawings of the mid-fifties.[52] re *Nude* (1954), may be read as caught in a tissue of such vectors, where the issues of sexuality, enmeshed in new forms of promotional representation, might be glimpsed. Hamilton has perpetually narrated himself as an enchanted child of twentieth-century mass media. He remembers a visit, at age eight, to the first talkie, *The Singing Fool*,[53] which he later incorporated as a scene beyond that island room of commodities in *Just what is it . . .?* (1956). His citation of *The Jazz Singer* as a paradigm of new technological modes implicates the incremental changes in entertainment technologies which compose, construct, and border upon the world of *Just what is it . . .?* In the early and mid-fifties, "some film men [said] 3-D will revolutionise production as the talkies did in 1929."[54] 3-D entertainment offered a utopia of plentitude and volume and fullness in space to the spectator.

To Hamilton such new technologies were a point of deep libidinal investment, as he admitted in 1960: "We must all have found that contact with the fantasy world is made all the more memorable when the bridge is a newly experienced technological marvel. . . ."[55] 3-D, arriving in London in March 1953 with the colonial-melodrama *Bwana Devil*, held the promise of a more complete specular identification. But it was the advent of the Cinemascope process – through the anamorphic "squeezing" and (Henderson-like) "stressing" of the framed picture – which actually effected the illusion more successfully, when it came to London at the close of 1953. "An acceptable true 3-D was one of the failed objectives of the fifties," wrote Hamilton.[56] This was, to be sure, generally true of cinematic experiments, but *still* 3-D photography was an immensely successful novelty, a "newly experienced technological marvel," widely circulating at the most popular magazine and pulp publishing level in 1953. Its gaze was an aggressive, erotic one, with female pin-ups predominating: nightclub dancers kicking and shocking the eye[57] and wrestling girls as well as "art photography" nudes. Hamilton is silent on the topic of still 3-D as a commercial regime of sight, but re *Nude*, which he presented in terms of concerns with spectatorship mobility and the passage of time, might also be read as an appropriation of this form. The nude is, in the bureaucratic signifier of the title, the object of technicist investigation; it is, in the pun, renewed, renovated. It could be read as a version of the most recent form of renovating the nude body: the multiple, purple contours registering the body could be detached from their Cézannesque cita-

tion and relocated among the photomechanical purple, pink and green laminations of body edges which define "glamour girls" in *Picture Post* photostories like "Two Girls in 3-D."[58]

Henderson, Hamilton, and Paolozzi traded in such spectacular, hyperbolic versions of the gendered and "sexualised" commercial body, particularly those with American sources – the polar types of pinup and muscle man. Charles Atlas, the Big Brother of the male body, proliferates through Henderson's early photo-collages and appears in Paolozzi's "seminal" Pop montage *Bunk!* (cat. no. 59). Here Atlas, a paternal ego-ideal, swells up his muscular body, like the crude medical diagram of the erect penis collaged next to him. This is a literally phallocentric representation, supporting a shrunken female pin-up and U.S. consumer products (motor car, cherry pies). Potency is the thematic, maintained against all the cuts and sectionings running through the picture, which is metaphorically "seminal" indeed, in the gouts and drops of glue. They secure the paper-carrying Charles Atlas, overlaying and overwhelming another picture whose caption and border can be seen: a genteel British "art photography" pinup titled "Evadne in Green Dimension." This occupation of the place of the genteel British body is important, yet all importance, all swelling is deflated in the scornful riposte of the lettering, "BUNK!," and identification with an (Americanised) paternal power is momentarily punctured and broken.

The translation of this phantasmic American body into a British cultural frame was, as has been noted by Dick Hebdidge, a component part of the scandal and phobias around "Americanisation" in the period.[59] Paolozzi in particular chose to represent the unconstrained, wild body of American provenance – a dancing, grimacing, enraptured body, in its postures *other* than received British social configurations of pose and decorum. This was often a body subjected to the catastrophes of technology, a body in violent display: facial flesh distended in wind-tunnel photographs or a stripperdancer juxtaposed with a crashing US Navy jet.[60] Such bodies can be seen in the photographs Paolozzi culled from magazines like *U.S. Camera Annual* and presented in his epidiascope lecture to the IG in 1952, which has since attained the mythic status of a foundational moment, as an origin of Pop Art. The aggressive combinatory topoi of pinups *and* advanced technology was the concern of Alloway in his 1956 essay, for the assumed male gaze, "Technology and Sex in Science Fiction." In this he foregrounded the Ziegfeld-Irving Klaw S&M costumes of the female pinups as behaviourally "orienting" devices which would have "a social function, that of entertaining our erotic appetites."[61] These were shock stimuli, convulsive remedies for a culture which some in the IG reckoned to be suffering from "a poverty of desire"[62] and which was in the course of a phantasmic forced modernisation by the IG.

In the mid-fifties there were other instances of modernist art being enrolled by the developing commercial structures of consumer entertainment to ratify the multiplying versions of the feminine coded as pin-up. The sculptor Reg Butler, an "engineer of emotional stresses" and the prime focus of the geometric-expressionist "Geometry of Fear" style, made a Brutalist trophy for a magazine beauty contest early in 1955.[63] Perhaps the very term Brutalism, like the male aggressiveness of the "Angries," needs unsettling and contextual amplification in the regions of sexuality, gender, and representation. We might then see how notions of sexuality and representation in the

1950s – an age of a seemingly reintegrated ideal of (American) maleness – were still marked and scored in Britain along the lines of a spectacular "brutality" and grotesquerie. We might look, for example, at Raymond Durgnat's observation on the British cinema of the mid-fifties: "Maleness and brutality revive together. The year before *Look Back in Anger*, Hammer movies began to penetrate the American market." Here Durgnat appears to be establishing a British *counter* to American masculinity through the post-genteel brutalism of Hammer and the "Angries."[64] The promotion of new imaginary models of the gendered body, formed in the productivity and obliterations of this emergent moment of technicism, were central to the project of those IG members we are discussing.

If male protagonists like Paolozzi, McHale and Henderson had colonised representations of the ruined yet still technicised head, a male locus of instrumental rationality under siege, then a more otherly, choric and semiotic – and specifically female – representation of the body was being constructed by Magda Cordell from within the IG. Her large, untitled polymer paintings from 1957 to the end of the decade have ambitious European affiliations and dwell between the ragged red canvases of Tapiés, the Spanish *tachiste*, and Dubuffet's shambling organic heaps of the human. But what is exceptional about them lies in their aspect of female signs; that is, they act as signs for an internal and – crucially – maternal body, unrepresented elsewhere in British art of this moment. They resemble Munch's undulating and sickly accounts of women and otherness, but shorn of his misogynies and fears. However, a new fear – a new hysteria – is present here: the paintings radiate another sickness in their red womb/x-ray connotations. Here is the hellish terror of "atomic dust," of the cancerous glows vented at the heart of the nuclear pile, as at Windscale in Northumbria in 1958. These tumours swell and wither on the painted ground of an imaginary body which resists over-coding by consumption. In Magda Cordell's pictures, woman is threatened both as ground and as body, on the plane of organic existence.

Hamilton, on the other hand, succeeded in relocating that over-coded masculine or feminine body to the territories of the commodity. Janice Worsnip has observed the essential scenario of *Just what is it . . . ?* in the British advertisements of the time: "Femininity is 'penetrated' in this double sense by masculinity [which] constructs femininity in its own image, for itself . . . and [is] contained within the capitalist commodity form. . . . Finally the relation between femininity and masculinity takes the fetishistic form of a relation between commodities."[65] The interior room of *Just what is it . . . ?* carries the trace of the many graphic and illustrative representations that itemised consumer durables within the home and that were in commonplace media circulation. Photomontage sets of domestic interiors, for example, were commissioned by Sir Edward Hulton for *Picture Post* in April 1956. Married couples were shown lodged in surreal domestic spaces, surrounded by aggregates of vacuum cleaners and electronic appliances that appear slightly out of perspectival kilter. The article's title, "Are We Enjoying Too Much of Tomorrow Today?"[66] makes explicit a journalistically prurient variant on the TIT slogan. Once again the future has impacted amid the anxious pleasures of the present. The scene of consumption is spread before the reader, legislated by a Tory Futurism which, under the chancellorship of R. A. Butler, loosened credit and installment plan, Hire Purchase (H.P.) controls in the

decisive budgets of 1953-54. "H.P. is a social safety valve amid rising material plenty," the caption runs, "a potent stimulus of the mass consumption needed for mass production. . . ."

But catastrophe enters in. The article goes on to imagine a change in circumstances, with the removal of easy credit and the subsequent deprivation of the tabulated consumer durables from each household. A hypothetical "Mr. C" is foregrounded: "a graduate teacher, 28, married but without (yet) a child. He has (above) a home, furniture, a radio, T.V. If you imagine Mr. C left only with what he's paid for, retaining only the T.V. set, you have (below) a melancholy and absurd situation." The aftermath of this small apocalypse for the consumer is melancholic: the consumer slips into a barren site, the screening walls of his house are gone and all around Mr. C and his wife is dreary, grey, broken earth – a raw, inchoate Brutalist metaphor – with an awkwardly perspectivised table holding a set. The zone of the domestic is left *unheimlich* once more. But as Hamilton's *Just what is it . . . ?* suggests, it was already an uncanny place in the society of the spectacle, "where the tangible world is replaced by a selection of images"[67]: a place of commodity fetishism.[68]

On this figurative site of fetishism, where do we locate Hamilton as subject-artist? There is no paternal struggle here; and issues and differences of gender in *Just what is it . . . ?* are probably a deflection, a feint away from the flattened stereometries of the selection of commodities. Looking again, we may discover Hamilton at the moment of ambiguously subsuming himself into such a commodity. On the table in front of the television set, a large tin of ham is sitting: its social connotation in post-rationing Britain was still that of a special treat, a sign of relative affluence for the lower middle classes, and of course it directed the consumer back to American origins, to cornucopias and satiation. For Hamilton, we might think, it is a product which enables him, as Hamilton, to be transformed by self-inscription into a commercial label, a brand marked "HAMilton." This was a masquerade he would perform again.[69] Here is the modernist gesture of self-inscription at the dawn of the epoch of consumerism. Thus HAMilton is sealed up in a circuit of commodification, the "splendid bargain" role he was to announce in 1960 of the artist-as-consumer.[70] Yet here, in 1956, the artist is already written into the scene as product *and* self-consumer.

1. Thomas Lawson, "Bunk: Eduardo Paolozzi and the Legacy of the Independent Group," This Is Tomorrow Today (New York, 1987), pp. 19-29.

2. Ibid., pp. 20, 21.

3. Richard Hamilton, "Portrait of Hugh Gaitskell as a Famous Monster of Filmland," typescript, 1964, published in Richard Hamilton, Collected Words 1953-1982 (London, 1983), pp. 56-59.

4. Basil Taylor, "Yesterday Certainly: Tomorrow Perhaps," Spectator, 17 August, 1956, p. 234.

5. Ibid.

6. See L. A. Seidentop, "Mr. Macmillan and the Edwardian Style," in The Age of Affluence, eds. Vernon Bogdanov and Robert Skidelsky (London, 1970).

7. Ibid., pp. 39, 52.

8. Kenneth Allsop, The Angry Decade: A Survey of the Cultural Revolt of the Fifties (London, 1958), p. 18. This is also the historical territory plundered by The Goons, the long-running BBC Radio comedians of the 1950s, who ceaselessly exploited an archaic British Imperial wonderland.

9. Harold Bloom has set out the various defence mechanisms deployed by "late-coming" poets within the narrative sequence of English literature in The Anxiety of Influence (New York, 1973).

10. See Michael Fried's use of Thomas Weiskel's The Romantic Sublime (Baltimore, 1976), in Realism, Writing, Disfiguration: On Thomas Eakins and Stephen Crane (Chicago, 1987), p. 66.

11. Richard Hamilton and Lawrence Gowing, Introduction, Man, Machine and Motion, exh. cat. (London, 1956). Reprinted in Hamilton, Collected Words, p. 19.

12. Bernard S. Myers, "The Inclined Plane," Ark, 18 (1956), p. 35.

13. All the memoirs of IG participants adamantly make a point of this antipathy to the prevailing styles of art behaviour. Notice that the word "amateur" is twice stigmatised in the WE HATE section of TIT.

14. "Contributors," Ark, 16 (1956), p. 10.

15. Bogdanov and Skidelsky, "Introduction," The Age of Affluence, p. 11.

16. C. P. Snow, "The Two Cultures," New Statesman, 6 October, 1956, p. 414.

17. Ibid.

18. See E. J. Hobsbawm, Industry and Empire (London, 1968), p. xxx.

19. The title of one of the many SF films seen in Britain in the mid-fifties.

20. See Zygmunt Bauman, "Industrialism, Consumerism and Power," Theory, Culture and Society, 1 (1983), pp. 32-43, esp. p. 40.

21. Dick Hebdidge, "In Poor Taste: Notes on Pop," Block, 8 (1983), pp. 54-68.

22. Kenneth Frampton, "New Brutalism and the Welfare State: 1949-59," in This Is Tomorrow Today, p. 51.

23. Sir Harry Pilkington, "Prospects," Picture Post, 1 January, 1955, p. 7.

24. The British electronics industry, which had employed ninety-eight thousand in 1943-44 – with Hamilton counted among them – employed one hundred ninety thousand in 1955.

25. Leonard Bertin, Atom Harvest (London, 1955), pp. 32-33.

26. See Daily Express, May 5, 6, 10, and June 3, 1956, commenting on the government report Automation.

27. See, for example, Fyffe Robertson, "Leisure Unlimited," Picture Post, 2 April 1955, pp. 15-18.

28. Official Guide to the Festival of Britain (London, 1951), pp. lviii-lvix.

29. Bauman, "Industrialism, Consumerism and Power," p. 42.

30. Ibid., p. 40.

31. Lawrence Alloway, "The Long Front of Culture," Cambridge Opinion, 17 (1959); reprinted in This Is Tomorrow Today, p. 32.

32. Ibid., p. 33.

33. Lawrence Alloway, "Technology and Sex in Science Fiction," Ark, 17 (1956), pp. 19-23, 20.

34. In their introduction to Man, Machine and Motion, Hamilton and Gowing suggest that the union of man and machine "liberates a deeper, more fearsome human impulse" than even the mythic centaur, "evoking . . . much that is terrible." See Hamilton, Collected Words, p. 19.

35. See Illustrated London News, 13 September 1952, p. 401.

36. Nigel Henderson, "Italy," Architectural Review, 111 (February 1952), p. 83.

37. See Susan Sontag's essay of this title on the topic of SF in Against Interpretation (New York, 1966), pp. 209-225.

38. Bertin, Atom Harvest, p. 145.

39. Illustrated London News, 11 October 1952, p. 58.

40. Bertin, Atom Harvest, p. 147.

41. Reyner Banham, "The New Brutalism," The Architectural Review, 118 (December 1955), p. 358.

42. Robert Melville, "Exhibitions," Architectural Review, 115 (February 1954), p. 133.

43. See Allsop, The Angry Decade, for a long account of the media rise and fall of Colin Wilson.

44. Robert Muller, "Why People Enjoy Horror Films," Picture Post, 21 June 1955, p. 27.

45. Here, as at earlier points in this essay, my use of the word "abject" refers and is indebted to the conceptual structure set out in Julia Kristeva, Powers of Horror (New York, 1982).

46. The Tate Gallery 1974-6, Illustrated Catalogue of Acquisitions (London, 1978), pp. 104-5.

47. See, for example, Ronald Searle's shift from the domestic comic grotesque of the St. Trinian's Girls School cartoons to his demoniac caricatures of Nasser in Punch in the summer of 1956.

48. Robert Muller, Picture Post, 16 October 1954, pp. 27-31, 50.

49. E.g., Goon Show no. 140, broadcast 27 December 1955, "The Mighty Wurlitzer," in which a giant Wurlitzer is "driven" across the Sahara to the "Hotel des Wogs" [sic] and then goes on to win the world's land speed record; a narrative rich in the absurdities of post-Imperial posturing, racism, and technicism.

50. Bauman, "Industrialism, Consumerism and Power," p. 40.

51. D. E. Harding, "Embodiment," Architectural Review, 117 (February 1955), p. 96.

52. E.g., Hamilton's versions of Muybridge and also the car-train film melodrama basis for the Trainsition works.

53. Hamilton, Collected Words, p. 113.

54. Jack Winocour "Hollywood 3-D Circus," Picture Post, 14 March, 1953, p. 10.

55. Hamilton, Collected Words, p. 113.

56. Hamilton, Collected Words, p. 120.

57. Picture Post, 27 June 1953, p. 32. See also Fried, Realism, Writing, Disfiguration, pp. 64-65, on the recoding of representations of the body through violent optical distortions.

58. Picture Post, "Two Girls in 3-D," 20 June 1953, p. 17.

59. Dick Hebdige, "Towards a Cartography of Taste, 1935-1962," Block, 4 (1981), pp. 39-56.

60. See Paolozzi's Windtunnel Test (1950) and Yours Till the Boys Come Home (1951), illustrated in this catalogue, nos. 55 and 56.

61. Alloway, "Technology and Sex in Science Fiction," p. 23.

62. This phrase, used to diagnose what was lacking in the British, was first attributed to Ernest Bevin, the British foreign secretary (1941-51).

63. See "Our Personality Girl Symbolised," Picture Post, 5 March 1955, pp. 24-27.

64. Raymond Durgnat, A Mirror for England (London, 1970), p. 144.

65. Janice Worsnip, Advertising in Women's Magazines, 1956-74 (Birmingham, 1980), p. 9.

66. "Are We Enjoying Too Much of Tomorrow Today?" Picture Post, 28 April 1956, pp. 13-15.

67. Guy Debord, The Society of the Spectacle (Detroit, 1983), Thesis 37, unpaginated.

68. See Lawson, "Bunk," p. 25, for this characterisation.

69. See the front jacket cover of his Tate Gallery retrospective exhibition in 1969, which doubles as artifact illustration and as monograph title, since the flat German-designed toaster is brandnamed "hamilton."

70. See Hamilton's "Selected Bibliography," item 13, in Collected Words, p. 273.

The Independent Group: Forerunners of Postmodernism?

by David Robbins

Postmodernism and the IG

Postmodernism in all its manifestations has played such an important role in shaping the terms of cultural interpretation that its influence inevitably informs any contemporary assessment of the Independent Group. Here I shall employ a few selected postmodernist perspectives as "significance frames" for the IG. The approach is necessarily pluralist. There have been so many postmodernisms since the mid-1970s that we now find we must carry rough maps of their differences in our heads. And since criticism has increasingly emphasized the interplay of texts rather than their authority, even the historical accounts of modernism (from which one's assumptions about the IG's aims are likely to derive) have become contested reference points within an ongoing meta-historical dialogue.

Reyner Banham announced the emergence of this "history of history" at the outset of his 1955 essay, "The New Brutalism,"[1] and he himself played a major role in producing it. Significantly, the IG was influenced less by Banham's vision of a New Brutalist movement (unified around the Henderson-Paolozzi-Smithson alliance) than by his critical aggressiveness, especially his subversive rereadings of the Modern Movement's canonical histories. For us, Banham's heterodox positions at the time of the IG (available in his journalism, although their separate emergence is not precisely datable) provide a reliable starting point in assessing the IG's anticipations of contemporary thinking. His use of industrial design issues to annul the traditional boundaries between high culture and the marketplace, his scholarly challenge to modernist claims of a unilinear historical development, and his belief that the "throw-away" culture of postwar consumerism constituted a decisive break with the social and technological conditions of the first half-century, all anticipate major themes of postmodernism, and they decisively influenced the intellectual direction of the Independent Group. The case of Banham also alerts us to the necessity of employing both modernist and postmodernist interpretive concepts. Banham's neo-futurist faith in technological innovation inspired a remarkably programmatic application of the modernist vow to "make it new." I shall argue, nevertheless, that the postmodernist viewpoint is indispensable to any contemporary view of the Independent Group. It suggests that we share much the same world as that which the IG members addressed in the 1950s. Or better, that they figured out how to live in the one we inherited.

We must come to terms with the IG's diversity and conflicts, however, if we are to improve upon the reductive portrayal that flourished in the 1970s, when the IG was treated as a subdivision of Pop Art. What makes this difficult is the paucity of documentation about the specific issues raised during the early stages of Independent Group meetings (1952-53), which Banham directed towards technology, and the seductive relevance to both Pop Art and postmodernism of the better-known sessions organized by Lawrence Alloway and John McHale (1954-55). Postmodernist perspectives, moreover, are at least as potentially reductive as that of Pop Art. The very idea of post-modernism implies a binary logic based on the rejection of modernism, whereas the IG's collective aim, if we can fairly infer one from the range of avant-garde paradigms it invoked, was a modernist renaissance with a radically inclusivist ("both-and" or "non-Aristotelian") outlook. By the 1980s, however, critics were generally cognizant of the fact that postmodernist interpretive norms like fragmentation, appropriation and textuality were essentially reruns of old avant-garde strategies. Jean-François Lyotard, pressing the paradoxical implications of this line, even calls postmodernism "the nascent state of modernism."[2]

The so-called postmodernism debates of the 1980s still dominate analyses of the social and cultural issues that are likely to be raised in a discussion of the Independent Group. Following Jürgen Habermas's 1980 attack on both architectural postmodernism and post-structuralism as opposite threats to the "uncompleted Modernist project,"[3] an international, politically charged cultural debate emerged that gathered theorists as different as Jean Baudrillard, Fredric Jameson, and Jean-François Lyotard under the rubric of postmodernism. Discipline-specific uses of the term became secondary to a periodizing usage that defined the media-saturated postwar culture as "a new type of social life and a new economic order."[4] Consumer culture was interpreted as a historic displacement of the Industrial Age labor-based categories of production, and its meanings (if any) were seen as systematically destabilized and aestheticized by the mass media.

The postmodernists produced a variety of response strategies, ranging from a mobile engagement with the heterogeneity of game-playing possibilities generated by capitalism (Lyotard) to a dialectic between ideological critique and recognition of the utopian desires behind commodity fetishism (Jameson) to a contemplative recognition of the disappearance of reality into simulations of the real that exploit its absence (Baudrillard). Rough equivalents of each of these approaches existed within the IG. Alloway drew upon game theory in his pluralist engagement with contemporary art and popular culture. Banham and Hamilton analyzed the techniques of commodification in relation to the dreams of the consumer. And the centrality of the image within the IG milieu, through *collagiste* appropriations for tackboards and art works, in photographic exhibitions and in critical discussions,[5] anticipated many of the issues raised by recent studies of the destabilized "society of the spectacle."

The relevance of the Independent Group to the postmodernist debate lies less in the IG's specific arguments about popular culture than in its profound suspicion of claims to stand outside or above it. Class issues certainly lay behind this (as Alloway and Banham reiterated, popular culture was "their" culture) and fed the IG's passionately anti-academic eclecticism. An undeniable intellectual recklessness worked to its advantage, drawing into currency a host of just-emerging perspectives that challenged hierarchic thinking, such as information theory and communications theory, media studies, cybernetics, and semiotics, within a theoretical horizon that foregrounded the realities of mass consumption.

The connections the IG assumed between avant-garde art strategies and advertising (a curiously scandalous discovery for many theorists of the 1980s) anticipated Fredric Jameson's argument that "the commodity is the prior form in terms of which modernism can be structurally grasped."[6]

237

Within the IG, this linkage emerged in three ways: from McLuhan's *The Mechanical Bride* (1951), which showed advertising borrowing avant-garde techniques from art and literature for audience manipulation; from the contacts of artists like Henderson, Paolozzi, and Turnbull with the collections of Paris-based Dadaists and Surrealists; and from the IG's practice of appropriating high-impact, sociologically revealing images from media sources for their tackboards, then for collages.

The most important point of agreement between the IG and postmodernism is that both are resolutely interpretive enterprises. Thus the indeterminacies and fragmentation of evidence that frustrate attempts to represent the IG in traditional terms, as an "art movement," are more easily accommodated from postmodernist interpretive perspectives that are skeptical of coherence and open to textual interplay. Anne Massey and Penny Sparke addressed the critical problem in their article, "The Myth of the Independent Group" (1985),[7] which is an indispensable discussion despite the reductiveness of some of their arguments. (The working class affiliations within the IG, for example, are far too significant to dismiss as mythical.) Rightly emphasizing the diversity of interests within the Group, they point out that the IG had disappeared as a public reference point before resurfacing as "historical" in the 1960s. It was indeed the later success of Pop Art that first enabled the IG to "count" as history. Significance, however, is always constructed out of the present, and the postmodernists' assumption that history is a negotiation between interpretations has a special relevance to this reappraisal. For what must be acknowledged in discussing the IG, but without Massey and Sparke's overtones of art-historical scandal, is the emptiness at its center.

There is scarcely any documentation about actual IG discussions and there is even some disagreement about when they began. We have only a set of notes on the topics of each meeting in the second series, probably made by the co-organizer, John McHale.[8] We are thus forced to work with traces of the past, inferring positions from texts that largely postdate the IG meetings. The exhibitions produced by IG members during this period have usually been treated as embodiments of an IG viewpoint. Yet none of them was produced with that intention, and some IG members deny that their shows had any connection with the Group.

In terms of modernist historiography, the Independent Group simply does not add up. The chief requirement of the modernist enterprise – the production of one or more masterpieces that epitomize a movement and exert a stylistic influence upon subsequent production – is absent. Although there are distinguished works of art by each of the artists in the IG, the only collective term that was ever used for them was Banham's "New Brutalism" in 1955, and that was not convincing enough to be carried on. The artworks that now seem prophetic of Pop Art did not even count as art until years later – Paolozzi's collages and Hamilton's collage for the TIT catalogue, *Just what is it that makes today's homes so different, so appealing?*

From the standpoint of postmodernism, on the other hand, the absence of paradigmatic masterworks and of any obvious historical influence simply enlivens the interpretive situation. Ultimately, the IG's "empty center" compels us to recognize that *everything* counts. Thrown open to the remarkable diversity of production by IG members – writings, exhibitions, art and architecture – we are forced to develop a more inclusive semantic field, one that can sustain dialogue with that which nourished the IG's own restless critical activity.

IG members appear to have been acutely aware of the doublesidedness of their historical position within modernism. Several had personal contact with major figures of modern art and architecture and saw themselves as successors, charged with the task of recuperating the lost international legacy. Nevertheless, theirs was the first generation to address the consequences of machine-age modernism, which had been around long enough for its products to accumulate. Much of the architecture that had been hailed as utopian in the 1920s and 1930s looked weathered and outdated after the war. Banham felt that the creative vitality of the Bauhaus had been debased into rote repetitions of its exercises in "basic design" studios. Independent Group members assumed a sympathetic but critically engaged relation to the Modern Movement, bringing a variety of sociological and "as found" anti-aesthetic perspectives to bear upon its academicizing tendencies. Out of this collective reappraisal, which foreshadowed the critiques of postmodernism, grew the IG's investigation of consumer culture as the previously overlooked reality of contemporary life.

In the following discussions of the art and architectural sides of the IG, I shall be drawing upon three major versions of postmodernism. The periodizing version, which assumes that the postwar transformations of capitalist society require new kinds of analysis, puts a special emphasis upon the second IG session, led by Lawrence Alloway and John McHale. Alloway's "Null-A" thinking encouraged horizontal mobility along the "continuum" of the total culture. This is strikingly similar to the self-consciously postmodernist approach of Jean-François Lyotard, for whom a field of "little narratives" displaces the authoritarian tendencies of culture. The most dramatic indication of this consonance with IG assumptions was Lyotard's 1985 art-and-technology exhibition at Beaubourg, called *Les Immatériaux*. This staging of the information society's postmodernist museum included a labyrinth of simulations and "collected readymades from the most diverse sources," linking the early avant-gardes with the electronic era. As John Rajchman observes, the show reflected a "monumental effort to find a place for 'Americanism' in the history and philosophy of Europe."[9]

Second, it will be useful to consider the connection between the art of IG members and the terms of postmodernism as it emerged in art historical discourse in the the mid-1970s, chiefly through Rosalind Krauss. Repudiating her own grounding in Greenbergian formalism, Krauss launched a theoretically informed emphasis on the copy rather than the original, on printing and photography rather than painting, and on issues of appropriation rather than self-expression. (The success of the ensuing critical movement, launched from Krauss's journal, *October*, contributed to an explosion of appropriation tendencies in art of the late 1970s and 1980s.) From the time of the earliest discussions of postmodernism in art, Robert Rauschenberg figured as both its pioneer and paradigm. It is evident, however, that the collage-based works of Paolozzi and Hamilton employed analogous strategies, with a thicker, sociologically inflected informational dimension.

Finally, the American architectural movement that was launched as "inclusivism" in the mid-1960s and dubbed "Post-Modernism" in the

mid-1970s shows numerous parallels with the IG's revisionist view of the city in the age of consumerism and the car culture. (I shall use the hyphenated term Jencks popularized, to distinguish the architectural movement from the miscellany of other postmodernisms.) This a case where a historical connection between the IG and American postmodernism is arguable, through the influence of the Smithsons, and perhaps Banham as well, upon Denise Scott Brown and Robert Venturi.

Between Art and Life

The Independent Group had an early role in the study of semiotics and aesthetics in the postwar period. Although we have no details of the discussions of communications theory among the theoreticians of the IG, the "tackboard" exhibit that Alloway, Holroyd, and del Renzio constructed for *This Is Tomorrow* should be seen as an important first step in the application of semiotic perspectives to Anglo-American thinking about the urban environment. Like much else that was informally developed within the IG milieu, however, this particular ball was not picked up until much later, when Charles Jencks and George Baird edited an issue of *Arena* (1967) that became *Meaning in Architecture*.[10] In the meantime, the theoretical investigation was carried on by the Italians – in the 1950s by Sergio Bettini and Gillo Dorfles, whom del Renzio brought to the ICA, and in the 1960s by Umberto Eco and others.[11]

When Group Twelve put up its two-sided board – on one side, a system of gridded panels of photo-images showing, as Holroyd puts it, "how to organize and think with imagery," and on the other, a "tackboard" dialogue between images that were to be changed daily – the chief aim was to emphasize the spectator's involvement in the construction of the urban world. In effect, this exhibit extended the IG members' use of tackboards to everyman. The democratizing impulse was supported by concurrent local developments in communications theory. In 1955 Colin Cherry, an electrical engineer and expert on information theory who appears to have been a familiar figure at the ICA (he later contributed an article to *Ark*, the IG follow-up journal), gave an invited lecture at the Communication Research Centre in which he emphasized the "pragmatics" aspect of Charles Morris's theory of signs – that is, signs in relation to users. Cherry argued that Claude Shannon's source-destination formula for information decoding (reproduced in the Group Twelve section of the TIT catalogue) ignored the complexities of communication events, which are "best expressed in the meta-language, not of an external observer . . . but of a *participant-observer*."[12]

It was Lawrence Alloway who most aggressively promoted the link between the "participant-observer" and post-war theories of communication and information, although others, especially Toni del Renzio, shared Alloway's enthusiasm for the new genres of discourse associated with technological developments. Shannon's information theory, Weiner's cybernetics, semiotics via Dorfles and Cherry, Huizinga's theory of play, early McLuhan, game theory, and topology all acquired a rapid if undisciplined currency among IG members. For Alloway, *Astounding Science Fiction*, edited by John W. Campbell, Jr., was a key resource, since it linked the theories and technologies of the electronic age with democratic political ideals. Beyond Campbell's promotion of anti-hierarchic thinking (calling it "Null-A," or non-Aristotelian, after the science fiction writer A. E. van Vogt), his journal con-

tained informed discussions of new scientific and philosophical perspectives and is a likely source of many ideas the IG is assumed to have derived from primary works. The themes of Campbell's editorials certainly remind us of the IG – for example, that the "laws of nature" can be treated as language conventions, that fast change is both necessary and "astounding," that paradoxes are tactical weapons for challenging any givens, and that "noise" (in Shannon's technical sense) is essential for thinking, if we do not wish to ignore facts. Eclectic and populist yet scientifically informed, *Astounding Science Fiction* was a perfect "low" genre resource for Alloway's intellectual development and for his polemical association of pluralism and anti-academicism with American-style democracy.

Alloway defended the proliferation of choice in consumer society both anthropologically, as the culture's way of adapting to rapid change ("everything in our culture that changes is the material of the popular arts") and politically, as a recovery of power from elitist professionalism. The following comment on the urban environment, written at the end of the 1950s, typifies Alloway's affirmative application of cybernetics to the mass media:

> The city as environment has room for a multiplicity of roles, among which the architect's may not be that of unifier. . . . Consider, for example, images of the city in the popular arts which reflect and form public opinions in that transmitter-audience feedback which is the secret of the mass media.[13]

Nothing could be further from Jean Baudrillard's ironic and antagonistic meditations of the 1980s:

> We should agree neither with those who praise the beneficial use of the media, nor with those who scream about manipulation – for the simple reason that there is no relationship between a system of meaning and a system of simulation. Publicity and opinion polls would be incapable, even if they so wished and claimed, of alienating the will or the opinion of anybody whatsoever, for the reason that they do not act in the space/time of will and representation, where judgment is formed.[14]

This strikes the familiar note of the postmodernist theorists' critique of mass media culture – a complete immersion in simulacra, the age of mechanical reproduction gone berserk. Like Alloway and most of the IG, however, Baudrillard starts from the elimination of hierarchies, including distinctions between high and low culture. This totalizing strategy opens the door to slippages of valuation. Beyond the binary oppositions that structure his rhetoric, Baudrillard finds the same "brutalist" pungency in American culture that delighted Banham and Hamilton in the car ads and that impelled McHale, Paolozzi, and Turnbull to separately accompany Alloway to grade B Hollywood films. It is the contrast between America's straightforward commercialism and European hierarchies and pretensions that triggers the convergence. Calling America "the primitive society of the future," Baudrillard remarks that "the latest fast-food outlet, the most banal suburb, the blandest of giant American cars or the most insignificant cartoon-strip majorette is more at the center of the world than any of the cultural manifestations of Europe."[15]

This "brutally naive" America functions for Baudrillard much as Algiers did for Camus in the late 1930s: barbaric clarities offering relief from bourgeois conventions. "Things, faces, skies, and deserts are expected to be simply what they are. This is the land of the 'just as it is.'"[16] The same modernist taste for pungent facticity lay behind the IG's fascination with America,

which continues to hold an exotic fascination for the European avant-garde. "America is the original version of modernity," Baudrillard remarks. "We are the dubbed or subtitled version."[17]

When Baudrillard refers to America as "the only remaining primitive society," we think of Eduardo Paolozzi, who exploited the same intuition in his collages and scrapbooks of the late 1940s and early 1950s. With major achievements behind him in several media, Paolozzi had by far the greatest artistic influence of anyone within the IG. In terms of the IG's intellectual development, however, Paolozzi's key work was his epidiascope showing at what is usually regarded as the first meeting. In appropriately rapid-fire images, he identified the aesthetic and commercial developments in popular culture that became the focus of IG discussions more than two years later. Although everyone was preoccupied with technology, especially Banham (a derisive presence that evening, by most accounts), Paolozzi was virtually alone at that time in recognizing the importance of the technology of image production. This may help explain the silence surrounding his collages and "scrapbooks" of mass media imagery from the late 1940s, although they appear to have had a curiously private status. What was publicly known of them during the period of the IG was through his epidiascope presentations at several venues and from Alloway's *Collages and Objects* show (1954), which included the *Psychological Atlas* collagebook as well as four "head" collages.

Jürgen Jacob traces the origin of Paolozzi's collages to two early modernist sources Paolozzi encountered in Paris in 1947-48. Mary Reynolds showed Paolozzi Duchamp's room papered with pages from American magazines, and Tristan Tzara showed him twenty Max Ernst collages from the early 1920s that represented Ernst's "idea of the age." The collages Paolozzi then produced from American magazines, Jacob argues, departed from the founding terms of Dadaist collage by failing to criticize bourgeois culture.[18]

Paolozzi's collages do function critically, although not by inviting the anti-capitalist readings assumed by the Berlin Dadaists in the twenties. They puncture the insular idealism of the official culture by juxtaposing symbolically loaded imagery, much of it sexual, from the "low" end of the mass media. This privileging of the marginal and the exotic occurs within a profoundly destabilizing visual discourse. The interaction of ephemeral images released from their contexts, the blurred cultural boundaries, and the absence of norms are certainly legible, for us, in terms of the postmodernists' "depthless" culture of equivalences.[19]

It will be more useful, however, to acknowledge Paolozzi's grounding in ethnographic Surrealism, for it directed his collage strategies toward a subversive expansion of cultural references, not as signs without depth but as "significant images" with "a hundred hidden meanings." Paolozzi clearly brought a more vital sense of anthropology into the IG than the ICA's British Surrealist founders had assumed in their MOMA-style exhibition of primitive-modernist affinities, *40,000 Years of Modern Art* (1949). Significantly, Paolozzi was in touch with both British and French enterprises of linking Surrealism and ethnography in interpreting their own societies. In the late 1930s the Surrealist-inclined founders of Mass Observation undertook to document British working class life through interviews, participant observation, photographs, and films. Kathleen Raine recalls that they treated everyday objects (ads, songs, souvenirs, etc.) as manifestations of the collective imagination,

combining the Surrealist concept of the found object with sociology.[20]

Paolozzi, who lived in Raine's house in the early 1950s, was also in touch with this "anthropology of ourselves" through the Hendersons. In his catalogue essay, David Mellor notes that Nigel Henderson had been personally associated with the Mass Observation project, and as James Lingwood notes, Tom Harrisson – the anthropologist who co-founded Mass Observation – assisted Judith Henderson in her field studies of working class family life. For Paolozzi and Nigel Henderson, Mass Observation provided a rare British validation of their choice of the street as visual subject and resource. It was a surprisingly uncommon theme in Surrealist art.

Paolozzi's *Lost Magic Kingdoms* show at the Museum of Mankind in London (1985) underscored his specific sense of indebtedness to the French legacy of ethnographic Surrealism. Dawn Ades argues that Paolozzi was inspired by the great Surrealist periodicals of the 1930s (*Documents* and *Minotaure*) to turn his own culture into an otherness, at once a play of the familiar and the strange and a "collection of documents" available for interpretation.[21] Ades cites James Clifford's 1981 study of ethnographic Surrealism, in which Clifford draws the norm of "ethnography as collage" from the same texts of the thirties, which treated all cultures as contingent, artificial arrangements. Stressing the incongruities, cuttings, and arbitrariness involved in the "constructivist procedures" of ethnographic discourse, Clifford has since established a postmodernist school of anthropology, charged with reflecting upon its own narrative practices.[22]

Paolozzi's Surrealist-inspired collages, however, suggest a more immersed and vulnerable interplay of self and world. The city figures as a labyrinth of *erreur*, where "savage" desires and fears are evoked for commercial manipulation, then "found" and recycled as collective manifestations. Throughout Paolozzi's work of the IG period, he presents the human form as a "matter" of monstrous indeterminacy, equally explicable in terms of comic vulnerability or heroic adaptability. Society appears as a prosthetic adventure, endlessly re-equipping the human (always, for Paolozzi, "primitive") while the rubbish heap serves as the point of interchange between the usable, the used-up, and the artifact.[23] The standard "either-or" polarity between technology and primitivism vanishes, displaced by monstrous constructs – the robot as a futurist vision of the wild man, or the consumer as an android of the car culture. The IG started from such intuitions of technology and metamorphosis, pressing them into formulation.

The collage aesthetic was a generally shared enthusiasm within the IG: if postwar culture was unstable, it nonetheless made all human experience available in graphic form. However one may evaluate Gregory Ulmer's contention that the "post-criticism" of our time is only the transformation into theory of modernist techniques, with collage as "the principal device,"[24] the idea certainly has an allegorical suggestiveness with respect to the IG. Its artists – four of whom exhibited in the *Collages and Objects* show (Henderson, McHale, Paolozzi, and Turnbull) – probably contributed more to the Group's assumptions than has been assumed. In 1952, Banham reviewed the ICA's *Young British Sculptors* show, which included works by Paolozzi and Turnbull. "The true myth of our own time is the Anthropological Man," Banham declared, "and the sculptors are breaking the mould of the ideal man of Democracy and Humanism."[25] Despite Banham's brief efforct to unify this

tendency around "The New Brutalism," it remained an anti-idealist impulse behind a diversity of artistic productions.

While William Turnbull chose silence as a rhetorical strategy for his sculpture – his primitivist forms were incised with markings that remained on the "dumb" side of sign content, rejecting the "noise" of consumerism – most of the artists in the IG turned the current revival of figuration into modes of discursive engagement. John McHale, in his visual studies of consumer man, used food metaphors and sumptuous collage colors to suggest both cornucopia and triviality. Magda Cordell, addressing a society whose commercial images of the female rendered women invisible, produced celebrations of woman as an awesome yet indeterminate physical presence, heightening the sense of otherness with allusions to science fiction and primitivist sources. After *This Is Tomorrow*, Richard Hamilton tackled the issue of sex and commercialism directly, exploring the calculated dismemberment of the human body in advertisements.

Iconographically, the artists' images are tantamount to acts of violence against the claims of "universal man" by critics like Herbert Read. They are convulsive reassertions of the body as the site of disintegrations and metamorphoses, with no "core of human nature" to rediscover, as Alloway observes with respect to McHale's collages.[26]

In this aggressively Brutalist sense, these images can be placed within the anti-aesthetic tradition Rosalind Krauss associates with Georges Bataille and a heterological "art of excess," where, she observes, "we find the body inscribed in a mimetic response to external forces." Krauss aligns this modernist counter-tradition of the lowly with Dubuffet's "materiological explorations" of the 1940s, which were probably the major influence on the human images of the IG artists.[27] Paolozzi's conflation of the body with ruins (the "comedy of waste") fully accords with this oppositional tradition, recalling Bataille's insistence that Surrealism means seeing the world from the standpoint of its decomposition.

A more affirmative reading of the Art Brut tendency was also in currency, associated with Alexander Dorner's *The Way Beyond "Art"* (1947), which Banham particularly valued. Dorner saw texture, once simply a modernist weapon against perspectival illusion, as acquiring an anti-formalist role by encouraging viewers to "become involved in the new play of energies."[28] Hence, in many works associated with Brutalism, the seductive ambivalence of the threshold zone between marks and signs, noise and signals. Once again, between disintegration and renewal there is no idea of the human, no convention to defy. If "man" has not yet been erased, as Foucault put it, his identity has been pushed to the limits of recognition, where the human image can function as a site of transformation. Significantly, much of the art of IG members registered both positive and negative valences of this instability, whereas the critical bias of the IG was resolutely affirmative.

What linked Alloway and McHale as leaders of the second IG session was a belief that an expanded consciousness was produced by the explosion of consumer options and even by the stresses of a destabilized society. Similarly, Hamilton's TIT catalogue statement addressed the new demands imposed upon human capacities in educative terms, as an opportunity for widespread self-improvement. What was needed was not a *selection* of images, "but the development of our perceptive potentialities to accept and utilize the continual enrichment of visual material."[29]

John McHale particularly emphasized the potential of this attitude, turning the breakdown of traditional art-life boundaries into a "future consciousness" with increased adaptability to change and new stimuli. In a 1973 dialogue between McHale and Alvin Toffler about futures research, Toffler raised the objection that Turnbull and the Smithsons embodied in their work and doubtless raised in IG discussions. Are we not so "bombarded with imagery" that we are "numbed and turned off?" Toffler asked. McHale responded that the job of artists is to *overstimulate* the viewer-participant, until the overload produces "new patterns or Gestalts." If "receptivity is not numbed but maximized," McHale argued, "you become extraordinarily alert to changes in your environment."[30] Through his futures studies, McHale would consolidate his linkage of technology, mass culture and an avant-garde zest for change in increasingly evolutionist terms.

McHale's technologist bias sharply contrasts with the preoccupation of other IG artist-members with the "prosthetic" fitting of the human body to a fully mechanized world. Paolozzi's comedic graphic of man-and-camera in battered inefficiency (cat. no. 43) and Hamilton's photographic "epic" of the pioneering adventures of *Man, Machine and Motion* suggest the awkwardness and sense of challenge accompanying new adaptations to the machine. What distinguishes McHale's art, however, is the exuberance of his plunge into technical processes. His collages reenact the Dubuffet head-landscape conceit in sensuous rather than "wasteland" terms, exploiting the improvements in color-printing technology as orchestral resources. As Alloway notes, McHale wanted the "original channels" of the U.S. magazines to remain identified, yet coalesce into the "coloristic unity" of an "expanded realm" of transformations.[31] The pungency of the Brutalist engagement with hard materials and artifacts, never far from ruin, is translated into a soft-textured, seductively bright and lyrical new order.

Richard Hamilton is the IG member who best fits the profile of the postmodernist artist, particularly if we focus on the post-1956 works that implemented the Pop program he was unable to persuade other IG members to join. His announced goal was to create a new aesthetic by putting popular culture items into a fine art context. The result was a translation of the language of advertising into a remarkably analytic visual discourse about its technique and iconography. It is surprising that his work has been given so little attention within postmodernist art criticism. Without speculating on why this might be so, it may be useful to consider the terms in which Rauschenberg's paintings of the late 1950s were classified as postmodernist by Leo Steinberg in 1972. Steinberg's argument, in turn, became the basis of Krauss's early formulations of a postmodernist aesthetic a few years later.

Steinberg praised Rauschenberg for "inventing a pictorial surface that let the world in again," revealing a "consciousness immersed in the brain of the city." Rauschenberg turned the picture plane into a "matrix of information" (Duchamp is cited) by treating it as a horizontal "flatbed" plane, a surface for anything *thinkable*.[32] The technical processes of making images are stressed, as are the "deepening inroads of art into non-art." On such an "all-purpose picture plane," the picture is not a glimpse of the world, but printed material. This, Steinberg concluded, should be called "post-Modernist painting."[33] Its models are the printing press and tabletop, not the vertical win-

dow. In 1974, Rosalind Krauss expanded upon Steinberg's model, introducing the discursive as a temporal factor in Rauschenberg's work that required an "image-by-image reading."[34] The parallels with Hamilton's paintings and graphics from 1956 and after are striking, although as both Richard Morphet and Richard Field have demonstrated, the analytic rigor with which Hamilton explores the techniques and iconography of commercial media is unparalleled in contemporary art.

Writing about his now famous *This Is Tomorrow* collage (*Just what is it...?*), Hamilton provided the list of subjects that he had prescribed for the work, concluding that "the image should . . . be thought of as tabular as well as pictorial."[35] Steinberg's "tabletop" information plane comes immediately to mind, although an IG tackboard is probably a more literal model. It was Hamilton's preoccupation with Duchamp that led him to go beyond this to dramatize the instability of the sign. This was also Rosalind Krauss's next critical move in the late 1970s.

The IG and the City

Although architectural issues were not central to the second series of IG meetings, a new idea of the city was at stake, and it was quite different from that of the heroic age of modernism. In his 1966 essay, "The Development of British Pop," Lawrence Alloway identifies it as "a sense of the city neither as a means to reform society (Mondrian) nor as the typical form of Ideal Form (Léger), but as a symbol-thick scene, criss-crossed with the tracks of human activity. The feeling is not an easy one to set down, but it was a kind of subjective sense of the city, as a known place, defined by games, by crowds, by fashion."[36]

This enthusiasm for the busy city of consumer society achieved a limited circulation among younger British architects by the early 1960s, and the IG milieu was acknowledged as its source. The 1963 *Living City* exhibition at the ICA, organized by the Archigram group, celebrated urban disorder and consumerism with an explicit sense of continuity with *This Is Tomorrow*.[37] However, it was not Archigram but the American architects later associated with Post-Modernism who brought the city as a "symbol-thick scene" to the foreground of architectural thinking in the 1960s.

To see exactly why this is so – and why Alloway's Dadaist-inspired defense of the existing city meant far more to the artist-members of the IG than to the architects – requires recognition of two other, competing ideas of the city within the IG, represented by the Smithsons and Banham. Here the perspective of Post-Modern architecture must be deferred. Although the positions of Alloway, Banham, and the Smithsons each anticipate key elements of Post-Modernism, especially in its inclusivist and populist 1960s phase, those of Banham and the Smithsons, at least, are quite incomprehensible in Post-Modernist terms. The Smithsons, above all, regarded themselves as the postwar avant-garde of the Modern Movement, and both they and Banham played largely oppositional roles during the heyday of Post-Modernism. If we understand the working strategies behind the Smithsons' ambitious redefinition of the city at the time of the IG, the factional tensions surrounding the popular culture emphasis of Alloway and McHale will be seen as inevitable, and less reducible to personality clashes.

The Smithsons' prestige in the 1950s was enormous, due to the re-

cognition given their school at Hunstanton, their leadership of Team 10 in challenging CIAM's rationalist dogmas, and the impact of Brutalism as an architectural translation of the "rough poetry" in ordinary realities, including mass production. Their astonishing range of achievements during the period of the IG, despite losing competitions with brilliant designs (Golden Lane, Coventry Cathedral, and Sheffield University), was accompanied by a correspondingly wide-ranging intellectual development. To appreciate the clarity and force of the Smithsons' productions, we should be aware of the irresolution haunting British architectural thinking at this time. James Stirling, who attended IG meetings without taking an active role in them, published important articles in the mid-1950s on Le Corbusier's shift to Mediterranean vernacular models in the Maisons Jaoul and Ronchamp and on the general trend towards regional architecture. In each essay, after a sympathetic analysis of Le Corbusier's new direction, Stirling complained of "the disappearance of the rational principles which are the basis of the modern movement."[38]

Stirling's ambivalence illustrates a widespread sense of impasse, with architecture viewed as suspended between reason and feeling (or culture and nature, or classicism and romanticism). This pseudo-explanatory dichotomizing, authorized by Sigfried Giedion, had become the standard way to cope with the simultaneous upsurge of romantic revolts from machine age rationalism and classical or scientific elaborations of it.

The Smithsons preempted such conflicts in two ways: by seeking to generate a new kind of order from the social and physical realities beneath style, and by devising ways to absorb both sides of the prevailing oppositions into their theories and designs. Looking back on their development in the 1950s, Peter Smithson stressed the coexistence of two tendencies. First, reacting against the excesses of the Festival of Britain, they called for a "retreat to order," inspired by Wittkower's *Architectural Principles in the Age of Humanism* and Le Corbusier's Unité. Second, Smithson recalls as "co-existing with this (surprisingly) and triggered off by the first European sight of Pollock (49ish), the relationship with the Dubuffet-Paolozzi-Appel 'revalidation of the human image' phenomenon, and the confidence inspired, especially by Pollock, that a freer, more complex yet quite comprehensible idea of 'order' might be developed."[39]

It would be hard to overestimate the importance of the Smithsons' alliance with Henderson and Paolozzi in this regard. Both had personal connections with the artists of the Continental avant-garde, and Paolozzi, who had worked with Jane Drew's architectural firm, was developing his own versions of what became known as Brutalism in quite different media. When the Smithsons joined Henderson and Paolozzi in producing *Parallel of Life and Art*, they were positioning themselves at a point of maximum tension. While mounting a sociologically based challenge to the older modern architects at the Congrès Internationaux d'Architecture Moderne (CIAM), they were also developing their Dadaist-inspired "as found" aesthetic in ways that fully tested their commitment to clarity and order.

The Smithsons' turn toward "human association" immediately became the collective aim of the young, dissenting CIAM architects who called themselves Team 10. Paolozzi certainly contributed to both aesthetic and sociological emphases, as did Henderson through his photographic engagement with the streets of Bethnal Green (see the Smithsons' *CIAM Grille*,

cat. no. 71). However, Judith Henderson appears to have been the crucial influence on the Smithsons' sociological perspective. Trained in anthropology at Cambridge and at Bryn Mawr,[40] her studies of working class neighborhood life were conducted in conjunction with a sociology course whose guiding principle would have counted for much with the Smithsons: "that a given community is an organic unity whose attitudes reflect the historical evolution of that community."[41]

Banham's 1955 article, "The New Brutalism," was an attempt to connect the anti-formalist side of the Smithsons with the art of other IG members like Cordell, Henderson, and Paolozzi by aligning them all with Dubuffet and *Art Brut*. Privileging the anti-classical concepts of image (affect) and topology (form), Banham's paradigm was the Smithsons' competition design for Sheffield University (1953). However, the Smithsons' writings of the period, especially the "Urban Re-Identification" essays that became the core of *Ordinariness and Light* (1970), provide a more trustworthy sense of the balance they sought from their wide-ranging sources.

On the one hand, the Smithsons affirmed a Purist taste for well-formed everyday objects, refined by a Japanese aesthetic. "Ordinariness" stood for a contemplative ideality of types – as the Smithsons phrased it, "the chair chair, the table table, the cup cup."[42]

On the other hand, as Peter Smithson suggested in the quotation above, their encounter with a Jackson Pollock painting in 1949 inspired an all-over, random or "scatter" aesthetic, subversive of fixities and hierarchies, which they called their "aesthetic of change." As the Smithsons observed with reference to Henderson's "life-in-the-streets" photographs, they wished to transform the Pollock-inspired notion of "manifestation" into architectural patterns responsive to the patterns of human association. Their radical concept of the street deck for Golden Lane housing (cat. nos. 67-68) illustrates the high modernist line, visionary and anti-historical, that was recuperated through this design process. Arguing that "the street has been invalidated by the motor car, rising standards of living and changing values," the Smithsons designed their elevated street decks as "an equivalent to the street form for the present day."[43]

House, street, and city were outmoded, in effect, by becoming continuous. That is the radical significance of the famous graphic pattern of Golden Lane City (cat. no. 69). It reflects the expressive graphism of the *tachiste* and *Art Brut* traditions (Peter Cook called it the "potent scribble"), while carrying a symbolic burden as an objective pattern of human activities. Like the structural patterns in the New Landscape macro-photography of Moholy-Nagy and Kepes, which played a key role in *Parallel of Life and Art*, the architectural pattern is intended to be read in dynamic terms, as the product of an interplay of forces or activities.

The Smithsons also adopted a dualist approach to cope with the polarities they absorbed into their concepts and designs. Here people and their ephemeral commodities figure as decorative elements foregrounded "as found" against the architectural units (see cat. no. 67). In their 1956 essay on advertising (reprinted here in "Critical Writings"), the Smithsons place the "throw-away object and the pop-package" within the contemplative context of Japanese aesthetics. At stake, as I suggest in my note on American advertising in this catalogue, was the need for strategies of control, to appropriate the images and ephemera of the new consumer culture while remaining free of its chaotic, "noisy" tendencies. In this quest the crucial resource was the work of the great California designer Charles Eames.

Eames apparently served much the same role with regard to "as found" commodities as Nigel Henderson served in relation to "as found" debris. Although we have no records of the discussions about Eames at the ICA, it appears that his productions were interpreted in at least two major ways, as Geoffrey Holroyd clarifies in his 1966 analysis of Eames's influence. Holroyd (who brought the Eameses' films and ideas to the ICA) first clarifies the high-impact communications side of Eames – the visual displays using "multi-image involvement" to "drive through the audience's habitual responses by the sheer quantity and rapidity of change of images in order to rearrange the responses."[44] We may assume that this aspect of Eames particularly appealed to Banham, Alloway, and McHale.

In Holroyd's next section, aptly titled "Place and Control," he argues that the specifically architectural application of Eames lay in his dualist strategy of treating structure and decoration as "not one idea but two, in disagreement with each other."[45] Eames's "House of Cards" display of structure as a vehicle for contrasting images, which directly influenced the Smithsons' exhibition designs, became a paradigm of the controlled dichotomy between the architectural unit and "as found" ephemera. Thus the Smithsons recall that they designed the structure for Patio and Pavilion in *This Is Tomorrow* and then left it to be "inhabited and so decorated by Nigel Henderson and Eduardo Paolozzi."[46]

Within the IG, the Smithsons' bias towards a "calm" city, at once structurally lucid and pragmatically organized (yet designed for surprisingly high densities), contrasted with the *laissez-faire*, "noisy" city favored by Banham, Alloway, and McHale, which was given over to rapid change and communications. (In a 1955 talk, Banham recommended an "aesthetic effect with high immediate signal strength" to "compete with the 'random noise' aroused in situations of practical use."[47]) Peter Smithson, following his first visit to America in 1957, wrote of his profound disappointment with both the architecture and the landscape. In response, he turned the dualist control strategy into a resigned figure-ground solution. Since only the "throwaway" commodities had any design virtues, he argued, the best option was a stabilizing "fix" or "background permanency" (e.g., the freeways or any unused space), against which objects and activities could appear in relief.[48] In effect, but for quite different, ultra-modernist reasons, the Smithsons found themselves in considerable agreement with the *Architectural Review*'s campaign against the unplanned American landscape.

Nothing better represents what most IG members opposed in the British architectural establishment than the famous December 1950 issue of the *Architectural Review* whose announced purpose was "to investigate the mess that is man-made America." The American landscape was attacked as a symptom of moral crisis, its "visual chaos" testifying to a perverse refusal to control the spread of "materialism."

> *At the very moment when the exhausted European had seen through the error of materialism, America, he is inclined to feel, has given it a build-up that may enable it to stagger through the twentieth century, postponing at one stroke the revival of civilization and threatening the survival of man.*[49]

The success of the Independent Group in challenging this New Humanist polemic was manifest in the May 1957 "Machine-Made America" issue of the *Review*, for which the "cover personage" was McHale's eerily beautiful collage robot ("assembled from one of America's favorite flattering mirrors, coloured magazine illustrations"[50]). The articles within, however, dodge the issue of the existing environment. They assume that America's commitment to mechanization is producing a new vernacular architecture that satisfies the aims of the modern movement in unexpected ways, through mass-produced options like prefabricated curtain walls.

McHale's "Marginalia" article prefaces this celebration of the American building boom. It typifies the IG's tendency, following Banham's lead, to turn architectural questions into issues of industrial design. McHale discusses specific products that either gratify the consumer or require active decision-making. He begins with his own idea of a "U-bild-it" house kit based on Charles Eames's choice of window elements from a steel company catalogue, then reproduces the catalogue page, with Eames's choice of unit combinations circled. The obvious referent is McHale's own sculptural constructions from the early 1950s, which Alloway analyzed as games of spectator choices.[51] Most of McHale's examples, however, are gadgets reflecting the "current consumer preference" for "curvy plastic build-up," from a hand sculpture to a rifle bolt mechanism to the back of a Chrysler. McHale refers the reader to Banham's 1955 "Machine Aesthetic" article in the *Review*, which defended "Borax" design – the pejorative term used by the *Review* since 1948 for the "tear-drop" streamlining that epitomized American commercialism.[52]

The point here is that the "noisy city" IG members, despite the environmental enthusiasms evident in their exhibitions, demolished the presuppositions of modernist design theory without worrying about an architectural alternative. Reyner Banham's tactic was to eat away at the architect's traditional domain, showing how much design is actually done (more effectively because more pragmatically) by industrial designers. In effect, the IG's investigations of mass culture simply pushed architecture to the side. Banham, however, always theorized this issue in neo-futurist terms, as a quest for an *architecture autre* that would translate as many traditional architectural functions as possible into technological innovations.

There were thus three different ideas of architecture and the city in tension within the IG. The Smithsons envisioned the translation of "city" into "home," as they emphasize in their writings of the 1950s collected in *Ordinariness and Light*. Within mixed-use areas of density, traditional neighborhood patterns of activity would be reassigned to high-rise structures where children could play and people would gather on the street decks.[53] In two essays of 1959, on the other hand, both Banham and Alloway clarified quite different assumptions about architecture and the city that each had been working from. The neo-futurist Banham agreed with the Smithsons (as Alloway would not) that "words like 'city' will have to go." However, he also argued (*contra* the Smithsons) that electronic communications and the car culture had outmoded the "group pressures" of the physically bonded traditional community. The old city had to be replaced ("or else") by the new "scrambled egg" cities of conurbation, where "only voluntary association takes place."[54] Instead of the Smithsons' elision of house, neighborhood, and city into a "potent scribble," Banham simply wanted "an infra-structure of usable facilities."

In contrast, Lawrence Alloway, in "City Notes" (1959), praised the "crowded, solid city" with its piling-up of activities, observing that idealist architects pit themselves against the users. "It is absurd," Alloway wrote, "to print a photograph of Picadilly Circus and caption it 'architectural squalor'." He then recalls the excitement of Chicago's "noisy, narrow corridor of neon," defending it against the mind-set of the *Architectural Review's* 1950 "man-made America" issue.[55]

Charles Jencks, writing in the late 1960s about the IG's "Pop theorists," declared that in effect they had "changed the captions" of the *Review's* 1950 photos indicting America for its "proto-pop icons of billboards and car dumps." "All that was needed was a new attitude, a new caption."[56] In spirit, Jencks's statement is correct, because the sympathies of the IG's "noisy city" spokesmen lay with popular culture. In fact, however, it was only Alloway who defended the existing city in its messy vitality. And it was the American Robert Venturi, in dialogue with Denise Scott Brown from the early 1960s, who literally "changed the captions" Alloway had rejected.

The original photographic study for the *Review's* 1950 critique was carried out by four Yale planning students under the direction of Christopher Tunnard, whose accompanying commentary bewailed the lack of "form-will" in American planning. Photos of diners, colonial snack bars, and scenes from "the city un-beautiful" were judged in townscape style, followed by contrasting examples of good planning. Tunnard called Levittown "an enormous speculative dormitory." Almost twenty years later, another group of Yale architecture and planning students, directed by Venturi and Scott Brown, was to provide the counter-argument by justifying Levittown in a 1969 field trip and study.

In 1964, after the *Review* had run Ian Nairn's polemical follow-up columns (called "Outrage") for more than a decade, Peter Blake published *God's Own Junkyard*, using the same types of photos used in the 1950 *Review* feature and restating its indictment of the unplanned American landscape. In 1966, Venturi reprinted Blake's photos of Main Street, Times Square, and other "junk" scenes in *Complexity and Contradiction in Architecture*, alongside his famous appeals to look again (is not Main Street "almost all right?"). Even in reversing the captions, however, Venturi was partaking in the *Review's* "townscape" tradition of reading photographs as mimetic "compositions" of the environment, with the lessons pointed out in the captions and texts. Venturi's first published article, in fact, appeared in 1953 as a townscape "case study."

A more significant polemic appeared in March 1968, when the first of the Las Vegas strip articles, co-authored by Denise Scott Brown and Robert Venturi, announced a shift away from Venturi's formalist approach to the study of symbolism and Las Vegas signage.[57] Here we find obvious parallels with the IG's interest in the high-impact image in a world of competing messages. Although Denise Scott Brown had been working with Venturi since 1960, this is precisely when her full collaboration with him began, including her partnership in their firm, Venturi, Rauch and Scott Brown.

Elsewhere in this catalogue, Scott Brown discusses the Brutalist influence upon her while she was a student at the Architectural Association. What may require some emphasis is the presence of interests parallel to those of the IG among younger British intellectuals. (Clearly, even the IG had a cultural context.) Scott Brown recalls photographing ads and public lettering

before she came to America, bringing her own British background of pop sympathies and rule-breaking wit play to her collaboration with Venturi. She also describes her considerable sense of debt to the achievements of the Smithsons, recalling the parallels she drew in 1967 between the ideas they contributed to Team 10 and those of the Yale-based American architects of *Perspecta 9/10*. It was the Smithsons' bold responses to previously ignored social realities that mattered – their "shocking directness" in problem-solving and their stress on "socio-plastics" and "built meaning." The Smithsons' "liking of the ugly – liking what they did not like," as Scott Brown put it, clearly anticipated the "ugly and ordinary" epithet Philip Johnson derisively assigned to a Venturi and Scott Brown mass housing design in 1968, a term they adopted with ironic relish in their subsequent writings.[58]

By 1969, however, Venturi and Scott Brown's defense of commercial vernacular development, along with their façadist ("decorated shed") solution to the dualist separation of decoration and function, had placed them in opposition to the Smithsons' calm aesthetic and structural emphasis. In a 1969 RIBA article, Alison Smithson accused Lutyens of fostering an "Americanized" stylistic eclecticism in British suburban housing ("a packaged environment" with "completely devalued symbols"). Architecture had a responsibility, she argued, to be "an anchor in the mess."[59] The Venturis responded that the architect "must illuminate the mess rather than jump over it, and will do so by first participating in it."[60]

In this debate, we seem to have come full circle from the old controversy over "the mess that is man-made America." Once again, the perceived threat is the linkage between America, capitalism, and chaos, but it is the Smithsons who now make the humanist appeal to stability. From the Venturis' standpoint, and in particular from that of Denise Scott Brown, who aligns herself with the sociological side of Brutalism and with the Pop side of the IG, the controversy with the Smithsons raises the central issue of a "nonjudgmental" engagement with popular culture and commercialism. The debate, of course, had already taken place at *This Is Tomorrow*, in the dialogue between the Group Two "fun house" exhibit and Patio and Pavilion, and it led to the Smithsons' disavowal of the Pop line in the early 1960s.

As for Banham, many of his ideas of the 1950s position him as a forerunner of Post-Modern architectural developments, such as his pioneering justification of façadism (a way of valuing "human disorder . . . because it is human"[61]) and his defense of architecture as "a branch of advertising," including appreciation of America's "exclamatory hamburger bars, and other roadside retail outlets."[62] Despite these convergences, however, Banham's technologism led in the 1960s to the visionary playfulness of Archigram, not to the Venturis' aesthetic, social, and historical commitments. In fact, Banham was even more actively opposed to Post-Modern architecture than the Smithsons. He fiercely attacked any sign of historical eclecticism. Hence his use of the *Review* as a forum in the late 1950s to condemn the Italian Neoliberty style, which effectively broke that movement.[63]

Almost twenty years later, in *The Language of Post-Modern Architecture*, Charles Jencks would celebrate Neoliberty as a "precursor" of Post-Modernism, after criticizing the Smithsons' Robin Hood Gardens housing development as a summation of Modernist design weaknesses.[64] Not surprisingly, the revival of the avant-garde architectural legacy in the 1980s

brought renewed appreciation of the Smithsons' achievements, led by Peter Cook of Archigram. However, by positioning Archigram as the avant-garde successor to the Smithsons, within a genealogy climaxing in "The New Spirit" of experimental architecture, Cook ignores the profound differences between Banham's "exclamatory" neo-futurism and the Smithsons' more contemplative adaptation of the avant-garde tradition.[65]

Between Modernism and Postmodernism

The historical and polemical complexities glimpsed in this account of the architectural side of the IG confirm the usefulness of employing a variety of modernist and postmodernist significance frames while recognizing their contextual limits. The IG itself mandated this pluralist agility, and Alloway's "fine art-popular arts continuum" became its paradigm. Moreover, as an art historical problem the IG's elusiveness and many-sidedness makes competing perspectives inevitable. The modernist basis of the IG was an inter-textual project – the recuperation of the international avant-garde in the teeth of the dispiriting insularity of British culture. The chief resource in this oppositional enterprise was the production of a text called "America," drawn from a broad range of verbal and visual sources, from scholars like Norbert Wiener and Claude Shannon to "action painters" like Pollock to America's magazines, movies, science fiction and technology. In this respect, the IG's total sphere of discourse, including the exhibitions organized by its members, constitutes a remarkably overt instance of *Americanisme* – America as the ultra-modernist projection of a "readymade" technological society unburdened by cultural baggage.[66]

The postmodernist debates of the 1980s, on the other hand, underscore the significance of the IG's connections between avant-garde techniques and the destabilizing tendencies of American consumerism. Since the politics of contemporary theory have been largely opposed to affirmative readings of capitalist society, recent discussions of the IG have tended to politicize the tensions within the Group. In his essay for this catalogue, for example, David Mellor develops Kenneth Frampton's privileging of "the Brutalist spirit of resistance." Frampton had pitted the Smithsons' "sympathy for old-fashioned working class solidarity" in Patio and Pavilion against their House of the Future, which is seen as a surrender to consumerism – in effect, reversing Banham's assessment of the same displays.[67] Mellor, armed with references to "Tory Futurism," views the Brutalist faction of the IG as an apocalypse-haunted opposition party, repudiating the commerical emphasis of Alloway, Banham and McHale.

One need only think of Paolozzi, who did more than anyone to launch the developments we now differentiate as Brutalist and pop, to grasp their complementary roles in the IG's quest for an aesthetic based on mobility and change – terms the Smithsons placed at the head of the Team 10 agenda. Challenging the conventional opposition between abstraction and figuration, both Brutalist and pop tendencies were "anti-art" immersions in the unprecedented proliferation of signs and sensory stimuli in the postwar city. Among the artists of the IG, the Brutalist fascination with what Paolozzi called "multi-evocative" markings (leading back through Dubuffet to Ernst's *frottages*) alternated with the "pop" practice (inspired by Dadaist photocollage) of exploiting the metaphoric suggestiveness of media images through collage. Paolozzi

moved freely between these two approaches in the late 1940s and early 1950s, and Nigel Henderson's 1949 screen (cat. no. 31) shows them interacting. (Richard Hamilton's mid-fifties shift to pop images from iconically charged markings was a rationalist equivalent.) Both tendencies contributed to the IG's critical achievement – demolishing cultural idealism by exposing its elitist restriction of experience and its fictions of coherence and permanence.

Brutalist texture and pop figuration promoted the same contradictory goals – a pre-conventional emphasis upon facts, structures and events "as found" ("what moves a New Brutalist is the thing itself," Banham observed in 1955), and an insistence upon interpretive freedom that was to be theoretically elaborated into a reception-based aesthetic within the IG. Inevitably, however, the Brutalist iconography of ruins and fragments inflected facts toward process, metamorphosis and suggestiveness. For Paolozzi, the laws of decomposition "naturalize" from below the passage from commodities to rubbish that Banham celebrated from above as the "throw-away aesthetic" of industrial design. Viewed in this light, the Brutalist landscape does not require an anti-consumerist reading, particularly in the age of existentialism. It functions as an archaeological figure for "the variable meanings of everything," as Alloway put it while explaining the use of tackboards.

Given the IG's anthropologically motivated emphasis on the fall of culture into the marketplace and its grasp of the interconnections between disparate aspects of consumer society, its anticipations of contemporary social analyses matter more than its "complicity," to use the fashionable term for an impossible political ultimatum. Postmodernist critical theory, moreover, has its own "post-Marxist" weaknesses, epitomized by its failure to find credible examples of a "postmodernism of resistance," and its inability to acknowledge partially successful social formations.[68]

Methodologically, both the IG and postmodernism agree that cultural meanings are not "given" but endlessly produced and contested. Thus the "signature" of the IG in the art and exhibitions of its members was the leap "beyond art" (Dorner) into discourse. Parallel of Life and Art, for example, problematized the boundary between art and society, literally surrounding spectators with signs of their world, then forcing them to keep switching reference frames, unlearning conventions of exclusion and separation. This environmentally defined "overspilling" of the work into life (Documents was the title before Parallel) accords with Jacques Derrida's reformulation of the Kantian sublime: by problematizing its own frame (parergon), "art" interacts with extra-aesthetic dimensions.[69]

However, the IG's passionately democratic respect for the competing discourses of urban culture figures as the antithesis of the poststructuralists' principled (and elitist) subversion of successful communication. A closer contemporary parallel with the IG can be found in the neopragmatist emphasis on the possibilities open to the symbolic life of community.[70] The task, from this perspective, is no different for us now than it was in the 1950s: to live the pluralism of the city as intelligently and generously as we possibly can.

1. Reyner Banham, "The New Brutalism," Architectural Review, 118 (December 1955), pp. 355-361.
2. Jean-François Lyotard, The Postmodern Condition: A Report on Knowledge, trans. Geoff Bennington and Brian Massumi (Minneapolis, 1984), p. 79.
3. Jürgen Habermas, "Modernity – An Incomplete Project," in The Anti-Aesthetic: Essays on Postmodern Culture, ed. Hal Foster (Port Townsend, Wash., 1983), pp. 3-26; originally delivered as a talk in September 1980 in Frankfurt.
4. Fredric Jameson, "Postmodernism and Consumer Society," in The Anti-Aesthetic, p. 113.
5. Reyner Banham has two important critical statements on the image – his 1953 review of Parallel of Life and Art and his 1955 essay on the New Brutalism. In the review, Banham argued that Parallel had turned the photograph into "an image, a work of art in its own right," displacing its documentary function through the interplay between images in a "new visual environment." See "Photography: Parallel of Life and Art," Architectural Review, 114 (October 1953), pp. 259-261. In "The New Brutalism," Banham describes the image in affective terms, as "something which is visually valuable." See "Critical Writings."
6. Fredric Jameson, "Reification and Utopia in Mass Culture," Social Text, 1 (Winter 1979), p. 135.
7. Anne Massey and Penny Sparke, "The Myth of the Independent Group," Block, 10 (1985), pp. 48-56.
8. See Appendix. Copies of this document exist in the files of Magda Cordell McHale and the Smithsons.
9. John Rajchman, "The Postmodern Museum," Art in America, 73 (October 1985), pp. 110-117, 171. There are other congruences with IG exhibitions: pathways demonstrating new mechanical extensions of the human body; macroscopic blowups of diverse substances; robots and computers mixed with avant-garde artworks, some of which, like Hausmann's The Spirit of Our Time, Mechanical Head, had influenced IG artists. The point of the show was to go beyond "art" by showing the ways a society based on technoscience abolished traditional classifications, like those between mind and matter and those between high and low culture. And just as an Alloway script was intended to be read by Robbie the Robot, welcoming visitors to This Is Tomorrow, so here Baudrillard's recorded voice lectured visitors on "the advent of the Age of the Simulacrum."
10. Charles Jencks and George Baird, eds., Meaning in Architecture (New York, 1969). The "Meaning in Architecture" issue of Arena appeared in June 1967.
11. A useful historical summary of the Italian contribution to semiotic theory and architecture appears in Tomàs Maldonado, Design, Nature and Revolution (New York, 1972), pp. 118-123.
12. Colin Cherry, "'Communication Theory' and Human Behaviour," in Studies in Communication, ed. A. J. Ayer, et al. (London, 1955), pp. 45-67. The quotation is on p. 65. The interdisciplinary Communication Research Centre was established in 1953 at the University College, London, and Colin Cherry was invited to assist the professors, who were leaders in a broad range of disciplines. A. J. Ayer talked to the IG as part of their first series (according to Graham Whitham, "between August 1952 and spring 1953"), with the apparent result that the members decided they were better off teaching each other. Cherry's On Human Communication appeared in 1957.
13. Lawrence Alloway, "City Notes," Architectural Design, 29 (January 1959), pp. 34-35.
14. Jean Baudrillard, "The Masses: The Implosion of the Social in the Media," New Literary History, 16 (Spring 1985), p. 579.
15. Jean Baudrillard, America, trans. Chris Turner (London, 1988), p. 28.
16. Ibid., p. 28.
17. Ibid., p. 76.
18. Jürgen Jacob, Die Entwicklung der Pop Art in England...von ihren Anfängen bis 1957 – Das Fine-Popular Art Continuum (Frankfurt, 1986), pp. 41 and 124, n. 93.
19. Fredric Jameson, "Postmodernism and Consumer Society," in The Anti-Aesthetic, pp. 118-119.
20. Kathleen Raine, Defending Ancient Springs (London, 1967), p. 47. Paolozzi lived in Kathleen Raine's house in Paulton Square, Chelsea in the early 1950s. See also Paul C. Ray, The Surrealist Movement in England (Ithaca, 1971), pp. 176-179. The three founders of Mass Observation were, besides Harrisson, the Marxist poet Charles Madge and the Surrealist painter, filmmaker and poet Humphrey Jennings, who was one of the organizers (with Mesens,

Penrose, Read and others) of the International Surrealist Exhibition in London in 1936. Jennings, a close friend of Breton and Eluard, "stressed the importance of the public image as against the Surrealists' private images." Alan Lovell and Jim Hillier, Studies in Documentary (New York, 1972), p. 165.

21. Dawn Ades, "Paolozzi, Surrealism, Ethnography," in Lost Magic Kingdoms and six paper moons from Nahuatl, exh. cat. (London, British Museum, 1985), pp. 61-66.

22. James Clifford, "On Ethnographic Surrealism," Comparative Studies in Society and History, 23 (1981), pp. 539-564. Clifford and George Marcus edited a collection of essays in 1986, Writing Culture, that amounted to a manifesto for postmodern anthropology. In Clifford's words, "culture is contested, temporal and emergent." Since our views of it are historically produced and endlessly negotiated, there can never be a final position, for the "perception and filling of a gap leads back to the awareness of other gaps." Writing Culture: The Poetics and Politics of Ethnography, ed. James Clifford and George E. Marcus (Berkeley, 1986), pp. 18-19.

23. See Michael Thompson, Rubbish Theory (London, 1979), for a study of the transfers of objects between social categories (durable, transient, rubbish) as processes of creating and destroying value. Paolozzi includes this in his "short bibliography" (along with Ozenfant and Breton) following his essay, "Primitive Art, Paris and London," in Lost Magic Kingdoms, p. 8.

24. Gregory L. Ulmer, "The Object of Post-Criticism," in The Anti-Aesthetic, pp. 83-110.

25. Reyner Banham, "Man and His Objects," Art News and Review, 3 (12 January 1952), p. 5.

26. Lawrence Alloway, in Class of '59, exh. cat. (Cambridge, Cambridge Union, 1959), unpaginated. "McHale symbolizes the proposition of social psychologists, that there is no core of human nature, given and absolute, only what the environment selects from the bundle of potentials which is a human being."

27. Rosalind Krauss, "Antivision," October, 36 (Spring 1986), pp. 147-154.

28. Alexander Dorner, The Way Beyond "Art": The Work of Herbert Bayer (New York, 1947), pp. 17, 114.

29. In effect, Hamilton's formalist indifference to the choice of iconography contrasts with Alloway's quest for an imagery suitable to the consumer age. In a 1956 article on "Action Painting," Alloway considers this the real aim of Abstract Expressionism ("Introduction to Action," Architectural Design, 26, January 1956, p. 30). In a 1956 article for Graphis, Alloway finds the problem of contemporary symbolism most effectively addressed by a corporate team of German graphic designers, whose scientific imagery of the body has a social as well as commercial service function ("Geigy," Graphis, 12, May 1956, pp. 194-199).

30. John McHale, "The Future and the Functions of Art: A Dialogue with Alvin Toffler," Art News, 72 (February 1973), p. 25.

31. Lawrence Alloway, in Class of '59, exh. cat. (Cambridge, Cambridge Union, 1959), unpaginated.

32. Leo Steinberg, "Other Criteria" in Other Criteria: Confrontations with Twentieth Century Art (New York, 1972), pp. 84, 85, 90, 91.

33. Ibid., p. 91.

34. Rosalind Krauss, "Rauschenberg and the Dematerialized Image," Artforum, 13 (December 1974), pp. 36-43.

35. Richard Hamilton, Collected Words: 1953-82 (London, 1983), p. 24. The images were gathered by Terry Hamilton and Magda Cordell from magazines brought back from America by John McHale.

36. Lawrence Alloway, "The Development of British Pop," in Pop Art, ed. Lucy R. Lippard (New York, 1966), p. 40.

37. See Living Arts, 2 (1963), for accounts of this show by the Archigram group that organized it. In his introduction, Peter Cook observes that "the architects of This Is Tomorrow have proved more versatile and able than those before them" (p. 69).

38. James Stirling, "Garches to Jaoul – Le Corbusier as Domestic Architect in 1927 and 1953," Architectural Review, 118 (September 1955), pp. 145-151 (quote from p. 151). The two complementary publications by Stirling are "Ronchamp," Architectural Review, 119 (March 1956), pp. 154-161, and "Regionalism and Modern Architecture," Architects' Yearbook, 8 (1957), pp. 62-68.

39. Peter Smithson, "The Idea of Architecture in the '50s," Architects' Journal, 131 (21 January 1960), p. 124.

40. See Christopher Mullen, "A Journey Around Nigel Henderson," in Nigel Henderson, exh. cat. (Norwich, England, Norwich School of Art Gallery, 1982), pp. 24 and 39, n. 43. Judith Henderson was Virginia Woolf's niece and part of the Bloomsbury milieu. Mullen notes that at Bryn Mawr she studied under Ruth Benedict and Margaret Mead.

41. Ibid., p. 39, note 43. The quotation is from Christopher Mullen's own thesis, but no reference is given in this catalogue.

42. Alison and Peter Smithson, Ordinariness and Light (Cambridge, Mass., 1970), p. 76.

43. See Uppercase 3, 1961, edited by Theo Crosby. The quotes are from captions to Henderson's photographs on the eighth page (unpaginated).

44. Geoffrey Holroyd, "Architecture Creating Relaxed Intensity," Architectural Design, 36 (September 1966), p. 30.

45. Ibid., p. 35.

46. Alison and Peter Smithson, The Shift (London, 1982), p. 28.

47. Reyner Banham, "A Throw-away Aesthetic", in Design By Choice, ed. Penny Sparke (New York, 1981), p. 92. See "Critical Writings."

48. Peter Smithson, "Letter to America," Architectural Design, 28 (March 1958), p. 97.

49. Architectural Review, 108 (December 1950), p. 341.

50. Architectural Review, 121 (May 1957), p. 293 (contents page).

51. Lawrence Alloway, "L'intervention du spectateur," Aujourd'hui: art et architecture, 5 (November 1955), p. 25.

52. Edgar Kaufmann, "Borax, or the Chromium-Plated Calf," Architectural Review, 104 (August 1948), pp. 88-92. Kaufmann, Director of Industrial Design at MOMA, attacked America's exploitation of the cliché associations of streamlining ("speed equals progress"). In "Counter-Borax," in the December 1948 Architectural Review, 104, pp. 300-303, the Review design editors (including Herbert Read) offer counter-examples of "good" American design, starting with Eames's molded plywood chairs and assailing American car styling as the paradigm of "borax" commercialism. In a letter in this same issue (p. 314), Kaufmann clarifies the meaning of "borax" (the "spurious eye-appeal" of "obviously heavy forms and elaborate jazzy ornament") and its origin: "The term originated in the furniture industry and by analogy is sometimes applied to kitchen appliances and more rarely to automobile design." The Review turned the American car into the new borax paradigm.

53. See Ordinariness and Light, pp. 24-48, esp. p. 43.

54. Reyner Banham, "The City as Scrambled Egg," Cambridge Opinion, 17 (1959), pp. 18-24.

55. Lawrence Alloway, "City Notes," Architectural Design, 29 (January 1959), pp. 34-35.

56. Charles Jencks, Modern Movements in Architecture (New York, 1973), pp. 247, 271. Reprinted from "Pop-Non Pop," Architectural Association Quarterly, 1 (Winter 1968-69), pp. 48-64, and (April 1969), pp. 56-74.

57. Robert Venturi and Denise Scott Brown, "Significance for A&P Parking Lots, or Learning from Las Vegas," Architectural Forum, 73 (March 1968), pp. 37-43.

58. Denise Scott Brown, "Team 10, Perspecta 10, and the Present State of Architectural Theory," Journal of the American Institute of Planners, 33 (January 1967), pp. 42-50. Quotation from p. 53. Regarding Philip Johnson's criticism of the "ugly and ordinary" Venturi-Scott Brown entry in the Brighton Beach Competition, see Robert Stern, New Directions in American Architecture, revised edition (N.Y., 1977), pp. 8-10.

59. Alison Smithson, "The Responsibility of Lutyens," Journal of the Royal Institute of British Architects, 76 (April 1969), p. 150.

60. Denise Scott Brown and Robert Venturi, "Learning from Lutyens: Reply to A. & P. Smithson," Journal of the Royal Institute of British Architects, 76 (August 1969), p. 354.

61. Reyner Banham, "Façade: Elevational Treatment of the Hallfield Estate Paddington," Architectural Review, 116 (November 1954), pp. 303-307. Moretti's Casa del Girasole, which influenced the façades of Venturi's Chestnut Hill house and Guild House, is featured in Banham's article, and praised for treating "the façade as an independent work of art."

62. Reyner Banham, "Towards a Pop Architecture," Architectural Review, 132 (July 1962). Reprinted in Design By Choice, ed. Penny Sparke (New York, 1981), p. 61.

63. Banham's position was already clear in 1952. See "Italian Eclectic," Architectural Review, 112 (October 1952), pp. 213-217. His influential attack on neohistoricism is "Neoliberty: The Italian Retreat from Modern Architecture," Architectural Review, 125 (April

1959), pp. 231-235. Toni del Renzio, who had long disagreed with Banham over these issues, defended the Italian rediscovery of Art Nouveau in 1960 ("Neo-Liberty," Architectural Design, September 1960). In After Modern Architecture (New York, 1980), Paolo Portoghesi blames the ruin of the Neoliberty movement on Banham's attack, claiming it "perfectly expresses the intolerant and dogmatic climate of the militant criticism of the Modern Movement" (p. 34).

64. Charles Jencks, The Language of Post-Modern Architecture (New York, 1981), third edition, p. 81 (Neoliberty), pp. 22-24 (Robin Hood Gardens). The first edition appeared in 1977.

65. Peter Cook, "The Smithsons: Time and Contemplation," Architectural Review, 176 (July 1982), pp. 36-43. See also Peter Cook, "Architecture Is On The Wing Again," Architectural Review, 180 (August 1986), pp. 1074-1077. In 1986 (p. 1074) Cook placed the Smithsons within the following genealogical sequence, based on "an attack upon space": the Constructivists in the 1920s, CIAM in the 1930s, the "audacities and battle cries" of the Smithsons in the 1950s, the "conscious audacity" of his own Archigram in the 1960s, and the "new spirit" of the deconstructionist architects (Zaha Hadid, Coop Himmelblau and Bernard Tschumi) in the 1980s.

66. This tendency, evident in early Duchamp as well as within the Soviet avant-garde, has an obvious relevance to studies of the Independent Group. An excellent symposium on the topic was held at the 1989 College Art Association meetings in San Francisco: "Americanisme: The Old World Discovers the New," chaired by Wanda M. Corn (16 February 1989).

67. Kenneth Frampton, "New Brutalism and the Welfare State: 1949-59," in Modern Dreams: The Rise and Fall and Rise of Pop (New York, 1988), pp. 49, 51.

68. As Fredric Jameson puts it, "we are within the culture of postmodernism" (i.e., consumer society), and "facile repudiation" is impossible. See Jameson, The Ideologies of Theory: Essays 1971-1986 (Minneapolis, 1988), vol. 2, p. 111. Hal Foster promotes a "postmodernism of resistance" in "Postmodernism: A Preface," in The Anti-Aesthetic: Essays on Postmodern Culture, ed. Hal Foster (Port Townsend, Wash., 1983), p. ix. Throughout the 1980s, Foster analyzed the works of "appropriation" artists of the late 1970s and 1980s as efforts to recode the commodified signifiers of the dominant culture, eventually concluding that the artists were inevitably caught up in the same fetishism of the signifier they were criticizing. (October critics such as Douglas Crimp came to the same conclusion.) See Foster, "Wild Signs: The Breakup of the Sign in Seventies' Art," in Universal Abandon? The Politics of Postmodernism, ed. Andrew Ross (Minneapolis, 1988), p. 264.

69. The goal of Derrida's rereading of Kant's third critique is to turn Kant's difficulties in separating art from the world inside out, by treating the boundary (parergon) as a catalyst of to-and-fro passage between work and world ("half work and half-outside-the-work"). Jacques Derrida, The Truth In Painting (Chicago 1987), p. 122. David Carroll gives an excellent account of the post-structuralists' "paraesthetic" logic in Paraesthetics: Foucault, Lyotard, Derrida (New York 1987). See especially pp. xiv and 143.

70. See John Fakete's introduction to The Structural Allegory: Reconstructive Encounters with the New French Thought, ed. John Fakete (Minneapolis, 1984), pp. xviii-xix. In his own essay, Fakete argues that the practical weaknesses of post-structuralist thinking return us to Wittgensteinian pluralism and "community-oriented American pragmatism," privileging the consumer rather than the producer of texts (p. 239). See also Richard Rorty, The Consequences of Pragmatism (Minneapolis, 1982). Rorty acknowledges the ethical motive behind his view of interpretation as the practice of "enlarging and deepening our sense of community," contrasting it with Foucault's notion of discourse as violence (pp. 205, 208).

Appendix:

Notes on the Independent Group Session of 1955

(Editor's note: The following account, almost certainly drawn up by John McHale, co-convener of the IG meetings in 1955, is the only contemporaneous record of IG discussions that has survived. It exists in mimeograph form in the archives of both Magda Cordell McHale and Alison and Peter Smithson. Three of the summaries below are identified as "speaker's abstracts." Thanks to this document, we have exact dates and attendance figures for the final series of IG meetings, which focused on popular culture.)

The Independent Group of the Institute of Contemporary Arts was formed in 1952 as a forum for the opinions of the younger members of the Institute (under 35). The Committee consists of Lawrence Alloway, Peter Reyner Banham, Richard Hamilton, John McHale, Eduardo Paolozzi, Toni del Renzio, Peter Smithson. Previously the I.G. had been convened by Reyner Banham to study techniques. In 1955 it was convened by Lawrence Alloway and John McHale for the purpose of investigating the relationship of the fine arts and popular art. The programme was not systematic but dependent on the current interests of the members who considered the I.G. as a trial ground for new ideas. From these closed meetings public lectures were subsequently developed.

11 February 1955
Paintings by Richard Hamilton. Discussion centered round the use of photographically defined new reality (with a stress on popular serial imagery) in a fine art context; its legitimacy and effectiveness in relation to paintings as individual gestures. Main speakers: Richard Hamilton, John McHale, Reyner Banham, Lawrence Alloway. (Attendance 14.)

4 March 1955
Borax, or the Thousand Horse-Power Mink, by Reyner Banham. Borax equals, in this context, current automobile styling. Its theme (vide two Plymouth ads) is Metal in Motion, by an iconography which refers to, e.g., sports and racing cars, aviation, science fiction; all relevant to the theme of transportation, but all exotic to the American automobile. Auxiliary iconographies postulate brutalism, oral symbols, and sex, emphasizing that Borax is popular art, as well as universal style (in U.S. not in Europe) and sex-iconography establishes the automobile's Dream rating—on the frontier of the dream that money can only just buy. (Speaker's abstract.) (Given as a public lecture, METAL IN MOTION, at the ICA on 7 July.) (Attendance 18.)

8 March 1955

Probability and Information Theory and Their Application to the Visual Arts, by E. W. Meyer. The statistical model devised by Shannon and others to explain the particular case of the transmission of information in an electrical communication network has proved eminently successful, but its introduction to the visual arts would appear difficult because of the hyperspherical dimensionality of the transmitter/medium-receiver complex. (Speaker's abstract.) (Extensive use made of visual aids; diagrams, epidiascope projection, black boar, gadgets.) (Attendance 22.)

15 April 1955

Advertising 1. A random, introspective survey of American advertisements with reference to the interplay of technology and social symbolism. Fantasy as a constant, topical presentation as a variable, received preliminary definition. Main speakers: Peter Smithson, Eduardo Paolozzi, John McHale, Lawrence Alloway. (Attendance 22.)

15 April 1955

Dadaists as Non-Aristotelians. The post-war dada revival has contradicted history of the movement. Dada as anti-absolutist and multi-valued, like advertising layouts, movies, etc. An attempt was made to connect dada with the Non-Aristotelian logic of provisional probabilities. Main speakers: John McHale, Anthony Hill, Donald Holmes, Toni del Renzio. (Attendance 14.)

Advertising 2. Sociology in the Popular Arts. Earlier attitudes to popular material criticised for aesthetic and moral prejudice. Intensive, multi-layered analysis of one advertisement as examplar of descriptive method with ''performance as referent.'' Main speakers: Lawrence Alloway, John McHale, Eduardo Paolozzi, Toni del Renzio. (Attendance 16.)

24 June 1955

Fashion and Fashion Magazines, by Toni del Renzio. Fashion is one of the popular arts peculiar to the age of technology. If its changes are not as rapid and as thorough as some mass-media communications would indicate, nonetheless its changes contribute and correspond to the changing conceptual image of woman. Audrey Hepburn is a typical symbol caught in the rival and co-operative coding processes of the cinema and the other mass media – other-directed antagonistic co-operation. (Speaker's abstract) (Attendance 16.)

1 July 1955

Aesthetics and Italian Product Design. Discussion between Gillo Dorfles and Reyner Banham. Dorfles represented topical Italian ideas about the complex relationship of industrial design to traditional aesthetics. He proposed an external standard of taste by which both objects of fine art and objects of good ''non-art'' could be judged. (Attendance 20.)

15 July 1955

Gold Pan Alley by Frank Cordell. The popular song as one of the arts that has emerged from the seminal interaction of technology and mass communications. Millions of pounds are spent annually by music, radio, and recording industries in producing and selling this product and its pervasive power is such that hardly any group or individual in the Western world can remain untouched by its manifestations. A study of commercial music in its producer-consumer relationships provides a revealing index of certain cultural and sociological emphases in the contemporary situation. (Attendance 14.)

249

BIBLIOGRAPHY
A note on its organization

This is a large but nonetheless selective bibliography. It is organized in two sections. Section one contains separate bibliographies for each of the major Independent Group members, arranged chronologically. Works by each author are separated from works about that person. Section two is a general bibliography of publications pertaining to this exhibition on the IG but not listed in the separate author sections. This is arranged alphabetically.

—D.R. and G.W.

1. BIBLIOGRAPHIES FOR INDEPENDENT GROUP MEMBERS

LAWRENCE ALLOWAY

WORKS BY:

"ICA Gallery" (Max Ernst). *Art News and Review*, 4 (27 December 1952), p. 4.

Nine Abstract Artists. London, 1954.

"Britain's New Iron Age" (Paolozzi and Turnbull). *Art News*, 52 (June 1953), pp. 18-20, 68-70.

"A Decline in Klee?" *Art News and Review*, 5 (9 January 1954), p. 4.

"Realism, Ruins and Frenchmen" (places McHale with Constructivists). *Art News*, 53 (June 1954), p. 33, 69.

"Re Vision" (Hamilton show). *Art News and Review*, 6 (22 January 1955), p. 5.

"Art News from London" (*Man, Machine and Motion*). *Art News*, 54 (May 1955), pp. 11, 65.

"L'Intervention du spectateur" (McHale's constructions as viewer-participative). *Aujourd'hui: art et architecture*, 5 (November 1955), pp. 24-26.

Introduction. *John McHale: Collages*. Exhibition catalogue. London, ICA, 1956.

Foreword. *Magda Cordell*. Exhibition catalogue. London, Hanover Gallery, 1956.

"Introduction to Action" (Abstract Expressionism at the Tate Gallery show, *Modern Art in the U.S.*). *Architectural Design*, 26 (January 1956), p. 30.

"London: Figures by Paolozzi." *Art News*, 54 (February 1956), p. 57.

"Quick Symbols" (graphic design and contemporary symbolism). *Encounter*, 6 (March 1956), pp. 93-94.

"Eduardo Paolozzi." *Architectural Design*, 26 (April 1956), p. 133.

"Sculptor-Painter" (Turnbull). *Architectural Design*, 26 (May 1956), p. 171.

"Geigy" (graphic design and contemporary symbolism). *Graphis*, 12 (May 1956), pp. 194-199, 271.

"Pasmore Constructs a Relief." *Art News*, 55 (June 1956), pp. 32-35, 55-56.

"Eames' World" (Charles Eames). *Architectural Association Journal*, 72 (July-August 1956), pp. 54-55.

"Battle Painter" (Georges Mathieu). *Architectural Design*, 26 (August 1956), p. 266.

"Technology and Sex in Science Fiction: A Note on Cover Art." *Ark*, 17 (Summer 1956), pp. 19-23.

Introduction. *This Is Tomorrow*. Exhibition catalogue. London, Whitechapel Art Gallery, 1956, unpaginated. Reprinted as "Design as a Human Activity" in *Architectural Design*, 26 (September 1956), p. 302.

"London: Beyond Painting and Sculpture" (review of *This Is Tomorrow*). *Art News*, 55 (September 1956), pp. 38, 64.

"The Robot and the Arts." *Art News and Review*, 8 (1 September 1956), pp. 1, 6.

"Dada 1956." *Architectural Design*, 26 (November 1956), p. 374.

Introduction. *an Exhibit*. Exhibition catalogue. London, ICA, 1957, unpaginated.

Introduction. *New Trends in British Art*. Rome, 1957, pp. 11, 14-15.

"Vorticism Unzipped or the Angular Plots of Wyndham Lewis." *Architectural Design*, 27 (January 1957), p. 28.

"Sculpture as Walls and Playground" (Turnbull). *Architectural Design*, 27 (January 1957), p. 26.

"Personal Statement." *Ark*, 19 (March 1957), pp. 28-29.

"an Exhibit." *Architectural Design*, 27 (August 1957), pp. 288-289.

"Communication Comedy and the Small World" (television comedy). *Ark*, 20 (Autumn 1957), pp. 41-43.

"The Arts and the Mass Media" (first published use of "Pop Art" term; answers Clement Greenberg's attack on popular culture). *Architectural Design*, 28 (February 1958), pp. 84-85.

"Symbols Wanting" (lack of effective symbols in British commercial design). *Design*, 113 (May 1958), pp. 23-27.

"Real Places." *Architectural Design*, 28 (June 1958), pp. 249-250.

"The Long Front of Culture" (fine art-popular art continuum). *Cambridge Opinion*, 17 (1959), pp. 25-26. Reprinted in *Pop Art Redefined*, ed. John Russell and Suzi Gablik (New York, 1969), pp. 41-43.

Class of '59. (Commentary on joint exhibition of Magda Cordell, John McHale, and Eduardo Paolozzi.) Exhibition catalogue. Cambridge, Cambridge Union, 1959, unpaginated.

"City Notes" (urban vitality vs. architects). *Architectural Design*, 29 (January 1959), pp. 34-35.

"Notes on Abstract Art and the Mass Media." *Art News and Review*, 12 (February 1960), pp. 3-12.

"Looking at the Martins" (Kenneth and Mary Martin). *Architectural Design*, 30 (June 1960), pp. 212-213.

"Paolozzi and the Comedy of Waste." *Cimaise*, 5 (October/December 1960), pp. 114-123.

"Notes on Sculpture: Venice Biennale 1960" (includes Paolozzi). *Architectural Design*, 30 (November 1960), pp. 479-480.

"Artists as Consumers" (the fine art-popular art continuum, Richard Hamilton and Richard Smith). *Image* (Cambridge), 3 (1961), pp. 14-19.

"Junk Culture" (modern art and urban objects). *Architectural Design*, 31 (March 1961), pp. 122-123.

"Pop Art Since 1949" (prehistory of English Pop Art). *Listener*, 68 (27 December 1962), pp. 1085-1087.

The Metallization of a Dream (with Eduardo Paolozzi). London, 1963.

"Jumping Objects" (U.S. Pop Art). *Architectural Design*, 33 (April 1963), pp. 192-193.

"Metal Man" (Eduardo Paolozzi). *Motif*, 11 (Winter 1963/1964), p. 2.

"The Development of British Pop." In *Pop Art*, ed. Lucy R. Lippard, New York, 1966, pp. 27-68.

Introduction (includes review of Art Brut in the 1950s). *Jean Dubuffet 1962-66*. Exhibition catalogue. New York, Guggenheim Museum, 1966, pp. 15-20.

"Pop Art: The Words" (three-stage history of Pop Art). *Auction*, 1 (February 1968), pp. 7-9. Reprinted in Lawrence Alloway, *Topics in American Art Since 1945*, New York, 1975, pp. 119-122.

"Popular Culture and Pop Art." *Studio International*, 178 (July/August 1969), pp. 17-21.

American Pop Art. Exhibition catalogue. New York, Whitney Museum of American Art, 1974.

Topics in American Art Since 1945. New York, 1975.

Network: Art in the Complex Present. Ann Arbor, 1984.

"Comments on John McHale." In *The Expendable Ikon: Works by John McHale*. Exhibition catalogue. Buffalo, Albright-Knox Art Gallery, 1984, pp. 31-35.

WORKS ABOUT:

Banham, Reyner. "Alloway and After." *Architects' Journal*, 126 (26 December 1957), pp. 941-943.

Reinish, James. "An Interview with Lawrence Alloway." *Studio International*, 186 (September 1973), p. 62.

Auping, Michael. "Field Notes: An Interview." In *Abstract Expressionism*. Exhibition catalogue. Buffalo, Albright-Knox Art Gallery, 1987, pp. 124-135.

REYNER BANHAM

WORKS BY:

("DBC" *indicates article is reprinted in* Design By Choice, *ed. Penny Sparke, New York, 1981.*)

"The Shape of Things: . . .'Take Courage'" (commercial design). *Art News and Review*, 2 (27 January 1951), p. 6.

"The Shape of Things: Packaging." *Art News and Review*, 3 (24 February 1951), p. 6.

"The Shape of Everything" (*Growth and Form* show). *Art News and Review*, 3 (14 July 1951) p. 2.

"Man and his Objects" (Paolozzi and Turnbull). *Art News and Review*, 3 (12 January 1952), p. 5.

"The Next Step" (Turnbull). *Art News and Review*, 3 (24 January 1952), p. 5.

"Review of Recent Trends in Realist Painting at the ICA." *Art News and Review*, 4 (12 July 1952), p. 5.

"Royal Institute Galleries" (petrol stations as facade architecture). *Art News and Review*, 4 (23 August 1952), p.4.

"Italian Eclectic." *Architectural Review*, 112 (October 1952), pp. 213-217.

"Review of Picture Fair at the ICA." Art News and Review, 4 (13 December 1952), p. 2.

"The Head." Art News and Review, 5 (21 March 1953), p. 5.

"Corbusier at the ICA." Art News and Review, 5 (2 May 1953), p. 2.

"Painting and Sculpture of Le Corbusier." Architectural Review, 113 (June 1953), pp. 401-404.

"ICA Dover Street. Collectors' Items from Artists' Studios" (Hamilton, Paolozzi, Turnbull). Art News and Review, 5 (22 August 1953), p. 4.

"Photography: Parallel of Life and Art." Architectural Review, 114 (October 1953), pp. 259-261.

"On Abstract Theory." Art News and Review, 5 (28 November 1953), p. 3.

"Paul Klee." Art News and Review, 5 (28 November 1953), p. 7.

"Klee's 'Pedagogical Sketchbook.'" Encounter, 2 (April 1954), pp. 53-58.

"Object Lesson" (relativity in perception). Architectural Review, 115 (June 1954), pp. 403-406.

"Collages at the ICA." Art News and Review, 6 (30 October 1954), p. 8.

"Vision in Motion" (Hamilton show). Art (London), 1 (5 January 1955), p. 3.

"Machine Aesthetic." Architectural Review, 117 (April 1955), pp. 225-228. (DBC, pp. 44-47.)

"Man, Machine and Motion." Architectural Review, 118 (July 1955), pp. 51-53.

"Vehicles of Desire," Art (London), 1 (September 1955), p. 3. Reprinted in Modern Dreams: The Rise and Fall and Rise of Pop, New York, 1988, pp. 65-69.

"Industrial Design e arte popolare." Civiltà delle Macchine, 6 (November/December 1955), pp. 12-15.

"The New Brutalism" (defines the Brutalist aesthetic to connect the Smithsons' architecture with art of other IG members). Architectural Review, 118 (December 1955), pp. 355-361.

"New Look at Cruiserweights" (motorcycles). Ark, 16 (March 1956), pp. 44-47.

"Things to Come" (The Smithsons' House of the Future). Design, 90 (June 1956), pp. 24-28.

"Marriage of Two Minds," Introduction 2. This Is Tomorrow. Exhibition catalogue. London, Whitechapel Art Gallery, 1956, unpaginated.

"Not Quite Architecture, Not Quite Painting or Sculpture Either" (This Is Tomorrow). Architects' Journal, 124 (16 August 1956), pp. 217-221.

"This Is Tomorrow: Synthesis of the Major Arts." Architectural Review, 120 (September 1956), pp. 186-188.

"Futurism and Modern Architecture." Journal of the Royal Institute of British Architects, 64 (February 1957), pp. 129-135.

"Alloway and After." The Architects' Journal, 126 (26 December 1957), pp. 941-943.

"Top Pop Boffin" (Frank Cordell). Architects' Journal, 127 (20 February 1958), pp. 269-271.

"Space, Fiction and Architecture" (science fiction as an aid to architecture). Architects' Journal, 127 (17 April 1958), pp. 557-559.

"Ideal Interiors" (Hamilton's gallery for a collector). Architectural Review, 123 (March 1958), pp. 207-208.

"The City as Scrambled Egg" (defense of conurbation trend). Cambridge Opinion, 17 (1959), pp. 18-24.

"Neo-Liberty: the Italian Retreat from Modern Architecture" (attacks historicist use of early modernist styles). Architectural Review, 125 (April 1959), pp. 231-235.

"Industrial Design and Popular Art." Industrial Design, 7 (March 1960), pp. 61-65. (English version of "Industrial Design e arte popolare," published 1955, above. In DBC as "A Throw-Away Aesthetic," pp. 90-94.)

Theory and Design in the First Machine Age. London, 1960.

"The Atavism of the Short-Distance Mini-Cyclist." Living Arts, 3 (1963), pp. 91, 97. (DBC, pp. 84-89.)

"John McHale: Transition." Magda Cordell/John McHale. Exhibition catalogue. London, ICA, 1961, unpaginated.

"Design by Choice 1951-61: An Alphabetical Chronicle of Landmarks and Influences." Architectural Review, 130 (July 1961), pp. 43-48. (DBC, pp. 97-107.)

"Apropos the Smithsons." New Statesman, 62 (8 September 1961), pp. 317-318.

"Towards a Pop Architecture." Architectural Review, 132 (July 1962), pp. 43-46. (DBC, pp. 61-63.)

"Who Is This Pop?" (cultural background to Pop Art). Motif, 10 (Winter 1962-63), pp. 3-13. (DBC, pp. 94-97.)

"Department of Visual Uproar" (RCA graphic design department). New Statesman, 65 (3 May 1963), p. 687.

"A Home is Not a House." Art in America, 53 (April 1965), pp. 70-77.

"Pop and the Body Critical" (review of books on Pop Art). New Society, 168 (16 December 1965), p. 25.

The New Brutalism: Ethic or Aesthetic? London, 1966.

"The Bauhaus Gospel" (autobiographical sketch of critical relation to Bauhaus pedagogy). Listener, 80 (26 September 1968), pp. 390-392.

"Representations in Protest" (Hamilton). New Society, 13 (8 May 1969), pp. 717-718.

"The Gutenberg Backlash" (on Pop Art Redefined show, Hayward Gallery). New Society, 14 (10 July 1969), p. 63.

"The Style: 'Flimsy. . . Effeminate'?" In A Tonic to the Nation: The Festival of Britain, ed. Mary Banham and Bevis Hillier. London, 1976, pp. 190-198.

Design by Choice. Edited by Penny Sparke. London, 1981.

"Comments on John McHale." In The Expendable Ikon: Works by John McHale. Exhibition catalogue. Buffalo, Albright-Knox Art Gallery, 1984, pp. 37-43.

WORKS ABOUT:

Sparke, Penny. Introduction. Design By Choice. London, 1981, pp. 8-18.

"Peter Reyner Banham" (recollections by Peter Cook, J. M. Richards, and John Hewish). Architectural Review, 183 (May 1988), pp. 9-10.

Del Renzio, Toni. "Peter Reyner Banham," Art Monthly, 116 (May 1988), p. 23.

Sparke, Penny. "Obituary: Peter Reyner Banham 1922-1988," Journal of Design History, 1 (1988), p. 141.

FRANK CORDELL

WORKS BY:

"Gold Pan Alley—A Survey of the Popular Song Field." Ark, 19 (March 1957), pp. 20-23.

MAGDA CORDELL

WORKS ABOUT:

Alloway, Lawrence. Foreword. Magda Cordell Paintings. Exhibition catalogue. London, Hanover Gallery, 1956, unpaginated.

Freeman, Robert. "The Human Image." Lady Clare: A Review (Clare College, Cambridge University), 44 (June 1959), pp. 6-9.

Fuller, Buckminster. "Magda Cordell Presences." In Magda Cordell/John McHale. Exhibition catalogue. London, ICA, 1961.

"Magda Cordell" (review of the Hanover Gallery show). Architectural Design, 26 (January 1956), p. 30.

"Magda Cordell." Uppercase, 1 (1958), unpaginated.

RICHARD HAMILTON

WORKS BY:

("CW" indicates item is reprinted in Richard Hamilton, Collected Words 1953-1982, London, 1982).

Introduction, with Lawrence Gowing. Man, Machine and Motion. Exhibition catalogue. London, ICA, 1955, unpaginated. (CW, pp. 19-20.)

"Acrylic Environment. Exhibit. Composed of Suspended Acrylic Panels at King's College, Newcastle." Art News, 56 (September 1957), p. 16.

"Hommage à Chrysler Corp." (analysis of the painting). Architectural Design, 28 (March 1958), pp. 120-121. (CW, pp. 31-32.)

"Towards a Typographical Rendering of the Green Box." Uppercase, 2 (1959), unpaginated.

Typographic Version of the Bride Stripped Bare by Her Bachelors, Even. London, 1960.

"Persuading Image" (defense of commercial design profession). Design, 134 (February 1960), pp. 28-32. (CW, pp. 135-143.)

"Popular Culture and Personal Responsibility" (defense of mass culture). Lecture given to National Union of Teachers 28 October 1960. (CW, pp. 150-156.)

"For the Finest Art Try—POP." Gazette, 1 (1961). (CW, pp. 42-43.)

"FOB + 10." Design, 149 (May 1961), p. 42. (CW, pp. 147-148.)

"Statement on Glorious Techniculture." Architectural Design, 31 (November 1961), p. 497.

"About Art Teaching, Basically." Motif, 8 (Winter 1961), pp. 17-23. (CW, pp. 176-178.)

"An Exposition of $he" (analysis of use of sources in the painting). Architectural Design, 32 (October 1962), pp. 485-486. (CW, pp. 35-39.)

"Urbane Image" (analysis of mass-media iconography). Living Arts, 2 (1963), pp. 44-59. (CW, pp. 49-53.)

"Text and Illustrations on the Commissioned Theme of Incidence and Selection of Images Experienced in Daily Life." Ark, 34 (Summer 1963), pp. 4, 14-16, 24-26, 34, 37.

"Duchamp." Art International, 7 (16 January 1964), pp. 22-28.

"Interview with Eduardo Paolozzi." Arts Magazine Yearbook, 8 (1965), pp. 160-163.

"Photography and Painting." *Studio International*, 177 (March 1969), pp. 120-125.

"Prints, Multiples and Drawings." In *Prints, Multiples and Drawings*. Exhibition catalogue. Manchester, England, Whitworth Art Gallery, 1972, pp. 9-11.

Collected Words 1953-1982. London, 1982.

"Comments on John McHale." In *The Expendable Ikon: Works by John McHale*. Exhibition catalogue. Buffalo, Albright-Knox Art Gallery, 1984, pp. 45-47.

WORKS ABOUT:

Banham, Reyner. "Vision in Motion" (Hanover Gallery show). *Art* (London), 1 (5 January 1955), p. 3.

Alloway, Lawrence. "Re Vision" (Hanover Gallery show). *Art News and Review*, 6 (22 January 1955), p. 5.

_____. "Pop Art Since 1949." *Listener*, 68 (27 December 1962), pp. 1085-1087.

Spencer, Charles. "Richard Hamilton; Painter of 'Being Today'." *Studio International*, 168 (October 1964), pp. 176-181.

"Son of the Bride Stripped Bare" (interview with Mario Amaya). *Art and Artists*, 1 (July 1966), pp. 22-28.

McNay, M. G. "Big Daddy of Pop." *Manchester Guardian*, 25 July 1966, p. 7.

Finch, Christopher. "Richard Hamilton." *Art International*, 10 (August 1966), pp. 16-23.

Banham, Reyner. "Representations in Protest." *New Society*, 13 (8 May 1969), pp. 717-718.

Morphet, Richard. Introduction and commentary. In *Richard Hamilton*. Exhibition catalogue. London, Tate Gallery, 1970, pp. 16-41.

Kennedy, R. C. "Richard Hamilton Visited." *Art and Artists*, 4 (March 1970), pp. 20-23.

Field, Richard. *The Prints of Richard Hamilton*. Exhibition catalogue. Middletown, Connecticut, Davison Art Center, Wesleyan University, 1973.

Renzio, Toni del. "Slipping It To Us – Richard Hamilton in den 50er und 60er Jahren." In *Richard Hamilton Studies-Studien, 1937-1977*. Exhibition catalogue. Bielefeld, Kunsthalle Bielefeld, 1978, pp. 79-98.

Waddington Galleries. *Richard Hamilton: Prints: A Complete Catalogue of Graphic Work, 1939-83*. Exhibition catalogue. London, Waddington Galleries, 1984.

NIGEL HENDERSON

WORKS BY:

"Memories of London." *Uppercase*, 3 (1961), unpaginated.

Introduction. *Nigel Henderson: Photographs of Bethnal Green 1958-52*. Exhibition catalogue. (Includes selections from Judith Henderson's journals.) Newcastle, Side Gallery, 1978.

"Heads Eye Wyn 1977-80" and "Speculations about Self rather than Self Portraiture 1980-81." In *Heads Eye Wyn: Nigel Henderson*. Exhibition catalogue. Norwich, England, Norwich School of Art Gallery, 1982, pp. 5-21.

WORKS ABOUT:

Nigel Henderson: Paintings, Collages and Photographs. Exhibition catalogue with essay by Anne Seymour. Anthony d'Offay Gallery, London, 1977.

Mullen, Christopher. "A Journey around Nigel Henderson" and "Facing up to It." In *Heads Eye Wyn: Nigel Henderson*. Exhibition catalogue. Norwich, England, Norwich School of Art Gallery, 1982, pp. 22-37.

GEOFFREY HOLROYD

WORKS BY:

"F. H. K. Henrion." *Architectural Design*, 30 (May 1960), pp. 266-267.

"Architecture Creating Relaxed Intensity" (Charles Eames). *Architectural Design*, 36 (September 1966), pp. 558-571.

"Charles Eames and Eliel Saarinen." *Journal of the Royal Institute of British Architects*, 86 (January 1979), pp. 29-30.

JOHN McHALE

WORKS BY:

"Gropius and the Bauhaus." *Art* (London), 1 (3 March 1955), p. 3.

"Josef Albers." *Architectural Design*, 26 (June 1956), p. 205.

"Technology and the Home." *Ark*, 19 (March 1957), pp. 25-27.

"Marginalia." *Architectural Review*, 121 (May 1957), pp. 291-292.

"McHale, Statement." *Three Collagists*. Exhibition catalogue. London, ICA, 1958.

"The Fine Arts in the Mass Media." *Cambridge Opinion*, 17 (1959), pp. 29-32. Reprinted in *Pop Art Redefined*, ed. John Russell and Suzi Gablik, New York, 1969, pp. 53-57.

"The Expendable Ikon." Parts 1, 2. *Architectural Design*, 29 (February, March 1959), pp. 82-83, 116-117. Reprinted in *The Expendable Ikon: Works by John McHale*, exhibition catalogue, Buffalo, Albright-Knox Art Gallery, 1985, pp. 19-25.

"Universal Requirements. Check List – Buckminster Fuller." *Architectural Design*, 30 (March 1960), pp. 101-110.

"Richard Buckminster Fuller." *Architectural Design*, 31 (July 1961), pp. 290-319.

"2000 +." *Architectural Design*, 37 (February 1967), pp. 65-95.

"The Plastic Parthenon." *Dotzero Magazine*, 3 (Spring 1967). Reprinted in *Pop Art Redefined*, ed. John Russell and Suzi Gablik, New York, 1969, pp. 57-53.

With Alvin Toffler. "The Future and the Functions of Art: A Conversation Between Alvin Toffler and John McHale." *Art News*, 72 (February 1973), pp. 25-28.

WORKS ABOUT:

Alloway, Lawrence. "L'Intervention du spectateur." *Aujourd'hui: art et architecture*, 5 (November 1955), pp. 25-26.

_____. Introduction. *John McHale: Collages*. Exhibition catalogue. London, ICA, 1956, unpaginated.

"Note on John McHale's Exhibition of Collages at the ICA." *Architectural Design*, 27 (January 1957), p. 28.

"John McHale." *Uppercase*, 1 (1958, edited by Theo Crosby), unpaginated.

Freeman, Robert. "The Human Image." *Lady Clare: A Review* (Clare College, Cambridge University), 44 (June 1959), pp. 6-9.

Banham, Reyner. "John McHale: Transition." In *Magda Cordell/John McHale*. Exhibition catalogue. London, ICA, 1961, unpaginated.

Commentaries by Alloway, Lawrence, Reyner Banham, and Richard Hamilton. In *The Expendable Ikon: Works by John McHale*. Exhibition catalogue. Buffalo, Albright-Knox Art Gallery, 1985, pp. 31-57.

EDUARDO PAOLOZZI

WORKS BY:

"Notes from a Lecture at the Institute of Contemporary Arts, 1958." *Uppercase*, 1 (1958), unpaginated.

"Metamorphosis of Rubbish – Mr. Paolozzi Explains his Process." *Times* (London), 2 May 1958.

Statement. In Peter Selz, ed., *New Images of Man*. Exhibition catalogue. New York, Museum of Modern Art, 1959, p. 117.

"Primitive Art: Paris and London." In *Lost Magic Kingdoms and six paper moons from Nahuatl*. Exhibition catalogue. London, British Museum, 1985, pp. 9-11.

"Sculpture and the 20th Century Condition." *Art and Design*, 3 (November/December 1987), pp. 77-81.

WORKS ABOUT:

Banham, Reyner. "Man and His Objects." *Art News and Review*, 3 (12 January 1952), p. 5.

Alloway, Lawrence. "Britain's New Iron Age." *Art News*, 52 (June 1953), pp. 18-20, 68-70.

Del Renzio, Toni. "Portrait of the Artist No. 120." *Art News and Review*, 5 (5 September 1953), pp. 1, 7.

Alloway, Lawrence. "London: Figures by Paolozzi." *Art News*, 55 (February 1956), p. 57.

_____. "Eduardo Paolozzi." *Architectural Design*, 26 (April 1956), p. 133.

"Paolozzi: Colossi at the Hanover Gallery." *Art News*, 57 (December 1958), p. 65.

Melville, Robert. "Eduardo Paolozzi." *Motif*, 2 (February 1959), pp. 61-69.

_____. "London: Paolozzi as Writer and Craftless Sculptor." *Arts Magazine*, 33 (February 1959), p. 15.

Roditi, Edward. "Interview with Eduardo Paolozzi." *Arts Magazine*, 33 (May 1959), pp. 52-58.

Melville, Robert. "Eduardo Paolozzi." *Oeil*, 65 (May 1960), pp. 58-63.

Alloway, Lawrence. "Paolozzi and the Comedy of Waste." *Cimaise*, 5 (October/December 1960), pp. 115-123.

_____. *The Metallization of a Dream*. London, 1963.

Reichardt, Jasia. "Eduardo Paolozzi." *Studio International*, 168 (October 1965), pp. 152-157.

Hamilton, Richard. "Interview with Eduardo Paolozzi." *Arts Magazine Yearbook*, 8 (1965), pp. 160-163.

Kirkpatrick, Diane. *Eduardo Paolozzi*. New York, 1969.

Schneede, Uwe M. *Eduardo Paolozzi*. London, 1970.

Whitford, Frank. *Eduardo Paolozzi*. Exhibition catalogue. London, Tate Gallery, 1971.

Hyman, Timothy. "Paolozzi: Barbarian and Mandarin." *Artscribe*, 8 (September 1977), pp. 35-38.

Konnertz, Winifred. *Eduardo Paolozzi*. Cologne, 1985.

Spencer, Robin. *Eduardo Paolozzi: Recurring Themes*. Exhibition catalogue. Edinburgh, Royal Scottish Academy and New York, 1985.

McLeod, Malcolm. "Paolozzi and Identity." In *Lost Magic Kingdoms and six paper moons from Nahuatl*. Exhibition catalogue. London, British Museum, 1985, pp. 15-58.

Ades, Dawn. "Paolozzi, Surrealism, Ethnography." In *Lost Magic Kingdoms and six paper moons from Nahuatl*. Exhibition catalogue. London, British Museum, 1985, pp. 61-65.

Thomas Lawson. "Bunk: Eduardo Paolozzi and the Legacy of the Independent Group." In *Modern Dreams: The Rise and Fall and Rise of Pop*. New York, 1988, pp. 19-28

TONI DEL RENZIO

WORKS BY:

"Is There a British Art?" (critique of *20th Century Form* show, with tribute to Smithsons' Coventry Cathedral). *Art News and Review*, 5 (18 April 1953), p. 2.

"Portrait of the Artist No. 120" (Paolozzi). *Art News and Review*, 5 (5 September 1953), pp. 1, 7.

"Neutral Technology – Loaded Ideology" (review of *Man, Machine and Motion*). *Art News and Review*, 7 (13 July 1955), p. 3.

"Shoes, Hair and Coffee" (new design in coffee shops as popular culture). *Ark*, 20 (Autumn 1957), pp. 27-30.

"After a Fashion." *ICA Publications*, 2 (1958).

"Neo-Liberty" (defends rediscovery of Art Nouveau). *Architectural Design*, 30 (September 1960), pp. 375-376.

"Multiple Authenticity" (IG use of the print produces a new aesthetic). *Art and Artists*, 9 (July 1975), pp. 22-27.

"Art & or Language" (continuity of avant-garde concern with language; Hamilton). *Art and Artists*, 10 (December 1975), pp. 10-13.

"Style, Technique and Iconography" (recalls IG's interest in America as not uncritical). *Art and Artists*, 11 (July 1976), pp. 35-39.

"Pop" (review of Schneede's *Pop Art in England* show, emphasizing the range and dissonances of IG theorizing). *Art and Artists*, 11 (August 1976), pp. 15-19.

"Slipping It to Us – Richard Hamilton in den 50er und 60er Jahren." In *Richard Hamilton Studies-Studien, 1937-1977*. Exhibition catalogue. Bielefeld, Kunsthalle Bielefeld, 1978, pp. 79-98.

"Ideology and the Production of Meaning." *Block*, 5 (1981), pp. 57-60.

"Pioneers and Trendies" (IG recollections). *Art and Artists*, 18 (February 1985), pp. 25-28.

ALISON AND PETER SMITHSON

WORKS BY:

"The New Brutalism." *Architectural Review*, 115 (April 1954), pp. 274-275.

"School at Hunstanton" (with comments by Philip Johnson). *Architectural Review*, 116 (September 1954), pp. 148-163.

"Collective Housing in Morocco." *Architectural Design*, 25 (January 1955), pp. 2-8.

"The Built World: Urban Reidentification." *Architectural Design*, 25 (June 1955), pp. 185-188.

"The Background to CIAM 10." *Architectural Design*, 25 (September 1955), p. 286.

"House of the Future at the Ideal Home Exhibition." *Architectural Design*, 26 (March 1956), pp. 101-102.

"Alternative to the Garden City Idea." *Architectural Design*, 26 (July 1956), pp. 229-231.

"Whither CIAM?" (report on CIAM 10). *Architectural Design*, 26 (October 1956), p. 343.

"But Today We Collect Ads." *Ark*, 18 (November 1956), pp. 49-52.

"The New Brutalism" (brief answer to criticisms in "Thoughts in Progress" section). *Architectural Design*, 27 (April 1957), p. 113.

"Aesthetics of Change." *Architects' Yearbook*, 8 (1957), pp. 14-22.

"Cluster City: A New Shape for the Community." *Architectural Review*, 122 (November 1957), pp. 333-336.

"The Appliance House." *Design*, 113 (May 1958), pp. 43-47.

"House at Watford, Herts" (Sugden House). *Architectural Design*, 28 (June 1958), p. 240.

"Scatter." *Architectural Design*, 29 (April 1959), pp. 149-150.

"Louis Kahn." *Architects' Yearbook*, 9 (1960), pp. 102-118.

"The Function of Architecture in Cultures-in-Change." *Architectural Design*, 30 (April 1960), pp. 49-50.

Review of Banham's *The New Brutalism*, *Architects' Journal*, 144 (December 28, 1966), pp. 1590-1591.

Urban Structuring. London, 1967.

Ordinariness and Light: Urban Theories 1952-1960. Cambridge, Massachusetts, 1970.

Without Rhetoric: An Architectural Aesthetic 1955-1972. Cambridge, Massachusetts, 1973.

The Shift. London, 1982.

ALISON AND PETER SMITHSON

WORKS ABOUT:

"Hunstanton Secondary Modern School." *Architectural Design*, 23 (September 1953), pp. 238-248.

Banham, Reyner. "The New Brutalism." *Architectural Review*, 118 (December 1955), pp. 355-361.

"This is a House?" (House of the Future). *Mechanix Illustrated*, 5 (September 1956), pp. 61-63.

"Thoughts in Progress: The New Brutalism" (editorial dialogue on Hunstanton and Banham's 1955 "New Brutalism" article). *Architectural Design*, 27 (April 1957), pp. 111-114.

"Alison and Peter Smithson." *Uppercase*, 3 (1961), unpaginated. (Special issue on the work of the Smithsons, including Nigel Henderson's Bethnal Green photographs. With introduction by Theo Crosby.)

"Apropos the Smithsons." *New Statesman*, 62 (8 September 1961), pp. 317-318.

Banham, Reyner. *The New Brutalism: Ethic or Aesthetic?* London, 1966.

Scott Brown, Denise. "Team 10, Perspecta 10, and the Present State of Architectural Theory." *Journal of the American Institute of Planners*, 33 (January 1967), pp. 42-50.

Cook, Peter. "Regarding the Smithsons." *Architectural Review*, 172 (July 1982), pp. 36-43.

Frampton, Kenneth. "New Brutalism and the Welfare State." In *Modern Dreams: The Rise and Fall and Rise of Pop*. New York, 1988, pp. 46-56.

ALISON SMITHSON

WORKS BY:

"And Now Dhamas are Dying Out in Japan" (on Charles Eames). *Architectural Design*, 36 (September 1956), pp. 16-18.

"Caravan – Embryo 'Appliance House'?" *Architectural Design*, 29 (August 1959), p. 348.

"CIAM Team 10." *Architectural Design*, 30 (May 1960), pp. 175-188.

Portrait of the Female Mind as a Young Girl. London, 1966.

PETER SMITHSON

WORKS BY:

"Just a Few Chairs and a House: An Essay on the Eames Aesthetic." *Architectural Design*, 36 (September 1956), pp. 12-15.

"Letter to America." *Architectural Design*, 28 (March 1958), pp. 93-97, 102.

"The Idea of Architecture in the '50s." *Architects' Journal*, 131 (21 January 1960), pp. 121-126.

"A Parallel of the Orders: An Essay on the Doric." *Architectural Design*, 36 (November 1966), pp. 557-563.

JAMES STIRLING

WORKS BY:

"Garches to Jaoul – Le Corbusier as Domestic Architect in 1927 and 1953." *Architectural Review*, 118 (September 1955), pp. 145-151.

"Ronchamp." *Architectural Review*, 119 (March 1956), pp. 154-161.

"Regionalism and Modern Architecture." *Architects' Yearbook*, 8 (1957), pp. 62-68.

WORKS ABOUT:

Jacobus, John. "Introduction." *James Stirling: Buildings and Projects 1950-1974*. New York and Oxford, 1975, pp. 14-24.

Rowe, Colin. "James Stirling: A Highly Personal and Very Disjointed Memoir." *James Stirling: Buildings and Projects*, ed. Peter Arnoll and Ted Bickford. New York, 1984, pp. 10-27.

WILLIAM TURNBULL

WORKS BY:

"Statements 1949-60." *Uppercase*, 4 (1960), unpaginated.
"Images Without Temples." *Living Arts*, 1 (1963), pp. 15-27.

WORKS ABOUT:

Banham, Reyner. "The Next Step." *Art News and Review*, 3 (24 January 1952), p. 5.
Alloway, Lawrence. "Sculptor-Painter." *Architectural Design*, 26 (May 1956), p. 171.
_____. "Sculpture as Walls and Playground." *Architectural Design*, 27 (January 1957), p. 26.
"Note on William Turnbull's Exhibition at the ICA." *Architectural Design*, 27 (November 1957), p. 428.
Alloway, Lawrence. "Marks and Signs." *Ark*, 22 (1958), pp. 37-41.
Reichardt, Jasia. "Bill Turnbull at the Moulton Gallery." *Apollo*, 72 (August 1960).
Sausmarez, Maurice de. "William Turnbull Talks to Maurice de Sausmarez." *Motif*, 8 (Winter 1961).
Morphet, Richard. Introduction and Commentary. *William Turnbull: Sculpture and Painting.* Exhibition catalogue. London, Tate Gallery, 1973, pp. 9-68.
Bevan, Roger. "William Turnbull." In *William Turnbull: Sculptures 1946-62, 1985-87.* London, Waddington Galleries, 1987, pp. 6-9.

2. GENERAL BIBLIOGRAPHY

Adcock, Craig. "Dada Cyborgs and the Imagery of Science Fiction." *Arts Magazine*, 58 (October 1983), pp. 66-71.
Amaya, Mario. *Pop as Art. A Survey of the New Super Realism.* London, 1965.
an Exhibit. Exhibition Catalogue, ICA, London, 1957.
Astragal. (Discussion at the ICA on Sigfried Giedion's *Walter Gropius*.) *Architects' Journal*, 121 (27 January 1955), p. 117.
Ayer, A. J., et al., eds. *Studies in Communication.* London, 1955.
Banham, Mary and Bevis Hillier, eds. *A Tonic to the Nation. The Festival of Britain, 1951.* London, 1976.
Black Eyes and Lemonade. Exhibition catalogue. Introduction by Barbara Jones. Exhibition organized by Barbara Jones and Tom Ingram. Whitechapel Art Gallery, London, 1951.
Blake, John. "Space for Decoration." *Design*, 77 (May 1955), pp. 9-23.
Bogdanov, Vernon and Herbert Skidelsky, eds. *The Age of Affluence 1951-64.* London, 1970.
Booker, Christopher. *The Neophiliacs. A Study of the Revolution in English Life in the Fifties and Sixties.* London, 1969.

Boyd, Robin. "The Sad End of New Brutalism." *Architectural Review*, 142 (July 1967), pp. 9-11.
Chambers, Iain. *Popular Culture: The Metropolitan Experience.* New York, 1986.
Cherry, Colin. *On Human Communication.* London, 1957.
_____. "Communication and the Growth of Societies." *Cambridge Opinion*, 17 (1959), pp. 11-12.
Coleman, Roger. "...And on the Shady." *Ark*, 18 (November 1956), pp. 55-56.
_____. "Dream Worlds Assorted." *Ark*, 19 (March 1957), pp. 30-32.
_____. "One of the Family." *Ark*, 20 (Autumn 1957), pp. 39-40.
_____. "Two Painters – Robyn Denny and Richard Smith." *Ark*, 20 (Autumn 1957), pp. 23-26.
Colquhoun, Alan. "Symbolic and Literal Aspects of Technology." *Architectural Design*, 32 (November 1962), pp. 508-509.
Compton, Michael. *Pop Art.* London, 1970.
Compton, Susan. "Pop Art – New Figuration." In *British Art in the 20th Century*, ed. Susan Compton. Munich, 1986, pp. 340-341.
Condesse, Gerard. "The Impact of American Science Fiction." In *Europe in Superculture: American Popular Culture and Europe*, ed. C. W. E. Bigsby and Paul Elex. London, 1975.
Cook, Peter. "Introduction: Our Belief in the City as a Unique Organism Underlies the Whole Project." *Living Arts*, 2 (1963), pp. 68-71.
"Counter Borax." *Architectural Review*, 104 (December 1948), pp. 300-303.
Crosby, Theo. "This Is Tomorrow: An exhibition at the Whitechapel Art Gallery." *Architectural Design*, 26 (September 1956), p. 302.
_____. "This Is Tomorrow." *Architectural Design*, 26 (October 1956), pp. 334-336.
_____. "A Slight Case of Aesthetic Control." *Architectural Design*, 27 (April 1957), pp. 119-120.
_____. "International Union of Architects Congress Building, South Bank, London." *Architectural Design*, 31 (November 1961), pp. 484-509.
_____. "Editorial." *Living Arts*, 1 (1963), p. 1.
Deighton, Len. "Impressions of New York." *Ark*, 13 (March 1955), pp. 33-35.
Finch, Christopher. *Image as Language: Aspects of British Art 1950-1968.* London, 1969.
Fletcher, Alan. "Letter from America." *Ark*, 19 (March 1957), pp. 36-39.
Freeman, Robert. "Living with the 60's." *Cambridge Opinion*, 17 (1959), pp. 7-8.
Giedion, Sigfried. *Mechanization Takes Command.* New York, 1948.
Glaser, Bruce. "Three British Artists in New York." *Studio International*, 170 (November 1965), pp. 178-183.
Growth and Form. Exhibition catalogue. Foreword by Herbert Read. (Exhibition organized and designed by Richard Hamilton.) ICA, London, 1951.
Gutkind, E. A. *Our World from the Air.* London, 1952.
Hall, Stuart and Paddy Whannel. *The Popular Arts.* London, 1964.

Harrison, Charles. *English Art and Modernism 1900-39.* London, 1981.
Hebdige, Dick. *Subculture: The Meaning of Style.* London, 1979.
_____. "Towards a Cartography of Taste, 1935-1962." *Block*, 4 (1981), pp. 35-56.
_____. "Object as Image: The Halian Scooter Cycle." *Block*, 5 (1981), pp. 44-46.
_____. "In Poor Taste. Notes on Pop." *Block*, 8 (1983), pp. 54-68.
Henri, Adrian. *Environments and Happenings.* London, 1974.
Hewison, Robert. *In Anger: Culture in the Cold War 1945-60.* London, 1981.
Hodge, John. "Collage." *Ark*, 17 (Summer 1956), p. 24.
Hodin, J. P. "International News and Correspondence: England." *Journal of Aesthetics*, 12 (December 1953), pp. 278-282.
Hoggart, Richard. *The Uses of Literacy.* London, 1957.
Jacob, Jürgen. *Die Entwicklung der Pop Art in England . . . von ihren Anfängen bis 1957 – Das Fine-Popular Art Continuum.* Frankfurt, 1986.
Jencks, Charles. "Pop-Non Pop." *Architectural Association Quarterly*, 1 (January 1969), pp. 48-64 (part 1) and (April 1969), pp. 56-74 (part 2). Reprinted as chapter 7 in *Modern Movements in Architecture*, New York, 1973.
Jones, Barbara. *The Unsophisticated Arts.* London, 1951.
Karpinski, Peter. "The Independent Group 1952-1955, and the Relationship of the Independent Group's Discussions to the Work of Hamilton, Paolozzi, and Turnbull 1952-1957." B.A. dissertation, Leeds University, 1977.
Kaufman, Edgar, Jr. "Borax, or the Chromium-plated Calf." *Architectural Review*, 104 (August 1948), pp. 88-93.
Kepes, Gyorgy. *The Language of Vision.* Chicago, 1944.
_____. *The New Landscape in Art and Science.* Chicago, 1956.
Korzybsky, Alfred. *Science and Sanity: An Introduction to Non-Aristotelian Systems and General Semantics.* Third ed. Lakeville, Connecticut, 1948.
Kozloff, Max. "Pop Culture, Metaphysical Disgust and the New Vulgarians." *Art International*, 6 (February 1962), pp. 34-36.
Lasdun, Denys. "MARS Group 1953-1957." *Architects Yearbook* 8 (1957), pp. 57-61.
Le Corbusier. *The City of Tomorrow.* 1921. Reprint, London, 1971.
_____. *The Modulor.* 1948. Reprint, London, 1954.
Levy, Mervin. "Pop Art for Admass." *Studio*, 161 (November 1963), pp. 184-189.
Lewis, Adrian. "British Avant-Garde Painting 1945-56." Parts 1-3. *Artscribe*, 34 (June 1982), pp. 17-31; 35 (July 1982), pp. 16-31; 36 (August 1982), pp. 14-27.
Lippard, Lucy R., ed. *Pop Art.* New York, 1966.
Lynch, Kevin. "The Form of Cities" ("cluster" concept). *Scientific American*, 190 (April 1954), pp. 55-63.
McLuhan, Marshall. *The Mechanical Bride: Folklore of Industrial Man.* New York, 1951.
Man, Machine and Motion. Exhibition catalogue. Introduction by Richard Hamilton and Lawrence Gowing, text by Reyner Banham; designed by Andrew Froshaug. ICA, London. 1955.

Whitford, Frank. *Eduardo Paolozzi*. Exhibition catalogue. London, Tate Gallery, 1971.

Hyman, Timothy. "Paolozzi: Barbarian and Mandarin." *Artscribe*, 8 (September 1977), pp. 35-38.

Konnertz, Winifred. *Eduardo Paolozzi*. Cologne, 1985.

Spencer, Robin. *Eduardo Paolozzi: Recurring Themes*. Exhibition catalogue. Edinburgh, Royal Scottish Academy and New York, 1985.

McLeod, Malcolm. "Paolozzi and Identity." In *Lost Magic Kingdoms and six paper moons from Nahuatl*. Exhibition catalogue. London, British Museum, 1985, pp. 15-58.

Ades, Dawn. "Paolozzi, Surrealism, Ethnography." In *Lost Magic Kingdoms and six paper moons from Nahuatl*. Exhibition catalogue. London, British Museum, 1985, pp. 61-65.

Thomas Lawson. "Bunk: Eduardo Paolozzi and the Legacy of the Independent Group." In *Modern Dreams: The Rise and Fall and Rise of Pop*. New York, 1988, pp. 19-28

TONI DEL RENZIO

WORKS BY:

"Is There a British Art?" (critique of *20th Century Form* show, with tribute to Smithsons' Coventry Cathedral). *Art News and Review*, 5 (18 April 1953), p. 2.

"Portrait of the Artist No. 120" (Paolozzi). *Art News and Review*, 5 (5 September 1953), pp. 1, 7.

"Neutral Technology – Loaded Ideology" (review of *Man, Machine and Motion*). *Art News and Review*, 7 (13 July 1955), p. 3.

"Shoes, Hair and Coffee" (new design in coffee shops as popular culture). *Ark*, 20 (Autumn 1957), pp. 27-30.

"After a Fashion." *ICA Publications*, 2 (1958).

"Neo-Liberty" (defends rediscovery of Art Nouveau). *Architectural Design*, 30 (September 1960), pp. 375-376.

"Multiple Authenticity" (IG use of the print produces a new aesthetic). *Art and Artists*, 9 (July 1975), pp. 22-27.

"Art & or Language" (continuity of avant-garde concern with language; Hamilton). *Art and Artists*, 10 (December 1975), pp. 10-13.

"Style, Technique and Iconography" (recalls IG's interest in America as not uncritical). *Art and Artists*, 11 (July 1976), pp. 35-39.

"Pop" (review of Schneede's *Pop Art in England* show, emphasizing the range and dissonances of IG theorizing). *Art and Artists*, 11 (August 1976), pp. 15-19.

"Slipping It to Us – Richard Hamilton in den 50er und 60er Jahren." In *Richard Hamilton Studies-Studien, 1937-1977*. Exhibition catalogue. Bielefeld, Kunsthalle Bielefeld, 1978, pp. 79-98.

"Ideology and the Production of Meaning." *Block*, 5 (1981), pp. 57-60.

"Pioneers and Trendies" (IG recollections). *Art and Artists*, 18 (February 1985), pp. 25-28.

ALISON AND PETER SMITHSON

WORKS BY:

"The New Brutalism." *Architectural Review*, 115 (April 1954), pp. 274-275.

"School at Hunstanton" (with comments by Philip Johnson). *Architectural Review*, 116 (September 1954), pp. 148-163.

"Collective Housing in Morocco." *Architectural Design*, 25 (January 1955), pp. 2-8.

"The Built World: Urban Reidentification." *Architectural Design*, 25 (June 1955), pp. 185-188.

"The Background to CIAM 10." *Architectural Design*, 25 (September 1955), p. 286.

"House of the Future at the Ideal Home Exhibition." *Architectural Design*, 26 (March 1956), pp. 101-102.

"Alternative to the Garden City Idea." *Architectural Design*, 26 (July 1956), pp. 229-231.

"Whither CIAM?" (report on CIAM 10). *Architectural Design*, 26 (October 1956), p. 343.

"But Today We Collect Ads." *Ark*, 18 (November 1956), pp. 49-52.

"The New Brutalism" (brief answer to criticisms in "Thoughts in Progress" section). *Architectural Design*, 27 (April 1957), p. 113.

"Aesthetics of Change." *Architects' Yearbook*, 8 (1957), pp. 14-22.

"Cluster City: A New Shape for the Community." *Architectural Review*, 122 (November 1957), pp. 333-336.

"The Appliance House." *Design*, 113 (May 1958), pp. 43-47.

"House at Watford, Herts" (Sugden House). *Architectural Design*, 28 (June 1958), p. 240.

"Scatter." *Architectural Design*, 29 (April 1959), pp. 149-150.

"Louis Kahn." *Architects' Yearbook*, 9 (1960), pp. 102-118.

"The Function of Architecture in Cultures-in-Change." *Architectural Design*, 30 (April 1960), pp. 49-50.

Review of Banham's *The New Brutalism*, *Architects' Journal*, 144 (December 28, 1966), pp. 1590-1591.

Urban Structuring. London, 1967.

Ordinariness and Light: Urban Theories 1952-1960. Cambridge, Massachusetts, 1970.

Without Rhetoric: An Architectural Aesthetic 1955-1972. Cambridge, Massachusetts, 1973.

The Shift. London, 1982.

ALISON AND PETER SMITHSON

WORKS ABOUT:

"Hunstanton Secondary Modern School." *Architectural Design*, 23 (September 1953), pp. 238-248.

Banham, Reyner. "The New Brutalism." *Architectural Review*, 118 (December 1955), pp. 355-361.

"This is a House?" (House of the Future). *Mechanix Illustrated*, 5 (September 1956), pp. 61-63.

"Thoughts in Progress: The New Brutalism" (editorial dialogue on Hunstanton and Banham's 1955 "New Brutalism" article). *Architectural Design*, 27 (April 1957), pp. 111-114.

"Alison and Peter Smithson." *Uppercase*, 3 (1961), unpaginated. (Special issue on the work of the Smithsons, including Nigel Henderson's Bethnal Green photographs. With introduction by Theo Crosby.)

"Apropos the Smithsons." *New Statesman*, 62 (8 September 1961), pp. 317-318.

Banham, Reyner. *The New Brutalism: Ethic or Aesthetic?* London, 1966.

Scott Brown, Denise. "Team 10, Perspecta 10, and the Present State of Architectural Theory." *Journal of the American Institute of Planners*, 33 (January 1967), pp. 42-50.

Cook, Peter. "Regarding the Smithsons." *Architectural Review*, 172 (July 1982), pp. 36-43.

Frampton, Kenneth. "New Brutalism and the Welfare State." In *Modern Dreams: The Rise and Fall and Rise of Pop*. New York, 1988, pp. 46-56.

ALISON SMITHSON

WORKS BY:

"And Now Dhamas are Dying Out in Japan" (on Charles Eames). *Architectural Design*, 36 (September 1956), pp. 16-18.

"Caravan – Embryo 'Appliance House'?" *Architectural Design*, 29 (August 1959), p. 348.

"CIAM Team 10." *Architectural Design*, 30 (May 1960), pp. 175-188.

Portrait of the Female Mind as a Young Girl. London, 1966.

PETER SMITHSON

WORKS BY:

"Just a Few Chairs and a House: An Essay on the Eames Aesthetic." *Architectural Design*, 36 (September 1956), pp. 12-15.

"Letter to America." *Architectural Design*, 28 (March 1958), pp. 93-97, 102.

"The Idea of Architecture in the '50s." *Architects' Journal*, 131 (21 January 1960), pp. 121-126.

"A Parallel of the Orders: An Essay on the Doric." *Architectural Design*, 36 (November 1966), pp. 557-563.

JAMES STIRLING

WORKS BY:

"Garches to Jaoul – Le Corbusier as Domestic Architect in 1927 and 1953." *Architectural Review*, 118 (September 1955), pp. 145-151.

"Ronchamp." *Architectural Review*, 119 (March 1956), pp. 154-161.

"Regionalism and Modern Architecture." *Architects' Yearbook*, 8 (1957), pp. 62-68.

WORKS ABOUT:

Jacobus, John. "Introduction." *James Stirling: Buildings and Projects 1950-1974*. New York and Oxford, 1975, pp. 14-24.

253

254

Rowe, Colin. "James Stirling: A Highly Personal and Very
Disjointed Memoir." *James Stirling: Buildings and Projects*,
ed. Peter Arnoll and Ted Bickford. New York, 1984,
pp. 10-27.

WILLIAM TURNBULL

WORKS BY:
"Statements 1949-60." *Uppercase*, 4 (1960), unpaginated.
"Images Without Temples." *Living Arts*, 1 (1963), pp. 15-27.

WORKS ABOUT:
Banham, Reyner. "The Next Step." *Art News and Review*, 3 (24
January 1952), p. 5.
Alloway, Lawrence. "Sculptor-Painter." *Architectural Design*, 26
(May 1956), p. 171.
_____. "Sculpture as Walls and Playground." *Architec-
tural Design*, 27 (January 1957), p. 26.
"Note on William Turnbull's Exhibition at the ICA." *Architec-
tural Design*, 27 (November 1957), p. 428.
Alloway, Lawrence. "Marks and Signs." *Ark*, 22 (1958),
pp. 37-41.
Reichardt, Jasia. "Bill Turnbull at the Moulton Gallery."
Apollo, 72 (August 1960).
Sausmarez, Maurice de. "William Turnbull Talks to Maurice
de Sausmarez." *Motif*, 8 (Winter 1961).
Morphet, Richard. Introduction and Commentary. *William
Turnbull: Sculpture and Painting*. Exhibition catalogue. Lon-
don, Tate Gallery, 1973, pp. 9-68.
Bevan, Roger. "William Turnbull." In *William Turnbull: Sculp-
tures 1946-62, 1985-87*. London, Waddington Galleries,
1987, pp. 6-9.

2. GENERAL BIBLIOGRAPHY

Adcock, Craig. "Dada Cyborgs and the Imagery of Science
Fiction." *Arts Magazine*, 58 (October 1983), pp. 66-71.
Amaya, Mario. *Pop as Art. A Survey of the New Super Realism*.
London, 1965.
an Exhibit. Exhibition Catalogue, ICA, London, 1957.
Astragal. (Discussion at the ICA on Sigfried Giedion's *Walter
Gropius*.) *Architects' Journal*, 121 (27 January 1955), p. 117.
Ayer, A. J., et al., eds. *Studies in Communication*. London, 1955.
Banham, Mary and Bevis Hillier, eds. *A Tonic to the Nation.
The Festival of Britain, 1951*. London, 1976.
Black Eyes and Lemonade. Exhibition catalogue. Introduction
by Barbara Jones. Exhibition organized by Barbara
Jones and Tom Ingram. Whitechapel Art Gallery, Lon-
don, 1951.
Blake, John. "Space for Decoration." *Design*, 77 (May 1955),
pp. 9-23.
Bogdanov, Vernon and Herbert Skidelsky, eds. *The Age of
Affluence 1951-64*. London, 1970.
Booker, Christopher. *The Neophiliacs. A Study of the Revolution in
English Life in the Fifties and Sixties*. London, 1969.

Boyd, Robin. "The Sad End of New Brutalism." *Architectural
Review*, 142 (July 1967), pp. 9-11.
Chambers, Iain. *Popular Culture: The Metropolitan Experience*.
New York, 1986.
Cherry, Colin. *On Human Communication*. London, 1957.
_____. "Communication and the Growth of Soci-
eties." *Cambridge Opinion*, 17 (1959), pp. 11-12.
Coleman, Roger. "...And on the Shady." *Ark*, 18 (November
1956), pp. 55-56.
_____. "Dream Worlds Assorted." *Ark*, 19 (March
1957), pp. 30-32.
_____. "One of the Family." *Ark*, 20 (Autumn 1957),
pp. 39-40.
_____. "Two Painters – Robyn Denny and Richard
Smith." *Ark*, 20 (Autumn 1957), pp. 23-26.
Colquhoun, Alan. "Symbolic and Literal Aspects of Tech-
nology." *Architectural Design*, 32 (November 1962),
pp. 508-509.
Compton, Michael. *Pop Art*. London, 1970.
Compton, Susan. "Pop Art – New Figuration." In *British Art
in the 20th Century*, ed. Susan Compton. Munich, 1986,
pp. 340-341.
Condesse, Gerard. "The Impact of American Science Fic-
tion." In *Europe in Superculture: American Popular Culture and
Europe*, ed. C. W. E. Bigsby and Paul Elex. London, 1975.
Cook, Peter. "Introduction: Our Belief in the City as a
Unique Organism Underlies the Whole Project." *Living
Arts*, 2 (1963), pp. 68-71.
"Counter Borax." *Architectural Review*, 104 (December 1948),
pp. 300-303.
Crosby, Theo. "This Is Tomorrow: An exhibition at the
Whitechapel Art Gallery." *Architectural Design*, 26 (Sep-
tember 1956), p. 302.
_____. "This Is Tomorrow." *Architectural Design*, 26
(October 1956), pp. 334-336.
_____. "A Slight Case of Aesthetic Control." *Architec-
tural Design*, 27 (April 1957), pp. 119-120.
_____. "International Union of Architects Congress
Building, South Bank, London." *Architectural Design*, 31
(November 1961), pp. 484-509.
_____. "Editorial." *Living Arts*, 1 (1963), p. 1.
Deighton, Len. "Impressions of New York." *Ark*, 13 (March
1955), pp. 33-35.
Finch, Christopher. *Image as Language: Aspects of British Art
1950-1968*. London, 1969.
Fletcher, Alan. "Letter from America." *Ark*, 19 (March 1957),
pp. 36-39.
Freeman, Robert. "Living with the 60's." *Cambridge Opinion*,
17 (1959), pp. 7-8.
Giedion, Sigfried. *Mechanization Takes Command*. New York,
1948.
Glaser, Bruce. "Three British Artists in New York." *Studio
International*, 170 (November 1965), pp. 178-183.
Growth and Form. Exhibition catalogue. Foreword by Herbert
Read. (Exhibition organized and designed by Richard
Hamilton.) ICA, London, 1951.
Gutkind, E. A. *Our World from the Air*. London, 1952.
Hall, Stuart and Paddy Whannel. *The Popular Arts*. London,
1964.

Harrison, Charles. *English Art and Modernism 1900-39*. London,
1981.
Hebdige, Dick. *Subculture: The Meaning of Style*. London, 1979.
_____. "Towards a Cartography of Taste, 1935-1962."
Block, 4 (1981), pp. 35-56.
_____. "Object as Image: The Halian Scooter Cycle."
Block, 5 (1981), pp. 44-46.
_____. "In Poor Taste. Notes on Pop." *Block*, 8 (1983),
pp. 54-68.
Henri, Adrian. *Environments and Happenings*. London, 1974.
Hewison, Robert. *In Anger: Culture in the Cold War 1945-60*.
London, 1981.
Hodge, John. "Collage." *Ark*, 17 (Summer 1956), p. 24.
Hodin, J. P. "International News and Correspondence:
England." *Journal of Aesthetics*, 12 (December 1953),
pp. 278-282.
Hoggart, Richard. *The Uses of Literacy*. London, 1957.
Jacob, Jürgen. *Die Entwicklung der Pop Art in England . . . von
ihren Anfängen bis 1957 – Das Fine-Popular Art Continuum*.
Frankfurt, 1986.
Jencks, Charles. "Pop-Non Pop." *Architectural Association Quar-
terly*, 1 (January 1969), pp. 48-64 (part 1) and (April 1969),
pp. 56-74 (part 2). Reprinted as chapter 7 in *Modern
Movements in Architecture*, New York, 1973.
Jones, Barbara. *The Unsophisticated Arts*. London, 1951.
Karpinski, Peter. "The Independent Group 1952-1955, and
the Relationship of the Independent Group's Discus-
sions to the Work of Hamilton, Paolozzi, and Turnbull
1952-1957." B.A. dissertation, Leeds University, 1977.
Kaufman, Edgar, Jr. "Borax, or the Chromium-plated Calf."
Architectural Review, 104 (August 1948), pp. 88-93.
Kepes, Gyorgy. *The Language of Vision*. Chicago, 1944.
_____. *The New Landscape in Art and Science*. Chicago,
1956.
Korzybsky, Alfred. *Science and Sanity: An Introduction to Non-
Aristotelian Systems and General Semantics*. Third ed. Lake-
ville, Connecticut, 1948.
Kozloff, Max. "Pop Culture, Metaphysical Disgust and the
New Vulgarians." *Art International*, 6 (February 1962),
pp. 34-36.
Lasdun, Denys. "MARS Group 1953-1957." *Architects Yearbook*
8 (1957), pp. 57- 61.
Le Corbusier. *The City of Tomorrow*. 1921. Reprint, London,
1971.
_____. *The Modulor*. 1948. Reprint, London, 1954.
Levy, Mervin. "Pop Art for Admass." *Studio*, 161 (November
1963), pp. 184-189.
Lewis, Adrian. "British Avant-Garde Painting 1945-56." Parts
1-3. *Artscribe*, 34 (June 1982), pp. 17-31; 35 (July 1982),
pp. 16-31; 36 (August 1982), pp. 14-27.
Lippard, Lucy R., ed. *Pop Art*. New York, 1966.
Lynch, Kevin. "The Form of Cities" ("cluster" concept).
Scientific American, 190 (April 1954), pp. 55-63.
McLuhan, Marshall. *The Mechanical Bride: Folklore of Industrial
Man*. New York, 1951.
Man, Machine and Motion. Exhibition catalogue. Introduction
by Richard Hamilton and Lawrence Gowing, text by
Reyner Banham; designed by Andrew Froshaug. ICA,
London. 1955.

Marwick, Arthur. *British Society Since 1945*. Harmondsworth, 1982.

Massey, Anne. "Cold War Culture and the ICA." *Art and Artists*, 213 (June 1984), pp. 15-17.

——————. "The Independent Group and Modernism in Britain 1951-56." *Association of Art Historians Bulletin* (July 1984), pp. 23-24.

——————. "The Independent Group as Design Theorists." In *From Spitfire to Microchip*. London, 1985, pp. 54-57.

——————. "The Independent Group: Toward a Redefinition." *Burlington Magazine*, 129 (April 1987), pp. 232-242.

Massey, Anne, and Penny Sparke. "The Myth of the Independent Group." *Block*, 10 (1985), pp. 48-56.

Meller, James. "Don't Knock the Rock." *Cambridge Opinion*, 17 (1959), pp. 33-35.

Melly, George. *Revolt into Style. The Pop Arts in Britain*. Harmondsworth, 1972.

Melville, Robert. "Exhibitions of the Institute and Notes on New Premises at Dover Street." *Studio*, 141 (April 1951), pp. 97-103.

——————. "Action Painting: New York, Paris, London." *Ark*, 18 (November 1956), pp. 30-33.

——————. "English Pop Art." *Quadrum*, 17 (1964), pp. 23-38.

Minsky, Marvin, ed. *Robotics*. Garden City, New York, 1985.

Moholy-Nagy, Laszlo. *The New Vision*. London, 1939.

——————. *Vision in Motion*. Chicago, 1947.

Morgenstern, Oskar, and John von Neumann. *The Theory of Games and Economic Behavior*. Princeton, 1953.

Myers, Bernard S. "The Inclined Plane. An Essay on Form and Flight." *Ark*, 18 (November 1956), pp. 34-42.

Myers, Bernard S., and Gordon Moore. "Americana." *Ark*, 19 (March 1957), pp. 16-19.

Newby, Frank. "The Work of Charles Eames." *Architectural Design*, 24 (February 1954), pp. 31-35.

——————. "Structural Engineering in the United States." *Architectural Design*, 24 (April 1954), pp. 106-111.

Ozenfant, Amédée. *Foundations of Modern Art*. 1928. Trans. John Rodker, New York, 1952.

Penrose, Roland. *Scrapbook 1900-1981*. London, 1981.

Pop Art in England. Beginnings of a New Figuration, 1947-1963. (Also shown at York City Art Gallery.) Exhibition catalogue. Essays by Uwe M. Schneede and Frank Whitford. Kunstverein, Hamburg, 1976.

Proktor, Patrick. "Techniculture." *New Statesman*, 68 (6 November 1964), p. 710.

Reichardt, Jasia. "Pop Art and After." *Art International*, 7 (February 1963), pp. 42-47.

Russell, John, and Suzi Gablik, eds. *Pop Art Redefined*. London, 1969.

Shannon, Claude E., and Warren Weaver. *The Mathematical Theory of Communication*. Urbana, 1949.

Sissons, Michael, and Philip French, eds. *The Age of Austerity 1945-51*. Harmondsworth, 1964.

Smith, Richard. "Ideograms." *Ark*, 16 (Spring 1956), pp. 52-56.

——————. "Film Backgrounds: 1. The City: On the Sunny Side of the Street." *Ark*, 18 (November 1956), p. 54.

——————. "Film Backgrounds: 2. At Home: Sitting in the Middle of Today." *Ark*, 19 (March 1957), pp. 13-15.

——————. "Man and He-Man." *Ark*, 20 (Autumn 1957), pp. 12-16.

——————. "Trailer: Notes additional to a Film." *Living Arts*, 1 (1963), pp. 28-35.

Tapié, Michel. *Un Art autre*. Paris, 1952.

This Is Tomorrow. Exhibition catalogue. Introductions by Lawrence Alloway, David Lewis, and Reyner Banham; designed by Edward Wright. Exhibition organized by Theo Crosby. Whitechapel Art Gallery, London, 1956.

This is Tomorrow Today. The Independent Group and British Pop Art. Exhibition catalogue. Clocktower Gallery, Institute for Art and Urban Resources, 1987. Reprinted in *Modern Dreams: The Rise and Fall and Rise of Pop*. New York, 1988.

Thistlewood, David. *A Continuing Process: The New Creativity in British Art Education*. London, 1981.

——————. "Organic Art and the Popularization of a Scientific Philosophy." *British Journal of Aesthetics*, 22 (Autumn 1982), pp. 311-321.

——————. "Creativity and Political Identification in the Work of Herbert Read." *British Journal of Aesthetics*, 26 (Autumn 1986), pp. 345-356.

Thompson, Michael. *Rubbish Theory. The Creation and Destruction of Value*. Oxford, 1979.

Tomorrow's Furniture. Exhibition catalogue. Essay by Toni del Renzio. Exhibition designed by Toni del Renzio. ICA, London, 1952.

Tucker, Albert W., and Herbert S. Bailey, Jr. "Topology." *Scientific American*, 182 (January 1950), pp. 18-31.

Voelcker, John, with Ruth Olitsky. "Form and Mathematics." *Architectural Design*, 24 (October 1954), pp. 306-307.

Voelcker, John. "CIAM 10, Dubrovnik 1956." *Architects' Yearbook*, 8 (1957), pp. 43-52.

Walker, John. *Art Since Pop*. Woodbury, New York, 1978.

——————. *Art in the Age of Mass Media*. London, 1983.

Wallis, Brian, et al., eds. *Modern Dreams: The Rise and Fall and Rise of Pop*. New York, 1988.

Weaver, Warren. "The Mathematics of Communication." *Scientific American*, 181 (July 1949), pp. 11-15.

Whiteley, Nigel. *Pop Design. Modernism to Mod*. London, 1987.

——————. "Arenas for Performance" (interior design developments from the House of the Future to the 1960s). *Art History*, 10 (March 1987), pp. 79-90.

Whitham, Graham. "The Independent Group at the Institute of Contemporary Arts: Its Origins, Development and Influences 1951-1961." Ph.D. dissertation, University of Kent at Canterbury, 1986.

Whyte, Lancelot Law, ed. *Aspects of Form: A Symposium on Form in Nature and Art*. London, 1951.

Wiener, Norbert. *The Human Use of Human Beings: Cybernetics and Society*. Boston, 1950.

Williams, Raymond. *The Long Revolution*. London, 1961.

Wilson, Simon. *Pop Art*. London, 1974.

Wright, Edward. "Writing and Environment." *Architectural Design*, 26 (December 1956), pp. 339-342.

FILMS AND BROADCASTS ABOUT THE INDEPENDENT GROUP

Arts Council of Great Britain, London. *Fathers of Pop (The Independent Group)*. Film by Reyner Banham and Julian Cooper. Color, forty minutes. 1979.

BBC. "Artists as Consumers: The Splendid Bargain." In the series Art - Anti-Art. Broadcast on BBC Radio, March 1960. Produced by Leonie Cohn.

BBC. "Richard Hamilton: Interviewed by Andrew Forge." Produced by Leonie Cohen. Broadcast on BBC Radio 5 April 1965 on the program New Comment.

BBC. "The Obsessive Image." Interview with Richard Hamilton, Allen Jones, Christopher Finch and Anne Seymour. Produced by Leonie Cohn. Recorded 3 May 1968 and broadcast 15 May 1968 on the Third Programme.

Open University. "The Independent Group: The Impact of American Pop Culture in the Fifties." Talk by Richard Hamilton. Broadcast by BBC Radio for the Open University 351 course.

ACKNOWLEDGMENTS AND CREDITS

*Photographs of works borrowed for this exhibition have been supplied
by their owners or custodians. We are also indebted to the individuals
and organizations named below for permission to reproduce materials
in this catalogue (photographs unless otherwise specified). A page
number without clarification refers to all illustrations on that page.*

Lawrence Alloway collection: 22 (L.A.), Sylvia Sleigh; 31,
Terry Hamilton; 43, Barratis Press, Ltd.; 163, Anthony
Hill.

Architects' Journal, London: 36 (Group Two), photo from
April 30, 1956 (p. 62).

Architectural Design Magazine, London: texts of "Hommage à
Chrysler" by Richard Hamilton (March 1958: 120-121)
and "The New Brutalism" by Alison and Peter
Smithson (April 1957: 274-275); excerpts from "Dada
1956" by Lawrence Alloway (Nov. 1956: 374), "City
Notes" by Lawrence Alloway (Jan. 1959: 34-35), and
"The Arts and the Mass Media" by Lawrence Alloway
(Feb. 1958: 84- 85). Photos from Oct. 1956 (pp. 335 and
336) of groups five and ten, respectively: 148, 144.

Architectural Review, London: excerpts from a review of *Paral-
lel of Life and Art* by Reyner Banham (with accompanying
illustration, Oct. 1953: 259-261), "The New Brutalism"
by Reyner Banham (Dec. 1955: 355-361), and "Towards
a Pop Architecture" by Reyner Banham (July 1962:
43-46). Photo of Sugden House by William J. Toomey,
111; cover of October 1953 issue, 128.

Art and Artists, London: excerpts from "Pioneers and
Trendies" by Toni del Renzio (Feb. 1984: 25-28).

Art News and Review, London: excerpts from "Notes on
Abstract Art and the Mass Media" by Lawrence Alloway
(Feb. 1960: 3, 12).

Mary Banham collection: 40 (P. R. Banham), Pictorial Ser-
vices, Pettswood, Kent; 40 (M. Banham), P. R. Banham.

Ben Blackwell: 59, 128 (cover).

Cambridge Opinion, Cambridge University: excerpts from
"The Long Front of Culture" by Lawrence Alloway (17,
1959: 41-43) and "The Fine Arts in the Mass Media" (17,
1959: 29-32).

Theo Crosby: posters from *This Is Tomorrow*, 122; text of
"Notes from a Lecture at the Institute of Contemporary
Arts, 1958" by Eduardo Paolozzi, *Uppercase* 1 (1958).

Davis Publications: covers of *Astounding Science Fiction* for
November 1953 and February 1951.

Design (London): 222 ("contemporary film set," August
1952); excerpts from "Persuading Image" by Richard
Hamilton (Feb. 1960: 28-32).

Dover Publications: 54, illustrations from Ozenfant's *Founda-
tions of Modern Art* (1952), pp. 150 and 296-297.

Richard Hamilton collection: 17, 29 (fish shop), 30, 36
(Smithsons), 40 (Pasmore), 46, 47 ("Glorious Technicul-
ture"; T. Hamilton), 48 (Fine Art Dept.), 49 130, 132
(Installation), 138 (side panel), 139, 160 (ICA), all by
Hamilton; 39 (Newcastle), 160 (Hutton) by Univ. of
Newcastle Department of Photography (set-up by
Hamilton); 28 (Terry H.) by Mark Lancaster; 42, 68
(R.H.), 178 by Terry Hamilton. Hamilton archives:

27 (Black Lagoon), 28 (re Nude), 32 (This Island Earth),
36 (McHale, Cordell, Stirling), 42, 68 (Hommage),
69 (Just what is it...?), 82 (installation), 120 ("Sungazer"),
132, (Terry H.), 160, (ICA), 161.

Janet Henderson collection and the Nigel Henderson
estate: 14 (Hunstanton), 16 (Judith Henderson), 18
(shop), 22 (Parallel), 23, 37, 94, 116, 126, 127, 128 (Parallel),
129, 138 (Group Two panel), 140, 141 (patio floor), 228
(studio), all by Nigel Henderson. Henderson archive
photographs: 16 (N.H.), 47 (N.H.), 76 (N.H.).

Biff Henrich: 65, 66, 67, 89, 90, 91, 92, 93.

Geoffrey Holroyd collection: 37 (with M. Farr), 146, 147, all
by Brian Shawcroft.

Institute of Contemporary Arts, London: 12 (*Forty Thousand
Years...*, both), 13 (*Aspects*; sculptures by E.P. and W.T.), 15
(Lannoy; Members' Room; Ten Decades), 16 (Growth and
Form), 18 (Kloman, et al.), 19 (del Renzio and F.P.), 20
(F.P.), 21 (del Renzio), 22 (Opposing Forces), 24 (Wonder and
Horror), 26, 39 (an Exhibit, ICA).

Industrial Design: excerpts from "Industrial Design and Popu-
lar Art" by Reyner Banham (March 1960: 61-65).

Sam Lambert estate: 28 (McHale in studio; McHale, Turn-
bull), 33 (Cordell), 35 (McHale and Cordell), 64
(sculpture), 88, 137, 138 (Group Two, front and back
views), 142 (Group Eight), 148 (Groups Three and
Four), 149.

Kim Lim: 121 (fig. 3).

Magda Cordell McHale collection: 45, 64 (portrait), 87
(portrait), all by E. Wilson; 87 (diner), John McHale;
Sam Lambert photos (first seven listed above). McHale
archive: 58 (earth view tear sheets).

Dorothy Morland collection and Roland Penrose estate: 13
(Penrose, et al.), Lee Miller.

National Arts Education Archives (U.K.): 214 (figs. 2-4), 215
(figs. 7-8).

Archive of the Department of Fine Art, University of
Newcastle-upon-Tyne: 215 (figs. 5-6, 9), 216, 217, 218,
219.

Oxford University Press, New York: 56, illustration from
Sigfried Giedion's *Mechanization Takes Command* (1948),
p. 580.

Eduardo Paolozzi collection: 20 (collage).

Paul Theobald Publishers, Chicago: 56, illustration from
Laszlo Moholy-Nagy, *Vision in Motion* (1947: 253).

Penguin Books, Harmondsworth 233.

Michael Pine collection: 142 (two of "bubble" sculpture),
143, all by David Wager.

Royal College of Art, London: text of "But Today We Col-
lect Ads" by Alison and Peter Smithson (*Ark* 18, Nov.
1956: 48-50); text of "Personal Statement" by Lawrence
Alloway (*Ark* 19, Spring 1957: 28); 40 (Roger Coleman,
from *Ark* 18, Nov. 1956: 23); 222 (Hotpoint kitchen,
from *Ark* 19, March 1957: 27).

Alison and Peter Smithson collection: 12 (A.S. and Crosby);
19 (ceiling; A.S.); 32 (A.S. and Simon); 34 (House of the
Future); 36 (Pogo chair); 48 (A.S.); 109 (Hunstanton
drawing); 141 (side of pavilion), all by Peter Smithson;
21 (Jenkins and Smithson) and 110 (Sheffield drawing)
by Alison Smithson. By other photographers: 109 (por-
trait), Anne Fischer; 110 (Hunstanton), Maltby; 110

(House of the Future), John McCann; 111 (Sugden
House), William Toomey.

The Tate Gallery, London: 25 (Reg Butler), and all photos by
John Webb.

Thames and Hudson Publishers, London: text of "Letter to
Peter and Alison Smithson" by Richard Hamilton (*Col-
lected Words* 1953-82: 28-29).

Time-Warner, Inc., New York: 59 (Plymouth ad from *Life*,
April 11, 1955).

William Turnbull collection: 117, 13 (W.T.), Rune Hassner.

Turner Enterprises, Inc., Culver City, Calif.: 60 (poster) and
62 (still) from *Forbidden Planet*.

Vanguard Press, New York: 58, illustration from Marshall
McLuhan's *The Mechanical Bride* (1951: 95).

Venturi, Scott Brown and Associates,: 205.

John Webb: 97, 98 (nos. 47, 48), 101 (no. 53), 103, 104 (no.
58).

Graham Whitham: 12 (ICA, Dover St.).

Colin St. John Wilson collection: 22 (E.P. maquette), 44, 69
("Hers is a lush..."), 134. 44 and 69 by Arthur Baker.

Patrick Young: 108 (no. 66).

CONTRIBUTORS TO THE CATALOGUE TEXTS

Lawrence Alloway's most recent book is *Network: Art in the Com-
plex Present* (1984). Currently he is collecting information for
a study of recent women's art in the United States.

Jacquelynn Baas is Director of the University Art Museum at
the University of California, Berkeley. Among her recent
publications is "Reconsidering Walter Benjamin: The Age
of Mechanical Reproduction in Retrospect" in *The Docu-
mented Image: Visions in Art History* (1987). She is currently
completing a book on Orozco's Dartmouth murals.

Theo Crosby organized *This Is Tomorrow* in 1956 and dissemi-
nated the ideas of the IG milieu as co-editor of *Architectural
Design* and as editor of five issues of *Uppercase* (1958-61) and
three of *Living Arts* (1963). He is an architect and designer
with the Pentagram Design Partnership in London, which
he founded in 1972. Among his best-known publications
are *Architecture: City Sense* (1965) and *The Necessary Monument*
(1970).

Barry Curtis teaches cultural studies and film at Middlesex
Polytechnic, London, and is co-editor of *Block* magazine,
for which he has written many articles. His essay on the
Festival of Britain is to appear in *Making Exhibitions of Our-
selves* (1990).

Diane Kirkpatrick is Professor and Chairman of the Depart-
ment of History of Art at the University of Michigan. She is
the author of *Eduardo Paolozzi* (1969) as well as numerous
publications on twentieth-century art.

James Lingwood is now an adjunct curator at the ICA, after
serving as curator of exhibitions for several years. Recent
publications include *Une Autre Objectivité* (with Jean-François
Chevrier, 1989) and *S. I. Witkiewicz, Photographs 1899-1939*
(1989).

David Mellor is Lecturer in History of Art in the School of
English and American Studies at the University of Sussex.
Recent publications include *Cecil Beaton, A Retrospective* (1986)
and *A Paradise Lost: The Neo-Romantic Cultural Imagination
1935-55* (1987). He is currently preparing an exhibition on
British culture in the 1960s for the Barbican Art Gallery.

David Robbins was Lecturer in English at the University of
Michigan and co-founder of Bear Claw Press. He is a free-
lance writer and editor in Berkeley, California, and is
currently writing a history of postmodernist architectural
theory.

Denise Scott Brown is engaged in several ongoing projects
with Venturi, Scott Brown and Associates, including the
addition to the National Gallery in London and a planning
study for Dartmouth College. She is currently the Eliot
Noyes Visiting Professor in the Graduate School of Design
at Harvard.

Alison and Peter Smithson continue their diverse activities in
architecture and design, writing, and teaching. Throughout
the 1980s their architectural focus was on their series of
new buildings at the University of Bath, where Peter
Smithson is Visiting Professor in the Department of Build-
ing Engineering and Architecture. They are now designing
furniture with Tecta in West Germany.

David Thistlewood is Lecturer in the School of Architecture at
the University of Liverpool and editor of the *Journal of Art
and Design Education*. His most recent book is *Herbert Read:
Formlessness and Form: An Introduction to his Aesthetics* (1984). He
has published extensively on the history of design educa-
tion.

Graham Whitham is Lecturer in Art and History of Art at
Orpington College of Further Education, Kent, and a Chief
Examiner for GCE Advanced Level. He has a degree in
graphic design and a PhD in art history from the University
of Kent. He is married with two children.